Public Monuments and Sculpture Association
National Recording Project

Public Sculpture of Liverpool

PMSA

PUBLIC SCULPTURE OF LIVERPOOL

Terry Cavanagh

UNIVERSITY OF LEICESTER

LIVERPOOL UNIVERSITY PRESS

First published 1997 by LIVERPOOL UNIVERSITY PRESS,
Liverpool, L69 3BX

The work on which this book is based
was undertaken by the author with the support of
The University of Leicester and
National Museums & Galleries on Merseyside

The National Recording Project is supported by the
National Lottery through the Heritage Lottery Fund

British Library Cataloguing-in-Publication Data
A British Library CIP record is available

ISBN 0-85323-701-8 (cased)
ISBN 0-85323-711-5 (paper)

Design and production, Janet Allan

Typeset in 9/11pt Stempel Garamond
by XL Publishing Services, Lurley, Tiverton
Origination by Radstock Reproductions Ltd, Midsomer Norton
Printed and bound in Great Britain by
Butler & Tanner, Frome and London

Preface

Since its foundation in 1991 the Public Monuments and Sculpture Association has had as its main aim the raising and maintenance of public awareness of our national heritage of public monuments and sculpture. It soon became clear however that to perform this function effectively it was necessary to establish a public record of the objects we were concerned with, that is to provide an accessible information resource to underpin any programme of conservation, research, education and enhanced appreciation. While there existed a number of local and limited national surveys – as well as a specific project, the National Inventory of War Memorials – these varied very much in scope and nature, and it was clear no single, fully comprehensive record existed. To meet this need the PMSA set up the National Recording Project on a limited scale, establishing a system of Regional Archive Centres based at host institutions in selected cities across Britain. With the provisional award of a substantial grant from the Heritage Lottery Fund the practical implementation of the national survey, which will build a public archive on database and in book form, has become a realistic objective.

A crucial feature of our submission to the Heritage Lottery Fund was the preparation of a valid pilot project. Among the local surveys already existing was that initially compiled under the supervision of Timothy Stevens while Director of the Walker Art Gallery which covered Merseyside and beyond. This provided a base for the pilot scheme that the present volume encompasses. With a grant from the University of Leicester Terry Cavanagh was engaged as a research assistant to write the text with the guidance of Professor Alison Yarrington, Head of the University's History of Art Department. We are most grateful for the University's unfailing and generous support for the PMSA's project, and to Terry Cavanagh for his authorship.

At Liverpool we are particularly grateful to National Museums and Galleries on Merseyside for making accessible the original sculpture survey and for providing considerable support in cash and in kind, as well as the tireless services of Edward Morris, Curator of Fine Art at the Walker Art Gallery, who has fostered the project from the start through his considerable regional contacts and knowledge, and who was able to supply the services of Martin Barnes (now of the Victoria and Albert Museum) for some last-minute revisions. The project received in addition significant extra financial support from John Lewis, through the inimitable agency of John Larson of the National Museums and Galleries on Merseyside Sculpture Conservation Department. The National Inventory of War Memorials under the co-ordination of Catherine Moriarty, who helped establish the NRP in its early stages, has provided helpful information on some of the city war memorials. Professor Wallace Pitcher of the University of Liverpool provided useful geological information.

The National Recording Project was first set up under my chairmanship, but when I was persuaded to take over this office for the PMSA as a whole, Ian Leith of the Royal Commission on the Historical Monuments of England was unanimously selected as my successor. There can be no doubt the successful momentum of the project up till now and (we confidently expect) into the future owes much to his knowledge, enthusiasm and determination. His contribution overall has of course been matched by that of Jo Darke, the National Recording Project's Co-ordinator, and we are most grateful to the Henry Moore Foundation and its Director, Tim Llewellyn, for providing the financial means to support Jo in this role. Lastly I would like to thank our publisher, Robin Bloxsidge of Liverpool University Press, for his courageous support of our project.

On behalf of the PMSA and indeed of all those who love and appreciate our great national treasure trove of public monuments and sculptures I wish to thank all those I have mentioned for their help in getting this major achievement under way.

BENEDICT READ
Chairman PMSA, University of Leeds

Note: It is inappropriate to single oneself out for mention, but it needs to be recorded that it was at Benedict Read's prompting and through his encouragement that the PMSA put into practice one of its original objectives – the National Recording Project. Our thanks are due to Ben for his unfailing and active support. – JD

Contents

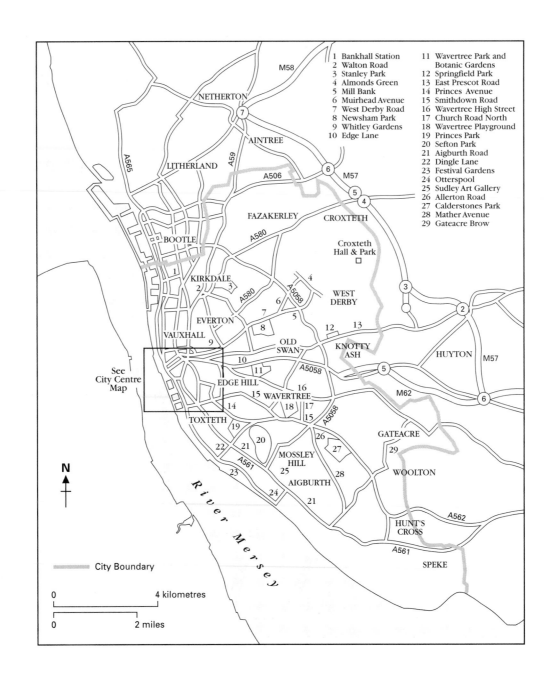

1 Bankhall Station
2 Walton Road
3 Stanley Park
4 Almonds Green
5 Mill Bank
6 Muirhead Avenue
7 West Derby Road
8 Newsham Park
9 Whitley Gardens
10 Edge Lane
11 Wavertree Park and Botanic Gardens
12 Springfield Park
13 East Prescot Road
14 Princes Avenue
15 Smithdown Road
16 Wavertree High Street
17 Church Road North
18 Wavertree Playground
19 Princes Park
20 Sefton Park
21 Aigburth Road
22 Dingle Lane
23 Festival Gardens
24 Otterspool
25 Sudley Art Gallery
26 Allerton Road
27 Calderstones Park
28 Mather Avenue
29 Gateacre Brow

City Boundary

0 4 kilometres

0 2 miles

N

River Mersey

GREAT HOWARD STREET
KING EDWARD ST
OLD HALL STREET
PALL MALL
LEEDS STREET
VAUXHALL ROAD
MARYBONE
GREAT CROSSHALL ST
BATH STREET
NEW QUAY
CHAPEL STREET
TITHEBARN STREET
MOORFIELDS
HATTON GDN
STANLEY ST
DALE STREET
NEW ISLINGTON
ISLINGTON
SHAW ST
MOSS ST
DAULBY ST
ERSKINE ST
PRESCOT STREET

Stock Exchange
Queensway Tunnel Entrance
CHURCHILL WAY SOUTH
John Moores University
Liverpool Museum & Library
Walker Art Gallery
MONUMENT PLACE
Royal Liverpool University Hospital

St Nicholas Church
Exchange Flags
Town Hall
QUEEN SQUARE
WLM BROWN ST
St John's Gardens
St George's Hall & Plateau
LONDON ROAD
SEYMOUR ST
PEMBROKE PLACE

ST NICHOLAS PLACE
WATER ST
CASTLE ST
India Building
VICTORIA STREET
WHITECHAPEL
HOOD ST
DAWSON ST
ROE ST
LIME STREET
Lime Street Station
COPPERAS
RUSSELL ST
HILL
University of Liverpool
Victoria Building
BROWNLOW HILL

Royal Liver Building
THE STRAND
GOREE PIAZZA
NORTH JOHN ST
COOK ST
MATHEW ST
LORD ST
CLAYTON SQUARE
RANELAGH STREET
BROWNLOW HILL
MOUNT PLEASANT
CLARENCE ST
Cathedral (R.C.)
MNT PLEASANT
University of Liverpool

Cunard Building
JAMES ST
Cavern Quarter
DERBY SQUARE
CHURCH ST
Bus Station
SCHOOL LANE
Central Station
RENSHAW STREET
MARYLAND STREET
John Moores University
HOPE ST
Everyman Theatre
University of Liverpool

Pier Head
George's Dock Building
SOUTH JOHN ST
STREET
Bluecoat School
WOOD STREET
CONCERT STREET
BOLD STREET
LEECE STREET
HARDMAN STREET
Philharmonic Hotel
MYRTLE ST
OXFORD STREET

Mersey Dock and Harbour Board Building
STRAND STREET
PARADISE STREET
HANOVER STREET
BERRY ST
RODNEY ST
Philharmonic Hall
CANNING STREET
CATHARINE STREET
MYRTLE ST

Maritime Museum
Tate Gallery
Albert Dock
WAPPING
PARK LANE
DUKE STREET
GREAT GEORGE STREET
UPPER DUKE STREET
HOPE STREET
Cathedral (C. of E.)
UPPER PARLIAMENT STREET

Wapping Dock
CHALONER STREET
JAMAICA STREET
ST JAMES'S STREET
Queen's Dock
PARLIAMENT STREET
PRINCE'S ROAD

0 400 metres
0 400 yards

Introduction

Liverpool possesses an abundance of monuments and sculpture in its public places, unsurpassed by any other city in England, excepting only London. That this should be so reflects the confidence of a city that in Victorian and Edwardian times was the principal port for trade with the Americas. It is the purpose of the present catalogue to document as fully as possible the complete range of the public monuments and sculpture of Liverpool from the earliest surviving item to the most recently erected. Just one clearly-defined category has been excluded from the survey: sculpture in an ecclesiastical context or executed for a sepulchral purpose, a category vast in extent, and necessarily forming the subject of a separate study. What remains is a rich and multifarious concentration within the city of not only independent pieces, such as grand monuments, portrait statues, abstract sculptures, and commemorative fountains, but also sculpture executed to embellish the city's civic and commercial architecture. Each item in the catalogue has been individually viewed and, where circumstances have allowed, closely examined. The physical evidence thus gathered has then been put into its historical context wherever possible, using contemporary sources, both archival and published, relating to the stated motivations of the patron(s), the selection of the artist, and the reception of the work.

Liverpool Public Sculpture up to the Second World War

The golden age of Liverpool's commercial prosperity in the nineteenth and early twentieth centuries is neatly paralleled in the overall chronology and specific historical concentration of the city's public monuments and sculpture. The earliest surviving example of a freestanding sculpture, from 1799, is the seated figure of *Britannia* on the dome of the Town Hall. Throughout the nineteenth century public commissions increased, reaching their greatest number during the second half of the nineteenth century and continuing, with only a slight reduction, throughout the Edwardian period.

The very types of sculptures commissioned were in themselves responsive to the changes taking place in Liverpool society. The earliest are expensive, comparatively large-scale monuments, erected to national figures such as Lord Nelson (1813) and King George III (1822), with Liverpool not only parading its nationalism and loyalty,

but also attempting thereby to assert its wealth and civic preeminence over rival towns. As with any artificially imposed historical construction, however, this early phase does not end conveniently as the next begins and three more large-scale monuments were to be erected later in the century. The first, the *Wellington Memorial* (1863) was occasioned by the death of the 'Iron Duke' in 1852, but was motivated, not by the achievements of his later, political career but, as the imposing list of his victorious battles indicates, by his services to the nation as commander of the British land forces in the Napoleonic wars at the beginning of the century. The next was stimulated by the premature death in 1861 of the much-loved Prince Albert. In response to this national tragedy, the Corporation of Liverpool, in common with many others throughout the realm, voted to express its loyalty with a large and imposing memorial in the civic centre. Liverpool's *Equestrian Monument to Prince Albert*, paid for with £5,000 of corporation money, was erected outside St George's Hall in 1866, to be joined by a companion *Equestrian Monument to Queen Victoria*, also costing £5,000, in 1870.

The next phase is represented by the raising of portrait statues to local worthies. From the *Statue of William Roscoe* (1841) onwards, there is a gradual increase in the numbers of local men who had achieved sufficient national prominence in the estimation of their fellows to merit lasting public commemoration. With the opening of St George's Hall in 1854 and its potential accommodation inside for twenty-six statues in niches around the Great Hall, plus six more outside on pedestals under the east portico, a veritable outburst of public commemoration was engendered. Between 1854 and 1911, twelve portrait statues were erected within the Great Hall, with one further in the Hall's North Vestibule. By the end of the century, the relatively exclusive confines of St George's Hall were to be superseded by the newly-created, slightly more egalitarian St John's Gardens, Liverpool's 'alfresco walhalla', with spaces for eight monuments. One space was never filled, but of the remaining seven, six were taken up between 1889 and 1907 by statues to local men (the seventh being the *Memorial to the King's Liverpool Regiment*).

In fact, the great majority of the public sculptures erected throughout the entire nineteenth century in Britain are commemora-

tive statues and almost all were erected by committees of men, in honour of men. Liverpool is no different in this respect and if monuments to Victoria in her guise as the reigning monarch are excluded, there are just three nineteenth-century monuments erected to women. The earliest, Pietro Tenerani's *Monument to Agnes Jones*, commemorates the nurse who, in 1868, at the age of 35, died from typhus contracted as a direct result of her pioneering work in the workhouse at Brownlow Hill, otherwise known as the Brownlow Hill Institute. (This monument, currently housed in the Oratory, St James's Cemetery, stood originally in the chapel of the workhouse, and is therefore outside the scope of the present catalogue.) The second was dedicated to Hannah Mary Thom (died 1872), both nurse and charity worker (see below, pp. 107–8); while the third, privately funded by Sir James Allanson Picton, was erected in 1884 as a personal tribute to his deceased wife, Sarah (see below, p. 244). The reasons for this imbalance are clear enough: during the nineteenth century women did not have the vote, could not serve in the armed forces, were excluded by and large from public life and, once married, rarely had independent wealth. Therefore they could not become politicians or soldiers and only in exceptional circumstances could run businesses or become public benefactors – which covers most of the principal spheres in which public commemoration was likely to occur.

The wealth and optimism of the early twentieth century in Liverpool was given grandiose expression with the creation of the Pier Head area, set between the bank of the River Mersey and the splendid backdrop of Edwardian commercial architecture formed by the Mersey Docks and Harbour Building (1907), the Royal Liver Building (1911), and the Cunard Building (1913). The Pier Head provided an ideal location for public sculpture and yet, of the four major memorials erected between 1913 and 1921, it is perhaps significant that the only one to a Liverpool worthy, George Frampton's *Monument to Sir Alfred Jones* (1913), was erected before the First World War. Jones was the last individual (excepting royalty) to be commemorated in such a public way in Liverpool and even here it is obvious that the fashion for 'coat-and-trousers' portrait statues had passed. The sculptor's demotion of portraiture from its customary full-length domination atop the pedestal to a head-and-shoulders relief panel set into one of the pedestal's faces, and its replacement with a rather more sculptural symbolic figure, was praised by the majority of informed commentators. Indeed, the hope was expressed by at least one correspondent to the local newspapers that the memo-

rial committee then collecting for a monument to King Edward VII, would have the same good taste (see below, p. 137).

The plea went unheeded and the committee eventually erected a conventionally-conceived *Equestrian Monument to King Edward VII*. A significant point, however, is that had it not been for an exceptionally long period of gestation from the formation of the King Edward VII Memorial Committee in 1910 to the unveiling of the monument in 1921, caused firstly by extended wrangles over the site and then the more pressing concerns of the war years, the monument would have incorporated flanking allegorical figures (see below, p. 140). Had these original intentions been realised, the monument would at least have manifested the contemporary taste for elaboration, so characteristic of the multi-facial and multi-figured compositions predominating in Liverpool in the years before the First World War. These include the above-mentioned *Monument to Sir Alfred Jones* and the *Memorial to the Engine Room Heroes* (1916), both also at Pier Head, the *Memorial to W.E. Gladstone* (1904) and the *Memorial to the King's Liverpool Regiment* (1905) in St John's Gardens, and the architectural and sculptural extravaganza of the *Monument to Queen Victoria* (1906) in Derby Square.

Although the patrons who paid for these monuments and portrait statues were interested principally in getting a good likeness for their money, the pieces nonetheless inevitably reflect the aesthetic preoccupations of each generation of sculptors who made them. Thus, the history of nineteenth- and early twentieth-century British taste in sculpture can be followed in microcosm in Liverpool from the neoclassicism of Westmacott, Chantrey and Gibson in the first half of the nineteenth century, through the prosaic naturalism of Theed, Fontana, Adams-Acton, Birch *et al* in the second half, to the virtuoso stylisation of surface in the works of the so-called New Sculptors at the turn of the twentieth century. In fact, Liverpool has what is undoubtedly one of the most representative collections of New Sculpture in its public places. The leading practitioners – George Frampton, Goscombe John, F.W. Pomeroy, C.J. Allen, and Alfred Gilbert – are all well represented in St John's Gardens and Sefton Park, and at Derby Square and Pier Head.

The watershed of the First World War marks a virtual end to the public commemoration of the individual that had formed the backbone of sculptural commissions over the previous one hundred years. The major sculptural projects in the public domain in the inter-war years were for the most part either war memorials or architectural

decoration. War memorials are perhaps the most significant, certainly the most ubiquitous, form of public sculpture in Britain in the years following the end of the First World War. Liverpool gave permanent expression to its citizens' mingled feelings of pride in an heroic duty done and grief at the loss of so many loved ones in a number of war memorials, the most important of which is Lionel Budden and Herbert Tyson Smith's *Liverpool Cenotaph* at St George's Plateau, 1926-30 (see below, pp. 98–102). In these same years, the field of architectural sculpture was dominated by one or two local craftsmen-artists: Edmund Thompson (the India Buildings of 1932), Thompson assisted by George Capstick (the George's Dock Building and Queensway Tunnel entrance of 1934), and Herbert Tyson Smith (Martins Bank of 1932).

Architectural sculpture had, in fact, been a feature of many of the more prestigious buildings throughout the entire hundred-and-forty year period from the *Britannia* of 1799 through to the above-mentioned works of the 1930s, albeit representing only a small percentage of the total amount of public sculpture recorded. As a percentage of *surviving* public sculpture it is even smaller owing to its generally inseparable union with the building it decorates, lost more often than not when the building itself is damaged or destroyed. Civic buildings and commercial offices in an age of expansion are inevitably outgrown by the more successful of their owners and just as inevitably demolished to make way for bigger and sometimes more grandiose premises. The point may be made with the two following examples of architectural demolition which incurred incidental sculptural loss: in 1896 William Grellier's Royal Insurance Buildings of 1847 were replaced by J.F. Doyle's new buildings for the same company, destroying in the process C.S. Kelsey's sculptured doorway (see below, p. 303); and in 1937 T.H. Wyatt's New Exchange Buildings of 1863-67 were demolished to make way for Gunton and Gunton's more capacious replacement, thereby destroying W.F. Woodington's sculptured pediment (see below, pp. 301–3).

Presumably much more architectural sculpture has been lost, but remains unrecorded because of the attitude, certainly prevalent throughout much of the nineteenth century, that sculptural embellishment was inevitably subordinate to the building it decorated. This situation is reflected in the anonymity of many of the sculptural executants, an anonimity which, in turn, has a tendency to reduce interest in the work itself for later generations. It is significant that whereas both Kelsey and Woodington were successful enough in their own time to receive mention in contemporary accounts of the buildings they embellished, the sculptor or sculptor-masons who in the 1860s produced the Liverpool Municipal Building's sixteen eight-feet-high statues appear, by contrast, to have gone unrecorded. As each statue is loaded down with allegorical paraphernalia, they were presumably considered an important addition to the building's public image at the time of their erection, but not even the minutes of the Sub Building Committee make any mention of their executants.

Architectural statuary, by virtue of its potential detachability, should be salvable when the host building is demolished, but even where the name of the sculptor was considered by contemporaries to be worthy of recording, the work is not necessarily preserved. There are, for example, the contrasting cases of Edwin Stirling's *Atlantes* and *Four Seasons* from J.A. Picton's Brown's Buildings of 1861-63 and W.F. Woodington's statues of explorers and navigators on Wyatt's New Exchange, these latter being described by the *Art-Journal* at the time of their execution as 'works of great merit'. Both sets of statues were removed from their respective buildings prior to demolition earlier this century, but whereas Stirling's statues were relocated by Liverpool Corporation as charming embellishments to the Harthill Estate entrance to Calderstones Park (see below, pp. 11–13), Woodington's, although also donated to the Corporation, have since been inexplicably lost (see below p. 303). It must, however, be admitted that Stirling's and Woodington's cases are exceptional – much architectural statuary undoubtedly failed to rise above journeyman stonemason's work and was understandably considered unworthy of the effort that would have been involved in saving it.

Architectural sculpture is also more often than not executed in stone and is therefore extremely vulnerable to the combined ravages of the British weather and urban pollution. Statues in particular, in exposed positions high up on parapets and entablatures, assailed from all sides by wind and rain, have a relatively short life expectancy: of the ten Portland stone statues by W.B. Rhind and E.O. Griffith, formerly on Matear and Simon's splendid Edwardian Baroque Cotton Exchange of 1905-06, only three were salvaged when the frontage was demolished in 1967 and these are weathered almost beyond recognition (see below, pp. 123–4). A similar condition of extreme erosion can be seen in C.J. Allen's standing allegorical figures flanking the main entrance of the Mersey Docks and Harbour Building, c.1907 (see below, pp. 128–9), and the anonymous seated allegorical figures on Shelmerdine's City Transport Offices, c.1905-07 (see below, pp.

71–2). Furthermore, recent examination of the sixteen statues on the Municipal Buildings has revealed all of them to be in a similarly friable state (see below, pp. 31–2). Remarkably, the most exposed of all architectural sculptures, the Coade stone *Britannia* atop the Town Hall dome (see below, pp. 72–4), despite being the earliest surviving free-standing piece, nonetheless appears to have weathered the best: surely adequate testimony to the veracity of Mrs Coade's claims for the durability of her artificial stone.

Liverpool Public Sculpture since the Second World War
In the economically depressed years following the Second World War, the number of commissions for public sculpture reduced to a relatively small sprinkling. Nevertheless, there have been two major sites of sculptural patronage within Liverpool since the Second World War: the University of Liverpool precincts and the Festival Gardens. The latter effectively had its collection of eleven sculptures formed in one go at the time of the 1984 International Garden Festival and is unlikely to be added to, whereas the former has built up its collection gradually over the years since its establishment as a University College in 1881. In its early years, the University indulged in its share of straightforward portrait commemoration, awarding commissions for statues, busts, and reliefs of its various benefactors, founders, and more eminent professors. Since the Second World War, however, the most public of the University's sculptures, by Dalwood, Hepworth and King, are intended, like those at Festival Gardens, to be viewed simply as works of art. The University's rationale for erecting sculpture in the precinct was stated in 1967 by Professor Myles Wright:

> ...students who will form the future leaders of the nation need to be brought into contact with works of art, and all the more so if these have been lacking in the environment from which they come (as quoted in Carpenter, 1989: 61).

Private enterprise has, perhaps unsurprisingly, not been a major patron in the domain of public sculpture in Liverpool: when financial resources are hard-pressed and when most businesses today are accountable to their shareholders, a quantifiable benefit must be seen to accrue from any significant outlay of money. The hard-headed Corporations of the nineteenth century who voted large sums of public money to major monuments, and the merchants, financiers and entrepreneurs who contributed their guineas to public subscriptions, were not funding first and foremost work of arts *per se*, so much as self-aggrandising monuments to themselves, their fellows and their

town. This must be seen as a major reason why the overwhelming majority of public sculptures in Liverpool, as in any major town or city, are portrait statues. They were erected, as was often stated in the extensive speeches that generally accompanied the official unveiling of any public statue, as a reward for conspicuous service to the community and as an incentive to others to do the same.

An encouraging sign for the continuance of public sculpture production in Liverpool is the presence of the Merseyside Sculptors Guild, a local training ground for aspirant sculptors and stonemasons, centred around Herbert Tyson Smith's old studio in the Bluecoat Chambers. The Guild was established and is presently run by three of Tyson Smith's former assistants: John Hogg, James McLaughlin and Terence McDonald. Their aim is to develop in their pupils the same traditional craft skills taught to them by their own master, Tyson Smith. The Guild's public commissions in Liverpool have to date been rather modest, for example the terracotta reliefs for the Villa Romana Restaurant in Wood Street (see below, pp. 299–300) and the bronze resin portrait roundel of Aldham Robarts for Liverpool John Moores University's Learning Resources Centre in Rodney Street (see below, p. 168). Their aspirations are rather grander, however, centering on no less a project than the replacement of the lost pediment sculpture of the south portico of St George's Hall. A one-sixth scale model has been made based on the original lithographs of W.G. Nicholl's sculpture; the will and arguably the skill are there to execute the actual work; but, unfortunately, full financial support has not yet been found. As Professor Quentin Hughes has said: 'They need our full support. Maybe we shall see [the pediment sculpture] back in place, a fitting climax to so splendid a monument' (Hughes 1964, 1993 postscript: 187).

Pattern of Patronage: The nineteenth and early twentieth centuries
The majority of contemporary documentation relating to sculptural patronage throughout the nineteenth and early twentieth centuries is to be found in the minute books of the corporation committees that voted corporation funding for, or gave corporation approval to, the erection within the city of statues and monuments to national and local worthies. The steps required to secure the sculptural commemoration of each individual were fairly similar. A group of citizens would gather together to discuss how best they might pay public tribute to a living fellow or commemorate the life-time achievements

of one recently deceased. If a certain degree of unanimity within the assembled company was reached, the Mayor would usually be petitioned to call a public meeting in order to generate the maximum of interest and commitment across the widest spectrum of citizenry possible. The meeting having expressed positive support for a permanent monument, a Memorial Committee would be elected, consisting in some cases of a relatively large number of individuals – for example, twenty-one for the *Nelson Monument*, fifty-one for the *Statue to George Canning*, and a remarkable one hundred and seven for the Sefton Park *Statue to William Rathbone* – too many to act as an executive body, but necessarily large in order that it comprise the maximum of influential supporters who would be willing to actively canvass subscriptions. From this body, thereafter called the General Committee, a much smaller Executive Committee, comprising a handful of citizens, would be formed to select a sculptor and oversee the execution of the work. This body was not usually empowered to act autonomously, however, and major decisions or changes of plan would have first to be approved by the General Committee.

There was often an upper limit to the amount donated under any individual subscription. This was imposed in order to spread the 'franchise' as widely as possible. William Rathbone expressed the sentiment fully in an early meeting convened to discuss the proposed memorial to S.R. Graves:

> I... propose the amount of contribution is limited to five guineas. The object, I am informed, of the limit, is that, as many will wish to contribute, there shall be no great preponderance of one over another, but that the subscription shall be on such a footing that all can contribute without making too great a difference between their contributions (*Liverpool Mercury*, 27 January 1873).

When, in 1892, it was suggested that a limit of ten guineas be imposed on the subscriptions to the proposed *Statue of Edward Whitley* for St George's Hall, the objection was raised in the *Liverpool Courier* (23 January 1892) that such a high limit would deter the working classes from contributing and the limit was immediately reduced to five guineas. Although it was vital to reach the necessary subscription target, it was perhaps even more vital that the monument to the individual should also be a monument to social cohesion, a tangible reminder of a unified and general movement to affirm values held in common by the entire community. Even five guineas was, of course, way beyond the means of any individual member of the working classes and, when it was felt that the person to be commemorated was held by them in particular affection, special arrangements might be made to organise collections door-to-door (as in the *Memorial to Canon Lester*, below, p. 183) or within the workplaces (as in the Sefton Park *Memorial to William Rathbone*, below, p. 190).

Choice of Site
In the early stages of any subscription a formal request would be made to the Corporation for permission to erect the intended monument. A specific site would be nominated and, unless there were problems of a practical nature inherent in the site itself, the request was usually approved. Such problems included the potential traffic congestion which the Corporation feared might result from the erection of Chantrey's *Canning Statue* at St George's Crescent (see below, p. 78) and from the proposed demolition of the high podium at the south end of St George's Hall in order to accommodate Goscombe John's *King Edward VII Statue* (see below, p. 142). Problems such as these were, however, exceptional. Given that most of the memorial committees included within their ranks members of the very Corporation committees to whom application had to be made for a specific site, approval was rarely denied.

In the more straightforward cases, the Honorary Secretary of the particular memorial committee would write to the Liverpool Corporation Finance and Estate Committee for permission to erect the monument at the specific location. Supposing the petition was received favourably, the Finance and Estate Committee would then convey its recommendation to the Council for consideration and approval at its next meeting. In some cases the proposed location might lie within the administrative responsibility of one of the more specific Corporation committees, in which cases they would either be approached directly by the Memorial Committee or else the Finance and Estate Committee might itself refer the matter to them: the Parks Committee (known until 1873 as the Improvements Committee) would be consulted where monuments were intended for erection in a public park or in St John's Gardens; the Health Committee when a drinking fountain was proposed for erection in an urban space, and the St George's Hall and Law Courts Committee (operating from 1840 until 1866 when its fuctions were superseded by the Finance and Estate Committee) when a statue was intended for St George's Hall or the Plateau.

Selection of the Artist

It should perhaps first be stated that throughout the entire nineteenth and early twentieth centuries there is no evidence to suggest that female sculptors were considered for public commissions in Liverpool, nor even that any competed for them. Given then, that this situation prevailed, it will be assumed in the ensuing section that the artist is at all times male.

The selection of architects and/or sculptors occurred usually when the memorial committee was able, or thought it was able, to gauge the likely size of the subscription. Once selected, a contract would be drawn up with the artist(s), including an agreed time scale for completion of the work and the method of payment. This was usually divided into three equal payments: the first upon submission of an approved design, the second upon completion of the full-scale model and the last once the work was completed.

The method of selection for public commissions took a number of forms, the most controversial being the open competition. Its merits, as far as the commissioning body was concerned, were the apparent increase of options from which to choose and the belief sometimes that an artist who had not yet established his reputation and who would therefore be prepared to do the job for a lower sum, might just also be the one to produce the best design solution. Indeed, in any open competition it always has been more than likely that the entries will be submitted chiefly by little-known artists. There are several reasons for this, but perhaps the most important is the understandable reluctance on the part of an established artist to place his reputation in jeopardy by entering a competition only to be beaten by a relatively unknown rival (Yarrington, 1989: 24). At the heights of their careers, both Sir Francis Chantrey and John Gibson, the two most successful British sculptors of their generation, refused to enter open competitions (see pp. 76, 151, below). Gibson gave his reason as a lack of confidence in the aesthetic judgement of committees which, it is true, did not always incorporate within their ranks a professional artist or critic. But, undoubtedly, there must also have been an understandable feeling among those artists at the tops of their professions that their previous work and their acknowledged ability, borne of years of experience, should have been enough to establish the correctness of their credentials.

Most usually, a sculptor was selected on the basis of his reputation – whether based on his acknowledged ability with a particular sort of sculpture, or the presitigious clients he had hitherto worked for, or the work he may have already executed in Liverpool, or a mixture of any of these factors. In some instances where a portrait statue was required, the commissioning body devolved selection of the artist to the subject (for example Queen Victoria selected Thornycroft, the Earl of Derby Theed, and possibly Gladstone Adams-Acton).

A particularly interesting phenomenon is the shift in the fortunes enjoyed by Liverpool-based artists throughout the period covered by this catalogue. Throughout most of the nineteenth century, the more prestigious public commissions were inevitably awarded either to London-based artists, or to artists born locally or with local connections, but working from studios in Rome (e.g John Gibson and B.E. Spence). This situation is most poignantly highlighted by the failure of George Bullock to win the competition for the *Nelson Monument* in 1807 (see below, pp. 54–5) and that of J.A.P MacBride to secure the commission for the *Wellington Monument* in 1861 (see below, pp. 27–8). This lack of success contrasts sharply with the growing influence of local artists from the late nineteenth century up until the Second World War, commencing with C.J. Allen's and Conrad Dressler's relief panels for St George's Hall (see below, pp. 263–4), the many other major commissions won by Allen in the early twentieth century (most notably the *Monument to Queen Victoria*; see below, pp. 36–43), and the later success of his pupil, Herbert Tyson Smith.

The Unveiling Ceremony

The monument having been successfully executed and erected, an official unveiling ceremony would be arranged with the most prestigious guest available invited to officiate. These ceremonies appear to have been extremely popular occasions throughout the nineteenth century, the local newspapers covering each unveiling in great detail. The extended eulogies delivered by the succession of committee-members and honoured guests were apparently fully recorded and invariably peppered with the parenthetic "cheers", "hear-hears", "applause" and even on occasion "loud and extended applause" of crowds that attendant reporters frequently emphasised encompassed all classes and creeds. One of the biggest occasions was the unveiling of Thornycroft's *Equestrian Statue of Queen Victoria* in 1870. Notwithstanding the fact that neither the monarch herself, nor any member of the royal family, nor the then Prime Minister, Liverpool-born W.E. Gladstone, was able to attend the ceremony and that it again devolved to the Mayor of Liverpool to officiate, crash barriers had to be set up and a crowd reportedly numbering 200,000 lined the

processional route from the Town Hall to St George's Plateau, with between 20,000 and 40,000 people witnessing the unveiling itself on the Plateau (*Liverpool Mail*, 5 November 1870).

More often than not the sculptor of the monument or statue would be in attendance and sometimes even be allowed to deliver his own short speech. Only on one occasion, though, does it seem that a sculptor was actually called upon to unveil his own work and that was in 1870 when G.G. Adams had to do so for his *Statue of the Revd Hugh McNeile* in St George's Hall (see below, pp. 280–2). McNeile, with his vituperative anti-catholicism, was perhaps such a controversial figure that even those councillors who had forced through his commemoration thought it wiser to abstain from such an open declaration of affinity.

Pattern of Patronage: The second half of the twentieth century

In the second half of the twentieth century the pattern of public patronage is more fragmented. At least two major commissions – the 1963 *Littlewoods Sculpture* and the 1993 *Time and Tide* group for the Customs and Excise Building – were awarded through open competition. Both competitions were again won by relatively unknown artists. The failure of the first competition to attract any big names was predicted on the day of its launch by Professor Bernard Meadows, then Head of Sculpture at the Royal College of Art:

...a project of this sort is going to take quite a lot of time – most established sculptors are so busy that they're not going to spend their time working on something which may or may not come off...established sculptors with an international reputation aren't really worried whether they win a prize in a competition or not (from a transcript of a *Radio Newsreel* interview, BBC Light Programme, 21 May 1963, in the Littlewoods Organisation company archives).

The limited competition, in which a specific group of sculptors is invited to participate represents perhaps a rather more considered approach, but one which few commissioning panels have taken. Perhaps this is because the initial selection of not just one, but a number of appropriate artists, presupposes an expertise not necessarily present within the ranks of any commissioning body. When the University of Liverpool decided on a limited competition for a sculpture to go outside the new Physics Building in 1958, it was because the building's architect, Sir Basil Spence, had advised the University

there was a school of very promising young British sculptors, arguably of world class, who were then in the actual process of making their names both at home and abroad. Five of the invited sculptors responded positively, namely Robert Adams, Kenneth Armitage, Hubert Dalwood, William Turnbull and F.E. McWilliam, with Robert Clatworthy and Austin Wright later replacing Armitage and McWilliams who had been forced to withdraw through pressure of existing work. It is testament to the soundness of Spence's informed judgement, that all of the above 'rising stars' are now regarded as among the most important British sculptors of their generation. In this case, as in most others in the post-war years, it is the erection of a building that provides the motivation for commissioning a publicly-sited piece of sculpture.

The increased availability of good colour photographs has provided selection panels with yet another mode of selection. They now have the opportunity to see existing works in similar architectural contexts, by any amount of sculptors. The object in these cases will be to purchase a typical piece from the sculptor or sculptor's agent. Usually the selection will be made in consultation either with the architect of the building the sculpture is intended to embellish (as in the case of Hepworth's *Squares with Two Holes* for the University of Liverpool Senate House; see below, pp. 226–7) or with the architect and an expert from the local art gallery (for example King's *Red Between* for the University of Liverpool Sydney Jones Library, selected in consultation with Timothy Stevens, then Director of the Walker Art Gallery; see below, pp. 227–8).

It is perhaps indicative of the problems facing anyone researching twentieth-century public sculpture that the three above-cited examples – the only ones in the present study with sufficient documentation to enable such a piciture to be formed – are all University commissions. In Liverpool it is only the University that has kept such consistent and accessible archival records: a similar wealth of material relating to the commissioning of public sculpture in the present century is nowhere else to be found. The Liverpool Record Office houses the minute books of Liverpool Corporation in an unbroken sequence running up until the 1960s. But whereas the nineteenth-century minute books are meticulously indexed, those of the twentieth century are not, making any search for information rather more laborious. Thus the circumstances behind the purchase of Richard Huws' *Piazza Waterfall* for Wilberforce House in 1966 are not presently known beyond the secondary information given in John

Willett's book, *Art in a City*. More recent records relating to sculpture, either managed or owned by the Corporation, are even more inaccessible, if they exist at all.

As for twentieth-century company archives, these are more liable to loss than those of the Corporation. This absence of documentary evidence even bedevils investigation into the genesis of what is undoubtedly the major piece of twentieth-century public sculpture in Liverpool, Jacob Epstein's *Liverpool Resurgent*, situated over the main entrance of Lewis's department store in Ranelagh Street (Silber, 1989: 103). A nineteenth-century public sculpture was almost invariably commemorative of a man whose celebrity was great enough to attract to the official unveiling very important guest speakers, large and enthusiastic crowds, and a suitably attentive and responsive press. Most of the documentary information that we do have relating to Epstein's *Liverpool Resurgent* is in fact from the local newspaper coverage of the unveiling which appears to have been the last to have been attended by sufficient spectators to warrant serious definition as a crowd. Epstein was, of course, a special case: by this time he was a grand old man of the art world, a knight of the realm and an artist whose public sculptures rarely failed to create controversy and sometimes even provoked extreme moral outrage (most notoriously, his nude figures for the BMA Building in London, unveiled in 1908; for which see Silber, 1986: 16-19).

Thus in this instance, and most unusually, it was the presence of the artist himself, coupled with the possibility of seeing something scandalous, that had drawn the crowds. Contemporary newspaper reports indicate that those who came to be scandalised were not disappointed. The explicit genitalia of the colossal nude figure (or 'Dickie Lewis' as he came to be popularly known), exposed in that most public of Liverpool's thoroughfares, over the very entrance to a department store patronised by respectable families, provoked a storm of controversy which raged with passionate intensity in the local press for weeks until, all passion spent, the public lost interest and the figure suffered the fate of most public sculpture, being subsumed into the fabric of the building and becoming, if not completely forgotten, at least largely ignored.

More recent unveilings seem to have been rather modest affairs, the size of the assembly of interested parties at most swelled by the momentary curiosity of passers-by. The very titles of the pieces explain the lack of popular interest: *Standing Figure*, *Renaissance*, *Reconciliation*, and *Time and Tide*. Today there is a greater diversity of more engaging entertainment readily available than could be provided by the unveiling of a piece of symbolic sculpture, executed by somebody of whom the majority of the population have never heard. In fact, the last and most recent of these examples was not so much unveiled as installed without ceremony.

The unveiling ceremony was, in any case, always more about the individual commemorated than the monument itself. Only when the individual's achievements have faded from popular memory can the intrinsic qualities of the commemorative monument as an attractive addition to the cityscape be properly evaluated. In the past, when a 'speaking likeness' was the main criterion of judgement, it was inevitable that the qualities of the monument as sculpture would be very much hit-and-miss. Given this situation, it is remarkable that there are public monuments in Liverpool of such high quality. The shift from a demand for portrait statues to a taste for art sculptures, and the continuing inclusion on the selection panels, of professionals from the Walker Art Gallery and the Tate Gallery Liverpool, must surely bode well for future commissions.

If a more consistent and committed approach to commissioning new works is important, the care of those already in existence is equally so. Exchange Flags would be visually much impoverished without the *Nelson Monument* as its centre-piece and yet even a passing glance reveals the delapidated state of the bronze; likewise Sefton Park without Gilbert's *Eros Fountain* and Frampton's *Peter Pan*, although these are thankfully now both the subject of conservation programmes. While the best of Liverpool's public sculpture may provide visual satisfaction, the collection as a whole gives the city identity by making public its civic, commercial and social histories: *W.E. Gladstone* in St John's Gardens, *The Beatles* in Cavern Walks and the shipworkers of Bews' *Time and Tide* at the Queens Dock each represent significant aspects of these histories. It is thus vital that this rich stock of public sculpture which provides such eloquent testimony to Liverpool's past greatness and present cultural wealth, is conserved and maintained for the enjoyment and edification of both present and future generations.

The Catalogue
The present catalogue is arranged in alphabetical order by location. In some instances, public access may be obtained only by prior arrangement, usually with the owner. Where this is the case, notice is given in the relevant entry. The information contained under each entry is as

detailed as accessable documentary sources and personal observation have allowed.

(i) Materials:
The information relating to the materials used for each item is as specific as possible. This may result at times in a certain imbalance between various entries, but it seemed of more use to designate an item as being of, say, 'Creetown granite' or 'Aberdeen granite', where information as specific as that is known (usually from contemporary accounts), even if in other cases, the material may only be listed as 'granite', or more loosely, 'stone' (the last instance being in the main only those entries where the items are relatively inaccessible to close examination).

(ii) Dimensions:
These are derived from a variety of sources, principally those taken by the author on site, those given in the Walker Art Gallery JCS files and those in contemporary newspaper accounts, the latter category being, until the end of the nineteenth century at least, extremely comprehensive and seemingly accurate. Wherever possible, the dimensions given in documentary sources have been checked against the monument or sculpture itself.

(iii) Ownership:
The ownership of the publicly-sited sculpture in this catalogue has not in all cases been easy to determine. Many pieces have been funded by public subscription and officially accepted into the care of the Corporation: in these cases the Corporation is actually custodian rather than owner, but in order to maintain consistency throughout the catalogue, its status here is defined as 'Owner/custodian'. Architectural sculpture and sculpture designed for a specific architectural setting also raises problems of ownership. It is reasonable to assume, in the absence of information to the contrary, that the owner of a particular building is also the owner of any fixed sculpture sited on it (e.g. *Liverpool Resurgent* on the Lewis's Building) or under it (e.g. the *Littlewoods' Sculpture* at the foot of the J.M. Centre). However, ownership has not been easy to ascertain in all cases (and not possible at all in a small number). Even where ownership appears to have been established, the designated company or individual may be anything from freeholder to head leaseholder (virtual owner) to sub-leaseholder (who may also be the occupier of the building).

Whilst every effort has been made to achieve accuracy, such specific definitions have not been possible to establish. Therefore all names that have been given by the respective companies or individuals have been designated simply as 'Owner'.

(iv) Listed status:
This information is taken from the lists of buildings of architectural and historical interest compiled by the Department of National Heritage (DNH). Free-standing monuments and sculpture are also potentially listable. Sculpture housed in or applied to a listed building automatically assumes the status of the building where it is part of the architect's original intention. Buildings and sculptures become eligible for listing thirty years after completion. The grades are designated as follows:
> Grade I. Works of exceptional interest.
> Grade II. Works of special interest, which warrant every effort being made to preserve them. Some particularly important works in Grade II are classified as Grade II*.

(v) Condition:
This section is not intended to be a technical evaluation, but merely an account of the visual appearance of the particular item at the time of viewing. In most cases this was undertaken during the first half of 1994.

(vi) Literature:
This section lists all significant known sources of information relating to a specific item, even where such information has not been used in the catalogue entry itself. Each 'Literature' section may be subdivided, the first section being archival material. In those cases where more than one archive has been used, the Liverpool Public Library Local Record Office (LRO), is listed first, followed by the University of Liverpool Archives, and then the archives of the Walker Art Gallery Job Creation Scheme Merseyside Sculpture Survey (WAG JCS). The last sub-division of each 'Literature' section is for published material, whether books, periodicals or newspapers. A newspaper may be listed either as a newscutting in the archival material sub-division, or as the newspaper itself in the published material sub-division; in the latter case the page number is given.
The sources, abbreviated according to the Harvard System, are given in full in the main bibliography pp. 342–8).

Abbreviations

The following abbreviations have been used in the catalogue:

1. Liverpool Public Library
LRO: *Local Record Office*
CH&T: *Cuttings Historical and Topographical Relating to Liverpool*
LCM: *Liverpool Cenotaph: Memorial Volume*
LTEB: *Liverpool's Three Exchange Buildings*
LTH: *Liverpool's Town Halls*
SPN: *Sefton Park – Newscuttings 1929 – 1958*
TCN: *Town Clerk's Newscuttings*
WAG 1877: *Documents and papers connected with laying the foundation stone, the opening ceremony...of the Walker Art Gallery, 1877*

2. University of Liverpool
NC: *Newspaper Cuttings 1922 to 1928*

3. Walker Art Gallery, Liverpool (WAG)
WAG JCS files: Walker Art Gallery archives, Job Creation Scheme files (Merseyside Sculpture Survey 1976/1977).

4. Other institutions
NMGM: National Museums and Galleries on Merseyside
RA: Royal Academy of Arts, Royal Academician (ARA: Associate of..., PRA: President of...)
RBS: Royal Society of British Sculptors (FRBS: Fellow of...)

RIBA: Royal Institute of British Architects (ARIBA: Associate of...; FRIBA: Fellow of...; PRIBA: President of...)
RSA: Royal Society of Arts (FRSA: Fellow of...)
TPI: Town Planning Institute (AMTPI: Associate Member of...)

5. Contemporary newspapers
In many instances, local newspapers have provided the principal source of information on public sculpture in Liverpool. During the nineteenth century in particular the reports were detailed and generally accurate. The following are all Liverpool titles and feature frequently in the bibliographies for each catalogue entry: *Liverpool Weekly Albion, Liverpool Chronicle, Liverpool Courier, Liverpool Weekly Courier, Liverpool Daily Dispatch, Liverpool Daily Post, Liverpool Echo, Liverpool Evening Express, Liverpool Mail, Liverpool Mercury, Liverpool Post and Mercury.*
As the great majority of the titles in the bibliographies are Liverpool papers, the usual practice of referring to them in full has been dispensed with so that, e.g., the *Liverpool Chronicle* becomes the *Chronicle*, the *Liverpool Daily Post* becomes the *Daily Post* etc.

6. Periodicals
A-J: *The Art-Journal*
ILN: *The Illustrated London News*
Journal of the RIBA: *Journal of the Royal Institute of British Architects*

Acknowledgements

Much of the material in this volume was derived from the detailed inventory of works of art (outside museums and art galleries) in and around Merseyside compiled in 1976 – 1977 by Stephen Archbold, Godfrey Evans, Richard Florsheim, Catherine Gibbons, Jonathan Greenberg, Ian Jones, Jim Lawson and Julie Lawson. This inventory was made for the Walker Art Gallery under the general guidance of its staff and consists of record cards describing and detailing the commissioning, making and subsequent history of some 2,000 works of art, with particular emphasis on public sculpture, together with photocopies and transcripts from published and unpublished sources and photographs of each painting or sculpture recorded; in many cases these photographs have been re-used in this book. The photographs, record cards, photocopies and transcripts have been made available by the Board of Trustees of the National Museums and Galleries on Merseyside which has been responsible for the Walker Art Gallery since 1986.

My personal thanks must go firstly to John Lewis for his generous grant to the project, donated via NMGM and the University of Leicester. I am also particularly indebted to the following people who have in various ways assisted me in the preparation of this catalogue: the staff of the Liverpool Public Library Local Record Office for all their helpful advice and co-operation over several months in the considerable effort of locating many of the primary sources; Adrian Allen and Janice Carpenter of the University of Liverpool for their generous responses to my frequent archival enquiries; Timothy Stevens of the Victoria and Albert Museum, Edward Morris of the Walker Art Gallery and Ian Leith of the National Monuments Record Centre for reading and criticising the typescript, and Martin Barnes for collating their comments and adding, through his local knowledge, one or two of his own; and Catherine Moriarty of the Imperial War Museum who provided information on a number of the war memorials. Also Ian Arnott and Miles Broughton, City of Liverpool Resources Directorate; Gaynor Kavanagh, University of Leicester; Colin Brooks, University of Leicester Central Photographic Unit; Kate Beecroft, Liverpool City Council; Gordon Locke, Littlewoods Organisation; Richard Davies, Merseyside Development Corporation; Chris Lawler, Lord Mayor's Office, Liverpool Town Hall; Pete Betts, Alex Kidson and Joseph Sharples, Walker Art Gallery; Henry Buckley and Jennie Loughran, Department of Mineralogy, Natural History Museum. In addition, I must thank Robert Burns, David Edwards, Sacha Gerstein, Dr Steven Gurman, Professor Quentin Hughes, Dr Philip Ward Jackson, Dr Phillip Lindley, Yasmin Maassarani, Pam Meecham, Fiona Pearson, Susan Poole, Peter Shaw and Joanna Soden. My especial thanks go to Janet Larson who spent a day trudging the length and breadth of Liverpool with me double-checking inscriptions. And finally I would like to thank Professor Alison Yarrington, Head of the Department of the History of Art at the University of Leicester, for reading the manuscript and providing academic guidance throughout.

TERRY CAVANAGH
University of Leicester

Sources of Illustrations

Grateful acknowledgement is made to the following for the supply of photographs and for permission to reproduce them: Philip Bews p. 157; Norman Childs pp. 61 (right), 63, 64; Conway Library pp. 11, 12, 269, 271, 272, 274, 275, 277, 279, 281, 283, 285, 286, 288, 289 (lower), 290, 291, 292, 293, 295; Courtauld Institute of Art, London pp. 44, 198, 199, 203 (right), 204, 206, 207, 304, 305; Tommy Howard p. 61 (left); David Lambert, Tate Gallery Photographic Dept p. 194; Liverpool Record Office, City of Liverpool Libraries and Information Services pp. 31 (right), 107, 150, 153, 301, 302; Derek Massey pp. 59, 66 (upper); Merseyside Development Corporation p. 60; John Mills pp. 57, 103, 140, 289 (upper), 294; Edward Morris p. 66 (lower); Ann Pownall p. 168; Alex Sanderson pp. 130, 138, 164, 195; University of Leicester Central Photographic Unit pp. 8, 9, 17, 18, 21, 22 (right), 29, 30, 33, 46, 51, 53, 70 (lower), 71, 74, 87, 90, 109, 110, 112, 114, 120, 128, 129, 155, 162, 171, 178, 183, 210, 215, 216, 219, 220, 221, 222, 223, 230, 231, 235, 238, 244, 251, 252, 268, 300; University of Liverpool pp. 106 (right), 225, 233, 306; Walker Art Gallery pp. 4, 5, 6, 7, 19, 22 (left), 24, 25, 26, 34, 37, 49, 70 (upper), 73, 76, 80, 81, 83, 84, 85, 86, 88, 89, 97, 98 (lower), 106 (left), 117 (right), 123, 124, 125, 127, 131, 132, 133, 134, 144, 149, 160 (left), 165, 166, 167, 172, 179, 181, 187, 188, 189, 191, 192, 200, 201, 202, 203 (left), 205, 214, 217, 239 (centre and right), 241, 242, 246, 250 (right), 255, 256, 257, 258, 261, 262, 263, 266, 296, 297, 299. Photographic sources on pp. 208, 236 are untraced. All other photographs are by the author.

I should be grateful if any individual or organisation, inadvertently not acknowledged, would draw the fact to the author's attention so that an appropriate amendment may be made in any future edition.

Located on the river front at the north end of Albert Dock:

Raleigh

Sculptor: Tony Cragg

Media: Cast iron horns and bollards; two blocks of granite

h: 76¹/₄" (193.8cms); w: 128¹/₂" (326.4cms); d: 134¹/₂" (341.7cms)

Explanatory plaque (with the words – Tate Gallery Liverpool – and crest at top right): RALEIGH 1986 / Tony Cragg Born 1949 / Tony Cragg returned to his hometown of Liverpool to / make a sculpture for this site beside the Tate. He used / different materials from those he normally worked with / to respond to the dock site and Liverpool's tradition of / heavy industry. He selected two granite and a number / of cast iron bollards from an artefact store and the / casts for the sculpture were made from Tony Cragg's / drawings by a local foundry. The horns symbolize a / fanfare of greeting or farewell, and also suggest messages / carried across the water.

Erected: 1986
Owner: Tate Gallery Liverpool (formally acquisitioned in 1987, cat. T 04903)

Status: not listed

Condition: Good

As part of a scheme to introduce modern art into the Albert Dock area prior to the Gallery's opening in May 1988, the Tate Gallery, in collaboration with Merseyside Development

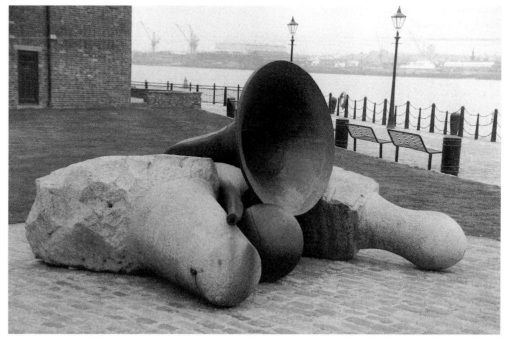

Corporation and the Walker Art Gallery, commissioned three works: Cragg's *Raleigh*, a painting by Steven Campbell, *Bonjour, Monsieur Foucault*, and Bruce McLean and David Ward's performance piece utilising the whole of the dock, *A Song for the North* (information supplied by the Tate Gallery Liverpool).

Cragg has for a number of years incorporated found objects made of glass, plastic and wood into his sculptures, but for this commission he felt that his work needed to reflect the monumental solidity of Jesse Hartley's Albert Dock. Hence the durable nature of the materials used here, selected from Merseyside

Development Corporation's artefact store. This is the first time that Cragg has used cast iron. The final sculpture was cast at Bruce and Hyslop's iron foundry in Bootle (*Events Summer 1986*: 14).

Literature: Curtis, P. (1988): 42, 43; *Events Summer 1986*: 14; *Tate Gallery Illustrated Biennial Report, 1986-1988* (1988): 86.

Almonds Green

Richard Robert Meade-King Drinking Fountain

A general broker importing petroleum, Meade-King (1850–1906) became a Liberal councillor

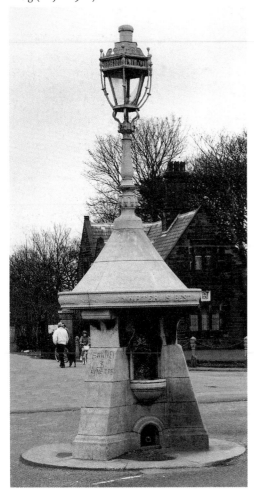

in 1891, serving on Liverpool City Council's Health Committee, Parks, Gardens and Improvement Committee, and Library, Museum and Arts Committee. He was also a prominent member of the Kyrle Society which sought to promote a taste for literature, music and outdoor recreational activities among the poor (source: Waller, 1981).

Architect: Arthur P. Fry
Sculptor: R. MacLeod

Inscription, running in a continuous band around the circular cornice of the canopy: "WATER IS BEST" THE GIFT OF RICHARD ROBERT MEADE-KING: 1894: (and in smaller lettering) DESIGNED BY / ARTHUR P. FRY.

Exhibited: WAG Spring Exhibition, 1895 (cat. 213), as *Models of Panels carved on public fountain at West Derby; presented by R. R. Meade-King, Esq. Arthur P. Fry, Architect; modelled and carved by R. MacLeod*

Owner/ custodian: Liverpool City Council
Listed status: Grade II

Description: A drinking fountain of Portland stone, located outside the gates to Croxteth Country Park, West Derby Village. It has a conical canopy sumounted by a bronze lantern. There is one basin with a back panel decorated with mosaic in gold, red and green, now very worn.

Condition: The fountain is no longer operational, the spout having been removed. The erosion of the Portland stone has rendered the inscription and carving faint. There is some grafitti. In the sheltered area under the canopy

there is extensive black encrustation and on the upper surface there is green staining from the bronze lantern.

Donated to West Derby Village by Councillor R. R. Meade-King in 1894 (Richardson, 1990: 38)

Literature: Richardson (1990): pp. 38-9.

Village Cross
Architect: William Eden Nesfield
Sculptor: James Forsyth

Erected: 1861-70
Owner/ custodian: Liverpool City Council
Listed status: Grade II*

Description: Located on the roadside in front of the West Derby Hotel, the monument, guarded by railings, faces west. Three steps lead up to a cluster of five Corinthianesque columns, a massive central shaft surrounded by four slender shafts in an arrangement similar to a Pisanesque pulpit. On the capital of the main column are small carvings of the four Evangelists and enthroned above in a Gothic tabernacle, Christ. Pevsner commented that the figure of Christ is 'too large for its tabernacle' (1969: 258-59). On either side of Christ are four doves in inscribed rings, the only inscriptions of which are still legible being *Knowledge* and *Strength*. Carved in relief on the back of the tabernacle is the open hand of God the Father pointing down from a cloud to two scenes, *The Temptation and Fall of Adam and Eve* and *The Crucifixion,* Christ's redemption of Adam and Eve's original sin.

Condition: All the carved details are heavily weathered.

The monument was donated by Mrs J. P. Heywood to mark the site of the altar of the chapel of West Derby, demolished when the Church of St Mary was built by (Sir) George Gilbert Scott in 1853-56, following West Derby's elevation to parish in 1848 (Richardson, 1990: 39–40).

Literature: Pevsner, N. (1969): 258-59; Picton, J.A. (1875, revised edn 1903) ii: 422; Richardson, A. (1990): 39-41.

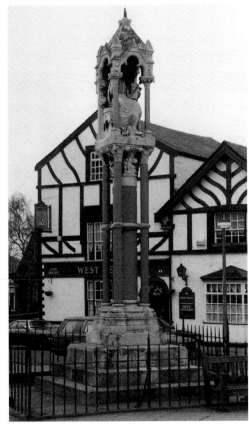

BANKHALL RAILWAY STATION. Along the length of the platform:

Refuge

Sculptors: Philip Bews and Diane Gorvin

High reliefs in bronze set within upended stone drinking troughs

Executed: 1992-93

Owner: British Rail
Status: not listed

Condition: Good

Description: Along the centre of the platform Bews has erected three pairs of drinking troughs. One of each pair faces the booking office and the other, the railway track. The upended troughs are re-used as niches for six bronze sculptures in high relief. The pair nearest the booking office contains (facing the booking office) *Sun*, a male face, by Philip Bews, and (facing the southbound line) *Moon*, a female face, by Diane Gorvin; the next pair (facing the booking office) *Fish*, by Philip Bews, and (facing the northbound line) *Rabbit*, by Diane Gorvin; the last pair (facing the booking office) *Factory* and (facing the northbound line) *Sailing Ship*, both by Philip Bews. In *Factory* Bews has modelled little figures of people and created a factory environment around them from the casts of actual nuts, bolts, cogwheels, screws etc. Each relief has a different coloured patina.

The overall scheme and paving design was devised by Bews. His also was the idea of re-using the six stone drinking troughs from the British Rail store. By upending them they

become not only niches for the bronze reliefs, but also echo the alcoves cut into the walls either side of the tracks which serve as actual refuges for the track workers (information from Diane Gorvin).

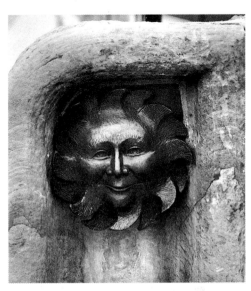

Bold Street

THE LYCEUM, designed by Thomas Harrison and built between 1800-02 as the joint home of the Lyceum gentleman's club and the Liverpool circulating library, now the Lyceum Post Office, at the corner of Bold Street and Ranelagh Street.

Three allegorical figured relief panels, between the Ionic half-columns of the façade facing Ranelagh Street.

Sculptor: F. A. Legé

Reliefs in sandstone

Each relief: h: 40" (101.6cms); l: 60" (152.4cms)

Owner of building: T. S. B. Pensions Ltd.
Listed status: Grade II

Description: From left to right, the panels represent

1) *Navigation*, a seated female figure, looking towards the viewer and leaning forward with her right arm extended to apply dividers to a globe set upon a tripod stand.

2) *The Arts* (here personified as the Greek god Apollo), a male figure seated upon a bench. His lower body and legs are draped, his upper body bare. With his right hand he holds a lyre which rests upon his right knee, whilst he extends his left hand away from his body, palm outwards. To his right is an incense burner on a stand with a serpent motif.

3) *Commerce*, a female figure seated on a bale of cotton in front of an antique ship whose prow is decorated with a bird. In her right hand, extended above the ship, she holds a caduceus, whilst in her left hand, lowered in front of the bale, she holds a money bag.

Condition: Apparently good – there are some accretions of bird droppings, but the panels are now covered by protective netting.

Literature: *Billinge's Liverpool Advertiser* (1802) 12 July: 4.

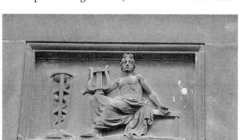
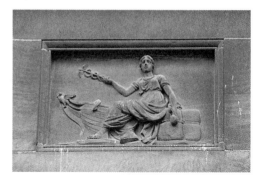

LIVERPOOL JOHN MOORES UNIVERSITY building, at the corner of Byrom Street and William Brown Street. Formerly the College of Technology (and Museum Extension), it was designed by E.W. Mountford and built 1896-1902. The main entrance in Byrom Street is embellished with sculpture, as are the pediments of the window bays on the William Brown Street frontage. Either side of the main entrance is an ornate lamp-post surmounted by a figure and inside the entrance

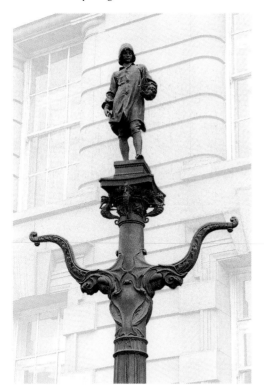

hall there are polychrome reliefs. All the desciptions below are obtained from the extensive and detailed reports in the *Daily Post* and the *Echo* for 25 October 1901.

Sculptor: Frederick William Pomeroy

Owner of building: Liverpool John Moores University
Listed status: Grade II*

Formally opened as the Central Municipal Technical School of Liverpool by the Duke of Devonshire, Saturday 26 October 1901

Exhibited: (i) F.W. Pomeroy: WAG Liverpool Autumn Exhibition 1900 (cat. 1469) as *Two Sketch Models (Plaster) for the Tympanum of the New Technical Schools, Liverpool*; (ii)E.W. Mountford: Royal Academy of Arts 1901 (cat. 1901) as *Liverpool Museum* (drawing of the pedimented window bay at the Picton Library end; reproduced in *The Builder*, 11 January 1902).

I. BYROM STREET FRONTAGE
a. Two **Ornate Lamp Standards**, one each side of the entrance, surmounting the newel-posts at the feet of the double flight of stairs.

Sculptor: Frederick William Pomeroy

Bronze founder: Singers of Frome

Inscription around the columns of the lamp standards: CORPORATION TECHNICAL SCHOOLS

Signed and dated on the base of each figure: F.W. POMEROY. 1902

Description: Crowning a stone newel-post,

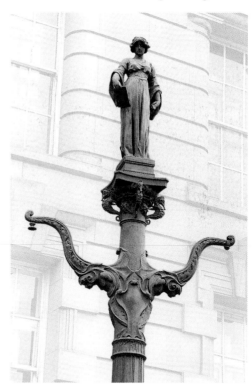

each bronze lamp standard is formed of a plinth supporting a fluted column surmounted by a downward-looking figure. The figure on the lefthand lamp standard, presumably representing *Navigation*, is a young man wearing a sou'wester, thigh-length coat, breeches and hose. In his right hand is a pair of compasses and in his left, an armillary sphere. The figure on the right-hand lamp standard, perhaps representing *Learning*, is a young woman in a long dress who looks down at a large rectangular

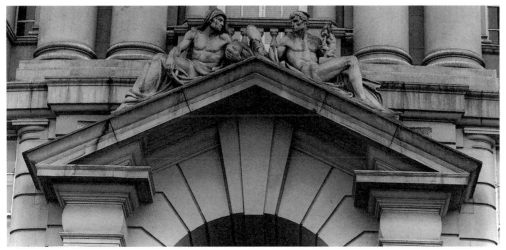

tablet held with her right hand and supported against her thigh. Below each figure the column capital is decorated with four seahorses arranged radially on the principal axes, alternated with conch shells. A fifth of the way down each column are two opposed lamp brackets, the crook of each being decorated with a downward-looking child's head. The column flutes, in their lower fifth, are decorated with four motifs like poppy pods. The column bases are supported by four exotic fish radially arranged on the secondary axes with snouts resting on the corners of the pedestal.

Condition: The lamp standards appear satisfactory: they are intact, but rather dirty.

As the date 1902, on the base of each figure indicates, the lamp standards were erected in the year following the official opening of the schools.

b. **Pediment Figures**: *Science* and *Art* [illustration above], allegorical statues reclining on the raking cornices of the pediment over the Byrom

Street entrance:

Sculptor: Frederick William Pomeroy

Sculptures in sandstone

Description: Both figures are male. *Science*, on the left, is semi-draped. His upper body, which is turned to the front, is bare. Drapery covers the top of his head like a hood, hangs down behind him and is brought round to the front to cover his legs. He leans on his left elbow and looks to his counterpart. In his left hand he holds a crucible and in his right a pair of callipers. *Art*, the figure on the right, is nude, his drapery having fallen from him, leaving a loop only folded over his right forearm. On his head he wears a bandeau. His pose reflects that of *Science*, save that he does not return his counterpart's gaze, but looks into a mirror (possibly holding up a mirror to nature) in his right hand. With his left hand he holds on his lap a small *écorché* figure, the so-called *écorché* of Michelangelo, a figure sometimes used in the nineteenth century as an identifying attribute of this artist (e.g. Carrier-Belleuse, bronze statuette, 1855; and the bronze relief showing Michelangelo as a personification of Sculpture on the Lecture Theatre building doors, designed by Godfrey Sykes, 1867, in the quadrangle of the Victoria and Albert Museum, London). Moreover, Pomeroy's reclining figures, along

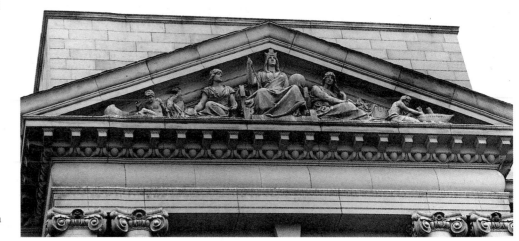

with those on the other pediments, are free variants on Michelangelo's symbolic figures on the tombs in the Medici Chapel, San Lorenzo, Florence.

Condition: Dirt-stained, but apparently undamaged.

2. WILLIAM BROWN STREET FRONTAGE

Tympanum Groups and *Pediment Figures*

Sculptor: Frederick William Pomeroy

Sculptures in sandstone

Condition: All upper surfaces of the tympanum groups and the figures reclining on the pediments below are whitened by bird droppings – the tympanum groups appearing worse than the figures below.

The pedimented window bay at the Byrom Street end:
a. Top pediment, tympanum sculptural group: '*Liverpool Presiding over Commerce and Industry*'

Description: The central figure of the group is a personification of *Liverpool*, crowned, enthroned and holding an orb and sceptre. She is flanked by two seated female allegories: the figure on the left, representing *Commerce*, holds a length of rope; on her right is a money bag and the Liver bird. The figure to the right of *Liverpool* represents *Industry*; she is seated next to a bale of cotton. A child fills each corner of the tympanum: the one at the left has a canoe, whilst his counterpart at the extreme right is building a model of a steamship.

b. *Geography* and *Astronomy*, allegorical statues reclining on the raking cornices of the pediment of the window niche.

Description: The two classically-draped figures

rest on their elbows and look away from each other. The figure on the left, representing *Geography*, is an old man who contemplates a globe balanced on his right knee and steadied by his right hand. His female counterpart, *Astronomy*, holds a scroll in her right hand, whilst holding in her left a large book or tablet which she supports against her right knee.

The pedimented window bay at the Picton Library end:
a. Top pediment, tympanum sculptural group:

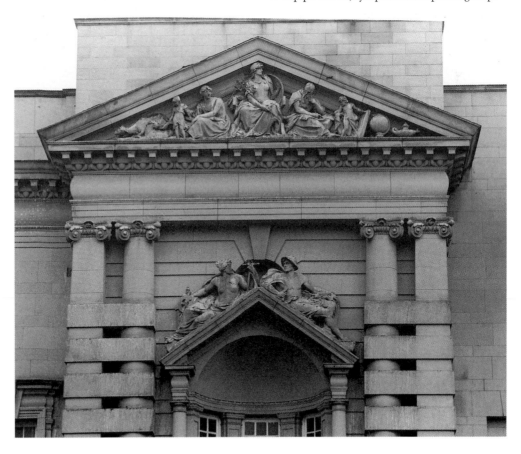

'Minerva, Symbolising the Wisdom of the City, Presides over the Education of the Community'

Description: According to the contemporary accounts (*Daily Post*, 25 October 1901, and *Echo*, 25 October 1901), the central figure is supposed to represent *Minerva*, though her trident would suggest an identification as *Britannia*; the substitution of trident for spear, however, may be a late change. The figure is enthroned, holding the trident in her right hand and her shield in her left, looking to her left towards a seated philosopher (a classically-draped, bald and bearded man who contemplatively strokes his beard). His right hand is poised in the act of writing on a scroll which is draped across his knees. To the right of him stands a small child who holds the top edge of a large tablet, balanced on the ground. Occupying the right corner is a globe and a lamp. To the left of *Minerva/Britannia* is a seated classically-draped female who rests her right hand on the shoulder of a standing child who, in turn, looks at two animals which occupy the left corner of the pediment.

b. *Navigation* and *Agriculture*, allegorical statues reclining on the raking cornices of the pediment of the window niche:

Description: The semi-draped female and male figures recline on the cornices and turn to look towards each other. On the left the female, representing *Navigation*, rests her left elbow near the apex of the pediment and holds an anchor. Behind her lowered right arm is a bollard and possibly an armillary sphere. The male figure, representing *Agriculture*, wears a sun hat and holds a sickle in his right hand.

3. THE ENTRANCE HALL (access only by prior arrangement):
a. ***Polychromed Bas-reliefs***, 'illustrating the

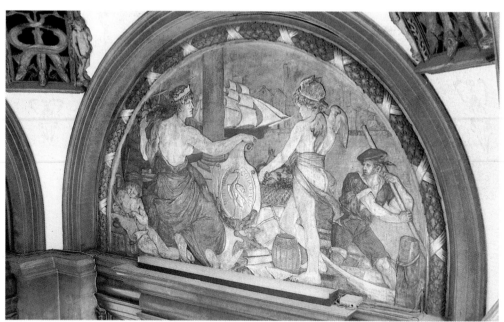

development of shipbuilding and technical crafts' (*Daily Post*, 25 October 1901).

Designed and modelled by Frederick William Pomeroy
Painted by Robert Anning Bell

Bas-reliefs in polychromed plaster

Description: The bas-reliefs are in lunettes high up to left and right of the main entrance. The lunette on the left represents an allegory set in a harbour. A female figure, nude from the waist up, sits on the left, resting her left hand on a basket brimming with fruit, whilst her right rests upon the top edge of the armorial crest of Liverpool: a Liver Bird and the motto 'DEUS NOBIS HAEC OTIA FECIT'. The scene then is Liverpool and the female figure's castellated crown identifies her as its personification. A winged child walks towards her from the right, bearing a wicker basket, brimful with fruit. The caduceus half-concealed at his feet would indicate that, despite his cupid-like appearance, he is Mercury (in his guise as god of commerce). A younger naked child sitting at bottom left writes with a quill pen upon a scroll of paper. A bale of cotton lies nearby. At the extreme right a sailor punts a boat towards the quayside. A sailing ship moves through the dock, warehouses filling the opposite quay across the water. Thus, the theme, many times repeated in Liverpool, is of the fruits and produce of the earth being brought home by her sailing ships.

The righthand lunette contains another allegory. A helmeted Minerva, wearing a breastplate decorated with the gorgon's head, and wielding a sceptre, is enthroned in the centre of the picture. Seated before her are a semi-nude female and male figure joining hands. Behind

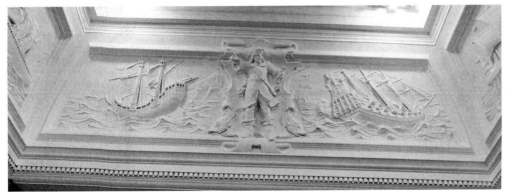

This then is again Liverpool, and Minerva, the goddess of wisdom, is here as patroness of the arts and industry.

Condition: Apparently good, though the colours appear to be dulled with grime.

Related works: Pomeroy, again for the architect E.W. Mountford: six lunette reliefs of the *Civic Virtues* for the entrance hall of Sheffield Town Hall (c. 1892-95); illustrated in Beattie (1983: 34,35).

b. ***White Bas-reliefs***, depicting shipping through history.

Designed and modelled by Frederick William Pomeroy

the female figure is an artist's palette leaning against a painting next to a table upon which is a sculpture and sculptor's mallet: she is the personification of *The Arts*. The male figure holds in his right hand a sledge-hammer, whilst behind him is a large cog-wheel and a pair of blacksmith's tongs: he is the personification of *Industry*. There are ships in the background.

Bas-reliefs in white painted plaster.

Description: The two successive bays along the entrance hall are lit by circular skylights set within square coved frames. Each coved side is decorated with a figurative bas-relief panel. The second bay repeats the scenes of the first, but in a different sequence. Each bas-relief has a large centrally-placed figure of a sailor flanked by two boats or ships of a type contemporary with the sailor's costume.

Condition: Apparently good.

c. *Lunette Relief* over the mantelpiece on the left of the second bay of the entrance hall.

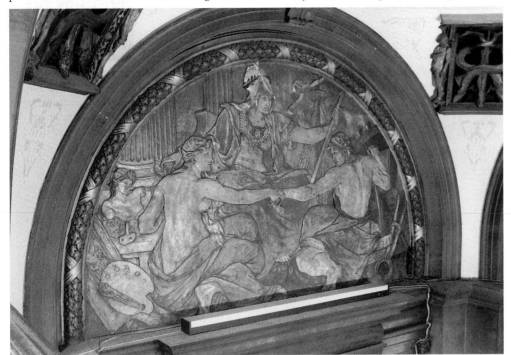

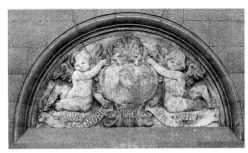

Sculptor: unknown

Lunette relief in alabaster from Uttoxeter
(*Daily Post*, 25 October 1901)

Description: 'The design is adapted from the
armorial bearings of the Liverpool
Corporation' (*Daily Post*, 25 October 1901).
The Liver Bird crest, surmounted by a scallop
shell, fringed with seaweed, is supported by two
seated, winged *putti*. A scroll beneath the crest
bears the city's motto, DEUS NOBIS HÆC OTIA
FECIT.

Condition: Good

Literature: (i) LRO newscuttings: *Daily Post* (1901)
25 October, in *CH&T 3*: 283-85; *Daily Post* (1901) 28
October, in *CH&T 3*: 285-91; *Echo* (1901) 25
October, in *CH&T 3*: 281-83; *Liverpool Review*
(1901) 2 November, in *CH&T 3*: 304-5; *Mercury*
(1901) 28 October, in *CH&T 3*: 291-97.
 (ii) Beattie, S. (1983): 121, 122; *Builder* (1902) 11
January: 40; Curtis, P. (1988): 9; Gray, A. S. (1985):
267, 269.

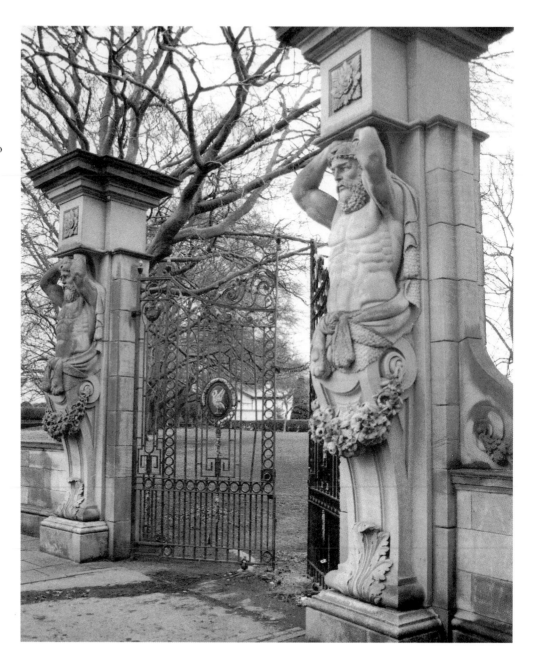

Calderstones Park

HARTHILL ESTATE ENTRANCE

Two Atlantes fronting the gateposts of the park entrance at the corner of Harthill Road and Calderstones Road, with **Statues of the Four Seasons** surmounting the flanking walls. Both the *Atlantes* and the *Four Seasons* were carved for Brown's Buildings, built by (Sir) James Allanson Picton, 1861-63, in Water Street, next to the Town Hall, and were acquired by Liverpool Corporation in 1928 following the demolition of Brown's Buildings (WAG JCS files). The *Atlantes* originally flanked the main Water Street entrance and the *Four Seasons* were ranged along the façade (Whitty, 1871: 37).

Sculptor: Edwin Stirling

Statues in sandstone

h. of *Atlantes*: c. 13' (3.96m)
h. of *Four Seasons*: c. 6' (1.83m)

Unsigned

Owner: Liverpool City Council
Listed status: Grade II

Description: The *Atlantes* have their arms raised, hands over their heads, palms upward, to 'support' the cornices above them; their torsos emerge from the scrolls of festoon-hung console brackets. Each wears a lion skin, the lion's head serving as a cap, the paws knotted across the waist. As with the similar *Atlantes* in St George's Hall of a few years earlier (see below, p. 292), these figures more accurately represent *Hercules*, wearing the skin of the Nemean lion, presumably in allusion to when he supported the world for Atlas while Atlas

obtained the apples of the Hesperides for him.

The Four Seasons are personified as women, ranged along the top of the park wall, two to each side of the entrance. From the left, *Spring* is a young, bare-footed woman sprightly stepping forward, sowing seeds from a roughly-shaped bowl held in her left hand. She wears a loose calf-length sleeveless dress. Behind her is a tree trunk, against which grows a small plant; other small plants dot the ground at her feet. *Summer* is a semi-nude young woman walking again barefoot. She has slipped her ankle-length dress from her shoulders, the front of her loosened garment forming a pouch in which to carry the mass of flowers at waist-level. In her right hand and in a wicker basket behind her are more flowers; and yet more small flowers grow from the earth at her feet. *Autumn* is a young barefoot woman stepping forward in an ankle-length dress, her right breast revealed as her dress slips from her shoulder. In her left arm is cradled a sheaf of corn and on her head is a wreath. The ground beneath her feet is bare and rocky. *Winter* is a motionless old woman, heavily dressed and hooded, her arms folded. She alone wears shoes. At her feet, on the rocky ground, was originally a vessel (now missing), intended to be either a funerary urn or a pot of fire, her most usual attributes.

Condition: In the early hours of George VI's coronation day (12 May 1937), the *Atlantes* had red, white, and blue paint thrown over them, while the *Four Seasons*, being more accessible, were heavily daubed with it (*Daily Post*, 15 May, 1 June, 1937). The Corporation carefully removed all the paint at this time but on, or

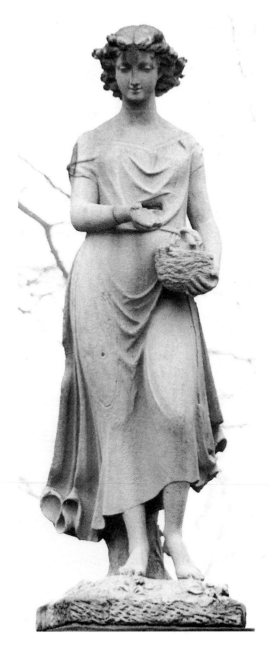

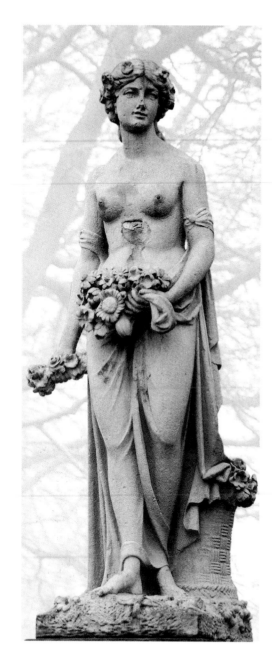
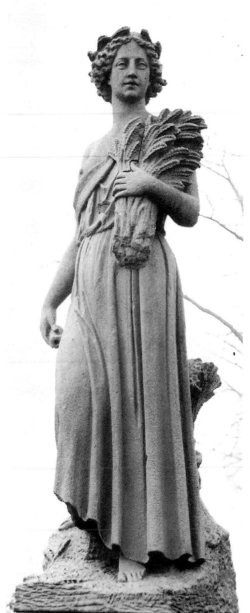
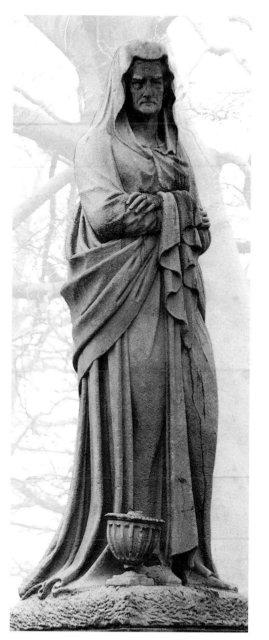

shortly after, V.E. day (8 May 1945) at least two (unspecified) of the *Four Seasons* were again vandalised: the face and arms of one being painted white and another red. Expert advice was sought and the paint again removed (*Daily Post*, 12 May 1945).

Currently, all the statues are stained with green biological growth and are very weathered. *Spring* is missing the right hand, most of the nose is lost, the skirts are chipped on the left side and extensively along the hem, and the surface of the right shoulder is damaged. *Summer* has lost the thumb of the right hand, suffered damage to the back of the left hand, the nose is chipped, and there is some spalling on the stomach area; there are also white stains on the mouth and nipples. *Autumn* is missing the tip of the nose, the hem of her robe is chipped, and the index finger of her right hand is missing the last two joints. *Winter* is in relatively fair condition (although rather weathered) and there is only one loss: to the left of *Winter*'s feet there once stood a funerary urn (visible in a 1985 Conway Library photograph) – now only the base remains.

Literature: *Daily Post* (1935) 29 August: 6; *Daily Post* (1937) 15 May: 6; *Daily Post* (1937) 1 June: 6; *Daily Post* (1945) 12 May: 2; Pevsner, N. (1969): 211; Richardson, A. (1990): 47; Whitty (1871): 36-7.

In the FLOWER GARDEN (by the Cacti and Succulents Greenhouse):

Jet of Iada Memorial Sundial
Jet was a black Alsatian dog born during the Second World War, one of a number of dogs owned by a local woman, Mrs Babcock Cleaver. In response to a government appeal for working dogs (and in order to solve her own problem of adequately feeding her pets during a time of

food rationing), Mrs Babcock Cleaver loaned Jet to the armed forces. He was first trained to sniff out snipers amongst the ruins of newly liberated towns, but in training proved himself so adept at locating his quarry that it occurred to his trainers that dogs might also be used to locate air-raid victims buried under rubble. Jet was responsible for saving numerous lives and so exceeded the expectations of his employers that he was awarded the Dickin Medal (Canine V.C.). After the war, in August 1947, Jet was called out of retirement to help find victims of the William Pit mining disaster at Whitehaven. Not only did he and his two fellow dogs locate all the bodies, but apparently Jet sensed the impending collapse of the mine roof, warned the

searchers in time, and saved all their lives. For this he was awarded, in April 1948, the RSPCA's Medallion for Valour. In 1949, following a short illness, he died at home with his owner, aged only seven (source: Dodd, 1950).

Designer: unknown

Column and base in grey granite
Portrait plaque in Lancashire greenstone

Overall h: 47³/₄" (121cms)
Base: w. 30" (76cms); d. 26³/₄" (68cms)

Inscriptions on the base:
– front face: JET OF IADA / DICKIN MEDAL & MEDALLION / FOR VALOUR, FIRST RESCUE DOG / AIR RAIDS 2ND WORLD WAR
– left face: RESCUE DOG / WILLIAM PIT DISASTER / AUGUST 1947
– rear face: LED BY CIVIL DEFENCE / THROUGH LONDON / IN / THE VICTORY PARADE / JUNE 1946
– right face: JET BELONGED / TO MANKIND / AND NEVER FAILED

Owner/ custodian: Liverpool City Council
Status: not listed

Description: The memorial marks the spot where Jet was interred on 22 October 1949 (Dod, 1950). It takes the form of a sundial on a fluted column mounted on a rectangular base. The dates and principal events of Jet's life are inscribed on the four faces of the base. Into the column is set an oval plaque carved with a portrait of Jet wearing his medals. Fixed to the top of the column is a bronze sundial disc.

Condition: The general condition is fair, although the greenstone medallion is rather worn and the image faint.

Related work: Edna Rose, *Jet of Iada, Rescue Dog*, 1949, bronze head, Mansion House,

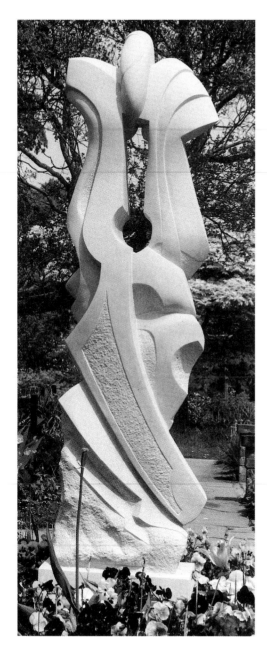

Calderstones Park (see below, p. 14).

Literature: (i) LRO – Dod, U.P. (1950).
(ii) Richardson, A. (1990): 46-7.

In the OLD ENGLISH GARDEN, in the centre of a circular flower bed:

Sentinel

Sculptor: Stephen R. Hitchin

Sculpture in Portland stone

h: 84" (213cms)

Inscription on a plaque affixed to a low octagonal block, also of Portland stone, at the edge of the circular flower bed surrounding the sculpture: SENTINEL / BY / STEPHEN R. HITCHIN / WITH SUPPORT FROM / LIVERPOOL CITY COUNCIL / & / VISIONFEST 93

Owner: Liverpool City Council
Status: not listed

Condition: Good

Related works: *Sentinel I* and *Sentinel II*, exhibited at the Hanover Gallery, Liverpool, 1991 (these are now in private collections; information from Stephen Hitchin).

In a printed artist's statement, dated January 1994, Stephen Hitchin explained:

> This commission was coordinated by Visionfest 93 with financial support from Liverpool City Council. The request was to produce a sculptural response to the original Neolithic Calderstones and encourage the "Young Friends of Caldersones" to be involved in these initial stages.
> The sculpture, carved from Portland stone and 7 feet tall, was developed from an illustration that suggested the original stones

were used as an entrance to the Tumulus (burial chambers). The piercing of the sculpture looked to respond to the concept of an entrance and thereby reflect the stone's original use. I also considered the markings on the original stones and, incorporated with incised lines, these strong linear marks within the sculpture.

> The sculpture was started at the Bridewell Studios, Liverpool and transported, unfinished, to Calderstones Park. During October [1993] the sculpture was completed on site to coincide with the Visionfest 93 Arts Festival.

In the entrance hall of the MANSION HOUSE:

Portrait Head of Jet of Iada, Rescue Dog

Sculptor: Edna Rose

Dog's head in bronze

Signed and dated: E. Rose '49

Owner: National Museums and Galleries on Merseyside; manager: Liverpool City Council (presented by Mrs Babcock Cleaver, 1967)

Status: not listed

Exhibited: WAG 'Women's Works' exhibition, 1988 (cat. 7003)

Condition: Good

Related work: *Jet Memorial Sundial*, The Flower Garden, Calderstones Park (see above, p. 13).

Literature: *Liverpolitan* (1946) June: 8; WAG (1988): 85.

ADELPHI BANK, 38 Castle Street, designed and built by William Douglas Caröe, 1890-94. Situated on the corner of Brunswick Street, it is now the Co-operative Bank.

Owner: Co-operative Bank plc
Listed status: Grade II*

Five Allegorical Statues

In niches, sheltered by semi-octagonal canopies and framed by slender columns, set between the second floor windows, two on the Castle Street frontage, three overlooking Brunswick Street.

Designed by William Douglas Caröe
Executed by Charles E. Whiffen of Norbury, Paterson & Co. Ltd.

Exhibited: WAG Spring Exhibition 1893 (cat. 981/9 & 981/10), as *Rough Sketch Models for Statues, 'Fortitude' and 'Plenty', Adelphi Bank, Castle Street.*

Descriptions:
On the Castle Street frontage, left to right – (i) a female figure in a full-length gown, her right breast bared, probably representing *Peace*. On her left shoulder is a dove, whilst the object in her right hand may be a stylized olive branch. (ii) a female figure, wearing a veil and full-length gown, her breasts bared, suckling a baby at her right breast, presumably representing *Charity*.
On the Brunswick Street frontage, left to right – (i) a female figure, veiled and wearing a full-length gown, holding a rudder, one of the principal attributes of *Plenty* or *Abundance*. This attribute derives from ancient Rome, when the grain harvest, the source of plenty, arrived at the city by boat (Hall, 1979: 3). (ii) *Justice*, a female figure wearing a mantle over a full-length gown. She is blindfolded, holding a sword in her right hand and scales in her left. (iii) *Fortitude*, a male figure, wearing a cloak over a suit of armour. With his right hand he holds the hilt of a broadsword, its tip resting on the ground between his feet, with his left hand he holds the rim of a shield resting on the ground at his left side.

Condition: The figures appear to be intact, but are weathered. Of the three on the Bruswick Street frontage, *Justice* and *Fortitude*, centre and right, have a whitish bloom on their left sides. Both figures on the Castle Street frontage are similarly affected.

Carved Decorative Frieze and *Spandrels* over Main Entrance

Designed by William Douglas Caröe
Executed by Charles E. Whiffen of Norbury, Paterson & Co. Ltd.

Exhibited: WAG Spring Exhibition 1893 (cat. 966/8), as *Details of Stone Carving in Adelphi Bank, Liverpool*; and (cat. 981/12), as *Rough Sketch Models for Spandrels*.

Bronze Doors

Designed by William Douglas Caröe
Modelled by Thomas Stirling Lee

Figures and relief panels cast by Buhrer of Chelsea; doors cast by Starkie Gardner & Co. of Lambeth

Exhibited: (i) WAG Spring Exhibition, 1893 (listed under W. D. Caröe, M.A., F.R.I.B.A.)

(cat. 966/5), as *Design of Bronze Doors, Adelphi Bank, Liverpool, and four Plaster Bas-reliefs in same, modelled by T. Stirling Lee, Sculptor.* (ii) Royal Academy of Arts, 1893 (listed under T.S. Lee and W.D. Caröe) (cats. 1756 & 1759), as *'Brotherly Love'; door(s) for the Adelphi Bank, Liverpool.* (iii) WAG Liverpool Autumn Exhibition, 1893 (listed under T. Stirling Lee) (cat. 1221), as *'Brotherly Love' (Doors for the Adelphi Bank, Liverpool).*

Description: The top half of each bronze door consists of two narrative bas-relief panels, one above the other, flanked by pilasters with niches into which statuettes are set. The niche figures are the heroes from the panels. When the doors are closed, the top rails form a continuous frieze giving the date of completion, '18' (left door) '92' (right door), supported by four *putti*. The doors are surmounted by a lunette with an elaborate grill. The subjects of the bas-reliefs were chosen, according to *The Builder* (1892, lxiii: 460), 'with special allusion to the name "Adelphi" [Greek for 'brothers']', and represent 'incidents of brotherhood from great historical periods.' They are as follows: left door – 1. *Jonathan's stratagem to aid the escape of David. 2. The Dioscuri (as clouds) guarding

and guiding the Argonauts. right door – 3. Achilles mourning Patroclus. 4. Orlando (Roland) rescuing Oliver.*

The panels and statuettes were modelled in wax by Lee and then cast in bronze by Buhrer of Chelsea using the *cire perdue* process (*The Builder*, 1892, lxiii: 460).

Condition: All the niche figures appear rather worn and all the weapons once carried by the figures are now missing: specifically, the top part of Jonathan's bow, above his right hand; the (?) lance once held in Castor's left hand; Patroclus's lance and Achilles's sword; and Roland and Oliver's swords. The bas-reliefs also appear very worn. The *Orlando* relief, lower right, has a 1/2" hole on the top edge of the panel and a number of smaller holes across the surface of the panel. The *David and Jonathan* and *Castor and Pollux* reliefs are also pitted with small holes.

Literature: *The Builder* (1892), lxiii: 460; Freeman, J.M. (1990): 3, 32, 86-7; Hall, J. (1974; rev. edn 1979): 3; Hughes, Q. (1969): 77-9; *Liverpolitan* (1936) September: 22; *Magazine of Art* (1894): 323-24; Reilly, C.H. (1921): 35.

Cavern Walks (see Mathew Street)

ATLANTIC TOWER HOTEL

In the lobby of the hotel:

Cormorants Diving

Sculptor: Seán Rice

Sculpture forged, beaten and welded in copper, bronze and gilding metal, 1972.

Diameter: approx. 72" (182.9cms)

Descriptive inscription plaque affixed to the wall at the back of the landing behind the sculpture: CORMORANTS / DIVING / SCULPTOR / SEÁN RICE / LIVERPOOL 1972

Owner: Mount Charlotte Thistle Hotels
Status: not listed

Rice states: 'The design of *Cormorants Diving* was a delight to undertake. A ceiling sculpture is an unusual concept, and it gave me an opportunity to visualise the ceiling level as the ocean surface with the birds diving through and disturbing shoals of fish' (letter, dated 12 June 1994, from the sculptor to the author).

Condition: Good

Literature: Richardson, A. (1990): 24.

In the courtyard of the hotel:

The Spirit of the Atlantic (Seagulls rising) [illustration p. 18]

Sculptor: Seán Rice

Sculpture beaten, forged and argon arc welded in phosphor bronze, silicon bronze and gilding metal, 1972.

h: (approx.) 17' (5.18m)

Signed: Rice

Owner: Mount Charlotte Thistle Hotels
Status: not listed

This work, like *Cormorants Diving*, was commissioned by the architects of the Atlantic Tower Hotel, Holford Associates. According to the sculptor, this piece was originally intended by the architects as the centre-piece of a fountain in which the gulls would appear to be rising out of the ocean spray (letter, dated 12 June 1994, from the sculptor to the author).

Condition: The sculpture is in good condition, but the fountain is not operating and the courtyard in which it is set is, at the time of writing, awaiting renovation.

Literature: Richardson, A. (1990): 24.

HARGREAVES BUILDINGS, 5, Chapel Street, on the corner of Covent Garden, designed by (Sir) James Allanson Picton and completed in 1861 for (Sir) William Brown, in the style of a Venetian *palazzo*. The spandrels of the ground floor round arched windows of all five bays of the Chapel Street frontage, and the first bay of the Covent Garden frontage, are decorated with *tondi* framing **Heads carved in High Relief** depicting historical personages connected with the discovery of America (Whitty, 1871: 41).

Sculptor: unknown

High relief heads in sandstone

Inscriptions beneath each head, as appropriate:
(a) *Covent Garden frontage, left to right:*
F. Pizarro; H. Cortez
(b) *Chapel Street frontage, from left to right:*
Anacoana, Amerigo, Rod Bermejo, Ferdinand R, Columbus, Isabella R.

Francisco Pizarro (*c.*1478-1541) was a Spanish adventurer who conquered Peru for Spain, overthrowing the empire of the Incas in 1531-33. Hernando Cortez (Cortés) (1488-1547), also a Spanish adventurer, conquered Mexico for Spain in 1519-21. The identity of Anacoana is less certain, but as she is portrayed as a romanticised Native American with feathered headdress, bow, and quiver full of arrows, she may be identical with Anacaona *(sic)* (d. 1503), Native American poetess and queen of the western part of what is now Haiti. The Spanish governor of the time, Fr Nicolás de Ovando, had her hanged and her followers massacred at Xaragua on the pretext of pre-empting a revolt. Amerigo Vespucci (1451-1512) was a Florentine explorer, naturalised in Spain, who sailed to America after Columbus (1499-1500 and 1501-02), explored Venezuela, and had the entire continent named after him by mistake. It has not been possible to trace any biographical details for Rod Bermejo, although his portrayal with a quadrant suggests that he was a navigator. Ferdinand II of Aragon ('Ferdinand R') (1452-1516), reigned jointly over Spain with Isabella of Castile ('Isabella R') (1451-1504) and funded the exploratory voyage of Christopher Columbus (*c.*1451-1506), who discovered the Americas in 1492.

Owner of building: The Racquet Club
Listed status: Grade II

Condition: Fair, though some surface erosion is apparent.

Literature: Whitty (1871): 40-1.

The William Simpson Memorial Fountain
Simpson (1829–83) was born in Lancaster, the son of a carpenter. After moving to Liverpool his chequered career took him at various times into shipping, catering, zoo management and bankruptcy. His political affiliations moved from Tory (he was active in the Liverpool Working Men's Conservative Association from its foundation until 1869-70, when he fell out with the Tory leaders over the issue of denominational education), to Independent (he was an Independent candidate for Liverpool in 1874), to Liberal (he joined the party in 1878 and was Liberal councillor for West Derby ward 1879-80 and candidate for Preston 1882). He was an Anglican, a teetotaller and a purity crusader; he

was also a conciliator in the 1879 dockers' strike and the originator of the Christmas Hot-Pot fund for the 'deserving poor' (source: Waller, 1981).

Architect: Thomas Cox
Sculptor: Joseph Rogerson

Bronze founders: Messrs J. and R. Cooper, of London Road, Liverpool (*Mercury*, 11 July 1885).

Architectural elements in Bolton Wood sandstone
Inscription slab in Aberdeen red granite
Basin and base in Dalbeattie granite
Portrait relief and lettering in bronze

h: 80" (203cms); w: 132" (335cms)

Inscription: SIMPSON / FOUNTAIN / 1885

Unveiled by Sir James Allanson Picton, Friday 10 July 1885

Owner/ manager: Liverpool City Council
Listed status: Grade II

Description: Located at the corner of Chapel Street and George's Dock Gates, the fountain is in Perpendicular Gothic Revival style. The architectural elements frame, within an ogee arch, a circular bronze portrait medallion of Simpson. Simpson's head, in high relief, is shown in three-quarter view facing towards his right, his long moustaches extending below the medallion's circular edge. The architectural framework is topped with a cornice, above which rises a domed roof surmounted by a carved foliated corona. The Perpendicular style of the architecture echoes that of St Nicholas' Church, into whose perimeter wall the fountain is set.

Condition: The fountain is no longer usable as

the bowl has been levelled with cement and the water outlet covered with a metal plate. Black paint has been splashed across the portrait relief, on the mullions to the left of the portrait, and across the granite basin and base. The surface of the extreme left mullion is in a friable state; the weathering of all the sandstone parts is worse towards the left (north) edge. The higher parts of the sandstone have soot-like staining. The stone was cleaned some time before the 1976 WAG JCS survey, at which time some of the metal letters were recorded as missing. All of the present letters are replacements and evidently smaller than the originals which occupied more space – the spaces and holes for the original 'S' and 'N' of SIMPSON and 'F and 'N' of FOUNTAIN are visible at the ends of both lines. Of the present lettering, the tail of the '5' is missing.

On 16 July 1883, very soon after Simpson's unexpected death, a meeting of contributors to the 'William Simpson Memorial' met in the Concert Hall, Lord Nelson Street. The Revd T. Major Lester, in the chair, spoke warmly of the deceased's beneficent presence on the Town Council and praised his philanthropic work among the poor. Joseph Thomas, the Honorary Secretary, announced that £62. 14s. 1½d. had been collected in a bowl placed, with the approval of the Dock Board, on the landing stage at Pier Head. Unfortunately, total subscriptions at that time amounted to only £109. 14s. 10½d. and it was recognised that any substantial monument would cost about £500. The most popular suggestion was that the memorial should take the form of a commemorative drinking fountain. It was resolved to form a committee to organise a public meeting to raise further funds (*Daily Post*, 17 July 1883).

The meeting was held on 31 July and the

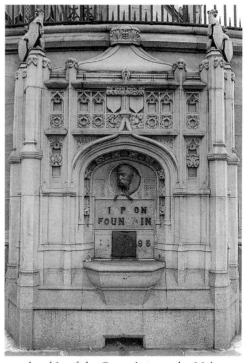

membership of the Committee, under Major Lester's chairmanship, was ratified. Joseph Thomas then announced that subscriptions had risen to about £150. The suggestion was again made that a drinking fountain would be the most appropriate form of memorial, especially in the light of Simpson's efforts in the cause of temperance, but some of those present felt that a fountain was an 'inadequate tribute' and the decision on the form of the memorial was deferred (*Mercury*, 1 August 1883). Notwithstanding these reservations, however, the fountain idea was later carried and, from a limited competition, the Memorial Committee selected the design of the architect, Thomas Cox (*Mercury*, 11 July 1885).

In October 1883 the Memorial Committee sought the Council's permission to erect the fountain in the area of Pier Head. The matter was duly passed to the Corporation Finance and Estate Committee who, despite giving the design some consideration, had still not arrived at a decision by early 1884. On 28 March 1884, the Finance and Estate Committee received a deputation from the Memorial Committee, who again showed them the design, assured them that even though sufficient funds had not yet been collected they shortly would be, and politely requested them to ask the Council to suggest an alternative site if the Pier Head area was not deemed suitable. At last, on 18 April 1884, the Finance and Estate Committee stated that, subject to Council approval, it would have no objection to 'the placing of a suitable mural memorial fountain against the new retaining wall of St Nicholas' churchyard' and, on 14 May 1884, J.W. Fairbrother of the Memorial Committee wrote to accept the offer (*Finance and Estate Committee Minutes*).

Now that a specific site had been proposed, Cox had to make a few modifications. He sent his new design to the Finance and Estate Committee on 11 July 1884 at which point, it

seems, certain members of the Committee became concerned about the excessive projection of the body of the fountain across the footway and felt obliged to refer the matter to the Corporation Health Committee. On 21 August 1884, the Borough Engineer reported to the Health Committee that, in his opinion, the fountain, as planned, would indeed constitute a potentially dangerous obstruction to passers-by (*Finance and Estate Committee Minutes*). The Health Committee thereupon advised that the scheme be rejected and the very next day the Finance and Estate Committee revoked permission to build (*Finance and Estate Committee Minutes*).

A considerable body of Councillors, however, considered the problems exaggerated and the objection therefore unjustified, and the debate continued throughout the Autumn of 1884 (*Council Minutes*) with Councillor James Barkeley Smith (according to the *Daily Post*, 11 July 1885) mounting something of a campaign to prevent the fountain's construction. The same article went on to report how the problem was coincidentally solved through the implementation of a road-widening scheme which necessitated appropriating the north-western

portion of St Nicholas' churchyard: with the setting back of the wall against which the fountain was to be set, there would no longer be any potential hazard to pedestrians. Thus, the supporters of the memorial triumphed (albeit fortuitously) and the fountain was erected. The *Daily Post* and the *Mercury* (11 July 1885) both warmly reviewed the fountain, with the former paper castigating Smith for the 'absurdity of [his persistent] opposition'. The official seal of approval was finally given when the Mayor, Alderman (Sir) David Radcliffe, accepting the *Simpson Memorial Fountain* on behalf of the citizens, predicted that it 'would be of great use to the thousands who were daily passing to and from the docks' (*Daily Post*, 11 July 1885).

Literature: (i) LRO manuscript sources: *Council Minutes*, 1/25: 211; *Council Minutes*, 1/26: 92, 163-66; *Finance and Estate Committee Minutes*, 1/29: 341, 392, 748, 764-65; *Finance and Estate Committee Minutes*, 1/30: 5, 15, 58-9, 71, 93, 242, 299-300, 354. (ii) *Daily Post* (1883) 17 July: 7; *Daily Post* (1885) 11 July: 4, 7; *Mercury* (1883) 11 July: 6; *Mercury* (1883) 28 July: 6; *Mercury* (1883) 1 August: 5; *Mercury* (1885) 11 July: 8; Picton, J.A. (1875, revised edn 1903), ii: 494.

Childwall Road Picton Clock. See Wavertree High Street

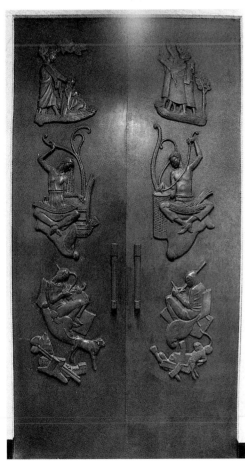

LIVERPOOL ROYAL SCHOOL FOR THE BLIND.

Inside are the bronze doors which once formed the street entrances to the extension to the school's previous building in Hardman Street,

on the corner of Hope Street, officially opened by the 17th Earl of Derby, Monday 31 October 1932. A double doorway gave entrance to the school shop on Hardman Street and a single doorway formed the side entrance to the school in Hope Street (Royden, 1991: 175, 178). Access to the present building only by prior arrangement.

Sculptor: James Woodford

High reliefs on one-eighth inch sheet bronze doors

Bronze founder: Morris Singer of London

Hardman Street doors: closed – 119" × 62" (302.26cms × 157.48cms)
– each leaf: w: 31" (78.74cms)
Hope Street door: h: 92" (233.68cms); w: 41¼" (104.77cms); d: 2¼" (5.7cms)

Hardman Street doors: signed on the lowest relief of the left leaf, at the bottom of the rug below the chair of the pupil weaving a rug:
JAMES / WOODFORD
Hope Street door: signed and dated on the lowest relief, towards the right end of the stylised wave pattern forming its bottom edge:
JAMES WOODFORD 1931

Exhibited: Royal Academy of Arts 1932 (cat. 1483), as *Model of bronze door, School for the Blind, Hardman St., Liverpool*; Royal Academy of Arts 1933 (cat. 1605), as *Model of bronze door, School for the Blind, Hardman St., Liverpool.*

Owner: Liverpool Royal School for the Blind
Status: not listed

Descriptions:
(i) Hardman Street doors. On each leaf are three vertically aligned scenes, representing 'the aspirations and work of the school' (*Architect and Building News*, 7 October 1932). The top of the left leaf has *Christ Healing the Blind*, whilst that on the right has *The Cured Giving Thanks*. Beneath these are four scenes showing blind pupils engaged in crafts and trades: one making a wicker chair seat and another a wicker basket and, below, one making a leather bag and another weaving a rug. Below the lower figures are, on the left, some brushes, a pair of boots and a toolbag and, on the right, paint brushes, a scarf, the head of a broom, a jumper and a ball of wool, representing the products of the pupils' industry with, on the left leaf, a calf, and on the right, a lamb, representing the leather and wool used in the various crafts. The design of the handle on each leaf is based on 'a clump of reeds growing in a stream' (Royden, 1991: 178).

(ii) Hope Street door. Three vertically aligned scenes, each framed by, at the bottom, a stylised wave pattern and at the sides, stylised reeds. The top relief shows a man gathering reeds; the middle, five girls making reed baskets seated around a circle of tables; and the bottom, two knitting machines.

The Architect and Building News (7 October 1932) considered these bronze doors 'the most remarkable feature of the exteriors [of the building]' and recorded that when exhibited at the Royal Academy, the full-size plaster casts for the double doors (now in the WAG) had 'attracted considerable attention'.

Condition: Good.

Related works:
(i) Full-size plaster casts, WAG (1994. 130.1/130.2).
(ii) Stone reliefs on the Hardman Street building (now the Merseyside Welfare Rights Centre), for which, see separate entry below, pp. 70–71.

Literature: *Architect and Building News* (1932) 7 October: 8-10; Pevs de, N. (1969): 182; Royden, M. (1991): 175-79.

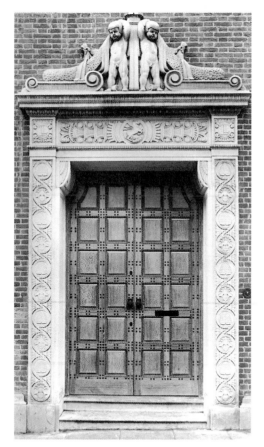

Formerly LLOYD'S BANK, now Olympus Sports, 17 Church Street, at the corner with Williamson Street. Built in 1930-31 by Herbert J. Rowse, it originally included much ***Architectural Sculpture***. The round-arched windows of the upper floor with their carved columns survive, as do the two mermaid roundels on the Williamson Street façade, but the most splendid feature, the elaborately carved main entrance has been demolished.

Sculptors: George Herbert Tyson Smith (designer) and Edmund C. Thompson (executant).

Architectural sculpture in Portland stone

Owner/custodian: untraced
Status: not listed

Tyson Smith's hand-written account book, detailing all the costs of this commission, survives in the George Herbert Tyson Smith Archive (Box 18) at Liverpool Public Library (LRO). For a general view of the main façade in Church Street and return frontage in Williamson Street as they appeared shortly after construction, see *The Architects' Journal*, 1932, vol. lxvi, p. 496.

Literature: (i) LRO manuscript sources: George Herbert Tyson Smith Archive, Box 18
(ii) *Architects' Journal* (1932) 19 October, lxvi: 496, 497-99; Poole, S.J. (1994): 44, 444.

SPINNEY HOUSE, erected 1954.

The Church Street and Church Alley frontages are decorated with ***Architectural Sculpture***, mostly on a maritime theme, including shell and

Church Street

lobster friezes, cresting wave friezes, dolphin capitals and sea-horse capitals, and a Triton in a roundel. Over the main entrance in Church Street is a large keystone carved as a bearded head with a crown of scallop-shells.

Sculptors: George Herbert Tyson Smith and workshop

Owner/custodian: untraced
Status: not listed

Condition: Apparently good.

Literature: (i) LRO manuscript sources: George Herbert Tyson Smith Archive, Box 31.
(ii) Poole, S.J. (1994): 44, 176-77, 377, 394.

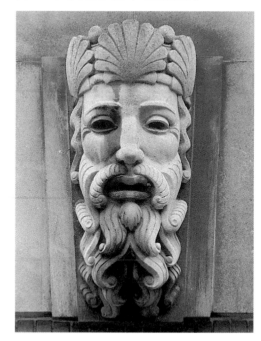

The Steble Fountain

Designer: Paul Liénard

Fountain and figures in cast iron with some bronze fittings

Diameter of outer circular basin: 30' (9.1m)
h. of shaft to octagonal basin: 12' (3.6m)
Diameter of octagonal basin: 12' 6" (3.8m)
Diameter of upper circular basin: *c.* 8' (2.4m)
Total h. of fountain: 23' (7m)

Founder: W.T. Allen & Co. of London

Inscriptions (in raised lettering)
– on a shield each side of the octagonal stem: PRESENTED / TO / THE TOWN OF / LIVERPOOL / BY / LIEUT. COL. R. F. STEBLE. / A.D. 1877.
– on a plate affixed to the end of the west arm of the base: W. T. ALLEN & CO / LAMBETH HILL / UPPER THAMES ST. / LONDON E.C.

Unveiled by (Sir) Thomas Bland Royden, Mayor of Liverpool, Thursday 1 May 1879

Owner/ manager: Liverpool City Council
Listed status: Grade II*

Description: The fountain is located on the triangular plot of land in front of the Walker Art Gallery to the west of the *Wellington Memorial*. It has an octagonal stem on a cruciform base in a shallow circular basin, with a marine deity seated on each arm of the cross. The four deities, alternating male and female, form two pairs. Each male deity looks to his left to his female neighbour, who returns his gaze. The *Mercury* (7 February 1878) records that the deities are Neptune and Amphitrite, and Acis and Galatea. Above them, supported by the octagonal stem, is a shallow octagonal bowl, the rim of which is punctuated with sixteen overflow outlets: those at the corners are embellished with a motif of scallops and a Lancastrian rose; whilst those in the middle of each straight side are embellished with marine grotesques. The central stem rises from this to a smaller circular bowl which is surmounted by a mermaid holding a cornucopia from which water once issued.

Condition: In working order. Restored by Liverpool City Council in August 1992 on the occasion of the Tall Ships Race. Restoration included replacement in cast iron of a missing bronze grotesque head water spout from the east side of the upper basin. The whole fountain was repainted in black, though in an effort to reach the deadline the undercoat was allowed insufficient drying time, with the consequence that the top coat bubbled up and is now peeling away in places. The gold leaf on the raised lettering is part of the 1992 restoration.

Two of the deity figures still have digits missing: the little finger of the right hand of the god facing east and the thumb of the right hand of the goddess facing north. There are blobs of white on all the figures and the god facing east has had white applied to the eyes.

Related work: *The Brewer Fountain*, *c.*1867, Boston Common, Boston, Massachusetts. The overall design is the same as for the *Steble Fountain*, as are the four marine deities seated around the lower stem, although other details are varied. An inscription gives the founder as *Fourment Houille & Cie. / Val d'Osie* (information supplied by Joseph Sharples, WAG). There are apparently other castings at Geneva, Lyon and Bordeaux (*Adopt-a-Statue Casebook*, 1990: 11).

The Boston *Brewer Fountain* (see above) was designed by Paul Liénard and shown at the 1867 Paris Exposition (*Adopt-a-Statue Casebook*, 1990: 11). The *Steble Fountain* is sufficiently close in its overall design but, more importantly, the marine deities so obviously derive from the same models, that Liénard can be credited with confidence as the designer of both fountains. Pevsner (1969: 158) gives the design to W. Cunliffe, although his source for this attribution is not known (the Penguin Books *Buildings of England* office were unable to ascertain Pevsner's original source when the WAG JCS team enquired in 1977 and the present author has been unable to find any record elsewhere of the activities of this artist). The *Mercury* (2 May 1879), on the other hand, attributes the design to W.T. Allen & Co. of London, although they were evidently solely responsible for the founding.

The site on which the fountain is located was the last remaining undeveloped patch of land in the new forum created between St George's Hall and the Neo-Classical group of buildings which was growing up along William Brown Street. The rubble-strewn patch of land was considered unsightly and aroused considerable comment in the local press. Then, on 12 January 1877, the *Mercury* announced that Lieutenant-Colonel R.F. Steble had offered £1,000 to the Corporation Improvement Committee towards the erection of a fountain on the site.

Steble suggests in his presentation speech (*Mercury*, 2 May 1879) that he was motivated to make his gift by the example of the surrounding donations by his fellow townsmen: Sir William Brown's Free Library, the Earl of Derby and Joseph Mayer's Museum, (Sir) James Picton's Reading Room and Sir Andrew Barclay Walker's Art Gallery. These, he saw as 'enduring evidences of the liberality and worth of the noble and honourable of our own times and locality', although he modestly proclaimed his own contribution 'a trifling one'.

The fountain was officially turned on by the Mayor with a commemorative silver key formally presented to him by Steble, but the low water pressure created a dismal effect. Furthermore, the realization that the exposed and windy location would mean that, were the water pressure any higher, passers-by would inevitably receive a soaking, occasioned disappointment from the onlookers and glee from the satirical writers of *The Porcupine* (7 June 1879).

More embarassment was to follow. The water was pumped up to the various spouts by a steam pump installed in the basement of St George's Hall, beneath the Civil Court. In the August following the fountain's inauguration, Justice Lush angrily ordered the cessation of the pump when the 'subterranean pulsations' of the machine managed to disrupt totally his court proceedings. The fact that the pump had been paid for with £400 of public money, occasioned bitter comment in the local press (*Liberal Review*, 8 June 1878; *The Porcupine*, 23 August 1879). The problem was solved only when the steam pump was replaced by an electric one.

Literature: (i) LRO (a) manuscript sources: *Finance and Estate Committee Minutes*, 1/23: 656, 666-67; *Finance and Estate Committee Minutes*, 1/24: 30, 312-13, 325-26, 372, 383-84; *Finance and Estate Committee Minutes*, 1/25: 300-01, 316-17, 351-53. (b) newscuttings: *Mercury* (1877) 12 January; *Mercury* (1877) 16 February, in *TCN 1/12*; *Mercury* (1878) 7 February, in *TCN 1/13*; *Mercury* (1879) 2 May, in *TCN 1/14*.
(ii) *Liberal Review* (1878) 8 June: 11; Pevsner, N. (1969): 158; *Porcupine* (1879) 7 June: 152-53; *Porcupine* (1879) 23 August: 331-32.

The Wellington Memorial

Arthur Wellesley, 1st Duke of Wellington (1769-1852), British general, statesman and Prime Minister. He is commemorated here as the victorious leader of the British land forces in the Peninsular War. In 1808, was sent to relieve Portugal where he achieved early successes against the French at Rolica and Vimiero. His victory at Talavera in 1809 earned him the title Viscount Wellington, with further victories throughout the peninsula ensuring his elevation to Earl, and then Marquis of Wellington in 1812. His successful campaign against the Napoleonic armies culminated in the expulsion of the French from the peninsula at Vittoria in 1813. In this year he was created Knight of the Garter and on his return to England in 1814, following Napoleon's abdication, was elevated to Duke. Napoleon's escape from Elba necessitated Wellington's return to active service and his final victory against Napoleon was achieved at Waterloo in 1815. (source: *DNB*)

Architect: Andrew Lawson
Sculptor: George Anderson Lawson

Foundations in Runcorn stone
Base (pedestal and steps) in granite
Roman Doric column in Darley Dale stone
Statue, panels and decorations in bronze

Stonework contractor: Messrs Holme and Nicol

h. overall: 132' (40.2m)
h. of statue: 15' (4.6m)
h. of column: 81' (24.7m)
Pedestal: 15' × 15' (4.6 × 4.6m)

Inscriptions on plaques set into the pedestal:
– north face: WELLINGTON.
– west face; SALAMANCA. BAYONNE. /
VITTORIA. ORTHEZ. / SAN SEBASTIAN.
TOULOUSE. / NIVELLE. QUATRE BRAS. /
WATERLOO.
– east face: ASSAYE. TALAVERA. / ARGAUM.
BUSACO. / ROLICA. FUENTES D'ONORO. /
VIMIERO. CIUDAD RODRIGO. / OPORTO.
BADAJOS.

Signed by the sculptor on the relief panel on the
south face of the pedestal: G.A. LAWSON S.C. /
LPOOL

Foundation stone laid by S.R. Graves, Mayor of
Liverpool, Wednesday 1 May 1861
Monument inaugurated by R.C. Gardner,
Mayor of Liverpool, Saturday 16 May 1863

Owner/ manager: Liverpool City Council
Listed status: Grade II*

Description: The monument is located on the
site of the old Islington Market. It consists of,
from the bottom, a three-course, stepped base,
leading up to a square pedestal which carries
four bronze plaques and is decorated at each
corner with a bronze eagle aligned axially and
standing on the ends of the swags which run
along the sides. The pedestal supports a fluted
Roman Doric column with a wreath around the
base. Inside the column 169 steps lead up to
give access onto the square viewing platform
(formed by the column's abacus). From the
platform rises a cylindrical structure with a
cupola, on top of which stands the bronze
statue of Wellington, supposedly cast from

trophies from Waterloo (WAG JCS archives –
no source given). Wellington holds in his right
hand a scroll, whilst his left hand rests on the
hilt of his sword.

The bronze plaques on the east and west
faces of the pedestal list Wellington's victories,
whilst that on the south face is a relief depicting
the final charge at the battle of Waterloo.
Infantry march from right to left. Wellington,
on horseback, holds a telescope in one hand and
the reins of his horse in the other. In the back-
ground, and slightly in advance of Wellington is
Lord Hill, drawing the Duke's attention to the
enemy's movements. Following in the rear, and
also mounted, is the Marquis of Anglesey
(*Mercury*, 13 December 1865).

Condition: There is some graffiti on the base
and steps. In the battle relief, the dying soldier
at extreme left is missing a hand; there is a hole
a quarter of the way in from the left of the relief
at the height of the marching soldiers' knees,
and the covering of black epoxy paint has
largely worn away to reveal the green bronze
beneath. The bronze eagles and swags appear
intact.

Following Wellington's death in September
1852, Liverpool joined the general move to
commemorate him as the hero of Waterloo. In
response to 'a numerously signed requisition',
the Mayor of Liverpool convened a public
meeting for 23 October to consider the most
suitable way the town could do this (*The Times*,
18 October 1852). At the meeting, in the
Sessions House, there was unanimous agree-
ment to Charles Turner's proposal that a public
subscription should be launched to fund a
monument 'worthy of the man in honour of
whom it would be erected' (*The Times*, 25
October 1852). A Wellington Testimonial
Committee was formed to supervise the
subscription (*Daily Post*, 18 May 1863), but any
significant progress in the scheme was delayed
by the large gulf between the magnitude of the
subscribers' ambitions and the relative paucity
of the funds gathered.

From the first, the Committee had favoured
a column surmounted by a statue of the Duke,
presumably in emulation of London's column
to Lord Nelson, Britain's other national hero of
the Napoleonic Wars (by William Railton,
1839-42). Expert opinion had told the

Committee to expect to pay between £10,000 and £12,000 for a column, and yet by 1856 only £5,893. 16s. 6d. had been subscribed. In a meeting convened to consider the options, Charles Turner maintained that a column could in fact be erected for as little as £7,000 and that that sum could be accrued from the existing subscriptions if they were allowed to gather interest. In complete contrast, William Rathbone and James Aikin expressed their preference for an equestrian statue. George Arkle, seemingly lending support to this alternative, stated his opinion that nowhere in Liverpool was there a site entirely suitable for a column. Nevertheless, the matter was finally settled in favour of Turner's reduced price column when the Commitee's Honorary Secretary, John Torr, stated his belief that an equestrian statue was out of the question as there was no English artist who was capable of modelling a horse. The *Art-Journal* (1856: 159), extracting this account of the meeting from an unnamed Liverpool newspaper, entreated the Committee to look at John Henry Foley's acclaimed *Equestrian Statue of Lord Hardinge*, then in the course of execution (for Calcutta, now in a private collection), if it really thought that there was no English artist who could 'model a horse'. The journal's plea went unheeded, however, and the Committee stuck to its plans for a column.

A little later in the year, the Testimonial Committee advertised a competition to find a suitable design for the monument. The advertisement asked for designs both for a column crowned with a statue of the Duke, and for a column alone. The column with a statue was to be preferred, provided that it could be carried out for the amount at the Committee's disposal. Each proposal was to be accompanied by a cost estimate and a description of the materials that were to be used. The winning entry would earn its designer a premium of £50, with the design thereafter becoming the property of the Testimonial Committee (*Art-Journal*, 1856: 382). The competition was won by the Edinburgh architect, Andrew Lawson, although at this point the Testimonial Committee was prepared to give approval to his design for the column only.

It was not until 9 September 1857 that the question of where to erect the column was first officially explored, when John Torr made a formal application to the Council 'for an eligible site' (*Council Minutes*). The Council referred the matter to the Corporation Finance Committee which, in turn, asked the Testimonial Committee to propose a site itself (*Finance Committee Minutes*). Eventually, at the beginning of December 1858, the Testimonial Committee requested the 'space formerly occupied by Islington Market'. Although this was indeed to be the column's ultimate location, the Finance Committee's initial response was to reject the request out of hand. Of all the sites the memorialists could have applied for, this was the least acceptable to the Finance Committee, deeming the land far too valuable to be released for such a non-remunerative purpose (*Daily Post*, 2 May 1861). Consequently, on 28 January 1859, the Finance Committee suggested alternative sites 'in Great George Square, Abercromby Square or at the top of Duke Street' (*Finance Committee Minutes*), none of which suggestions seem to have appealed to the memorialists for, on 1 July 1859, they applied for permission to erect the column at Monument Place, London Road (*Finance Committee Minutes*).

Although this would have necessitated the removal of Westmacott's *King George III Monument*, the Finance Committee made a recommendation to the Council to concede this site, provided that the memorialists bore the full cost of the removal and the safe re-erection of the earlier monument. Understandably, the Council, for its part, was not prepared to give its sanction before an acceptable new location for the *King George III Monument* had first been found. The Finance Committee considered the possibilities and, on 29 July, recommended the site in front of the New Library and Museum (William Brown Street). This, however, did not meet with the satisfaction of the Council and, on 3 August, the Finance Committee was asked to consider the matter further (*Finance Committee Minutes*).

By early 1860, the subscribers were evidently becoming frustrated by the Corporation's continued failure to suggest or approve an acceptable alternative to their favoured location. Consequently, on 30 April, John Torr wrote directly to the Mayor, T.D. Anderson, expressing the subscribers' impatience and asking that the Testimonial Committee's original suggestion be re-considered (*Finance Committee Minutes*). Despite its continued objections, the Finance Committee finally yielded to the subscribers' sustained pressure and recommended that the Council give approval to the Islington Market site, which it did in its meeting on 6 June 1860 (*Finance Committee Minutes*).

By early 1861, the Committee was sufficiently confident of reaching its £7,000 target to advertise a competition for a statue to surmount the column. Six models were duly submitted (*Art-Journal*, 1861: 332). One of the models, by Liverpool sculptor J.A.P. MacBride, was evidently well received by Torr and three other members of the Committee at a preliminary viewing. The sculptor, on hearing of this, wrote at least two letters to one of the Committee

members, in the first asking him to use his influence to elicit support for his work from two more members, and in the second giving an account of his considerable familiarity with the leading bronze founders, as well as his own first-hand experience in all the finishing processes required after casting (photocopies of letters dated 12 April 1861 and 10 May 1861, WAG JCS files). Nevertheless, despite MacBride's blatant lobbying, at the final adjudication the winning entry was announced as being that submitted by George Lawson, brother of the architect of the column (*Art-Journal*, 1861: 332; see also Read, 1989: 37).

The foundation stone was laid on 1 May 1861, the anniversary of the Duke's birthday. The silver trowel with which the Mayor of Liverpool performed the ceremony – praised for its beauty and workmanship by the local press – was made in the workshop of Joseph Mayer. The blade bore an engraving of the *Wellington Monument* with the inscription:

> Presented to Samuel Robert Graves, Esq, Mayor of Liverpool, on the occasion of his laying the first stone of a column erected by public subscription to the memory of Field-Marshal the Duke of Wellington, K.G., on the 1st day of May, 1861 (*Daily Post*, 2 May 1861).

Into a cavity beneath the foundation stone was placed a glass bottle containing contemporary newspapers and silver coins, and the cavity was sealed with a brass plate engraved by Messrs Leatherbarrow of Liverpool with the following inscription:

> The foundation stone of this column, erected by public subscription to the memory of the immortal Duke of Wellington, was laid by his Worship the Mayor of Liverpool, Samuel Robert Graves, Esq., on the first day of May, 1861. Thomas Edwards Moss, Esq., treasurer; John Torr, Esq., secretary. A. and G.A. Lawson, Glasgow, architects; Holme and Nicol, Liverpool, builders (*Daily Post*, 2 May 1861).

Unfortunately, the construction of the monument was to meet with almost as many delays as had the raising of the funds to finance it. Liverpool builders Holme and Nicol made slow progress, apparently because of problems of subsidence, and the idea of the column sinking into fathomless quicksand and emerging upside down in New Zealand kept the writers of the local satirical journal, *The Porcupine*, amused for some time (see especially *The Porcupine*, 1861: 65, 171, 200, 236, cited in Read, 1989: 37).

Given the delays that the Wellington Testimonial Committee had suffered, it is not surprising that the the unveiling ceremony was scheduled for as soon as possible after the completion and fixing of the statue, when the various bronze accoutrements for the pedestal were still some months away from completion. Four hundred people had subscribed a total of £6,000 which, according to T.E. Moss, the Committee Treasurer, had, through skillful investment, finally increased to £8,000 (*Daily Post*, 16 May 1863).

The Liverpool *Wellington Monument* was eventually completed towards the end of 1865 when George Lawson's relief panel of the final battle at Waterloo was fixed in place on the pedestal (*Mercury*, 13 December 1865).

Literature: (i) LRO manuscript sources: *Council Minutes*, 1/8: 228; *Council Minutes*, 1/10: 621, 674; *Finance Committee Minutes*, 1/7: 461, 618; *Finance Committee Minutes*, 1/8: 140, 170, 259-60, 261-62, 263-64, 272, 276, 281, 283, 438, 440, 478.
(ii) WAG JCS files – photocopies of two letters, dated 12 April 1861 and 10 May 1861, from J. A. P. MacBride.
(iii) *Art-Journal* (1856): 159, 382; *Art-Journal* (1861): 332; *Art-Journal* (1863): 139; *Art-Journal* (1865): 60; *Daily Post* (1861) 2 May: 7; *Daily Post* (1863) 16 May: 5; *Daily Post* (1863) 18 May: 5; *Daily Post* (1938) 22 October: 6; *Daily Post* (1951) 28 March: 1; *Echo* (1938) 25 February: 8; *Echo* (1959) 17 June: 2; Hughes, Q. (1969): 60; *Mercury* (1865) 13 December: 6; Picton, J.A. (1875, revised edn 1903), ii: 186; *Porcupine* (1861): 65, 165, 171, 200, 236, 248, 249; *Porcupine* (1862): 279, 295; *Porcupine* (1863): 62; Read, B., 'From Basilica to Walhalla', in P. Curtis (ed.) (1989): 36-7; Reilly, C.H. 1927 (a): 4-5; *The Times* (1852) 18 October: 6; *The Times* (1852) 25 October: 4.

Concert Street

Located near the junction of Concert Street with Bold Street.

Reconciliation

Sculptor: Stephen Broadbent

Founders: Varleys of St Helens

Sculpture in cast iron

h: 13' 4" (4.06m)

Inscription on the base: RECONCILIATION

Unveiled by Dorothy M. Gavin, Lord Mayor of Liverpool, Wednesday 19 September 1990.

Owner/ manager: Liverpool City Council
Status: not listed

Condition: There is graffiti on the lower part of the sculpture and there are rust stains around the base.

Related works: Two further copies are located at Carlisle Memorial Gardens, Carlisle Circus, North Belfast; and outside the Pollok Shopping Centre, 45 Cowglen Road, Pollok, Glasgow.

The simultaneous unveiling of three identical statues entitled 'Reconciliation' at Liverpool, Glasgow, and Belfast on Wednesday 19 September 1990 was for the sculptor the consummation of a two year plan. In a brochure relating to the unveiling, Broadbent stated:

> The aim has been to unite three cities and various communities – each with historical links and stark problems... [The sculpture] is a very simple statement of a basic desire. Through their embrace, two figures become

one. This unity is emphasised by the root solidarity of the form. The individuals have become grounded in each other, potentially to become one in 'body and spirit'. The figures are universal. Within their features can be identified any one of us, any group of us, transcending the boundaries of gender, colour or creed.

The site chosen for the Belfast sculpture was felt to be particularly appropriate as it stands at an intersection of the Catholic and Protestant communities.

The model for the statue was produced during the course of one week, from Monday 1 to Friday 5 August 1989 in Belfast in a converted Methodist church, Carlisle Memorial Centre. The sculptor, with colleague Paul Greggs and photographer Dave Williams, gathered together with seven young helpers from schools in each of the cities for which the statues were destined: Emil Cromby and Zapher Iqbal from Liverpool; James Paterson and Joseph Wilson from Glasgow; and Marion Rock, Karen Rock and Michelle Granville from Belfast. With regard to Belfast it was considered particularly important that young people from both communities were selected to assist in the production in order that Catholics and Protestants alike should feel a sense both of mutual participation in the project and of ownership of the resulting sculpture.

Once in Belfast, one helper from each city (Zapher, Karen and James) was delegated to go with Greggs to the local library to research appropriate lettering styles for the inscription on their city's sculpture – the style of Rennie

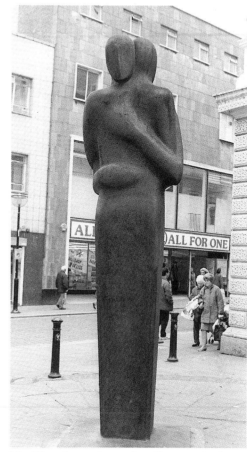

MacKintosh was chosen for Glasgow, Gaelic for Belfast and a Gothic scroll for Liverpool (although the Liverpool inscription was ultimately executed in plain sans serif capitals). Joseph was to work with the photographer recording the project, and Marion, Michelle and

Emily were to assist the sculptor in carving the model from a polyurethane block.

Broadbent first pinned actual-size drawn profiles to each face of the block. Then, over the next three days, the assistants carved away the areas outside the profiles. On Tuesday 2 August, designated as open day, the project received positive coverage from local television, radio and press. By Friday 5 August, the rough modelling stage had been completed and the base was strengthened with fibreglass. Finally, on Saturday 6 August, the model was delivered to Belfast docks for shipment to Liverpool.

Over the next two months Broadbent worked on the model at Bridewell Studios, Liverpool, preparing it for casting. On 3 October the finished 13ft 4in. model was displayed to the public in the Studios and on 9 October it was delivered to Varleys Iron Foundry in St Helens. Broadbent ensured that the first 4½ ton copy was cast successfully and then, on 9 November, invited his assistants from their various cities to stay a week in Liverpool and to witness the casting of the second copy.

Funding had been raised, and support for the project given, by the respective local City councils, local action groups, senior churchmen and politicians, and three voluntary groups, namely the Glasgow Council for Voluntary Service, the Merseyside Council for Voluntary Service, and Belfast's Bryson House. The final cost, which included casting, and the landscaping of, and final erection at, each of the three sites, amounted to £50,000.

Literature: *Daily Post* (1990) 20 September: 10; Davies, P. (1992): 69; *'Reconciliation'* (1990); Richardson, A. (1990): 78.

Dale Street

IMPERIAL CHAMBERS, 58-66 Dale Street, *c.*1860-70. The centre bay of the façade is surmounted by a triangular pediment framing a segmental tympanum with **Allegorical Figures** in high relief.

Sculptor: unknown

High relief in sandstone

Owner of building: Mr Eric Mahoney
Listed status: Grade II

Description: An enthroned female figure holds up a distaff; two *putti* stack bales of cotton at her feet.

Condition: The relief appears to be in relatively good condition.

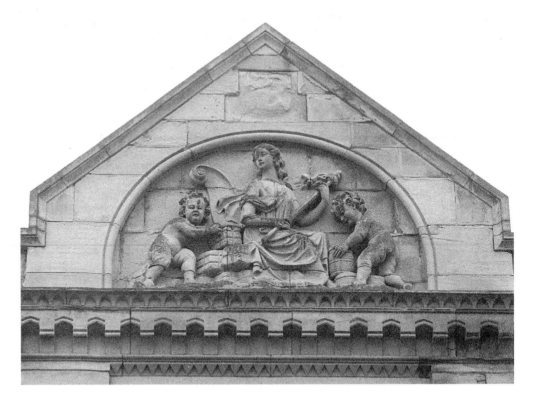

LIVERPOOL AND LONDON AND GLOBE INSURANCE, 1 Dale Street, designed and built by C.R. & F.P. Cockerell, 1855-7. Located on a corner site next to the Town Hall, the exterior is richly carved, with a continuous guilloche frieze above the ground floor windows and carved keystones crowning the monumental doorways.

Carving: Edwin Stirling and William Grinsell Nicholl

Sandstone

Owner of building: Petros Developments Liverpool
Listed status: Grade II

Description of sculpture: The main entrance is surmounted by a broken-bed pediment, in the tympanum of which is the combined coat of arms of Liverpool and London, supported by double-tailed mermaids. The pediment is contained within an archway, the keystone of which is carved as a human head. The spandrels of the arch are draped with richly-carved garlands.

Condition: Relatively good, but rather grimy, with bird droppings on the coat of arms in the tympanum.

McMorran (1964: 437) has suggested that Alfred Stevens was consulted on the design of the carved decoration. This is on the evidence of: 'some very rough suggestions for plaque and panel decoration [on a sheet of studies in the RIBA collection, with a] faint, half-obliterated inscription "London and Liverpool Insurance Company".' Although Stevens's involvement as consultant is not hereby proven, it is certain at least that William Grinsell Nicholl carved some of the external sculptural decoration as records show that he was paid £733 for the job (Watkin, 1974: 231). The majority of the carving, however, was executed, according to *The Builder* (17 January 1857: 42, cited in Gunnis, 1951: 374), by the Liverpool sculptor, Edwin Stirling.

Literature: *Builder* (1857) 17 January: 41-2; Gunnis, R. (1951): 374; McMorran, S. (1964): 437; Watkin, D. (1974): 230-31.

MUNICIPAL BUILDINGS. Designed and commenced by John Weightman, Corporation Surveyor, they were completed with some modifications by his successor, E.R. Robson, 1860-6. The buildings are designed to a symmetrical plan with projecting corner pavilions plus, on the Dale Street façade, a central tower.

Sixteen Allegorical Figures
stand on the entablature of the giant order at the level of the second floor windows. According to Whitty:

> In the entablatures of the north front are placed large emblematic sculptured figures to represent art, industry, engineering skill, plenty, navigation, and science, while in other prominent positions are placed figures representing the inhabitants of the four quarters of the globe (Whitty, 1871: 66).

Thus, the figures are symbolic of the various

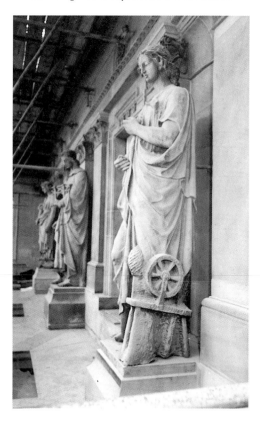

arts, sciences, and industries which flourished in England as a by-product of Liverpool's successful harvesting, through her maritime commercial enterprise, of the resources of the four quarters of the globe.

Sculptor: unknown

Statues in sandstone

Each statue, h: 8' 2½" (2.5m) approx.

Owner of building: Liverpool City Council
Listed status: Grade II*

Description of the allegorical figures (all of which originally had identifying attributes):
1. DALE STREET FAÇADE:
– left hand pavilion: the statue on the left represents *Europe* as a woman in classical drapery. With her left hand she holds a shield decorated with a cross; her right hand (which once held perhaps a lance) is raised. The statue on the right represents *Asia* as a woman in a turban. With her left hand she holds a shield decorated with a horse's head; in her right hand she holds a fly-whisk.
– right hand pavilion: the statue on the left represents *Africa* as a black woman with braided hair, wearing ear-rings, necklace, wrist and ankle bracelets, and a jewelled headdress. She is dressed in a fringed shawl, the hem of which she gathers up in her right hand, whilst in her left she holds a richly-decorated casket. The statue on the right represents *America* as a young man wearing a robe with a fringed hem and a feathered head-dress. In his right hand he holds an arrow, whilst three further arrows are contained in a quiver on his back. In his left hand he holds a bow.
– between the lefthand pavilion and the central tower are, from left to right: *Agriculture* as a woman carrying in her right hand a cornucopia

with, at her left side, a ploughshare; *Engineering* as a young man holding the model of a bridge; and *Spinning* as a woman holding a distaff, with a spinning wheel at her left side.
– between the central tower and the righthand pavilion are, from left to right: *Navigation* as a woman holding up a sextant in her right hand, her left hand resting on a ship's mermaid figurehead; *Astronomy* as a bearded man holding in his right hand a telescope and in his left a scroll, with a celestial globe by his right foot; and *Commerce*, a woman with a ribbon in her hair, her left hand leaning on a bundle tied with rope, her right hand raised.

2. CROSSHALL STREET FAÇADE:
– rear pavilion: On the left *Industry* is represented as a bearded man holding a rolled scroll in his right hand, with a large cog-wheel by his left foot; on the right is *The Arts* as a woman with a bow in her hair. Her right hand rests on one end of a scroll, unrolled over the top of a section of fluted column, while with her left hand she gathers up before her the drapery of her robe.
– pavilion at the corner with Dale Street: On the left is a woman presumably representing *Electricity*: she has a bundle of thunderbolts in her left hand, her right hand rests upon her hip, upon her forehead is a star, and she stands before a (somewhat inaccurately conceived, but nonetheless recognisable) telegraph. On the right is *Medicine* as a bearded, turbaned man who leans on a branch around which is coiled a snake – the attribute of Asclepius, the classical god of healing. At his left side, behind the branch, is an apothecary's mortar and pestle.

3. SIR THOMAS STREET FAÇADE:
– pavilion at the corner with Dale Street: On the left is *Architecture* as a bearded man with an unrolled scroll and set square in his right hand, a pair of compasses in his left; on the right is an

unidentified female figure with her cloak gathered up over her left hand.
– rear pavilion: On the left is *Poetry* as a woman holding a lyre in her right hand and an open scroll in her right; on the right is *Printing* as a man reading from an open book held in his right hand, whilst with his left hand he leans on a printing press.

Condition: All the statues are in poor condition, with numerous small losses.

The first (unspecified) statue was in place on the Dale Street front by 27 July 1866 (*Minutes of the Sub Building Committee*).

Literature: (i) LRO manuscript sources: *Minutes of the Sub Building Committee*, 1/3: 161.
(ii) *Builder* (1867) 9 November: 819; Whitty (1871): 66.

Bust of (?) John Gibson

Dale Street entrance hall, mounted on a pedestal against the wall, behind the enquiry desk.

Sculptor: John Adams-Acton

Bust in marble

h. including base: 29½" (75cms); excluding base: 24½" (62cms)

Signed and dated on the back of the bust, below the collar: JOHN ADAMS ACTON FECT. ROMA. 1864.

Owner: Liverpool City Council
Listed status: not known

Condition: The bust has recently been restored (see below).

Related work: John Adams-Acton, *Bust of John Gibson*, marble, inscribed 1862, WAG (cat. 4145).

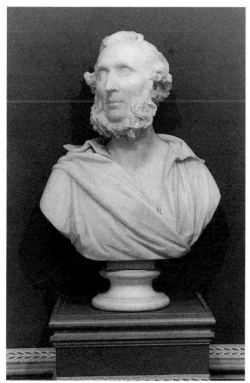

The bust was re-discovered in January 1989 in a cupboard in the basement of the Municipal Buildings, broken into two pieces. The Corporation commissioned Jim McLaughlin of the Merseyside Sculptors Guild to repair the bust and it is now on permanent display in the public area of the entrance hall (details of the restoration confirmed in conversation with Miles Broughton of Liverpool City Architects). Although the identity of the subject is not certain, Miles Broughton has pointed out the resemblance to the sculptor John Gibson, whose pupil in Rome Adams-Acton was. See also 'Related work', above.

PRUDENTIAL ASSURANCE BUILDING, 30-38 Dale Street, by Alfred Waterhouse, built in 1885-86, with the tower and the eastward bay added in 1906. Between the first floor windows of the tower, above the main entrance:

Prudentia

Sculptor: unknown

Statue in terracotta

h: 8' (2.44m)

Inscription on curved base: PRUDENTIA

Owner of building: Legal and General Assurance Society Ltd
Listed status: Grade II

Description: Located in a canopied niche and standing on a curved base, the standing female figure wears a loose gown, her hair held in place by a head band. In her left hand she holds a book and in her right a serpent, the traditional attributes of *Prudence* personified.

Condition: The statue appears to be in good condition; there are bird droppings on the upper surfaces.

According to Cunningham and Waterhouse (1992: 260), all of the terracotta work was executed by J.C. Edwards of Ruabon. It is likely, however, that Edwards executed the *Prudentia* to another's design (see, e.g., C.J. Allen's *Physiology and Pathology*, below, p.228).

Literature: Cunningham, C., and Waterhouse, P. (1992): 260; Pevsner, N. (1969): 172.

THE STATE CLUB, 14 Dale Street, originally the State Insurance Building, built in 1905 by W. Aubrey Thomas. The foyer and ballroom of the State Restaurant, part of the original

building, are decorated with:
Ten figurative Bas-relief Roundels set into lunettes flanked by **Figurative Bas-relief Spandrels.**

Artist: Alfred R. Martin

Roundel and spandrel bas-reliefs in poly-chromed plaster

Diameter of roundels: 72" (183cms)

Width of spandrels: 168" (427cms)

Each roundel signed: Alfred R. Martin.

Owner of building: Bernard Start
Listed status: Grade II

Description of reliefs: Within each coloured marble lunette the roundel is framed by rococo scrolls formed in a clock-like pattern. The marble within the clock shape is alabaster coloured, whereas that outside is a mottled green like onyx. The pilasters which separate the bays, and the archivolts which frame the lunettes, are of green-veined white marble. Additionally, the pilasters are flanked by narrow pilaster strips of white-veined black marble. Beneath the lunettes is a dado of red mottled marble. Many of the reliefs are titled at the crowns of their framing lunettes (all titles listed below are as recorded in the WAG JCS files).

The first four of the reliefs are in the foyer of the restaurant. They are as follows:

1. *The Gay Goshawk* (the title of a ballad collected by F.J. Child and published in 1882-98, ii: 355-67). The roundel shows a knight seated in the foreground of a landscape with a castle; he rests the side of his head on his right fist, contemplating a goshawk which stands on his right knee. In the spandrel to the left is a young woman with a wind-blown headdress:

she looks at the goshawk (sent to her by the knight with a message of love), perched upon her right wrist. In the righthand spandrel the helmeted knight leans over the young woman who appears to be unconscious.

2. *The Battle Song*. In the roundel are two

armoured knights on horseback, galloping from left to right, wielding jousting lances. The foreground knight has a shield hanging from his saddle, bearing a device of three roses arranged diagonally. In the left spandrel is an armoured and cloaked figure blowing a trumpet; in the right spandrel an armoured knight lies dead.

3. *The Blind Beggar's Daughter*. In the roundel a young armoured and mounted knight leans from his saddle to a lift a young woman onto his horse. In the left spandrel a young woman sits in the foreground of a landscape; a castle can be seen in the background. In the right spandrel a bearded, hatted tramp sits on the ground, a walking staff in his left hand, a dog seated between his knees.

4. *The Three Ravens* (the title of a ballad collected by F.J. Child and published in 1882-98, i: 253-54). In the roundel an armoured knight lies supine on the ground, his head towards the viewer. On the right are two hunting dogs, one appearing to bark at two birds flying above; a hind also appears to be watching the birds from behind a slender tree. In the spandrels are piles of discarded armour; three ravens stand on branches over that to the left, more birds wheel above that to the right. The reliefs continue in the restaurant:

5. *The Mermaid* (the title of a ballad collected by F.J. Child and published in 1882-98, v: 148-52). In the roundel three sailors, who appear to be just below the crow's nest, haul up a ship's sail. In the left spandrel a smiling mermaid, sitting on some seaweed-strewn rocks, looks into a mirror, held in her left hand, and arranges her hair. Over her left shoulder can be seen the sails of an oncoming ship. In the right spandrel is another mermaid, with a sailing ship in the distance.

6. *Come Lasses and Lads*. A man in a three-cornered hat, jacket, waistcoat and breeches, dances around a maypole with a young woman who smiles at the viewer. On the right, following the couple, is a young boy who also looks out towards the viewer, whilst on the left another woman dances in the opposite direction, about to pass behind the main couple. Flag-topped tents close off the middle ground at the right. In the left spandrel are two young women who look out towards the viewer. In the right spandrel is an aged fiddler in a three-cornered hat, by a table upon which are two tankards; in front of the table is a laurel-wreathed barrel and a bench; in the background is a flag-topped tent.

7. *Black-eyed Susan*. In the roundel an old sailor sporting a droopy moustache and wearing a sailor's cap is rowing a boat towards the viewer. A woman, dressed in a bonnet and cloak, stands in the boat and waves with her handkerchief towards a galleon in the distance. In the left spandrel a seaman in a short jacket and tarred hat is shown on the deck of a ship. He points with his left hand and laughs, apparently at the scene in the right spandrel, also set on deck: a young woman in a cloak and broad-brimmed hat, clasps her hands before her and looks imploringly towards the viewer, whilst over her right shoulder stands a rugged-looking sailor with side-whiskers, looking eagerly at her, leaning forward and resting his head on his right hand.

8. *John Gilpin* (the following three scenes derive from the poem, *The Diverting History of John Gilpin*, by William Cowper, published in 1782). In the roundel a fat man (John Gilpin), wearing a broad-brimmed, low-crowned hat and cape, mounts a horse; he looks at a young woman who stands by his side wearing a lacy bonnet and carrying an umbrella over her left wrist; she, in turn, looks at the viewer. Beyond the horse can be seen a man in a three-cornered hat and spectacles. The horse and rider stand beneath Gilpin's drapery shop sign, half-obscured by the frame of the roundel, upon which the letters GIL of Gilpin can be seen. In the left spandrel an elderly woman (Gilpin's wife) in a wide-brimmed bonnet, leans from a balcony, looking towards the viewer; at her side is a small boy wearing a peaked cap with a tassel. In the right spandrel an elderly gentleman (Gilpin's friend, the calenderer) stands smoking a long-stemmed pipe, his left thumb tucked into the waistband of his trousers. Low fences before and behind him, leading to a house at the right edge of the picture, indicate that he is standing in the front garden of his house. In the distance on the left is a half-timbered house.

9. *The Power of Beauty*. In the roundel, a military man in epaulettes and wig, and a young woman, sit facing each other on separate benches, in a garden. The officer looks lovingly at the woman who, in turn, looks pensively at the viewer, while she winds off wool into a ball from a skein held out by the former. In another garden scene in the left spandrel a plump gentleman holds up in his left hand a miniature, presumably of his beloved, which he gazes at wistfully. In the right spandrel is a townscape with, on the left, a church spire and a domed building. In the foreground are a young man in academic robes and mortar board, with an older man who raises an admonishing finger to him. The younger man appears to ignore the advice of his elder and looks eagerly away in the opposite direction.

10. *The Three Jolly Huntsmen*. In the roundel are three men on horseback wearing three-cornered hats. In the left spandrel are two young girls walking through an arboreal landscape. The girl on the right wears a bonnet and carries a painting canvas under her arm, whilst

her friend carries a basket. In the right spandrel a young man in a three-cornered hat has his right arm around the shoulders of a young woman who is wearing a flat bonnet.

11. *Mistress Mine*. The left spandrel (the lunette is blank) depicts a figure in feathered cap and tights who carries a cloak over his left shoulder and strides to the right, his left arm outstretched before him. In the right spandrel (painted over in a uniform wash of cream) is a young woman in a long dress with voluminous sleeves looking to her right; she is in a topiary garden.

12. *Untitled* (again, spandrels only). In the left spandrel (painted in a uniform wash of blue) is a man in a sailor's cap leaning with his left hand against a post. In the right spandrel (painted over in cream) is a corpulent man (bearing a resemblance to Henry VIII) in a fur-trimmed coat, slashed doublet and saucer-shaped feathered hat, holding a pikestaff in his right hand.

Condition: Many of the roundels appear to have areas of paint loss. At the time of visiting (early 1994) many were half-covered by posters.

According to the *Echo* (27 June 1977), Martin was paid £700 for his mural reliefs. After completing them he left England for South Africa, but revisited Liverpool 'in the 1920s to help with the renovation of the murals that had suffered years of wear and tear'.

The State Restaurant had been opened in 1905 at a cost of *c*.£250,000, closing in 1949 and serving subsequently as a social club for Littlewoods. When Littlewoods moved to larger premises the building remained closed for some time before re-opening as the State Club.

Literature: Child, F.J. (1882–98; 1956 edn) i: 253-54, ii: 355-67, v: 148-52; *Daily Post* (1977) 27 June: 7; *Echo* (1977) 27 June: 7; *Studio* (1906) xxxvi: 80, 81.

Derby Square

Derby Square marks the former site of Liverpool Castle, built sometime between 1232 and 1247. After a period of gradual decline the last remains of the castle were demolished in 1726 to make way for St George's Church (erected 1734; largely rebuilt 1819-25; pulled down 1897-98). The present *Monument to Queen Victoria* occupies therefore a position invested with considerable historical significance (Picton, 1875, revised edn 1903, ii: 1-11, 531; Touzeau, 1910, ii: 350, 357, 418-19).

Monument to Queen Victoria

Architects: Professor Frederick More Simpson, in collaboration with **William Edward Willink and Philip Coldwell Thicknesse**
Sculptor: Charles John Allen.

Building contractor: W. Thornton and Sons.
Bronze founders: A.B. Burton of Thames Ditton and Singer & Sons of Frome

Architectural elements in Portland stone
Sculpture in bronze
Monumental urns in lead
Decoration inside dome in gold mosaic

h. of monument: over 60' (18.3m)
Diameter of base: 90' approx. (27.4m)

Inscriptions:
– front face of the central pedestal supporting the figure of Queen Victoria: VICTORIA
– rear face of the central pedestal: ERECTED BY / THE CITIZENS / OF LIVERPOOL
Plaque inscriptions:
– N. E. plaque: (beneath a laurel wreath): FOUNDATION STONE / LAID BY / FIELD-MARSHAL / EARL ROBERTS / K.G. V.C. / OCTOBER 11TH 1902.
– S. E. plaque: (in a circular band encircling a rose motif): DIEU ET MON DROIT (below which is): THIS MEMORIAL / WAS UNVEILED BY / HER ROYAL HIGHNESS / PRINCESS LOUISE / DUCHESS OF ARGYLL / 27TH SEPTEMBER 1906
– S. W. plaque (no inscription; decorated with the coat of arms of Great Britain and Ireland).
– N.W. plaque (beneath a castle in bas-relief): ON THIS SITE / FORMERLY STOOD / THE CASTLE / OF / LIVERPOOL – (signed and dated at bottom left by the sculptor): C.J. Allen. Sc. 1906 – (and at the bottom right corner by the founder): A. B. Burton. Founder. / Thames Ditton.

Foundation stone laid by Earl Roberts,

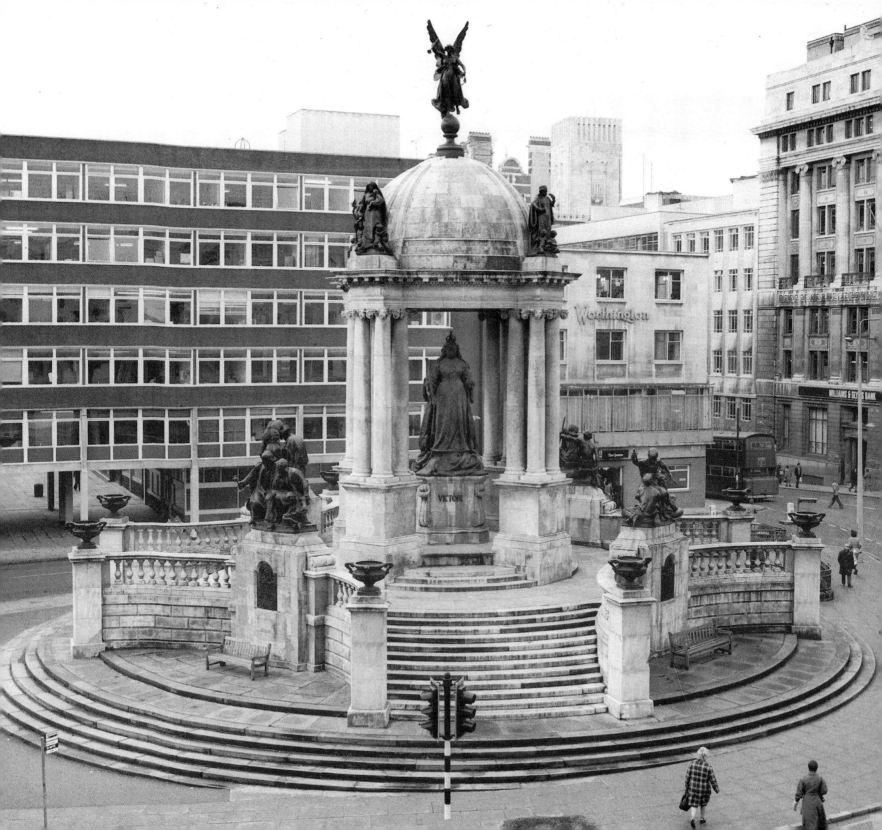

Saturday 11 October 1902
Monument unveiled by Princess Louise, Duchess of Argyll, Thursday 27 September 1906

Owner/ custodian: Liverpool City Council
Listed status: Grade II

General description:
From a low, circular base, four broad staircases, located at the cardinal points, climb to a central circular podium. The bottom of each staircase is flanked by a pair of tall pedestals surmounted by lead urns (executed by Thomas Elsley). Starting from these pedestals, each pair of staircase balustrades curve outwards as they approach the podium, forming intermediate concave bays. On the central podium stands a domed baldacchino supported by four clusters of four unfluted Ionic columns positioned on the diagonal axes of the monument. Crowning the dome, and facing east, is a winged figure of *Fame*. Over each cluster of columns, at the base of the dome, the entablature breaks forward to provide a platform for an allegorical sculptural group. Clockwise from NW, they are *Justice*, *Wisdom*, *Charity*, and *Peace*: 'emblematic of the virtues by which our late Queen was distinguished' (*Daily Post and Mercury*, 28 September 1906). The colossal figure of *Queen Victoria* herself stands under the baldacchino on a high pedestal, in the centre of the monument, facing east. On pedestals at the perimeter of the central podium, at the point where it is met by the arcs of the staircase balustrades (and on the same axis as the Queen's personal virtues), are bronze groups representing *Agriculture*, *Industry*, *Education*, and *Commerce* – 'the glories of her reign' (*The Studio*, 1907: 253). Each of the pedestals supporting these groups is inset with a bronze plaque.

General state of conservation: There appear to

be no losses. The masonry is weathered in places; beneath the bronze sculpture the stone is stained green and there are also some areas of green biological growth; there is some graffiti.

Exhibited: WAG Liverpool Autumn Exhibition 1902 (cat. 1408), as *Model of Queen Victoria Memorial for Liverpool*.

Individual figures and groups:

Queen Victoria

h. of statue: 14' 6" (4.42m)
h. of pedestal: 6' 8½" (2.04m)

Signed and dated by the sculptor on the right face of the bronze base towards the rear: CHAS. J. ALLEN. SC. 1906
– and by the founder on the rear face of the bronze base to the left: SINGER & SONS, FOUNDERS. / FROME.

Description: *Victoria* wears a richly embroidered dress modelled in intricate low relief, a veil, and a cloak which falls in heavy folds around the raised base upon which she stands. Portrayed in her maturity, she is crowned and holds the sceptre in her right hand and the orb in her left.

Condition: Coated with black epoxy paint

ALLEGORICAL SCULPTURES ON THE DOME (relating to the Queen herself):
At the summit of the dome: *Fame*. Dressed in flowing robes, she holds a long-stemmed trumpet in her right hand and a laurel wreath in her left. She stands on a pawn-shaped base. The model was apparently one of Allen's regular models, Louise Gunnery (Bisson, 1965: 12). Around the base of the dome: *Justice* is represented in traditional form as a female figure with a veil over her eyes, scales in her right hand, and a sword, tip resting on the ground, in

her left. Two children are at her feet: that on the left clutches a bare root; that on the right, a fruiting apple branch. *Wisdom* is helmeted and dressed in long robes; she reads from a book held in her right hand and has a serpent (from 'be ye therefore wise as serpents', Matt. 10:16) wrapped around her left arm. Two children sit at her feet: that on the left holds a globe in his left hand and compasses in his right; that on the right holds a scroll or book. *Charity*, a traditional Madonna-like figure in a long veil, is represented with three small children: one cradled in her left arm; the other two at her feet clinging to her draperies. *Peace* holds up her left hand to allow a dove to perch on it. In her right hand she holds the stem of a palm branch which drapes around her shoulders. The two children at her feet each hold a cornucopia and an olive branch.

h. of each group: c. 7' (2.13m)
Exhibited: WAG Liverpool Autumn Exhibition 1903 (cat. 1496), as *Charity – sketch model, one third full size...*; Royal Academy of Arts 1905 (cat. 1766), as *Justice – sketch model for a group on the Liverpool Victoria Memorial*.

Condition: The dome sculpture appears to be in good condition, although it is all coated in black epoxy paint.

Related works: C.J. Allen, *Statuette of 'Fame'*, bronze, h: 13½" (34.2cms), private collection (shown at the WAG exhibition: *The Art Sheds, 1894 – 1905*, 1981, cat. 13). A silver version of the statuette of *Fame* (present location unknown), mounted on a pedestal of green marble bearing the inscription: 'Liverpool, Victoria memorial, Sept. 27th, 1906.' was presented by Allen to Princess Louise at the unveiling ceremony (*Courier*, 28 September 1906). Allen's *Fame* echoes Alfred Gilbert's

Victory, cast as an independent statuette in various sizes over the years since 1887 when a version had first appeared surmounting the globe held by Victoria in his *Jubilee Memorial to Queen Victoria* at Winchester Castle. See particularly the 1910 cast of *Victory* in the Ashmolean Museum, Oxford (illustrated in Dorment, 1985: 78).

ALLEGORICAL SCULPTURES ON THE PERIMETER of the podium (relating to the achievements of Victoria's reign):

Agriculture (N. W. facing)

Signed by the sculptor on the back of the bronze base at the left: C. J. ALLEN. S<u>C</u>
– and by the founder on the back of the bronze base at the right: A. B. BURTON. FOUNDER. / THAMES DITTON.

Description: A seated young woman, *Agriculture* is flanked by two male figures. She is dressed in a rustic sun-bonnet, blouse and skirt. She holds in her right hand the fruiting branch of an apple tree, and in her left, a bunch of flowers. Seated on the ground at her left, is an old man representing *Animal Husbandry*; he is dressed in a smock and holds a shepherd's crook. Looking up at *Agriculture*, he grasps an apple hanging from the branch held by her. To her right is seated *Horticulture*, a bare-chested young man, looking towards her and holding in his right hand a scythe. On the ground beneath his feet is a sheaf of corn.

Condition: As far as is discernible, considering the covering of black epoxy paint, the group appears to be in good condition.

Industry / Manufacture (N. E. facing)

Signed and dated by the sculptor on the rear of the bronze base at the left: CHARLES. J. ALLEN,

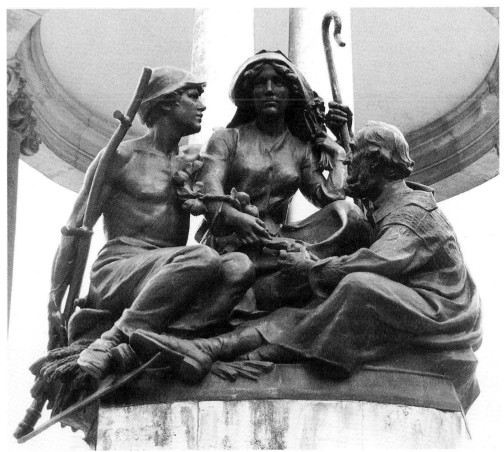

S<u>C</u> 1906
– and by the founder on the left face of the bronze base: SINGERS. FOUNDER.

Description: A group of three figures, the central one of which is a young man with a bare torso, wearing a worker's apron and sitting upon an anvil; his right arm is extended forwards to hold the long handle of a sledge-hammer; his left extended backwards, holding a 'governor' – a device for regulating the steam pressure in the pump which stands behind him: he thereby is intended to personify physical and mechanical energy. Seated upon the ground on his left side is a woman, her sleeves rolled above her elbows, holding a distaff, symbolising the Northern spinning industry. Leaning against the central figure's right knee is another bare-chested male, an engineer, who holds in his left hand a ship's propeller blade, the motive power by which Liverpool's maritime trade is

conducted.

Condition: As far as is discernible, considering the covering of black epoxy paint, the group appears to be in good condition.

Education (S. E. facing)

Signed and dated by the sculptor on the back of the bronze base at the left: CHARLES. J. ALLEN. S͟C 1906.
– and by the founder on the left side of the bronze base: SINGERS. FOUNDER

Description: A group of three figures. On the left, seated on an Ionic capital, is a distinguished-looking man with a bald head, wearing academic robes over a jacket and trousers. The model for this figure was Sir Oliver Lodge, one of the first professors of the University (*Daily Post and Mercury*, 28 September 1906). He ponders on the action of a gyroscope held in his right hand. To his left, a young man also gazes at the gyroscope, his right hand supporting his chin, whilst his left rests upon the shoulder of a little boy in short trousers who is seated at his feet, reading from a book. Between the academic figure and the student, visible only from the rear, is a globe resting on a low pedestal.

Condition: As far as is discernible, considering the covering of black epoxy paint, the group appears to be in good condition.

Related work: C.J. Allen, *Bust of Professor Sir Oliver Lodge*, marble, h: 32¹/₂" (82cms), 1901, Collection of the University of Liverpool.

Commerce (S. W. facing)

Signed by the sculptor on the right side of the bronze base: C. J. ALLEN. S͟C
– and by the founder on the left side of the bronze base: A. B. BURTON / FOUNDER

Description: A group of three male figures. On the left, seated on a bale, is a bearded man wearing a hat and greatcoat. In his right hand he holds some papers and a book, whilst with his left hand, he holds the stern of a model steamship, the bow of which is held by a bare-chested figure in labourer's boots and trousers, seated on the ground at his left. Another labourer stands and leans forward over the first so that he too may look at the ship, his arm resting on his seated companion's shoulder. He stands astride some sacks, another heavy-looking sack upon his back. *Commerce* is thus represented with appropriate maritime references in the context of England's principal commercial port.

Condition: As far as is discernible, considering the covering of black epoxy paint, the group appears to be in good condition.

Following Queen Victoria's death on 22 January 1901, a group of Liverpool citizens, headed by the Lord Mayor, Arthur Crosthwaite, decided to raise a memorial to commemorate the glorious achievements of her sixty-three year reign. The Liverpool Queen Victoria Memorial Committee was formed on 7 March 1901, and on 11 March, at a meeting in the Town Hall, elected from among its members an Executive Committee, entrusted with the task of considering the possible forms the memorial might take and supervising the appeal for subscriptions. It was decided that there should be no limit set for individual contributions in order to ensure that the maximum amount would be raised (*Courier*, 12 March 1901).

On 14 March, Edward Pickmere, Town Clerk and Honorary Secretary of the Memorial Committee, wrote to the Corporation Finance Committee and persuaded it to postpone initiating any schemes for the redevelopment of the site of the recently demolished St George's Church, to allow the Memorial Committee to consider the suitability of the site (*Finance Committee Minutes*). In the ensuing weeks the Memorial Executive Committee discussed a number of possible forms for the Liverpool memorial, including:

> … a public hall, the rebuilding of the Children's Infirmary, the establishment of a university for Liverpool, and the erection of a monument containing a statue of her late Majesty (*Daily Post*, 14 May 1901).

At a general meeting convened on 13 May 1901 the Lord Mayor, speaking from the chair, announced that it was the last of these options that had been selected because:

> It was felt… that whatever was decided upon should be popular with all classes. The committee wished to sink all individual whims and desires, and they thought the memorial should be one that would secure the handsome donations of the opulent, the smaller contributions given with thankful wishes of the less wealthy, the half-crowns, shillings, and sixpences of the working classes, and even the coppers of the school children. The committee also felt that the memorial should be something handsome, and should secure the acquiescence of the Corporation if land belonging to the city was required; that it should be worthy of Liverpool as the first seaport of the kingdom, and one that posterity could view as erected in the first year of the twentieth century, expressive of admiration, esteem, and affection of the greatest of English monarchs, the good Queen Victoria (*Daily Post*, 14 May 1901).

Committee member Robert Gladstone now formally proposed the St George's Church site. He suggested marble as the most appropriate material for the statue of a lady, recommending that it should be enclosed by some sort of architectural structure to protect it from the city's atmosphere. He thought that a worthy model for Liverpool's monument might be the circular *Monument of Lysicrates* at Athens or, to give an illustration closer to home, the *Huskisson Mausoleum* in St James's Cemetery – though obviously, he assured the members, the *Victoria Monument* would be on a grander scale. With only one objection raised – that the St George's Church site was marred by tramlines – the meeting agreed that there was no significant alternative and thus, on 16 May, a formal request for the site was made to the Corporation Finance Committee. The Corporation decided, however, that the site could not be released until the exact nature of the monument had been firmly established (*Finance Committee Minutes*).

Thus, the Memorial Committee launched the subscription fund which would give substance, and set the material limits, to its plans. On 21 May 1901 the Lord Mayor issued a letter, distributed to six thousand of Liverpool's citizens, asking for subscriptons to the monument and encouraging the maximum generosity by suggesting that, if necessary, contributions could be spread over a three year period (*Courier*, 21 May 1901). At a meeting on 30 May, it was agreed that all local newspapers should be asked to publicise the appeal and to set up their own subscription funds. The various banks of Liverpool had already agreed to display advertisements and to accept contributions. At this point, the amount subscribed was just £5,432. 3s. 6d. whereas it was estimated that the scheme would require at least £10,000

(a somewhat optimistic figure as it transpired, as the final cost was around £16,000). So, as a further encouragement to potential subscribers, the Committee resolved to acknowledge in the press all contributions from 1s. upwards. Furthermore, every member of the Committee was to carry a collecting book and the Lord Mayor agreed to use his influence to encourage the formation of an artisans' fund-raising committee (*Mercury*, 31 May 1901).

In the meantime, on 13 June 1901, with the fund at only £6,627, the Lord Mayor presided over a meeting of local tradesmen in the Town Hall and persuaded them to form their own fund-raising committee (*Daily Post*, 14 June 1901). A few days later he called his proposed meeting of artisans in the Picton Hall and persuaded them to do the same. Attendance, however, was rather low and therefore, in the opinion of the Liberal *Liverpool Review* (15 June 1901), was unrepresentative. The *Review*, in fact, condemned the whole scheme as misguided and irrelevant to the needs of the majority of Liverpool people. In its following issue (22 June 1901), it renewed its attack by quoting the view of *The Clubman* (the journal of the Junior Reform Club), which proclaimed that as the £5,432. 3s. 6d. that had been collected by 30 May 1901 had 'represented the donations *of 151 persons only*', the projected memorial could not yet be considered 'representative of the whole community' and, until it became so, it would be misleading to refer to it as the *Liverpool* memorial to Queen Victoria.

Notwithstanding questions raised by the *Review* concerning the dubious morality of putting such immense efforts into raising funds for an expensive monument to a deceased monarch when so many of Liverpool's inhabitants were living in extreme poverty, the mainstream local papers continued to promote the

project and regularly published lists of subscribers. (It is interesting to note that in the list of subscribers published in the *Courier* for 13 July 1901, C.J. Allen, the future sculptor of the monument, is recorded as having made two separate donations, amounting to five guineas.) On 17 July, the Memorial Committee announced that the fund had reached £8,485. 8s. 5d. In addition, Hooper & Co. of New York, had dispatched to their Liverpool office a bale of cotton which was to be auctioned and the proceeds (the bale eventually realized £16. 5s.) donated to the fund (*Mercury*, 17 July 1901).

As the subscription fund crept towards its target, the Committee felt sufficiently confident to invite designs for the monument. On 31 July 1901 they announced that all the most prominent sculptors in the land had been invited to submit their proposed designs on paper by 15 October (*Courier*, 1 August 1901). On 31 October 1901, the Committee awarded premiums to the three best designs: the £100 premium for first place went to sculptor R. Lindsay Clarke of Cheltenham in collaboration with architect R.A. Briggs of London; the second place premium of £75 went C.J. Allen with Simpson, Willink & Thicknesse, of Liverpool; and the third place premium of £50 went to sculptor Henry Fehr with architect J.G.S. Gibson, both of London. (An unsuccessful entry from the sculptor Frank Lynn Jenkins is illustrated, with commentary, in *The Magazine of Art*, 1902: 298, 299, 301). Each of the shortlisted teams was next asked to produce from its drawn design a model, upon the success of which the commission would be awarded (*Evening Express*, 31 October 1901).

On 6 March 1902, the Memorial Committee awarded the commission to the team of C.J. Allen and Simpson, Willink and Thicknesse (*Daily Post*, 7 March 1902) on condition that

they agree to alter the statue of Queen Victoria from an enthroned to a standing figure, a change the winners agreed to only reluctantly (letter from Allen and partners to the *Daily Post and Mercury*, 24 May 1911). Pickmere, the Honorary Secretary, then made a second formal request to the Corporation to approve the St George's Church site. The Corporation Finance Committee gave its approval on 7 March, the Chairman expressing particular satisfaction that the commission had been awarded to local talent (*Courier*, 8 March 1902), and on 9 April the Council gave its official sanction (*Finance Committee Minutes*). Meanwhile, the winning model went on public display at the Walker Art Gallery (*Courier*, 8 March 1902).

The Finance Committee was concerned not only with the monument itself, but with the development of the entire area and on 25 April 1902 instructed the Corporation Surveyor, Thomas Shelmerdine, to formulate some suggestions (*Finance Committee Minutes*). On 11 July, after consultations with the monument architects, Shelmerdine recommended a course of action that involved minor adjustments to the area around the proposed monument: instead of erecting the monument exactly over the site of St George's Church, to one side of the available open space, as originally intended, he suggested that it would create a more harmonious prospect if located in the centre, at the axial point of Lord Street and Castle Street, thereby neatly closing the vista at the mutual end of the two converging roads. Placing the monument in the centre of the area would, he considered, still leave around it 'good broad thoroughfares', and also give the Corporation the opportunity to eliminate the awkward corners at the northern and southern extremities of the site. He had conferred with the architects and they had agreed that such an

arrangement would be a considerable improvement. The only impediment to the plan was the existing layout of tramlines, some of which would need to be removed. He then moved on to the problem of the subscription fund, which was still £6,000 short of the required £16,000. Indeed, the Memorial Committee had even been considering substituting simple pediments for the bronze groups at the base of the dome (having already scrapped the idea of having four drinking fountains in the bays between the staircases). Shelmerdine then made a shrewd appeal to the Finance Committee's sense of civic pride – such further reductions in the material splendour of the monument would, he implied, reflect badly on Liverpool. He urged the Committee to recommend that the Corporation make up the shortfall in the subscription fund so that the original design could be carried out. After all, he reminded them, had the *Victoria Monument* not been proposed the Corporation would have been laying out considerably greater sums redeveloping the area (*Finance Committee Minutes*).

Unfortunately Shelmerdine's redevelopment scheme did not meet with the approval of the City Engineer, who advised the Finance Committee, in his report dated 18 July 1902, that positioning the monument in the centre of the area would, in his judgement, both spoil the streets and restrict the flow of traffic. Shelmerdine hastily conceded defeat on this point and instead redirected his efforts to persuading the Finance Committee to recommend that the Corporation at least make up the Memorial Committee's financial shortfall. He suggested that the cost of the memorial should be split precisely between the Corporation and the Memorial Committee: the Corporation to pay for everything from the foundations up to the podium, including the four bronze groups

on the balustrades (an estimated total cost of £5,500); and the Memorial Committee to pay for the whole of the remaining work (an estimated £10,000). Thus, the initial outlay would be borne by the Corporation. The Finance Committee agreed to Shelmerdine's suggestion and the Council approved its recommended grant of £6,000 on 1 August 1902 (*Finance Committee Minutes*).

The first payment of £2,000 was issued to the architects on 19 February 1904 and on 26 August Shelmerdine reported that the Corporation's part of the memorial was completed except for the four large bronze groups on the balustrades. According to C.J. Allen and F.M. Simpson these sculptures would ultimately cost £3,000, although the greater part of that sum would not be needed until casting was undertaken. For their present expenses they requested an interim payment of £1,000. This the Finance Committee made available (*Finance Committee Minutes*).

While the architectural part of the monument was being erected in the square, Allen had been at work on the sculpture in his studio. On 12 December 1904 the Memorial Executive Committee visited the sculptor to inspect the now completed full-size model of the Queen which he had been working on since February. The *Daily Post* (13 December 1904) reported that the piece, weighing seven tons, was 'a majestic work'. Especial praise was accorded the 'bold and beautiful treatment of the draperies' with their lace pattern 'in complicated low relief'. The Committee formally accepted the statue and arrangements were made to put it on display for several days for the benefit of the subscribers before it was sent away for casting, a task it was estimated would take about nine months to complete.

By 28 July 1905, all the bronze groups

around the base of the dome were in place and the memorial architects informed Shelmerdine that one of the lower groups was ready to be cast, with 'another… complete as to the small model and halfway through in the full-size'. They requested a further £1,000, which the Finance Committee granted (*Finance Committee Minutes*). By the date of the unveiling ceremony on 27 September 1906, however, only two of the lower groups, *Education* and *Manufacture*, had been installed, with *Agriculture* and *Commerce* reaching completion at a later date (*Daily Post and Mercury*, 28 September 1906). Although there is no subsequent mention of the bronze groups, an instalment of £1,000, paid to the architects on 21 December 1906 (leaving only a £500 payment, issued on 13 December 1907) may indicate their completion date. The design for the last of the large bronze plaques, that carrying the Royal Coat of Arms, was finally approved by the Finance Committee on 10 May 1907 (*Finance Committee Minutes*) and presumably installed later that year.

By November 1908 the Town Clerk had cause to write to the architects complaining that some of the Portland stone blocks of the monument had begun to appear 'blotchy', while the masonry below the bronze groups was now stained green. In a letter dated 30 November 1908, the architects explained that there was no cause for concern regarding the blotchiness, as newly-cut Portland stone always appears variable 'in texture and density' and that only time would 'produce the [desired] evenness of colour'. Regarding the green run-off on the masonry below the bronze sculpture, the architects advised the Town Clerk that those stains already on the stone were unfortunately unremovable, but to prevent future discolouration the bronze sculptures should be 'cleaned by scrubbing, and the metal coated with lacquer' every five years or so, by 'a sculptors' founder, such as Mr Burton or Mr Singer'. If these measures were taken, future deposits would not form and as for the present stains, they would in any case be rendered unnoticable before long by the build-up of soot from the atmosphere (WAG JCS files: typed transcription of architects' letter).

Despite subsequent proposals to alter the structure of the monument – most critics advocating the removal of the canopy which from the start had been considered the monument's least successful feature (*Daily Post and Mercury*, 10 May 1911); or to radically relocate it in order to ease traffic congestion (*Echo*, 14 July 1931); and despite the flattening of the entire surrounding area during the Second World War blitz, Liverpool's *Monument to Queen Victoria* remains materially unchanged to this day.

Literature: (i) LRO (a) manuscript sources: *Finance Committee Minutes*, 1/51: 577-78, 688-89; *Finance Committee Minutes*, 1/52: 408-9, 461, 487-88, 612-15, 620-21, 659-62; *Finance Committee Minutes*, 1/54: 595-56; *Finance Committee Minutes*, 1/55: 531-32; *Finance Committee Minutes*, 1/56: 633; *Finance Committee Minutes*, 1/57: 104, 131, 243, 283. (b) newscuttings: *Courier* (1901) 12 March, in *CH&T 3*: 1; *Courier* (1901) 21 May, in *CH&T 3*: 7; *Courier* (1902) 8 March, in *CH&T 3*: 34; *Daily Post* (1901) 14 May, in *CH&T 3*: 6-7; *Daily Post* (1901) 14 June, in *CH&T 3*: 18; *Daily Post* (1901) 18 June, in *CH&T 3*: 21; *Daily Post* (1901) 17 July, in *CH&T 3*: 25; *Daily Post* (1901) 1 August, in *CH&T 3*: 26; *Daily Post* (1902) 7 March, in *CH&T 3*: 33-34; *Daily Post and Mercury* (1904) 13 December, in *CH&T 5*: 351; *Daily Post and Mercury* (1911) 24 May, in *TCN 1/36*; *Evening Express* (1901) 31 October, in *CH&T 3*: 27; *Liverpool Review* (1901) 15 June, in *CH&T 3*: 18-20; *Liverpool Review* (1901) 22 June, in *CH&T 3*: 18-20; *Mercury* (1901) 31 May, in *CH&T 3*: 8; *Mercury* (1901) 1 June, in *CH&T 3*: 8.
(ii) WAG JCS files – typed transcript of correspondence, dated 30 November 1908, from the architects to the Town Clerk.
(iii) Bisson, R. (1965): 12, 23-4; *Builder* (1906) xc: 232; *Courier* (1902) 29 March: 6; *Courier* (1906) 28 September: 7-9; *Daily Post* (1902) 7 March: 7; *Daily Post* (1902) 13 October: 7; *Daily Post and Mercury* (1906) 28 September: 9-10; Dorment, R. (1985): 78; *Magazine of Art* (1902): 298, 299, 301; Read, B., 'From Basilica to Walhalla', in P. Curtis (ed.) (1989): 39; *Studio* (1902) xxv: 203-04; *Studio* (1907) xxxix: 253-55; *Studio* (1908) xlii: 148-49.

Dingle Lane

TURNER MEMORIAL HOME, designed and built by Alfred Waterhouse 1881-83. Access only by prior arrangement.

Listed status: Grade II

In the entrance hall:

Memorial to Charles Turner and Charles William Turner

Born in Yorkshire, Charles Turner (1803-75) moved to Liverpool and established himself as a merchant. He was elected to Parliament and also held office as the first Chairman of Liverpool's port authority. In addition to his business and political interests he, like many of his wealthy contemporaries, involved himself in various charitable causes. His son, Charles William (1845-80) survived his father by only five years.

Sculptor: (Sir) William Hamo Thornycroft

Group and pedestal in marble

h. overall including pedestal: 90½" (230cms)
h. of group including base: 62½" (159cms)
w. of group: 66½" (169cms)
d. of group: 39" (99cms)

Signed and dated on the left face of the base:
HAMO THORNYCROFT, A.R.A. / SC. 1885.

Owner: Turner Memorial Home
Listed status: not known

Description: A seated double-portrait. The son, Charles William, sits on the left, sporting side-whiskers and dressed in a three-piece suit and bow tie; he holds a pair of gloves in his left hand and a soft-brimmed hat in his right; he

turns slightly to look at some plans on his father's lap, which the latter appears to be explaining. Charles, in full beard and wearing a suit, is wrapped in a blanket which goes around his shoulders, across his knees and trails on the floor at his feet.

Condition: Good

Anne Turner's husband, Charles, died in 1875. Her grief was doubled when the death of her husband was followed within five years by that of Charles William, her son. She resolved to

commemorate the family name by founding the 'Turner Memorial Home of Rest for Chronic Sufferers' and, in addition, to commission a more personal memorial to her husband and son in the form of a marble portrait group for the entrance hall to the home.

It seems likely that Mrs Turner was advised on the choice of sculptor by her architect, Alfred Waterhouse, a friend and active promotor of the young Hamo Thornycroft. Waterhouse had already been instrumental in persuading the Duke of Westminster to commission Thornycroft to translate his life-size plaster *Artemis* (Royal Academy 1880) into marble for Eaton Hall, Cheshire, then under restoration by the architect (Cunningham and Waterhouse, 1992: 106). Mrs Turner approached Thornycroft in 1882. He apparently welcomed the money, but not the prospect of designing a portrait group in modern dress. In his diary for 1 July 1882, he writes that having taken up his sketch book he found himself:

> … casting aside somewhat in disgust a sketch I have been trying to make of a group of modern gentlemen, both excellent citizens no doubt, but beyond the limit of my capacity to make anything satisfactory of them and at the same time please the widowed lady, my client, who comes with a friend equally towelled up in black crepe, and the two seat themselves and form a group to shew me how I had better treat the subject; then is shewn to me a photograph of a picture of the deceased by the Hon. H. Graves, also deceased, the figure of which is the very image of Mr. T.

My mind, indeed everything at this point seems a complete blank: 'Is it natural to cross the right foot over the left?' I am asked; I suggest the requirements of the composition: which brings silence but not conviction. In spite of all the funniness and at the same time the extreme gravity of intention of these conversations, I feel there is a lot of good sense on the part of my client and also that I am not a genius in any way. This, however, I have never been deluded into: but sometimes I feel more stupid than usual. For him who can make a statue out of coat and trousers, I have the greatest envy…

… I ought to begin again the struggle with coat and trousers. I will take the wax sketch out in the garden, perhaps my faculties may be brighter there, the wax will be softer, at any rate… (as quoted in Manning, 1982: 85)

In an article for *The Magazine of Art* (1883: 512-18), describing Thornycroft's house at Melbury Road, Kensington, Helen Zimmern states that whenever possible the sculptor worked in the open air, either on a first-floor balcony when working on small wax sketches or, for larger work, on a purpose-built patio just outside his studio doors, as he considered natural daylight more conducive than artificial light to a sensitive judgement of sculptural form.

Happily, Thornycroft managed to go some way to solving the aesthetic problem presented by the unsculptural nature of contemporary 'coat and trousers' by cloaking Charles Turner in the voluminous folds of a great blanket and by creating a smooth horizontal plane across his lap by the introduction of some plans which father and son appear to be considering. In August, Anne Turner confirmed the commission by choosing one of the designs the sculptor had worked up:

At last I have received a good commission from Mrs. Turner of Liverpool and I feel more happy now, as it will set me up for a year or two… (as quoted in Manning, 1982: 87)

Accompanying *The Magazine of Art* article referred to above, is an engraving (1883: 516) illustrating Thornycroft's studio, in the foreground of which is a modelling stand upon which is a wax sketch exploring an alternative composition for the present sculpture, with the son standing casually, ankles crossed, leaning on the back of his seated father's chair, looking down over his father's shoulder at the plans.

The following account of the progress of the approved composition derives from Manning (1982: 211): by November, the quarter-size model was under way and was approved on 10 January 1883. Thornycroft commenced work on the full-size clay model in early February 1883, completing it by the end of May 1884, with the assistance of his pupil, Henry Pegram. Translation from clay to marble, using a pointing machine, began with the figure of Charles on 1 June and that of his son on 1 July. In the laborious task of rough-hewing the design from the marble block, Thornycroft was assisted throughout the winter of 1884/85 by George Hardie, his chief carver, and Michael Lawlor, who had assisted him on the marble *Artemis* (1882). The group was *in situ* at the Turner Memorial Home by September 1885.

Literature: Cunningham, C. and Waterhouse, P. (1992): 106; Manning, E. (1982): 85-87, 211; *The Turner Home* (brochure); Zimmern, H. (1883): 512-18.

Drury Lane

WILBERFORCE HOUSE, designed and built by Gotch & Partners in 1965-67. In the forecourt is an ingeniously designed modern fountain.

Piazza Waterfall or *Bucket Fountain*

Designed by Richard Huws

Constructed by Cammell Laird & Company

Bronze posts with pivoting stainless steel cups of various sizes in a black-tiled basin.

Inscription on a bronze plaque shaped like an African shield with two spears, affixed to the wall below the detached viewing platform (to the left of the fountain, approaching from Drury Lane): 'GOREE-PIAZZA', ORIGINALLY TWO ARCADED / WAREHOUSES IN THE MIDDLE OF THE OLD / DOCK ROAD, WAS NAMED AFTER THE ISLAND / 'GOREE', OFF THE WEST COAST OF AFRICA / [*space*] / ON THE 14TH. OF SEPTEMBER 1802, THE / PIAZZA WAS GUTTED BY A SPECTACULAR / FIRE, DESCRIBED BY THOMAS DE QUINCEY / [*space*] / IN 1817, WASHINGTON IRVING WORKED AT / NO 1 AND 1853-7, NATHANIEL HAWTHORNE, / AMERICAN CONSUL IN LIVERPOOL HAD HIS / OFFICE AT 'WASHINGTON-HOUSE GOREE' / [*space*] / THE OLD PIAZZA WAS SEVERELY BOMBED / IN THE AIR RAIDS OF 1941 AND FINALLY / DEMOLISHED BETWEEN 1948 AND 1950 / [*space*] / IN 1967, TO MARK THE COMPLETION OF THE / NEW PIAZZA, THIS PLAQUE WAS KINDLY / PRESENTED BY CAMMELL LAIRD & COMPANY / (S & E) LIMITED, BUILDERS OF THE FOUNTAIN

Owner: Liverpool City Council
Status: not listed

Description (by Richard Huws):

It is a waterfall of a strange new kind which instead of streaming steadily hurtles down unexpectedly in detached lumps in all directions. The sight and sound of waterspouts and waterfalls is so spellbinding that they have always been centres of attraction in the landscape and, in the places where we live and work, where they seldom occur naturally, we are prompted to create them artificially in the form of descending cascades. Their perpetual bubbling, however, tends to pall after a while and to make it more exciting we contrive various means of providing added animation, such as changing sequences and coloured lighting, or jets and sprays which rise and fall or twist and whirl. Our waterfall is yet another such contrivance; it was conceived as yet another way of adding animation and excitement, but unlike the former expedients it does not depend on elaborate hydraulics or complicated controls; it depends only on a very simple device which interrupts the regular flow so as to create a round of action, the sound and movement of which is no longer that of the monotonous ever-burbling river, but that of the restless temperamental sea. There are 20 cascading cups and water enters them through holes in concealed branch pipes which serve also as bearing shafts or axles. The number and size of the holes is different for each cup so as to vary the rate of filling and timing of the cascades. The spent cascades mingle with the reserve water in the pool, from which a pump draws the required amount to replenish the pipes so that water does in fact flow continuously in a circuit' (as quoted in Hughes, 1969: 140).

Condition: The fountain is no longer in use. The posts and buckets are intact. The circular basin has some graffiti and scuffing, but appears to be in reasonable repair. The two viewing platforms have missing and broken tiles, and crumbling plaster. There are also various encrustations. The viewing benches also have missing tiles and graffiti. The entire installation appears decrepit and is strewn with litter and broken glass.

According to Willett (1967: 108-09), the fountain was commissioned by the Merseyside Civic Society, an independent body run by 'a mixture of architects and laymen' which in the 1960s concerned itself with Liverpool's redevelopment and enjoyed close links with the Corporation. Originally the fountain was intended for erection at some unspecified location outside Liverpool, but the Corporation arranged for it to be erected in the forecourt of their new Wilberforce House building 'to commemorate the starting of work on the city centre'. The Arts Council of Great Britain contributed £750 towards the cost of the fountain which was completed in 1966.

Literature: Hughes, Q. (1969): 136-40; Willett, J. (1967): 108, 109.

East Prescot Road

The 'Miss Thompson' Memorial Drinking Fountain [see illustration overleaf]

Fountain in Portland stone

Inscription in niche: WATER'S BEST / E.T. 1887

Owner/ custodian: Liverpool City Council
Listed status: Grade II

A simple niche fountain set into the wall of the local bowling green, opposite the *Knotty Ash* public house.

Condition: The fountain is no longer operational.

Literature: Richardson, A. (1990): 43.

Exchange Flags

EXCHANGE BUILDINGS, designed and built in 1939 by Gunton and Gunton.

Owner: Walton Group Plc
Status: not listed

In a niche between the archways to Tithebarn Street:
News Room War Memorial and flanking sculptures.

Sculptor of the *News Room War Memorial*: Joseph Phillips
Sculptor of the flanking sculptures, *Mother and Child* and *Father and Child*: Siegfried Charoux
Stone inscriptions: George Herbert Tyson Smith

News Room War Memorial in bronze
Mother and Child and *Father and Child* in Portland stone

h. of bronze group: 14' (4.3m) (estimated)
w. of bronze group: 10' 6" (3.2m)
h. of Portland stone groups: 6' 8" (2m) (estimated)

Inscriptions:
– on a centrally placed, bronze plaque, beneath the bronze sculptural group: THE BOOK OF SERVICE / LIES IN THE NEWS ROOM / PRO PATRIA / 1914 – 1919 / – / IN REMEMBRANCE OF MEMBERS OF THE LIVERPOOL EXCHANGE / NEWSROOM WHO GAVE THEIR LIVES FOR RIGHT AND FREEDOM / AND WHOSE NAMES ARE RECORDED ON THE ADJOINING TABLETS / AND OF THOSE SONS OF MEMBERS WHO LAID / DOWN THEIR LIVES IN THE SAME GREAT CAUSE / IN GRATITUDE ALSO TO ALL MEMBERS AND SONS OF MEMBERS / WHO SERVED THEIR COUNTRY / DURING THE WAR / THE NAMES OF ALL ARE RECORDED / IN THE BOOK OF SERVICE
– beneath this, carved into the stone: THIS MEMORIAL WAS RE-ERECTED / IN THIS POSITION IN 1953
– on two stone tablets, one each side of the bronze plaque, are carved the names of the twenty-six employees of the Liverpool Exchange News Room who fell in the First World War.

Exhibited: Siegfried Charoux, Royal Academy of Arts 1955, as *Mother and Child – half size model for carving in Portland stone* (cat. 1297) and *Father and Child – half size model for carving in Portland stone* (cat. 1310).

The *News Room War Memorial* was unveiled by Edward George Villiers Stanley, 17th Earl of Derby, in the Newsroom of Derby House, Wednesday 18 July 1924 and re-located to its present position in 1953.

Description: Located in a semi-circular niche between the entrances to the archways leading to Tithebarn Street and facing across the Exchange Flags towards *Monument to Lord Nelson*, the bronze war memorial consists of a pyramidal composition of figures grouped around a field gun. At the apex, standing high above the rest of the group, is Britannia, wearing a fish-scale breastplate, antique Greek helmet and wind-blown cloak decorated round the edges with dolphins, sea-horses and shells. In her raised right hand she holds a trident decorated with a small draped figure of a

woman in a head-dress holding a garland before her in her lowered hands. Britannia, like a secular 'Madonna of Mercy', rests her left hand on the shoulder of a small girl whom she protectively shelters within the ample folds of her cloak. Below, gathered around the field gun, are five figures. At the extreme left kneels a private soldier in a steel helmet bearing a rifle, looking to the right. Next to him and looking straight out, stands a captain, also in a steel helmet, wearing jodpurs and knee-length laced boots. In his lowered right hand he holds a pistol; in his left hand, raised to chest level, is perhaps a whistle. Both the private and the captain carry gas mask bags and share the same rocky background. To the right of the rocky background is the field gun, over the top of which a sailor leans. He scans the horizon, looking to the right, his left hand shielding his eyes. In front, and to the right, of the field gun a kneeling nurse tends to a bare-headed, semi-reclining, wounded sergeant dressed in a kilt. She faces towards the front, kneeling behind her patient, supporting him in a sitting position against her lap and in her arms. She lowers her head to look at a wound on his chest that she is in the process of cleaning with a swab held in her right hand. Her left forearm rests upon the sergeant's left shoulder and in her left hand she holds a bowl. The wounded sergeant's legs are sprawled parallel to the forward edge of the memorial, his right knee raised slightly, his left lower leg folded under his right. He rests his right hand on his raised knee and his left forearm against the nurse's lap. He turns his head upwards to look into the face of the nurse who tends him.

The semi-circular niche has a mosaic-covered coved ceiling and is flanked by two engaged stone columns surmounted by Portland stone figure groups. On the left is the *Mother and Child* and on the right, the *Father and Child*.

Note: The *News Room War Memorial*, in common with many others, bears the dates 1914-1919 not, as one might expect, 1914-1918. This is because although hostilities were suspended on 11 November 1918 (Armistice Day), Britain's official 'Peace Day' Victory Parade did not take place until 19 July 1919, following the signing of the peace settlements with Germany (28 June 1919) and her allies (Boorman, 1988: 2).

Condition: The bronze group appears to be in good condition, although the Portland stone figure groups surmounting the columns flanking the niche are rather eroded.

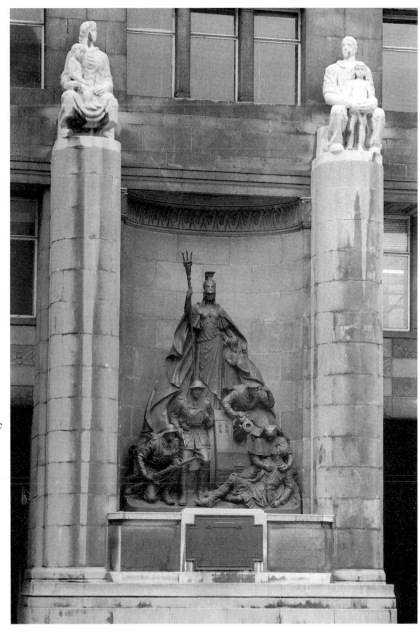

The *News Room War Memorial* was funded by a subscription raised amongst the members of the Liverpool Exchange Company in 1916 and was originally intended to be dedicated simply to all those 'members and their sons who [had] joined the forces' (*The Times*, 16 June 1916: 5). The *Courier* (6 June 1916: 6) hailed it as 'the first public memorial of the part Britain has played in the world war'. By the end of the war, the emphasis had changed, not surprisingly, to give priority to those members and their sons who had laid down their lives.

The plaster model for the present bronze group was unveiled by Lord Derby in the Newsroom of the old Exchange (1863-67, by T.H. Wyatt) on 22 June 1916 (*Daily Post and Mercury*, 23 June 1916: 3). The bronze differs in several ways from the original model (photograph in *Daily Post and Mercury*, 21 June 1916: 7). Notably, Britannia's cloak billows out more in the bronze and her trident, unembellished in the model, is decorated in the bronze with a motif of a woman holding a garland; the infant carried in Britannia's left arm in the model is replaced in the bronze by a young girl standing at Britannia's left side, sheltering under her cloak; the khaki service dress caps worn by the soldiers in the model are replaced in the bronze by steel helmets (the latter not having been introduced at the time the model was designed); and the Red Cross nurse of the model becomes a Queen Mary's Auxiliary Services nurse in the bronze. Also, there appears to be a dog, altogether absent in the bronze, crouched, in the model, at the extreme right of the group. Earlier, the *Courier* (6 June 1916: 6) had stated that the sculptor, Joseph Phillips, was in the process of working on a series of narrative relief panels to go either side of the memorial's pedestal. The writer of the article had apparently seen the sculptor's drawings for the

reliefs, the subjects of which included 'the sinking of the Lusitania, a fight in the air, and other dramatic episodes'.

At the unveiling of the model, members of the Exchange were invited to suggest alterations or additions to the design of the memorial. By the following day, a sketch had been proffered in which Britannia was replaced by a personification of Liverpool bestowing a wreath of laurel, with Britain and her Empire being represented instead by a Union Jack (*Daily Post and Mercury*, 23 June 1916: 3). These suggestions were obviously not taken up and the flanking reliefs never carried out.

The *Daily Post and Mercury* (19 July 1924: 7), reporting on the unveiling of the memorial, described it as. '…[a] fine memorial, a bronze allegorical group on a marble base, flanked by the names of the dead…'

When the decision was taken to demolish the old Exchange Buildings and replace them with more commodious modern premises, it was intended that the *News Room War Memorial* should 'occupy a worthy position in the new building' (*Daily Post*, 10 August 1937). A plan, dated 1936, by the new Exchange Building's architects Gunton and Gunton (copy in *Liverpool's Three Exchange Building's*: 109), shows the memorial as it was intended to look in the new News Room. With the outbreak of the Second World War in September 1939, however, the memorial was 'removed to a safe place' (*Daily Post*, 18 September 1953).

In 1952, it was decided to rebuild the News Room yet again. Evidently there was no place for the memorial within this (fourth) News Room and the decision was taken to instal it instead in its present exterior niche. The new News Room was opened by Lord Derby in early March 1953 (*Evening Express*, 9 March 1953) and the memorial placed in the niche

outside by September (*Daily Post*, 18 September 1953). The stone inscriptions were carved shortly after this time (George Herbert Tyson Smith, *Payments Book for September 1949 – March 1955*).

The reason for setting up Charoux's *Mother and Child* and *Father and Child* either side of the *News Room War Memorial* is given in the *Daily Post*, 25 November 1957: 'They were designed at the express wish of the directors of the Liverpool Exchange Company in order to bring some reference to civilian war effort into the feature.'

Literature: (i) LRO (a) newscuttings: *Daily Post* (1937) 10 August, in *LTEB*: 73; *Daily Post* (1957) 25 November, in *LTEB*: 162; (b) other related material: *Official Invitation to the Unveiling By Lord Derby of the News Room War Memorial* (1924) 1 July, in *LTEB*: 73; *Plan of Exchange Buildings by architects Gunton & Gunton* (1936), in *LTEB*: 109; *Exchange Buildings Liverpool*, pamphlet, in *LTEB*: 143; (c) George Herbert Tyson Smith, *Payments Book for September 1949 – March 1955*, in George Herbert Tyson Smith Archive, Box 18.
(ii) WAG JCS files – transcriptions of newspaper articles: *Daily Dispatch* (1916) 7 April; *Daily Post* (1953) 18 September.
(iii) Boorman, D. (1988): 2; Compton, A., 'Memorials to the Great War', in P. Curtis (ed.) (1989): 93; *Courier* (1916) 6 June: 6; Curtis, P. (1988): 26; *Daily Post and Mercury* (1916) 21 June: 7; *Daily Post and Mercury* (1916) 23 June: 3; *Daily Post and Mercury* (1924) 18 July: 5; *Daily Post and Mercury* (1924) 19 July: 7, 11; Richardson, A. (1990): 25.

The two side wings of Exchange Buildings (Walker House on the left and Horton House on the right), have sculptural bas-reliefs over the doorways.

Walker House **bas-reliefs**: *Neptune*
Horton House **bas-reliefs**: *Mercury*

Sculptors: Edmund C. Thompson and George T. Capstick

Bas-reliefs over smaller entrances in Portland stone
Bas-reliefs over main entrances in bronze

Each bas-relief: h: 20" (50.8cms); l: 50" (127cms)

Status: not listed

Description: Each wing of the buildings has a single stone bas-relief over the smaller entrance and doubled bas-reliefs over the main entrance beneath the portico. The reliefs on each wing are uniform: those on Walker House represent *Neptune*, a crowned and bearded head, flanked by horses rearing from stylised waves. Those on Horton House represent *Mercury*, wearing a winged helmet and holding up a caduceus in each hand.

Condition: Good

Thompson and Capstick's reliefs were executed for Gunton and Gunton, before 1939.

Literature: *Builder* (1939) 26 May: 988-90.

Monument to Lord Nelson

Admiral Horatio Nelson (1758 – 1805) is here commemorated as the supreme English naval hero who died at the moment of his greatest victory against the French Napoleonic forces at Trafalgar in 1805. To the merchants of Liverpool, Nelson's destruction of the French fleet meant that their own ships could once again ply their international trade unmolested.

Designer: Matthew Cotes Wyatt
Sculptor: (Sir) Richard Westmacott

Basement: granite
Pedestal: Westmorland marble
Vent grills on basement: iron
All sculptural work: bronze

– the original basement was of Westmorland marble

h. of basement: 6' ¹/₂"(1.84m) – circumference of basement: 95' 4" (29m)
h. of pedestal: 8' 10" (2.7m)
h. of bronze group: 14' 2" (4.3m) – the figures are each 7' (2.1m)
h. of monument overall: 29' (8.84m) – original h. overall: 24' 6" (7.5m)

Continuous inscription in metal letters around the cornice of the drum beneath the *Apotheosis* group: ENGLAND EXPECTS EVERY MAN TO DO HIS DUTY

Exhibited: Matthew Cotes Wyatt, British Institution 1808 (cat. 486), as *Model of a Monument to the memory of the Late Lord Nelson*

Unveiled Thursday 21 October 1813

Owner: Formerly Liverpool City Council, but now, according to the City of Liverpool Development & Environment Services Directorate, the property of the Walton Group, on whose freehold land the monument is situated.
Listed status: Grade II*

Description: Around the drum-shaped pedestal surmounting the granite basement, four shackled prisoners in poses of anguish and resignation are seated on blocks positioned at the cardinal points: they represent Nelson's four great victories at Cape St Vincent, the Nile, Copenhagen, and Trafalgar. As Yarrington has observed (1983: 325), these figures recall Pietro Tacca's bronze 'slaves' around the base of Giovanni Bandini's *Monument to Ferdinand I* (completed 1624, Piazza della Darsena, Livorno). Between the prisoners, set into the drum, are four bronze bas-reliefs depicting

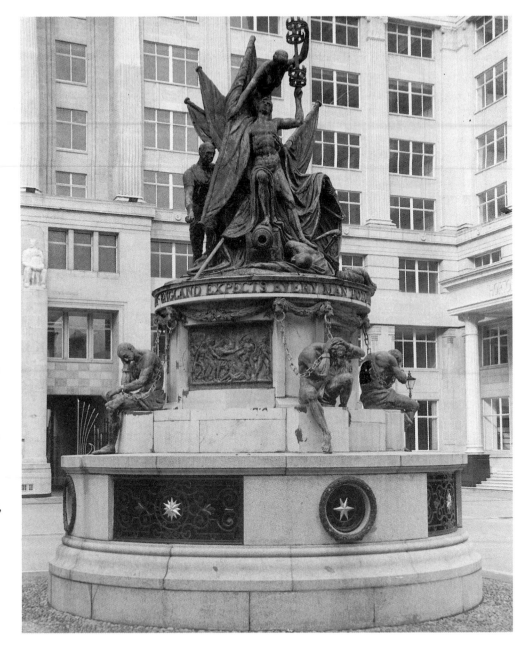

various naval actions in which Nelson engaged. Encircling the drum below the cornice are swags of laurel, four longer ones above the reliefs and four shorter above the prisoners. The swags are slung from behind lion's heads located at the top corners of the pilasters framing the prisoners. Rings in the lion's mouths are attached to chains to which, in turn, the prisoners are manacled.

Surmounting all is the *Apotheosis* group, consisting of a roughly pyramidal group of five figures, entangled in the voluminous drapes of four large captured flags, their poles at various angles. An anchor and rope lie on the ground. An idealized nude Lord Nelson, his right foot on a canon and his left foot on the corpse of a conquered enemy, raises in his left hand a sword, upon which *Victory* personified is putting a fourth crown to indicate his fourth naval victory, Trafalgar. At the same time she lowers a captured enemy flag to conceal Nelson's missing right arm. To the right of Nelson, and half-hidden by the lowered flag, is the skeleton *Death*, reaching out to touch him, indicating that he died at the moment of his final victory. A lance-wielding British seaman strides forward from the left of Nelson to avenge his death. Behind Nelson, kneeling with bowed head, is *Britannia* lamenting his death: she wears a Greek helmet and her right hand, slung disconsolately over the top of her shield, holds a laurel wreath and Nelson's decorations – one medal bears the inscription: NILE / FIRST AUG / 1798.

Condition:

1. *Apotheosis* group: the lance is now missing from the advancing sailor's right hand and his forearm has a rust-coloured stain. The top is missing from the flagpole held by *Victory*. Verdigris is now showing through the black

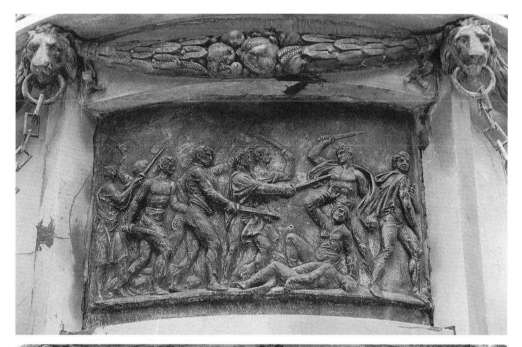

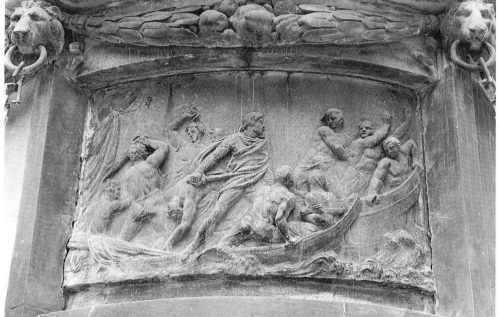

epoxy paint which once coated all the bronze parts.

2. The *Prisoners*: the *Prisoner* facing north has a line of deep vertical splits along the calf muscle of the left leg; the *Prisoner* facing west has corrosion and rust on the back of the left leg

and there is more rust on the heel and sole of the left foot; the south-facing *Prisoner* has rust on the sole of the right foot and the instep is corroded and pitted; the east-facing *Prisoner* is in relatively fair condition.

3. The battle reliefs: the N. E. relief has some small white patches in the upper half; the N. W. relief has some similar white patches scattered across the surface; the S. W. relief has some cracking at top left; and the S. E. relief has patches of white with small black centres, plus some graffiti.

4. The pedestal is cracked in a number of places and stained with green run-off from the bronze.

Related works by Westmacott: *Monument to Lord Nelson*, bronze, 1806-9, Birmingham; *Monument to Lord Nelson*, bronze, 1810-13, Bridgetown, Barbados.

On 14 November 1805 a Special Council meeting was held at Liverpool Town Hall to agree upon the wording of an address to the King to express the town's gratitude for the decisive victory of the English fleet at Trafalgar, while at the same time lamenting the loss of the national hero, Lord Nelson, at the moment of this, his greatest triumph (Touzeau, 1910, ii: 729). In addition, the Council resolved to call a public meeting for the following day to consider the erection in Liverpool of a monument to commemorate Nelson's patriotic sacrifice, authorizing the Mayor, Henry Clay, to give notice that £1,000 from the general Corporate Fund had been voted towards the project (Touzeau, 1910, ii: 730).

At the public meeting, also held at the Town Hall, it was resolved that a public subscription should be launched for a 'Naval Monument' to Lord Nelson; that the monument be 'erected in the centre of the area of the New Exchange Buildings'; and that it be inscribed with

Nelson's memorable last orders to his men: 'England expects…' A Committee of twenty-one, chaired by George Case, and including the Mayor, John Bolton, John Foster Snr, John Gladstone, and William Roscoe, was formed to select an appropriate design and to oversee its execution (*Report…*: 7-9). Such was the warmth of feeling for Nelson that in just over two months the subscription fund had reached £8,930 (*Chronicle*, 22 January 1806; quoted in Yarrington, 1988: 119). Picton records that, in addition to the Corporation's contribution of £1,000, the underwriters at Lloyd's contributed £750 and the West India Association £500 (Picton, 1875, revised edn 1903, i: 269).

As the final report of the Memorial Committee states, the monument's location just outside the Exchange was considered to be particularly appropriate, because:

> The people of Liverpool, and their descendants to remote ages, should, in the midst of their mercantile transactions, and daily concerns, be perpetually reminded of the man to whom they are so greatly indebted, for the vindication of their rights, and the protection of their commerce, at a period when they were threatened with destruction by a vindictive and powerful enemy (*Report…*: 10).

An open competition for the design of the monument was announced, for which models or drawings had to be submitted before 1 February 1807, with financial compensation offered to unsuccessful competitors (*Report…*: 11). Despite competition from the most celebrated sculptors in the land – Flaxman, Rossi, Westmacott and Bacon the Younger had been expressly invited to participate by the Committee (Farington, 14 May 1806: 2760) – and despite the publication by local sculptor,

George Bullock, of a pamphlet explaining the nationalistic programme of his submitted maquette which the *Literary and Fashionable Magazine* praised for its exemplary Britishness (see Stevens, 1989b: 44-5) – the winning design was declared to be that submitted by the relatively unknown Matthew Cotes Wyatt. The fact that the winner's father, James Wyatt, was external advisor to the competition and had been architectural collaborator on the rebuilding of Liverpool Town Hall with John Foster Snr (a leading member of the Memorial Committee), has led to the suspicion that 'a form of nepotism' may have played a part in the choice (Yarrington, 1989: 24; see also Penny, 1977: 12-13).

In any case, Wyatt's inexperience as a practising sculptor, and the size and complexity of his composition, meant that it was felt necessary to enlist the proven modelling and bronze casting skills of Richard Westmacott to translate idea into actuality (*Report...*: 14). And yet, perhaps Wyatt's design really did meet the requirements of the Committee: as the *Mercury* (22 October 1813), in its report of the unveiling, explained:

In preferring an historical group to a naval column, or a single statue, and in selecting the subject above described from a considerable number of designs of great excellence, it was one of the principal aims of the Committee to erect such a Monument as should not only do honour to the Town of Liverpool, as an effort of art, but should excite in the breast of the spectator those feelings, moral and patriotic, which a work of the highest class ought always to inspire.

The contract was signed by the Committee and Westmacott on 3 February 1809; Wyatt was to receive eight percent of the agreed £8,000 (Busco, 1994: 49). The fact that Wyatt was not a signatory to the agreement suggests that he may have relinquished his rights to any control over the realisation of his drawn design. There is much to support this hypothesis. Most importantly, whereas the monument as completed undoubtedly adheres to the overall shape of Wyatt's original design, it has been observed that the individual figures nevertheless fit unproblematically into Westmacott's oeuvre. Furthermore, rather than delegating the casting to assistants, Westmacott involved himself personally, and with considerable enthusiasm, in all stages of the casting processes. Such personal involvement would strongly suggest that he had 'developed the design rather than simply reproduced a replica' (Yarrington, 1988: 127-28).

In a letter of 27 July 1811, mostly concerned with preliminary discussions for his *Monument to George III* , Westmacott reveals:

'Nelson now occupies all my thoughts. The sailor was seen on 25th and is I think the best cast I have had – if possible [it] exceeds the Captives' (*Records... 2/5*, quoted in Yarrington, 1983: 324).

The first stone was laid on 15 July 1812 and the monument unveiled on 21 October 1813, this latter date having a particular poignance, it being, as the Memorial Committee pointed out:

... the anniversary of the glorious Victory of Trafalgar, and of the lamented Death of Lord Nelson (*Report...*, introduction).

The Committee retained responsibility for the care of the monument for a further ten years

until the cost of repairs rendered it necessary for them to request that the Council take it into their safekeeping. The Council agreed and, although there was never a formal handing over ceremony, resolved that it would 'take upon itself the perpetual repair of the Monument, and that the expense of such repair be from time to time defrayed out of the Corporation Estate' (Touzeau, ii: 730).

The monument was moved to its present location nearer the Town Hall in 1866 in order to make way for T.H. Wyatt's extension to the Exchange Buildings (demolished 1937). At the same time the original Westmorland stone base was replaced by the present granite base, six feet higher and pierced with ventilation grills which open into a receiving chamber under the monument, from which air was formerly conducted via an underground shaft to the basement areas of the Exchange Buildings (*The Albion*, 5 November 1866).

Literature: (i) LRO – *Records relating to the statue of King George III, 1809-1822*: correspondence from Richard Westmacott to John Foster Snr, dated 27 July 1811: 2/5.
(ii) *Albion* (1866) 5 November: 4; *Art-Journal* (1866): 320; *Builder* (1866) xxiv: 835-36; Busco, M. (1994): 46-51; *Chronicle* (1806) 22 January: 2; *Chronicle* (1806) 19 February: 1; Farington, J. (1982 edn) vii: 2687, 2721, 2760; *Kaleidoscope* (1823-24) iv: 141-42; *Mercury* (1813) 22 October: 136; *Mercury* (1813) 29 October: 143; Penny, N. (1976): 547-48; Penny, N. (1977): 12-13; Picton, J.A. (1875, revised edn 1903), i: 269, 319; *Report of the Committee for... the Monument to... Lord... Nelson* (1823); Stevens, T., 'Sculptors working in Liverpool in the early nineteenth century', in P. Curtis (ed.) (1989b): 44-5; Touzeau, J. (1910) ii: 728-30; Whitty (1871): 30-1; Yarrington, A. (1983): 315-29; Yarrington, A. (1988): 116-34; Yarrington, A., 'Public Sculpture and Civic Pride 1800 -1830', in P. Curtis (ed.) (1989): 22-6.

Festival Gardens

The Liverpool International Garden Festival was held between 2 May and 14 October 1984 in Festival Gardens, a 125 acre site reclaimed from industrial wasteland in south Liverpool on the Mersey riverside. The idea for the Garden Festival was derived mainly from the example of those held in Germany following the end of the Second World War. As part of a programme for urban regeneration, Germany's garden festivals had also provided the cities in question not only with free publicity leading up to and during the event, but also with areas of developed park land that could be used afterwards. In July 1980 the Department of the Environment issued a paper entitled *Garden Exhibitions and the United Kingdom*, advocating the adoption of a similar scheme in the UK. In August 1980 applications were invited from interested cities and Liverpool and Stoke-on-Trent were short-listed. Early in 1981, responsibility for Liverpool's proposals – hitherto controlled by the City and County Councils – was assumed by the recently formed Government-appointed body, the Merseyside Development Corporation (MDC). In spring 1981, the two cities were invited to submit their proposals. MDC's ownership of a suitable riverside site, plus its access to the necessary funding for that site's development, obviously gave Liverpool a clear lead over its rival: a lead that the eruption of civil unrest in Toxteth in July 1981 could only have served to consolidate. Thus it was that the Liverpool International Garden Festival became the first of a biennial series of garden festivals to be held in the UK, in which sculpture was to be a major feature. (A full account of the background to the setting up of the Festival is given by Curtis, 1989: 111-15).

The idea of incorporating sculpture into the Festival was a late initiative from Timothy Stevens, then Director of the Walker Art Gallery, and Dr John Ritchie, then Director of Development in the MDC. Stevens saw the Festival as an opportunity to feature sculpture in a way similar to the Festival of Britain in 1951. He also wanted the new park to contain modern works that would complement the Victorian and Edwardian sculpture of Sefton Park. Stevens and Ritchie duly sought advice from Alister Warman, responsible for the Arts Council's Art in Public Places scheme. Warman suggested appointing a Sculpture Co-ordinator and nominated Sue Grayson-Ford who subsequently accepted the appointment (Curtis, 1989: 112). The work of fifty-five sculptors (complete list in Curtis, 1989: 115) was chosen for display throughout the gardens by Stevens, Warman, and Grayson-Ford, and the project was funded jointly by MDC (£87,700), Merseyside County Council (£20,000), and the Arts Council of Great Britain (£30,000) (Curtis, 1989: 112).

While most of the sculptures were borrowed for the Festival and returned to their owners at its close, ten pieces were specifically commissioned and one purchased for the gardens. One commissioned piece, *Wind Clock*, by Tim Hunkin, was a temporary installation which was dismantled at the close of the Festival, but the other ten commissioned pieces have remained as permanent fixtures (although most of the original locations have changed). Additionally, one piece, *Dragon*, by Jane Ackroyd, from the Festival's temporary 'Sculpture Zoo' display, has remained on site.

Following the close of the Festival, about fifty per cent of the area was reassigned to a housing development (i.e. all of the section to the north-east of Riverside Drive). This necessitated the relocation of some of the remaining sculptures. It was originally intended that the reduced gardens and the sculptures they contained be managed thenceforth by Liverpool City Council, but the Council declared itself unable to allocate any of its hard-pressed financial resources to the upkeep of the site and thus MDC have by necessity retained control, leasing the site out to a succession of private companies (Meecham, 1991: 2). At times during the ensuing years, the sculptures in Festival Park, as the gardens are now known, have become almost inaccessible: the first private operator ceased trading in 1986 and, from that date until 1992, when the current tenants, Tomorrow's Leisure, opened their Pleasure Island theme park, there have been extended periods of closure (Meecham, 1991: 2). Given that an admission charge is imposed for access to the park itself to cover the cost of using the on-site amusement facilities, there remains the awkward discrepancy that there is currently no free public access to a group of sculptures that were part-funded by public money. MDC's ownership of the sculptures will be resigned in March 1998, the date set for the Corporation's dissolution. Initiatives to safeguard the collection are at present being pursued.

Literature: *Architects' Journal* (1984) April: 19-25; Curtis, P., 'Liverpool Garden Festival and its Sculpture', in P. Curtis (ed.) (1989): 111-15; *Daily*

Post, *International Garden Festival Supplement* (1994) 12 May; *Festival Sculpture* (1984); Meecham, P. (1991): 1-13.

COMMISSIONED WORKS

Arena Theatre [illustration p. 57]

Designer: Richard Cass
Sculptor: Raf Fulcher, in association with George Carter and Elizabeth Tate

Executed in mixed media, 1984

Dimensions:
Cascade doors – h: 10' (3.05m); w (closed): 8' (2.44m)
Obelisks – h: 7' (2.13m)

Commissioned for the International Garden Festival 1984

Owner: Merseyside Development Corporation
Status: not listed

The artists state:

> We are concerned that the artist should contribute to the improvement and transformation of the environment on as large a scale as possible. Hence our interest in the garden, landscape and architecture. Even after the loosening-up brought about by the Post-Modern revolution in architecture there seems to be little correlation between buildings and their settings, to say nothing of their style or their symbolism. Given the professional separateness of architect and landscape architect, a sculptor – with a strong interest in spatial articulation, material, symbolism and the rest, seems in a good position to suggest an overall scheme for a building and its setting: not just as a cosmetic afterthought but as an integral part of the planning

process. The sculpture here reinforces the Garden Festival theme, with incidents symbolic of elements, the daily and seasonal cycles – the prerequisites of plant growth. Cosmic explosions, stars, comets and planets are ranged high up above the theatre's columns, flanking a large lead thunder cloud with gilded lightning flashes. One pair of the stage doors carries wooden reliefs representing cascading water, the other carries obelisks with frozen cascades of water (*Festival Sculpture*, 1984: 33).

Condition: Areas of wear and damage. Paint is peeling from the wooden parts in many places – note particularly the '*Frozen Cascade*' stage doors facing the amusement complex: the 'back-stage' room is now used as a storage area for large metal containers etc. and the doors have suffered damage from these and the nearby rubbish skips. There is some paint loss and the wood is splintered in places. There are also areas of loss to the wood on the '*Cascading Water*' doors facing the amphitheatre. The lead disc from the front face of the *Apollo* pedestal (to the left of the entrance to the amphitheatre) is missing.

The copper finials which once crowned the posts at the back of the stage area had to be removed when it was realised that they interfered with, and were damaged by, the large canvas awning, drawn over the auditorium on rainy days. These, mostly bent out of shape, are currently in store.

The design of the Arena Theatre is derived from that of a Greek amphitheatre; its sculptural treatment was commissioned by Sculpture Co-ordinator Sue Grayson-Ford (Meecham, 1991: 24). Appropriately, the entrance is flanked by busts of Apollo, patron of poetry and music, and Diana, his sister, while the semi-circular stage area is backed by a pair of classically pedimented doorways, decorated with '*Cascading Water*' (the backstage doorways being decorated with '*Frozen Cascades*').

Literature: *Festival Sculpture* (1984): 12, 33; Meecham, P. (1991): 24-5.

Dry Dock

Designed by Graham Ashton

Media: concrete and steel, painted, 1983/84.

Dimensions (approx.): circumference: 50' (15.24m); diameter: 15' – 20' (4.57m – 6.10m); depth: 3' (0.91m).

Designed and constructed 1983/84

Commissioned for the International Garden Festival 1984

Owner: Merseyside Development Corporation
Status: not listed

Exhibited: Watercolours of preliminary ideas for *Dry Dock*, in *Graham Ashton: Recent Watercolours on two themes*, Fischer Fine Art Ltd, London, 13 September – 5 October 1984.

Description: *Dry Dock* is a roughly oval concrete pit (reminiscent of a children's sandpit, emptied of sand). The encircling flight of three shallow steps invites visitors to descend to the floor of the pit (the 'sea bed') and to play and fantasise amongst the listing ship, life buoy, boom, and torpedo. Ashton states:

> The images in *Dry Dock* have been developed from events and objects associated with my own childhood on the River Mersey and its maritime history. The compass gives direction and the sundial gives the time (correct for only a brief period in early summer) based on the sinking of the SS

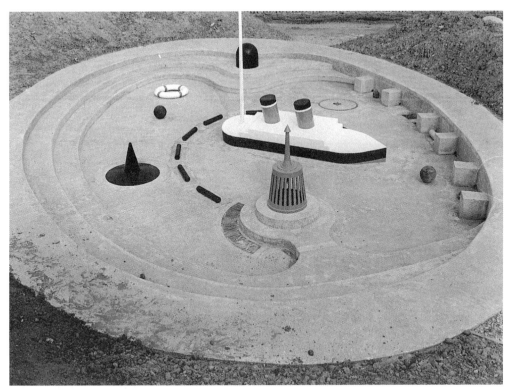

Lusitania. The ship (on which anyone can be captain) is either listing or turning sharply, the boom-like structure around the ship can be seen as either a torpedo track or in fact as a boom around a sinking ship. (I remember the Empress of Canada sinking at the Pier Head.) The sculpture is intended to reach maturity in 10-15 years, when the parkland has become firmly established; with repeated painting the objects will take on the surface texture of a well-painted superstructure and the concrete base will have the patina of staining and use (*Festival Sculpture*, 1984: 29).

Condition: Generally in good repair; some small areas of rust on painted steel ship, etc. Last re-painted in 1992, as directed by MDC.

Related works: *Maquette for Dry Dock*, (made for Ashton by Roy Irlam and John Welsh, respectively foreman joiner and apprentice joiner in the WAG), wood, 155.5 × 125.5 × 38cms (WAG 1993.66), bought from the artist for £500.

Selected by Timothy Stevens when Ashton was Artist-in-Residence at the Walker Art Gallery and Bridewell Studios, Liverpool, in 1983-84. The cost was an overall £8,938: £6,438 being for construction and £2,500 for the artist's prelimi-

nary ideas and for his supervision of the making of the maquette. Built into the landscape as a permanent fixture, it is one of the few pieces to have retained its original siting.

Literature: *Festival Sculpture* (1984): 9, 29; Fischer Fine Art Ltd (1984); Meecham, P. (1991): 17-18; WAG (1984b).

Flight of Rooks

Sculptor: David Kemp

Medium: wooden fencing off-cuts

Commissioned for the International Garden Festival 1984

Owner: Merseyside Development Corporation Status: not listed

Condition: The two most accessible rooks on the roof have been broken off and stolen, as have those placed on the handrail of the bridge railings. The remainder appear to be in generally good condition.

Kemp states:

> I live in the country and I make my 'sculptures' out of the junk people dump there. Behind the hedgerows lurk any number of derelict domestic appliances – I see more fridges than foxes. One aspect of my work is to recreate the original denizens of the landscape – birds, animals and insects – from the junk that has replaced them. In 1980 I worked as resident sculptor in Grizedale Forest, Cumbria; I made and sited sculptures there from natural materials I found in the forest – branches, stone, timber, off-cuts, etc. I made a group of *Rooks* there from the wedge-shaped off-cuts and 'pointings' left from fence post-making. The *Flight of Rooks* was commissioned especially for the

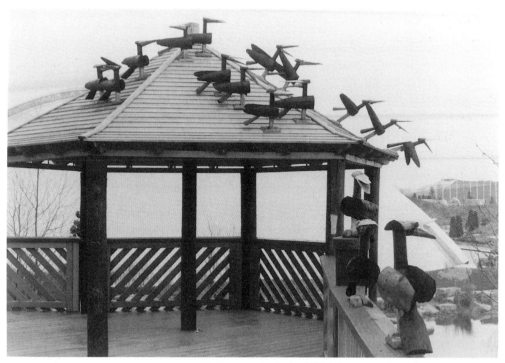

sung loud and sweetly by the male to attract its mate. The sheep faces occured from discovering the simplicity of one drawn line becoming head/horns and expressing the whole character of a sheep. (One sheep does not look exactlly like another – except in the flock.) The fish are swimming upstream to spawn. Since childhood I have relished the special quality of passing through rural kissing gates; yet they nearly always perform their function without decoration. The decoration in mine helps direct the person passing through to a unique involvement with the gates (*Festival Sculpture*, 1984: 29).

Selected by Sculpture Co-ordinator Sue

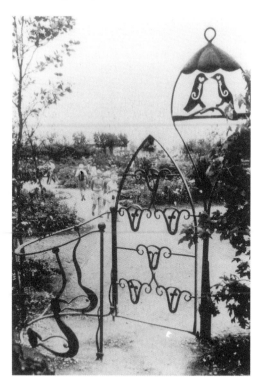

International Garden Festival. It is simply made. The most difficult part was finding the right shaped 'pointings'. I joined them together and grouped them on the roof, landing on one side and about to take off on the other (*Festival Sculpture*, 1984: 35).

Selected by Sculpture Co-ordinator Sue Grayson-Ford (Meecham, 1991: 27). The gazebo upon which the *Flight of Rooks* has 'landed', retains its original position on the bridge, although the miniature railway that once passed beneath no longer operates.

Literature: *Festival Sculpture* (1984): 13, 34-5; Meecham, P. (1991): 27.

The Kissing Gate

Designed by Alain Ayers

Forged steel, fabricated by Theo Grunewald, blacksmith, Glamorgan, Wales, 1984

Purchased for the International Garden Festival 1984

Owner: Merseyside Development Corporation
Status: not listed

Condition: Dismantled, but generally in good repair; some small areas of paint loss and rust.

Ayers states:

The gates began with drawn images of birds and cages and referred to the canary song:

Grayson-Ford, *The Kissing Gate* was located on that part of the Festival Gardens site which is now a housing estate (Meecham, 1991: 19). Following the close of the festival it was disassembled and placed in store. It is intended that at a date yet to be determined, it be restored, reassembled, and relocated somewhere in the present area of Festival Park.

Literature: *Festival Sculpture* (1984): 9, 29; Meecham, P. (1991): 19.

Palanzana

This piece is named after Palanzana, near Viterbo in Italy, the location of the quarry for the volcanic Peperino stone out of which the sculpture is carved (*Festival Sculpture*, 1984: 32).

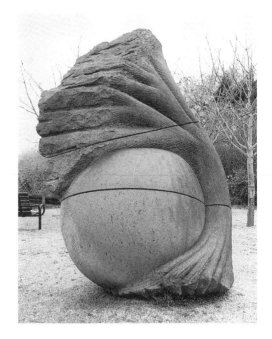

Sculptor: Stephen Cox

Sculpture in Peperino stone, 1983/84

h: 118" (300cms); w: 59" (150cms); d: 55" (140cms)

Commissioned for the International Garden Festival 1984

Owner: Merseyside Development Corporation
Status: not listed

Exhibited: sketches and *modelli* for *Palanzana* at Nigel Greenwood Inc., London, 1 May– 1 June 1984.

Description: A tree-like form half-enwraps, but does not engulf, a large sphere. Cox juxtaposes the generally smooth surface of the sphere with the fibrous surface of the tree-form and the rough, unfinished surface of the natural stone. The plant-like form and sphere are tied together by two deep circumferent channels. The robust material and the organic forms into which it has been carved, were intended to suit the hilly parkscape setting (*Festival Sculpture*, 1984: 4).

Condition: Good

Related work: *Modello for Palanzana*, Portland stone, 1983, WAG, cat. 10462 (purchased from Nigel Greenwood Inc.).

Selected by Sculpture Co-ordinator Sue Grayson-Ford, *Palanzana* cost £11,000 (Meecham, 1991: 22). Designed specifically for this site (Curtis, 1989: 113), the sculpture retains its original location.

Literature: Arnolfini (1985); Curtis, P., 'Liverpool Garden Festival and its Sculpture', in P. Curtis (ed.) (1989): 112; *Festival Sculpture* (1984): 4-5, 10-11, 30-31; Meecham, P. (1991): 22-23.

Sitting Bull

Sculptor: Dhruva Mistry

Sculpture in concrete, originally drip-painted, on a metal armature

h: 120" (305cms); l: 132" (335cms); d: 96" (244cms) approx.

Commissioned for the International Garden Festival 1984

Owner: Merseyside Development Corporation
Status: not listed

Description: The massive *Bull* sits with head erect and turned to the right. The artist's original drip-painted technique gave a striated, hair-like texture to the colouring of the *Bull*'s hide; sadly, the *Bull* has since been repainted in a rather less interesting uniform red. The eyes are the only spots of different colour: the complete circles of the black pupils standing starkly against the whites, intended to give a look of fierceness. The overall weight is eighteen tons, the supporting armature alone weighing three tons (Meecham, 1991: 29).

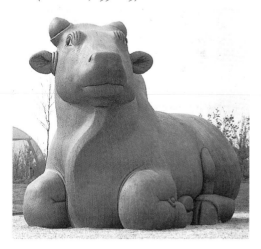

Condition: The body is in good repair, but the original paint surface is lost. The 1992 re-painting, carried out under the direction of MDC, is now also worn due to wear from children clambering onto the upper surfaces of the legs, etc., and onto the back of the *Bull*.

Related works: 1. *Sitting Bull*, polychromed plaster, 1983/4, Victoria and Albert Museum; 2. *Sitting Bull*, carved chalk coated with shellac and polychromy, 1983/4, collection of William Feaver; 3. *Sitting Bull*, (maquette for Festival sculpture), plaster with yellow-ochre polychromy, inscribed (inside) 'DHRUVA MISTRY 83' (WAG.10397); 4. *Sitting Bull*, polychromed cement and sand (WAG.10832).

Selected by Sculpture Co-ordinator, Sue Grayson-Ford, and the then Director of the Walker Art Gallery, Timothy Stevens, *Sitting Bull* cost £5,000 and was executed on site over a period of two months. The original location has now been redeveloped as a housing estate, following the reduction of the area of the gardens. An early suggestion was that *Sitting Bull* should remain where it was to form the centre-piece of a picnic area. This idea was discarded, however, and the piece relocated in the heart of the new enclosed Festival Park (Meecham, 1991: 29).

The subject derives from Nandi, the bull ridden by the Hindu god, Shiva. Mistry, who intended the bull to convey an impression of potential power and strength in repose, has said, 'I wanted to make a bull which would make a tiger run away'.

It was, apparently, the most popular of the Festival Gardens sculptures.

Literature: Curtis, P. (1988): 62, 63; Curtis, P., 'Liverpool Garden Festival and its Sculpture', in P. Curtis (ed.) (1989): 113; *Festival Sculpture* (1984): 6, 35; Kettle's Yard Gallery (1985); Meecham, P. (1991): 29; WAG (1984c): 113.

The Tango
Sculptor: Allen Jones

Sculpture in steel plate, painted

h: 15' (4.57m)

Signed at the foot of the sculpture: AJ

Commissioned for the International Garden Festival 1984

Owner: Merseyside Development Corporation
Status: not listed

Description: A festive mood has been created with a few bright colours – red, yellow, peach, pink and black – and the switchback rhythms of the couple's dancing forms. Jones conveys the exuberant eroticism of the tango as the bodies interpenetrate, the black of the man's suit passing through the woman's peach skirt, his red tie whipping out behind as he changes direction, balanced by the yellow of her hair streaming out in the opposite direction; her extended arm providing a counterthrust to her partner's momentum. More than one snapshot moment, *The Tango* is intended to be a conflation of the whole dance.

Condition: Re-painted in 1992, under the direction of MDC. The re-painting is now peeling on the upper parts. There is graffiti, along with numerous scuff marks on the lower parts. Patches of rust can be seen in various places.

One of a series of dancing figures cut from steel plate, *The Tango* was Jones's first public sculpture. It was selected for the site by Sculpture Co-ordinator Sue Grayson-Ford and cost £18,000 (Meecham, 1991: 28).

Having first worked out his ideas in paper

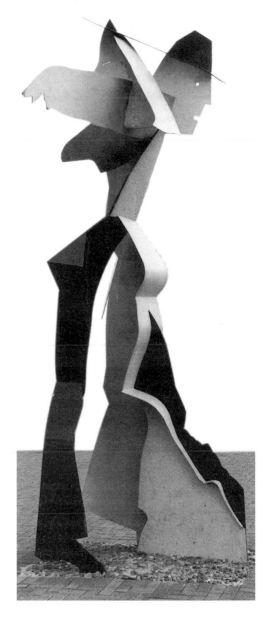

and wood, Jones then fabricated the finished piece with assistance from Paragon Engineering. It was originally located at the Herculaneum entrance, but after the reduction of the Festival Gardens site, *The Tango* was moved to its present location (in consultation with Alex Kidson of the Walker Art Gallery) near the car park, between the main entrance to 'Pleasure Island' and the 'Great Explorations' centre (Meecham, 1991: 28). The sculpture is set into a circular six foot diameter steel base plate, concealed beneath the surrounding paving.

Literature: Curtis, P. (1988): 62, 63; Curtis, P., 'Liverpool Garden Festival and its Sculpture', in P. Curtis (ed.) (1989): 113; *Festival Sculpture* (1984): 6, 34; Meecham, P. (1991): 28.

Unknown Landscape 3

Designer: Nicholas Pope
Executants: Barry Baldwin with a team of masons

Sculpture in Hollington sandstone, 1983/84

h: 96" (244cms); w: 80" (203cms); d: 35½" (90cms)

Commissioned for the International Garden Festival 1984

Owner: Merseyside Development Corporation
Status: not listed

Exhibited (with maquettes 1, 2, 3 & 5): Waddington Galleries, London, 2 – 26 May 1984.

Description: The sculpture is formed of three pieces: a base, and two larger pieces, one supporting the other. The pieces are all boulder-like and affect the appearance of having been shaped by the natural weathering of wind and

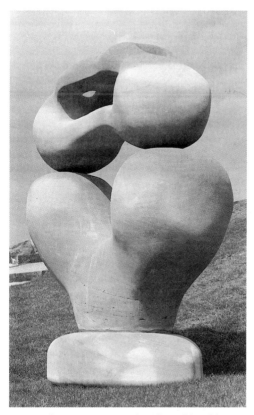

water. The upper, inverted u-shaped boulder, balances on a y-shaped boulder, creating a large intermediate hole; a wide, mouth-shaped cavity perforates the top piece from front to back. The roof of the cavity is further perforated by two smaller holes towards each end.

Condition: Fair, but with some chips out of the lower stone and some graffiti on the lower parts.

Related works: *Maquette for an Unknown Landscape No. 1*, Wellingtonia, 55¼" × 147½" × 19½" (140 × 375 × 75cms),1983; *Maquette for an Unknown Landscape No. 2*, wood, 66¼" ×

75½" × 40¼" (168 × 192 × 102cms), 1983; *Maquette for an Unknown Landscape No. 3*, elm, 78¾" × 90½" × 31½" (200 × 230 × 80cms), 1983; *Maquette for an Unknown Landscape No. 5*, Wellingtonia and cedar, 75" × 71" × 43½" (190 × 180 × 110cms), 1983.

Unknown Landscape 3 was selected for the site by Alister Warman (Meecham, 1991: 30). Pope carved the maquette in elm wood. It is one of a series of five variants executed in different types of wood. In 1984, Pope stated:

> These sculptures have all been made since I moved to the Herefordshire side of the Malvern Hills a year and a half ago. This landscape has been an inspiration to many, as it has been and will be for me. The models and full size maquettes have all been made with the idea of a final version in stone. So far Barry Baldwin and his masons have made No. 3 in mottled Hollington sandstone; the others will follow in different English stones. (Waddington Gallery, 1984: 3).

Literature: *Festival Sculpture* (1984): 5, 15, 36; Meecham, P. (1991): 30; Waddington Gallery (1984).

Wish You Were Here

Sculptor: John Clinch

Sculpture in glass reinforced polyester on a stainless steel armature, 1983/4

Three over life-size figures

Commissioned for the International Garden Festival 1984

Owner: Merseyside Development Corporation
Status: not listed

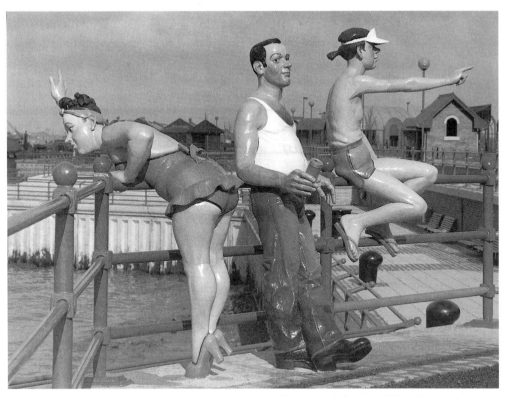

Clinch states:

> Whilst I'm not really advocating a 'Carry on Sculpting' approach, I am drawn towards the past 'journeyman tradition' of popular objects and imagery: fairground carvings, cigar-store 'Indians', ships' figureheads and tin toys. They're urban art forms; skillful, affirmative and witty. It would be good to see large-scale groups of figures in public settings. Complex and highly colourful sculptures disporting themselves in airport departure lounges, leisure centres and the like. 'Art as an accompaniment to everyday life', Leger said; if you can imagine a three dimensional version of his painting *Les loisirs*, that's the sort of thing I have in mind (*Festival Sculpture*, 1984: 30).

Condition: At an initial examination in October 1993 extensive damage was noted: the glass reinforced polyester on all three figures was covered with cracks. The woman was most heavily vandalized: a large hole had been made in her bottom, a smaller one on her right side, and there were deep lateral cracks at her left elbow, across the back of her left hand and at the joint of the thumb of her right hand. Two large areas of graffiti on her back had been crudely painted over. Furthermore, the railings, onto which the figures had been originally cast, were crudely sawn into their separate sections and then tack-welded to the fixed railings at their subsequent relocations; the woman's ankles being, in addition, tied to the present fixed railings with wires. At a second visit to the site in March 1994, it was noted that the group had suffered more damage: the right hand of the woman and the pointing index finger of the girl had been broken off and were missing; there were fresh areas of surface damage to all figures; and the figure of the woman had been tipped forwards, the wire securing the ankles having been broken. The group has since been removed and placed in store.

Related works: *Maquette for 'Wish You Were Here'*, poured resin, 22" × 29¹/₂" × 19¹/₂" (56 × 75.5 × 50cms), signed and dated 'John Clinch 83', WAG, cat. 10522 (purchased from the artist); *Head of C-D*, fibreglass, 1984, WAG, cat. 10521 (purchased from artist; preparatory study for standing male figure).

Selected for the site by Alister Warman, '*Wish You Were Here*' cost £18,500 (Meecham, 1991: 20). The maquette (WAG) shows that the group was originally to have consisted of four figures: the fourth being a black boy leaning backwards, both feet on the bottom rail and holding onto the railings with one hand. The pose was natural and worked well in the overall composition but, as Timothy Stevens had pointed out to the artist, it rendered the figure extremely vulnerable to vandalism (referred to in correspondence dated 15 December 1984, from Clinch to Stevens: WAG archives). Clinch tried to resolve the problem but, in leaving this figure till last, ran out of time and had to compromise by having only three figures. The short deadline is referred to several times by Clinch in correspondence relating to the commission (WAG

archives), starting with his initial proposal to the Festival Committee (18 April 1983) in which he expresses his keenness to secure their approval and commence work.

The three remaining figures also underwent changes from the maquette: the woman retained her pose, but her summer dress was substituted for a 1950s style swimsuit; the adolescent girl seated on the railings pointing had her frock substituted for a tee shirt, shorts and baseball cap; and the man had his cigarette substituted for a beer can. According to Meecham, this last alteration was made at the request of the Festival organisers (presumably considering a beer can less contentious), although Sue Grayson-Ford's suggestion that the man should be represented holding a can of Guinness and wearing a Guinness tee shirt in order to earn advertising revenue, was not taken up by the sculptor (Meecham, 1991: 21).

The sculpture was originally sited on the riverside walk, overlooking the Mersey. At the close of the Festival, however, this area lay outside the reduced park site and so the group was removed to the relative security of the enclosure. Clinch had himself suggested such a measure in his initial proposal, so the fact that he was not consulted about the relocation was not in itself a problem – what did give him cause for complaint was the repositioning of the figures. Furthermore, the figure of the girl had been damaged and Clinch was uncertain whether this had been inflicted by vandals, or accidentally sustained during the course of removal. Nevertheless, Clinch repainted the figure and redid the railing mounting at his own expense (correspondence dated 20 January 1987, from Clinch to Stevens, WAG archives).

The figures, as they appear in the finished work, are more obviously derived from 1950s 'saucy' postcard cartoons of working class day trippers than in the maquette; it was this 'sauciness', and the accessibility of the over life-size figures, that presumably invited vandalism even within the park, and the group was soon placed in store 'for its own protection' (Meecham, p. 20). The three figures were then at some later period restored and again relocated in an even more brutalised rearrangement, outside the amusement dome on the walkway across the pond. By March 1994, however, they had suffered such destructive vandalism that they were again removed to store. Clinch had been aware from the start that without adequate protection, the medium, glass reinforced polyester, would be liable to damage and had hoped for approval to use bronze; his £33,500 estimate for bronze, however, being almost twice the £18,500 estimated for glass reinforced polyester, may have had some bearing on the Festival Committee's decision (WAG archives: Clinch's initial proposal to the Festival Gardens Sculpture Committee, dated 18 April 1983).

At the time of writing, the sculpture's future is uncertain. Festival Park in its present usage as a theme park is an unsuitable location for such a vulnerable work and a proposal to locate the group at the Albert Dock – the prospect of which delighted the sculptor – seems to have come to nothing (correspondence dated 20 January 1987, Clinch to Stevens, WAG archives). Furthermore, only major restoration will return the sculpture to an acceptable state.

Literature: (i) WAG archives (a) Clinch's initial proposal dated 18 April 1983, to the Festival Gardens Sculpture Committee; (b) correspondence from Clinch to William Gillespie and partners, landscape architects to the Festival Gardens; correspondence from Clinch to Timothy Stevens; correspondence from Stevens to Clinch.
(ii) Curtis, P., 'Liverpool Garden Festival and its Sculpture', in P. Curtis (ed.) (1989): 114; *Festival Sculpture* (1984): 14, 30; Meecham, P. (1991): 20-1.

PURCHASED WORK

Three Bronze Deckchairs

Sculptor: Kevin Atherton

Sculpture in bronze, 1983

Life-size

Purchased for the International Garden Festival 1984

Owner: Merseyside Development Corporation
Status: not listed

Condition: Each chair has sustained damage. Two have single breaks on the top rail. The third chair has two breaks on the top rail and a broken diagonal rail. All need cleaning.

The *Three Bronze Deckchairs* were made by Atherton in 1983 for *The Sculpture Show* at Kensington Gardens and selected for the Festival Gardens by Timothy Stevens at a cost of £2,200 (Meecham, 1991: 31). The intention was to give them a 'permanent siting on the Mersey frontage where they [were to] have established an interesting relationship between themselves and the distant views'. Atherton wanted them to be used as real deckchairs, the deliberate contradiction being that these deckchairs in bronze, 'a precious metal', could be sat upon free of charge, whilst their wood and canvas counterparts invariably had to be hired (*Festival Sculpture*, 1984: 29).

Notwithstanding the intended permanence of their site, the *Deckchairs* have been moved several times and now are in store: recurrent vandalisation has made their status as usable objects unpractical, and thus they are unlikely to return to their original riverside location.

Literature: Meecham, P. (1991): 31-2.

FROM THE SCULPTURE ZOO

When it was first agreed that sculpture should be included in the Garden Festival, only one small area was set aside for its display. Before Grayson-Ford managed to secure agreement to have the sculptures erected throughout the site, she had tried to make the most of this severe limitation by creating a 'Sculpture Zoo', containing only sculptures based on animals which would, under the umbrella of such a theme, not appear as cramped as would a collection of totally disparate sculptures (Curtis, 1989: 112, 113).

Dragon [illustration below left]

Jane Ackroyd

Sculpture in steel, painted, 1984

Sponsored by the Henry Moore Foundation

Owner: Merseyside Development Corporation
Status: not listed

The Dragon has been re-located to the edge of the pond by the *Blue Peter Ship*.

Ackroyd states:

The Dragon was inspired by a Chinese legend. The Emperor of China commissioned a painting of a dragon for the largest wall of the palace. When this was completed it was discovered that the painter had not depicted eyes. The Emperor insisted that the eyes should be painted. Against his will the painter added the eyes... and the dragon flew away! So as you may have guessed, I've left the eyes out (*Festival Sculpture*, 1984: 29).

Condition: Generally in reasonable condition, though there are some small patches of rust. In 1992 MDC restored the piece on site, using shot-blasting treatment to remove surface scaling. The piece was then re-painted in an approximation of the original colour scheme.

The village green was presented by Sir Andrew Barclay Walker to the people of Gateacre (his birthplace) as a memorial of Queen Victoria's Golden Jubilee in 1887 and was restored for the Silver Jubilee of Queen Elizabeth II in 1977. At the east side of the green, beneath some trees:

Monument to Queen Victoria.

Sculptor: Count Victor Gleichen

Bust in bronze
Pedestal in red granite

Bust: h: 39" (99cms); w: 29" (73.7cms); d: 21" (53.3cms)
Pedestal: h: 62" (157.4cms)

Inscriptions:
– on the front face of the pedestal below the crown: VI *(monogram)*;
– below which, the date: 1887 *(note: the 7 is a recent replacement.)*
– on an inscription plaque on the rear face of the pedestal: THIS MONUMENT / AND / VILLAGE GREEN, / WERE PRESENTED / AS A MEMORIAL OF / THE JUBILEE / OF / VICTORIA, / QUEEN / OF GREAT BRITAIN / AND IRELAND, / EMPRESS OF INDIA; / BY / SIR ANDREW BARCLAY / WALKER, BART., / HIGH SHERIFF / OF LANCASHIRE, / 1886-7.

Signed and dated on the rear of the bust:
Gleichen. / 1887. fecit *(in script)*

Owner/custodian: Liverpool City Council
Listed status: Grade II

Description: At each corner of the red granite pedestal is a bronze-based colonnette with a

lotus capital. Affixed to the front face of the pedestal are, from top to bottom: a crown, an interwoven 'V' and 'I' (Victoria's monogram), and '1887', (the date of Victoria's jubilee year). Inset into the rear face of the pedestal is the inscription plaque. The lower edge of the bust is masked by a framing of two laurel sprays. Victoria is crowned and wears decorations on her left breast.

Condition: The righthand rear colonnette of the pedestal has a large chunk missing about one-third of the way up, and there are smaller chips out of the cornice on all sides. The bust itself

appears to be in good condition.

Version in marble: *Bust of Queen Victoria,* signed and dated 1888, London, Victoria and Albert Museum (cat. A.16-1963).

Related work: *Bust of Queen Victoria,* marble, h. 36" (91.4cms), National Museums and Galleries on Merseyside, WAG cat. 4171 (shown at the WAG Liverpool Autumn Exhibition 1876, cat. 1114).

Sir Andrew Barclay Walker also commissioned from Count Gleichen a *Statue of the Duke of Albany,* Queen Victoria's recently deceased youngest son, which he donated to the then University College of Liverpool (see below, pp. 224–25).

Literature: *Art-Journal* (1886): 350.

At the western edge of the green is a *gazebo* which once housed the now lost *Memorial Fountain to John Hays Wilson.*

Memorial Gazebo to John Hays Wilson

Gazebo in Sandstone

Inscription on the string course between the arches and the attic storey: ERECTED BY THE PEOPLE OF GATEACRE IN MEMORY OF JOHN H WILSON 1883

Status: not listed

Description: The gazebo is octagonal with a pavilion roof containing a dovecote. There is relief carving in the spandrels of the arches and in the attic course above. The spandrels of the

arches are carved with grotesque animals. The attic course reliefs are more varied: on the SE face is a Liver Bird crest; on the W and N faces are double-tailed mermaids, one blowing a double horn, one playing cymbals; and on the S, NW and NE faces are grotesque heads, variously poking out a tongue, smiling and with mouth agape. From the NNW corner projects one outsized gargoyle carved in the form of a leaping dog.

Condition: The gazebo has some graffiti on the pillars of the arches. The right elbow of the horn-blowing mermaid is missing and there is some damage to the horn in the left hand. Otherwise the condition is relatively good.

John Hays Wilson lived locally at Lee Hall and was, until his death, Chairman of the Liverpool Corporation Water Committee, hence the fountain and its mermaid decorations. In his official capacity, he was instrumental in securing a constant supply of fresh water for Liverpool, from the creation of the Lake Virnwy reservoir in Wales (Picton, 1875, revised edn 1903, ii, 551-62). He further endeared himself to the people of Gateacre in particular by opening for their enjoyment, the grounds and gardens of his house and establishing there from 1881 the Tarbock Races (Richardson, 1990: 49).

Literature: Picton, J. A. (1875, revised edn 1903), ii: 551-62; Richardson, A. (1990): 49-50.

George's Dockway GEORGE'S DOCK BUILDING. See Pier Head

George's Pierhead

MERSEY DOCKS AND HARBOUR BUILDING, ROYAL LIVER BUILDING, *Memorial to Sir Alfred Lewis Jones*, *Equestrian Monument to King Edward VII*, *Cunard War Memorial*. See Pier Head

Grange Lane

In GATEACRE COMPREHENSIVE SCHOOL:

Boy seated by a Pool

Sculptor: Stanley Sydney Smith English

Statue in stone, *c*.1959-62

h. (including base, but excluding head, now lost): 38³/₄" (98.5cm)

Owner: Liverpool City Council Educational Directorate
Status: not listed

Description: The sculpture is located on the edge of a rose bed, formerly an ornamental pool, in a quadrangle between the entrance foyer and the boy's gymnasium. It represents a seated boy, leaning forward, with arms folded, his left hand flat against his right upper arm just above the elbow, his right hand resting against the inside of his left knee. He is naked but for a large towel draped across his lap and reaching down to his ankles.

Condition: The statue has been decapitated and the remaining surfaces appear weathered.

Gateacre Comprehensive School was opened in 1958. Intended originally as a secondary modern school for girls, boys were also admitted pending the building of a secondary modern school for boys. It was decided, however, to make Gateacre the first of Liverpool's comprehensive schools. This necessitated a major re-building programme which lasted from 1959-62. *Boy Seated by a Pool* was executed specifically for the newly-expanded school, though the pool it once decorated has since been filled in and converted into a rose bed.

Note: According to Willett (1967: 93), Stanley English executed a 'rather forlorn small figure... standing in a pool' for Springfield Park Comprehensive School. Springfield Park Comprehensive is now Thingwall Special School (according to Liverpool City Council Educational Directorate) and it has not been possible to trace the figure referred to by Willett. The present author assumes that, notwithstanding the differences in description and location, Willett's and the present figure, both by English, are one and the same.

Great Howard Street

RAILWAY BRIDGE (dismantled in July 1977), across Gt Howard St, between Blackstone Boundary and Boundary St.

Formerly affixed to the south side of the bridge parapet:

Plaque and Bust to William Stuart
Liverpool merchant. A director and, from June 1849 until his retirement in August 1859, Deputy-Chairman of the Lancashire and Yorkshire Railway.

Sculptor: Edward Davis

Plaque and inset bust in bronze

h. of bust: *c.* 36" (91.4cms)
h. of pedestal: *c.* 24" (61cms)

Inscriptions:
– within the small upper laurel wreath: 1855
– within the main laurel wreath, below the bust: WILLIAM STUART
and below the coat-of-arms: SPERO MELORA

Bust signed: E DAVIS / SCULP

Exhibited: Royal Academy of Arts 1856 (cat. 1302), as *William Stuart, Esq.; model for bronze bust for Great Howard Street, Liverpool.*

Owner: The National Museum of Science & Industry. (The bust is now in the collection of

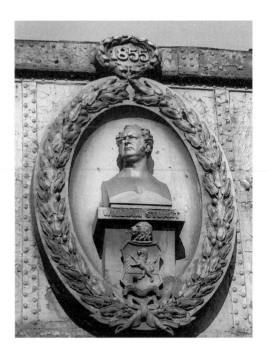

the National Railway Museum, York).
Status: not listed

Description: In its original position on the parapet of the bridge the bust was mounted upon a square plinth. Below the plinth was a shield bearing a rampant lion and, on the upper edge of the shield, a lion's head in profile. At the lower edge of the shield was a scroll with the Latin inscription: 'Spero meliora' (*I hope for better things*). All was contained within an oval-shaped laurel wreath, surmounted by a smaller laurel wreath enclosing the date, 1855.

Condition: The 1976 WAG JCS sculpture survey noted that the bust had been cleaned at the time of its separation from the surround.

The railway line which passed over the bridge was officially opened on 26 March 1855 and the bridge was finally dismantled following the line's closure in July 1977, whereupon the plaque was removed from the southern parapet. According to Marshall (1969: 145), there was a similar plaque (presumed lost) on the northern parapet which was probably removed during the 1881-83 widening of the bridge.

Literature: Marshall, J. (1969) i: 145.

Hardman Street

Merseyside Welfare Rights Centre, formerly the LIVERPOOL SCHOOL FOR THE BLIND, 24 Hardman Street, at the corner of Hope Street. In 1931-32, Anthony Minoprio and Hugh G.C. Spencely erected an extension to A.H. Holme's School for the Blind of 1850-1 (Royden, 1991: 175).

Main building listed status: Grade II

The five bays of the extension in Hardman Street and the first bay in Hope Street are decorated, above the windows and main entrance, with sculptural reliefs.

Sculptor: John Skeaping

High reliefs in Portland stone

Each relief: h: 27" (68.58cms); w: 12" (30.48cms)

Listed status: not known

Description: According to the *Architect and Building News* (7 October 1932: 9), 'the subjects relate to the life and work of the school'. The relief above the window in the first bay in Hope Street represents balls of wool and a pair of crossed knitting needles. The reliefs in Hardman Street represent, from left to right, brushes; hands reading the pages of a braille book; a half-made wicker basket (i.e. above the main entrance); hands playing the keys of a piano; and lastly, at extreme right, brushes (a variant of the brushes relief at the other end of the Hardman Street frontage).

Condition: All six high reliefs appear to be in good condition.

Related works: The main entrance on Hardman Street and the smaller side entrance on Hope Street originally had sculptured bronze doors. The doors were removed when the school vacated this building and have been re-erected inside its new premises at Church Road North (see separate entry, above, p. 21). The stone lintel of the Hope Street doorway bears the inscription (composed by the Revd Dr Allen Brockington): CHRIST HEALS THE BLIND / FOR WHO DENIES / THAT IN THE MIND / DWELL TRUER SIGHT / AND CLEARER LIGHT / THAN IN THE EYES?

Literature: *Architect and Building News* (1932) 7 October: 9; Pevsner, N. (1969): 182; Royden, M. (1991): 175.

Hatton Garden

CITY TRANSPORT OFFICES, 1905-7, by Thomas Shelmerdine, Corporation Surveyor.

Seated on ledges on either side of the first floor bay windows: two pairs of **Allegorical Figures**.

Sculptor: unknown

Figures in Portland stone

Owner of building: Merseyside Passenger Transport Executive
Listed status: Grade II

Description: The pair of figures either side of the lefthand bay window represent *Water Power* and *Shipping*. To the left of the window, facing left, *Water Power* is represented as a seated woman, wearing a loose sleeveless gown and a headdress secured by a headband, her right hand resting upon a water wheel. To the right of the window, facing right, *Shipping* is a seated female nude. A swathe of drapery, like a wind-filled sail, arcs over her head and is held at one end by her right hand, its other end being concealed by a model of a galleon, upon which the figure rests her left arm.

The figures either side of the righthand bay window represent *Industry* and *Electrical*

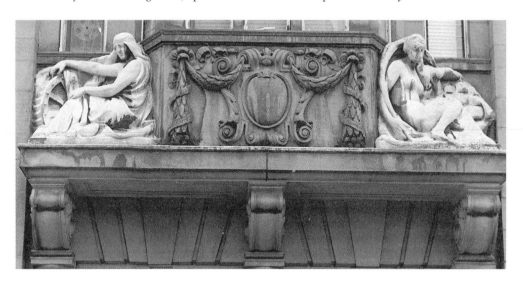

Power. To the left of the window, facing left, *Industry* is a seated woman, resting her right hand upon a large cog-wheel by her feet; her drapery billowing out around behind her forming a shell shape. To the right of the window, facing right, *Electrical Power* is also encircled by billowing drapery. In her right hand are lightning flashes and thunder bolts; at her feet is an electrical coil and an eagle raising its wings (source for allegorical identifications: WAG JCS files)

Condition: All figures are very weathered with black encrustation on all undersurfaces and in crevices. There are also major losses: the right forearm of *Shipping* is missing and the face is crumbling; both hands of *Industry* are missing and the face has crumbled away entirely; *Electrical Power* is missing the left hand, whilst the right hand and face are very eroded. Only *Water Power* appears to be intact, although that is also very weathered.

High Street

TOWN HALL, designed and built by John Wood the Younger of Bath in 1748-55 as a nine-bay square block. James Wyatt designed, and John Foster Senior built, the less ornately carved northern extension in 1789-92. Also added at this time was a pedimented three-bay centre to the western frontage to match Woods' central bay on the eastern frontage. The building was gutted by fire in 1795. Retaining the original exterior, Wyatt and Foster reconstructed the interior and added the present dome (1802) and south portico (1811) (Picton, 1875, revised edn 1903, ii: 28-32).

Owner of building: Liverpool City Council
Listed status: Grade I

Crowning the summit of the dome:

Statue of Britannia / Minerva

Sculptor: John Charles Felix Rossi

Statue in Coade stone, 1801-02

h: 15' (4.6m)

Description: A seated female figure, classically draped, wearing a Greek helmet and holding a long spear in her left hand. The figure is mounted upon a pedestal which has a scallop shell against each face and a dolphin at each corner. Draped across the backs of the dolphins are festoons which are suspended from the cornice of the pedestal above each of the scallop shells.

The *Daily Post* (11 May 1937) quotes the following Council minute from November 1792:

> It is ordered that the figure of Britannia designed for the domination of the intended Dome of the Exchange [i.e. Town Hall] be contracted for with Mr. Westmacott, engaging that it shall be a 12 ft figure executed in a masterly manner in antique green bronze according to the design and to the entire satisfaction of Mr. Wyatt. (from a typed transcription in the WAG JCS files)

The sculptor referred to here must be Richard Westmacott the Elder (1747 – 1808), who sometimes worked with the architect James Wyatt, executing statues to the latter's designs (Gunnis, 1951: 423). Picton (1875, revised edn 1903, ii: 30) records that 'on Sunday, July 24, 1795, the whole interior was destroyed by fire...The present dome and cupola were added about the year 1802'. As he does not mention the Westmacott statue, it is uncertain whether it was by then completed and *in situ*, and therefore lost in the fire. In any event, following the completion of the new dome, a different sculptor, J.C.F. Rossi, was entrusted with the commission, as is attested by the Treasurer's accounts covering the period 18 April 1800 to 11 December 1802:

18 April 1800 Remitted C. Rossi on acct. of figure £100.
17 January 1801 Pd. freight of figure for Dome £13.12s.1d.
2 April 1801 Pd. Chas. Rossi on acct. of figure £100.
15 July 1801 Pd. Insurance of figure for Dome £18. 4s. 6d.
18 December 1801 Pd. C. Rossi on acct. of figure £5.

11 December 1802 Remitted C. Rossi balance of his account for the figure for the Dome £224.5s.4d.

(as transcribed in WAG JCS files)

Although the Treasurer's account book is unspecific as to the identity of the 'figure for the dome', all the other known early sources refer to her as *Britannia* (the Council minutes for 1792; *The Monthly Magazine*, 1799; and *The Art-Union*, 1839). And yet, presumably because she does not bear all the traditional iconographical attributes associated with *Britannia* (she has neither trident nor shield), more recent sources (e.g. correspondence published in the *Mercury*, 16 April 1902; an article in the *Express*, 12 March 1917) refer to her as *Minerva*. Unfortunately she also lacks some of *Minerva*'s more conclusive attributes, such as her breastplate, her aegis, and her owl, and the *Express* does not give any reason, nor reveal any source for the change of identification. Therefore, it seems reasonable to retain the original identification of the statue as *Britannia*.

Although *The Monthly Magazine* (1799, ii: 904) simply refers to *Britannia*'s material as 'artificial stone', the strongest likelihood is that it is actually Coade stone, an artificial cast stone manufactured and marketed by Eleanor Coade's firm in Lambeth, south London. Alison Kelly (1990: 360) states that it is listed in the *Coade's Gallery Handbook*, published in 1799, although the present author has been unable to find specific reference either to *Britannia/Minerva* or to the Liverpool Exchange/Town Hall in the copy at the British Library. Nevertheless, Rossi did work as a modeller of designs for the firm of Coade in the earlier part of his career (Gunnis, 1951: 326) and even though he later formulated his own type of artificial stone intended to 'rival in firmness

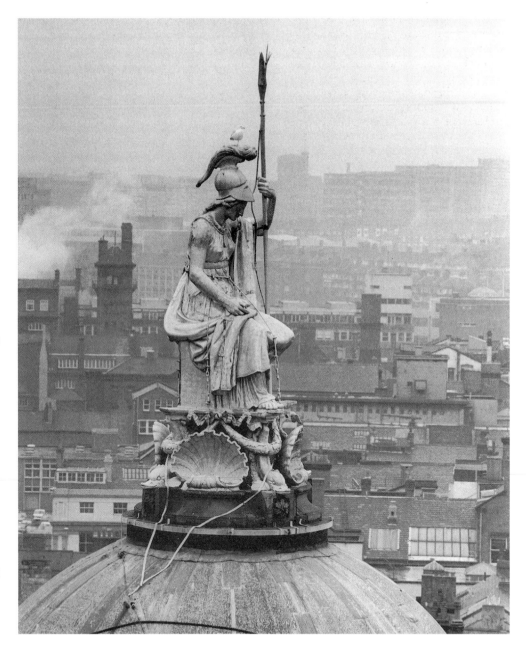

and durability the same description of material of the ancients' (*Gentlemen's Magazine*, 1827, ii: 395), his first commercial venture with it in partnership with James George Bubb was not until 1818, for the London Customs House, and the poor initial results (*New Monthly Magazine*, 1818: 154) would tend to suggest that he was at that time still perfecting the manufacturing process. Thus, it seems safe to assume that the artificial stone used for Rossi's 1799 figure – which appears to have lasted as well as Mrs Coade's advertisements promised it would – was indeed Coade stone.

Literature: (i) WAG JCS files: typed summaries and short extracts relating to LRO material, including newscuttings: *Daily Post* (1937) 11 May, in *LTH*: 53; *Express* (1917) 12 March, in *LTH*: 5; *Treasurer's accounts* (LRO reference not given).
(ii) *Art-Union* (1839) i: 22; *Gentlemen's Magazine* (1827) ii: 395; Gunnis, R. (1951): 326, 328, 423; Kelly, A. (1990): 68, 77, 127, 133, 360; *Monthly Magazine* (1799): 904; Pevsner, N. (1969): 160; Picton, J.A. (1875, revised edn 1903), ii: 30.

Four stone figures on the parapet above the Exchange Flags portico

The *Express* (12 March 1917) states: 'In 1792 four sculptured figures, by Westmacott, representing the seasons, at a cost of 105 guineas each, were placed on the north façade...' (as transcribed in WAG JCS files). According to Whitty, however, the statues on the parapet represent: 'the four quarters of the globe [and were] said to have been purchased by the Town Council when the Parliament House in Dublin was converted to the uses of the Bank of England' (1871: 29).

Pevsner makes the same claim, but with more certainty (1969: 160), although his source is not given and he may merely be following

Whitty. Richard Westmacott the Elder did sometimes execute statues to Wyatt's designs, however, and he had already been contracted in 1792 to execute a statue of *Britannia* for the original dome (see above, p. 72), so the attribution to him of the four parapet statues is not unreasonable.

Condition: Very weathered with black encrustations on under surfaces.

Literature: *Express* (1917) 12 March: 5; Pevsner, N. (1969): 160; Whitty (1871): 29.

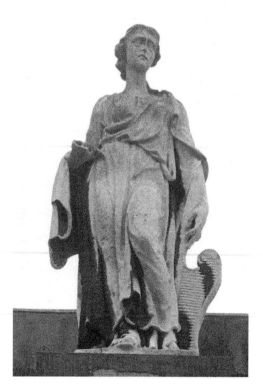

Bas-relief on the original pediment (see below, 'Lost Works', p. 302).

Carved frieze at the level of the Corinthian capitals of the giant order of pilasters on the original nine bay block.

Description: The composition of the frieze, interrupted by the pilaster capitals, is determined by the triadic organisation of the bays on each of the nine-bay faces of the building. The central triad of bays breaks forward under a pediment and the central strip of frieze of each triad is generally emphasized with a full-faced carved head. The bays on the High Street and Dale Street faces show exotic 'foreigners' in plumed headdresses and turbans, flanked by the equally exotic animals of their lands: African elephant, bison, crocodile, camel, lion etc. On the Exchange Street West face the lefthand bay shows a lion's head with sprays of oak, symbolic of England, flanked by military trophies; the central bay shows Neptune as god of navigation, flanked by cherubs carrying cornucopiae and riding hippocampi; and the righthand bay shows Mercury as god of commerce flanked by anchors, ropes, barrels and bales of cotton. The themes treated in the frieze are those one would expect from the Exchange Building (the Town Hall's original designation) of a major English port, the wealth of which depended upon colonial power and maritime commerce.

Condition: The frieze appears to be in relatively good condition, although grimy and splattered with bird droppings.

The Corporation Treasurer's accounts record payments, possibly relating to the execution of the frieze, amounting to £60 and £35 respec-

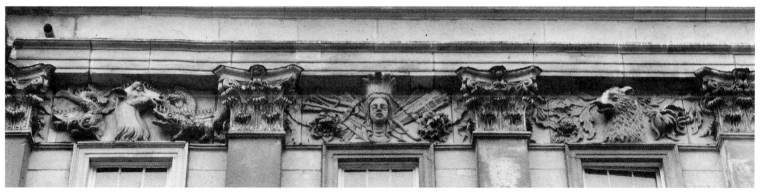

tively, to Wm. Mercer, carver, and Ed. Rigby, carver, for the period 31 July 1753 to 8 March 1754.

Literature: LRO – *LTH*, i: 5, 6, 8; *Treasurer's Ledger*, 1/1/3.

Inside the Town Hall, on the first landing of the main staircase (access only by prior arrangement):

Statue of George Canning

(1770-1827), statesman. Originally a Whig, he supported Pitt's policies during the French Revolution and became a Tory, enjoying a number of important posts under various administrations. He was Foreign Secretary in 1807-09 and 1822-27 and, for the last five months of his life in 1827, Prime Minister. From 1812-22 he had been M.P. for Liverpool, transferring his seat to Harwich when he became Foreign Secretary (source: *DNB*).

Sculptor: (Sir) Francis Legatt Chantrey

Statue and pedestal in marble

Statue: h: 94" (238.8 cms); w: 28" (71.1 cms); d: 33" (83.8 cms)
Pedestal: h: 42" (106.7 cms)

Inscribed on the front face of the circular base:
RT. HONBLE. GEORGE CANNING, M.P. 1770-1827
– and on the page edges of the upper of the two books behind Canning's feet:
GEORGE CANNING
Signed and dated on the page edges of the lower of the two books behind Canning's feet:
CHANTREY, / SCULPTOR, 1832.

Exhibited: Royal Academy of Arts 1832 (cat. 1171), as *Statue, in marble, of the Right Hon. George Canning. Executed, by subscription, for his friends and admirers in Liverpool, and to be erected in the Town Hall.*

Unveiled to the public at Liverpool Town Hall, on the first landing of the main staircase on Friday, 28 September 1832.

Owner: National Museums and Galleries on Merseyside (cat. 8228), transferred from the City Estates, 1972.
Listed status: as for building

Description: Canning is represented as a semi-classical standing figure in a long cloak and knee-breeches, looking to his left. His weight is borne on his right leg; his left leg is placed slightly forward with the foot protruding over

the front edge of the circular base. Two books, partly hidden by the folds of the cloak, rest on the floor behind the feet. His arms are folded across his body to gather up the folds of the cloak; his right hand holds a scroll.

Condition: Good, although rather grimy.

Related works: Pencil *camera lucida* drawing of the head, National Portrait Gallery, London (cat. 316a); plaster model from this, Ashmolean Museum, Oxford (cat. 533/21). The model for the head of the present statue is the portrait bust of 1818 – 19 (commissioned by John Bolton for Liverpool but now in the Palace of Westminster) though without the incised treatment of the eyes.

Other versions: (i) marble, 1829-34, Westminster Abbey. There are some variations in the drapery, and the books at Canning's feet are differently placed. (ii) marble, 1834, untraced. Yarrington (1994: 293) suggests that this version, bought by the 2nd Duke of Sutherland at a reduced price after its rejection by Chantrey because of an imperfection in the marble of the leg, is probably a copy of the Westminster Abbey version, rather than the earlier Liverpool version.

On 27 August 1827, in response to a petition signed by fifty of Liverpool's most eminent citizens, the Mayor, Thomas Littledale, convened a public meeting at the Town Hall to discuss how best to commemorate the late George Canning and to express the people of Liverpool's gratitude for his work as their Member of Parliament, as well as their pride in his national achievement (for a full study of this commission in its immediate context, see Yarrington, 1989: 27-30). It was decided that a monument should be erected and a public subscription launched to pay for it. A Committee of fifty-one members (including the Mayor) was formed to organise the subscription and receive all contributions. It was empowered to make only recommendations as to the specific form and location of the monument, the actual decisions to be determined by the cast votes of all the subscribers (*Canning...Minutes*: 1-6).

The following day the Committee elected Littledale as Chairman and made arrangements to canvass subscriptions. By 16 October 1827, the unwieldy group of fifty-one had designated itself the General Committee and elected an Executive Sub-Committee 'to consider plans and designs and to report thereon to the General Committee' (*Canning...Minutes*: 11). On 8 November, the Sub-Committee made its recommendation that the statue should be of bronze (*Canning...Minutes*: 12, cited in Yarrington, 1989: 28) and two days later, Committee-member John Foster Jnr wrote to Francis Chantrey, the most celebrated English portrait sculptor of the time, asking whether he was willing to undertake the commission. Foster advised the sculptor that the Committee expected to be able to amass £4,000 for both statue and pedestal and needed to know in addition whether he could cast the statue himself and how long it would take (*Canning...Minutes*:

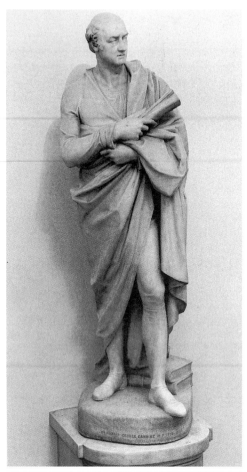

14). The fact that there was already in Liverpool a marble bust of Canning by Chantrey, commissioned in 1818 by Committee-member John Bolton, may also have informed the Committee's choice (*Canning...Minutes*: 13; Yarrington, 1989: 28).

Foster's letter was received by Allan Cunningham, Chantrey's secretary and foreman who, in his master's absence, wrote that

Chantrey would undoubtedly be delighted to take on the commission: he had been personally acquainted with Canning, had full-length paintings of him 'by first rate artists' and also was in the process of 'erecting furnaces', at which (Cunningham shrewdly added), he was about to cast bronzes of the King, Mr Pitt and Mr Watt (*Canning...Minutes*: 13, cited in Yarrington, 1989: 29). On 24 November 1827, Chantrey wrote to Foster to confirm his interest in the commission and undertook to complete the statue within three years of the date of the agreement. He declared, however, that before he could formulate a design for the statue he would have to make himself familiar with the proposed location and advised the Committee to bear in mind that any outdoor statue, in order to achieve its full effect 'ought to look towards the south or south west so that the likeness may be aided by the light of the sun' (*Canning...Minutes*: 14-15, quoted in Yarrington, 1989: 29).

Having thus established that Chantrey was interested, Foster, on the Committee's instructions, wrote to him again on 6 December 1827, rather tactlessly enquiring whether he would be willing to participate in a competition with other sculptors or, should the commission be 'given to [him] without competition [whether he] would make various designs or such alterations in the first as would meet the approbation of the Committee'. Chantrey flatly refused to participate in a competition, but assured the Committee that it was in any case his professional practice to produce not one but several alternative designs and that he was willing to make any reasonable alterations requested of him. He also reminded the members that no other sculptor enjoyed the advantage of having modelled Canning from life *Canning...Minutes*: 17-18, quoted in Yarrington, 1989: 29).

On 16 January 1828, the Committee called a meeting of all subscribers and Committee-member John Gladstone (who had been Canning's principal supporter and confidant in Liverpool) read a speech advising them of the current position. The subscription, he informed them, had reached just over £3,500. This was somewhat short of the £4,000 Foster had originally suggested to Chantrey would be ultimately available and provides a possible reason for the Committee's belated consideration of holding a competition – in which presumably a young sculptor, eager for recognition, might be engaged less expensively. Whatever the case, £3,000 had by now been invested with the Dock Trustees, 'to be vested in Dock Bonds…at the rate of four per cent per annum' and the Committee clearly still hoped that the necessary amount would be reached by the time of the completion of the work. Thus, in the light of Chantrey's known qualities and the corresponding uncertainties attendant upon engaging a possibly untried competition winner, Gladstone strongly recommended engaging him. He also proposed St George's Crescent, at the head of Lord Street, as the only really satisfactory location for the statue. The subscribers approved both recommendations and a new Executive Sub-Committee of twenty-five was appointed to supervise the commission. (*Canning…Minutes*: 21-23, cited in Yarrington, 1989: 29).

Gladstone makes it clear in his speech that Chantrey was the Committee's first choice for the commission. (Sir) Richard Westmacott had also been approached by Foster at the same time as Chantrey, but evidently only as a founder, should the necessity arise (*Canning …Minutes*: 15). On 23 January 1828, John Gibson requested that he be considered, but by that time Chantrey's engagement was official

(*Canning…Minutes*: 25-26).

On 1 April 1828, a Committee meeting was held with Chantrey in attendance, during which was accepted a recommendation from Thomas Colley Porter, (the new Mayor), that marble, rather than bronze, would be better 'calculated to display [Chantrey's] unrivalled genius and talents' (*Canning …Minutes*: 18-29). By this time it had been accepted that the necessary £4,000 would not be reached and it is clear that marble had in reality been considered solely because it was a less expensive medium (Yarrington, 1989: 29). On 12 April, the subscribers approved the recommendation and Littledale wrote to Chantrey with the good news (*Canning …Minutes*: 32). On 21 April, the sculptor replied, expressing his great satisfaction at the decision and confessing that 'in [marble] I can much better express the sentiment I wish to embody, and give form to those recollections of character impressed on my mind by personal acquaintance' (*Canning …Minutes*: 34, quoted in Yarrington, 1989: 29). Having agreed to change to the less durable medium of marble, the Committee next sought a suitable indoor location and on 28 August, the first landing of the principal staircase of the Town Hall was proposed (*Canning …Minutes*: 35).

At the general meeting of subscribers, held on 8 September 1828 to ratify these suggestions, however, John Gladstone proposed that the change to marble was ill-advised and that they should return to the original idea of a bronze statue in the open air at St George's Crescent. Gladstone had previously circulated a letter to all subscribers telling them that Chantrey was still prepared to work in bronze should the subscribers so wish it, implying that the sculptor had himself recommended the change to marble solely in order to avoid the labour

involved in casting bronze. The subscribers, unhappily for Porter, Littledale and Foster, fully backed Gladstone's proposal (*Canning …Minutes*: 36-37; Yarrington, 1989: 29).

Chantrey was advised of the turn of events by Littledale on 15 September 1828 and received a copy of Gladstone's circular. He dispatched an indignant reply to Littledale on 26 September in which he denied being 'influenced by any sordid motive' to short-change the subscribers. He explained:

It is indeed infinitely less trouble to an Artist to make a figure in bronze than in Marble, inasmuch as when the Model for the Bronze is completed, his own labours are comparatively at an end which is not the case when they are to be employed upon Marble. – If he does justice to his work, his chisel must pass over all the important parts, and to the last day that it remains in his possession he finds employment both for his head and his hands (*Canning …Minutes*: 43, quoted in Yarrington, 1989: 29-30).

As a consequence of Gladstone's circular, any possibility of favourable pricing terms from Chantrey was lost and the sculptor instead implemented his regular scale of charges. The Committee was dismayed to discover that the lowest price for a bronze statue – £3,700 for one eight feet high (*Canning …Minutes*: 44) – was beyond their means. Just £3,650 had been subscribed, and incidental costs, including the excavation of the foundations, had also to be covered (*Canning …Minutes*: 47). On 27 October, Littledale wrote to Chantrey asking for an explanation of the scale of prices (*Canning …Minutes*: 48-50). In his letter of 12 November, Chantrey justified his scale of prices which, he declared, fairly reflected the prevailing market. He also referred again to

how he had been 'deeply hurt' by Gladstone's unwarranted circular. Yet despite this, he was prepared to offer the Committee a concession, as a gesture of his good intentions and to show that it was not the money that mattered to him. He would, in this one instance, reduce his £3,700 price by £100 to accommodate the limited funds of the Committee. His letter ended with a postscript requesting that he should have no further communications with Gladstone (*Canning...Minutes*: 51-53; Yarrington, 1989: 30).

When the only acceptable outdoor site, St George's Crescent, was turned down by the Council on the grounds that there the monument would cause an obstruction, the Committee was forced to reconsider the possibility of having a marble statue in an indoor location (*Canning ...Minutes*: 55-56). On 10 December 1828, the Secretary of the Liverpool Royal Institution at Colquitt Street wrote to the Committee, offering to house the statue on a temporary basis, should the need arise, and to allow access to subscribers. Littledale wrote to Chantrey on 23 December, informing him of developments and asking his price for a nine foot high statue in marble, telling him that the Committee now wanted to reserve £500 for incidental expenses, including any alterations required to provide a satisfactory environment for the statue (*Canning ...Minutes*: 57-59).

Chantrey replied on 3 January 1829 that he thought a nine foot high figure was unnecessarily large for the sort of setting the Committee had in mind and that anyway such a figure would cost £6,000. He was clearly exasperated at the further reduction of their available funds (i.e. £4,000 in the original commission, £3,650 at their last discussion and now, as he states, £3,100). Nevertheless, he confirmed his willingness to undertake a seven foot high marble figure for 3,000 guineas (to include the cost of making a plain marble pedestal). Before submitting Chantrey's offer to the subscribers, the Committee requested the sculptor's advice 'as to the dimensions of the room in which the statue should be placed' (*Canning ...Minutes*: 60-63). On 20 January 1829, Chantrey wrote in reply that a smaller, rather than a larger room, would be best suited to a portrait statue of such proportions but that, of far greater importance, was the direction and angle of light, which ideally should fall laterally and at an angle of 45°. He referred the Committee to John Foster, with whom he had discussed the ideal lighting conditions on the first landing of the staircase in the Town Hall, which site, at the head of the stairs, had the additional advantage of giving the statue an increased elevation (*Canning ...Minutes*: 64-67).

The subscribers were called together on 4 June 1829 and agreed to a seven foot high marble statue to be temporarily placed in the Liverpool Royal Institution (*Canning ...Minutes*: 79-84). On 6 June, Littledale wrote to Chantrey, requesting him to draw up a draft contract (*Canning ...Minutes*: 84-85). The contract, to take effect from 24 June 1829 ('Midsummer') established that Chantrey would receive his payment in three equal amounts: the first when the agreement was signed, the second when the full-size model was completed, and the final payment when the marble statue and pedestal were completed. At his own cost, Chantrey was to provide the packaging and arrange for shipment from the Port of London. He would also supply a man to superintend the erection of the statue in Liverpool (*Canning ...Minutes*: 87-88).

The statue was finished by 14 January 1832 and Chantrey wrote requesting specific details of the location so that he could have the pedestal made (*Canning ...Minutes*: 88). In a subscribers' meeting on 6 February it was at last agreed that the first landing of the main staircase of the Town Hall would have to suffice, albeit only as the best available temporary measure, pending a more accessible permanent location being found (*Canning ...Minutes*: 90-93). The Council approved the request on 8 March and agreed to the Committee's proposals for viewing the statue, namely that it should be accessible to subscribers and 'strangers' accompanied by a subscriber '(Sundays and Thursdays excepted) between the hours of eleven and four'. The general public were to be allowed access to view the statue for the first two months after erection only, although from no closer than two-thirds of the way up the stairs (*Canning ...Minutes*: 94-96).

On 9 April 1832, the Committee approved Chantrey's request that, prior to the statue's shipment to Liverpool, he be allowed to exhibit it at the Royal Academy Summer Exhibition, on condition that the catalogue should clearly state that they, the subscribers in Liverpool, had commissioned it (*Canning ...Minutes*: 97-98). The statue arrived in Liverpool on the afternoon of 21 September (*Mercury*, 21 September 1832) and was made available for public viewing a week later (*Mercury*, 28 September 1832), though the restricted view allowed to the general public gave the correspondent for the *Mercury* (12 October 1832) some cause for complaint. Chantrey's statue of Canning was unanimously well-received and, at a meeting of the subscribers on 11 March 1833, it was agreed that the residue of the fund should finance a print of the statue for each of the subscribers. Colnaghi's was approached to produce the print, but their prices were not affordable. In the event, Chantrey's offer to supervise the production himself at a lower cost was

accepted. The drawing was executed by Henry Corbould and the engraving (retouched by Chantrey) by Samuel Cousins (*Canning ...Minutes*: 104-05). Indeed, Chantrey's prices were low enough to allow in addition the establishment of Canning Scholarships at the Liverpool Collegiate Institution, Royal Institution, and Mechanic's Institution (*Canning ...Minutes*: 129).

Literature: (i) LRO manuscript source: *Canning Memorial Meeting and Committee Minute Book*. (ii) Holland, J. (1851): 289; Jones, G. (1849): 79, 84, 231-32; *Mercury* (1832) 8 February: 38; *Mercury* (1832) 10 February: 45, 46; *Mercury* (1832) 21 September: 302; *Mercury* (1832) 28 September: 312; *Mercury* (1832) 12 October 1832: 326; Picton, J.A. (1875, revised edn 1903), i: 406; Walker, R. (1985) i: 93; Yarrington, A., 'Public Sculpture and Civic Pride 1800 – 1830', in P. Curtis (ed.) (1989): 27-31; Yarrington, A. et al (1994): 241-42, 293.

Hope Street

FEDERATION HOUSE, designed and built by Gilling, Dod & Partners 1965-66. It houses the headquarters of the Liverpool Building Employers Confederation.

A continuous **Relief Decoration** enfolds the building at first floor level and extends downwards to cover a section of ground floor wall to the right of the main entrance.

Sculptor: William Mitchell

Relief in concrete

Owner of building: National Federation of Building Trade Employees Investments.
Status: not listed

Condition: Generally good, although there are some small losses to the surface in places.

The abstract design has been described by Hughes (1969: 135) as 'neo-Aztec', while Willett (1967: 110) has condemned it rather harshly as 'a humdrum regurgitation of modern art conventions which has no real identity of its own and [which] could date disastrously as soon as the fashion supporting it has collapsed'.

Literature: Davies, P. (1992): 75; Hughes, Q. (1969): 135, 136; Willett, J. (1967): 110-11.

Note: On the building opposite Federation House (A.J. Buckingam Ltd.) is a white-painted keystone above the central doorway with a carved *Head of Prince Albert* (sculptor/ stone-mason unknown).

PHILHARMONIC HALL, designed and built by Herbert J. Rowse 1933-39. The Grand Foyer and auditorium have sculptural decoration.

Owner of building: Royal Liverpool Philharmonic Society
Listed status: Grade II

IN THE GRAND FOYER BAR:
Two wall panels

Sculptor: Edmund C. Thompson

Plaster with gold leaf

Each panel: 15' × 7' 5" (4.6 × 2.3m)

Descriptions:
1. *Apollo being Instructed by Pan.* Pan sits upon a tree stump conducting Apollo's musical efforts, a twig serving as a baton, raised in his right hand. Apollo is seated on the ground at Pan's feet playing pan-pipes.
2. *Apollo Enchanting the World by his Art.* Apollo sits upon a tree stump playing the lyre to an audience of animals including a stag and a doe, a squirrel, a frog, and three birds.

Thompson is also responsible for the semi-abstract incised designs representing *Percussion*, *Strings*, *Brass*, and *Woodwind*.

IN THE AUDITORIUM:
(a) Six incised panels of female figures decorating the wall above the boxes and representing, according to *Liverpolitan* (June 1939: 26) 'musical moods'.

Sculptor: Edmund C. Thompson

Plaster panels with painted incised design

Over life-size

On the lefthand side, from the front to the

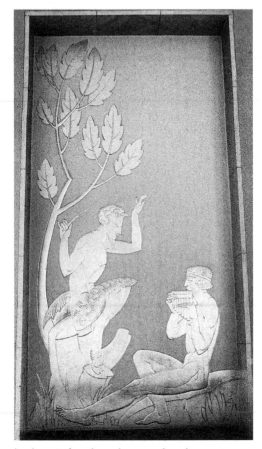

back: 1. A female nude, eyes closed languorously, rests her left hand upon her harp. 2. A female satyr performs a wild high-stepping dance, her thyrsus (a pine-cone tipped wand) held in her right hand, pan pipes raised to her lips in her left. 3. A female nude performs a sedate measure on a portative organ.

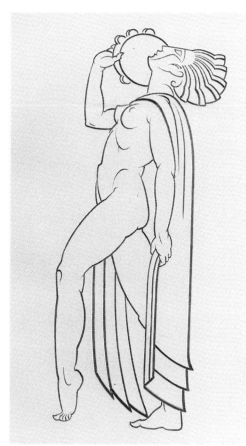

On the right-hand side, from the front to the back: 1. A winged female figure in a long gown, merges into the strings of her harp. 2. A semi-nude *bacchante*, her cloak and head thrown back, dances ecstatically to the rhythm of the tambourine held in her raised right hand. 3. Another semi-nude *bacchante* dances to the clash of the cymbals held in her raised hands.

Condition: Good

Literature: *Liverpolitan* (1939) June: 26.

(b) *Adagio*

a kinetic sculpture on the wall at the back of the concert platform

Sculptor: Marianne Forrest

Sculpture in glass-reinforced polyester and aluminium

Description: The sculptor gave the following description of *Adagio* in her proposal to the Royal Liverpool Philharmonic Society:

> A sinuous form swings slowly across the wall moving the musical notes as it goes. The form is derived from two subjects, the Mersey and a human face. The Mersey for its association with Liverpool and the face to represent the audience in the auditorium. In conjunction with the other forms around it, the face also describes musical instruments very much in keeping with the existing Artworks around the building. A spiral twirls slowly on its own suggesting sound waves emanating from a loud speaker. All parts move on this piece. The materials of the piece are intended to reflect the incised lines of the decorative panels (i.e those by Thompson, see above).

In typically basic fashion, however, the members of the orchestra have likened *Adagio* to 'a wriggling sperm' (*Guardian*, 7 September 1995).

The Philharmonic Hall's architect, Herbert J. Rowse, had always intended that a sculpture should decorate the back wall of the concert platform. The *Daily Post* (31 October 1936) reproduced his drawing for a 'striking design in bas-relief', with motifs symbolising '"wireless waves", heavy music and light, and so on'. Notwithstanding the newspaper's enthusiasm, however, Rowse's design was never carried out – presumably because of the extra cost involved – and ash panelling was put up instead.

Marianne Forrest's *Adagio* was commissioned as part of a £10 million refurbishment, completed in 1995.

Literature: *Daily Post* (1936) 31 October: 6, 12; *The Guardian* (1995) 7 September: 7; *Philharmonic Hall Autumn 1995 Programme*: 8.

PHILHARMONIC HOTEL, 36 Hope Street, at the corner of Hardman Street, designed and built by Walter W. Thomas, 1898-1900.

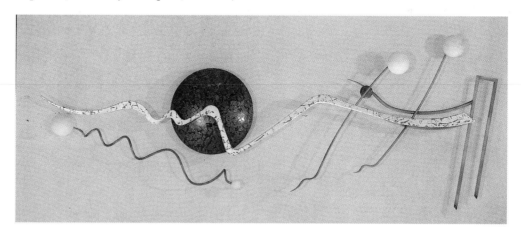

According to *The Studio* (1901, xxiii: 209): 'In the interior decoration the architect has collaborated with several designers and craftsmen under the immediate superintendence of the artist, Mr G. Hall Neale, assisted by Mr Arthur Stratton'. The journal then refers to the individual contributions of C.J. Allen, H. Bloomfield Bare and Thomas Huson.

Owner of building: Tetley Walker Ltd
Listed status: Grade II*

Ornamental Gates
to main entrance in Hope Street

Designer: Henry Bloomfield Bare

Gates in wrought iron and gilded copper

Description: Set into a round arch, the gates are of elaborate Art Nouveau style metalwork wrought into typically symmetrical linear patterns of whiplash curves and tendrils, and including, at the top, an arrangement of female heads around a central crest consisting of a shield with an eagle device, supported by antelopes beneath a bunch of grapes.

Condition: The gates appear to be undamaged, with relatively little loss of gilding.

THE MAIN BAR:
Repoussé Panels
decorating the ingle-nook, set into the dark mahogany panelling either

side of the fireplace. All depict half-length music-making figures.

Designer: Henry Bloomfield Bare

Panels in copper

Dimensions of the panels:
– the two panels each side of the fireplace: 35" × 16" (89 × 41cms)
– the four panels on the side walls of the ingle-nook: 28" × 16" (71 × 41cms)
– the panel on the extension of the right side wall of the ingle-nook: 44" × 16" (112 × 41cms)

Each panel signed and dated: H. Bloomfield Bare. 1900

Description of the panels:
– The left wall of the ingle-nook:
1. Two female figures facing each other; that on the left plays at a keyboard, whilst her partner sings from a music book. A vase of flowers fills the space between them; leaves decorate the upper part of the panel. 2. Two female figures; that on the left plays a lyre, whilst her partner sings from a music book. Leaves again decorate the upper part of the panel.
– The back wall of the ingle-nook, to the left of the fireplace:
3. Three female figures: that on the left plays a mandolin, whilst the two on the right sing from a music book held between them. Leafy tendrils decorate the upper part of the panel.
– The back wall of the ingle-

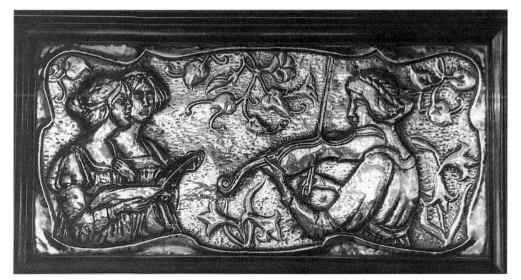

THE GRANDE LOUNGE (originally the Billiard Room):

The Murmur of the Sea

a decorative plaster relief over the bar, flanked by two plaster terms in the form of mermaids; and *Apollo With Female Attendants*, a corresponding composition over the doorway opposite, flanked by two plaster terms in the form of satyrs with pan-pipes hanging from their waists. A painted and gilded plaster frieze of stylized flowers, also by Allen, runs around the room above the level of the wood panelling.

Designer: Charles John Allen

Reliefs in white painted plaster

nook, to the right of the fireplace: 4. Three female figures: that on the right plays a violin-like instrument; her two partners on the left sing from a music book. Leaves and tendrils fill the spaces around the figures.

– The right wall of the ingle-nook: 5. Two female instrumentalists facing each other. On the left, a lyrist; on the right a guitarist. Leafy decoration again. 6. A male figure on the right plays a pipe or flute to a female who faces him, holding a bird in her right hand. A tree grows between them, filling the space over and behind their heads with leafy tendrils.

– The extension of the right wall of the ingle-nook: 7. Five figures make music indoors in front of a window: on the extreme left is an organist facing away from the others; glimpsed in profile, half-hidden behind the organ pipes, is the face of a young man; in the middle of the panel, facing towards the right, is a violinist; next is a figure singing from a music book, and on the extreme right a young woman in profile.

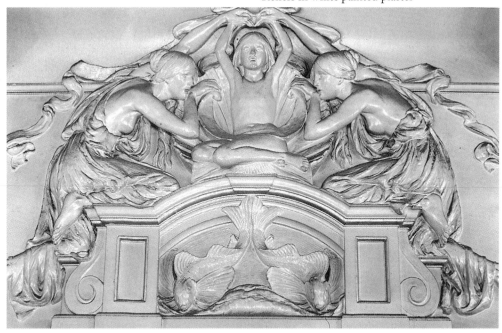

Figures are life-size

Exhibited: WAG Liverpool Autumn Exhibition 1900 (cat. 1467), as *Panel and Caryatides, forming portion of Plaster Work for the Decoration of a Billiard Room. Subject: The Murmur of the Sea.*

Descriptions:
(a) *The Murmur of the Sea.* The elaborate mantelpiece over the bar (formerly the fireplace) serves as a dais for a nude boy enthroned in an open scallop shell. His hands are raised over his head and are clasped by the farther hands of two loosely robed female attendants who kneel, in profile, on the edge of the dais either side of his throne. From behind their clasped hands appears a bow, the ribbons of which flutter out to the sides of the composition. The attendants lay their nearer hands on the lip of the shell-throne, their chins resting upon the backs of their wrists. Beneath the shell-throne are two decorative fishes, their tails touching, their heads facing outwards. The composition is entirely symmetrical. At either side are mermaid terms whose stylized tails frame the bottoms of the console brackets. The model for these figures was, according to both Hughes (1964, 1993: 93) and Bisson (1965: 12), Allen's friend, Mrs Ryan.
(b) *Apollo with female attendants.* On the opposite side of the room over the doorway, is an elaborate lintel with a segmental pediment, designed to echo the form of the mantelpiece. Here two female attendants are seated outwards on the opposite edges of the pediment, their upper bodies turning inwards towards the centre to place a wreath over a bust of Apollo. The wreath is tied with a bow, the ribbons of which flutter out to the side to be clasped and held aloft by the attendants' outstretched hands. Terms either side are in the form of fauns, their pan-pipes hanging below their waists, their

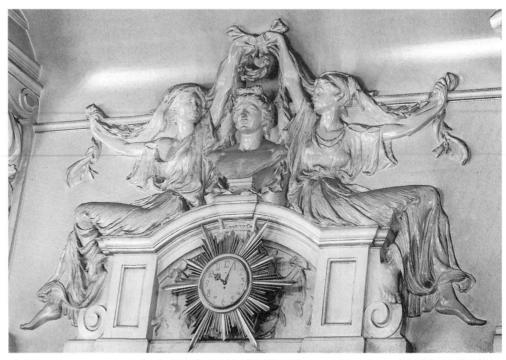

cloven hooves emerging from the bottoms of the console brackets.

Condition: Good, though the plaster is rather yellowed.

In a letter to E.R. Dibdin (then Curator of the Walker Art Gallery), dated 6 November 1912, the sculptor, C.J. Allen, explained that the *Murmur of the Sea* was intended to represent vocal music – 'the songs of the deep' – and *Apollo*, on the opposite side of the room, its complementary, instrumental music. He also indicated that certain parts of the plaster work were picked out in gold (WAG archives).

Repoussé Copper Panels
set into the mahogany panelling of the Grande Lounge, approximately 5' (1.5m) from floor. There are twenty-four panels in all: sixteen are of animals, birds, fish, and floral motifs by Henry Bloomfield Bare, and eight are scenes of the port of Liverpool by Thomas Huson.

Exhibited: H. Bloomfield Bare, WAG Liverpool Autumn Exhibition 1901 (cat. 1628), as *Design for Decorative Metal Panel (Plaster).*

Description of panels, moving clockwise around the room, commencing at the entrance from the Main Bar:
1. *Two cockerels.* 37½" × 9" (95 × 23cms); signed and dated: H. Bloomfield Bare. 1900.
2. *Six fantastic fish.* 37½" × 9" (95 × 23cms); signed and dated: H. Bloomfield Bare. 1900.
3. *Cockerel, hen and two chickens.* 37" × 9"

(94 × 23cms); signed and dated: H. Bloomfield Bare. 1900.

Right of the door:

4. *Floral motif.* 17³/₄" × 9" (45 × 23cms); unsigned.

5. *Five floral motifs.* 33" × 9" (84 × 23cms); signed: H. Bloomfield Bare (very faint).

Right of the fireplace:

6. *Five floral motifs.* 33" × 9" (84 × 23cms); signed and dated: H. Bloomfield Bare. 1900. (very faint).

7. *Three floral motifs.* 31" × 9" (79 × 23cms); unsigned.

8. *Two birds of prey perched on an oak branch before a landscape.* 43" × 9" (109 × 23cms); by Bare, but signature virtually illegible.

9. *Two fish.* 43" × 9" (109 × 23cms); signed and dated: H. Bloomfield Bare. 1900.

10. *Three crows on branches in a wood.* 43" × 9" (109 × 23cms); signed and dated: H. Bloomfield

Bare. 1900.

11. *Seascape – cliffs to the left with a lighthouse, a boat sailing on rough sea, the sun setting.* 35" × 9" (89 × 23cms); by Thomas Huson, signed: T H (encircled, at bottom left).

12. *Seascape – rocky shoreline in the foreground with cliffs to the left and three sailing boats on the sea.* 35" × 9" (89 × 23cms); by Thomas Huson, signed: T H (encircled, at bottom left).

13. *Seascape – choppy sea with four sailing boats on the horizon and a rowing boat in the foreground.* 35" × 9" (89 × 23cms); by Thomas Huson, signed: T H (encircled, at bottom left).

14. *Seascape – cliffs to the right with a lighthouse; rough sea with three storm-tossed sailing boats on the horizon, one in the foreground.* 35" × 9" (89 × 23cms); by Thomas Huson, signed: T H (encircled, at bottom left).

Right of the bar:

15. *View of a port with ships approaching.* 35" ×

9" (89 × 23cms); by Thomas Huson, signed: T H (encircled, at bottom left).

16. *View of a port with ships approaching (variant of above).* 35" × 9" (89 × 23cms); by Thomas Huson, signed: T H (encircled, at bottom left).

17. *View of a port (possibly New Brighton) with a fort and a lighthouse abutting the coastline, the sun setting behind the land to the right and a sailing boat approaching the harbour.* 35" × 9" (89 × 23cms); by Thomas Huson, signed: T H (encircled, at bottom left).

18. *View of a port with many buildings including, to the left, a church (possibly St Nicholas) and many boats in the harbour.* 35" × 9" (89 × 23cms); by Thomas Huson, signed: T H (encircled, at bottom left).

19. *Two squirrels in an oak tree.* 43" × 9" (109 × 23cms); signed and dated: H. Bloomfield Bare. 1900.

20. *Rabbits in undergrowth.* 46" × 9" (117 × 23cms); signed and dated: H. Bare 1900.

21. *Bird of Paradise on a bough.* 35" × 9" (89 × 23cms); signed: H. Bloomfield Bare.

22. *A fish and an eel.* 35" × 9" (89 × 23cms); signed and dated: H. Bloomfield Bare. 1900.

23. *Bird of Paradise with fruit.* 35" × 9" (89 × 23cms); signed: H. Bloomfield Bare.

24. *Two fish.* 35" × 9" (89 × 23cms); signed and dated: H. Bloomfield Bare. 1900.

Condition: There is a considerable loss of detail from years of polishing. Panel no. 11 has a wooden slat 4" wide running from top to bottom, 8¹/₂" from the right edge, presumably to cover some damage.

Literature: (i) WAG archives: typed transcript of letter and accompanying notes, from C.J. Allen to E.R. Dibdin, dated 6 November 1912.
(ii) Bisson, R. (1965): 12, 23; Hughes, Q. (1964, 1993): 93; Stamp, G., 'Architectural Sculpture in Liverpool', in P. Curtis (ed.) (1989): 10; *Studio* (1900) xx: 52-54; *Studio* (1901) xxiii: 206, 209.

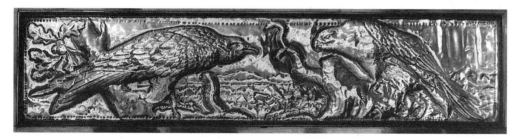

Hunter Street

GERARD GARDENS FLATS (demolished)

The Builder and *The Architect*

High relief sculptures formerly mounted on the exterior walls at Gerard Gardens Flats, Hunter Street. The flats are now demolished and the sculptures are in store at the Walker Art Gallery.

Sculptor: George Herbert Tyson Smith

High reliefs in Portland stone

h. of *Architect*: 8' 8" (2.64m)
h. of *Builder*: 8' 11½" (2.73m)

Signed on the base of the *The Architect*, front right: H. TYSON SMITH

Owner: Liverpool City Council (on loan to the Walker Art Gallery at the time of writing)
Status: not listed

Descriptions: *The Architect* is made from four horizontal sections and *The Builder* from five. Both were formerly fixed on a level with the second and third floor windows above entranceways to the flats. *The Builder* looks to his right. He wears an open-necked shirt with sleeves rolled above the elbows, belted trousers tied below the knees, and boots. He holds a hod of bricks against his left side. *The Architect* (representing the architect of Gerard Gardens Flats, Sir Lancelot Keay), stands facing towards the right, his right foot on a step. He is dressed in knee-length smock and trousers, holding a board upon which is drawn the layout of the block of flats. He contemplates the design, his left hand touching his chin.

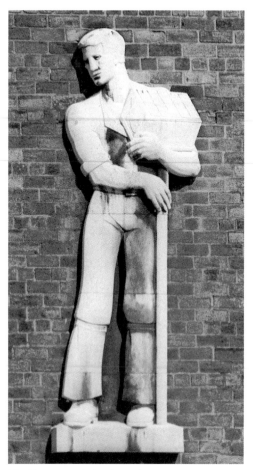

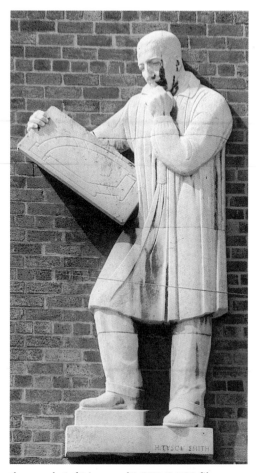

Condition: Each has been disassembled and is in store. Both are weathered and have some areas of black encrustation. *The Builder* has a corner chunk missing from the lower edge of the torso section, at the right hip.

The foundation stone of the flats was laid by the Rt Hon. Sir Kingsley Wood, M. P., Minister of Health, on 21 June 1935 'at the inception', he stated,' of a great rebuilding scheme for housing the people [of Liverpool]' (WAG JCS files ; source not given). The rebuilding scheme was completed in 1950 and it was in this year that Keay commissioned the two figures from Tyson Smith (Poole, 1994: 180).

Literature: (i) LRO manuscript sources: George Herbert Tyson Smith Archive, Box 1.
(ii) *Evening Express* (1935) 21 June: 9; Poole, S.J. (1994): 180; Willett, J. (1967): 92.

Knotty Ash

'Miss Thompson' Memorial Drinking Fountain.
See East Prescot Road
Nelson Obelisk. See Springfield Park

Lime Street

NORTH WESTERN HOTEL, by Alfred Waterhouse, built between 1868 and 1871 for the London and North Western Railway, opposite St George's Hall.

On the façade over the main entrance: two *Allegorical Female Figures*

Figures executed (i.e. all stone carving) by **Farmer & Brindley** (Cunningham and Waterhouse, 1992: 232).

Statues in stone

h: 8' 4" approx. (254 cms)

Owner of building: Liverpool John Moores University
Listed status: Grade II

Description: Two free-standing female figures: that to the left of the main entrance wears a loose robe over armour and, upon her head, a castellated crown. In her right hand she holds callipers and a mason's chisel. Her left hand rests on a shield bearing the device of a rearing horse. Along the forward edge of the shield leaves are sprouting. On the ground at her right side, mounted upon a pedestal, is a bust of a Greek-helmeted woman. The figure to the right

wears a feathered head-dress, a cloak, a knee-length skirt and sandals. On her ankle is a band decorated with a head motif. Her left hand rests upon an unstrung bow, around which is loosely coiled a rope. She has a sheaf of arrows over her right shoulder. A small reptile (perhaps intended to be a cayman) stands on her right, its tail curled around to the back. The attributes of these two figures would perhaps suggest that they are intended to represent, respectively, *Europe* and *America*.

Condition: From the street, the figures appear weathered. They are both afflicted with green biological staining and black encrustation.

Literature: Cunningham, C., and Waterhouse, P. (1992): 232.

THE VINES public house, 81 Lime Street, at the corner of Ranelagh Place. Designed and built by Walter W. Thomas in 1907.

Owner of building: Tetley Walker Ltd
Listed status: Grade II*

The lounge bar fireplace is decorated with:

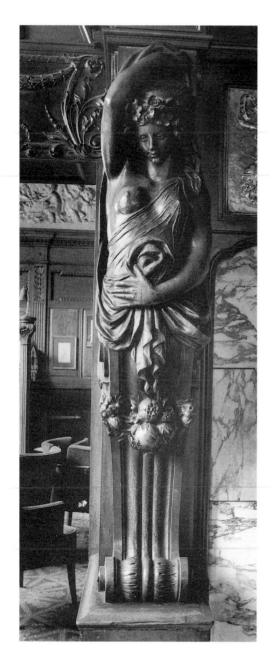

(i) *A Repoussé Copper Panel*

Artist: unkown

Description: The horizontal panel above the fire is decorated with a central motif of a quiver of arrows crossed with a lighted torch encircled by a wreath. This is flanked by fruit hanging from swags.

Condition: Highly polished, with a consequent loss of detail.

(ii) *Two Female Terminal Figures*

Artist: unkown

Mahogany

h: 65" (165cms)

Description: Located either side of the fireplace, the two terminal figures rise from console bases wreathed with carved flowers. Both are half-length female figures draped in diaphanous garments and wearing coronets of flowers over loose hair. The outer arm of each is raised to lift the back of the drapery train above the head, whilst the inner arm holds the front of the drapery in a bunch at waist height to reveal the top of the console base. The left-hand figure fully exposes, while the right-hand figure half exposes, the breast below the raised arm. Each looks slightly down and outwards.

Condition: Relatively good; undamaged

The Queensbury Room overmantel is decorated with:

(i) *'Viking Longboats'*

Artist: Henry Gustave Hiller

Bas-relief in wood, painted

$52^{1}/_{2}$" × $27^{1}/_{2}$" (133 × 70cms)

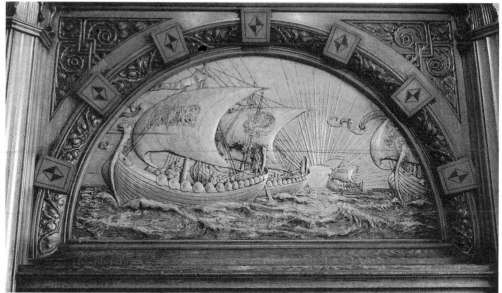

Signed: H Gustave Hiller

Description: Located above the fireplace, the lunette-shaped, painted bas-relief is set into a richly carved rectangular wooden frame. Four Viking longboats are sailing through choppy seas, from right to left. The sun rests on the horizon behind them, its rays filling the semi-circular area of sky. Over a predominantly golden-yellow ground, Hiller has created a rich chromatic effect with the addition of red for the ribbon-like flags flying from the mastheads and green for the 'Viking' emblems on the sails and for the sea which also has touches of gold and red for the sun's reflections.

Condition: There are three horizontal cracks, 18", 14" and 4" long. There has been considerable loss of colour from the relief, with the result that the golden-yellow ground is today even more predominant.

(ii) Around the walls is a continuous **Putti Frieze**, consisting of fifteen plaster bas-reliefs of various lengths, painted white, and framed in dark wood panelling.

Artist: unkown

h. of frieze: 37" (94cms)

Description: There are eight different scenes, some of the reliefs being repeated. All depict *putti* in rustic settings, some with mythological allusions. Over the fireplace is a relief (l: 62"/ 157cms, not repeated) depicting six *putti*: one *putto* carries a spear and four carry a litter

loaded with a sheaf of corn and a basket containing a boar's head; another *putto*, wearing a helmet and armed with a quiver full of arrows, holds two hunting dogs on a leash. Moving clockwise around the room, the next relief (l: 70"/ 178cms, repeated twice in other parts of the frieze) shows six *putti* harvesting corn. Then a relief (l: 31½"/ 80cms, repeated twice in other parts of the frieze) depicting four *putti* dancing around a garland-hung pedestal supporting a statue of a winged cupid. Then a relief (l: 21"/ 53cms, not repeated) with two *putti* with an over-laden basket of fruit: one sits holding the basket handle, whilst his standing partner holds a bowl filled with more fruit. Then (l: 25½"/ 65cms, not repeated) a single *putto* with a sack over his shoulder. In the next relief (32"/ 81cms, repeated twice in other parts of the frieze) four *putti* decorate with garlands a bust of Pan mounted on a pedestal; a *putto* at bottom right contemplates a mask which he holds in his hand. Then (l: 72"/ 183cms; repeated once in

another part of the frieze) a scene with seven *putti* taking flowers and fruits from two baskets, whilst another on the left blows on a horn. The next four scenes are all repeats. The remaining scene (l: 114½"/ 291cms; not repeated) is the largest: in the centre three *putti* shake fruit from a tree; on the right four *putti* are seen with baskets and bowls of fruit and on the left two *putti* dance. At the extreme left is a sack-carrying *putto* identical to one in an earlier panel.

(iii) The ceiling is decorated with an oval **Zodiacal Bas-Relief** in white-painted plaster

Artist: unkown

Description: The oval's twelve zodiacal panels alternate with panels depicting flora and fauna.

Condition: Both the *putti frieze* and the *zodiacal circle* are undamaged, but smoke-stained.

Literature: Hughes, Q. (1964, 1993): 90-1; Pevsner, N. (1969): 174.

Lime Street: St George's Plateau

ST GEORGE'S PLATEAU: the esplanade between the east façade of St George's Hall and Lime Street. (For St George's Hall see below, p. 253 ff; for the statues of *Disraeli* and *Major-General Earle* see below, pp. 265–67 and pp. 267–69 respectively)

Decorative lamp standards

Designer: C.R. Cockerell
Cast by the Coalbrookdale Iron Company

Lamp standards in cast iron

Owner: Liverpool City Council
Listed status: not known

Description: The lamp standards are set at intervals around the perimeter of the esplanade and under the porticoes of St George's Hall. The base of each standard is a truncated triangle with concave sides. From the centre of each triangular base rises a supporting column around which are entwined three dolphins whose snouts rest on the truncated points of the base. Above the dolphins is an acanthas motif, from which rises the fluted shaft of the column and at the top, a glass globe of four longitudinal segments. According to Watkin (1974: 241), these lamp standards, erected in the 1850s, 'anticipate those set up in 1870 on the Victoria Embankment in London'

Condition: All the lamps, both in the portico and on the plateau, have been restored.

Literature: (i) LRO manuscript source: *Law Courts and St George's Hall Committee Minutes*, 1/2: 392. (ii) Watkin, D. (1974): 241.

Four Recumbent Lions

Designer: Charles Robert Cockerell
Sculptor: William Grinsell Nicholl

Statues in sandstone

Length of each *Lion*: 169½" (430 cms)

Owner: Liverpool City Council
Listed status: Grade II

Description: The *Four Recumbent Lions* are mounted upon individual pedestals, two to each side of the carriageway entrance to St George's Plateau from Lime Street, opposite the eastern portico of St George's Hall.

Condition: All four *Lions* are very weathered and there are areas of green biological growth on each. Yellow colouring has been applied to all of the eyes at some time.

Related works: In 1839 Nicholl had carved the four stone lions at the foot of the stairways of the portico for George Basevi's Fitzwilliam Museum at Cambridge (Gunnis, 1951: 271).

On 9 December 1854, the Law Courts and St George's Hall Committee approved Cockerell's drawings for the *Lions* and agreed to recommend to the Council that the work be carried out at a maximum cost of £800 (*Law Courts and St George's Hall Committee Minutes*). At the Council meeting of 10 January 1855, there seems to have been some resistance to the suggested location (i.e. the eastern approaches to the Hall), but whatever the objection had been, it was soon resolved to the satisfaction of the majority for, on 12 February 1855, the Law Courts and St George's Hall Committee autho-

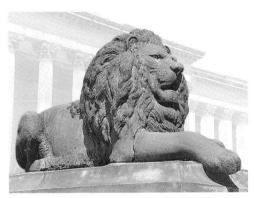

rised Cockerell to instruct his sculptor Nicholl to proceed with their execution (*Law Courts and St George's Hall Committee Minutes*). Notwithstanding the £800 limit set by the Committee, the Treasurer's Ledger for 1858 records that they ultimately cost £1,820. 17s. 11d.

On 10 January 1866, the Council considered a proposal submitted by the Law Courts and St George's Hall Committee to completely remove the *Lions* as part of a re-arrangement of the plateau for the purpose of accommodating Thornycroft's *Equestrian Statue of the Prince Consort* in a central position (see below, p. 93). The removal of the *Lions* would have permitted a second entrance to the plateau enclosure to be opened up, thereby giving easier access to carriages having to pass around and behind Thornycroft's statue on their approach to the great eastern portico of the Hall (*Council Minutes*). Alderman John Hayward Turner advised his fellow councillors that the Queen herself had taken great interest in the statue and was known to favour the proposed siting. He sought to justify the removal of the *Lions* by referring to their lack of critical favour (see especially, *The Porcupine*, 1866, vii: 397-98) and to the fact that 'it was never intended that they

should occupy their present site' (*Daily Post, supplement*, 11 January 1866). This latter point is untrue, however, for as indicated above, although the Council evidently had some sort of initial reservation concerning the proposed siting of the *Lions*, it had been resolved by the time of the Law Courts Committee meeting on 12 February 1855. Following on from Turner, James Picton then expressed his concern that, should the *Lions* remain where they were, they would 'dwarf the appearance of the statue [of Prince Albert]', a concern that had, he said, already been voiced by the sculptor, Thornycroft, who feared their proximity would reduce his statue 'from the heroic to life size' (*Daily Post, supplement*, 11 January 1866). The suggestions for the location of the *Lions* included setting them at the opposite ends of the Plateau, arranging them around the *Wellington Column*, or even (a suggestion which occasioned much laughter in the Council chamber) giving them to Leeds for their new Town Hall (*Daily Post: supplement*, 11 January 1866).

A number of Councillors objected to the unnecessary expense involved in constantly re-arranging the Hall and Plateau, but the motion to remove the *Lions* was carried nonetheless (*Daily Post: supplement*, 11 January 1866). No action was ever taken, however, for by the end of July the plans had changed again. On 1 August 1866 the Council approved a new recommendation from the Law Courts Committee that the *Equestrian Statue of the Prince Consort* would be better located after all at the south end of the Plateau (*Law Courts and St George's Hall Committee Minutes*). The only possible reason for the relinquishment of this central position must have been that the decision had already been taken, even though not officially approved until later in the year, to grace the Plateau with the companion

Equestrian Statue of Queen Victoria, also by Thornycroft. Thus, the necessity to relocate the *Lions* was removed and they remain to this day in their original locations.

Literature: (i) LRO manuscript sources: *Council Minutes*, 1/13: 171-72; *Law Courts and St George's Hall Committee Minutes*, 1/2: 366, 369, 386-87; *Law Courts and St George's Hall Committee Minutes*, 1/4: 144-45; *Treasurer's Ledger*,1/1/11: supplementary insert between pp. 60-61.
(ii) *Daily Post (supplement)* (1866) 11 January: 2; Gunnis, R. (1951): 271; Picton, J.A. (1875, revised edn 1903), ii: 186; *Porcupine* (1866) vii: 397-98.

Equestrian Statue of Albert, Prince Consort

(1819-61). Prince Albert had married Queen Victoria in 1840. Although he became Victoria's chief political adviser and frequently offered (generally unsolicited) advice to her ministers, his real achievement lay in his encouragement of the arts. Peel had placed him at the head of the Royal Commission on the rebuilding of the Houses of Parliament in 1841, and the Great Exhibition of 1851 was largely Albert's own idea. The Liverpool statue is one of the many monuments around the country erected to Albert at his death, the most notable being the national monument, the *Albert Memorial* at Kensington.

Sculptor: Thomas Thornycroft

Statue in bronze
Pedestal in granite

Bronze founder: Elkington & Co. of Birmingham

Statue: h: 13' 6" (4.1m)
Bronze base: h: 8" (20cms)
Pedestal: h: 9' (2.75m); w: 7' 7" (2.3m); d: 14' 6" (4.4m)

Inscriptions:
– left side of the pedestal: ALBERT / PRINCE CONSORT / BORN 1819 DIED 1861.
– right side of the pedestal: THIS STATUE / OF A WISE AND GOOD PRINCE / IS ERECTED / BY THE CORPORATION OF LIVERPOOL / OCTOBER 1866

Signed and dated on the right face of the bronze base, towards the front: T. THORNYCROFT SC. / *LONDON 1866*
Founder's name on the left face of the bronze base, towards the rear: ELKINGTON. & CO. / *FOUNDERS.*

Unveiled by John Farnworth, Mayor of Liverpool, Thursday 11 October 1866

Owner: Liverpool City Council
Listed status: Grade II

Description: Located at the south end of the esplanade in front of St George's Hall, Prince Albert, seated astride a charger, wears civilian dress with the sash of the Order of the Garter over his left shoulder and, on his left breast, the Star. He carries a top hat and gloves in his right hand and holds the reins loosely in his left.

Condition: The black epoxy paint which once entirely coated the bronze has mostly worn away and graffiti has been scratched into the areas that remain. The reins have come adrift from the Prince's left hand. Otherwise in fair condition.

Related works: Bust exhibited at the Royal Academy of Arts in 1863 (cat. 1011), as *The Prince Consort; heroic size, from the model of a public statue revised by Her Majesty* (note: although the RA catalogue entry does not state that 1011 is a bust, it is listed as such in the *Art-Journal*, 1863: 116). Thornycroft's Halifax and Wolverhampton equestrian monuments to the

Prince Consort were commissioned by the corporations of those towns at about the same time. The bust exhibited at the RA was in all likelihood the model for all three monuments.

Following his sudden death in December 1861, the Corporation of London voted that a national memorial to Prince Albert should be raised in the capital (for a full account of which see Bayley, 1981). In order to erect a suitably grand monument, the Lord Mayor of London wrote to the mayors of all the principal towns and cities throughout Britain, requesting that they set in motion the means for raising the necessary funds. On 29 January 1862, the Corporation of Liverpool met and formed a Special Committee to consider the matter, consisting of Robertson Gladstone, John Hayward Turner, John Buck Lloyd, James Allanson Picton, John Stewart, and Samuel Holme (*Council Minutes*).

The Special Committee convened its first meeting on 31 January 1862 and, after resolving that the Mayor of Liverpool (Robert Hutchison) should be asked to act as Chairman, decided to recommend to the Council that any local funds raised should be applied to the erection of a suitable memorial within its own town. It was agreed that the Liverpool memorial should take the form of an equestrian statue, that it would be best located in the open area on the east side of St George's Hall, and that the Council should be requested to appropriate £5,000 for the scheme from the Corporation's surplus funds (*Special and Sub-Committees Minutes*). The recommendations of the Special Committee were approved by Liverpool Council on 5 February 1862 (*Council Minutes*).

The Art Journal (1864) considered that ratepayers' money would have been better

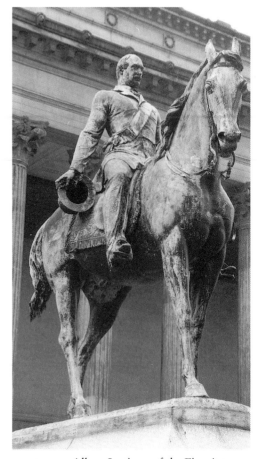

spent on an Albert Institute of the Fine Arts, which, it reminded its readers, would have been more consonant with what the Prince would have wished. To Liverpool Corporation, however, an equestrian statue was evidently more desirable on all counts: it was a more personal tribute, a more immediate and visible expression of local pride, and a dramatic ornament to a newly created civic centre.

The Corporation drew up a shortlist of three

prospective sculptors for the commission: John Henry Foley, Baron Carlo Marochetti and Thomas Thornycroft. The final choice of sculptor seems to have been settled on the basis of a letter of recommendation from a friend and early patron of Thornycroft, the Macclesfield surgeon W.B. Dickinson, a man whose opinion the Corporation apparently respected (Manning, 1982: 40). There were, however, two other points in Thornycroft's favour: firstly his 1853 equestrian statuette of Queen Victoria had been well-received by its subject and selected for reproduction by the Art Union (fifty copies were made, including WAG cat. 6110), and secondly, he and his sculptor wife Mary, had for some years both enjoyed a warm relationship with the Queen and Prince Albert. Whatever the deciding factors were, the Special Committee's selection of Thornycroft on 8 April 1862 was unanimous (*Special and Sub-Committees Minutes*).

On 25 October 1862, Thornycroft attended a meeting of the Committee, bringing with him a photograph of his model for the monument. Evidently this was not considered adequate for the Committee to form a proper judgement and the sculptor was asked to return on 4 November with the actual model. This particular meeting – if indeed it took place – is not minuted, but at the next minuted meeting on 11 November the Committee expressed its wish to see Thornycroft's design for the monument's pedestal, with a written description and material specifications, though adding that, given Thornycroft's 'acknowledged good taste and experience' in such matters, his would be the final word (*Special and Sub-Committees Minutes*).

On 4 December Thornycroft submitted a 'geometrical drawing' of the pedestal, plus a 'perspective drawing' of the whole monument

'*in situ*' so that the Committee could fully appreciate the final effect. (It should be remembered that at this time the Plateau was empty but for the *Four Recumbent Lions* and that the statue of Prince Albert would have been intended for its centre). Thornycroft rounded off his accompanying letter with the encouraging news that:

> On Friday last I laid before Her Majesty the accompanying drawing and had the honour to receive Her Royal approval that the statue should represent a philosophical prince rather than an honorary soldier (*Special and Sub-Committees Minutes*, cited by Darby and Smith, 1983: 75).

Thus, the Committee, having been assured of Victoria's royal approval, could do no more than approve Thornycroft's drawings, with the one proviso that the sculptor discuss with the Corporation Surveyor, John Weightman, his proposal to provide the pedestal with a wide plinth to protect the monument from the wheels of carriages approaching St George's Hall (*Special and Sub-Committees Minutes*).

Once the design and material specifications had been approved, responsibility for the erection of the monument passed to the Law Courts and St George's Hall Committee. On 11 October 1864, almost two years after his designs had been approved, Thornycroft wrote to inform the Committee that his full-size clay model was nearly complete, that arrangements had already been made for its casting in bronze, and that he hoped to have the statue ready for erection at some time during the following May. In the meantime he asked for the return of his watercolour sketch (presumably his perspective drawing of the monument *in situ*) so that he could begin work on the granite pedestal (*Law Courts and St George's Hall Committee*

Minutes). Either Thornycroft was here misleading the Corporation regarding his progress, or he must at this point have suffered some kind of major setback for, by 3 August 1865, the Corporation had still not received their statue and felt compelled to write to him to ascertain what progress had been made (*Law Courts and St George's Hall Committee Minutes*).

Not until 5 December 1865 was Thornycroft able to announce the near completion of 'the Statue' (by which he meant the full-size model), asking the Committee for permission to commence laying in the foundations for the pedestal (which at least had been completed) (*Law Courts and St George's Hall Committee Minutes*). The sculptor wrote again to the Committee towards the end of the month announcing the actual completion of the full-size model and on the 28th the Corporation Treasurer was authorised to send the sculptor a payment of £1,500 (*Law Courts and St George's Hall Committee Minutes*).

On 21 December 1865 Thornycroft attended a special meeting of the Law Courts and St George's Hall Committee and put to them a proposal that the *Lions* be removed completely from the Plateau so that his equestrian statue could be erected closer to the Lime Street side, thus allowing easier access for carriages making their way behind it towards the east portico entrance to St George's Hall. The Committee re-convened outside on the Plateau to examine the proposed site and, seeing the merit in Thornycroft's proposal, agreed to recommend the alterations to the Council. On 3 January 1866, despite a move for a deferral until some thought had been given both to the cost of removing the *Lions* and indeed to where they should be relocated, the Council gave its approval (*Law Courts and St George's Hall*

Committee Minutes).

By 28 June 1866, however, the Committee resolved to seek Thornycroft's opinion as to the placement of the statue at the south end of the Plateau (*Law Courts and St George's Hall Committee Minutes*). He visited the site on 19 July and the following day wrote to the Committee that he thought the new site 'admirably adapted for the purpose' (*Law Courts and St George's Hall Committee Minutes*). It seems more than likely that Thornycroft's readiness to accept a site at one end of the plateau instead of the prime position in the centre was motivated by the prospect of executing its companion, the *Equestrian Statue of Queen Victoria*, approved for the north end of the plateau on 23 October of the same year (*Finance Committee Minutes*).

On 21 March 1866, Thornycroft wrote to the Committee, reporting that there was to be a further delay. In February he had apparently asked Elkington's, the founders, to have the statue cast by Whitsuntide, but in early March they had informed him that they would not be able to deliver the completed bronze until July (*Law Courts and St George's Hall Committee Minutes*). On 7 April 1866, they wrote again to Thornycroft, confessing that even with the greatest efforts, considering the size of the task and the means at their disposal, the statue would not be ready before the end of July at the very earliest (*Law Courts and St George's Hall Committee Minutes*).

In fact, the statue arrived in Liverpool towards the end of August 1866 and was raised onto its pedestal on the 31st of that month (*Law Courts and St George's Hall Committee Minutes*). The inscription on the pedestal was composed by Thornycroft and approved by the Committee on 27 September 1866 (*Law Courts and St George's Hall Committee Minutes*).

The Corporation had hoped that Victoria would agree to come to Liverpool to unveil the monument but, on 13 September, the Queen's Private Secretary wrote to the Earl of Derby (then Prime Minister, but apparently acting as intermediary between the Queen and his fellow townsmen), regretfully refusing on the grounds that her Majesty was not equal to undergoing the fatigue of such ceremonies. He asked Derby to assure the Liverpool Committee that a similar refusal had been sent to Manchester, following that town's invitation to unveil their newly erected *Albert Memorial* (*Law Courts and St George's Hall Committee Minutes*). Nevertheless, the Queen did attend the unveiling of Thornycroft's Wolverhampton monument to Prince Albert in November of that year. According to the *Art-Journal* (1867: 24), Victoria had requested that for the Wolverhampton monument, Thornycroft portray Albert in his Field Marshall's uniform, lending it and the horse's saddle cloth to the sculptor specifically so that he could use them as models. If this is correct then it was presumably Thornycroft's idea that Albert should be portrayed as a 'philosophical prince' in the Liverpool monument, but Victoria's taste that determined he should look like a soldier in at least one of the equestrian monuments. So, Victoria's decision to attend the Wolverhampton unveiling ceremony, but not those at Liverpool or Manchester, would seem to reflect not so much an aversion to those towns, so much as an attachment to her own vision of Albert as reflected in the Wolverhampton monument.

Despite the Mayor of Liverpool's praise for the work at the unveiling (*Mercury*, 12 October, 1866), both the site and the qualities of the statue itself were the subjects of a certain amount of debate: at a meeting of the Liverpool

Architectural and Archaeological Society concern was expressed by some members that the close proximity of the statue to the Hall dwarfed the latter and spoiled the neo-classical purity of its lines (*Proceedings*, 2nd meeting, 17 October 1866: 19); and letters to *The Weekly Albion* for 29 October 1866, generated by an article in the previous week's edition which had praised the statue's naturalism, objected most strongly that there were inaccuracies both in the horse's anatomy and in the Prince's riding posture (Read, 1989: 37).

The Liverpool equestrian monument to Albert (and also that of Victoria) became the subject of concern again in 1885. On 1 May of that year, Thomas Shelmerdine, the Corporation Surveyor, reported that the bronze of both monuments was already scaling badly. Furthermore, he suggested that the bronze appeared to be of 'an unsatisfactory character' (*Finance and Estate Committee Minutes*). He contacted Elkington & Co who undertook to examine them. The Corporation, having paid £5,000 for each of the statues was understandably concerned and asked Elkington & Co for a full explanation. On 12 June 1885, Shelmerdine reported to the Finance Committee that the founders had revealed that the metal had been supplied by the sculptor himself and that it was 'not actual Bronze but Gun Metal'. The coating, which looked like scaling, was in fact verdigris, but it was not, they assured the Corporation, injurious to the metal; should the Corporation want the statues cleaned and 'rebronzed', however, Elkington & Co offered to carry out the work for around £92 (*Finance and Estate Committee Minutes*). The Corporation here deferred action, but on 21 May of the following year, paid the Liverpool firm Norbury, Paterson & Co to clean both equestrian statues (plus the *Disraeli*), for the considerably smaller sum of

£50 (*Finance and Estate Committee Minutes*).

Literature: (i) LRO manuscript sources: *Council Minutes*, 1/10: 113-16, 136, 482; *Finance and Estate Committee Minutes*, 1/12: 483; *Finance and Estate Committee Minutes*, 1/31: 230, 293, 338, 366; *Finance and Estate Committee Minutes*, 1/32: 726; *Law Courts and St George's Hall Committee Minutes*, 1/4: 2, 65, 88, 89, 92, 94, 98, 101, 112, 119-20, 123, 137, 144 – 45, 149 – 50, 155 – 56, 164, 169, 170; *Special and Sub-Committees Minutes*, 1/2: 89-104.
(ii) *Art-Journal* (1862): 173; *Art-Journal* (1864): 28; *Art-Journal* (1866): 285; *Art-Journal* (1867): 59; *Daily Post: supplement* (1866) 12 October: 1; Darby, E., and Smith, N. (1983): 75, 82; *Liverpool Architectural and Archaeological Society, Proceedings* (1866) 17 October: 17-24; *Liverpool Architectural and Archaeological Society, Proceedings* (1866) 31 October: 25-8; Manning, E. (1982): 40; *Mercury* (1866) 12 October: 7; *Mercury* (1866) 19 October: 6; Picton, J.A. (1875, revised edn 1903), ii: 186; *Porcupine* (1862) 18 January: 182; *Porcupine* (1866) 29 September: 303; *Porcupine* (1866) 13 October: 331; Read, B., 'From Basilica to Walhalla', in P. Curtis (ed.) (1989): 37; *Times* (1866) 30 August: 8; *Times* (1866) 7 September: 8; *Times* (1866) 11 September: 6; *Times* (1866) 12 October: 7; *Weekly Albion* (1866) 15 October: 4; *Weekly Albion* (1866) 22 October: 4; *Weekly Albion* (1866) 29 October: 5; Willett, J. (1967): 260.

Equestrian Statue of Queen Victoria
Commissioned by Liverpool Town Council as a pendant to the *Equestrian Statue of Albert, Prince Consort* (above).

Sculptor: Thomas Thornycroft

Statue in bronze
Pedestal in granite

Bronze founder: Elkington & Co. of Birmingham

Statue (approx.): h: 14' 6" (4.42m); l: 14' (4.27m)
Pedestal: h: 9' (2.75m); l: 14' 6" (4.4m); w: 7' 7" (2.3m)

Inscriptions:
– left side of the pedestal: VICTORIA / D. G. REGINA F. D.
– right side of the pedestal: ERECTED / BY THE CORPORATION OF LIVERPOOL / IN THE THIRTY-FOURTH YEAR OF / HER REIGN.

Signed and dated on the left side of the bronze base, towards the rear:
T. THORNYCROFT SC. / LONDON. 1869.
Founder's name on the right side of the bronze base, towards the rear:
ELKINGTON & CO / FOUNDERS

Unveiled by Alderman Joseph Hubback, Mayor of Liverpool, Thursday 3 November 1870.

Owner: Liverpool City Council
Listed status: Grade II

Description: Located at the north end of the esplanade in front of St George's Hall, the Queen is shown riding side-saddle, her legs over the left side of the horse. She wears a plumed hat and across her breast, the riband of the Order of St George. In her left hand she holds the horse's reigns and in her right, a riding whip. According to the *Art-Journal*, the Queen:

is represented in the half-military dress she usually wore when visiting the camp at Chobham with the Prince Consort. The features are unmistakeably those of the Queen, but very properly the cast is somewhat younger than we now see it. The horse is full of impatient action, which tells on the sway of the figure; an effect difficult to express well in sculpture (*Art-Journal*, 1869: 195).

Condition: Most of the black epoxy paint which once coated the bronze has worn away

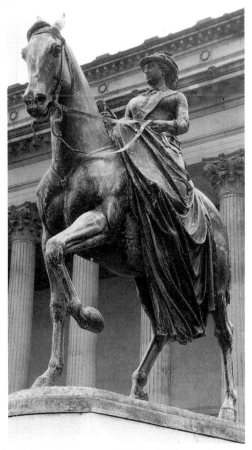

and there is some graffiti scratched into the areas that remain. The horse's reins have come adrift from the right side of the bit. The knee of the horse's right foreleg has a rust-coloured stain. Only the handle of the riding crop remains in Victoria's left hand. There is a vertical split in the front face of the bronze base towards the left corner.

Related work: *Equestrian Statuette of Queen Victoria*, h: 22¹/₂" (58cms), bronze, signed and

dated: 'T. THORNYCROFT fecit / London 1853', WAG, cat. 6110.

On 23 October 1866, the Council of Liverpool Corporation approved a motion that an equestrian statue of Queen Victoria be erected on St George's Plateau 'as a counterpoise and companion' to that of Prince Albert and that, resources permitting, £5,000 should be allocated for the purpose out of surplus funds (*Finance Committee Minutes*). On 26 October, the Finance Committee reported that funds were indeed sufficient (*Finance Committee Minutes*) and at the Council meeting of 9 November a Special Committee of eight members was formed to select a sculptor and to supervise the execution of the commission (*Council Minutes*).

The Special Committee met for the first time on 7 December 1866 and John Hayward Turner was voted Chairman. The other seven members were John Stewart, Robertson Gladstone, and James Allanson Picton – all of whom had officiated on the Committee for the *Equestrian Statue of Albert, Prince Consort* – plus Joseph Hubback, Edward Lawrence, Edward Whitley and Joseph Gibbons Livingston. On 11 December the Committee decided to request the Mayor (John Grant Morris) to ask the Earl of Derby to ascertain Victoria's view as to whether there should be a competition to select the sculptor or whether she might prefer to nominate a sculptor herself (*Special and Sub-Committees Minutes*). At the next meeting, on 27 December, the Mayor took the Chair and informed the Committee that – not surprisingly – the Queen favoured Thomas Thornycroft, whose *Equestrian Statue of Albert, Prince Consort* had been unveiled earlier that month (see above).

Thornycroft had first executed an equestrian statue of the Queen in plaster for the Great Exhibition of 1851. According to Elfrida Manning, the sculptor's grand-daughter (in a letter to the Walker Art Gallery, WAG JCS files), Thornycroft received no commissions for this work and subsequently the plaster was broken up. In this first version the Queen was portrayed wearing a crown; two years later, Thornycroft designed a second version with the Queen dressed in a plumed hat. This modification was evidently successful as the work was chosen as the model for a limited edition Art-Union bronze statuette. The statuettes were cast by Thornycroft himself at his Stanhope Street studio and each of the fifty copies was awarded as a lottery prize, one of which is now in the Walker Art Gallery collection (cat. 6110). In 1854 Thornycroft exhibited at the Royal Academy (cat. 1417) another equestrian bronze statuette of the Queen, this time for Prince Albert, which seems to have been one further cast of the Art-Union model. These statuettes resemble the final full-scale 1867-70 statue, though with slight differences in the positioning of the Queen's arms and in the depiction of a more active horse with right foreleg extended.

Both Thomas and his sculptor-wife, Mary (who had enjoyed the greater share of royal patronage thus far and who from 1867 was to be teacher of sculpture to the princesses), were on friendly terms with Victoria and Albert, and Victoria's favourite chestnut, Hammon, had been regularly sent to the sculptor's studio whilst he was working on the first equestrian statue for the 1851 Great Exhibition (Manning, 1982: 30).

Thornycroft submitted a small model to the Committee on 23 May 1867. Rather than exercise its own judgement, however, the Committee asked Thornycroft to ensure that the model met with Victoria's approval and during the summer of that year the sculptor informed the Town Clerk that royal approval had been secured (*Special and Sub-Committees Minutes*).

Thornycroft completed the full-size clay model, but would proceed no further until Victoria had personally approved it (*Art-Journal*, 1869: 195). On 18 April 1869, he wrote the following letter to Committee-member, James Picton:

> I think you will feel pleased to hear that The Queen yesterday came to see your statue and expressed herself very much gratified. She remained in the studio some time and inspected the work in every view. The Princess Louise came with The Queen; Her Royal Highness has really great art faculty and she was quite warm in her approval of the work and sent me this morning a complimentary letter (photocopied letter in WAG JCS files).

After the casting in the Elkington foundry at Birmingham, the bronze statue was conveyed by road to Liverpool, arriving on Monday, 12 September 1870. It was immediately surrounded by hoarding and tarpauline and it, and the pedestal upon which it was soon to be mounted, remained covered pending the official unveiling ceremony on 3 November (*Mercury*, 13 September 1870).

Having been disappointed by the Queen's inability to attend the unveiling of the companion *Equestrian Statue of Albert, Prince Consort*, the Corporation hoped that she might be able to attend the unveiling of her own statue. But in the event, neither she nor any other member of the royal family was available. The Corporation next approached the Liverpool-born Prime Minister (W.E. Gladstone), but he was committed to a prior engagement. Thus, the town was again disap-

pointed and again the Mayor himself had to officiate (*Mail*, 5 November 1870). But at least this time the statue received wider and more generous approval than had its predecessor (see above, p. 94): the horse was praised for its beautifully correct anatomy, and the likeness of the Queen was held to be without equal (*Mercury*, 13 September 1870; *Courier*, 14 September 1870; *Mail*, 5 November 1870).

As recounted above (p. 94), in 1885 both statues were the subject of the Corporation's concern following the report of the

Corporation Surveyor, Thomas Shelmerdine, that the metal surfaces were scaling. During consultation with Elkington's, the founders, it was revealed that the metal, which had been supplied by Thornycroft himself, was not in fact bronze, but 'Gun Metal' .

Literature: (i) LRO (a) manuscript sources: *Council Minutes*, 1/15: 247; *Council Minutes*, 1/16: 397; *Finance Committee Minutes*, 1/12: 483, 495; *Finance and Estate Committee Minutes*, 1/14: 522; *Finance and Estate Committee Minutes*, 1/17: 250, 278-79; *Special and Sub-Committees Minutes*, 1/2: 158-67; (b) newscuttings: *Courier* (1870) 14 September, in *TCN*

1/5; *Mail* (1870) 5 November, in *TCN 1/6*; *Mercury* (1870) 13 September, in *TCN 1/5*; *Mercury* (1870) 4 November, in *TCN 1/5*.
(ii) WAG JCS files – newscutting: *Mercury* (1870) 12 October; photocopy of letter from Thornycroft to J.A. Picton, dated 18 April 1869; photocopy of part of letter from Elfrida Manning to the WAG, date unknown.
(iii) *Art-Journal* (1867): 59; *Art-Journal* (1869): 195; Manning, E. (1982): 30-34, 40; Picton, J.A. (1875, revised edn 1903), ii: 186; *Porcupine* (1870) 5 November: 332-33; Read, B., 'From Basilica to Walhalla', in P. Curtis (ed.) (1989): 37; *The Times* (1866) 25 October: 7.

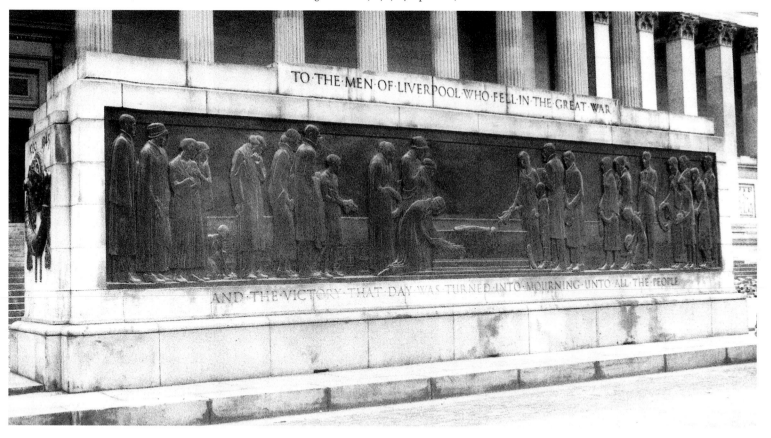

Cenotaph

Architect: Lionel Bailey Budden
Sculptor: George Herbert Tyson Smith

Cenotaph in Stancliffe stone with reliefs in bronze
Supporting platform in Yorkshire Silex stone

Bronze founder: Morris-Singer Co.
Stonework contractor: A.E. Bradley & Co.

Cenotaph: height 11' (3.35m); length 35' (10.67m)
Supporting platform: length 61' (18.6m); depth 15' (4.57m)
Bronze relief panels: length 31' (9.4m)

Inscriptions:
(i) east face (towards Lime Street)
– above the relief: TO THE MEN OF LIVERPOOL WHO FELL IN THE GREAT WAR
– below the relief: AND THE VICTORY THAT DAY WAS TURNED INTO MOURNING UNTO ALL THE PEOPLE
(ii) west face (towards St George's Hall)
– above the relief: AS UNKNOWN AND YET WELL KNOWN AS DYING AND BEHOLD WE LIVE
– below the relief: OUT OF THE NORTH PARTS ... A GREAT COMPANY AND A MIGHTY ARMY
(iii) north and south faces (end elevations)
– above the Liverpool coat-of-arms: 1939 1945
– below the Liverpool coat-of-arms: 1914 1919

Signed on the east facing relief:
– at lower left: LIONEL B. BUDDEN ARCHITECT
– at lower right: H. TYSON SMITH SCULPTOR

Founder's name on the west facing relief, at lower left: THE MORRIS-SINGER CO / LONDON SW1 / FOUNDERS

Unveiled by Edward George Villiers Stanley, 17th Earl of Derby, Tuesday 11 November (Armistice Day) 1930; additional inscription, '1939 1945', unveiled by Alderman W.G.

Gregson, Lord Mayor of Liverpool, Sunday 10 November (Remembrance Sunday) 1946.

Owner/ custodian: Liverpool City Council
Listed status: Grade II

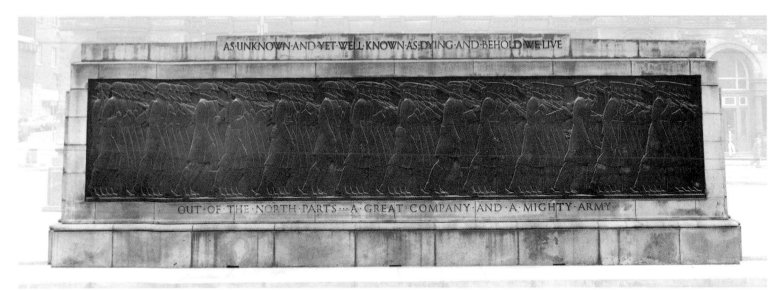

Description: Located centrally on St George's Plateau and oriented on an axis parallel to St George's Hall, the *Cenotaph* was 'designed to harmonise both in shape and material with the main lines and fabric of [the Hall]'. It is a massive altar- or tomb-like structure, raised upon a low stone platform 'in order both to increase the effectiveness of its setting and to provide a protected space for wreaths'. The supporting platform is 'emphasised by terminal blocks', access to the platform being 'gained by steps between the blocks at each of the shorter ends'. The principal features of the two long sides are the bronze panels in low relief, representing 'contrasting aspects of the Great War' (*The Liverpool Cenotaph*, official programme). The panel facing the Hall represents an army on the march and was intended 'to indicate a vast sustained movement' (*Daily Post and Mercury*, 16 October 1926). Above the panel runs a quotation, 'As unknown and yet well known...' from II Corinthians, vi, 9, and below, 'Out of the north parts...' from Ezekiel, xxxviii, 15. The panel facing Lime Street, shows 'the commemoration of Armistice Day' in the form of some figures 'grouped about a Stone of Remembrance' with, in the background, 'the headstones of a great military cemetery' (*The Liverpool Cenotaph*, official programme). This panel was intended to express 'united and widespread silence and grief' (*Daily Post and Mercury*, 16 October 1926). The inscription below this panel, 'And the victory that day...', is from II Samuel, xix, 2. In accordance with Tyson Smith's professed sensitivity to architectonic requirements, his bronze panels are 'taken close up to the angles of the monument, and are in very low relief, so that they do not weaken the effect of the total mass' (*Daily Post and Mercury*, 16 October 1926). The end elevations are identical, each 'marked by a symbol of defence, a bronze circular shield bearing the Civic Arms of Liverpool and by pendant bronze festoons' (*The Liverpool Cenotaph*, official programme). Beneath are inscribed the dates '1914 1919' and above (added in 1946) '1939 1945'.

The *Liverpool Cenotaph*, in common with many others, bears the dates 1914-1919 not, as one might expect, 1914-1918. This is because although hostilities were suspended on 11 November 1918 (Armistice Day), Britain's official 'Peace Day' Victory Parade did not take place until 19 July 1919, following the signing of the peace settlements with Germany (28 June 1919) and her allies (Boorman, 1988: 2).

Condition: Generally good. In a few places on the bronze panels green is showing through the covering of black epoxy paint.

Related works:
(a) Tyson Smith's models for the *Cenotaph* sculpture:
1. Three sections, in plaster, for the relief *Out of the North parts – a great company and a mighty army*: (i) lefthand section: 21½" × 38½" (54.7 × 98cm), WAG, cat. 8821; (ii) centre section: 21½" × 25¼" (54.7 × 64.1cm), WAG, cat. 8822; (iii) righthand section: 21½" × 39" (54.7 × 99.2cm), WAG, cat. 8823.
2. Three sections, in plaster, for the relief *And the Victory that day was turned into Mourning unto all the people*: (i) lefthand section: 22" × 33" (55.9 × 83.5cm), WAG, cat. 8818; (ii) centre section: 22" × 36½" (55.9 × 92.7cm), WAG, cat. 8819; (iii) righthand section: 22" × 30½" (55.9 × 77.1cm), WAG, cat. 8820.
3. Model, in plaster, for the *Coat of Arms of the City of Liverpool*, 24½" × 24¾" (62.2 × 62.8cm), WAG, cat. 8827, inscribed DEUS. NOBIS / HAEC. OTIA FECIT (on scroll) – of the same size as the bronze coat of arms on the *Cenotaph*; it was used again for the signed coat of arms in the Dale Street Magistrates Court in 1966.
4. *Self Portrait*, plaster, 15¾" × 16½" (39.8 × 41.7cms), WAG 8817. A head and shoulders portrait which served as the model for the full length self portrait, six figures from the right in the *Cenotaph* relief: *And the Victory was turned into mourning...*

(b) Other civic war memorials:
1. Budden and Tyson Smith: *Birkenhead War Memorial*, 1923-25, Hamilton Square, Birkenhead.
2. Budden: war memorials in (i) Stanley Gardens, Blackpool, and (ii) Merchant Taylor's School, Crosby.
3. Tyson Smith with Professor C.H. Reilly (architect): *Accrington War Memorial*, begun 1921, Oakhill Park, Accrington.
4. Tyson Smith with Grayson, Barnish and McMillan (architects): *Southport War Memorial*, 1923-27, Lord Street and Nevill Street, Southport.
5. Tyson Smith with Harold E. Davis (architect): *Fleetwood War Memorial*, begun 1927, Fleetwood.

When the Lord Mayor of Liverpool first proposed that the city should erect its own permanent memorial to those of its citizens who had fallen in the Great War, he assumed that it would be funded by public subscription. In November 1920, however, he was forced to announce the postponement of the scheme 'in view of the amount of unemployment now existing' (as quoted in Boorman, 1988: 153). It was to be another five years before the decision was taken by the City Council to set up a 'Cenotaph (Special) Committee' and fund the memorial with Corporation money (*Daily Post*

and *Mercury*, 3 December 1925). Remarkably, for the whole period between the end of the Great War in 1918 and the unveiling of Budden and Tyson Smith's *Cenotaph* in 1930, Liverpool's Armistice Day services had to be held before a temporary wooden Cenotaph, 'conveyed to and from the St George's Hall plateau on a handcart' (*Daily Post and Mercury*, 16 August 1930).

The Plateau having been established as the official site for Liverpool's Armistice Day services, it was inevitable that it would also be regarded as the obvious site for Liverpool's permanent memorial. Nevertheless, its precise location on the Plateau, which by this time had accumulated four stone lions, two equestrian statues and a *Statue of Lord Beaconsfield*, was, from the first, problematic. It was evidently Sir William Forwood who suggested moving the latter statue from its prime position in the centre of the Plateau in order to accommodate the proposed Cenotaph (*Daily Post and Mercury*, 3 February 1926). The Committee decided to seek the expert advice of C.H. Reilly, then Roscoe Professor of Architecture at the University of Liverpool. On 22 February 1926 Reilly submitted his report to Sir Archibald Salvidge, Chairman of the Committee, in which he expressed his agreement that there was 'only one place for the Cenotaph… between the [equestrian] statues of Queen Victoria and Prince Albert centrally on the transverse axis of [St George's] Hall.' Moreover, the *Statue of Lord Beaconsfield* was, in his opinion, on an overhigh pedestal. Re-erecting it on an appropriately lower pedestal 'at the bottom of the first flight of steps [of the east portico of the Hall] but not encroaching on the great landing' would greatly improve the appearance of the Plateau overall. Should this scheme be adopted, he concluded, the *Statue of Lord Beaconsfield* would then

exist in a new and harmonious relationship with the colonnade of the east portico (Report of Professor C.H. Reilly, M.A., … February 22nd, 1926, *Proceedings of the Council*).

The Council was evidently convinced by the argument and Reilly was appointed advisor to the Committee. An open competition for designs for the Cenotaph was announced on 3 June 1926 (*Daily Post and Mercury*, 4 June 1926), with Reilly as assessor and adjudicator of the competition entries. Entrants were invited to apply to the Town Clerk for 'a drawing, showing the general arrangement of the site, together with a copy of the printed Conditions and Instructions' and to include with their application a deposit of ten shillings which would 'be returned on receipt of a bona-fide set of drawings'. An upper limit of £10,000 was fixed for the estimated cost of erection (*Daily Post and Mercury*, 16 October 1926). The winning designer would be awarded a premium of £200 (payable within one month of the award being announced), that amount to be merged into the overall payment of 500 guineas as the work was carried out. A second place premium of £150 was created specifically for any entrant who was an ex-service man, with third and fourth place premiums, open to all comers, amounting to £100 and £50 respectively. The deadline for submission of designs to the Town Clerk's office was 30 September 1926 (*Daily Post and Mercury*, 4 June 1926).

By the time of the deadline, a total of 767 drawings and thirty-nine models had been received from 257 competitors 'from all parts of the United Kingdom, Canada and France' and, for one week from Monday 18th to Saturday 23rd October, were exhibited publicly in the Central Technical School, Byrom Street (*Builder*, 22 October 1926). The entries were judged anonymously by Reilly, and the

winners, agreed unanimously by the Committee, were announced on 15 October 1926. The first premium was awarded to Lionel Budden, M.A., A.R.I.B.A., of Liverpool; the second to Vernon Constable, A.R.I.B.A., of Dundee; the third to F. Hamer Crossley, A.R.I.B.A., of Wallasey, Cheshire; and the fourth to E. Berry Webber, A.R.I.B.A., of London (see *The Builder*, 22 October 1926, for reproductions of all four premiated designs). As Constable had not served in the war his premium for second place was, in accordance with the conditions of the competition, reduced to £100, while the premium awarded to third-placed ex-service man Hamer Crossley was increased to £150 (*Daily Post and Mercury*, 16 October 1926).

On 3 March 1927 the *Daily Post and Mercury* reported that the Committee had recently accepted William Thornton & Sons' tender of £178 to relocate the *Statue of Lord Beaconsfield*, and by 8 March the work had been carried out (*Daily Post and Mercury*, 9 March 1927). With the centre of the Plateau now clear for the first time since 1883, a number of local people saw enormous merit in keeping it that way (see correspondence in, e.g., *Daily Post and Mercury*, 29 March 1927, and *Daily Post and Mercury*, 2 April 1927). Not only was there now an unimpeded view of the east façade of Liverpool's most admired civic building, but the city had also regained a majestic open space suitable for official pageants (*Builder*, 29 July 1927: 156).

Despite the many doubts raised over the suitability of the *Cenotaph*'s proposed location, both in the local press and in *The Builder* (see, e.g., 25 March 1927: 471, and 5 August 1927: 193), the Corporation was not to be swayed from its course. On 13 June 1927 the Committee invited tenders for the *Cenotaph*'s

erection, setting the deadline for the 17th of that month (*Daily Post and Mercury*, 13 June 1927). The earlier sporadic objections finally found their official voice in the form of a petition signed by 34 local architects, requesting that a full-scale model of the *Cenotaph* be placed *in situ* for a period of about four weeks so that the public could judge the effect for themselves, before any final decision was taken. The Committee objected that the protest had been left rather late. Here *The Builder* (22 July 1927: 118) rose to the petitioners' defence, pointing out that the competition conditions had led all to believe that a full-scale model would be erected *in situ* for a period long enough for those interested to be able to assess the *Cenotaph*'s effect on St George's Hall. Instead, the model 'was erected "so early in the morning", and removed before an inspection could be made'. The only justification for this apparent subterfuge – which Tyson Smith seems to have related to an interviewer many years later – was that 'there were rumours abroad that plans were afoot to wreck [the model]' (Brack, 1968: 51).

On 27 July 1927 the Council considered the architects' petition, but its case was evidently lost the moment it was revealed that eleven of the signatories had in fact applied for competition conditions and that nine of those eleven had been unsuccessful competitors. This disclosure led to much derisive laughter in the Council Chamber and the meeting went on to vote by 66 votes to 18 to accept a tender of £8,356 from A.E. Bradley & Co for the *Cenotaph*'s construction, as originally proposed, in the centre of the Plateau (*Daily Post and Mercury*, 28 July 1927).

Professor Reilly, at least, was convinced that Budden's *Cenotaph* would complement St George's Hall. In selecting Budden's design, he

had borne in mind that a horizontal monument, located in the centre of the Plateau, would provide the most harmonious foil both to the strong verticals of the colonnade of the east portico of St George's Hall, and to the lofty column of the nearby *Wellington Monument*. Also, as befitting the classical lines of the Hall, he had gone for a design whose horizontal mass was composed with the utmost 'dignity, simplicity and reserve'. Such qualities, he felt, would also express an 'idea of permanence and immovability' suitable to a Cenotaph (*Daily Post and Mercury*, 16 October 1926).

By mid-August 1927, building operations had begun (*Daily Post and Mercury*, 16 August 1927). In May 1930, Sir Thomas White, the new Chairman of the Cenotaph Committee (Salvidge had died in 1928), announced his expectation that the memorial would be ready for unveiling by Armistice Day (11 November) that year. The architectural part of the *Cenotaph* had been virtually completed by March 1928 (as can be seen in a photograph in the *Daily Post and Mercury*, 14 March 1928), but the sculptural elements were evidently taking considerably longer. The official line on the delay, as released to the *Daily Post and Mercury* (16 August 1930), was that it had been necessitated by the sculptor's admirable determination to work without assistance, in order to preserve 'the personal touch'. Nevertheless, he had some time ago cast the clay models in plaster and sent them in sections to the founders in London.

Roderick Bisson (1965: 169-70) was later to give a rather more pragmatic set of reasons for the delay. According to Bisson, Tyson Smith had only been obliged to take on the whole project by himself when the main contractor had gone bankrupt. To make matters worse, this was one of the busiest periods of the

sculptor's career. Since 1927, he had been engaged in designing and supervising the execution of the extensive sculptural programme for Rowse's Martins Bank (completed 1932; see below, pp. 241–43). Then there was the *Fleetwood War Memorial*, also begun in 1927, for the execution of whose sculptural parts he was solely responsible. Contrary to Tyson Smith's assertion in the above-cited newspaper report that he had been working on the *Cenotaph* models 'unremittingly for two years', Bisson states that the sculptor had felt obliged to devote his daytime studio hours to the work he was engaged upon for Rowse with the consequence that the *Cenotaph* reliefs could only be worked on at home in the evenings.

The question of exactly when Tyson Smith joined Budden on the commission is also unclear. Certainly the designs submitted to the competition in the summer of 1926, which include rough sketches for the two long relief panels, are signed solely by Budden. The two men had, however, already collaborated on the *Birkenhead War Memorial* (1923-25), so Tyson Smith may well have been involved from the very beginning. Whatever the case, the reliefs as executed by Tyson Smith reveal considerable differences from Budden's original sketches (reproduced in *The Builder*, 22 October 1926). The relief facing Lime Street had been imbued with contemporary significance by the substitution of modern costume for the generalised 'rustic dress' of the original mourning group, and by the replacement of the original blank bankground with a representation of a vast Imperial War Graves Commission Cemetery (Compton, 1989: 89). The relief facing St George's Hall had also been transformed, with the naturalistically grouped marching soldiers of the sketch replaced by Tyson Smith's 'serried ranks', the formal rhythm of whose progress

across the frieze has been seen as 'almost futurist' (Compton, 1989: 89).

By mid-August 1930 all but one of the sections of the reliefs had been cast in bronze (*Daily Post and Mercury*, 16 August 1930) and by October it was clear that White's hopes for an Armistice Day unveiling were to be fulfilled (*Daily Post and Mercury*, 24 October 1930). The unveiling took place before an estimated 80,000 people at 11 a.m., immediately prior to the two minutes' silence. The veil was, 'a vast green cloth to which 12,000 poppies had been sewn by hand, and which also bore a Union Jack, and, in scarlet the word "Triumph".' (Boorman, 1988: 154). Remarkably, it had been intended that there should be no religious aspect to the ceremony so as to avoid any hint of divisive sectarianism. This, however, incurred such widespread criticism that in the end representatives of all the main religious communities were invited to take part in the ceremony (Boorman, 1988: 154).

Although not everybody was convinced of the aesthetic quality of the *Cenotaph*, or the prudence of its location, Reilly remained convinced of its success on both counts. Invoking antique precedence, he confidently declared, '...it will be seen that Liverpool has placed in front of her finest building, as the Greeks placed in front of their temples, a great altar' (letter to the *Daily Post and Mercury*, 12 July 1930). Nevertheless, he did concede that the Plateau now looked cluttered. The fault, though, lay not with the *Cenotaph*, but with the four recumbent lions and two equestrian statues which, he insisted, were inappropriate for what should be an august, architecturally-determined, open space. He suggested that the four lions be relocated to the area around the base of the *Wellington Monument* and the two equestrian statues 'to a site flanking the steps of the

William Brown Museum'. In his opinion the *Cenotaph* was of such importance that nothing should be allowed to 'mar its scale or... iiinterfere with its significance'. These suggestions were, of course, never taken up.

The *Liverpool Review* (1930: 483-84) backed Reilly absolutely, praising the *Cenotaph* and expressing itself happy to be able to contradict those who had in recent years been denying the need for such a memorial so long after the war. 'The younger generation', the journal declared 'may not understand the War, but there are still many thousands who gave their sons and daughters during that dread time, whose hearts feel the loss of blood so mercilessly shed'.

Sadly, this 'younger generation' were soon to understand only too well the grief and suffering of a World War. Following the end of the Second World War, most towns and cities throughout the Empire and Commonwealth, rather than erect new memorials, simply rededicated existing cenotaphs to commemorate the dead of both conflicts, adding the dates of the Second World War to those of the First.

Thus, in October 1946, Liverpool Corporation General Purposes Committee approved the addition of the dates '1939 – 1945' to the *Cenotaph*. This was carried out in time for a second unveiling at the Remembrance Sunday ceremony on 10 November 1946. The *Daily Post* (11 November 1946) reported: 'A few minutes before the guns signalled the Two Minutes Silence, the Lord Mayor (Alderman W.G. Gregson) pulled a cord and two Union Jacks at either end of the Cenotaph fell to reveal the newly-carved figures "1939 – 1945".'

Literature: (i) LRO (a) newscuttings – *Builder* (1926) 22 October, in *LCM*; *Builder* (1927) 24 June, in *LCM*; *Courier* (1926) 24 February, in *LCM*; *Daily Echo* (1927) 3 March, in *LCM*; *Daily Echo* (1927) 4 March, in *LCM*; *Daily Echo* (1932) 9 May, in *LCM*; *Daily Post and Mercury* (1925) 3 December, in *LCM*; *Daily Post and Mercury* (1926) 3 February, in *LCM*; *Daily Post and Mercury* (1926) 4 June, in *LCM*; *Daily Post and Mercury* (1926) 16 October, in *LCM*; *Daily Post and Mercury* (1927) 3 March, in *LCM*; *Daily Post and Mercury* (1927) 9 March, in *LCM*; *Daily Post and Mercury* (1927) 29 March, in *LCM*; *Daily Post and Mercury* (1927) 2 April, in *LCM*; *Daily Post and Mercury* (1927) 4 April, in *LCM*; *Daily Post and Mercury* (1927) 13 June, in *LCM*; *Daily Post and Mercury* (1927) 28 July, in *LCM*; *Daily Post and Mercury* (1927) 16 August, in *LCM*; *Daily Post and Mercury* (1928) 14 March, in *LCM*; *Daily Post and Mercury* (1929) 15 March, in *LCM*; *Daily Post and Mercury* (1930) 12 July, in *LCM*; *Daily Post and Mercury* (1930) 15 July, in *LCM*; *Daily Post and Mercury* (1930) 26 July, in *LCM*; *Daily Post and Mercury* (1930) 16 August, in *LCM*; *Daily Post and Mercury* (1930) 8 November, in *LCM*. (b) related documents: *The Liverpool Cenotaph* (official programme of the unveiling ceremony, 11 November 1930), in *LCM*; 'Proposed Cenotaph. Report of Professor C.H. Reilly, M.A.,...February 22nd, 1926', *Proceedings of the Council*, in *LCM*; Town Clerk's Office (1926) June, *City of Liverpool. Cenotaph (Special) Committee. Architectural Competition for a Cenotaph for Liverpool. Conditions*, in *LCM*; (c) George Herbert Tyson Smith Archive, Boxes 2, 7, 57. (ii) WAG JCS files: photocopies of newscuttings, etc: *Daily Echo* (1930) 24 October; *Daily Post and Mercury* (1930) 24 October; *Daily Post and Mercury* (1930) 1 November; *Evening Express* (1926) 9 June; *Liverpool Review* (1930) v: 483-84. (iii) *Architects' Journal* (1930) 19 November: 762-63; Bisson, R. (1965): 169-70; Boorman, D. (1988): 2, 153-54; Borg, A. (1991): 132; Brack, A. (1968): 51; *Builder* (1927), 25 March, cxxxiii: 471; *Builder* (1927), 1 July, cxxxiii: 9; *Builder* (1927), 15 July, cxxxiii: 80, 85; *Builder* (1927), 22 July, cxxxiii: 118, 123; *Builder* (1927), 29 July, cxxxiii: 156; *Builder* (1927), 5 August, cxxxiii: 193, 194, 196, 200; *Builder* (1927), 19 August, cxxxiii: 271; *Builder* (1927), 16 September, cxxxiii: 419; Compton, A., 'Memorials to the Great War', in P. Curtis (ed.) (1989): 89-90; Curtis, P. (1988): 6; *Daily Post and Mercury* (1930) 12 November: 9, 10; *Daily Post* (1946): 3; Davies, P. (1992): 66, 73-74; Penny, N. (1981): 38; Pevsner, N. (1969): 158; Poole, S.J. (1994): 108-18, 327, 376; Richardson, A. (1990): 3-4; *University of Liverpool Recorder* (1956) October: 5; WAG (1975): 30-31; Whittick, A. (1946): 6.

MONUMENT PLACE

Equestrian Monument to King George III

George III (1738 – 1820) reigned from 1760, although from 1810 he suffered a complete mental collapse, necessitating the regency of his son (the future George IV). A simple, pious and kindly man, he was popular throughout the kingdom, although his lack of sophistication and his political ineptitude incurred the contempt of London society (source: Palmer, 1983).

Sculptor: (Sir) Richard Westmacott

Statue in bronze
Pedestal in Westmorland granite

Statue: h: 10' (3.05m)
Dado and cornice: h: 10' 9½" (3.29m); l: 7' (2.13m); w: 3' 8" (1.12m)
Plinth: h: 3' 6" (1.07m); l: 9' (2.74m); w: 5' 8" (1.73m)
Pedestal overall h: 14' 3½" (4.36m)
Monument overall h: 24' 3½" (7.4m)

Inscriptions:
– left side of the pedestal: IN COMMEMORA-TION / OF THE 50TH ANNIVERSARY / OF THE ACCESSION / OF HIS / MOST GRACIOUS MAJESTY / KING GEORGE III. / TO THE THRONE / OF THESE REALMS.
– right side of the pedestal: ERECTED / BY / PUBLIC SUBSCRIPTION

The statue was erected Monday 30 September 1822.

Owner/ custodian: Liverpool City Council
Listed status: Grade II

Description: The statue originally stood on the central axis of Monument Place, but some years prior to 1910 was moved westward 'to facilitate the laying out of the surrounding ground in an ornamental manner' (Touzeau, 1910, ii: 755). The design of horse and rider is taken from the 2nd-century A.D. bronze Equestrian Statue of Marcus Aurelius in Rome (then in Piazza del Campidoglio, now Museo Capitolino): King George is represented in a short Roman tunic, military cloak and sandals. He rides without a saddle and is 'stretching forth his paternal hand over his people' (*Gentleman's Magazine*, 1822, as quoted in Haskell & Penny, 1981: 255).

Condition: All the metal letters are replacements and the present 'T' of THRONE and 'U' of PUBLIC are damaged. The bronze rider and horse are in fair condition, as is the pedestal.

Related works: (Sir) Richard Westmacott,

Equestrian Statue of King George III, bronze, Windsor Great Park, 1831. Derived, like the Liverpool statue, from the *Equestrian Statue of Marcus Aurelius*

After its switch from Whig to Tory at the accession of King George III in 1760, Liverpool Town Council remained largely supportive of the monarch, despite his bouts of mental instability. The *Equestrian Statue of King George III* was proposed as Liverpool's own contribution to the nationwide celebrations of his jubilee, to be erected by a combination of public subscriptions and a donation of £500 from Corporation funds (Touzeau, 1910, ii: 755). On 17 October 1809, a Memorial Committee was appointed, including William Roscoe, John Gladstone, the Revd Jonathan Brooks, John Foster Snr and the then Mayor of Liverpool, John Clarke (*Records...* 1/1). On 25 October 1809, the Mayor laid the foundation stone in Great George Square (*Records...* 1/2). A plate was affixed to the foundation stone, expressing the intentions of the subscribers (as recorded in *Gore's Directory*):

> This Stone, the foundation of a Statue, erected by public subscription, in commemoration of the 50th anniversary of the accession of his most gracious Majesty George the Third to the throne of these realms, was laid on the 25th day of October, 1809, by John Clarke, Esq., Mayor of Liverpool.

The subscription appeal does not seem to have aroused much public support. The required amount was not reached and presumably any further incentive to commemorate the

King dissolved with his collapse into permanent mental illness at the end of 1810 and the resultant declaration of the Regency in early 1811 (Yarrington, 1989: 26).

The subscription fell into abeyance until 30 August 1815 when, following the cessation of the costly war with France, the Committee resolved to seek designs from Richard Westmacott, John Bacon the Younger and Matthew Cotes Wyatt, with a brief limiting the cost of the statue to a maximum £2,700 (*Records...* 1/3). Westmacott had, in fact, been in communication with John Foster Snr on the subject of the *Equestrian Statue of King George III* as early as 25 September 1809, whilst he was still hard at work on the *Monument to Lord Nelson* (*Records...* 2/1). His estimates at this time had been £5,000 for a statue in bronze and £2,000 for one in Portland stone with the reservation that the latter, if selected, would require heaps of trophies etc. to be piled under the horse to help its relatively slender legs support the weighty mass of stone which formed the horse's body and superincumbent rider. Putting the prestige of an equestrian commission in England before financial gain, Westmacott, on 15 July 1811, submitted a reduced estimate to the Committee:

> This composition, the principal figure or Statue of the King to a scale of six feet six inches in height executed of Bronze will amount to the Sum of Three Thousand Pounds.
> This estimate does not include the Pedestal or Foundation, packing cases or carriage to Liverpool (*Records...* 2/3)

In the accompanying letter he proffered the suggestion that the King be portrayed in the 'Habit and Robe of the Order of the Garter' in order to avoid modern costume. (The unsculp-

tural nature of contemporary male attire was to be a constant aesthetic problem to portrait sculptors throughout the century, cf. Hamo Thornycroft, pp. 44–5; George Frampton, p. 137.) Westmacott advised the Committee that he had prepared drawings of the horse in action, but had found achieving the required balance very difficult and presumed (or perhaps hoped) that the Committee would in any case prefer to present a more reposeful image of the King (*Records...* 2/2). The Committee found even Westmacott's newly reduced price too high for the funds at its disposal and on 27 July 1811 the sculptor wrote again to Foster, informing him that his estimate of £3,000 could not be reduced further unless the Committee was willing to reduce the height of the figure of the King to six feet, in which case the price could be lowered to £2,500. Westmacott clearly did not wish to lose the commission for he at this point stressed not only the extreme skill involved in the execution of equestrian statues, but also emphasised the advantage he enjoyed over any rival in being able to cast it himself at his own foundry (*Records...* 2/5). It is at this point that the project seems to have been temporarily shelved.

When Foster informed Westmacott on 2 October 1815 that the project had been revived, the sculptor responded enthusiastically (although not until 12 October, as he had been in Paris visiting the Louvre in order to see Napoleon's plundered art treasures prior to their restitution). Despite his 1811 costs estimate remaining unchanged, he agreed to drop his price to £2,700, purely, he admitted, for the rare opportunity of executing an equestrian statue (*Records...* 2/7).

Notwithstanding this generous reduction, there next followed a delay of over two years. This was due perhaps partly to the Committee's continued efforts to raise sufficient subscrip-

tions, and partly because it had been negotiating a more prominent site for the monument on London Road, 'the commanding entrance into the Town' (*Records...* 14). The new site having been agreed, on 14 January 1818 the Committee requested John Foster's son, John Foster Jnr, to contact the same three sculptors as before, along with 'any other artist he may think proper' with a view to obtaining design submissions from them. The brief was now more fully defined in that it stipulated that the figure of the King was to be not less than eight feet high. There was also a provision that the sculptors whose designs were not chosen would each receive a remuneration of ten guineas. That the total funds available for the statue itself were still uncertain is suggested by the blank space left in the Memorial Committee's minutes where the price should have been entered (*Records...* 1/4).

In a letter of 24 February 1818, Westmacott advised the Committee that his design submission, a sketch model, was on its way to them by coach. The (revised) composition was, he explains:

> ...formed upon the celebrated Equestrian Statue of M. Aurelius now existing on the Capitol at Rome of which I have many studies and also the advantage of Casts from the original. The scale at which I propose its execution would be that of the Statue at Charing Cross [i.e. Hubert Le Sueur's *Charles I*] & I would engage to complete it in Bronze & deliver it at the Paddington Canal for the Sum of £3,000 (*Records...* 2/8).

On 13 April 1818, the Committee approved Westmacott's model, confirmed £3,000 as the price and officially awarded him the commission, subject to terms being agreed (*Records...* 1/5). Westmacott wrote to the Committee on

17 April, confirming his acceptance and 'cautiously' estimating a period of three years to complete the work. Usually in commissions of this kind payment would have been in equal thirds: the first at exchange of contracts, the second on confirmation that the full-size model had been completed and the third at completion of the finished piece. Westmacott, however, cognisant of the fact that the full £3,000 would only be reached by the accumulation of interest, helpfully suggested a first payment of one-sixth (£500) only, the deferred £500 to be added to the second payment at completion of the model. In answer to the Committee's request for an expert in London who would be prepared to report to them on the progress of the work, Westmacott suggested the celebrated portrait painter, Sir Thomas Lawrence R.A. (P.R.A. from 1820; (*Records...* 2/10). The details having been agreed by both parties, Westmacott sent his draft contract to the Committee, the terms and conditions were confirmed, and the final contract was signed on 11 May 1818. The contractual specifications for the statue were that it should be:

Nine feet four inches in height including Man and Horse by Eight feet Six inches in length being to the scale and proportion of the Equestrian Statue of King Charles I erected and now standing and being at Charing Cross...[and that it] shall be of good Bronze Metal (*Records...* 4).

By 14 February 1820, Westmacott was able to report that the figure was modelled, all but the head, and that various parts of the horse were ready for casting and waiting only for 'the weather [to] allow me to run the moulds without risk' (*Records...* 2/14). The horse was cast in bronze by 13 October 1820 and, the model being no longer needed at the foundry,

Westmacott transferred it to his studio, so that he could sit the model of the King on it and seek the opinion of his friends and particularly that of Lawrence who did indeed make a few suggestions to which Westmacott duly attended. The sculptor then conveyed his intention to Liverpool that 'the King' would be cast 'early in the Spring or as soon as the severe weather leaves us...' (*Records...* 2/17). On 3 April 1821, he reported that the 'lower limbs of the King' were by now 'in metal' and he expressed the hope that the casting would be complete by the end of the summer.

Despite the interest accrued on the fund, it had in the meantime become obvious that the total was not going to reach the necessary £3,000 and on 25 July 1820, the Committee agreed to petition the Nelson Memorial Committee to grant them 200 guineas out of their surplus of £850 (*Records...* 1/8). (It is indicative of the difference between the public's enthusiasm for Nelson and their relative lack of it for the debilitated – and, since 29 January 1820 deceased – monarch, that the Nelson Fund had accrued such a surplus, whereas that for the monarch had failed to reach target even after several years extension to allow interest to accumulate. The money was eventually granted by the Common Council of Liverpool on 7 March 1821 (*Records...* 1/7; 11) and, on 22 March, John Foster Jnr was authorised to contract out for the pedestal and ensure that it was ready in time for the statue's arrival in Liverpool (*Records...* 1/6). The pedestal was executed by Frank Webster of Kendal for the sum of £300, paid out on 2 February 1822 (*Records...* 1/9; Webster's bill, dated 26 January 1822, *Records...* 9/4). It was erected by William Hetherington of Liverpool (*Records...* 14).

The bronze statue was shipped to Liverpool on 20 August 1822 (*Records...* 2/20). By 16

November, Westmacott had received his final payment, at which time the Committee asked his advice on the type of lettering that should be used on the pedestal. They evidently wanted bronze letters, but Westmacott warned that they could never be fixed securely enough to prevent theft. He suggested incised lettering, but added shrewdly that should they be determined to have bronze letters he, of course, could produce them in his foundry (*Records...* 2/22). This he ultimately did (and, as he predicted, all of the original letters were stolen).

Literature: (i) LRO manuscript source: *Records relating to the statue of King George III, 1809-1822.* (ii) 'Annals of Liverpool', in *Gore's Directory*; Busco, M. (1994): 65-69; *Gentleman's Magazine* (1822) xcii, ii: 453; Haskell, F., and Penny, N. (1981): 255; *Mercury* (1822) 27 September: 110; Picton, J.A. (1875, revised edn 1903), ii: 316-17; Touzeau, J. (1910) ii: 755; Yarrington, A., 'Public Sculpture and Civic Pride 1800 – 1830', in P. Curtis (ed.) (1989): 22, 26-27.

PRINCE OF WALES HOTEL (public house), c.1870-80, 225-27 London Road, on the corner of Moss Street.

Owner of building: unknown (for sale or lease at time of writing)
Listed status: Grade II

Portrait statues in exterior niches at the first floor level:

Edward, Prince of Wales and **Alexandra, Princess of Wales**

Sculptor: unknown

Statues in sandstone

h: over life-size.

Description: The statues are set into niches on the first floor level at the extreme ends of the

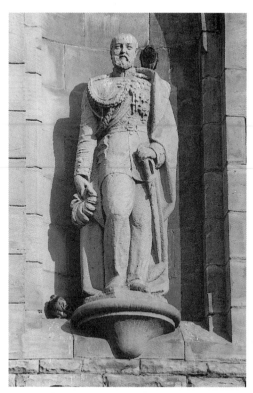

curving façade at the junction of London Road and Moss Street.

Condition: Both figures are very weathered, although there appear to be no significant losses.

Lord Street

Formerly in the display window of JOHNSON'S TV SHOP (no longer in business): *Printed Circuit*

Sculptor: Arthur Ballard

Mural in mixed media: wire mesh, sheets of welded copper and zinc, plaster

h: 126" (320cms); w: 69" (175cms)

Owner: Professor J. Quentin Hughes
Status: not listed

Condition: good.

According to Professor Quentin Hughes (in a letter, dated 12 June 1994, to the author), he commissioned the mural on behalf of the owners of Johnson's TV shop. Intended for placement in the shop window, the idea was that only three televisions would be on display at any time and that these would be set off by the mural behind them and three metal *objets trouvés* in front. These latter were supplied by an (unidentified) member of the Liverpool School of Art staff. Ballard had never worked with metal on such a scale before, had little knowledge of welding, but was keen to attempt something new. The outcome could have been a disaster. Instead it was, at least in John Willett's estimation (1967: 98), the 'best modern Liverpool mural'. When the owners moved premises, they offered the work to Hughes, who willingly accepted it and hung it in his room at the Liverpool School of Architecture, where it remained until he retired. Unable thereafter to accommodate it, he requested that the University keep it in store until a suitable new location could be found. At the time of writing it is still in store at the University.

Literature: Willett, J. (1967): 97-8.

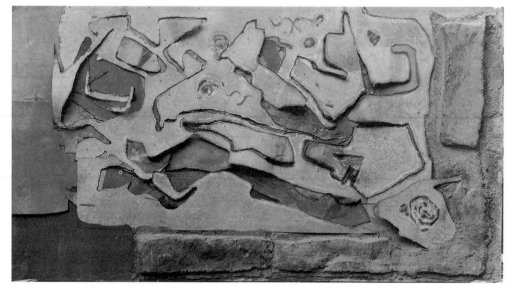

Marybone

In the garden of MAZENOD COURT:

Hannah Mary Thom
Memorial Drinking Fountain

Born Hannah Mary Rathbone (1817 – 72), she was a daughter of the William Rathbone commemorated in Sefton Park (see below, pp. 186–90) and elder sister of the William Rathbone commemorated in St John's Gardens (see below, pp. 171–73). She married the Liverpool Unitarian minister, the Revd John Hamilton Thom (a locally admired philanthropist) and endeared herself to the poor people of the Marybone area both through her works of charity amongst them and her efforts as Lady Superintendent of District Nurses (*source: Daily Post and Mercury, 17 May 1928*)

Designers: Wills Bros

Statue in bronze
Base of statue in *Nabresina* (Yugoslavian limestone)
Basin in Aberdeen granite

Founders: The Coalbrookdale Company

h. of bronze statue: 49" (124.46cms)
h. of limestone base of statue: 8" (20.32cms)
h. of granite basin: 39¼" (99.7cms)

Inscription around the circular stone base:
This Fountain was erected to the memory of
HANNAH MARY THOM / BORN NOVEMBER
24TH 1817. DIED DECEMBER 31ST 1872 / by
many friends in this neighbourhood whom she
visited in sickness and sorrow
Note: the original fountain (now demolished)
also bore the inscription: 'This memorial is in
the care and trust of the priests and parishioners
of Holy Cross Parish' [as transcribed in LRO –
Photographs of Statues...: 66].

Inscribed on the right of the bronze base:
WILLS BROS. Sculpts. London
Inscribed on the left of the bronze base:
CAST BY THE COALBROOKDALE / COMPANY
Inscribed on the top face (now concealed) of
the circular stone base: JAMES MCLAUGHLIN /
SCULPT / MILES BOUGHTON *[sic]* / ARCHT /
LIVERPOOL / AUGUST 1987

The restored fountain was unveiled by R.S.
Rathbone, Friday 11 September 1987.

Owner/ custodian: Liverpool City Council
Status: not listed

Description: A female figure in bronze, representing *Temperance*, pours water from a pitcher into a vase. The figure surmounts a drinking fountain (no longer active) consisting of a circular, shallow basin on a stem.

Condition: According to Miles Broughton (in conversation with the author), the Aberdeen granite basin is original, but the base to the statue, which was of less durable white Sicilian marble, had perished and has been replaced with one of Yugoslavian limestone. The letters of the inscription on the base, which had been of lead, had all been lost. The present inscription faithfully follows the wording of the original as recorded in the *Daily Post and Mercury* (17 May 1928), but the new lettering is incised and the Gothic lettering style is conjectural. Prior to its restoration, the figure had lost both its pitcher and vase, as well as its right arm. The missing parts were replaced and the figure

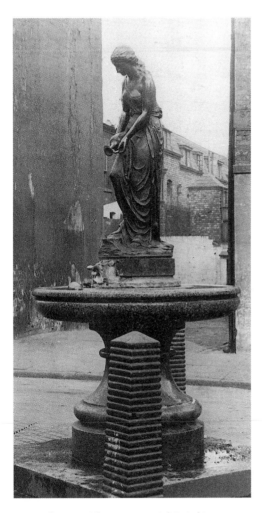

Hannah Mary Thom Memorial Drinking Fountain in its original location in Standish Street.

restored by Jim McLaughlin of the Merseyside Sculptors Guild, with only the engraving in *Art-Journal* (1861: 149) and the 1928 newspaper photograph as guides. The casting was carried out at Lunts of Birmingham (formerly operating as Morris Singer).

Related works: (i) drinking fountain, Queen Victoria Street, by Blackfriars Bridge, London, EC4, signed by Wills Bros and the Coalbrookdale Company; the figure and granite basin are identical. Commissioned by Samuel Gurney, M.P., for erection outside the Royal Exchange, London (*Art-Journal*, 1861: 148). (ii) Gurney so liked the figure that he commissioned another version for himself, in marble (*Art-Journal*, 1861: 148; see below); present location unknown.

Related work exhibited at Royal Academy of Arts 1860 (cat. 1091), as *Model of a drinking fountain, subject, Temperance, in marble.*

Erected (after 1872) by a public subscription amongst the poor of the Marybone area, to whom Hannah Thom had administered as Lady Superintendent of District Nurses, by 1928 the fountain had already been vandalized and the pitcher stolen (*Daily Post and Mercury*, 17 May 1928). The parish priest eventually had the fountain's figure stored for safety in the local Holy Cross Church where it remained for many years until it came to the attention of Miles Broughton, Chairman of the local Victorian Society, who organised a subscription to pay for the restoration of the figure and the fountain and their re-erection. Originally located in the middle of Standish Street, the fountain now stands, still visible from the road but relatively safe from vandalization, in the grounds of Mazenod Court sheltered accommodation.

Literature: *Art-Journal* (1861): 148-49; *Daily Post and Mercury* (1928) 17 May: 5; Richardson, A. (1990): 37-8.

Mathew Street

Close to the South John Street end, high up in a niche on the lefthand side of the street:

Four Lads Who Shook the World
This is the sculptor's play on the title of John Reed's eye-witness account of the Russian revolution, *Ten Days that Shook the World* (1919), published in England by the British Communist Party in 1926. The 'Four Lads' are the Beatles – John Lennon, Paul McCartney, George Harrison, and Ringo Starr (Richard Starkey). Born in Liverpool, they together formed the most successful and influential pop group of all time. With the exceptional song writing talents of Lennon and McCartney, they dominated and transformed the UK and US pop scene during the 1960s, opening up hitherto unimagined possibilities for popular musical expression, aided greatly by the sensitive and imaginative guidance of their classically-trained producer, George Martin. The group finally broke up in 1970.

Sculptor: Arthur Dooley

Mixed media: wood, bronze and plastic baby dolls

h. of niche: 91" (231cms); w: 45½" (115.5cms).

Inscriptions within the brick niche:
– on a 'street sign' above the head of 'Mother Liverpool':
BEATLE / STREET / Liverpool Four
– on a rectangular plaque below her feet: FOUR LADS / WHO SHOOK / THE WORLD
Inscription on the plaque below the niche (removed during the summer of 1994):
10 yards from this point across the street was the / entrance to the famous CAVERN CLUB. / The Club hit the headlines in 1962 as the launching / platform for the most successful climb to fame of / any act in showbusiness – / THE BEATLES / Many other famous people have since appeared on the / CAVERN stage including such names as / THE ROLLING STONES – ARGENT – GARY GLITTER – / WILSON PICKETT – HERMANS HERMITS – CILLA BLACK – / FREDDIE STARR AND THE MIDNIGHTERS – GERRY AND / THE PACEMAKERS – THE SEARCHERS – ETC. – ETC. /

On May 27th 1973 the old CAVERN closed to make way / for an excavation shaft from a new underground / railway link line – the CAVERN was moved across the / street to its present position. / In 1976 it was decided that the CAVERN was due for a / Revolutionary change of style – hence the cavern club / now incorporated the new title REVOLUTION CLUB. / High above the door is a plaque sculpted as a tribute / to the BEATLES by famous local sculptor Arthur Dooley. / It shows the Mother figure of Liverpool holding 3 / cherubs representing John, George and Ringo – Paul has / Wings and has gone off on his own. / The plaque was presented to the city by ROY ADAMS of / Cavern Enterprises Ltd and unveiled by TOM O'CONNOR / and the SPINNERS. Others now famous who have appeared / at the CAVERN – BEN E. KING – THE WHO – CHUCK / BERRY – THE SHADOWS – ROD STEWART – / HOWLIN' WOLF – MUDDY WATERS – THE SPINNERS – / STATUS QUO – FAMILY – STEVIE WONDER – THE ANIMALS.

Two further wooden plaques were placed either side of the niche following the murder of John Lennon in 1980:
– inscription on the plaque to the left of the niche:
How lonely she is now / The once crowded city! / Widowed is she / Who was mistress over nations; / The princess among provinces / Has been made a toiling slave. / *[space]* / Bitterly she weeps at night, / Tears upon her cheeks / With not one to console her / Of all her dear ones; / Her friends have all betrayed her / And become her enemies. / *[space]* / The old man has abandoned the – / gate, / The young man his music; / The joy of our hearts has ceased. / Our dance has turned into mourning. / Lead us back to you O Lord / That we may be restored. / Give us anew such days as we – / had of old. / We need a start! / *[space]* / Apologies in *[sic]* Lamentations of Jeremiah A.D. 1984
– inscription on the plaque to the left of the niche:
Imagine theres no heaven, / Its easy if you try, / no hell below us, / above us only sky's. *[sic]* / *[space]* / Imagine no possessions, / I wonder if you can, / no need for greed or hunger, / a brotherhood of man. / John Lennon, 1971.

Unveiled by Tom O'Connor and the Spinners, Saturday 20 April 1974

Owner: untraced
Status: not listed

Description: Within a niche formed by a bricked-up window (opposite the site of the original Cavern Club), a cloaked female figure, *Mother Liverpool*, holds three babies (gold-painted plastic baby dolls) in her arms. Originally Dooley placed a fourth to the right, but still within the niche; it was winged and blew upon a trumpet: this was Paul McCartney, the first Beatle officially to split from the group, the wings punningly referring to McCartney's new group of the same name. Following John Lennon's murder on 8 December 1980 the composition was re-arranged. The winged doll was removed, and another doll, representing Lennon, holding a guitar, its head surrounded with a halo inscribed "Lennon Lives", was placed to the right of the niche. The appropriately inscribed plywood plaques either side of the niche were also set up at this time: that to the left bears quotations from *The Lamentations of Jeremiah*, specifically 1:1,2 and 5:14, 15, 21, with the addition of an original last line, 'We need a start!'; that to the right quotes the first two verses of John Lennon's song, *Imagine*. Above the niche, the street sign bearing the name 'Beatle Street Liverpool Four' is another Dooley pun, the street actually being in Liverpool 2.

Condition: Given the nature of Dooley's approach to sculpture, it is difficult to say what is decrepit and what intentionally ragged-looking. It can be stated with certainty, however, that the plywood inscription plaques are, at the time of writing (early 1994), in poor condition – the lefthand plaque now tattered, peeling and almost unreadable; the righthand plaque less damaged, but the words to *Imagine* showing only faintly.

Postscript: The inscription plaque below the niche, detailing the history of the Cavern with an explanation of Dooley's sculpture, was removed during the summer of 1994 (its former position is marked by a plain brick rectangle, the wall having been painted black after the plaque was affixed). The inscription plaques either side of the niche were replaced in 1995.

The money for the memorial was raised by

Peter Price, a Liverpool club compère. The sculpture cost £500 and all the money left over was donated to the Liverpool Boys' Club (*Daily Post*, 22 April 1974). Dooley constructed the *Mother* figure himself, but the four 'Beatles' were, in fact, plastic dolls, bought from Woolworths and painted gold. He also made the street sign to go above the group; the *Post* reported that Dooley had hoped that the sign would generate a move to rename Mathew Street after the most famous stars of its world-famous club. The sculpture and sign were erected by George Pateman and John Kelly of the Cavern Club (*Daily Post*, 20 April 1974).

Literature: *Daily Post* (1974) 20 April: 1; *Daily Post* (1974) 22 April: 3; *Guardian* (obituary of Arthur Dooley, (1994) 17 January; WAG (1984a): 77, 80.

Opposite, in CAVERN WALKS, is located:

The Beatles
(for biographical details, see p.108 above)

Sculptor: John Doubleday

Group in bronze

Life-size

Inscriptions:
– on a plaque at the front of the platform by John Lennon's right foot:
THE BEATLES / This Statue which was sculptured by / JOHN DOUBLEDAY / was commissioned by Royal Life Insurance Ltd. / and donated to the City of Liverpool / on 26th April 1984 / the Statue was part funded by contributions / received from Beatles fans world wide.
– on a plaque to the right of the platform in front of George Harrison's right foot:
THIS PLAQUE IS TO COMMEMORATE / THE

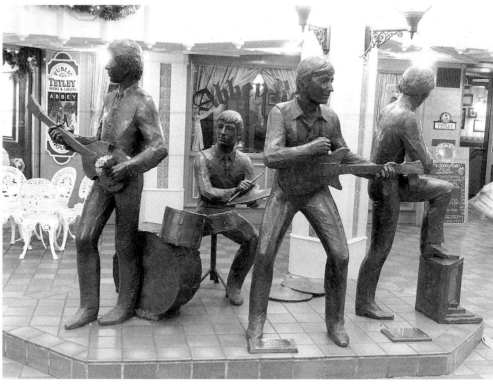

CHARITABLE WORK UNDERTAKEN / BY / "FATHER TOM MCKENZIE" / COMPERE TO THE BEATLES / WITH THANKS FROM BEATLES FANS WORLDWIDE

Unveiled by Mike McCartney, brother of Paul, Thursday 26 April 1984

Owner: Royal Life Insurance Ltd
Status: not listed

Condition: Good

Commissioned and currently insured by Royal Life Insurance Ltd, the present sculpture was originally intended for Chavasse Park opposite the Albert Dock, but 'was switched [to Cavern Walks] after plans for the park were postponed because of lack of resources' (*Daily Post*, 11 September 1987: 13).

Literature: *Daily Post* (1984) 26 April: 13; *Daily Post* (1987) 11 September: 13; WAG (1984a): 77, 80.

In a niche to the right of the entrance to FLANAGAN'S APPLE, 18 Mathew Street:

Bust of Carl Gustav Jung
(1875-1961) Swiss psychologist. From 1907-12 he was closely associated with Sigmund Freud, but later moved away from Freud's mechanistic psychological model, towards one which gave

the individual a more purposeful place in the universe. To balance the theory that an individual's behaviour is determined by a personal unconscious, Jung developed his theory of the collective unconscious which manifests itself in the recurrent phenomena, across ostensibly unconnected cultures, of archetypal images. Behaviour is further modified by the individual's aims and aspirations, his or her striving towards individuation – the achievement of psychic wholeness – the path to which is marked by images and symbols experienced in dreams and visions (source: *Oxford Companion to the Mind*).

Sculptor: Johnathon Drabkin

Bust in plaster, painted with bronze pigment

Over life-sized

Inscription on a stone slab set into the wall beneath the niche containing the bust: Liverpool / is the / pool of / life / C.G. Jung. 1927.

Signed across the shirt collar: J. Drabkin

Owner: Robert Burns (manager of 'Flanagan's Apple')
Status: not listed

Description: Located in a high, square niche to the right of the entrance to 'Flanagan's Apple', the bust is angled inwards to the left, so that Jung appears to be looking along, as opposed to straight across, the street. He is portrayed with a high-domed balding head and wears a moustache.

Condition: Good

The present bust was completed in July 1993, to replace an earlier bust which had been vandalised beyond repair. The first bust, by

Laurence Sidorczuk, was unveiled by the sculptor on 18 December 1987. According to Robert Burns (the patron of both busts), this first sculpture portrayed Jung 'from the waist up' and wearing spectacles. The spectacles and hands were removed by vandals and there was even an attempt to remove the head. Thus, the second bust, commissioned from local sculptor Johnathon Drabkin, was designed without detachable accoutrements and in a deliberately more robust, head-and-shoulders only, format (letter from Robert Burns to the author).

The inscription on the stone tablet below the niche, comes from the English translation of Jung's autobiographical *Memories, Dreams, Reflections* (1962, 1983 edn: 224). Jung never actually visited Liverpool, but in his book he recounts a dream he had experienced many years earlier, in which he found himself in the city on a cold and rainy winter's night with a group of Swiss friends. The city was dirty and sooty. He and his friends were walking through steep streets leading from the harbour. They eventually reached a plateau, around which all the quarters of the city were arranged radially. In the middle of the plateau, Jung saw a round pool, in the centre of which was an island. Despite the fog, rain and soot which obscured everything else, the island blazed with sunlight. In the middle of the island stood 'a single tree, a magnolia, in a shower of reddish blossoms'. From his friends' comments, Jung realised that only he could see the beautiful tree. It was at this point that he awoke.

He interpreted the dream as representing his situation at the time. The dark, cold and rainy streets were the period of doubt and uncertainty he had been going through:

> But I had had a vision of unearthly beauty, and that was why I was able to live at all.

Liverpool is the 'pool of life'. The 'liver', according to an old view, is the seat of life – that which 'makes to live' (Jung, 1962, 1983 edn: 225).

The beautiful magnolia tree at the centre of the plateau was the Self to which the goal of all psychic development should, in Jung's view, be directed:

> Through this dream I understood that the Self is the principle and archetype of orientation and meaning. Therein lies its healing function. For me, this insight signified an approach to the centre and therefore to the goal. Out of it emerged a first inkling of my personal myth (Jung, 1962, 1983 edn: 225).

Robert Burns adds to this a piece of local lore which tells that Jung further interpreted his dream of Liverpool as being prophetic of a cultural renaissance which would take place in Liverpool in the 1950s and '60s (letter from Robert Burns to the author). This, of course, provides the *raison d'etre* for a bust of Jung in this particular street, just a few doors along from the site of the Cavern Club from which the Beatles launched their world-dominating pop career in the early 1960s.

Literature: Jung, C.G. (1962, 1983 edn): 223-25.

Above THE BEATLES SHOP, 31 Mathew Street, is a half-length portrait group of the Beatles:

From Us to You
(for biographical details of The Beatles, see p. 108 above)

Sculptor: David Hughes

Group in bronze

Over life-size

Inscription on the plaque to the right of the shop doorway: FROM US TO YOU / THIS THE FIRST BEATLES STATUE IN / LIVERPOOL HAS BEEN FUNDED BY / BEATLES FANS FROM ALL OVER THE / WORLD AND SUPPORTED BY THE BEATLES / SHOP. THIS TRIBUTE TO THE WORLD'S / GREATEST GROUP WAS SCULPTED BY / LIVERPOOL ARTIST DAVID HUGHES / ERECTED 1984

Owner of shop and sculpture: Iain Wallace
Status: not listed

Condition: Good

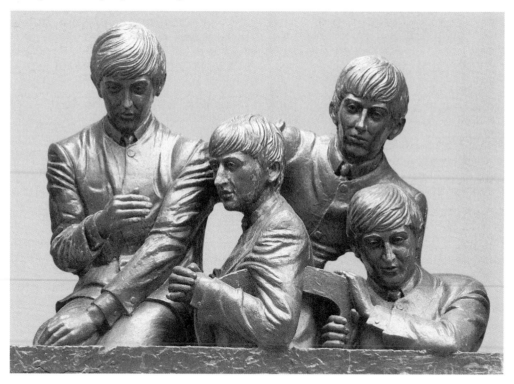

Thomas Bowden Memorial Fountain

Architect: unkown

Grey Creetown granite with bronze fittings

Inscriptions
– on a bronze plaque on the front face of the monument: THE / THOMAS / BOWDEN / FOUNTAIN / . . . / ERECTED / BY / HIS SISTER / 1911
– in raised lettering in a recessed panel, cut directly into the granite of the rear face of the monument: ERECTED BY / MRS. HUGH MCCUBBIN

Inaugurated Saturday 11 June 1911

Owner/ custodian: Liverpool City Council
Listed status: Grade II

Description: Located in Mill Bank at the junction with Queen's Drive West Derby, the fountain is in Edwardian Baroque style. The front and rear faces bear inscriptions and the side

faces each carry a basin. The fountain is surrounded by a low circular wall with an opening at each side for access to the basins. The *Daily Post & Mercury* (13 June 1911) described it as 'on slightly elevated ground, with a background of trees, the whole forming a pleasing feature of the landscape'.

Condition: No longer operational, the metal plates and spouts having been removed and the

exposed conduits blocked. At the time of viewing (early 1994) the basins were full of rubble. There is some graffiti.

Related work: *Frederic Bowden Memorial Fountain*, 1913, West Derby Road (see below, p. 245).

Erected in memory of the donor's late brother and intended for the use of the general public, the drinking fountain was accepted for the City at a formal inauguration, by Councillor W.H. Parkinson of the Health Committee. During his acceptance speech Councillor Parkinson offered condolences to Mrs McCubbin for the even more recent loss of her father (*Post and Mercury*, 13 June 1911). Nor were the luckless Mrs McCubbin's trials over, for her husband was to die later that year on 25 September 1911.

Literature: (i) LRO newscutting: *Daily Post and Mercury* (1911) 13 June, in *TCN 1/36*.
(ii) Richardson, A. (1990): 41-2.

Minster Court

Built as a Council-owned block in the 1930s, the flats were converted by Barratt Developments in the 1980s and are now privately owned. The residents pay for the upkeep of the flats and grounds, along with the sculpture on the landscaped beds to the right of the entrance (visitors should report first to the security lodge to the left of the entrance):

Renaissance

Sculptor: Seán Rice

Group in bronze, 1983

h. of group: 72" (182.9cms)

Signed on the upper surface of the bronze base: Rice of Liverpool

On the rear face of the base: Asst JR

Unveiled by the Rt Hon. Tom King M.P., then Secretary of State for the Environment, Friday 4 March 1983, to inaugurate the opening of the first five flats in the renovated and privatised block.

Owners: Minster Court residents
Status: not listed

Condition: Good

According to the sculptor (letter, dated 12 June 1994, to the author) *'Renaissance'* was commissioned by Barratt Developments specifically to commemorate the opening of the renovated flats. It was cast by Seán Rice and his wife, Janet – the 'JR' referred to by the monogram on the base – using the *cire perdue* process. Rice intended the aspiration of the young couple reaching up towards the dove of peace to symbolise the hope and rebirth embodied in the flats, saved from demolition and modernised for sale to young couples.

Literature: *Echo* (1983) 4 March: 3; Richardson, A. (1990): 37.

Mossley Hill Road

On what was once the croquet lawn, now a garden planted with rose beds, in the grounds of Sudley Art Gallery and Museum:

The Sudley Sundial
(The Hillsborough Memorial)

Designed by Larry Neild
Executed by David Strachan of Evans & Burkey, Monumental Sculptors, Smithdown Road, Liverpool.

Pedestal in black granite
Sundial in brass

Overall h. of pedestal: 40" (102cms)
– dimensions of plinth: h: 5¹/₂" (14 cms); w: 36" (91.4 cms); d: 24" (61cms)
– dimensions of cornice: h: 4" (10 cms); w: 20¹/₂" (52.1 cms); d: 19¹/₂" (49.5cms)

Inscriptions:
– on the front face of the pedestal, half encircling a rose: THE SUDLEY SUNDIAL
below the rose: TIME MARCHES / ON / BUT WE WILL / ALWAYS / REMEMBER
– on the left face of the pedestal: THOSE FROM OUR / COMMUNITY / WHO LOST THEIR LIVES / STEPHEN PAUL COPOC 20 / A GROUNDSMAN AT / SUDLEY HALL / PHILIP HAMMOND 14 / OF ROSEMONT ROAD / SARAH LOUISE HICKS 19 / OF CARNATIC HALLS / OF RESIDENCE / AND HER SISTER / VICTORIA JANE 15 / PETER MCDONNELL 21 / OF HILLVIEW
– on the right face of the pedestal: THIS SUNDIAL WAS / ERECTED BY THE PEOPLE OF / AIGBURTH AND / MOSSLEY HILL / AND PAID FOR BY PUBLIC / SUBSCRIPTION / IN

MEMORY OF THE 95 / LIVERPOOL F.C. / SUPPORTERS / WHO DIED AT / HILLSBOROUGH / 15TH APRIL 1989

Signed on the front face of the plinth: DAVID STRACHAN STONEMASON / EVANS AND BURKEY

Unveiled and dedicated by the Revd Kenneth Lane, Aigburth Methodist Minister, Sunday 29 October 1989.

Owner/ custodian: Liverpool City Council
Status: not listed

Description: The sundial stands outside the Sudley Art Gallery amidst flower beds planted with ninety-five rose bushes in commemoration of the ninety-five victims of the tragedy. The pedestal is constructed of three pieces of granite, namely a plinth, a dado with battered sides, and a cornice. Mounted upon the top of the pedestal is the brass sundial itself. The significance of the sundial form was explained by Revd Kenneth Lane at the unveiling:

> Through the centuries the sundial has been an emblem of the passing of time: it is such now. However many years may pass our loved ones will always be in our remembrance. This sun-dial is sacred to their memory. We shall never pass it without a silent prayer; always it will awaken hallowed thoughts and cherished recollections [as recorded in *The Sudley Sundial*, undated].

Facing towards the sundial are two commemorative benches.

Condition: The metal sundial has twice been

broken off by vandals, the last time being in mid October 1993. At the time of writing (mid-1994) it has been repaired and re-installed by the Council.

Ninety-five Liverpool Football Club supporters died in the crush of people falling forward when a crowd barrier gave way at Sheffield's Hillsborough Stadium on 15 April 1989. Five of the victims had either lived or worked in the Aigburth and neighbouring Mossley Hill areas of Liverpool.

The following account derives from an unpublished booklet, with contributions by Larry Neild, W.G. Andrews, and the Revd Kenneth D. Lane, held at Sudley Art Gallery: Shortly after the tragedy a group of local people

began discussing how they might express in some permanent way, their sense of loss for the victims, and sympathy for the grieving friends and relatives. One of the group, Larry Neild, suggested erecting a memorial sundial. Once the idea was agreed, it became clear that a public subscription would be needed to fund the project. The group enlisted the help of W.G. (Gordon) Andrews, a retired college lecturer, to organise an appeal and act as Honorary Treasurer. He later told a reporter:

> Five young people from our community went to Hillsborough and never returned. People generally felt that a memorial that will last for centuries would be a fitting thing to show the families just how deeply we all

feel about their losses (*Daily Post*, 30 October 1989).

Money was raised through individual donations and various sponsored events, with contributions increasing significantly after a front page article publicising the appeal appeared in the *Liverpool Weekly Star*. The final amount exceeded expectations and paid for the two commemorative benches nearby and the rose beds laid out around the sundial.

Larry Nield had sketched an idea (afterwards 'perfected' by Frank Harris, an artist working for the *Liverpool Echo*) for the design of the sundial. In the course of visiting several local stonemasons, Gordon Andrews took the drawing to the premises of Evans and Burkey,

opposite Sefton General Hospital. Apparently, there in the stoneyard were three blocks of black granite which had been lying around for some time, ideally proportioned for Nield's design.

Though the memorial specifically names the five young people of Aigburth and Mossley Hill who died at Hillsborough, it is nevertheless dedicated to all ninety-five victims of the disaster.

Literature: (i) Neild, L., Andrews, W.G., Lane, Revd K.D. *The Sudley Sundial* (undated unpublished booklet held at Sudley Art Gallery).
(ii) *Daily Post* (1989) 30 October: 15; Richardson, A. (1990): 77-8.

Mount Pleasant

ROSCOE GARDENS, on the righthand side of Mount Pleasant, approaching from Renshaw Street, between Newington and Benson Street. In the centre of the gardens:

Renshaw Street Chapel Memorial.
An octagonal tempietto-like structure with eight Doric columns supporting a small dome.

Architect: Thomas Shelmerdine

Erected 1905

Inscriptions:
– *on the (NE) face towards the Mount Pleasant entrance to the gardens, on a rectangular bronze plaque, set into the masonry:* THIS MONUMENT

/ IS ERECTED AS A MEMORIAL OF / RENSHAW STREET CHAPEL / BUILT IN 1811 / FOR THE WORSHIP / OF ALMIGHTY GOD / [*space*] / ALSO / IN GRATEFUL REMEMBRANCE OF / THOSE WHO MINISTERED THEREIN / AMONG WHOM WERE / JOHN HAMILTON THOM / WILLIAM HENRY CHANNING / CHARLES BEARD / [*space*] / AND IN MEMORY OF / THE WORSHIPPERS / WITHIN ITS WALLS / AND OF / WILLIAM ROSCOE / JOSEPH BLANCO WHITE / AND ALL WHO WERE LAID TO REST / IN THIS GROUND / [*space*] / THE FAITHFUL OF EVERY LAND / WHO CHRISTS OWN RULE OBEY / THE HOLY DEAD OF EVERY TIME / THE CHURCH OF CHRIST ARE THEY

– *on the (SE) lefthand face, approaching from Mount Pleasant, on a rectangular, landscape format, panel of glazed tiles:* SEVILLA EN HOMENAJEA / JOSE BLANCO WHITE / 24 MAYO 1948 – *on an oval City of Liverpool plaque beneath:* CITY OF LIVERPOOL / JOSEPH BLANCO WHITE / 1775 – 1814 / Spanish writer and political / exile was buried / near here.
– *on the (SW) far side from Mount Pleasant, on a rectangular bronze plaque, set into the masonry:* THE CHAPEL STOOD / TO THE SOUTH OF THIS SPOT / FACING RENSHAW STREET / [*space*] / THE MONUMENTAL TABLETS / WITHIN IT / ARE PLACED IN THE CLOISTERS / OF ULLET ROAD CHURCH / TO

WHICH THE CONGREGATION REMOVED / IN 1899 / [space] / THE SITE OF / THE CHAPEL AND GRAVEYARD / WAS SOLD TO THE / CORPORATION OF LIVERPOOL / WHO MADE THIS GARDEN / PRESERVING A RECORD / OF THE GRAVES / AND THE INSCRIPTIONS THEREON / WHICH MAY ALSO BE SEEN / AT THE CHURCH / [space] / THIS MONUMENT WAS ERECTED / IN 1905 / BY ONE WHO WORSHIPPED HERE / FOR SIXTY YEARS – *the (NW) righthand face, approaching from Mount Pleasant, has a recessed stone panel like the other faces, but has neither bronze plaque nor any inscriptions.*

Owner/ custodian: Liverpool City Council

Listed status: Grade II

Condition: The structure is largely undamaged, although the sandstone cornice and stringcourse are crumbling in places and the frieze has some scaling, most noticeably on the SE face. There is much green biological staining on the steps and some graffiti on the lower walls of the memorial.

The demolished Renshaw Street Chapel which this memorial commemorates was on the site now occupied by Central Hall (*Liverpool Heritage Bureau*, 1978: 69)

Literature: Liverpool Heritage Bureau (1978): 69; Picton, J.A. (1875, revised edn 1903), ii: 241; Roberts, H.D. (1909): 247.

WELLINGTON ROOMS, now the Liverpool Irish Centre. Designed and built by Edmund Aikin in 1815 (Picton, 1875, revised edn 1903, ii: 212).

Winged figures bearing festoons
Relief panels either side of the circular portico, set into the ashlar façade.

Sculptor: unknown (but see below)

Reliefs in stone

h: 32" (81.28cms); l: 140" (355.6cms)

Owner of Liverpool Irish Centre: Michael Finnegan
Listed status: Grade II*

Description: Each panel is made from three slabs. The compositions are symmetrical and almost identical. At either end of the left-hand panel a winged figure floats, holding in one hand a palm branch, which is rested against the shoulder, and in the other, raised above the head, the end of a ribbon attached to a festoon (a garland of fruit and flowers). The festoon is, in turn, attached at the centre of the panel to an elaborate stand. Above each festoon is a rose motif. The right-hand panel follows the same basic design as the left, but with numerous small differences of execution, the most noticeable being the variation of the rose motifs. The rose of the left-hand panel has a convex centre and eight petals, whilst that on the right-hand panel has a hollow centre and six petals. Furthermore, there is a slight difference between the colour of the stone of each panel.

Condition: The lefthand panel is grimy, but appears intact. In the righthand panel, both angels have lost the hand which holds the palm. The details appear to be more weathered in the righthand panel and the entire surface is pitted with small holes.

In 1923, Professor Reilly stated that the carved panels either side of the entrance to the Wellington Rooms were by [John] Gibson (1923: 53). By 1929, however, he was more circumspect, stating only that they were 'reputed to be by John Gibson' (1929: 43-6). If the reliefs were indeed carved by Gibson then it would have to have been during his apprenticeship (which lasted until his departure for London in 1817) to the stonemasons S. and F. Franceys of nearby Brownlow Hill. The attribution is perhaps not incredible for, although the panels are now in rather poor condition, it is still apparent that they were ably-enough executed to have been by the young John Gibson, Pevsner describing them as 'finely carved' (1969:185).

Literature: Pevsner, N. (1969): 185; Reilly, C. H. (1923): 53; Reilly, C. H. (1929): 43-6.

Myrtle Street

City of Liverpool Community College, formerly the LIVERPOOL EYE AND EAR INFIRMARY, designed by C.O. Ellison & Son, dated 1879 and completed in 1881.

Owner of building: unknown
Listed status: Grade II

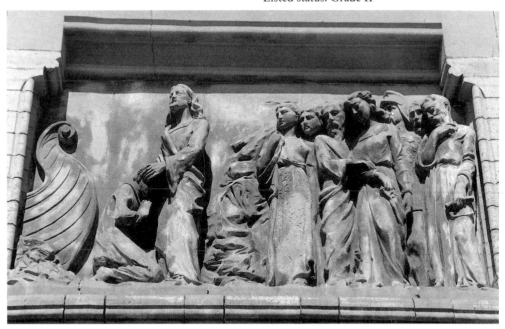

Either side of the main entrance is: a figurative high relief with a scene of
Christ Healing

Sculptor: unknown

High reliefs in terracotta

h: 34" (86.36cms); l: 58" (147.32cms)

Description: In both reliefs a crowd of apostles and spectators witnesses Christ healing. In the relief on the left Christ, in the centre, lays his hands on the head of a naked man who half crouches and appears to be reaching out to touch Christ's robe. Behind the man a palm tree serves to indicate an outdoor setting. In the relief on the right Christ stands towards the lefthand edge on a rocky shore, his hands upon the head of a man who kneels, hands together in supplication. The prow of a boat is cut by the left edge of the picture.

Condition: Both panels have white-edged, black encrustation. The righthand panel has no apparent losses, but in the lefthand panel the head of the central female figure opposite Christ is missing.

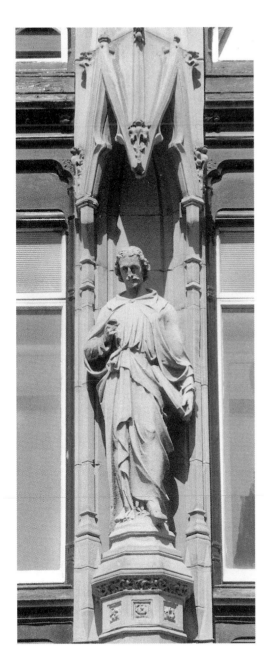

On Henry Sumners' later extension to the Liverpool Eye and Ear Infirmary is a Gothic canopied niche containing a figure of:

Saint Luke

Sculptor: John Cartwright of Norbury, Paterson & Co. Ltd.

Statue in stone

h: 72" (182.9cms) approx.

Exhibited: WAG Spring Exhibition 1893 (cat. 981/11), as *Rough Sketch Model for Statue 'St.*

Luke', St. Luke's Buildings, Myrtle Street

Description: Set within a Gothic-style canopied niche at the level of the first floor windows is a standing figure of St Luke (described by St Paul as 'the beloved physician', Col. 4:14; see also Hall, 1979: 196). He looks downwards, his right hand raised, his left hand holding a large book.

Condition: The figure appears rather weathered and the raised right hand particularly so.

Literature: *City of Liverpool Public Health Congress Handbook* (1903): 57; Hall, J. (1974; rev. edn 1979): 196.

North John Street

MERSEY TUNNEL VENTILATION TOWER, by Herbert J. Rowse, before 1935.

Relief decoration

Sculptor: Edmund C. Thompson

Reliefs in Portland Stone

Owner of building: Mersey Tunnels
Listed status: Grade II

Description: The top of the façade overlooking North John Street has a frieze carved with a chevron moulding, with circular motifs filling the lower triangular spaces and inverted 'V' shapes, the upper. At either end of the façade are winged horses, facing towards the frieze ends. The cornice continues on the returns of the building. Decorating the wall just beneath the cornice are five large circular motifs, each one above a tall tripartite fluted panel which rises from the string course between the ground and first floors.

Condition: The sculptural decoration appears to be in good condition, but the surfaces are rather grimy.

The *Daily Post* (18 April 1935) explains the design problem addressed by Rowse as follows:

> At North John-street the tower had to harmonise with the lines and height of a narrow thoroughfare. It was given a sheer façade, relieved by a geometrical design. The cornice was embellished by horse's heads, to commemorate the fact that that had been the site of Bartholomew Bretherton's great

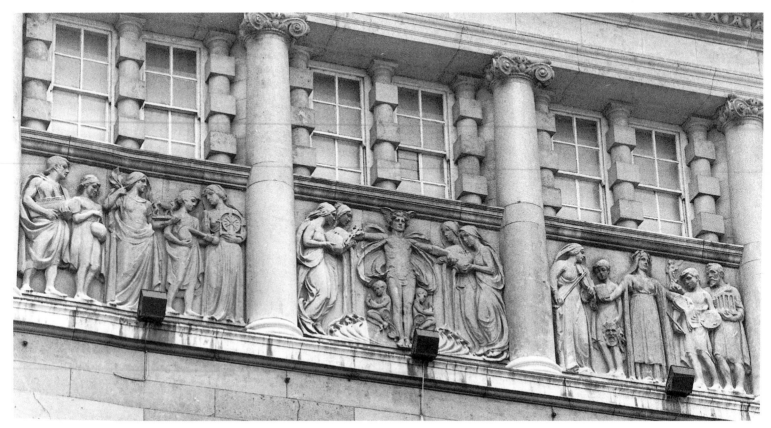

coaching stables, and wings were added to the horses to typify speed.

Although this may be the case, the winged horse motif also decorates the base of the figure of *Mercury* on the George's Dock Building (see p. 131, below) and was intended as a general symbol of power and speed harnessed.

Literature: *Architects' Journal* (1932) 28 December, lxxvi: 813; *Daily Post* (1935) 18 April: 6.

ROYAL INSURANCE BUILDING, 1 North John Street, at the corner with Dale Street (1896-1903, by James Francis Doyle). The building occupies the whole block on the south side of Dale Street up to Princes Street.

Architectural sculpture:
Allegorical group over the main entrance in North John Street and *Figurative Friezes* beneath the third floor windows in North John Street, Dale Street and Princes Street.

Sculpture designed by Charles John Allen

and James Francis Doyle; executed by Charles John Allen

All sculpture in Portland stone

Building officially opened Tuesday 16 June 1903.

Owner of building: Royal Insurance
Listed status: Grade II

Description of allegorical group:
Royalty with Kingly Power and Honour supported by Plenty and Justice. Framed by the

sides of a broken segmental pediment is a seated woman symbolising *Royalty*, wearing a heavy gown and crowned with a laurel wreath. In her right hand she holds a crown and in her left, an orb surmounted by a figure of *Fame* or *Honour* blowing upon a trumpet. On either side of the throne stands a nude boy: each leans against an arm of the throne and turns his head towards the other. The boy on the left, *Plenty*, holds a palm branch draped over his right shoulder; the boy on the right, *Justice*, holds scales in his right hand and in his left, a large sword which he rests against his shoulder.

Description of figurative friezes:
There are three reliefs on the Dale Street frontage and one each in North John Street and Princes Street. The Dale Street panels represent rather general themes, whereas those overlooking the side streets deal more specifically with the work of an insurance company. According to Hetherington (1903: 13), 'the five panels of the frieze are intended to portray in a figurative manner the objects of Insurance and its results, direct and indirect, at the present day.' The following descriptions derive from Hetherington's comprehensive account:

The Dale Street panels are, from left to right:
1. *The Sciences*, showing those sciences that have minimised the risks to, and assisted the development of, the various forms of business which rely on Insurance. The central figure is *Biology* who holds, as her attributes, a plant and a mounted animal skeleton. To her left are *Chemistry*, a boy holding a condensor, and *Electricity*, a young woman holding an electrical generator; to her right are *Mathematics*, a boy carrying a small globe which he measures with compasses, and *Engineering*, a man carrying the model of a steamship.
2. The central panel, a completely symmetrical

Art Nouveau-type design, shows *Mercury, God of Commerce*. In the centre of the panel *Mercury* (his caduceus in his right hand), stretches his arms out to control the flow of water from four uptilted urns held by the *Powers of Nature*, represented by young women, two to each side of him: they pour the water to 'extinguish the flames of a burning world' (Hetherington, 1903: 14) and to prepare the way for *Plenty*, represented by the two cornucopia-bearing *putti* at *Mercury*'s feet.
3. The panel on the right represents *The Fine Arts, Music and Drama* which, though not rendered indestructable by the efficacy of Insurance, can be restored or replaced by its implementation. At the centre stands *Genius*, a helmeted Minerva-like figure in a long robe, her arms outstretched, a book in her right hand, a manuscript in her left. To her left stands a young painter with palette and brushes, behind whom is a bearded architect holding a model of a Greek temple in his left hand and a *Winged Victory* in his right.

That an architect should be represented literally holding up a piece of sculpture was evidently intended to symbolise the ideal working partnership between architect and sculptor, the results of which are manifest in the greatest of the temples of ancient Greece, in which the architect designs his buildings with sculpture as an integral and meaningful part. That the motif should be interpreted in this way is corroborated by the fact that the model for Allen's bearded architect is none other than the architect of the Royal Insurance Building himself, James Francis Doyle (cf. his photograph in Pike, 1911: 410).

To the right of *Genius* is a boy representing *Drama*, holding the masks of Tragedy and Comedy, and a young woman playing the violin, representing *Music*. All the figures in

these three panels are dressed in generalised antique robes as befits their allegorical status. An overall unity between the separate panels is created through the absolute symmetry of the central panel, and the direction of the gazes of the majority of the figures in the outer panels towards the central panel.

The North John Street panel is the largest of the series. It depicts *The Direct and Indirect Results of Fire Insurance*. In the centre stands *Invention*, offering to the fireman on her left a model of a fire-engine with which to protect Church property, itself symbolised by a model of a church building upheld by a choirboy and a bishop; and municipal property, symbolised by a model of the Town Hall upheld by the Mayor. On the left of the panel a fireman carries an infant on his right arm, while its mother leans against his shoulder for support. He reaches past the mother to take a model of an extending ladder from *Invention*. It is inventive genius that has provided society with the means to protect both life and property from fire and, so the relief tells us, the leading insurance companies which have encouraged their use.

The Princes Street panel shows *The Benefits Derived from Life Insurance*. The central figure, *Wisdom*, comforts a widow and holds out a book for a youth to read; his older companion, on the extreme left, carries a scythe and a sheaf of corn: thus, heeding *Wisdom*'s counsel leads to material abundance. To the right of the panel are a frail old man and a naked (and therefore helpless) young boy whom *Wisdom* has entrusted to the care of *Commerce*, a woman who carries a sailing ship.

Condition: All reliefs appear to be undamaged, but grimy.

Related works: (i) The general arrangement of frieze panels carved with standing figures, set between the lower shafts of attached columns, derives from those by Hamo Thornycroft for Belcher's Institute of Chartered Accountants, Moorgate Place, London, 1888-93, on which Allen worked as chief assistant (Beattie, 1983: 69, 79). (ii) In 1901 Allen produced a variant of his own Royal Insurance Building frieze panels for Parr's Bank (now National Westminster Bank), St Martins, Leicester (for architects J.B. Everard and S. Perkins Pick) – note also the close correspondence between the attendant boys in the Royal Insurance Building *allegorical group* (illustrated in Hetherington, 1903: 13) and those in the Parr's Bank frieze panel, *Commerce* (illustrated in *The Builder*, 26 October 1901:364).

Literature: Beattie, S. (1983): 79; *Builder* (1901) 26 October: 364; Gray, A. S. (1985): 88; Hetherington, J. N. (1903): 13-16; Pike, W. T. (1911): 410.

Old Churchyard

MERSEY CHAMBERS, 2 Old Churchyard (off Chapel Street), built in the 1860s for T. and J. Harrison, shipbuilders. The façade over-looking the public gardens behind St Nicholas's Churchyard is decorated with architectural sculpture. The dormer of the centre bay has a *Relief Panel Of A Sailing Ship* with a shell hood over. Surmounting the dormer is a *Bronze Liver Bird*, painted in white. The hood-moulds of the round-arched ground floor windows have *Stops Carved as Animals and Birds*, mostly of a fabulous or bizarre nature.

Sculptor(s): unknown

Owner of building: untraced
Listed status: Grade II

Condition: All scuptural decoration appears to be in good condition.

Literature: Liverpool Heritage Bureau (1978): 32-3.

The new LIVERPOOL COTTON EXCHANGE, designed and built by H.A. Matear and F.W. Simon in 1905-6, was opened on Friday 30 November 1906 by the Prince and Princess of Wales. Matear and Simon's façade was demolished in 1967.

Owner of building and associated sculptures: Courtaulds Pensions Investment Trustees
Listed status: Grade II

On the pavement outside the remodelled building is a colossal statue formerly surmounting one of the two end towers. In the courtyard are two more colossal statues, the only survivors of the eight that once stood at the angles of the towers. They represent, respectively, *The River Mersey*, *Navigation* and *Commerce*.

Sculptors: William Birnie Rhind and E.O. Griffith

(i) *Statue of the River Mersey*

Statue carved from four blocks of Portland stone

h. (with base): 12' (3.66m)
h. (excluding base): 8' 8¹/₂" (2.65m)

Inscription on the top of the left side of the base: A10

Listed status: as for building

Description: Mounted on an octagonal base, the heavily-draped, flowing-haired, bearded male figure is seated, clasping in his left hand an anchor, a tiller and a length of rope, whilst in his right he holds the lip of an urn from which liquid pours onto the head of a dolphin. He looks towards his left.

Condition: The surface is generally badly weathered. The right elbow, the big toe of the right foot, and the three small toes of the left foot are missing. Also a piece from the edge of the wind-blown drapery on the back of the figure is missing.

Formerly crowning the right hand tower of the Cotton Exchange, its pendant on the left hand tower, *Ocean*, is lost. The architects' perspective view of the building as it was first proposed in 1904 shows a rather different idea with, on each of the towers, a globe supported by three or four atlantes (*The Builder*, 9 July 1904, plate between pp. 42 and 43); the basic motif being perhaps somewhat reminiscent of Carpeaux's *Les Quatre Parties du Monde*, 1868-72, now in the Musée d'Orsay, Paris.

(ii) Allegories of **Navigation** and **Commerce**. These are the only two survivors of the eight statues that once decorated each of the four shorter sides of the two octagonal towers. They included symbolic representations of *Architecture*, *Industry*, *Science*, *Agriculture*, *The Arts*, *Navigation* and *Commerce* (WAG JCS files; source not given).

Each statue is carved from three blocks of Portland stone

h. of each statue: 7' (2.13m)

Inscription on the lower part of *Navigation*'s back: C2X
(*Commerce* appears to have no inscription)

Both statues are unsigned

Listed status: as for building

Description: *Navigation* is a draped and cowled, twice-life-size female figure seated on a barrel and a ship's prow. She holds a model of a ship in her left hand and looks toward her right. The statue is at present situated in the far left corner of the courtyard of the Cotton Exchange building. *Commerce* is a twice-life-size male figure seated on a pile of four ledgers, beside

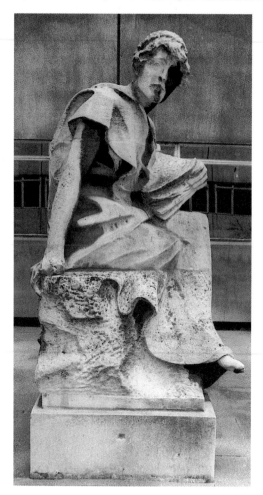

which stand two money bags. He holds a ledger in his left hand, leans on his right hand and looks to his right. The statue is at present situated in the far right corner of the courtyard.

Condition: Both figures are very weathered, especially the carving of the feet. *Navigation* appears to have no significant losses; *Commerce* is missing the thumb and index finger of right hand.

Literature: (i) WAG JCS files: newscuttings – *Courier* (1906) 15 October; *Echo* (1967) 18 July; *Liverpool Cotton Gazette* (1906) December.
(ii) *Builder* (1904) 9 July: 42; *Builder* (1906) 8 December: 666-67; *Builder* (1910) 29 January: 115; *The Modern Building Record* (1910) i: 12-15.

In the courtyard of the Liverpool Cotton Exchange:

Cotton Exchange War Memorial

Sculptor: Francis Derwent Wood

Statue in bronze

h. of statue, including bronze base: 72" (182.9cms) (approx.)
h. of plinth: 9" (22.9cm)

Inscription on nearby bronze wall plaque:

1914 – 1919 / THIS MEMORIAL / WAS UNVEILED BY / FIELD MARSHAL / EARL HAIG / OF BEMERSYDE / 5TH APRIL 1922

Signed and dated on the right face of the bronze base: DERWENT WOOD 1921

Listed status: not known

Unveiled by Field Marshal Earl Haig, Wednesday 5 April 1922

Description: The memorial is miserably situated, located close to the righthand wall of the

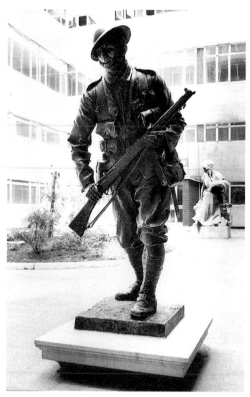

courtyard of the Liverpool Cotton Exchange. It takes the form of a bronze statue, mounted on a low, white-painted, metal plinth, bolted to the pavement. The statue represents a First World War infantryman, wearing a steel helmet and striding resolutely forward, bearing his rifle (formerly with a fixed bayonet) in both hands before him.

As can be seen in a photograph of 1922 (original in *Photographs of War Memorials in Liverpool*: 6; reproduced in P. Curtis, ed., 1989: 93), the statue was originally erected in front of Matear and Simon's Cotton Exchange, mounted on a pedestal and standing before a wall plaque

bearing a long list of names of those employees of the Cotton Exchange who had 'died for their country in defence of liberty and justice' (*Daily Post and Mercury*, 6 April 1922: 4). Neither the original pedestal nor the wall plaque appear to have survived.

Note: The *Cotton Exchange War Memorial*, in common with many others, bears the dates 1914-1919 not, as one might expect, 1914-1918. This is because although hostilities were suspended on 11 November 1918 (Armistice Day), Britain's official 'Peace Day' Victory Parade did not take place until 19 July 1919, following the signing of the peace settlements with Germany (28 June 1919) and her allies (Boorman, 1988: 2).

Condition: As stated above, the pedestal and original wall plaques are missing. The statue appears to be complete, apart from the bayonet once fixed to the rifle. The black epoxy paint which once covered the bronze surface has worn away in many places to reveal the underlying green of the metal.

A total of 2,500 men of the Liverpool Cotton Exchange enlisted in the British army during the First World War. The present memorial commemorates the 358 of that number who lost their lives. On the day of the unveiling ceremony, present staff and relatives of the dead assembled inside the Exchange. After listening to eulogistic speeches from Earl Haig and Lieutenant-Colonel J.J. Shute, the assembly passed to the front of the building where Haig unveiled the memorial.

The Bishop [of Liverpool, Dr F.J. Chavasse] pronounced a dedicatory sentence and offered prayer and the ceremony came to a conclusion with the sounding of the "Last Post" and "Reveille" by a bugle party from

the 5th Battalion of the King's (Liverpool) Regiment (*Daily Post and Mercury*, 6 April 1922: 4).

The ceremony concluded with the traditional laying of wreaths around the base of the memorial.

Literature: (i) LRO *Photographs of War Memorials in Liverpool...*, 1923: 5a, 6.
(ii) Compton, A., 'Memorials to the Great War', in P. Curtis (ed.) (1989): 93; *Daily Post and Mercury* (1922) 6 April: 4.

J M CENTRE, formerly the headquarters of Littlewoods Mail Order Plc. On the concourse by the main entrance:

Littlewoods Sculpture

Sculptor: Patrick Glyn Heesom

Sculpture in aluminium
Founder: Morris Singer at Basingstoke

h: 29' (8.84m)

Owner: Centreville Estates
Status: not listed

Description: The sculptor described the piece as a 'growing thresh of wings or limbs' (*The Times*, 28 February 1964); the reporter in the *Echo* (29 January 1965) as a 'split column sculpture'.

Condition: There is considerable scaling and bubbling of the 'skin'; some rusting at the base; some horizontal scratch marks at a height of about 2 – 3 feet; and some white chalky patches on north-facing surfaces.

On 21 May 1963, Mr William Stevenson, head of architecture and planning for Littlewoods Mail Order Stores Ltd, announced in London a competition to choose a 'sculpture or three-

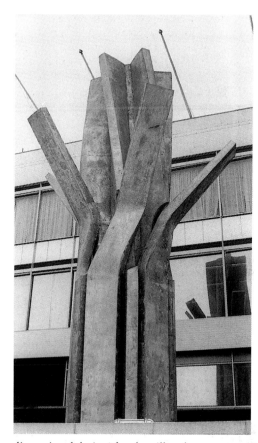

dimensional design' for the pillared concourse and main approach to the proposed new seventeen-storey Littlewoods headquarters building in Liverpool (*The Guardian*, 22 May 1963). The imposed artistic and technical problem was that the piece should 'bring the very large and rather stark headquarters building into closer contact with members of the public' (*Architect and Building News*, 29 May 1963). The space to be filled was 56 feet high, 66 feet wide and 49 feet deep (*Architect's Journal*, 19 June 1963). The solution was 'left entirely to the designer'

(*Stores and Shops*, July 1963) – there were no restrictions imposed on the type of materials to be used, nor were there any guidelines offered as to the kind of design preferred. The competition was open to British citizens only (*The Guardian*, 22 May 1963) and the closing date for registration was 30 September 1963 (*Architect and Building News*, 29 May 1963).

'Sketches or models' were to be submitted by 18 January 1964, following which date six would be shortlisted by a panel of judges. Each shortlisted entrant would receive £500 to develop his or her idea for the judges' final selection. (In addition, there would be six travelling scholarships, valued at £250 each, for other entries of special merit.) The prize for the winner was to be £5,000, over and above the cost of materials and installation (*The Guardian*, 22 May 1963).

The panel of judges consisted of Sir William Coldstream, C.B.E., D.LITT., Slade Professor of Fine Art at the University of London; Milner Gray, R.D.A., F.S.I.A., founder member of the Society of Industrial Artists; and Peter Chamberlin of Powell and Bon, the architects for the City of London Barbican scheme (*Financial Times*, 27 May 1963).

About 450 entries from throughout Britain and the Commonwealth were received and assessed, and on 17 February 1964 the six final-ists were announced as John Dougill, Patrick Heesom, R.M. Jones, Michael Kenny, David Troostwyck, and John Whiskerd; the six travel-ling scholarships were awarded to Roger Dean, Henry Gregory, Fianach Jardine, Frederick Kennett, Christopher Sanderson, and Peter Startup. (Of these twelve, the only Liverpool sculptors were Kenny and Dean.) The maque-ttes by the six finalists and six runners-up, along with a selection of about two dozen of the other entries, were then put on display at the Bluecoat Chambers until the following Saturday (*Echo*, 17 February 1964). Photographs of the six final-ists' maquettes appeared in the *Architects' Journal* for 26 February 1964 and photographs of the maquettes by runners-up Roger Dean and Peter Startup were published in *Studio International Art* (May 1964: 218) and Willett (1967: 106), respectively.

In January 1965, the six completed scale models were exhibited at the Royal Institute Galleries, Piccadilly, and on 29 January the winner was announced as 27 year-old Patrick Glyn Heesom, of St Asaph, North Wales (*Echo*, 29 January 1965). All six scale models were then shown in an exhibition devoted to civic art, *Industry and the Artist* (28 February – 28 March 1965) at the Walker Art Gallery, Liverpool.

John Willett, writing in 1967, offered his esti-mation of the importance of the competition (pp. 105 – 07):

> It was an important precedent both as repre-senting an extension of the principle of the Moores Exhibitions into the field of public art – i.e. an attempt to open out the scheme of patronage in the city – and also as part of an all-round effort to raise design levels in a big firm... Perhaps the sculpture competition has not brought quite the results the firm hoped for, since none of the accepted big names in modern British sculpture chose to enter... None the less it stimulated a number of highly original designs – notably Peter Startup's brightly-coloured wooden "maritime forms" and the "hydromobile" by C.L. Crickmay of Liverpool, neither of which got prizes, as well as some good draw-ings by P.G. Heesom...

Literature: (i) The Littlewoods Organisation company archives: newscuttings *Architect and Building News* (1963) 29 May; *Architect and Building News* (1965) 10 February; *Architects' Journal* (1963) 19 June; *Architects' Journal* (1964) 26 February; *Architects' Journal* (1965) 24 February; *Daily Post* (1965) 2 March; *Design* (1963) June; *Drapers Record* (1965) 6 February; *Echo* (1963) 21 May; *Echo* (1964) 17 February; *Echo* (1965) 29 January; *Guardian* (1963) 22 May; *Stores and Shops* (1963) July; *Times* (1964) 28 February; *Times* (1965) 30 January. (ii) *Studio International Art* (1964) May: 218; WAG (1965); Willett, J. (1967): 105-7.

Otterspool Promenade

*Otterspool Riverside Promenade
Commemorative Plaque*

**Architect: Ronald Bradbury
Sculptor: George Herbert Tyson Smith**

Relief in Westmorland greenstone

Overall: h: 47" (119.5cms); w: 72½" (184cms); max. d: 7" (17.8cms)

Pictorial relief: h: 16" (40.5cms); w: 51" (129.5cms)

Inscription beneath the pictorial relief:
CITY OF LIVERPOOL / THIS STONE COMMEM-
ORATES THE OPENING OF / OTTERSPOOL
RIVERSIDE PROMENADE / ON 7 JULY 1950 BY
/ ALDERMAN THE REV. H. D. LONGBOTTOM /
LORD MAYOR / ALDERMAN W. T. ROBERTS J.
P. / CHAIRMAN HIGHWAYS AND PLANNING
COMMITTEE
– immediately below, on the left, in smaller
lettering:
THOMAS ALKER / TOWN CLERK
– and on the right:
HENRY T. HOUGH M.I.C.E. / CITY ENGINEER
& SURVEYOR

Pictorial relief signed: H TYSON SMITH
M.A F.R B.S.

Unveiled by Alderman the Revd Harry Dixon
Longbottom, Lord Mayor of Liverpool, Friday
7 July 1950.

Owner: Liverpool City Council
Status: not listed

Description: Located in the central section of

the promenade, the commemorative tablet is set into a stone wall facing towards the Mersey River. The rectangle containing the inscription is overlapped along the top edge by a smaller rectangle containing a pictorial relief depicting three otters, the largest holding a fish in its mouth, a smaller otter looking up at it, and behind these, a third otter with an eel in its mouth.

Replica of pictorial relief (white-painted background with black-painted otters): set into the wall of a house in Jericho Lane, Liverpool 17.

Plaster model of pictorial relief: untraced, formerly at the Bluecoat Chambers, School Lane, Liverpool.

Condition: Badly vandalised. At some time before 4 February 1990, the face of the otter holding the fish was completely hacked away, possibly with a chisel. Graffiti has been scratched into the surface of the relief and there are hairline cracks in places. The cornice above the relief has been replaced in a different type of stone and the commemorative plaque seems

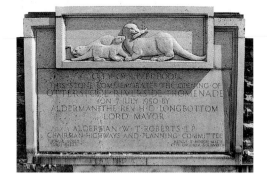

thereby to have lost about 3¾" in overall height (compared with measurements taken for 1976 survey in WAG JCS files).

The proceedings of the Highways and Planning Committee of the Council for 4 January 1950 record the passing of the following resolution:

> That the quotation of Mr. H. Tyson Smith, of Bluecoat Chambers, College Lane, Liverpool, for the execution, in Westmorland Green Stone, of the central feature on the Otterspool Promenade, in accordance with the design prepared by the City Architect and Director of Housing, to commemorate the public opening of this portion of the Promenade, for the sum of £283, plus an additional sum of £31 for fixing, be accepted.

The official opening of the Otterspool Promenade brought to completion a twenty-one year project. In 1929, Liverpool Corporation had decided to reclaim the area now occupied by the Promenade from the wasteland of the 'Cast Iron Shore'. By 1932, a sea wall enclosing forty-three acres of muddy foreshore had been built. Into the area between this wall and the higher ground behind, were deposited over the years many thousands of tons of domestic refuse, in a programme of controlled tipping. Once the refuse had settled, forming a solid base now high above the water-line, it was used as the foundation for the present Promenade with its pleasant roads, footpaths, lawns, shrubberies and flowerbeds. The Lord Mayor of Liverpool, speaking at the official opening of the promenade, emphasised that economy had been the watchword guiding

the entire project: the construction of the wall had provided local employment in the lean inter-war years and the subsequent controlled dumping of local refuse into their own stretch of wasteland had saved thousands of pounds that would have been expended on incineration and sea dumping. Even the major part of the stonework they could see around them was from old stone flags, salvaged from the city streets (*Daily Post*, 8 July 1950).

Literature: (i) LRO manuscript sources: George Herbert Tyson Smith Archive, Box 18; *Proceedings of Liverpool City Council 1949-50*, i: 555. (ii) *Daily Post* (1950) 8 July: 5; Poole, S.J. (1994): 324-27.

Pier Head

In the following section covering the Pier Head area, buildings with sculptural decoration are catalogued first, and then free-standing memorials and sculptures. Each category is ordered chronologically, buildings by the dates of their erection and monuments by the dates of their unveiling.

(1) BUILDINGS

MERSEY DOCKS AND HARBOUR BOARD BUILDING by (Sir) Arnold Thornely in collaboration with Briggs & Wolstenholme. Completed in 1907, it is designed in the style of an Italian Renaissance *palazzo*. On the west side of the building, facing the River Mersey, the central, main entrance bay is embellished with allegorical sculpture, both relief and free-standing.

Sculptor: Charles John Allen

Reliefs and free-standing statues in Portland stone

Owner of building: The Mersey Docks and Harbour Company
Listed status: Grade II*

Relief sculpture
in the top pediment:

Description: In the centre of the top pediment is an oculus around which are a pair of opposed dolphins carved in high relief. The tips of their snouts are confronted at a scallop shell at the bottom of the window, their heads emerging from a mass of seaweed and shells which covers their backs, their tails visible near the crown of the window.

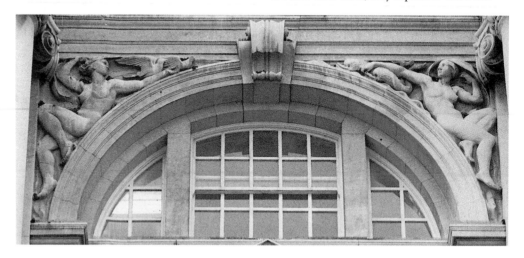

Relief sculpture
in the spandrels of the thermal window:

Description: The thermal window of the central bay is situated below the pediment and is framed between the doubled columns of a colossal Ionic order. The spandrels of the window are embellished with allegorical female nudes carved in high relief. Reclining against the haunches of the window arch and looking towards each other, they represent *Wind* and

Water. *Wind*, in the lefthand spandrel, extends her left arm towards the crown of the window arch to release two doves, while with her right hand she holds to her head a sail-like, wind-filled veil which billows out behind her. *Water*, the figure in the righthand spandrel, reflects the pose of her counterpart except that with her right hand, extended towards the crown of the arch, she guides two dolphins.

Relief sculpture
on the spandrels of the main entrance arch:

Description: In each spandrel is a cartouche from which hangs a wreath composed of an inverted cornucopia and its spilt contents. From the left wreath emerges a steamship and from the right, a sailing ship. Below each wreath is a seagull with wings extended in flight, picking at the bunches of fruit which hang down from the cornucopia.

Free-standing statues
flanking the entrance.

Each figure: h: 9' 11" (3.02m)

Each pedestal: h: 3' 6½" (1.08m); w: 4' 9" (1.45m); d., including 4" d. of the garland relief on the front face of the pedestal: 3' 11" (1.19m)

Listed status: as for building

Description: The standing, classically draped female figures represent *Commerce* and *Industry* and are mounted upon pedestals which extend forward from the piers either side of the doorway. Each figure is backed by an ornamental buttress from which at mid height a plinth projects upon which the figure's attributes are placed. *Commerce*, on the left is crowned with a wreath. She raises her right arm, whilst her left rests upon a model of a sailing ship located on the plinth behind her. At

the other end of the plinth, appearing from behind her right side is an inverted cornucopia, its narrow end twining up her right arm to the crook of her elbow. On the other side of the doorway is *Industry* who raises a distaff in her right hand. Located upon her plinth, on her left side, is a loom of turned wood.

Condition: The right hand of *Commerce* and the left forearm of *Industry* are missing. Both

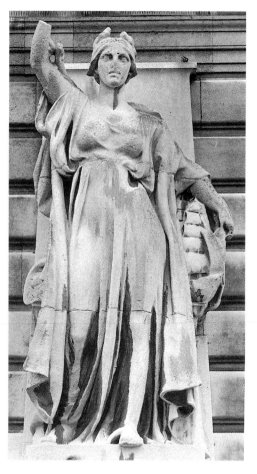

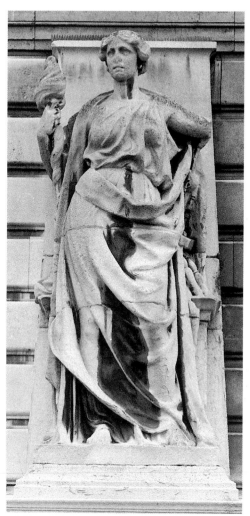

figures are very weathered and there is black encrustation on both pedestals and figures.

Literature: (i) WAG JCS files transcript: *Daily Post and Mercury* (1906) 5 March.
(ii) *Builder* (1907) xcii: 17.

ROYAL LIVER FRIENDLY SOCIETY
BUILDING, designed by Walter Aubrey
Thomas in 1908 and completed in 1911. The
twin clock towers are each crowned by a Liver
Bird.

Liver Birds
made by George Cowper and the Bromsgrove Guild

Hammered copper plates bolted together on an
armature of rolled steel joists, *c.*1910

h: 18' (5.5m)

Owner of building: Royal Liver Friendly
Society
Listed status: Grade I

Description: The two birds face away from each
other, one towards the river, the other towards
the City. The poses are traditional, the birds
standing with half-upraised wings, each
carrying a sprig of seaweed in its beak. A
detailed description is given in the *Daily Post*
for 27 May 1911: 'The head alone of each bird is
3½ feet in length, the spread of wings is 12 feet,
and their length 10 feet; the legs are 2 feet in
circumference... The body and wings are of
moulded and hammered copper heavily gilt.'

Condition: Apparently good.

The height of the birds was such that during
their construction a pit had to be excavated in
the workshop and the roof raised to accom-
modate them. Once Cowper and the Guild
were satisfied with their work, the birds were
dismantled, transported to Liverpool and
reassembled (Crawford, 1977: 19). Each bird is
securely fixed in place by a rolled steel arma-
ture, with girders some twenty-five feet in
length stretching from the top of the head
through the legs and well into the dome (*Daily*

Post, 27 May 1911). They are each then further
stabilised by four steel rods stretching from
wing tips and breast to the base of the dome.

Although the bird on the arms of Liverpool
is officially designated a cormorant, for most
people it is the Liver Bird that is the symbol of
Liverpool. According to Gordon Read (1976),
the Liver Bird probably derives from a case of
mistaken identity. In 1207, King John granted
Liverpool's first charter and some time after a
local artisan was commissioned to model
Liverpool's corporate seal which by now incor-
porated King John's heraldic eagle (he adopting
it from the attribute of his name saint, John the
Evangelist). The bird on the Liverpool seal
(copies of which exist in the Merseyside collec-
tions) was inexpertly executed and sufficiently

unrecognisable that by the seventeenth century
it was taken for a cormorant (a fairly common
bird in the Mersey estuary) and the original
sprig of broom (*planta genista*) carried by King
John's eagle, mistaken for seaweed. Later in the
century the confusion was further compounded
when Liverpool's heraldic cormorant became
identified with yet another bird, the spoonbill,
on the strength of its name in Low Dutch being
lefler, pronounced 'lever' in English, thus
'explaining' the name Liverpool as the pool
inlet inhabited by Liver (i.e. *lefler*) birds. This
latter connection evidently caught the popular
imagination and thus the fabulous Liver Bird is
abundantly represented throughout Liverpool,
whereas the cormorant exists only on the offi-
cial Liverpool coat-of-arms. The Royal Liver
Friendly Society's adoption of the Liver Bird as
its emblem derives from the name of the inn in
which the original society first met.

Literature: (i) WAG archives – Crawford, A. (1977):
19.
(ii) *Architectural Review* (1911) October: 213-14;
Curtis, P. (1988): inside back cover; *Daily Post* (1911)
27 May: 9; Read, G. (1976).

GEORGE'S DOCK BUILDING by Herbert
J. Rowse, opened in 1934. Built to conceal the
principal Queensway (Mersey Tunnel) venti-
lating shaft (see also p.119). According to the
Daily Post:

> Mr. H.J. Rowse, the architect, conceived the
> buildings with sculpture as an essential part
> of their exteriors, and all this sculpture has
> been the work of Mr. Edmund C.
> Thompson, the Liverpool artist already
> responsible for much valuable work on other
> Liverpool buildings (*Daily Post*, 16 May
> 1934).

E.H.W. Atkinson wrote:

> The modelled forms clearly show the origin of their inspiration in the engineering elements with which the architect had to deal. The rhythmic movements of machinery, the conception of tremendous forces held in control, the inclusion of elements relating to transport, to speed and to travel, have all obviously given a strong, individual character to Mr. Rowse's designs (*Architectural Review*, June 1934).

Owner of building: Mersey Tunnels
Listed status: Grade II

Literature: *Architects' Journal* (1932) 28 September, lxxvi: 393; Atkinson, E. H. W. (1934): 202-4; *Daily Post* (1934) 16 May: 13; Stamp, G., 'Architectural Sculpture in Liverpool', in P. Curtis (ed.) (1989): 11.

GEORGES DOCKWAY FRONTAGE:

Speed – the Modern Mercury
located above the main entrance, facing the rear of the Mersey Docks and Harbour Building in Georges Dockway.

Designer: Herbert J. Rowse
Sculptors: Edmund C. Thompson, assisted by George T. Capstick

Relief in Portland stone

h. including base: 23' 1½" (7.05m)

w. figure only: 4' 9¾" (1.47m)

Description: Carved in high relief, the figure represents speed, or the modern Mercury (the classical messenger of the gods). Symmetrical along its vertical axis, it is an extremely stylized, tall, streamlined figure, wearing a motor racing helmet with raised goggles. Apart from the head, all human characteristics are eliminated from the slender block to emphasize the long,

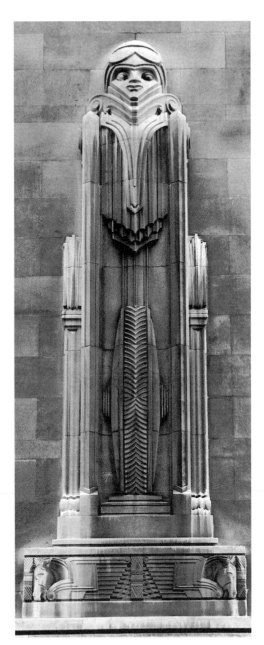

vertical lines which are intended to convey motorized speed. On the central axis of the figure, up to waist height, is a wheel, represented edge on – as if a motor bike is racing over the viewer's head. The base of the relief is ornamented with a symmetrical design consisting of two extremely stylized, back-to-back, crouching, winged horses fitted exactly to the confining rectangle.

Condition: Good – recently cleaned.

Literature: *Daily Post and Mercury* (1934) 16 May: 13.

Night and Day
two free-standing sculptures set into fluted rectangular niches either side of the main entrance in Georges Dockway.

Sculptor: Edmund C. Thompson

Statues in black basalt

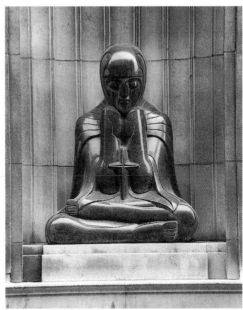

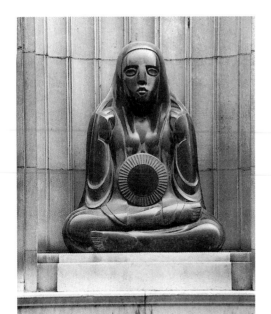

Night – h: 37¹/₂" (95cms); w: 30¹/₄" (77cms); d: 15³/₄" (40cms)
Day – h: 37¹/₂" (95cms); w: 30" (76cms); d: 15" (38cms)

Listed status: as for building

Description: *Night* and *Day* are intended to be symbols of the never-closing Mersey Tunnel (cf. the figures of Apollo and Pluto on the Mersey Tunnel coat of arms; see below, p. 159). The figures, which are brought to a highly polished finish, are cowled and sit in half-lotus position. *Night*, with closed eyes, sits to the left of the entrance. Her elbows rest on her crossed legs, her chin upon her fists. Between her elbows, against her stomach, is a star. *Day* looks straight ahead, her hands raised to shoulder-height, her fists half-closed, her index fingers resting on her shoulders. The top of her head is covered by a cowl, open at the throat and hanging down,

half-covering her breasts, its ends draped on her crossed legs. Resting against her stomach is a sun disc.

Condition: Replaced in their niches 12 May 1994, having been in store since their recovery following theft. Both are in fair condition: *Night* has some very small chips out of the star upon her lap and *Day* a small chip from her nose.

CORNER PAVILIONS, MANN ISLAND AND
BRUNSWICK STREET FRONTAGES
Four Large Relief Panels
These represent *Civil Engineering*, *Construction*, *Architecture*, and *Decoration*, the disciplines essential to the construction of the tunnel. The design of each relief is based on a common unifying pattern: a symmetrical composition with a central male figure in hieratic frontal pose who presents an object relevant to the specific theme of the panel, his lower legs obscured by a rectangular block upon which is carved a geometric motif. Filling the space either side of his head is a horizontal motif, varied in each case. The male figure is flanked by two female figures, each of whom places one foot on the edge of the central block and looks towards her opposite number. Each places one hand upon her head, whilst her other is lowered to hold an appropriate attribute representing an aspect of the specific profession represented. The order of the panels appears to follow a rational sequence, progressing from the forward to the rear edge of each of the lateral faces of the building: *Civil Engineering* is followed by *Construction* on the Mann Island face and, on the Brunswick Street face, *Architecture* is followed by the relief representing the final embellishment of any building, *Decoration*.

Sculptors: Edmund C. Thompson, assisted by George T. Capstick

Reliefs in Portland stone

Each relief: h: 7' 8¹/₂" (2.35m); w: 4' 9³/₄" (1.47m)

Descriptions:
Civil Engineering, on the lefthand corner pavilion of the Mann Island frontage. The central figure wears a striped loincloth and holds before him in both hands, a disc containing a cross-section of the double tunnel. The rectangular block at his knees is inscribed with a circle superimposed on a triangle, the lower corners only of the triangle visible, but the apex obscured. The horizontal motif either side of his head is a row of lightning flashes.

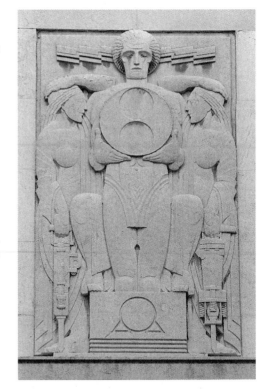

This lightning flash pattern is echoed in the stylized hair of the flanking female figures. Virtually mirror images of each other, they each hold the handle of a different type of pneumantic drill.

Construction, on the righthand corner pavilion of the Mann Island frontage. The central male figure holds in front of him a model of trabeation consisting of two vertical bricks supporting one horizontal. The rectangular block below his knees is inscribed with a square. Either side of his head is a line of triangular shapes like stylized pyramids. He is flanked by two female figures wearing Egyptian headdresses. Each is naked to the waist, the lower body covered by ankle-length drapery, a fold of which is slung over the lowered arm. The female figure on the left holds a Lewis Bolt, whilst the female figure on the right holds a trowel.

Architecture, on the righthand corner pavilion of the Brunswick Street frontage. The central figure holds in front of him an Ionic capital, the design flanking his head is now in the form of chevrons, and the rectangular block is inscribed with a triangle. Each attendant female figure wears a skirt, hitched above one knee to allow her to place a foot upon the central block, the hem of the skirt against the outer edge of the panel descending in a vertical zigzag of folds to the ground. The female figure on the left holds in her right hand a set square and the female figure on the right holds in her left hand a large pair of compasses. Whereas the main compositional lines of the female figures in *Civil Engineering* and *Construction* are mostly parallel to the central vertical axis, the flanking female figures in *Architecture* are rather more animated with poses forming a zigzag pattern of diagonal lines.

Decoration, on the lefthand corner pavilion of the Brunswick Street frontage. The central male figure wears a loincloth. He looks straight ahead and holds in front of him an Assyrian capital of two back-to-back crouching bulls.

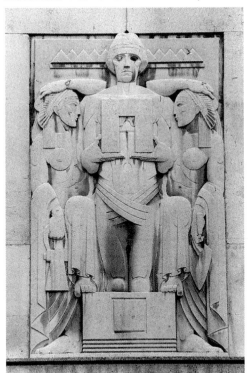 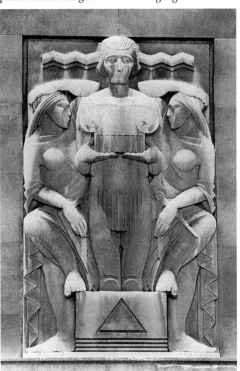 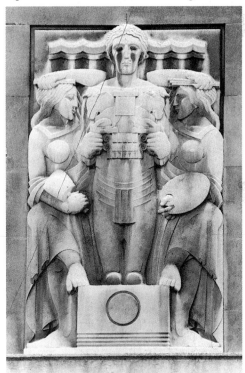

The rectangular block below his knees is incised with a circle and the space either side of his head is filled with a stylized wave motif. The two female figures either side of him have long, wavy hair and wear ankle-length dresses: the angular severity of the female figures' drapery folds in *Architecture* is now softened into a series of curves. The figure on the left holds a sculptor's mallet in her lowered right hand and a chisel in her raised left hand, whereas the figure on the right holds an artist's palette in her lowered left hand and three paintbrushes in her raised right hand.

Condition: All four reliefs appear to be in good condition and have been recently cleaned.

Ventilation
a large relief panel repeated on all four faces of the central ventilating shaft, flanked by columns with Liver Bird capitals

Sculptors: Edmund C. Thompson, assisted by George T. Capstick

Reliefs in Portland stone

h: 15' 5" (4.7m); w: 6' 5" (1.96m)

Description: The large rectangle of *Ventilation* is flanked by two columns with convex shaft mouldings, and capitals formed of nesting Liver Birds with large upraised wings, in full-frontal view (cf. Tyson Smith's earlier and very similar Liver Bird reliefs for the main entrance of Rowse's Martins Bank of 1927-32 in Water Street, p. 242 below.) The relief panel contains a completely symmetrical design based on a ventilator shaft blowing out vitiated air, represented by a zigzag pattern. On each side of the shaft is a circle representing the tunnel entrances either side of the River Mersey, itself represented by three rows of wave shapes below the shaft.

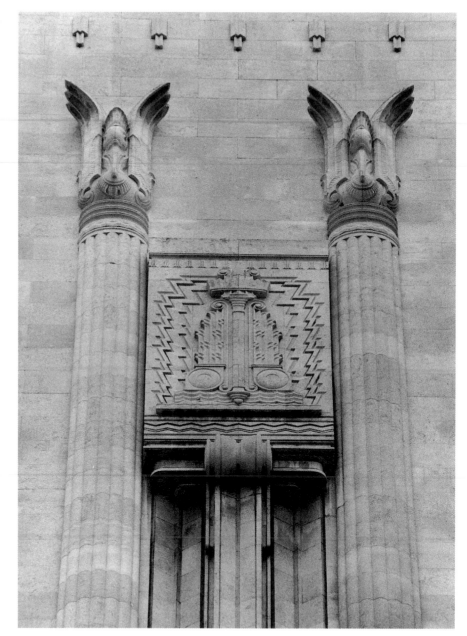

Condition: Fair, some black encrustation on the undersides of the carving.

Literature: *Daily Post* (1935) 18 April: 6.

(2) FREE-STANDING MEMORIALS AND SCULPTURES:

Memorial to Sir Alfred Lewis Jones

(1845 – 1909), Liverpool shipowner and philanthropist. He was born at Carmarthen and was educated at Liverpool Institute and Jesus College, Oxford. A senior partner of the Liverpool firm of Elder, Dempster and Co., shipowners, he was also Chairman of the Bank of British West Africa Ltd, Consul for the Congo Free State, President of the Liverpool Chamber of Commerce, founder and President of Liverpool School of Tropical Medicine, Justice of the Peace for the City of Liverpool and President of the Liverpool Steamship Owners' Association. He was created a Knight Commander of St Michael and St George in recognition of his services to the West African colonies and to Jamaica (source: *Dictionary of Edwardian Biography. Liverpool*).

Sculptor: Sir George Frampton

Sculpture in bronze
Pedestal in Aberdeen granite

Bronze founder: A.B. Burton of Thames Ditton
Stonework contractor: Kirkpatrick Bros of Trafford Park, Manchester (*Journal of Commerce*, 7 July 1913)

Overall h: 28' 6" (8.69m)
Base: 18' × 18' (5.49m × 5.49m)

Inscriptions:
– on the front (west) face inscribed into the bronze below the relief portrait of Jones:
1845-1909

below which is inscribed into the granite:
IN MEMORY OF / SIR ALFRED LEWIS JONES K.C.M.G. / A SHIPOWNER STRENUOUS IN BUSINESS HE EN- / LARGED THE COMMERCE OF HIS COUNTRY BY HIS / MERCANTILE ENTERPRISE AND AS FOUNDER OF / THE LIVERPOOL SCHOOL OF TROPICAL MEDICINE MADE / SCIENCE TRIBUTARY TO CIVILIZA-TION IN WESTERN / AFRICA AND THE COLONIES OF THE BRITISH EMPIRE
– on the lefthand (north) face inscribed into the granite projection below the bronze figure:
FRUITS OF INDUSTRY
– on the rear (east) face inscribed into the granite projection below the bronze relief of the sailing ship: ENTERPRISE
below which is inscribed: UNVEILED BY THE RIGHT HON / THE EARL OF DERBY / 5TH JULY 1913
and at the bottom on the lowest projection of the pedestal: ERECTED BY HIS FELLOW CITI-ZENS
– on the righthand (south) face inscribed into the granite projection below the bronze figure:
RESEARCH

Signed on the front face of the monument, at the righthand end of the bronze base below the fasces: GEO. FRAMPTON. R.A.

Unveiled by Edward George Villiers Stanley, 17th Earl of Derby, Saturday 5 July 1913

Owner/ custodian: Liverpool City Council
Listed status: Grade II

Description: The memorial faces west towards the River Mersey and stands in the open space in front of the Mersey Docks and Harbour Company Building on Pier Head. It is in the form of a tall and slender pedestal with two projecting base courses. The tall pedestal is

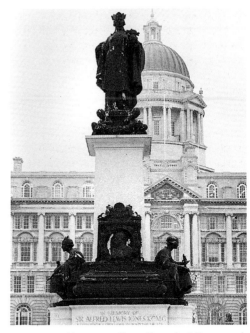

surmounted by a standing allegorical figure and the side projections of the upper base course by two seated allegorical figures.

The female figure surmounting the pedestal represents Liverpool. She wears a castellated crown and a long tabard bearing the city's device. In her left hand she holds up a model of a ship upon a globe, whilst her right hand is slightly extended, 'symbolical of welcoming Commerce to the Port of Liverpool' (*Finance Committee Minutes*, 1/62: 134). At her feet above the angles of the pedestal cornice are seated *putti*, between which festoons are suspended. The figure seated on the lefthand projection of the pedestal has wings in her hair and carries in her left hand a caduceus. In her lap is a basket of fruit and flowers and beneath her is the inscription: FRUITS OF INDUSTRY.

The figure on the righthand projection has an open book in her lap and in her right hand, half resting on an open page of the book, a microscope. Beneath her is the inscription: RESEARCH. It was intended that these two figures should be 'indicative of [Jones's] work in connection with the Tropical School of Medicine and his great commercial activity' (*Journal of Commerce*, 24 November 1911).

The front and rear of the pedestal each carry a bronze relief above an ornate bronze base in the form of fasces bound by straps and bracketed by sea-horses. Each relief is in a roundel encircled by a laurel wreath contained within an aedicule. On the front face the relief carries a profile portrait of Jones facing towards the left and that on the rear face, a relief of a (medieval) sailing ship. The curved pediments of the aedicules are each decorated with a scallop and two dolphins.

Condition: The pedestal is relatively clean with very little graffiti. The bronze is heavily coated in black epoxy paint, matt on the upper surfaces and peeling in many places.

Shortly after Sir Alfred Jones's death a public meeting was called at the Town Hall to consider the most appropriate way to commemorate his achievements both as one of Liverpool's leading merchants and as a philanthropist. The meeting resolved to launch a public subscription to erect a monument 'in recognition of his services to the City of Liverpool and the Empire' (*Journal of Commerce*, 7 July 1913). As was usual, a large General Committee of influential supporters was formed, out of which a smaller Executive Committee was elected to carry out the scheme, including the Earl of Derby as Chairman, and P.F. Corkhill and A.H. Milne as Honorary Secretaries (*Daily Post and Mercury*, 7 July 1913).

By 21 July 1910, it had been unanimously agreed that the memorial should take the form of 'an allegorical monument, with a medallion or some other suitable representation of Sir Alfred' (*The Times*, 22 July 1910). The idea was that the allegory should be 'symbolical of Sir Alfred Jones's shipping interests and his philanthropic and social aspirations' (*African Mail*, 2 August 1910; as quoted in Stevens, 1989a: 84).

The Committee hoped to secure the services of Sir George Frampton (*The Times*, 22 July 1910), then the most celebrated English designer of public sculptures, having executed a whole series of monuments to Queen Victoria from Calcutta to St Helens (Stevens, 1989a: 81). In Liverpool itself he was well-known as the sculptor responsible for the statues of William Rathbone, Sir Arthur Forwood and Canon Lester in St John's Gardens (see below, pp. 171–3, 175–6, 182–4). Frampton's acceptance of the commission was confirmed by the beginning of August 1910 (*African Mail*, 2 August 1910; quoted in Stevens, 1989a: 84) and, on 23 November 1911, the Executive Committee approved, subject to a few minor modifications, his sketch model (*Journal of Commerce*, 24 November 1911).

From the outset, the Committee had favoured Pier Head as the site for its monument (*The Times*, 22 July 1910). On 4 December 1911, the Earl of Derby (who had been recently elected Lord Mayor), made a formal application to the Corporation Finance Committee for permission to erect the monument on one of two sites in this area, either at the foot of Brunswick Street, or opposite the newly-erected Royal Liver Building. Unfortunately, the whole of the Pier Head area was at this time undergoing major improvements and the Finance Committee felt itself unable to make a specific commitment (*Finance Committee*

Minutes). On 23 May 1912, Derby applied again, this time suggesting a site in front of the Mersey Docks and Harbour Board building. To encourage the Corporation to reach a favourable decision, the Memorial Committee offered its surplus of £200 from the subscription towards the cost of excavating the foundations (*Finance Committee Minutes*). This was in fact a considerable inducement, since, in the case of memorials donated to the City, the Corporation traditionally met the whole expense of work on the foundations (see, e.g., *Finance Committee Minutes*, 1/62: 135).

The Corporation Surveyor, Thomas Shelmerdine, having been instructed to examine the proposed site and report back, did so in the following week, along with the Earl of Derby and the Chairman of the Mersey Docks and Harbour Board. The site looked ideal, but, owing to the singular composition of the ground upon which the monument was to stand, serious consideration had first to be given to the structure of its foundations. Frampton was at this time away 'on a sea voyage' (*Daily Post and Mercury*, 30 May 1912). On his return, Shelmerdine discussed the matter with him and, on 3 January 1913, made his report to the Finance Committee. He advised that the nature of the 'sub-soil and strata', consisting of 'filling in, silt, river sand and gravel', would necessitate introducing:

reinforced concrete piles driven in as far as the nature of the strata will permit, with a reinforced concrete platform a few inches below the pavement level, which would receive the base of the Statue (*Finance Committee Minutes*).

Eventually, on 2 May 1913, the Memorial Committee's site request was officially approved by a Special Corporation Sub

Committee, specifically set up to address itself to the development of the Pier Head area (*Finance Committee Minutes*). The final cost of the memorial to its subscribers was £2,500, exclusive of the excavation of the foundations (*Finance Committee Minutes*, 1/62: 134).

Frampton's *Memorial to Sir Alfred Jones* was unveiled on 5 July 1913 to unanimous critical acclaim: 'The memorial is at once beautiful and striking' (*Courier*, 5 July 1913 and *Journal of Commerce*, 7 July 1913); and 'there is a consensus…that Frampton has achieved a triumph' (*Daily Post and Mercury*, 7 July 1913). Contemporary accounts of the unveiling are remarkable for the number of times Frampton, who was present at the ceremony, receives favourable mention. The Lord Mayor considered it 'a magnificent memorial' and the crowd responded with 'loud applause' at the mention of the sculptor's name. Mr Harrison Williams of the Memorial Committee went so far as to proclaim the monument as much a testimony to Frampton's artistic skill as it was a memorial to their late friend (*Journal of Commerce*, 7 July 1913). Councillor Meade-King was sufficiently impressed to write to the *Daily Post and Mercury* a few days later (9 July 1913), expressing the hope that the example it set of restricting the contemporary-dress portrait to a relief roundel and employing instead beautiful ideal figures to embody the sentiments of the memorial, would be followed in the projected *Monument to King Edward VII*.

It is not known who had originated the idea for the symbolic treatment of the monument, but it was certainly congruent with Frampton's views. In 1905 Frampton had told the *Southport Guardian*:

When a monument is put up to a man, we do not want to see his frock-coat or the partic-ular coat he wore, but we want a fine, symbolic monument. If his portrait is required a medallion would serve the purpose (as quoted in Stevens, 1989a: 84).

Perhaps, as Stevens has suggested (1989a: 84), the Memorial Committee had been impressed with the effect obtained by Goscombe John's symbolic figure of Britannia on the recent *Memorial to the King's Liverpool Regiment* (see below, pp. 177–80). Certainly the newly developed waterfront site, backed by the Edwardian neo-Baroque splendour of the Mersey Docks and Harbour Board building was more enhanced by the poetry inherent in Frampton's allegorical approach than it would have been by the prose of traditional 'coat-and-trousers' portaiture.

Literature: (i) LRO (a) manuscript sources: *Finance Committee Minutes*, 1/61: 147, 525-26; *Finance Committee Minutes*, 1/62: 134-35, 443, 479, 636. (b) newscuttings: *Courier* (1913) 5 July, in *CH&T* 14: 1; *Journal of Commerce* (1913) 7 July, in *CH&T 14*: 2-5; *Daily Post and Mercury* (1912) 30 May, in *TCN 1/37*. (ii) WAG JCS files – typed transcript of article in *Journal of Commerce*, 24 November 1911. (iii) *Courier* (1913) 5 July: 9; *Courier* (1913) 7 July: 6; *Daily Post and Mercury* (1913) 7 July: 5; *Daily Post and Mercury* (1913) 9 July: 5; *Journal of Commerce* (1913) 7 July: 2; Reilly, C.H. (1927a): 3; Stevens, T., 'George Frampton', in P. Curtis (ed.) (1989a): 83-4; *The Times* (1910) 22 July: 13; *The Times* (1913) 7 July: 7.

Memorial to the Engine Room Heroes

Sculptor: Sir William Goscombe John

Memorial in granite with some gilding

h. overall: 48' (14.6m)

Inscriptions on the pedestal:
– on the south face of the dado: THE BRAVE DO NOT DIE / THEIR DEEDS LIVE FOR EVER / AND CALL UPON US / TO EMULATE THEIR COURAGE / AND DEVOTION TO DUTY
– on the north face of the dado: IN HONOUR OF / ALL HEROES OF THE / MARINE ENGINE ROOM / THIS MEMORIAL / WAS ERECTED BY / INTERNATIONAL SUBSCRIPTION / MCMXVI
– on the bases beneath the corner figures at the foot of the obelisk: WATER (north-west); EARTH (north-east); FIRE (south-east); AIR (south-west)

Signed at the righthand end of the west face of the plinth: W. GOSCOMBE JOHN R. A.

Exhibited: Royal Academy of Art 1916, as *Stokers* (cat. 1763); and *Engineers* (cat. 1764). *Models of groups for Engine Room Heroes' Memorial, Liverpool*. Royal Academy of Art 1918, as *Air* (cat. 1457); and *Water* (cat. 1458). *Models of granite figures for the Engine Room Heroes' Memorial, Liverpool*.

Unveiled Monday 8 May 1916.

Owner/ custodian: Liverpool City Council
Listed status: Grade II

Description: Located at St Nicholas Place on Pier Head, the memorial is in the form of an obelisk mounted on a pedestal with a high plinth. On the south and north faces of the pedestal are inscriptions beneath each of which is carved a wreath encircling a ship's propeller – that on the north a wreath of oak, that on the south of laurel. On the west and east faces of the pedestal are full-length figures of the 'Engine Room Heroes' carved in high relief and set against projecting piers. On the west face are two engineers: the figure on the left holds a stoking-hatch lever and the figure on the right, a spanner. In the corresponding position facing east are two stokers: the figure on the left,

naked to the waist, holds a cloth, whilst the figure on the right rests one hand on his comrade's shoulder and in the other holds a shovel. The projecting piers also provide the figures with a platform upon which to stand and a cornice under which to shelter and effectively isolate them from the low-relief stylized waves which run all around the pedestal at a level with their knees.

Above the pedestal, at the foot of the obelisk, are crouched corner figures symbolizing the elements. Between them and up to a level with the tops of their heads are more stylized waves carved in low relief, from which, on each face of the obelisk, a gilded sun rises. On each of the four faces at the top of the obelisk stands a diaphanously draped female figure, representing the sea. These form a complete ring around the obelisk, linked by the breeches-buoys which each holds in common with her immediate neighbours. Crowning the obelisk is a gilded torch flame.

According to the *Journal of Commerce* (20 May 1916), the memorial is:

> symbolic in design and treatment, the motive chosen by the sculptor being the contending nature of the elements fire and water...The obelisk is surmounted by a group of female figures symbolic of the sea, and by a gilded torch suggestive of the triumph of Fire, and commemorative of the services rendered by those who keep the lights burning.

Condition: The north and east faces of the pedestal are peppered with holes, presumably resulting from bomb damage. The east face is worst affected: a large piece is missing from the corner of the projecting platform below the stoker's shovel. The head and left bicep of this figure is damaged, as is the cornice above his head. His companion has a chunk missing from the left elbow.

The memorial was originally to have been dedicated primarily to the thirty-two engineers of the *Titanic* who stayed at their posts on the night of 15 April 1912 in order to keep the ship afloat a little longer so that as many passengers as possible might escape. Even at this early stage, however, 'spaces [were] to be left to receive at some future time the records of other heroic deeds done by sea-going engineers' (*The Engineer*, 5 July 1912, as quoted in *The Journal of Commerce*, 20 August 1912).

On 1 August 1912, Arthur Maginnis, the Chairman of the Site and Designs Committee of the memorial fund, applied to the Corporation Finance Committee for the allocation of a suitable site at Pier Head. Unfortunately, the Corporation felt itself unable to allocate a site at that time as the improvements to the area were still being carried out (*Finance Committee Minutes*). By mid-August 1912, the fund, which was receiving contributions worldwide, had reached nearly £3,500 and was expected to reach £4,000 (*Journal of Commerce*, 20 August 1912; the article also stated that the site had by now been allotted, but this was clearly premature).

Towards the end of this year, however, it is evident that at least the choice of sculptor had been agreed. On 22 November 1912, Percy Corkhill, a member of the City Council, wrote to William Goscombe John, inviting him to come up on the 30th to visit Liverpool's docks, evidently in order that the sculptor could make preparatory sketches. Corkhill's letter survives, inserted into a sketchbook now in the library of the Royal Academy of Arts, London (*Sir William Goscombe John Sketchbook*, 621. i). The sketchbook itself includes an annotated drawing of the engine room of the SS. Caronia,

plus drawings and written descriptions of the working costumes and tools used by the engineers and firemen of the SS. Arabic. According to Fiona Pearson, it is probable that Corkhill was instrumental in awarding the commission of the *Memorial to the Engine Room Heroes* to Goscombe John, as he had some years previously been involved in the commissioning of the sculptor's *Memorial to the King's Liverpool Regiment* for St John's Gardens (Pearson, 1979: 16).

A further four months were to pass before, on 2 April 1913, Maginnis again wrote to the Corporation, now applying for a specific site at Pier Head (the precise location of this first choice is not known as it was indicated only on a map, now lost, submitted with Maginnis's letter). Maginnis urgently requested the Corporation's approval as the Memorial Committee was eager to start the process of selecting a design and, even more pressing, the subscribers, having donated their money, had begun to enquire as to the progress of the memorial. The matter was referred to the Special Sub-Committee that had been formed to supervise the improvements at Pier Head and, on 2 May 1913, the Memorial Committee's specific suggestion was considered, rejected, and an alternative site on the nearby Princes Parade (i.e. the present site, now known as St Nicholas Place) offered and accepted (*Finance Committee Minutes*).

Following the outbreak of war it was felt by some that a memorial giving primacy to the engine-room heroes of the 'Titanic' was inappropriate in the light of the many tragic losses then being sustained at sea: on 12 February 1915, Councillor David Jackson tried unsuccessfully to persuade the Finance Committee to rescind its approval for the memorial's erection (*Finance Committee Minutes*).

The Memorial Committee was perhaps not insensitive to the sentiments thus expressed and later that same month, at the Corporation Finance Committee's meeting on the 26th, Maginnis submitted, and received approval for, a dedication broadened to include all maritime engine room fatalities incurred during the performance of duty. A front panel was to state: 'A tribute to the Engine Room Heroes of all time'; and a reverse panel: 'Erected by international subscription' with a reference below to the unveiling and by whom it had been performed (*Finance Committee Minutes*).

Nevertheless, even with an amended dedication, it evidently was still the 'Titanic' memorial to Councillor Jackson and, on 3 March, when the Finance Committee's overruling of his objection came up for Council ratification he tried again (unsuccessfully) to secure a rescindment of Corporation approval for the memorial's erection (*Council Minutes*).

Towards the end of the year (3 December 1915), the Finance Committee approved an amendment from Maginnis: the inscription was now to include the motto, 'The brave do not die...' (*Finance Committee Minutes*). By now, though, the earlier reference to the unveiling had been omitted altogether. Perhaps Councillor Jackson's reservations were shared by others and were a contributory factor to the absence of any official unveiling ceremony, a situation which the *Journal of Commerce* (20 May 1916) had explained as a necessary expediency 'owing to the war'.

Notwithstanding the memorial being unveiled 'without ceremony', the *Daily Post and Mercury* (9 May 1916) reported that the informal unveiling 'attracted large crowds', many of whom were obviously 'mourners for lives lost in [the Titanic] or the Lusitania', though unlike the rapturous reception extended to Frampton's 'symbolic' *Memorial to Sir Alfred Jones* at the other end of Pier Head three years previously (see above, p. 137), Goscombe John's equally 'symbolic' memorial got a mixed reception, consisting of 'criticisms, favourable and otherwise'.

On 19 June 1916, the Lord Mayor formally accepted the memorial on behalf of the City. The Memorial Committee also presented him with a cheque for £200 to cover maintenance, which he duly forwarded to the Finance Committee whose responsibility the memorial now became (*Courier*, 3 July 1916).

The *Memorial to the Engine Room Heroes* shows Goscombe John at his most 'modernist'. It also stands as a rare example in Liverpool of the commemoration not of a single, high-ranking individual, but of the 'ordinary' workers of the city.

Literature: (i) LRO (a) manuscript sources: *Finance Committee Minutes*, 1/61: 694; *Finance Committee Minutes*, 1/62: 443; *Finance Committee Minutes*, 1/64: 197, 225, 235, 686; *Finance Committee Minutes*, 1/65: 246-47, 271. (b) newscuttings: *Daily Dispatch* (1916) 7 April, in *CH&T 1916*; *Liverpool Journal of Commerce* (1912) 20 August, in *CH&T 13*.

(ii) Royal Academy of Arts Library, London, manuscript source: *Sir William Goscombe John Sketchbook*, 621. i

(iii) *Builder* (1916) 14 July: 22; Compton, A., 'Memorials to the Great War', in P. Curtis (ed.) (1989): 91; *Courier* (1916) 3 July: 6; Curtis, P. (1988): 28; *Daily Post and Mercury* (1916) 9 May: 3; *Journal of Commerce* (1916) 20 May: 9; Pearson, F. (1979): 16, 68.

Equestrian Monument to King Edward VII
(1841 – 1910). Edward, the eldest son of Queen Victoria and Albert, Prince Consort, acceded to the throne on 22 January 1901 and died on 6 May 1910.

Sculptor: Sir William Goscombe John

Statue in bronze
Pedestal in granite

Bronze founder: A.B. Burton of Thames Ditton
Stonework contractor: John Stubbs of Crown Street, Liverpool

Statue – h: 16' (4.88m)
Pedestal – h: 14' (4.27m); l: 15' 6" (4.72m); w: 8' 1" (2.46m) (approx.)

Inscription on the (west facing) front face of the pedestal: EDWARD VII

Signed and dated on the (north facing) left side of the bronze base: W. GOSCOMBE JOHN. R.A. 1916

Founder's name on the (south facing) right side of the bronze base: A. B. BURTON. / FOUNDER. THAMES DITTON.

Exhibited: Royal Academy of Arts 1911 (cat. 1792), as *H. M. the late King Edward VII. Portrait study for King Edward Memorial, Liverpool*; Royal Academy of Arts 1916 (cat. 1952), as *H. M. King Edward VII. Equestrian statue to be erected in Liverpool.*

Unveiled by Edward, Prince of Wales, Tuesday 5 July 1921

Owner/ custodian: Liverpool City Council
Listed status: Grade II

Description: Located in the middle of the open space in front of the Cunard Building, the statue portrays the King wearing military

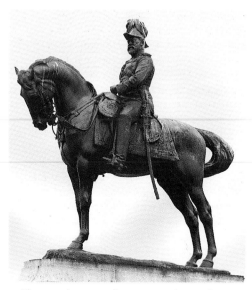

uniform and mounted upon a stationary horse. He holds the reins in his left hand and in his half-lowered right hand, a marshall's baton. He looks slightly to his left.

Condition: Heavily coated with black epoxy paint, matt on exposed surfaces and peeling away in many places.

Following King Edward VII's death in 1910, a group of Liverpool's leading citizens gathered together and agreed that the city should raise its own memorial to the deceased monarch. The King Edward VII Memorial Committee was duly formed and, at a meeting on 23 September 1910 at Liverpool Town Hall, presided over by the Lord Mayor, W.H. Williams, offered the commission for the memorial to the sculptor, William Goscombe John, on the strength of his plaster of Paris model consisting of an equestrian portrait of the late King, flanked by two figures emblematic of peace and concord. It was reported (*Courier*, 24 September 1910) that the

Corporation Finance Committee had already agreed to recommend to the Council that permission should be granted for the erection of the memorial at the south end of St George's Hall and now there only remained the business of launching an appeal for public subscriptions. The work was to be completed within two years and would necessitate the removal of the high podium-like wall, from the top of which the south portico of St George's Hall overlooked St John's Lane. The wall would be replaced by steps, climbing in one broad flight from the Lane before dividing into two to pass between the pedestals of the central equestrian statue and its flanking allegories immediately in front of the portico. The stairways between the pedestals were to have been closed off with ornamental gates.

There was, however, intense resistance to this scheme from local architects, most notably from the respected Professor C.H. Reilly of Liverpool University School of Architecture, who considered that the proposed removal of the St John's Lane wall would vitiate the grandeur of St George's Hall. He praised the Hall in its existing arrangement as 'a sort of architectural dream raised high above the turmoil of the street', in which scenario the high wall is to St George's Hall what the Acropolis is to the Parthenon. Furthermore, the monument itself, in Reilly's view, would appear dwarfed by its close proximity to the Hall (*Courier*, 28 January 1911; cf. adverse criticism of the placement of Thornycroft's *Equestrian Statue of the Prince Consort*, see above, p. 94).

Alternative sites were proposed, including St George's Plateau, between the equestrian statues of *Queen Victoria* and *Prince Albert*, where the *Cenotaph* now stands, but which was then occupied by the *Statue of Lord Beaconsfield* (suggested by Liverpool architect

Walter W. Thomas in a letter to the *Courier*, 7 January 1911); the Steble Fountain site, which would have necessitated the relocation of the fountain to a park in the suburbs; one of two open spaces outside the Anglican Cathedral, under construction since 1904; and Pier Head, then in the early stages of its development as an open public space (*Daily Post*, 19 January 1911).

The most formidable opposition to the scheme to alter St George's Hall came from the Council of the Royal Institute of British Architects, on behalf of which the PRIBA, Leonard Stokes, wrote to the Lord Mayor of Liverpool (S.M. Hutchinson, then Chairman of the Memorial Committee), on 22 January 1911, opposing any alterations whatsoever to the structural lines of the Hall (letter published in the *Post and Mercury*, 31 January 1911). This petition was followed on 1 February by the publication in the *Post and Mercury* of a second, signed by 'some of the most eminent architects in the country', including, apart from Leonard Stokes, the previous PRIBA (Sir) Ernest George, Sir Alfred Brumwell Thomas, A. Beresford Pite, Edwin Lutyens, and the editors of the *Builder*, the *Building News*, and *Architects' and Builders' Journal*.

Meanwhile, the Memorial Committee had sought professional advice from a panel of five independent experts: the architects John Belcher, Sir Aston Webb, (Sir) Reginald Blomfield, and Richard Norman Shaw, and the sculptor, (Sir) William Hamo Thornycroft. A majority of the panel did not object in principle to making alterations to the south end of St George's Hall, but were evidently dissatisfied with certain specifics of Goscombe John's design. Shaw proposed some amendments and produced his own model which was accepted by the sculptor, and which he then submitted to his fellow experts (*Courier*, 30 January 1911).

Two of the panel of five endorsed Shaw's amended model, giving Shaw a majority of three to two; and, at its meeting on 26 January 1911, the Memorial Committee added its official approval (*Weekly Mercury*, 28 January 1911). The two outvoted experts on the panel, Webb and Blomfield, later revealed to the press that they had been 'strongly opposed to breaking the magnificent podium' (*Daily Post and Mercury*, 1 February 1911). In Shaw's amended design, Goscombe John's monument was to have retained its central positioning, but would stand further forward, on a high base, away from the columns of the portico; most significantly, the two flanking allegories, set apart from the equestrian statue in the original design, were to have been integrated with it in one centrally-placed monument (*Courier*, 30 January 1911; *The Times*, 4 February 1911).

In order to carry out the scheme, the Memorial Committee had not only to secure Corporation approval, but also to persuade it to agree to defray the quite considerable costs involved. Consequently, the 26 January Memorial Committee meeting ended with the Lord Mayor, S.M. Hutchinson, and ex-Lord Mayor, W.H. Williams, being asked to form a deputation with fellow Committee-member P.F. Corkhill and the sculptor, to petition the Corporation Finance Committee at its meeting on the following day (*Courier*, 28 January 1911). After a lengthy consultation, a majority of the Finance Committee voted in favour of the scheme, but decided to postpone consideration of the matter, pending a cost report from the Corporation Surveyor (*The Times*, 4 February 1911).

Meanwhile arrangements were made to let the public see Shaw's revised model, firstly, from 28 January – 2 February, in the vestibule of the Town Hall, then, from 3 – 6 February, in

the Exchange Newsroom, and finally, from 7 – 9 February, in the Walker Art Gallery (*Daily Post and Mercury*, 31 January 1911). This generated the publication of a string of disputatious letters and articles in both of the principal local daily newspapers (see particularly 31 January and 1 February 1911). Also, on 28 February, one of them, the *Daily Post and Mercury*, published a petition from eighteen of the most influential businessmen in Liverpool, protesting at what they called the proposed 'mutilation' of the Hall. Finally, the matter was considered to be of sufficient national interest to receive comprehensive coverage between 27 January and 1 March 1911 in *The Times* (see 'Literature', below).

Although the general weight of criticism was still against any alterations whatsoever to St George's Hall, there were some celebrated advocates of the scheme, notably (Sir) Giles Gilbert Scott, the architect then engaged on the Anglican Cathedral, the sculptor Sir George Frampton, and the painter Sir Lawrence Alma-Tadema (*Courier*, 30 January 1911). Also, the *Courier* had now changed its editorial stance and was wholly supportive of the scheme, a reversal ridiculed by its competitor, the *Daily Post and Mercury* (1 February 1911), which remained resolute in its opposition.

At the end of the two week moratorium, the Corporation Surveyor, Thomas Shelmerdine, submitted his report on the estimated cost of the scheme to the Finance Committee, with Hutchinson and Goscombe John in attendance. The Committee voted nine to four in favour of proceeding with the removal of the podium wall, but, at the suggestion of Alderman Louis S. Cohen, recommended to the Memorial Committee that instead of placing the monument in the centre of the flight of steps, pedestals should be erected to either side, with

the pedestal at the Lime Street side being allocated to the statue of King Edward (*The Times*, 11 February 1911; *Daily Post and Mercury*, 16 March 1911). At the next meeting of the Memorial Committee, the Finance Committee's proposal was considered and it was decided to again seek expert advice (*The Times*, 15 February 1911).

Although the statue would not now be in a position to interrupt the view of the columns of the south portico, there was still much opposition to the scheme (*The Times*, 1 March 1911). The strongest argument against the podium wall had always been that it was not certain whether it was part of the original architect H.L. Elmes's plans, or even those of his successor, C.R. Cockerell, since both were dead by the time of its construction (letter from 'R' to the editor, *Courier*, 30 January 1911). Consequently, the case for the wall was much strengthened when Professor Reilly published drawings proving that it had indeed been part of Elmes's plans (*Daily Post and Mercury*, 16 March 1911).

Notwithstanding the growing strength of the argument against the scheme, the Council was still generally in favour, while at the same time remaining cautious about committing itself to such a large financial outlay. The Memorial Committee, for the meantime, was busy in consultation with its experts in London and thus the forward momentum went temporarily out of the project and it is not until almost the end of the year that further significant action is recorded.

On 29 November 1911, the new Chairman of the Memorial Committee, Lord Derby (recently elected as Lord Mayor), wrote to the Finance Committee announcing his intention to attend its next meeting (1 December), accompanied by Committee-member Robert Gladstone

and sculptor Goscombe John. The deputation duly arrived with a new model, based on the Finance Committee's earlier recommendation, but incorporating refinements suggested by its London experts. As this model is now lost, it is not known whether the accompanying allegories still formed a part of the design, although there is no further mention of them. The Finance Committee approved the new model – subject to any minor modifications it might in future deem necessary – and, furthermore, proposed that the necessary alterations to the site might be funded by borrowing the sum of £2,500 from the London-based Local Government Board. At the Council meeting for 6 December, approval of the new model was ratified, as was the proposal that the Local Government Board be approached for a loan, notwithstanding vehement opposition and calls for another moratorium to allow local architects to air their views. The chief objection raised by Alderman Meade-King was that the appearance of 'our magnificent classical Hall' would be seriously damaged by the flight of steps which would, of necessity, have to end in a slant on the slope of St John's Lane. His suggestion that the monument might be located 'on the triangle south of St George's Hall' went unheeded (*Finance Committee Minutes*).

In a final measure to ensure that the best possible solution had been reached, the model was sent to London to see whether any modifications might still be needed. On 12 July 1912, Shelmerdine reported that John Belcher had approved the model, but that Shaw had been too ill to discuss it (he was to die later that year). The model was then inspected by the Finance Committee and Shelmerdine was authorised to invite tenders for the re-building work (*Finance Committee Minutes*). It should be noted that throughout this year, the local

newspapers had continued to publish articles and letters in increasing numbers, mostly objecting to what was seen as civic vandalism. Nevertheless, in the Council meeting of 4 September 1912, and regardless of renewed opposition in the chamber, a tender for £2,357 was accepted from local contractor, Messrs William Tomkinson & Sons. The new objection here added to the existing catalogue was that St John's Lane would have to be narrowed by an unacceptable twenty feet to accommodate the bottom of the flight of steps (*Finance Committee Minutes*; see also artist's impression in *Daily Post and Mercury*, 25 September 1912, and article in *Daily Post and Mercury*, 8 February 1913). The opponents of the scheme decided that the time had come to take legal action. On 11 September 1912, the *Daily Post and Mercury* reported that a group of influential citizens – presumably the same as had unsuccessfully petitioned the Lord Mayor the previous year – had now engaged a top firm of solicitors to oppose the Council's loan application. Then, on 16 September, the paper itself launched a public subscription, 'The St George's Hall Preservation Fund', to pay the legal costs of the opposition. On 23 September, the Historic Society of Lancashire and Cheshire sent a strong protest to the Council (*Finance Committee Minutes*) and on 18 October a further protest from the RIBA Council was published in the *Daily Post and Mercury*.

There was to have been an official enquiry to determine the validity of the loan, but this was rendered unnecessary by the Corporation's receipt of a letter from the Board, dated 29 January, stating that it could not – for reasons that were a matter of contemporary speculation – give the loan its sanction (*Finance Committee Minutes*; *Daily Post and Mercury*, 8 February 1913). Notwithstanding Pier Head being

frequently suggested as an alternative site in the press and, on 30 April 1913, it being proposed as 'the best site' by the Liverpool City Guild (*Daily Post and Mercury*, 1 May 1913), the scheme fell into abeyance and then all effective action on the part of the Memorial Committee was suspended anyway for the duration of the First World War.

Meanwhile, Goscombe John continued to work on the statue and exhibited the plaster model at the Royal Academy of 1916 (illus. in Pearson, 1979: 68). The casting of the bronze, however, was delayed by the sculptor's convalescence following a 'severe operation' (*Courier*, 29 October 1917) and it is not until early 1919 that there is a suggestion that the bronze may have been completed or was nearing completion, for on 24 March 1919 the Memorial Committee submitted a new request to the Corporation Finance Committee for approval to erect the monument at what was still their preferred location, the south end of St George's Hall (*Finance Committee Minutes*).

The new scheme, however, seems to have been a much reduced version, reflecting the financially-straitened conditions of post-war Liverpool. There is now no suggestion that the podium wall should be demolished and a grand flight of steps constructed in its place. Instead the Memorial Committee ask merely for permission to erect the statue 'in a central position on the terrace in front of the South Entrance of St George's Hall'. After a series of postponements, the Memorial Committee's request was endorsed by the Finance Committee on 25 April 1919, but was finally rejected by the Council on 9 May (*Finance Committee Minutes*). Thus, the Memorial Committee found itself the owner of a completed equestrian bronze statue with no place to put it. The Committee's solution, on

27 May, was to write to the Finance Committee, formally donating the statue – minus pedestal – to the Corporation, for erection anywhere within the city boundaries (*Finance Committee Minutes*).

On 13 June 1919, the Finance Committee appointed a Sub-Committee to consider possible locations (*Finance Committee Minutes*). The Sub-Committee seems to have approached its task with little enthusiasm as there is no sign of any action until 21 September 1920 when it met and agreed on two possibilities. The favoured option was in front of the Cunard Building at Pier Head; failing that, there was a site close by the entrance to Princes Park which was deemed to be 'admirably suited'. All other sites examined had inherent problems. The Pier Head site was duly approved (*Finance Committee Minutes*) and, on 6 October 1920, confirmed by the Council (*Council Minutes*).

On 15 October 1920, the Corporation Surveyor, A.D. Jenkins, was instructed by the Finance Committee to confer with Goscombe John and to secure from him a design for the pedestal (*Finance Committee Minutes*). Tenders were then requested for its construction. Messrs Kirkpatrick of Manchester competed as usual, but this time, on 21 January 1921, the job was awarded to a local firm, Messrs John Stubbs of Crown Street, Liverpool (*Finance Committee Minutes*). The statue was finally unveiled on 5 July 1921, during a whistle-stop royal tour of Lancashire. The extreme brevity of the ceremony contrasts dramatically with the almost eleven years of the work's gestation. The *Courier* (5 July 1921) gives the day's itinerary:

> 4. 10. Arrive at Pierhead. Unveiling of the King Edward Memorial.
> 4. 20. Leave the Pierhead...

Literature: (i) LRO (a) manuscript sources: *Council Minutes*, 1/53: 166; *Finance Committee Minutes*, 1/61: 131, 142, 649, 720-22, 727-28, 770-71; *Finance Committee Minutes*, 1/62: 262; *Finance Committee Minutes*, 1/67: 217, 266, 308e, 368, 417; *Finance Committee Minutes*, 1/68: 273, 710, 746; *Finance Committee Minutes*, 1/69: 16, 102. (b) newscuttings: *Courier* (1911) 7 January, in *TCN 1/35*; *Courier* (1911) 28 January, in *TCN 1/35*; *Courier* (1911) 30 January, in *TCN 1/35*; *Courier* (1911) 1 February, in *TCN 1/35*; *Daily Post and Mercury* (1911) 19 January, in *TCN 1/35*; *Daily Post and Mercury* (1911) 30 January, in *TCN 1/35*; *Daily Post and Mercury* (1911) 31 January, in *TCN 1/35*; *Daily Post and Mercury* (1911) 1 February, in *TCN 1/35*; *Daily Post and Mercury* (1911) 28 February, in *TCN 1/36*; *Daily Post and Mercury* (1911) 16 March, in *TCN 1/36*; *Daily Post and Mercury* (1912) 14 September, in *TCN 1/37*; *Daily Post and Mercury* (1912) 25 September, in *TCN 1/37*; *Daily Post and Mercury* (1913) 10 February, in *TCN 1/38*; *Daily Post and Mercury* (1913) 29 April, in *TCN 1/38*; *Daily Post and Mercury* (1913) 1 May, in *TCN 1/38*.
(ii) *Connoisseur* (1916) xlv: 124; *Courier* (1910) 24 September: 5; *Courier* (1917) 29 October: 6; *Courier* (1921) 14 June: 7; *Courier* (1921) 5 July: 5; *Daily Post and Mercury* (1921) 6 July: 6, 10; Pearson, F. (1979): 14, 68; *Royal Academy Illustrated* (1916): 95; *The Times* (1911) 27 January: 13; *The Times* (1911) 4 February: 13; *The Times* (1911) 11 February: 10; *The Times* (1911) 15 February: 11; *The Times* (1911) 1 March: 11; *The Times* (1921) 6 July: 7; *Weekly Mercury* (1911) 28 January: 9.

Cunard War Memorial

Architect: Arthur Joseph Davis
Sculptor: Henry Alfred Pegram

Statue in bronze on a Roman Doric column in granite with bronze mouldings and details

Bronze mouldings and details: The Bromsgrove Guild
Stonework: John Stubbs & Sons

Inscription on the west face of the pedestal of the column: PRO PATRIA / 1914–1918/1939–1945

Signed on the back of the bronze ship's prow, forming the base beneath the figure: …PEGRAM… (only the surname of the signature is discernible)

Exhibited: Royal Academy of Arts 1921 (cat. 1209), as *Victory. Model of bronze statue for Cunard War Memorial, Liverpool.*

Unveiled by Edward George Villiers Stanley, 17th Earl of Derby, Saturday 22 October 1921.

Owner: untraced; ownership not acknowledged by Cunard
Listed status: Grade II

Description: The memorial is located in front of the main entrance of the Cunard Building (1913-18, by Willink and Thicknesse, in collaboration with A.J. Davis of Mewés and Davis), formerly the head offices of the Cunard Company. It takes the form of a monolithic Roman Doric column on a pedestal, surmounted by a nude male figure in bronze. The column, with a Roman ship's prow in bronze projecting to each side about a third of the way up the shaft, is modelled on a Roman rostral column. According to the *Cunard Magazine* (1921: 186) these bronze prows 'were adapted from the prow of a Roman ship now in the Louvre Museum at Paris'. Each prow is decorated at its tip with a profile head in a medallion and, close to the junction with the column shaft, a grotesque front-facing head. The torus mouldings of the column base are also of bronze, the lower designed to represent a rope, the upper formed of five rings cross-tied at the principal axes. A motif of sea shells replaces the usual egg and tongue pattern of the capital's echinus moulding. Suspended from the echinus at front and back is a rope and anchor in bronze. All these decorative details 'thus giving a naval character to the design' (*Cunard*

Magazine, 1921: 186). The surmounting bronze figure is nude, but for a wreath of olive leaves on his head, a fig leaf covering his genitals, a cloak billowing out behind him and a circular shield on his left arm, lowered and turned backwards. He strides forward, his right foot stepping on the prow of a Roman galley, his left leg swung backwards. In his raised right hand he carries a wreath of oak leaves. According to the *Cunard Magazine* (1921: 149) this figure is a personification of Victory. It was also noted that:

> The bronze of which the statue is cast is peculiarly hard, and the sculptor has adopted the unusual course of burnishing it in the belief that this will still further harden the metal, and thus retard the disintegrating effects of the atmosphere (*Cunard Magazine*, 1921: 187).

Condition: Generally good. The letters 'i' and 'a' of 'patria', once missing, are replacements.

In 1919, the two architectural practices Willink & Thicknesse and Mewés & Davis were asked to submit designs for a war memorial to stand outside the Cunard Building at Pierhead. On 2 April the Cunard Steamship Company's Executive Committee selected the design by A.J. Davis. Willink & Thicknesse, who had designed the Cunard Building in collaboration with Davis, maintained a close involvement with the execution of the scheme and were now required to work up the details of the memorial at full size and to submit the designs to Davis for his approval. Pegram was at this point approved as sculptor for the bronze figure which was to surmount the column and which was to cost a maximum of £2,000 (*Minutes...*, 2 April 1919). The names of those members of the Company who had lost their lives in the war

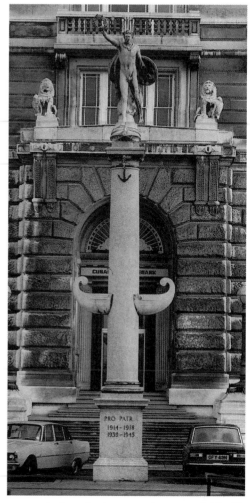

were to be inscribed, not on the memorial itself, but on stone tablets in the vestibule of the Cunard Building (see *Minutes...*, 7 December 1921 and 19 July 1922).

By 31 July 1919 Willink had seen and approved Pegram's sketch model and he had paid the sculptor £650. Pegram was to be paid

in the traditional way, namely in three instalments: the first when the sketch was approved, the second on completion of the full-size clay model, and the third on delivery of the finished bronze figure (Minutes..., 30 June 1920). Altogether it was estimated that the memorial would cost £4,050, that is to say, in addition to the £2,000 allocated for the bronze figure, £1,450 for the stone column and pedestal, and £600 for the column's bronze mouldings and details (Minutes..., 3 September 1919).

At the meeting of 16 June 1920, Willink & Thicknesse advised the Cunard Committee that the granite for the architectural part of the memorial had arrived in Liverpool and was currently stored with the stonework contractors, John Stubbs & Sons. The architects' recommendation of payment to the contractors of an initial £800 to commence their work was therefore approved (Minutes..., 16 June 1920). On 30 June, the Cunard Committee authorised payment of a second instalment of £650 to Pegram following Willink's report that he had the previous week visited the sculptor's studio in London and had seen and approved his completed full-sized clay model (Minutes..., 30 June 1920). At the Committee's next meeting, on 7 July, a request from the sculptor for an additional £400 to cover increased costs was approved, bringing the cost of the statue to £2,400 (Minutes..., 7 July 1920).

Evidently the bronze was completed by 7 September 1921, for on this date the balance of £1,100 was paid out to Pegram, this figure presumably consisting of a third instalment amounting to £700, plus the agreed £400 to cover increased costs (Minutes..., 7 September 1921). The remaining work on the memorial seems to have been completed by 11 January 1922, since a final payment of £700 to John Stubbs & Sons was authorised, bringing the cost of the stonework to £1500, along with a one-off payment of £500 to the Bromsgrove Guild for the bronze mouldings and details (Minutes..., 11 January 1922). The final cost to the Cunard Steamship Company was £4,400 for the memorial itself, plus a further £283. 4s. 0d. (paid to John Stubbs & Sons on 19 July 1922: Minutes..., 19 July 1922) for the wall tablets in the Cunard Building vestibule listing the names of the fallen.

The aim of the architects was to achieve a harmony between the memorial and their existing, Italian Renaissance palazzo-style, Cunard Building. To this end they adjusted the scale of the column to match the lower storey of the building (Compton, 1989: 87). Davis's design appears to have been perfectly acceptable to the Cunard directors, although a last minute concern about the respectable image of the company seems to have impelled them to insist that Pegram cover Victory's genitals with a fig leaf – a move that, not surprisingly, had irritated the sculptor greatly (Compton, 1989: 87).

At the unveiling ceremony, the deputy-chairman of the company, Sir Thomas Royden, referred to the all-embracing nature of the Cunard War Memorial's commemoration. It was intended as a memorial both 'of the victorious efforts of this country' and of the contribution of the Cunard Company itself during the Great War (Cunard Magazine, 1921: 184). He declared to the large crowd gathered before the memorial that some 1,550 men had left the company during the recent war in order to serve their country. Of this number, 134 had 'made the supreme sacrifice'. The Cunard War Memorial was first and foremost erected in commemoration of the 134 who had died, but it was also erected to the men who had survived, both those who had served in the armed forces and those who had carried on working for the Cunard Company and:

… who, braving the hidden menace of torpedo and mine, never failed [the Company] in manning their ships and thus kept open the communications overseas which were so vital for the successful prosecution of the war, and indeed the existence of the country (Cunard Magazine, 1921: 184-85).

Lord Derby spoke next, alluding to what he saw as the long-term purpose of all such memorials:

… erected throughout the length and breadth of the land [they] would always serve as an incentive to those who came after them to do their duty by their country, and at the same time to do all they could to ensure peace (Cunard Magazine, 1921: 185).

At the close of his speech he unveiled the memorial by pressing an electric button, thus severing the string holding the Union Jack, which covered the figure surmounting the column (Courier, 24 October 1921).

Lord Derby's sentiments were seconded by the last speaker, Mr E. Russell-Taylor, Lord Mayor of Liverpool, who drew attention to the way the very design of the memorial would serve this end, '...the column, indicative of strength and beauty, would ever remind the passer-by of those who nobly did their duty' (Cunard Magazine, 1921: 185). And finally he endorsed the deputy chairman's praise for the courage of the men who continued to staff the company's ships throughout the war by reminding the assembled crowd of the Lusitania, the Cunard Company luxury liner, sunk by a German torpedo with a total loss of life on 8 May 1915.

Finally, the Bishop of Liverpool, Dr F.J.

Chavasse, offered prayers; the 'Last Post' was sounded by four trumpeters of the Police Band; and Sir Thomas Royden placed a large laurel wreath at the base of the memorial. The ceremony concluded with "Rule Britannia" and the National Anthem, again from the Police Band (*Courier*, 24 October 1921).

The crowd included the sculptor, Henry Pegram, and the architects, A.J. Davis and W.E. Willink (P.C. Thicknesse having died the previous year). At some time presumably in the second half of the 1940s, the dates '1939 – 1945' were added, thereby extending the dedication to cover those employees of the Cunard Company who had served in the Second World War.

Literature: (i) LRO (a) newscuttings: *Courier* (1921) 24 October, in *CH&T 1921*: 80-81; (b) *Photographs of War Memorials in Liverpool...*, 1923: 5.
(ii) University of Liverpool Archives – *Minutes of the Executive Committee of the Cunard Steamship Co. regarding the War Memorial outside the Cunard Building at Pierhead.*
(iii) Compton, A., 'Memorials to the Great War', in P. Curtis (ed.) (1989): 86, 87, 90; *Cunard Magazine* (1921), vii: 149, 184-87; Davies, P. (1992): 74; Gray, A.S. (1985): 160; Reilly, C.H. (1927a): 2.

Merchant Navy War Memorial (Memorial to the Missing of the Naval Auxiliary Personnel of the Second World War)

Architects: Stanley Harold Smith and Charles Frederick Blythin
Sculptor: George Herbert Tyson Smith

Column and semi-circular enclosure in reinforced concrete faced with Portland stone; lenses at the summit of the column in glass; inscription plaques on the enclosure in bronze.

Inscriptions:
– on a bronze plaque, at the entrance to the enclosure, on the end face of the left wall:

THE REGISTER CONTAINING / THE NAMES RECORDED / ON THESE PANELS / MAY BE SEEN / AT THE OFFICES / OF THE TOWN CLERK / AND THE MERSEY DOCKS / AND HARBOUR BOARD
– on a bronze plaque, at the entrance to the enclosure, on the end face of the right wall:
THIS MEMORIAL WAS BUILT / AND IS MAINTAINED / BY THE COMMONWEALTH / WAR GRAVES COMMISSION
– carved in the Portland stone of the column, facing the entrance to the enclosure:
THESE OFFICERS / AND MEN OF THE / MERCHANT NAVY / DIED WHILE / SERVING WITH / THE ROYAL NAVY / AND HAVE NO / GRAVE BUT / THE SEA / 1939 – 1945

– on twenty-five bronze plaques are inscribed the names of the 1,390 'officers and men' of the Merchant Navy who lost their lives in the Second World War, arranged in alphabetical order under the names of the more than 120 ships on which they had served. The plaques are, specifically: twenty-four on the upper part of the outside face of the enclosure walls, bearing the names of those who died at sea; and one, below this line, towards the extreme right of the wall, bearing the names of those who died on land, but whose grave is unknown.

Note: the memorial register referred to on the bronze plaque by the steps lists the names of the dead in straight alphabetical order, not as on the memorial itself, under the names of their

ships.

Unveiled by Admiral of the Fleet Viscount Cunningham, Wednesday 12 November 1952.

Owner / custodian: Commonwealth War Graves Commission
Status: not listed

Description: The memorial is located opposite the Mersey Docks and Harbour Board Building, a short distance from the *Memorial to Sir Alfred Lewis Jones*, against the railings of the Mersey river wall. It consists of a raised semi-circular enclosure, with short straight walls extending to either side, following the line of the river wall. The whole is faced in Portland stone. The enclosure is entered from the Pier Head promenade by a centrally-placed flight of six steps. The lowest step of the flight of six is extended to each side along the outside base of the enclosure walls to form a low shelf upon which to place wreaths. Sunk into the upper faces of these walls are twenty-four tall, rectangular, bronze plaques with the names of the dead (eight on each of the curving walls to either side of the entrance steps, and four more on each of the straight extensions), plus an extra name plaque, below this level, towards the far end of the right wing, making twenty-five in all. Each plaque is like a shallow 'v' in section, in imitation of the pages of an open book. The gate posts to either side of the steps are surmounted by white stone globes: that on the left being a terrestrial globe showing the seas and land masses of the world; that on the right being a celestial globe bearing the signs of the Zodiac. Within the semi-circular enclosure, against the interior faces of the curved walls, are stone benches. At the centre of the enclosure is a circular column, also faced in Portland stone, and surmounted by silver-backed glass lenses to

suggest a lighthouse, 'the mariner's guide' (architect's plans, in *The Builder*, 27 February 1948: 253). Near its base, beneath a Naval badge and Naval crown, wreath and foul anchor, is the inscription: 'These officers and men...'. The design of the pavement around the base of the column is based on a mariner's compass.

Condition: The memorial is in generally good condition, although the surfaces of the Portland stone enclosure are eroded. The terrestrial and celestial globes have some felt-tip graffiti.

Related work: Sir Edwin Lutyens with additions by (Sir) Edward Maufe: *Mercantile Marine Memorial*, 1922-52, Trinity Square, Tower Hill, London.

Whereas those men who had lost their lives serving on Merchant Navy vessels during the two world wars are commemorated on the *Mercantile Marine Memorial* at Tower Hill, London (see 'Related Work' above), the *Merchant Navy Memorial* at Pier Head, Liverpool, was erected specifically to commemorate the 1,390 merchant seamen who, during the Second World War, had lost their lives serving on Royal Navy vessels. The Liverpool memorial, like its counterpart in London, is principally dedicated to those whose only grave is the sea, and is more correctly entitled, *Memorial to the Missing of the Naval Auxiliary Personnel of the Second World War*.

The merchant seamen here commemorated had enrolled with the Royal Navy under the then newly-instituted T124 agreement, under the terms of which they would be subject to Royal Navy discipline whilst retaining their Merchant Navy rates of pay and other conditions. These men had served in a variety of auxiliary ships, 'at first mainly in armed merchant cruisers, but also in armed boarding

vessels, cable ships, rescue tugs, and others on special service' (Imperial War Graves Commission, 1952: 13). More than 13,000 merchant seamen had signed the T124 agreement and the most appropriate location for their national memorial was felt to be Liverpool, since it was here that the T124 manning depot had been established.

The *Daily Post* (12 November 1952: 4) proudly pointed to another reason for the suitability of Liverpool as the site of the memorial, this being that:

...from February 1941 when Admiral Sir Percy Noble raised his flag in Derby [now Walker] House, this war-scarred port, itself the object of enemy attack, became the citadel of Western Approaches, whence the Battle of the Atlantic was directed until its victorious outcome.

A competition for the design of the memorial was announced in *The Builder* (19 September 1947: 317). Architects who had served in the forces were invited by the Imperial War Graves Commission (IWGC) to apply for competition conditions and instructions before 24 October 1947, with the closing date for submissions set at 19 December. A further report appeared in the following week (*Builder*, 26 September 1947: 340) with more details. The budget for the memorial had been set at £5,000, inclusive of the successful competitor's remuneration at the rate of '£5 per cent of the amount'; the character of the design and the choice of materials were to be at the competitor's discretion, although it was emphasised that only those materials which would 'not involve upkeep expenses' would be considered; it was essential that space be provided for the then estimated 1,200 names of the dead, although the 'arrangement and method of

recording them' was left to the competitor; and finally, competitors were required to submit a design for the area leading up to the memorial, which was to be laid out by Liverpool Corporation as a public garden.

By the closing date, which had been extended to 16 January 1948 (*Builder*, 28 November 1947: 610), a total of eighty-eight designs had been submitted, and a short list of seven was selected by the competition judge, (Sir) Edward Maufe, then Principal Architect for the United Kingdom to the Imperial War Graves Commission. Of the seven, the bottom four received commendations and the top three, prizes of £30, £60, and £100. The four commended architects were William Logan, ARIBA, of Edinburgh; R.E.E. Beswick, MBE, ARIBA, of Swindon; Ainslie Threadgold, FRIBA, of Liverpool; and F.H. Crossley, Diploma in Architecture (Liverpool), ARIBA, of Duffield, near Derby (in 1926 Crossley had been placed third in the competition for the Liverpool *Cenotaph*, see above, p.100). In third place was H. St John Harrison, FRIBA, of London; in second, C. Duncan Ostick, ARIBA, AMTPI, of Belfast; and in first, Stanley H. Smith, ARIBA, and Charles Blythin, FRIBA, of London. All seven designs were publicly displayed at the IWGC offices at 32 Grosvenor Gardens, SW1, from 1-3 March 1948 (*Builder*, 27 February, 1948: 252).

In his assessor's report, Maufe expressed a certain dissatisfaction with the general standard of the entries. Many, he wrote, 'had to be ruled out on purely practical grounds'. The chief problem experienced by the competitors was the large number of names that had to be given due prominence. Then again, many competitors had placed the name plaques either too high (short-listed architect Crossley's plaques were, for example, fourteen feet from the ground!), or

too low (Threadgold's were so low as to be vulnerable 'to defilement by dogs'). Then again, many had submitted plans for structures that would have obstructed the promenade, or which had excessively high walls and would have blocked the view and furthermore proved difficult for police to supervise. Some, ignoring the question of the permanence of the memorial, were 'designed in an ephemeral manner' or proposed in non-durable materials which would not have withstood the English weather. Cost also proved to be a stumbling block to many competitors whose submissions would clearly have exceeded the restricted budget. At the other extreme, Maufe lamented the fact that so few competitiors had managed to incorporate 'appropriate symbols', particularly since the competition instructions 'clearly stated that "Royal Navy symbols apply"'. He himself considered 'how significant...a ship might have been as a device' (*Builder*, 27 February 1948: 252). However, as St John Harrison regretfully explained, 'Sculpture has to be omitted on the grounds of economy, and stone carving reduced to a minimum' [i.e., in his case, no more than the badge of the Royal Navy] (*Builder*, 5 March 1948: 283).

Maufe awarded the first prize to Smith and Blythin without, it seems, much enthusiasm. It was, he conceded, an 'eminently practical' solution to the problem, but one 'somewhat lacking in inspiration'. He approved of the general silhouette, the mariner's compass, and, most importantly, the manner in which the names of the dead were recorded. He suggested a number of improvements to the memorial, although the only one that appears to have been acted upon was, for reasons of child safety, that the proposed, widely-spaced, horizontal railings overlooking the Mersey be replaced by closely-spaced vertical railings. Maufe considered Smith

and Blythin's garden design (the ground-plan of which was based on an anchor motif) unconvincing and declined to recommend it to the Corporation, suggesting instead that they adopt the design submitted by third-placed St John Harrison. Ultimately, neither design seems to have been carried out.

There are a small number of differences between Smith and Blythin's competition design and their finished memorial, the most significant being the increase in names from a projected 1,200 to an eventual 1,390, the addition of an extra name plaque unaligned with the rest, and the omission of the planned horizontal bands on the sculptured globes, that on the terrestrial globe having been intended to bear the inscription, THEIR BATTLE-FRONT WAS THE WORLD (*Builder*, 27 February, 1948: 253).

The unveiling ceremony took place on 12 November 1952. In addition to the usual civic dignitaries, it was attended by naval officers, members of the Consular Corps, representatives of various shipping companies, Merchant Navy personnel of all ranks and, most importantly, the relatives of the dead. The ceremony opened with the arrival of the Admiral of the Fleet, Viscount Cunningham. The naval guard of honour standing in attendance before the memorial received him with a 'General Salute' and the Band of the Royal Marines played the traditional first eight bars of 'Rule Britannia'. After inspecting the guard, the Admiral spoke to some of the merchant seamen there present. A section of the Birkenhead male voice choir then led the singing of the hymn, 'O God our help in ages past' and a prayer was offered by Archdeacon F. Noel Chamberlain, Chaplain of the Fleet. Having been invited by Vice-Admiral Sir Maurice Mansergh to unveil the column, the Admiral responded with the customary speech (included in which was a message from Prime

Minister [Sir] Winston Churchill) and at its close pulled 'the lanyard, the linked white and red ensigns [of which] fell, to show the inscription [on the column]' (*Daily Post*, 13 November 1952: 4). H. Gresford Jones, Bishop of Liverpool, then dedicated the memorial, and the Reverend J.D.W. Richards, president of the Merseyside Free Church Federal Council, and Imam A.H. Ali Hizam, representing the many moslems commemorated on the memorial, both offered prayers. (The *Daily Post* also referred to 'Mohammedan seamen with long blue robes and red sashes...in the parade of Merchant Navy personnel'.) 'Reveille' was then sounded, wreaths were laid, and the National Anthem sung. Finally, at the close of the ceremony, the guard of honour marched off and the dignitaries departed, 'and only the relatives of the dead were left' (*Daily Post*, 13 November 1952: 4).

Literature: (i) LRO manuscript sources: George Herbert Tyson Smith Archive, Box 18.
(ii) *Architects' Journal* (1948) 26 February: 185; *Builder* (1947) 19 September: 317; *Builder* (1947) 26 September: 340; *Builder* (1947) 21 November: 573; *Builder* (1947) 28 November: 610; *Builder* (1948) 27 February: 252-54; *Builder* (1948) 5 March: 282-83; Compton, A., 'Memorials to the Great War', in P. Curtis (ed.) (1989): 92; *Daily Post* (1952) 12 November: 4; *Daily Post* (1952) 13 November: 4, 5; Imperial War Graves Commission (1952): 13, 14; *Journal of the RIBA* (1950) March, lvii: 203; Pevsner, N. (1969): 176; Poole, S.J. (1994): 142; Richardson, A. (1990): 30; *Syren and Shipping* (1952) 19 November, ccxxv: 283; *The Times* (1952) 13 November: 3.

Ship's Mast
erected on the roundabout at George's Dock Gate, Pier Head

Owner/ custodian: Liverpool City Council

Status: not listed

Description: a metal warship's mast, occupying the centre of the traffic island at the junction of New Quay and Chapel Street

The mast was erected in 1983 as part of a highway improvement scheme under the direction of John Barry, then Development and Planning Officer with Merseyside County Council.

Literature: Kidson, A., 'Charlotte Mayer's "Sea Circle"', in P. Curtis (ed.) (1989): 116.

Princes Avenue / Princes Road

Monument to William Huskisson
(1770–1830), statesman, born in Warwickshire. From 1783 – 92, he was in Paris, his experience of the French Revolution exerting a lifelong influence on his political views. On his return to England, he became an M.P. in William Pitt's party. In the first two decades of the nineteenth century he held various junior offices, eventually rising to President of the Board of Trade (1823 – 27) in Lord Liverpool's cabinet. Shortly thereafter he was selected to succeed his friend, George Canning, as Tory M.P. for Liverpool (1823 – 30), thus becoming the principal representative of Liverpool mercantile interests in Parliament. Always a keen advocate of free trade, in 1825 he reduced import duties on foreign commodities. He was also a firm supporter of Roman Catholic emancipation, supporting the successful passage of the bill of emancipation in 1828. He died on 15 September 1830, as a result of injuries sustained from falling under the wheels of a moving train, whilst attempting to walk across the line to greet the Duke of Wellington at the opening ceremony of the Liverpool and Manchester Railway at Parkside (source: *DNB*).

Sculptor: John Gibson

Statue in bronze
Pedestal in grey granite

Bronze founder: Ferdinand Miller of Munich

Statue h: 100" (254cms); w: 41" (104cms); d: 28" (71cms)

Pedestal – inscription affixed to the front face: WILLI[A]M HUSKISSON (all metal lettering

from the line below this is missing)

Statue – inscribed with the names of the sculptor and the founder, and the date, on the back of the bollard behind the figure: OPUS IOANNIS GIBSON ROMÆ. / FUDIT FERD. MILLER MONACHII. / MDCCCXLVII.

Unveiled before the north front of the Customs House, in Canning Place, immediately opposite South Castle Street, by George Hall Lawrence, Mayor of Liverpool, Friday 15 October 1847 (shown on illustration at right); moved to its new site towards the north end of the meridian boulevard separating Princes Avenue and Princes Road, Saturday 25 September 1954. Today the pedestal only remains on site. According to the Development and Environmental Services Directorate of Liverpool City Council, the *Monument to William Huskisson* was pulled from its pedestal in 1982 'by local people' who believed (erroneously) that Huskisson had been a slave trader. The statue is now housed at the Oratory, St James's Mount Gardens (listed status: Grade I).

Owner/ custodian: Liverpool City Council
Status: not listed

Description: The subject is represented as a standing figure in a Roman toga, his right shoulder and breast exposed. He holds a scroll in his right hand. Behind him is a bollard.

Condition: The bronze statue is now separated from the granite pedestal. At some time the statue has been coated in black epoxy paint which is now worn away in places. The surface of the bronze is extensively pitted. The figure

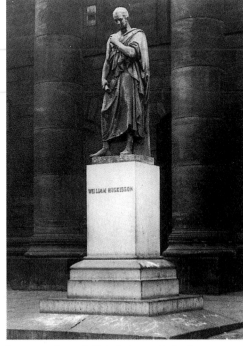

has a number of slightly larger holes between the shoulders and on the back of the neck and head, presumably from the bombing of the Customs House.

Related works: preparatory studies – (a) Two drawings by Gibson for the *Monument to William Huskisson* are reproduced in *Imitations of Drawings by John Gibson R. A., Sculptor* (engraved by G. Wenzel and L. Prosseda), London, 1852. The frontal view portrays Gibson with a covered right arm and shoulder. The Memorial Committee had attempted to get

Gibson to cover these parts when the statue was at the clay model stage, but was persuaded by Mrs. Huskisson to agree to them. Thus, this drawing is likely to be either an early idea or an attempt to see if the arrangement demanded by the Committee would work (WAG JCS files information sheet).

(b) Other versions. 1. Marble, 1833, for the Huskisson mausoleum in St James's Cemetery, Liverpool (damaged by vandals in 1968; in store, at the time of writing, at NMGM Albert Dock conservation workshops); 2. Marble, 1836, originally intended to be located in the Custom House, Liverpool, placed instead at the Royal Exchange, London, now in Pimlico Gardens. It is from this second version that the bronze is taken.

On 18 September 1830, three days after the tragic accident that had abruptly terminated William Huskisson's life, the Mayor of Liverpool called a special meeting in the Council Room of the Town Hall. He informed the assembled councillors that in response to a petition 'numerously and respectfully signed by the inhabitants of the town', Huskisson's widow had consented to have her husband interred within the town precincts (at St James's Cemetery). The meeting had been called, he said, to obtain sanction to receive Huskisson's body in the Town Hall prior to the funeral (Touzeau, 1910, ii: 859-60). On 6 October, at a regular meeting of the Council, regret at Huskisson's passing was again expressed and the sum of £500 voted to cover 'the expenses incurred in paying the last tribute of respect to Mr. Huskisson' and to go towards the erection of a more permanent monument to his memory (Touzeau, 1910, ii: 860).

On 3 November 1830, a public meeting was held in the Sessions House and the public

subscription for Huskisson's memorial officially launched. Ultimately, about £3,000 was raised (Picton, 1875, revised edn 1903, i: 420). The Memorial Committee agreed to hold a competition to select a sculptor and John Gibson, then residing in Rome (although raised and trained in Liverpool), was asked if he would be prepared to participate. Gibson certainly wanted the commission, but was not prepared to submit himself to a competition to secure it. According to his biographer, Lady Eastlake, he believed that the judges of such competitions were generally ill-equipped to assess works of art (Eastlake, 1870: 113). But this is only part of the reason. Chantrey had similarly refused to compete for the *George Canning Memorial* (see above, p. 76). Both men were at the top of their profession and failure to secure a commission in competition would doubtless have damaged their reputations.

As had Chantrey before him, Gibson managed to convince the Memorial Committee to award him the commission without recourse to a competition. He also persuaded the members to go against the prevailing fashion and to allow him to treat the subject in classical drapery, rather than contemporary dress (Eastlake, 1870: 113). As he explained in a letter dated 18 September 1832 to a friend in Liverpool:

My intentions are in [the statue of Huskisson] to avoid altogether everything like English portrait statues. I shall represent him simple, grave, and reflecting, with grand drapery. This style will not please the vulgar, – for the modern dress, or morning gown, brings the deceased more naturally before them. I am very much pleased with the committee for allowing me that scope, which every artist of good taste and proper ambi-

tion requires (published in the *Mercury*, 12 October 1832).

He also wrote that he was at that time 'preparing to make the model', which he later told Eastlake was completed in five months (he gave the year as 1831, but presumably he had mis-remembered) (Eastlake, 1870: 113). The completed model was greeted in Rome with such critical acclaim that Huskisson's widow journeyed there to see it. She too greatly admired the sculptor's work. Meanwhile, word had got back to the Committee in Liverpool that Gibson had represented Huskisson with a bare arm and shoulder and, concerned that such a portrayal would be indecorous, sent instructions that the parts should be covered. Gibson showed the letter to Mrs Huskisson who apparently implored the sculptor not to change a thing. She quickly took steps to convey her feelings to the Committee which duly wrote a second letter to Gibson, giving him permission to leave the statue as it was. The clay model was then reproduced in marble and placed in the mausoleum specially designed by John Foster Jnr in St James's Cemetery (Eastlake, 1870: 114).

The marble statue was in place by 1834 at the latest, since towards the end of that year somebody signing himself 'A Tourist' wrote an erudite letter to *The Times*, protesting that the mausoleum was poorly designed and that its cramped dimensions rendered it wholly inadequate as a receptacle for Gibson's statue (*The Times*, 3 December 1834). In fact, the statue could only be viewed from within the structure and then only from an unsatisfactory vantage point below its base. Apparently quite a number of the subscribers complained about the situation (Hughes, 1964: 162). Gibson, in his account of subsequent events to Lady

Eastlake, generously makes no mention of any criticism of Foster's mausoleum, but simply states that 'a Liverpool gentleman' proposed that the statue should be removed from the mausoleum and placed instead inside the Liverpool Customs House, for the positive reason that the latter place had such strong associations with Huskisson's efforts in the cause of free trade (Eastlake, 1870: 114). Mrs Huskisson, whilst liking the idea of having her late husband commemorated in the Customs House, presumably found no fault with the mausoleum, since she expressed a strong wish that the statue should remain there over her husband's remains. Her solution was to offer to pay for a second version for the Customs House. The Corporation, into whose care the statue had now passed, accepted her offer and Gibson began work on a second marble statue of Huskisson (Eastlake, 1870: 115).

Gibson altered a number of details in this version including, at Mrs Huskisson's suggestion, some aspects of the face, in order to create a closer likeness (Eastlake, 1870: 115). Also at the widow's request, the sculptor journeyed to England in 1844 to supervise the exact placing of the statue within the Customs House. Following an examination of the only available location, however, he decided that the lighting was inadequate. Such was Mrs Huskisson's enthusiasm for her husband's commemoration at the Customs House that she suggested Gibson execute a third version, this time in bronze, and again at her expense, so that it could be placed outside the building. After some deliberation, the Corporation accepted her new offer.

Mrs Huskisson spent the winter of 1845-46 in Rome, in constant touch with the sculptor. On her return journey to England in May 1846, she stopped off with him at the Royal Foundry in Munich, where the bronze had just been cast (Eastlake, 1870: 116, 118-20). By the beginning of July, all work on the bronze had been completed and a report appeared in *The Builder* in which it was announced that the Inspector of the Royal Foundry, Ferdinand Miller, had employed a new technique to impart a 'uniform mellow appearance' to the surface of the metal. Instead of using mineral acids to tone down, with an instant patina, the over-bright appearance of the freshly-cast bronze, Miller had 'resorted to the method of dead chasing' and had thereby established a 'uniform tone' which promised that the natural patina, as it appeared in the course of time, would also take on a uniform tone. Miller's method was described as follows:

By the use of different sorts of files, a really different *grain* of the metal has been cut out, which the artist was able to produce in accordance with the nature of the part thus treated. This method is said to be a real advance in the mechanism of the bronze-founding process (*Builder*, 4 July 1846: 315).

The bronze statue was in England by the middle of the following year (*The Times*, 15 July 1847) and by mid-August 1847 the foundations were being excavated in front of the north side of the Liverpool Customs House (*The Times*, 18 August 1847). In October, Gibson made another of his rare visits to England for the unveiling ceremony. The ceremony was performed on 15 October, during the course of a progress through Liverpool, laid on for Sir Robert Peel on the occasion of his unexpected visit to the town, the first in twenty years. After inspecting St George's Hall, then under construction, the party proceeded to the Coburg Dock to view the ship, *The Great Britain*, and then on to the Customs House, at the bottom of South Castle Street, for the unveiling. The statue had been placed upon its pedestal that very morning. Crowds had gathered here as this was the only pre-arranged and publicised part of the tour.

The journalist for the *Chronicle* (16 October 1847), covering the day's events, wrote of the statue:

The face and head of the statesman are well preserved and striking; but the folds of the drapery seem stiff and formal. The front of the statue faces the street, with the fingers of the right hand pointing to the Custom House behind, indicative, probably, of what the lamented statesman had done to free the commerce of his country from the swaddling clothes of protection in which it had been well nigh smothered. The inscription on the granite pedestal is plain – merely "William Huskisson", minus date and description. One would have thought the occasion opportune to have perpetuated the right hon. gentleman's official connexion with Liverpool, with some allusion to the melancholy accident which severed it. The statue has been erected at the expense of the deceased senator's widow, who has made a present of it to her late husband's constituents. Compared with the splendid marble statue in the Mount Cemetery, where Huskisson's body lies entombed, it appears humble as a work of art, and by no means does justice to the fine talents of our celebrated townsman, Gibson, who has earned too high a niche in the temple of fame to be shaken by this imitation of his skill.

Literature: (i) WAG JCS files – information sheet: 'Two studies for the Huskisson Memorial'. (ii) *Art-Union* (1847): 335; *Art-Union* (1848): 98; *Athenaeum* (1844) 1 June: 504; *Athenaeum* (1847) 17 July: 767; *Builder* (1846) 4 July: 315; *Chronicle* (1847)

16 October: 5; Eastlake, Lady (ed.) (1870): 113-120; Gunnis, R. (1951): 172; Hughes, Q. (1964, 1993 postscript): 161-63; Matthews, T. (ed.) (1911): 79-80, 107-109; *Mercury* (1832) 12 October: 326; Picton, J.A. (1875, revised edn 1903), i: 420; Read, B., 'From Basilica to Walhalla', in P. Curtis (ed.) (1989): 32-3; *The Times* (1834) 3 December: 3; *The Times* (1846) 6 July: 7; *The Times* (1847) 15 July: 5; *The Times* (1847) 18 August: 3; Touzeau, J. (1910) ii: 859-60.

Monument to Hugh Stowell Brown

(1823 – 86), born in the Isle of Man, he moved to Liverpool in 1847 to take up his post as pastor of the Myrtle Street Baptist Church. Much concerned with the welfare of the whole community, but particularly the working classes, he worked among them, administered charity to them, established a savings bank for them, and delivered lectures which were immensely popular with them, at the Concert Hall, Lord Nelson Street (sources: *Daily Post*, 16 October 1889; *Daily Post*, 24 February 1936).

Sculptor: Francis John Williamson

Statue in marble
Pedestal in red granite

h. of statue: 95" (241cms)
h. of base: 5¹/₂" (14cms)

Inscriptions on the pedestal:
front face of the dado: HUGH STOWELL BROWN / BORN 1823 DIED 1886 / HE LABOURED / FOR 39 YEARS / TO IMPROVE THE SOCIAL / AND SPIRITUAL CONDITION / OF HIS FELLOW MEN
– then further down: THIS STATUE ORIGINALLY STOOD / IN THE GROUNDS OF MYRTLE STREET BAPTIST CHAPEL / AND WAS MOVED TO THIS SITE 25TH SEPTEMBER 1954.
– front face of the plinth: THIS STATUE WAS ERECTED / BY THE / CITIZENS OF LIVERPOOL

Originally signed and dated on the right side of the base of the statue, in metal letters, all of which are now lost (the holes into which the letters were affixed mark their positions).

Unveiled in the churchyard before Myrtle Street Baptist Church, Tuesday 15 October 1889 (this original location is shown in the illustration at right); moved on Saturday 25 September 1954 to the Princes Gate end of the meridian boulevard between Princes Avenue and Princes Road. The pedestal only remains at Princes Gate. It is not certain when the statue was removed from this site, but it is likely that the Council put it into store following the toppling of the *Monument to William Huskisson* at the other end of Princes Avenue. The statue remains in store.

Owner/ custodian: Liverpool City Council
Listed status: Grade II

Description: Brown is represented standing, in dress contemporary to the 1880s. In his left hand he holds a flat object, now deteriorated beyond recognition, described in a newspaper article covering the inauguration as 'an open book'.

Condition: Very poor. The statue is badly weathered and there is much green biological staining. The edge of the figure's overcoat is extensively chipped, the right hand and tip of the left foot are lost. A large triangular piece of the base, 28" (71cms) has been broken off, but is retained.

On 1 June 1886, a public meeting was convened at Liverpool Town Hall to consider the question of the most appropriate form of commemoration to their recently deceased fellow citizen, Hugh Stowell Brown. It was agreed that a public subscription should be launched to pay for the memorial and an influential Committee

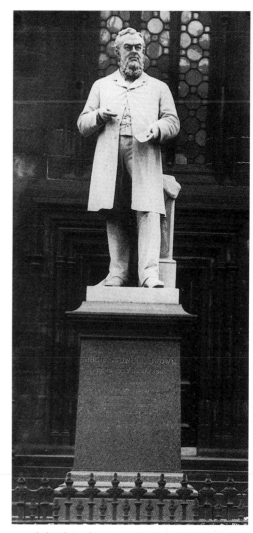

was duly elected to supervise it, with Sir David Radcliffe (Mayor of Liverpool 1884-86) as Chairman. The sum of £1,200 was ultimately raised, which was sufficient to engage a leading sculptor to produce a 'heroic size' statue in

marble with a granite pedestal. The Committee selected Williamson on the basis of his reputation: he had executed successful public statues in London, Birmingham and Walsall and, most importantly, was private sculptor to the Queen, a fact which Radcliffe proudly noted in his unveiling address (*Daily Post*, 16 October 1889).

The Committee's confidence in Williamson as a portraitist was not misplaced in the opinion of the subject's son who, speaking at the unveiling ceremony, marvelled at the 'faithful portrait' of his father as he had been 'in the most active period of his life'. This was considered especially commendable as the sculptor, never having met Brown in life, had worked exclusively from photographs (a not uncommon situation for memorial statues, of course) (*Daily Post*, 16 October 1889).

The site, in front of Myrtle Street Baptist Church (photograph in the *Daily Post*, 10 August 1939), was deemed particularly apt as it was a 'spot [Brown had] loved so well, and where the highest and best of his work was accomplished...' (*Daily Post*, 16 October 1889). Yet it was this very site that was to compound a problem that arose in the early 1940s when the church was demolished to make way for the Liverpool Radium Institute. Owing to an administrative oversight on the part of the original Memorial Committee, it was not certain that the Corporation was, in fact, responsible for the care of the statue. Certainly, the correct procedure had been followed at the unveiling ceremony: Radcliffe, on behalf of the Memorial Committee, had handed over the statue to the then Mayor of Liverpool, E.H. Cookson, who, in turn, had accepted it on behalf of the City. Unfortunately the Committee failed to follow this up with a formal letter of donation to the City and thus there was no officially minuted

record of the Corporation's resolution of acceptance. The absence of relevant documentation and the statue's presence in the grounds of Myrtle Street Baptist Chapel led to the supposition that it was church property (*Daily Post*, 9 July 1940).

The Corporation ultimately accepted responsibility (although exactly when is not certain), but a new site for the statue could not be agreed upon. No suitable location could be found in either St George's Hall or St John's Gardens, although Falkner Square was briefly considered in the light of the fact that Brown had died at No. 29 (*Daily Post*, 11 July 1940). An extended debate occupied the local press for some days in July 1940, but the more urgent problems of the war and its aftermath intervened and the statue remained in its original location for a number of years where, according to the Revd T.F. Hughes, writing in the *Echo* in 1952, it stood encased in wood 'between iron railings and a disused carriageway'. In fact, it was not until 1954 that the statue was moved to its new site at Princes Gate, where it remained until removed from its pedestal in 1982.

Literature: (i) WAG JCS files newscuttings: *Daily Post* (1936) 24 February; *Daily Post* (1936) 27 February; *Daily Post* (1939) 10 August; *Daily Post* (1939) 29 September; *Daily Post* (1940) 9 July; *Daily Post* (1940) 10 July; *Daily Post* (1940) 11 July; *Daily Post* (1940) 15 July; *Daily Post* (1940) 17 July; *Echo* (1939) 16 October; *Echo* (1939) 23 October; *Echo* (1940) 22 July; *Echo* (1952) 2 April.
(ii) *Daily Post* (1889) 16 October: 7.

Memorial to Florence Nightingale

(1820–1910), English nurse and pioneer of hospital reform. In 1854 she obtained permission from the then War Secretary to go to the Crimea with thirty nurses to tend the sick and wounded. She improved sanitary conditions

and medical services in general and became known affectionately as 'The Lady with the Lamp'. Though physically debilitated from her Crimean experiences, she spent the remainder of her long life organising health reform and the training of nurses (source: Palmer, 1983).

Architects: William Edward Willink and Philip Coldwell Thicknesse
Sculptor: Charles John Allen

Architectural work in Hopton Wood stone
Sculptural work in Pentelic marble

Bas-relief: h: *c*.120" (305cms); w: 46" (116.8cms)

Inscriptions:

– lefthand inscription panel: THIS MEMORIAL WAS / ERECTED IN 1913 BY / CITIZENS OF LIVERPOOL / IN GRATITUDE TO / FLORENCE / NIGHTINGALE / STRONG OF / HEART AND UNDAUNT / ED BY DIFFICULTIES SHE / BROUGHT SUCCOUR TO / THE SICK AND WOUNDED / IN THE CRIMEA AND / TAUGHT THE NATIONS / HOW THE SUFFERINGS / OF WAR CAN BE REDEEM / ED BY MERCY AND / HEROISM. / IN YEARS OF PEACE / BY [INS]PIRATION AND / GUIDANCE SHE WON / FOR THE VOCATION / OF [THE NURSE A] PLACE / OF H[ON]OUR IN [TH]E / NA[TION]A[L] LI[FE].

– beneath the central relief: FLORENCE / NIGHTINGALE / 1820-1910

– righthand inscription panel: FOR FIFTY YEARS / THE NURSING INSTITU / TIONS OF LIVER-POOL / ALIKE IN WORKHOUSE / HOSPITAL DISTRI[C]T / AND TRAINNG HOME / FOUND IN HER A FRIEND / AND COUNSELLOR RIPE / IN EXPERIENCE WISE IN / JUDGEMENT UNWEARIED / IN SYMPATHY / TO PERPET-UATE / HER NAME PROVISION / HAS BEEN

MADE FOR / THE MAINTENANCE / OF
SPECIAL NURSES / [ON THE STAFF] OF [THE]
/ DISTRICT NURSING / ASSOCIATION

Unsigned

Memorial unveiled by Miss Rosalind Paget,
Thursday 2 October 1913

Owner/ custodian: Liverpool City Council
Listed status: Grade II

Description: Located on the south-east corner
of Princes Road and Upper Parliament Street,
the memorial forms part of the perimeter wall
of Rathbone College, formerly the Queen
Victoria Nursing Association. The memorial, in
classical Greek style, is symmetrically arranged:
stone benches before a wall flank a higher
central structure carrying tall inscription tablets
either side of fluted Ionic pilasters supporting a
pedimented entablature and framing a marble
bas-relief. The bas-relief represents Florence
Nightingale administering to two ailing men. In
her left hand she raises an oil lamp over their
heads. A bearded man kneels on his haunches,
supporting his comrade who is lying propped
up on his lap. From a small jug held in her right
hand Nightingale pours liquid into a bowl held
up by the kneeling man.

Condition: Extensively vandalized. The faces of
all three figures in the marble relief have been
hacked off, that of Florence Nightingale being
most severely damaged. In addition, the
undamaged areas of the relief appear to be
rather weathered.

The memorial was funded by a public subscrip-
tion initiated by Herbert Reynolds Rathbone
(*Architectural Review*, 1914: 86), Honorary
Secretary of the Liverpool Queen Victoria
District Nursing Association and member of
the Committee of the Liverpool Royal

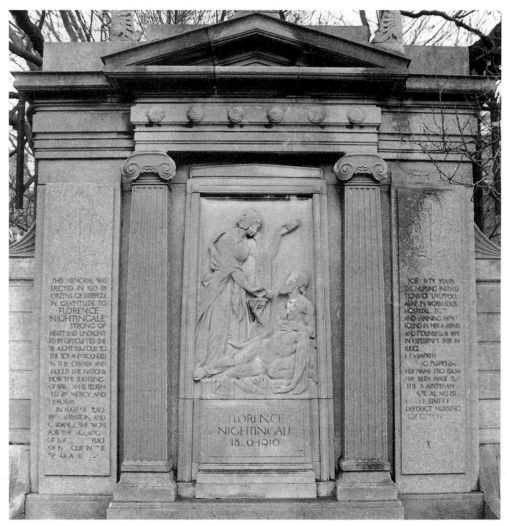

Infirmary. The memorial fund was five times
over-subscribed and the surplus money used to
pay the salary of 'at least four Florence
Nightingale nurses' (WAG JCS files informa-
tion docket – source of quotation not given).

Literature: *Architectural Review* (1914) xxxv: 86;
Builder (1916): 28 January: 82-3; *Daily Post and
Mercury* (1913) 3 October: 5; *Liverpool Diocesan
Review* (1929) January: 14; *Weekly Mercury* (1913)
4 October: 12.

Princes Park

Memorial Drinking Fountain to Richard Vaughan Yates
(1785–1856), philanthropist and founder of Princes Park, the first public park in Liverpool, laid out for Yates by (Sir) Joseph Paxton in

1842. Yates purchased the land from Lord Sefton for £50,000 with the intention of converting it into a park, but despite offering £10,000 to any responsible body, preferably the Corporation, which would be prepared to assume its future maintenance, his offer was not taken up and he had to accept the entire responsibility himself, nearly incurring his own financial ruin. Yates donated Princes Park to the public in 1849 (sources: Pevsner, 1969; Richardson, 1990).

Designer: A. MacDonald

Obelisk in polished red Aberdeen granite.

Inscription on the front face of the pedestal (facing the Princes Avenue gate): TO THE MEMORY / OF / RICHARD VAUGHAN YATES / THE ENLIGHTENED & PHILANTHROPIC / FOUNDER / OF / PRINCES PARK / – / ERECTED BY PUBLIC SUBSCRIPTION / 1858

Signed on the left face of the plinth to the left of the urn: A. MACDONALD / SCULP. / ABERDEEN.

Owner/ custodian: Liverpool City Council
Listed status: Grade II

Description: The fountain is located at the north-west entrance to Princes Park, facing Princes Avenue. A square base of three grey granite steps leads up to the polished red Aberdeen granite pedestal with two urn-shaped fountain basins placed against its left and right faces. Surmounting the pedestal is an obelisk of two pieces of polished red Aberdeen granite.

Condition: There is extensive graffiti on the pedestal and lower part of the obelisk. The metal water outlet plates and spouts have been removed and the outlet holes sealed up. The rims of both basins are badly chipped.

The memorial fountain was installed shortly before 24 July 1858. The *Courier* for that day described the fountain thus:

> On the front is a brief record; on each side, a fountain, emblematic of the unfailing and unostentatious philanthropy of a life of which so large a portion was given to educate the poor, to increase their sources of innocent pleasure, and to elevate and improve their social position.

Literature: *Courier* (1858) 24 July: 469; Picton, J.A. (1875, revised edn 1903), ii: 477-78; Richardson, A. (1990): 45-6.

Queens Dock

On the river front outside the CUSTOMS AND EXCISE BUILDING, 1991–3, by PSA Projects:

Time and Tide

Designed and executed by Philip Bews
Frieze relief executed by Diane Gorvin

Steel columns fabricated by Oldroyd Bros Ltd, Runcorn
Bronze figures cast by Castle Fine Art Foundry, Oswestry

Frieze relief in glass-reinforced concrete painted in acrylic and bolted onto the curved dock wall; two figures in bronze mounted on blue-painted steel columns; setting of concrete paving slabs

Frieze relief: 2 × half-panels: 39½" × 19¾" (100 × 50cms); 46 × square panels: 39½" × 39½" (100 × 100cms). Overall length of frieze: 154' 2" (47m)

Bronze figures on steel columns: h. 23' (7m)

Inscriptions:

– at the left end of the frieze: TIME AND TIDE / PHILIP BEWS 1993 / THE SCULPTURE TAKES AS A THEME THE PAST AND / FUTURE USES OF QUEENS DOCK. THESE ARE / REPRE-SENTED BY IMAGES OF SHIP REPAIR AND / MODERN COMPUTER USERS. BRONZE SHIP REPAIR / WORKERS ARE SET ON STEEL COLUMNS WHICH / EVOKE A SHIP'S PROW AND BOILER SECTION. / THE RELIEF PANELS ON THIS ORIGINAL DOCK / WALL WERE MADE BY DIANE GORVIN.
– at the right end of the frieze: TIME AND TIDE / PHILIP BEWS 1993 / CO-SPONSORED BY: /

H M CUSTOMS AND EXCISE / MERSEYSIDE DEVELOPMENT CORPORATION / P S A BUILDING MANAGEMENT MANCHESTER / P S A PROJECTS / WIMPEY CONSTRUCTION U K / NORTH WEST ARTS BOARD / THE ESMÉE FAIRBAIRN FOUNDATION / THE FOUNDATION FOR SPORT AND THE ARTS / BUCKNALL AUSTIN PLC

Owners: The co-sponsors. (Responsibility for maintenance rests with H M Customs and Excise]

Status: not listed

Description: The frieze consists of forty-six one metre square panels with a half panel at each end. The two half-panels (which are identical) are decorated with life-casts taken from employees of the Customs and Excise Building and some of their personal effects and business equipment: a face, five hands, a merchant navy serial number (R502077), a telephone and receiver, a computer mouse, etc. Inward from these half-panels are the two square inscription panels, around the borders of which are casts of feet and hands. The remaining forty-four square panels consist of five different panels repeated: a

woman in a wheelchair operating a computer, two panels together, across which a ship is represented and two panels of ship builders. The official booklet for the opening of the Queens Dock explains: 'These panels depict images of both maritime Liverpool and modern high-tec VAT operation, bringing together the use of the site past and present' (*Queens Dock*, 1994).

Standing a little forward of either end of the frieze are two tall steel columns, mounted with bronze figures of ship repairers 'of an earlier age'. The straight tubular column at the south end is surmounted by a ring representing a boiler section, inside which is crouched a riveter wielding a hammer; whilst the curved, triangular-sectioned column at the north end is intended to evoke the prow of a ship and is topped by a standing figure hauling a taut rope. In these figures, Bews acknowledges the shipyard paintings of Stanley Spencer as a strong influence (as stated in the sculptor's shortlist proposal document).

The paving setting was also designed by the artist: a seven metre wide arc of buff concrete paving slabs extends the curve of the dock wall to meet the concentric circles of paving around the steel columns to the sides and the kerb edge of the Kings Parade directly in front.

Condition: Good

Related works: *Ship Repairers*, bronze casts of the two original maquettes, mounted on wooden bases, h. (i) 23½" (60cms); (ii) 27½" (70cms). Two sets were cast: the first is in the possession of the artist; the second HM Customs and Excise. *Maquette for Wall Relief*, glass-reinforced concrete on a wooden base, h: 7½" (20cms); w: 39½ (100cms); in the possession of the artist. A bronze cast of this is in the possession of HM Customs and Excise. *Maquette for 'Heroic Heads' columns*, heads in plaster, columns in red sandstone (not included in the final work); in the possession of HM Customs and Excise.

The idea that a competition should be launched to find an artwork which would help make the Queens Dock a 'pleasant and stimulating environment' was first proposed in late 1992 (*Queens Dock*, 1994). It was part of the aspiration for the whole redeveloped dockland area that it would be frequented not merely by workers passing to and from the new offices, but also by people attracted by the area's new leisure facilities.

The competition, co-sponsored by HM Customs and Excise, the owners of the building, and Merseyside Development Corporation, responsible for the redevelopment of the docklands, was announced in December 1992 (*Queens Dock*, 1994). Additional sponsorship was provided by a number of other companies, as is acknowledged in the inscription on the wall frieze. The adjudicating panel, chaired by Peter Jefferson Smith (Deputy Chairman of Customs and Excise), consisted of Lis Woods (VAT Commissioner); Paula Ridley (MDC); Lewis Biggs (Tate Gallery Liverpool); Tony Woof (North West Arts Board); Bev Durham (PSA Design Team); Chief Ben Agwuna (Charles Wootton Centre); and Bob Scrivens (local artist) (*Queens Dock*, 1994).

From a total of ninety submitted designs, a shortlist of six was selected in February 1993. Apart from Bews and Gorvin, the finalists consisted of Rob Ward, Nicholas Eames, Peter Fink, Hideo Furuta, and Michael Kenny (who had also been one of the six finalists in the 1964 Littlewoods sculpture competition, see above, p.126). The finalists were next required to produce maquettes which were afterwards put on public display in the atrium of the Royal Liver Building (the headquarters of MDC). In order that those members of the public sufficiently interested to attend the exhibition should have a say in the ultimate choice, a questionnaire was provided and the results taken into consideration by the panel, who announced Bews and Gorvin as winners on 30 April 1993 (*Queens Dock*, 1994).

The winning solution included two alternative treatments for the column sculptures. The panel chose the *Ship Repairers*. The rejected option consisted of two 'heroic-sized' heads on columns, one head to represent a ship worker and the other an African woman – the latter, according to the sculptor, to represent 'the people whose work created the basis of much of the wealth and power of this city' (as stated in his shortlist proposal document).

Bews also explained in the same document how both the colours used for the sculpture and the deployment of the sculptural elements were intended to work in harmony with the site: the buff yellow of the reliefs matches the Yorkstone-coloured masonry facing blocks of the building, whilst the blue steel columns of the *Ship Repairers* match the building's blue steel framing. The large scale of the sculpture reflects the open river front site and the monumentality of the building, whilst the symmetry of the sculpture reflects the symmetrical layout of the building (the riverside frontage consisting of a four storey steel and glass bridge structure connecting two five storey, masonry clad, gabled end blocks). Bews also appealed to the judges' sense of Liverpool's historical importance as a trading port by referring to the influence on his design of the similarly-sited twin columns on the Piazza San Marco, Venice, and to their sense of local identity by referring to

the use of similar columnar designs for the *Memorial to the Engine Room Heroes* (see above, pp. 137–9) and the *Cunard War Memorial* (see above, pp. 143–6) at Pier Head nearby.

As detailed in a letter from the sculptor to the author (dated 7 June 1994), the designs for the wall reliefs were first drawn out by Bews and then clay maquettes were modelled by Diane Gorvin at a scale of 1:5. From these, flexible vinyl/rubber moulds were taken and then filled with glass-reinforced concrete (grc). The grc was sprayed into each mould (in a commer-

cial process developed by BCM Contracts Ltd of Whitchurch) and then manually compressed in order to expel any trapped air bubbles and to ensure a faithful reproduction. Once these maquettes were approved, the full-size versions were executed in the same way with up to twelve repeat castings being made from each design (the duplicates being held in store by HM Customs and Excise). After curing, the relief panels were painted to match the masonry cladding of the building and then bolted, by Bews and an assistant, to the dock wall.

The maquettes for the ship repairer figures

and their columns were designed and executed by Bews in plaster and wood (at a scale of 1:10) and then cast in bronze at a foundry, the original plaster being destroyed in the lost wax casting process. These maquettes having been approved, the full-size bronze figures were cast by Castle Fine Art Foundry, the supporting steel columns fabricated by Oldroyd Bros, and the installation supervised by Bews.

Literature: *Queens Dock* (1994) (official opening brochure).

Queensway Tunnel Entrance

Work on the tunnel was inaugurated by Mary, Princess Royal (Viscountess Lascelles), on 16 December 1925. By April 1931, a financial deficit had been incurred and the Tunnel Committee had taken the decision not to have any kind of expensive architectural finish at either entrance to the tunnel. But then, on 18 July 1933, the Mersey Tunnel Act was passed, conferring further borrowing powers to facilitate the completion of the tunnel itself and to allow the execution of the architectural finish of the entrances, for which Herbert J. Rowse, already architect for the ventilation buildings, was awarded the commission. The tunnel was officially opened by King George V on 18 July 1934. The entrances incorporate sculptural decoration, including chevron mouldings etc.

Owner: Mersey Tunnels

Listed status: Grade II

Sculptural Relief
over the Queensway entrance

Designer: Edmund C. Thompson
Executants: Edmund C. Thompson and
George T. Capstick – under the direction of
the architect Herbert J. Rowse

Relief in Portland stone

Description: Beneath a winged disc motif, two winged bulls, 'symbolic of swift and heavy traffic' (*The Story of the Mersey Tunnel*, 1934: 101) confront a roundel containing the Mersey Tunnel coat-of-arms. The arms consist of a shield with, in the lower part, a black circle in the centre of a masonry pattern, symbolising the tunnel itself, and in the upper part a

cormorant (official armorial bird of Liverpool since 1797, see above, pp. 130) between two estoiles (stars with wavy rays). The crest above the shield has two leaping lions holding a wheel between their forepaws. The supporters of the shield are Apollo, on the left, with his sun-ray mane, and Pluto, on the right, armed with his bident. Apollo and Pluto appear in their guises as the gods of the day and the night, intended to symbolise the never-closing Mersey Tunnel (as were the *Day* and *Night* statues outside the George's Dock Building, see above, pp. 131–2). The motto on the scroll beneath the shield, RIPÆ ULTERIORIS AMORE, is from Virgil's *Aeneid* and translates as, 'In longing for the further bank'.

Condition: The details are weathered and the surface overall seems pitted. The lower part of

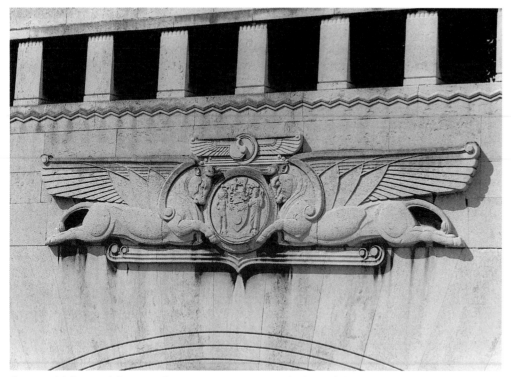

the idea was not his, he was foremost in steering the scheme through the many initial difficulties with which it was beset and allowed the honour, at the end of March 1928, of personally 'holing through' the last thin wall of rock to join the two halves of the tunnel that had been excavated from each side. (sources: *DNB 1922–1930*; *Daily Post*, 19 October 1950)

Sculptor: Edward Carter Preston

Bas-relief in Westmorland green stone

Diameter: 26" (66cms)

Inscribed into the Portland stone of the pylon below the bas-relief: IN COMMEMORATION OF / ALDERMAN THE RIGHT HONOURABLE / SIR ARCHIBALD T. SALVIDGE. P. C. K. B. E. / FIRST CHAIRMAN OF THE MERSEY / TUNNEL JOINT COMMITTEE 1925 – 1928 / BY WHOSE VISION FAITH AND COURAGE THIS / TUNNEL WAS CONCEIVED AND CONSTRUCTED

Signed to the left of the portrait face: E. CR. P.

the roundel frame of the coat of arms appears to be crumbly.

Although the winged bulls had been *in situ* since *c.*1934, the roundel was blank until 1952 when the arms were granted by the College of Arms and the coat of arms duly carved (*Daily Post*, 4 October 1952).

Literature: (i) LRO newscuttings: *Daily Post and Mercury* (1934) 16 May, in *MRT*, ii: 119; *Daily Post and Mercury* (1934) 17 May (photographs of entrance arch relief), in *MRT*, ii: 121 ; *Times* (1934) 9 July, in *MRT*, ii: 139.
(ii) *Daily Post* (1952) 4 October: 3; *Liverpolitan* (1934) August: 21; Mersey Tunnel Joint Committee (1934); *Times Trade and Engineering Supplement* (1934) 28 April: 29.

On the base of the pylon to the right of the entrance to the tunnel:

Portrait Medallion of Sir Archibald Tutton Salvidge

(1863–1928). Salvidge was born at Birkenhead, educated at Liverpool Institute and entered Bent's Brewery, ultimately becoming its managing director. An enthusiastic and influential political organiser for the Conservative party, he nonetheless refused to contest a parliamentary division, and in 1910 declined the Lord Mayorality of Liverpool, on the grounds that his business responsibilities would suffer. He is commemorated here in his role as a consistent advocate of the Mersey road tunnel. Although

Unveiled Wednesday 21 February 1951 by Alderman A. Ernest Shennan, Chairman of the Mersey Tunnel Joint Committee and leader of Liverpool City Council. An identical medallion at the Birkenhead entrance was unveiled earlier the same day by Alderman Charles McVey, Deputy Chairman of the Joint Committee.

Description: A medallion-shaped bas-relief portrait, the frame carved with stylized laurel leaves articulated at the top and bottom with basketwork decoration. Salvidge is depicted three-quarter-face, looking to the left. He wears a jacket, waistcoat, shirt and tie. Speaking at the unveiling ceremony, Salvidge's son congratulated the sculptor, Carter Preston 'on the remarkable fidelity of the likeness in the plaques' (*Daily Post*, 22 February 1951).

Condition: Good

In 1929 Sir Thomas White had advocated that the tunnel should be called the 'Salvidge Tunnel' in recognition of Archibald Salvidge's untiring promotion of its construction. The suggestion was not taken up, but in March 1934, with the tunnel nearing completion, the *Daily Post* and *Echo* renewed the call for at least some form of permanent memorial to Salvidge's efforts (*Daily Echo*, 27 March 1934). The solution was to erect two identical portrait roundels of Salvidge with an accompanying inscription, one at each entrance.

Literature: (i) LRO newscuttings: *Echo* (1951) 21 February; *Evening Express* (1951) 21 February, in *MRT*, iv (unpaginated).
(ii) *Daily Post* (1950) 19 October: 5; *Daily Post* (1951) 22 February: 5; *Echo* (1934) 27 March:11.

Above the tunnel entrance in Dale Street:

Statues of King George V
(1865–1936) and
Queen Mary
(1867 – 1953). George, second son of Edward and Alexandra, became heir to the throne at the death of his elder brother, Albert Victor, in 1892. He married Princess Mary of Teck in 1893 and acceded to the throne in 1910.

Sculptor: Sir William Goscombe John

Statues in bronze
Pedestals in concrete
Black marble plaques affixed to the pedestals

Bronze founder: A.B. Burton of Thames Ditton

h. of *King George V*: 9' 9" (2.97m)
h. of *Queen Mary*: 9' 3" (2.82m)

Gilt inscriptions on black marble plaques set into the respective pedestals:

– left of the tunnel mouth, set into the lefthand face of the pedestal:
KING GEORGE V / To commemorate the Diamond Jubilee of the / Queensway Tunnel, this statue was rededicated on / 26th July 1994 by / H. R. H. THE DUKE OF KENT
– right of the tunnel mouth, set into the right-hand face of the pedestal:
QUEEN MARY / To commemorate the Diamond Jubilee of the / Queensway Tunnel, this statue was rededicated on / 26th July 1994 by / H. R. H. THE DUKE OF KENT
Inscription on the back of the parapet of the tunnel entrance (between the piers which were the original location of the statues):
ERECTED IN HONOUR OF THEIR MAJESTIES / BY THE CITIZENS OF LIVERPOOL

King George V
– signed by the sculptor on the right face of the

bronze base towards the front:
W. GOSCOMBE JOHN. / R. A.
– and by the founder on the left face of the bronze base towards the front:
A. B. BURTON / FOUNDER / LONDON

Queen Mary
– signed on the left face of the bronze base towards the front: W. GOSCOMBE JOHN. / R. A.
– and by the founder on the left face of the bronze base towards the back: A. B. BURTON / FOUNDER / LONDON

Exhibited: Royal Academy of Arts 1939, as *His Majesty King George V* (cat. 1184) *and Her Majesty Queen Mary* (cat. 1286) – *models (one-third full size) of bronze statues for King George V Memorial, Liverpool.*

Unveiled by H.R.H. Prince George, then Duke of Kent, Friday 7 July 1939; rededicated by H.R.H. Prince Edward, the present Duke of Kent, Tuesday 26 July 1994.

Owner/ custodian: Liverpool City Council
Status: not separately listed. (The Queensway Tunnel entrance is listed Grade II; the Council Planning and Development Services assumes the statues to be included in this listing.)

Original setting:
The Queensway Tunnel had been opened on 18 July 1934, so the statues were not part of the original plan and the architect to the Tunnel Committee, Herbert J. Rowse, had to make certain alterations to accommodate them when the decision was taken to place them there in 1936: specifically, he increased the height of the parapet over the tunnel entrance to give them an appropriate setting and removed two black granite flower bowls to make way for them (WAG JCS files information docket – source not given). The statues were then placed in

position at the rear of the terrace laid out by Rowse, facing towards Birkenhead. *King George V* stood against the north pylon and *Queen Mary* against the south pylon of the parapet (the green staining from the bronze is still visible on the stonework where the truncated trains of the royal robes stood flush against the pylons).

First relocation:

The 1939 setting was partially destroyed when Churchill Way South was constructed in 1971, necessitating the demolition of the northwestern corner of the terrace. The two statues were then relocated at the southern edge of the reduced terrace, standing closer together and facing the shopfronts of Dale Street.

Present location:

The two statues were removed to their present positions by 26 July 1994, in time for the sixtieth anniversary celebrations marking the official opening of the tunnel. They are now mounted on pedestals set against the walls of the car parks either side of the approach road, in the corners formed where the side walls of the tunnel approach road break forward slightly before the road enters the tunnel. Sited thus, the statues appear to stand atop the walls and overlook the approaching traffic.

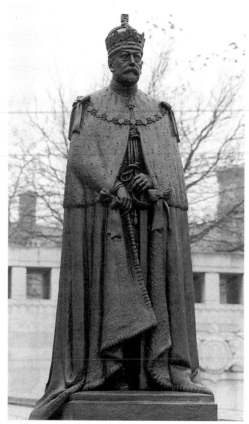

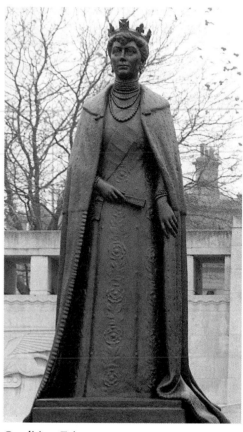

Description: Both monarchs look straight ahead. They are crowned and wear ermine-trimmed robes which trail behind them. The ends of the robes are truncated where once they were flush with the tunnel entrance parapet. *King George V*'s robe is closed at the throat and almost totally enfolds him, save where his hands emerge from beneath, at waist height. His right hand grasps and raises slightly the edge of the garment, while his left hand rests on the pommel of a ceremonial sword, the tip of which stands upon the ground between his feet. At his

throat hangs the Badge of the Order of the Bath and around his shoulders, the Collar and George of the Order of the Garter. *Queen Mary* wears, at her left breast, the Star (bearing the motto, HONI SOIT QUI MAL Y PENSE) of the Order of the Garter and at the lower end of her sash, the Lesser George of the same order. Her robe is open, revealing a dress heavily brocaded with roses. Her left hand holds back the edge of the robe, whilst in her right she holds a closed fan. At her throat is a pearl necklace and on each wrist a pearl bracelet.

Condition: Fair

On 10 March 1936, in response to King George V's death on 20 January, the Lord Mayor of Liverpool, Councillor R.J. Hall, presided over a meeting of the City's leading citizens at the Town Hall to discuss the question of a memorial. The idea in principle being approved, a General Memorial Committee was formed and a smaller Executive Committee appointed from its ranks, to consider the matter (*Daily Echo*, 10 March 1936).

At first it was proposed that a statue be errected to the King only, but a proposal to Queen Mary that a statue to her be erected as a companion having received royal consent, the following resolution was unanimously passed at a meeting of the General Committee on 29 June 1936 (*Daily Post*, 30 June 1936):

That, as a tribute to his Majesty's twenty-five years' reign and as an expression of our loyalty and affection for his late Majesty King George V., the Liverpool memorial shall take the form of bronze statues of his late Majesty and her Majesty Queen Mary, to be placed in the vicinity of the Queensway Tunnel.

That the Lord Mayor be requested to make an appeal for approximately £30,000 for this purpose, and for such philanthropic schemes as may be determined later.

The proposed site was an obvious choice as the Tunnel had been officially opened by the King two years earlier and thus the memorial would also serve to commemorate his last official visit to Liverpool.

On 1 July 1936, the day following the meeting, the Lord Mayor's appeal appeared in the principal local newspapers. £30,000 was acknowledged to be a much greater sum than the statues would cost, but such was the presumed popularity of the monarchs that it was believed to be an achievable target. The *Daily Echo* (1 July 1936) considered that the consent of Queen Mary to a statue of herself as companion to that of the King would increase the appeal to potential female subscribers. Once the statues were paid for, the remainder would be allocated either by the Committee or, where individual contributors specified, to the causes of their choice.

Lists of subscribers with their contributions, plus the overall total received, were published at regular intervals. By the time the Lord Mayor published the third list in the *Daily Post* on 21 October, the fund had risen to a disappointing £8,267, not enough even to pay for the statues and their architectural setting which had now been designed as a completion of the Tunnel entrance by the Tunnel's architect, H.J. Rowse. The idea was that the memorial would form a dignified termination to Dale Street, as one approached it from the Town Hall. The estimated cost was in the region of £15,000.

The *Daily Post* for 2 November 1936 described the proposed setting as follows:

...it was decided that the terrace adjoining the great portal of the Kingsway [now called Queensway] entrance would provide a site easily accessible to the public, sufficiently removed from the street to enjoy a dignified quiet, and visibly related to the scene of the historic opening ceremony with which, for so many citizens of Liverpool, the memory of King George V will be associated in future...The existing paved terrace will remain as a forecourt to the memorial, to be approached by the curved steps leading from the pavement. The existing side steps will be substituted by low flanking walls, verged with formal planted beds of bright flowers or evergreen shrubs, according to the season of the year.

On 2 April 1937, the Lord Mayor (Alderman W. Denton) was pleased to announce the receipt of an anonymous donation of £2,000 to the Royal Memorial appeal. The Memorial Committee now had in the region of £12,000 and hoped that such a patrotic example would inspire others so that the remaining £3,000 could be raised and instructions to start the work issued (*Daily Post*, 3 April 1937). The required amount was eventually reached and the celebrated, but now rather elderly sculptor, Sir William Goscombe John, was commissioned to execute the work. The statues were delivered to the site on 4 July 1939 (*Daily Echo*, 4 July 1939; *Daily Post*, 5 July 1939: photographs of installation of statues in both newspapers).

Literature: (i) LRO newscuttings *Daily Post* (1936) 23 April, in *TCN 1/62*; *Daily Post* (1937) 23 March, in *TCN 1/64*; *Daily Post* (1937) 3 April, in *TCN 1/64*; *Daily Post* (1939) 5 July, in *TCN 1/70*; *Daily Post* (1939) 8 July, in *TCN 1/70*; *Echo* (1936) 10 March, in *TCN 1/62*; *Echo* (1936) 1 July, in *TCN 1/62*; *Echo* (1939) 4 July, in *TCN 1/70*; *Evening Express* (1936) 5 May, in *TCN 1/62*; *Evening Express* (1939) 7 July, in *TCN 1/70*.
(ii) WAG JCS files – 'Statues of King George V and Queen Mary' information docket.
(iii) *Daily Post* (1936) 30 June: 6; *Daily Post* (1936) 21 October: 6; *Daily Post* (1936) 2 November: 9; *Evening Express* (1939) 29 June: 9; *Liverpool Diocesan Review* (1936) May: 127-29; *Royal Academy Illustrated* (1939): 123.

Ranelagh Street

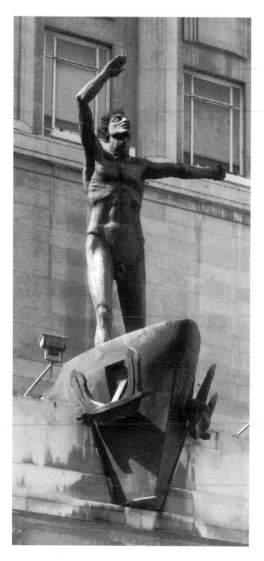

LEWIS'S STORE

The present building was built after the war, its predecessor having been almost completely destroyed in an air raid on the night of 3 May 1941. The main entrance façade of the store, set diagonally at the corner of Ranelagh Street and Renshaw Street, was originally to have been concave with a convex entrance portico, but in the later stages of construction the directors of Lewis's decided to commission a sculpture for the main entrance and instructed the architects to alter the design of the entrance façade specifically to accommodate it (Silber, 1989: 104).

Liverpool Resurgent

Sculptor: Sir Jacob Epstein

Figure and plinth in bronze

Bronze founder: Morris Singer

Figure h: 17' 8" (5.4m) (approx.)
Plinth h: 7' 6" (2.3m) (approx.); w: 9' (2.7m); d: 13' 6" (4.1m)

Unveiled by F.J. Marquis, First Baron Woolton, President of Lewis's Investment Trust, Tuesday 20 November 1956

Owner of building: Capital and Counties plc
Status: not listed

Description: A colossal naked male figure, his left arm stretched out sideways with clenched fist, his right arm raised above his head, elbow crooked, palm outwards, strides forward looking up to the sky. His right leg is flexed and tensed beneath him to take his weight, while his left leg stretches out behind him, heel raised and foot poised on tiptoe. The figure stands on a plinth fashioned like a ship's prow emerging from the fabric of the building and appearing to cut through the main entrance entablature, 42 feet above the street (cf. Epstein, *Youth Advancing*, 1949 – 50, Manchester City Art Gallery).

Condition: The upper surfaces have a whitish appearance, whereas the under surfaces have darkened. In general, however, the condition appears sound.

Related works:
Liverpool Resurgent, version with torso only, 1954, bronze, h. 84" (213 cms), location unknown (Silber, 1986: 218).
Ship's Prow with Figures, maquette for the Lewis's commission, 1954, clay or plasticine, destroyed (Buckle, 1963: 366; Silber, 1989: 108).

Liverpool Resurgent was commissioned in 1954 by the directors of Lewis's department store, Liverpool, to symbolise 'the struggle and determination of Liverpool to rehabilitate itself after the grim, destructive blitz years' (*Evening Express*, 20 November 1956) and to mark the centenary of Lewis's store group (for a full account of this commission and its place in Epstein's oeuvre, see Silber, 1989: 102-10). As Silber admits, any account of this important twentieth-century public commission is hampered by a remarkable dearth of documentary evidence: no correspondence between Epstein and any of the directors of Lewis's has yet been uncovered and even Epstein's fee is unknown (Silber, 1989: 103). Initial proposals for the sculpture seem to have included a family group (Silber, 1989: 103), an appropriate enough suggestion for a department store, but this was

abandoned for reasons unknown and the far more daring symbolism of the city's regeneration after the devastation of the war aimed at. The attraction of this theme to Lewis's directors was, as Silber has pointed out, that it enabled 'Lewis's to identify themselves as leaders and partners in the City's revival' (Silber, 1989: 105).

Epstein was supplied with a model of the entrance façade and portico and some time in early 1954 submitted a plasticene maquette (destroyed) which was approved by Lewis's directors. The work was to be transformed beyond recognition, however, and some of the directors were somewhat surprised at the final outcome (Silber, 1989: 105, 110). In a letter to his daughter, Peggy Jean, dated 23 July 1954, Epstein describes his commencement of a figure rising from the sea, although by September he had decided that the figure should be full-length and was looking for a larger studio to accommodate it (Silber, 1989: 105). In November 1954, John Skeaping, Professor of Sculpture at the Royal College of Art, loaned Epstein one of the College's large studios and it is from this time that Epstein's first reference to the ship's prow plinth comes (Silber, 1989: 105).

By January 1955, the figure was ready for casting in plaster and by February the casting had been completed (Silber, 1989: 105). From July to September 1955, Epstein was in the USA and Paris, work on the ship's prow plinth eventually commencing in October 1955 (Silber, 1989: 107-08). A plasticene maquette (destroyed; reproduced in Silber, 1989: 108) shows a ship with two funnels and lines of portholes which appears to be ploughing through a writhing mass of figures. At some time this was transformed into the smooth outlined form of the present prow with its hauled-in anchors projecting from the hawse-holes at each side. Epstein was assisted in the

plaster moulding of the plinth by his regular specialists, Bill Olds and Jan Smith. The figure and plinth were cast at the Morris Singer Foundry between November 1955 and October 1956 (Silber, 1989: 108).

The statue arrived in Liverpool in early November 1956 (*Daily Post*, 8 November 1956) and stayed under wraps until the unveiling on the 20th, at which Epstein was present. The *Echo* (20 November 1956) reported that there

was 'a murmur of approval' as the covering was removed from the figure, 'punctuated by a few gasps at the uncompromising masculinity of the 18ft high figure.' Epstein is alleged to have told the reporter from the *Echo* that if an alternative title was wanted, it could be 'Adventurous Youth', and professed, 'I count this one of my major works and I am extremely proud of this fine commanding position it has been given in the centre of the city.'

Epstein's sculpture generated an intensely passionate debate over the ensuing weeks with letters to the local press from correspondents denouncing it as a 'Demon from Hell' (*Daily Post*, 29 November 1956) or an 'eyesore' unworthy of a leading department store (*Echo*, 30 November 1956), but with a considerable number of correspondents defending the figure as 'art' and accusing its detractors of 'philistinism' (*Echo*, 11 December 1956). The offence lay in the naked figure's explicitly defined genitals: Councillor Skinner appeared on 'Sharp at Four', a Granada television programme, denouncing the work and declaring that it was 'not a statue I would like my wife and daughters to stand and gaze at' (*Daily Post*, 1 December 1956, quoted in Silber, 1989: 109). But perhaps the most accurate assessment of the situation came from the correspondent who suggested that familiarity would breed complacency and that within a few months the statue would, like most public sculpture, be 'forgotten and ignored by the passing throng' (*Echo*, 30 November 1956). C.F. Shaw, in *My Liverpool* (pp. 27-8), perceptively likened the fuss to that surrounding the unveiling of the first two of T.S. Lee panels on St George's Hall (see below, p. 260), raising the question: 'how many of the thousands who daily pass the building have ever seen them?'

Beneath *Liverpool Resurgent*, immediately above the three doorways of the main entrance are three reliefs:

Children Fighting, Baby in a Pram, Children Playing

Sculptor: Sir Jacob Epstein

Reliefs in ciment fondu

h. of each: 40" (101 cms); w: 72" (183 cms).

Status: not listed

Description: The lefthand relief depicts young boys scrapping. The central relief shows a baby sitting up in a pram, arms extended and looking straight out, with a dog seated on the ground to the right of the pram, its right foreleg raised, looking up at the child. The righthand panel depicts children playing: in the centre are two children playing leapfrog; a boy to their right does a handstand; and behind him a girl stands on a swing, her upper body arched back to gain momentum. Three other children, who may be playing tag, rush in from the right. The vigorous activity of the outer panels is balanced by the iconic stillness of the central panel, its uncluttered near-symmetry creating a principal focal point in the triad of reliefs.

Condition: All reliefs appear grimy and the lefthand relief, in particular, is spattered with bird droppings. The surfaces, however, appear to be sound.

Preparatory pencil sketches: *Children Fighting, Child in a Pram, Children Playing* – each 6¹/₂"/16.5cms × 10¹/₄"/26cms (reproduced in Silber, 1989: 106) (Collection of Dr and Mrs Martin Evans).

Related works:
1. central relief (*Baby in a Pram*): the head of the baby derives from *First Portrait of Annabel Freud (with Bonnet)*, 1952, bronze bust, h. 7" (18 cms); and the dog from *Frisky*, 1953, bronze

statuette, h. 12" (31 cms) – Annabel being Epstein's granddaughter by his daughter Kitty and her husband Lucian Freud and Frisky being Epstein's Shetland Sheepdog. The pose of the baby in the pram is also clearly related to the Christchild with outstretched arms in the *Madonna and Child* group at Cavendish Square, London (1950-52, lead, h. 12' 9¹/₂" (390cms).
2. righthand relief (*Children Playing*): the head

of the boy leapfrogging derives from *Third Portrait of Jackie (Ragamuffin)*, 1939, bronze bust, h. 9" (22.8cms). (Jackie is Epstein's son by Isabel Nicholas.) In Gardiner (1992), pl. 39 shows Epstein at work on the Lewis' relief with the *Ragamuffin* head by his side.

The Manchester Guardian (21 November 1956), states that the reliefs were meant to represent 'the children for whom the new Liverpool is being planned' (quoted in Silber, 1989: 109). As with the figure of *Liverpool Resurgent* above them, no documentary evidence has been uncovered detailing their genesis. Although there is general agreement that Epstein executed them at his own expense, the exact circumstances of their origin are not clear. Silber (1989: 105) states that the reliefs were Epstein's own suggestion, while Gardiner (1992: 456) suggests that it was Lord Woolton who generated the idea with his expressed wish for some form of decoration to fill the three empty panels above the doors. Buckle (1963: 391) adds the information that Epstein included them in the price of *Liverpool Resurgent* rather than have them executed by a 'lesser artist'. In a letter to Peggy Jean, dated 16 February 1955, Epstein reveals that he has just commenced work on them (as quoted in Silber, 1989: 105-06). Epstein used existing portrait studies of his own children, grandchildren and friends' children as models (Gardiner, 1992: 456). The reliefs were completed by the end of June 1955, prior to his departure to the United States (Silber, 1989: 107) and were *in situ* for the unveiling on 20 November 1956.

Literature: (i) WAG JCS files – newscuttings: *Daily Post* (1956) 8 November; *Daily Post* (1956) 21 November; *Daily Post* (1956) 27 November; *Daily Post* (1956) 1 December; *Echo* (1956) 30 May; *Echo* (1956) 20 November; *Echo* (1956) 5 December; *Evening Express* (1956) 20 November; *Manchester*

Guardian (1956) 21 November; *The Statue*, (Lewis's staff magazine) (1984) May / June: 8-9.
(ii) Buckle, R. (1963): 366, 379, 387, 390, 391 – 93, 422, 429, *579, 580, 581, 587, 600*; Curtis, P. (1988): 10; Gardiner, S. (1992): 450, 456, 457, 463, *39*; Shaw, C.F. (1971): 27-8; Silber, E. (1986): 55-61, 218-19, *41, 42*; Silber, E., 'Epstein's Liverpool Colossus', in P. Curtis (ed.) (1989): 102-10; *Times* (1956) 21 November: 6; Willett, J. (1967): 92.

Rodney Street

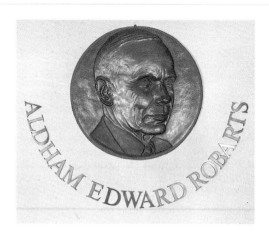

THE ALDHAM ROBARTS LEARNING RESOURCES CENTRE, John Moores University. The Centre is behind St Andrews Presbyterian Church. Access is from Maryland Street. In the entrance hall, fixed to the wall to the left of the exit turnstile:

Portrait Medallion of Aldham Edward Robarts

Sculptor: Terence McDonald

Bas-relief in cold-cast bronze (bronze resin)

diameter: 16" (40.6cms); depth: 1¹/₂" (3.2cms)

Inscription (letters in a semi-circle below the tondo, affixed individually to the wall):
ALDHAM EDWARD ROBARTS

Signed on the underside of the tondo: T. McDONALD. FECIT.

Unveiled on the occasion of the official opening of the Aldham Robarts Learning Resources Centre by the Rt Hon. David Hunt M.P., then Secretary of State for Employment, Friday 15 July 1994.

Owner: Liverpool John Moores University
Status: not listed

Description: Robarts is represented three-quarter-face, looking to the right. He wears a collar and tie.

Condition: Good

Related works: Plaster cast and cold-cast bronze resin replica at the Bluecoat Studios, Church Lane.

Literature: *Merseyside Sculptors Guild* (mission statement).

St George's Hall See William Brown Street
St George's Plateau See Lime Street. St George's Plateau

The gardens were officially opened 'for the enjoyment of the public in perpetuity', on Wednesday 29 June 1904 by Joseph Ball, J.P., Chairman of the Joint Committee of the Finance and Parks Committees, which had directed and supervised the design and execution of the scheme (*Mercury*, 30 June 1904; for early photographs of the completed site see *St George's Hall: Collection of Illustrations, Photographs, Newscuttings...*: 64-5, 68). The area had originally been a burial ground and then the site of St John's Church. The use to which the area might be put had been under discussion for several years, with many advocating it as a suitable site for the proposed new cathedral of Liverpool. Ultimately, however, on 6 March 1889, the Council decided that such a large open space, in the centre of the city, immediately beneath the grandiose walls of St George's Hall, would serve a more useful purpose if opened up as a public space and laid out with gardens and promenade (Picton, 1875, revised edn 1903, ii: 517). Following the closure of the church, and its subsequent demolition in March 1898, ownership of the grounds passed to the Corporation (*Mercury*, 29 June 1904). The site's former usage as a burial ground meant that many human remains had to be re-interred during the course of laying out the gardens and, later, during the excavations for the foundations of the individual monuments.

The design of the gardens, by the Corporation Surveyor, Thomas Shelmerdine, was approved by the Council on 1 August 1900 (*Courier*, 2 August 1900). George Frampton advised on the original design, but it was subsequently much altered and the sculptor publicly disclaimed any significant role in the final scheme when it came under critical attack (letters from Frampton to the *Daily Post*, 25 October 1904, cited in Stevens, 1989a: 80; and to the *Mercury*, 25 October 1904, cited in Read, 1989: 38). On 21 October 1900, the *Courier* had described the gardens as an 'appalling spectacle' and complained that Liverpool had wanted a garden and been given a stoneyard – there was quite simply too little greenery. Furthermore, neither the curiously 'tapering pillars' nor the 'tortuous ironwork' harmonised with the 'classic design' of St George's Hall.

What evidently ignited the *Courier*'s hostility was the announcement that the Joint Committee had just approved spending the large sum of £2,500 on four allegorical sculptures to crown the pedestals flanking the two stairways from the upper terrace of the gardens. This certainly was Frampton's conception. According to the *Daily Post* (5 December 1903), his original idea had been that 'pillars' crowned with 'bronze ships' should be placed upon the pedestals (presumably like rostral columns), but on trying out the idea by placing plaster models *in situ* the result was 'found not to harmonise with the surroundings'. He then suggested that the Corporation commission 'four rising young' artists to design seated allegorical figures of *Spinning*, *Shipping*, *Machinery*, and *Mining* – representative of the bases for the material wealth of the port. The *Courier*'s objection was based on the fact that this proposed expenditure of public money had not been announced in advance and, to make matters worse, the two relatively obscure sculptors who had been awarded the commission – Francis Derwent Wood and Henry Pooley – were not even local men. Subsequently, on 26 October, the Council rejected the Joint Committee's recommendation and the sculptures, as proposed by Frampton, remained unexecuted.

Nevertheless, not every review of the final design of the gardens was hostile. The *Mercury* published an article on the day of their inauguration (29 June 1904), welcoming the gardens as 'another important step in the direction of beautifying the city'; and the Mayor (Sir Robert A. Hampson), if his speech at the opening ceremony is to be believed, was greatly pleased with the completed project and evidently considered that the gardens complemented their surroundings superbly. He explained that they 'had been laid out in the Italian style' specifically so that they would in fact harmonise with St George's Hall and the neo-classical buildings of William Brown Street. Furthermore, the total cost – an important point – at £31,850, was considerably less than the original estimate. The purpose of the gardens was, he proclaimed, to provide not only a resting place for the weary but also – and undoubtedly of more importance – a site for commemorative monuments. It is this latter factor that gives St John's Gardens its special quality: rather than being an existing public space gradually embellished with sculpture – the usual pattern in Britain – St John's Gardens was intentionally planned as 'Liverpool's al fresco Valhalla' (*Liverpool Review*, 11 March 1899: 3; quoted in Read, 1989: 38).

By the day of the inauguration of St John's Gardens, all of the seven monuments that were to make up the eventual ensemble had been

erected or were at least planned: two had already been unveiled (*Alexander Balfour* and *William Rathbone*), two more had been erected and were shortly to be unveiled (*William Ewart Gladstone* and *Sir Arthur Bower Forwood Bart.*), places had been allocated to two more (*The King's Liverpool Regiment* and *Monsignor Nugent*), and the last (*Canon T. Major Lester*) had been given approval for erection in the gardens, albeit the specific site was still under discussion. As the Mayor explained, the statues would be:

> placed there in memory of the sons of Liverpool who were deemed worthy of that honour, and upon which would be inscribed the record of their services as a memorial to worthy men who had departed and as an incentive to the zeal and enthusiasm of the younger generation (*Mercury*, 30 June 1904).

It is perhaps of some significance that, for a space largely devoted to working class recreation, there is, in the selection of the figures commemorated, a notable bias towards men involved in philanthropic works and social improvement.

St John's Gardens, as they stand today, fulfil the intentions as reported in the *Mercury* (29 June 1904), except on two small points. Firstly, it had been intended that the buttresses of the circular parapet surrounding the projected *Memorial to the King's Liverpool Regiment* would eventually be crowned with busts; and secondly, for the symmetry of the overall plan to be complete, a monument should have been raised on the south-east side of the gardens to balance the *Monument to Alexander Balfour* on the north-east.

Literature: LRO (a) manuscript sources: *Council Minutes*, 1/42: 430; *Finance Committee Minutes*, 1/51: 632. (b) newscuttings: *Courier* (1904) 21 October, in

TCN 1/31; *Daily Post* (1900) 2 August, in *TCN 1/28*; *Daily Post* (1903) 5 December, in *TCN 1/30*; *Daily Post* (1904) 15 October, in *TCN 1/31*; *Mercury* (1904) 29 June, in *TCN 1/30*; *Mercury* (1904) 30 June 1904, in *TCN 1/30*; *Mercury* (1904) 22 October, in *TCN 1/31*; *Mercury* (1904) 25 October, in *TCN 1/31*. (ii) *Builder* (1900) 21 July: 50; *Liverpool Review*, 11 March 1899: 3; Picton, J.A. (1875, revised edn 1903), ii: 517; Read, B., 'From Basilica to Walhalla', in P. Curtis (ed.) (1989): 38; Stevens, T., 'George Frampton', in P. Curtis (ed.) (1989a): 79-80.

The following inventory of the monuments in St John's Gardens is arranged in chronological order:

Monument to Alexander Balfour

(1824-86) shipowner and philanthropist. Born in Leven, Fife, he arrived in Liverpool in about 1846. A senior partner in the firm of Balfour, Williamson & Co. from 1851 until his death, he established lucrative trade links between the port of Liverpool and Valparaiso and San Francisco. He did much to improve the conditions of the men who worked on his ships and in Liverpool helped to found, or contributed to, the Seamen's Orphanage, the Seamen's Institute, and the Sailors' Home. He also founded, with Samuel Smith, M.P., the Young Men's Christian Association at Mount Pleasant and, in his capacity as a member of the Liverpool Council of Education, instituted, with Christopher Bushell, Scholarships for Boys of Elementary Schools. A member of Liverpool Town Council from 1873 to 1881, he was a staunch presbyterian and an uncompromising apostle of the temperance movement (sources: *Liverpool Review*, 24 April 1866; *Liverpool Pulpit*, December 1894; *Modern English Biography*).

Sculptor: Albert Bruce Joy

Statue in bronze
Pedestal in granite

Bronze founder: Henry Young & Co. of London
Stonework contractors: Bessbrook Granite Co. Ltd

h. of statue: 10' 8" (3.25m)
h. of pedestal: 13' 4" (4.06m)

Inscriptions on the pedestal:
– on the front face of the dado: ALEXANDER BALFOUR / MERCHANT AND SHIPOWNER / BORN 2ND SEPTEMBER 1824 / DIED 16TH APRIL 1886 / – / HIS LIFE WAS DEVOTED TO GOD. / IN NOBLE AND MUNIFICENT EFFORTS / FOR THE BENEFIT OF SAILORS, / THE EDUCATION OF THE PEOPLE, / AND / THE PROMOTION OF ALL GOOD WORKS. / – THIS STATUE, ERECTED BY PUBLIC / SUBSCRIPTION *(sic)* WAS UNVEILED / ON THE 15TH DAY OF NOVEMBER 1889.

Signed and dated by the sculptor on the right face of the bronze base: A. BRUCE JOY. SC. 1889.
Signed by the founder on the rear of the bronze base towards the right: H. YOUNG & CO. / ART FOUNDERS. / LONDON.
Signed by the granite masons on the right face of the plinth, towards the rear: BESSBROOK GRANITE CO. LTD.

Unveiled by the Revd Canon Ellison, M.A., Saturday 23 November 1889

Owner/ custodian: Liverpool City Council
Listed status: Grade II

Description: Erected before Shelmerdine's replanning of the area, the *Balfour Monument* was moved eastwards to its present location in the north-east corner, when the gardens were laid out. Balfour, in contemporary dress, wears an Inverness cape over an open frock-coat. His weight is borne chiefly upon his left leg, his

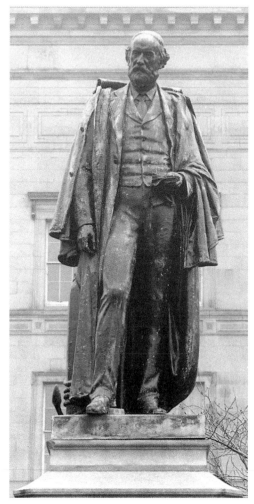

right leg placed forward with the foot protruding over the forward edge of the base. In his left hand, raised to waist level, he holds papers, whilst his right hand hangs relaxed at his side. At his right side is a bollard, an anchor and a rope.

Bruce Joy had met Balfour on several occa-sions, but the latter was evidently a reluctant sitter and the sculptor had to work largely from photographs and a cast taken after the subject's death. The portrait likeness was considered a great success by those who had known Balfour (*Mercury*, 25 November 1889).

Condition: The statue is in apparently fair condition, but the pedestal has some graffiti.

Soon after Balfour's death a group of his friends met and resolved that a public subscription should be launched to pay for the erection of a monument to him in acknowledgement of the good works he had promulgated throughout the city (Lundie, 1889: 319-20). From the assembled group, a Committee of five men was elected to supervise the subscription, consisting of James Beazley (Chairman), Thomas Matheson (Vice-Chairman), Charles J. Bushell and H.B. Gilmour (Honorary Treasurers), and Clarke Aspinall (Honorary Secretary) (*Mercury*, 25 November 1889). From the start it was intended that the monument be located, not in the exclusive confines of St George's Hall, but in a public place, preferably near the river, close to 'the sailors for whom [Balfour] toiled so earnestly' (Lundie, 1889: 319-20; Read, 1989: 38).

On 5 June 1889, the Council received a formal application from the Memorial Committee for permission to have the statue of Balfour erected in 'the Churchyard of St John'. Thus, this was the first monument to be erected in the grounds later to be renamed St John's Gardens. Provision was granted that, at the expense of the Memorial Committee, any remains that might be disturbed by the neces-sary excavations would be re-interred 'in some other suitable portion' of the churchyard (*Council Minutes*).

The choice of an open and easily accessible location for this monument met with general approval. According to the *Mercury* (25 November 1889) in its account of the unveiling, there were, in addition to the worthies accom-modated within the gardens, 'crowds of working folk' watching the ceremony from the Old Haymarket, St John's Lane and the plateau in William Brown Street – which attendance was seen as a testament to Balfour's popularity. As was usual with such events, the good quali-ties of the subject were fulsomely expressed. The sculptor could not himself attend, having succumbed to a bad cold, but his letter in praise of Balfour was read to the assembly by Honorary Secretary Mr Clarke Aspinall. Among the personal eulogies showered upon Balfour that day, came Edward Whitley's wider hope that this 'monument of the sculptor's art would stand to remind future generations of Liverpool that after all the great aim of this life was to do good while we lived'.

Literature: (i) LRO (a) manuscript sources: *Council Minutes*, 1/29: 222. (b) newscuttings: *Mercury* (1889) 25 November, in *TCN 1/22*.
(ii) *Liverpool Review* (1866) 24 April: 10; Lundie, R.H. (1889): 39-20; *Mercantile Marine Service Association Reporter* (1886) July: 309-12; Read, B., 'From Basilica to Walhalla', in P. Curtis (ed.) (1989): 38.

Monument to William Rathbone

(1819–1902) merchant and philanthropist. As the eldest son of the same William Rathbone who is commemorated by Foley's statue in *Sefton Park* (see below, pp. 186–90), he was the sixth William Rathbone in direct succession. An early visit to America convinced him of the advantages of free-trade. In 1841 he became a partner in the family firm. His philanthropic work began in 1849, when he served as a visitor for the District Provident Society and witnessed the living conditions in the slums. A founder of

district nursing in Liverpool, he set up in 1862, on Florence Nightingale's advice, the Liverpool Training School and Home for Nurses. He also effected reforms to nursing in the workhouses. Such was the success of his ideas that his influence spread to London. He was Liberal M.P. for Liverpool, 1868-80, and Caernarvonshire, 1880-95. He was also instrumental in the foundation of both Liverpool and North Wales University Colleges. In 1891 he was made a Freeman of Liverpool. (sources: *DNB 1901-1911, Waller, 1981*)

Sculptor: (Sir) George Frampton

Statue in bronze
Inscription panel and bas-relief panels in bronze
Pedestal in Portland stone

h. of statue: 10' (3m)
h. of pedestal: 12' 6" (3.8m)
Bas-relief panels: 28½" (72.4 cm) × 22" (55.9 cm)
Main inscription panel: 21¾" (55.5cms) × 28¼" (71.5cms)

Inscription on the panel on the front face of the pedestal: WILLIAM RATHBONE. / BORN 1819. DIED 1902. / – / HONORARY FREEMAN OF THE CITY OF / LIVERPOOL. / – / MEMBER OF PARLIAMENT FOR LIVERPOOL / 1869 TO 1880 AND FOR CARNARVONSHIRE *(sic)* / 1880 TO 1895. / – / A GUARDIAN OF THE POOR IN LIVERPOOL / FOR THIRTY-FIVE YEARS. / – / A FOUNDER OF THE UNIVERSITY OF LIVER-POOL / AND OF THE UNIVERSITY OF WALES. / – / INSTITUTED THE TRAINING SCHOOL FOR / NURSES AND BROUGHT TRAINED NURSES INTO / THE HOMES OF THE POOR AND SUFFERING FIRST / IN LIVERPOOL AND LATER THROUGHOUT THE / COUNTRY. / – / ERECTED BY THE CITIZENS OF LIVERPOOL.

Inscriptions below the bas-relief panels of the pedestal:
– front face: HAVING FAITH IN GOD HE COULD / NEVER DESPAIR OF MEN.
– left face: HE HELPED THE POOR BY GIVING / HIS HEART WITH HIS HELP.
– rear face: HE DEEMED THE FEAR OF OBSTA-CLES / THE GREATEST OBSTACLE.
– right face: SEEING THE BEST IN OTHERS HE / DREW FROM THEM THEIR BEST.

Signed and dated on the front face of the bronze base of the statue: GEORGE FRAMPTON / 1899
– also on the bas-relief panel on the right face of the pedestal: G F 1900
– signed, but not dated, on the rear bas-relief panel at the extreme right: G F

Exhibited: Royal Academy of Arts 1899 (cat. 1928), as *William Rathbone, Esq.; bust. Study for statue in Liverpool*; WAG Liverpool Autumn Exhibition 1899 (cat. 1425), as *William Rathbone, Esq. (Bust, Plaster). Study for the Statue to be erected in Liverpool*; now at the Queen's Nursing Institute, London.

Unveiled by Arthur Crosthwaite, Lord Mayor of Liverpool, Friday 26 July 1901.

Owner/ custodian: Liverpool City Council
Listed status: Grade II

Description: Located at the north end of the raised concourse close against St George's Hall, Rathbone is shown wearing the silk gown of an honorary Doctor of Laws of Victoria University, Manchester (of which Liverpool University College was then a part). In his left hand he carries papers whilst over his left forearm the gown is bunched to create a lively arrangement of folds in the drapery down his left side, contrasting with the vertical fall of the gown at his right. The gown almost totally

concealed the trousers, except that the right leg is placed slightly forward and the foot protrudes over the edge of the base. Contemporary observers considered the likeness striking. As the *Mercury* (27 July 1901) remarked: 'Mr. Frampton has Pygmalion-like wrought many statues into being, but none are so vivid in presentation as that of William Rathbone'.

The original panel set into the front face of the pedestal was in green marble and bore the simple inscription: WILLIAM RATHBONE. Following Rathbone's death the following year, the present bronze panel was substituted with its fuller inscription. The bronze bas-reliefs on the three other faces of the pedestal illustrate Rathbone's philanthropic achievements: his

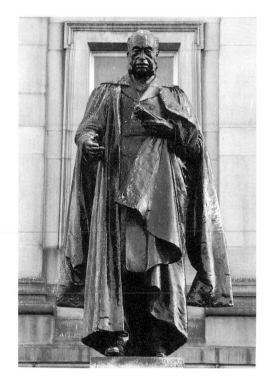

advocacy of education (left); charitable work amongst the poor (rear); and the nursing of the sick poor in their own homes (right). Frampton also designed the pedestal, complete with surrounding stone seat (*Daily Post*, 27 July 1901).

Condition: The black epoxy paint that coated the bronze statue and reliefs is now worn. The left and right panels have some graffiti. The stone of the pedestal looks roughened; it is stained green from the bronze; and there are small areas of black encrustation.

The decision to launch a public subscription for a monument to William Rathbone was unusual in so far as it was taken while its subject was still alive (Stevens, 1989a: 78). By 30 May 1899, George Frampton had already been chosen as sculptor, since on that date the *Mercury* reported that he had submitted for the Memorial Committee's approval, a portrait bust (see 'Exhibited', above), plus an 18 inches high scale model of the whole figure (illustrated in *The Tatler*, 16 April 1903; see Stevens, 1989a: 78). On 7 July 1899, Frampton wrote to Rathbone: 'The sketch for the statue was passed by the committee some weeks ago – they liked the design very much'. He added a postscript expressing his hope that the gown that Rathbone had lent him for the statue had been received in good condition and that he might be able to use it again when convenient (*Rathbone Papers*, ix, 7. 127, quoted in Stevens, 1989a: 78-79).

On 2 July 1900, the *Mercury* announced that the bronze was 'nearing completion' (cited in Stevens, 1989a: 80), whereas by the end of that year work on laying out St John's Gardens had not even commenced. As this was the site favoured by the Rathbone Memorial Committee, A.F. Warr, one of the Joint Secretaries, wrote to the Corporation Finance Committee on 15 November 1900, requesting permission to have the statue erected 'as soon as possible', in order that Rathbone – who was by now aged and in frail health – might be honoured whilst still alive. To pre-empt any concerns the Finance Committee might raise over possible damage to the monument during construction of the surrounding site, the memorialists assured it that a temporary covering around the monument would be sufficient protection (*Finance Committee Minutes*). The Corporation approved the request and on 29 March 1901 the Corporation Surveyor, Thomas Shelmerdine, reported that the contractors had completed the work on the foundations and base (*Finance Committee Minutes*). Shortly afterwards, the Joint Committee of the Finance and Parks Committees gave approval for Frampton's (unnamed) mason to start building the pedestal.

In his speech at the unveiling ceremony on 26 July (sadly, Rathbone was by now too ill to attend) the Lord Mayor, Arthur Crosthwaite, enumerated those of Rathbone's qualities that the City wished to commemorate in the reliefs:

1. Mr. Rathbone's great attention and interest, whether he were engrossed with political affairs or not, in poor law work. 2. His establishment of a system of nursing for the poor, which attracted such general attention in the country as to be the means of stimulating a similar work in other populous centres; and 3. The leading part he took in securing facilities for the acquirement of knowledge – of the establishment in our midst of that connection with a university which has already done such excellent work, and bids fair to expand to much greater dimensions. (*Courier*, 27 July 1901)

Further, he summed up the motivation for such public commemoration and its value to the City:

On this once sacred enclosure – a local campo santo – near which rest the remains of many belonging to the years long past, is it not an appropriate site on which to erect the figure of him who, in his generation, has set so grand an example of a noble citizen's life – (loud applause) – in the hope that the acts to which I have alluded… .may be handed down to posterity, and thus act as a stimulus to lead others to emulate and be a reminder of what our duty should be, that whilst making us feel the reality of a positive world, we may at the same time be uplifted from it. (*Courier*, 27 July 1901)

Literature: (i) LRO (a) manuscript sources: *Finance Committee Minutes*, 1/51: 114, 244, 306-7, 484, 602-3, 614. (b) newscuttings: *Courier* (1901) 27 July, in *TCN 1/28*; *Daily Post* (1901) 27 July, in *TCN 1/28*. (ii) University of Liverpool Archives (Special Collections, Sydney Jones Library) – *Rathbone Papers*, (correspondence): ix. 7. 127; ix. 7. 128. (iii) *Mercury* (1899) 30 May: 8; *Mercury* (1899) 15 November: 8; *Mercury* (1900) 2 July: 8; Rathbone, E.F. (1905): 468-69; Stevens, T., 'George Frampton', in P. Curtis (ed.) (1989a): 78-80, 85.

Memorial to William Ewart Gladstone

(1809-98). Born in Liverpool, the son of John Gladstone, merchant, he was four times Liberal Prime Minister: in 1867-74, 1880-85, 1886 and 1892-94 (see also pp.278–9).

Sculptor: (Sir) Thomas Brock

Statue, allegorical figures, panels, cartouches and swags in bronze
Pedestal in granite

h. of statue of Gladstone: 10' (3.05m)
h. of pedestal 20' (6.1m)

Inscriptions:
– on a bronze plaque on the front of the pedestal: WILLIAM EWART GLADSTONE / BORN IN LIVERPOOL / 29TH DECEMBER 1809 / DIED AT HAWARDEN / 19TH MAY 1898 / BURIED IN / WESTMINSTER ABBEY
below which, on a bronze cartouche with a raised domical centre, Gladstone's monogram: W.E.G
– left side of the pedestal, on a bronze plaque below a winged allegorical figure: TRUTH
– rear of the pedestal, inscribed in the granite, below a bronze bas-relief: BROTHERHOOD
below which, on a bronze cartouche: 1809-1898
– right side of the pedestal, on a bronze plaque below a winged allegorical figure: JUSTICE

Signed on the base of the ornamental pedestal against which Gladstone stands: T. BROCK R.A.S.
– also at bottom right of the bas-relief at rear of the actual pedestal: T. BROCK R.A.S.

Unveiled by the 5th Earl Spencer (John Poyntz Spencer), K.G., Saturday 16 July 1904.

Owner/ custodian: Liverpool City Council
Listed status: Grade II

Description: Located at the centre of the gardens within a semi-circular stone enclosure, Gladstone is represented as a full-length figure standing before an ornamental pedestal, over which a piece of drapery is arranged. Large books are piled on the ground on his left. With his right hand he holds his lapel, while, in his left hand, down at his side, he holds some documents. He wears a frock-coat and waistcoat. Gladstone is depicted in the act of delivering a speech. Swags of laurel link the cartouches, on the front and rear faces of the pedestal, to the two side figures. The loosely draped figure on the left is *Truth*. On her head is a laurel wreath

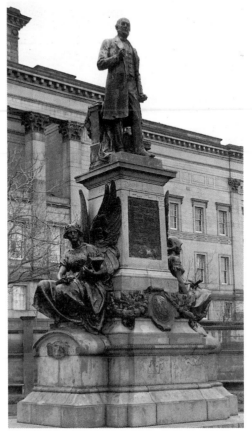

and in her right hand a sprig of laurel. In her left hand she holds the Book of Knowledge. *Justice*, her opposite number, holds a pair of scales in her lowered right hand, and in her left hand a sword which rests across her lap. She is helmeted and breastplated. Both female figures are seated and winged and both look towards the front of the monument. The bas-relief on the rear of the pedestal, entitled *Brotherhood*, shows three male figures. A senatorial figure in a toga holds a document in his left hand and

shakes hands with a labourer, stripped to the waist and holding a spade, head lowered deferentially. A third figure, behind the labourer, witnesses the agreement (for a general account of iconography associated with Gladstone in the many other monuments to him throughout Britain, see Read, 1982: 379-86).

Condition: The pedestal is heavily covered with applied graffiti and the rear bronze panel and the figure of *Justice* are marked with some scratched graffiti. Of *Justice*'s sword, only the hilt remains. The black epoxy paint which once covered all the bronze parts of the monument is now worn: most noticeably from the figure of *Truth*, which has lost a considerable amount, but also from the figure of *Gladstone*, where it is worn away in places.

Related work: Thomas Brock, *W.E. Gladstone*, marble, unveiled 1903, Westminster Abbey (shown at the Royal Academy of Arts 1902, cat. 1609).

Almost a year after Gladstone's death, *The Liverpool Review* (11 March 1899) reported that the city was finally doing its duty to 'that illustrious man' and that the Lord Mayor, in response to 'a requisition signed by a number of leading citizens', had announced that a public meeting would be held on Monday 13 March 1899 to discuss an appropriate memorial. The journal declared that the existing statue inside St George's Hall (see below, pp. 278–80) was insufficient commemoration for such a notable figure, and proposed as the most appropriate form of monument a statue 'in the most prominent [open-air] position that can be acquired'. It suggested that the most suitable location was without doubt the junction of Lord Street, Castle Street and James Street (i.e. what is now Derby Square), where the half-demolished St

George's Church still stood, on the site of Liverpool Castle. No more historic or commanding site for a monument could be found in Liverpool, and there could be no more worthy candidate for such a site than Liverpool's most illustrious son. On the other hand, the journal advised against selecting St John's Churchyard (as St John's Gardens was still called) for the monument: it would be like putting Gladstone in the 'back yard of St George's Hall', while Disraeli (who was not even a citizen of Liverpool) stood proudly out in front with Queen Victoria and Prince Albert.

Indeed, as the subscription gathered momentum and the monument's location still remained unconfirmed, it was alleged that some potential subscribers were hesitating to commit themselves in case St John's Churchyard was ultimately selected (Read, 1989: 38); and sure enough, the amount subscribed by 26 April 1899, when the *Daily Post* announced the imminent closure of 'The *Daily Post* and *Echo* Fund' for the Gladstone memorial, was somewhat less than had been expected. The paper felt confident, however, that there were still many people in Liverpool and throughout Lancashire who would want to ensure that the monument was suitably magnificent. Especial encouragement was given to the 'working classes', for whom 'the greatest son which the city has ever produced' had done so much, by promising that the name of every subscriber, of 'however small' an amount, would be published in its own pages and those of the *Echo*.

By 29 November 1899, 'upwards of £5,000' had been collected and the sculptor, Thomas Brock, attended a meeting in the Town Hall to submit some 'photographic views' of his proposed memorial (*The Times*, 30 November 1899: 6). The monument, as described in the newspaper, anticipates the finished work fairly closely, except that a second relief panel, representing *Progress*, was intended for the front of the pedestal where the main inscription plaque was ultimately placed. At this point, the site was still unknown.

The matter was settled sometime in 1901. On 28 June of that year, the Honorary Treasurer of the Gladstone Memorial Committee, Robert D. Holt, wrote to the Corporation Finance Committee requesting – notwithstanding, it would seem, the reservations entertained by the *Liverpool Review* – 'the central position in the Upper Terrace of St John's Churchyard' (*Finance Committee Minutes*). On 5 July, the Corporation Surveyor, Thomas Shelmerdine, having been instructed by the Finance Committee to investigate the suitability of the proposed memorial for this particular position, reported back with a photograph of 'the Statue...a fine colossal group with a large base and pedestal'. On the evidence of what he had seen, he felt that Brock's memorial would indeed be a 'magnificent work of art' and one that would fully merit a central position, although he judiciously recommended as a better and more prominent position, not the upper terrace, but 'the lower plateau or sunk garden' (*Finance Committee Minutes*).

The true significance of the St John's Gardens *Memorial to W.E. Gladstone* to the city that erected it was unequivocally expressed at the unveiling ceremony by Lord Spencer. He reminded the assembled citizens of Liverpool (and, via the newspaper coverage, informed readers across the nation) that Gladstone's family was of Liverpool, that Gladstone himself was born in Liverpool, raised in Liverpool, met, as a child, that other great man associated with Liverpool, George Canning, and that ultimately Gladstone, like Canning, had achieved national importance and worldwide fame. Such an excellent work of art by a 'great sculptor' on a 'splendid site' in a 'great city' was the only fitting tribute to such a man (*Mercury*, 18 July 1904). The ceremony was brought to a close, as usual, with the Memorial Committee, in the person of Honorary Treasurer Robert D. Holt, inviting the Lord Mayor, as represenive of the City of Liverpool, to accept the statue and to preserve it for the citizens.

Literature: (i) LRO (a) manuscript sources: *Finance Committee Minutes*, 1/52: 31, 45. (b) newscuttings: *Mercury* (1904) 18 July 1904, in *TCN 1/30*. (ii) Curtis, P. (1988): 8; *Daily Post* (1899) 26 April: 5; *Liverpool Review* (1899) 11 March: 3; *Liverpool Review* (1899) 18 March: 4-5; Read, B., 'From Basilica to Walhalla', in P. Curtis (ed.) (1989): 38; *The Times* (1899) 30 November: 6; *The Times* (1904) 18 July: 3.

Monument to Sir Arthur Bower Forwood Bart

(1836-98). A Liverpool merchant shipowner, he entered his father's office and, following his father's retirement in 1862, became senior partner. His trading concerns operated between Liverpool, New York and the West Indies. In 1871 he was a member of Liverpool City Council and, in 1877-78, served as Mayor. He was Chairman of the Liverpool Constitutional Association from 1880, the Conservative candidate for Liverpool in 1882, and M.P. for Ormskirk from 1885 until his death. He was First Secretary to the Admiralty 1886-92, Privy Councillor 1892, and was created baronet in 1895. (sources: *Modern English Biography*; Waller, 1981)

Sculptor: (Sir) George Frampton

Statue and four plaques in bronze
Pedestal in sandstone

h. of statue: 10' (3.05m)
h. of pedestal: 12' 6" (3.8m)

Inscriptions on the pedestal:
– front plaque: THE RIGHT HONORABLE / SIR
ARTHUR BOWER / FORWOOD, / BARONET. /
PRIVY COUNCILLOR / M.P., J.P. / BORN 1836
DIED 1898
– left plaque: EARNEST & INDOMITABLE / – /
ENDOWED WITH GREAT TALENTS / FREELY
GIVEN TO THE / PUBLIC SERVICE / – / A /
LEADER OF MEN
– rear plaque: ERECTED / BY / THE CITIZENS
OF LIVERPOOL / IN GRATEFUL RECOGNITION
OF / THE LABOURS OF A STRENUOUS / AND
SELF SACRIFICING LIFE / DEVOTED TO THE
BEST / INTERESTS OF THE / MUNICIPALITY
AND THE PORT
– right plaque: MEMBER OF THE CITY
COUNCIL / 1871 TO 1898 / – / MAYOR 1877-
8 / MEMBER OF PARLIAMENT / ORMSKIRK
DIVISION / 1885 TO 1898 / – / SECRETARY
TO THE ADMIRALTY / 1886 TO 1892

Signed and dated on the front face of the bronze
base: GEO. FRAMPTON R. A. 1903

Unveiled by Frederick Arthur Stanley, 16th
Earl of Derby, Thursday 21 July 1904

Owner/ custodian: Liverpool City Council
Listed status: Grade II

Description: Located at the south end of the
raised concourse close by St George's Hall, the
subject is represented, according to the *Courier*
for 22 July 1904, 'in his favourite pose when
delivering a speech, with his left hand held
forward and his right hand on the breast lapel'
(quoted in Stevens, 1989a: 80). Forwood is
shown in contemporary dress, his left foot
pointing over the forward edge of the base. It
was, according to Stevens (1989a: 80),
Frampton's first attempt to render contempo-
rary dress without concealing it beneath an
'academic gown or other masking device'.

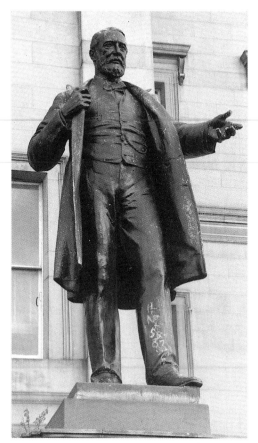

Condition: The black epoxy paint that covered
the bronze statue is worn and graffiti has been
scratched onto the left trouser leg. The surface
of the pedestal is roughened and there is some
faded graffiti. All the panels are weathered, so
that the underlying green of the metal shows
through the black paint; in addition graffiti has
been scratched into the remaining areas of
black.

Forwood was still a member of Liverpool City
Council at his death and the movement to

commemorate him with a public memorial was
generated from within this body, both as an
expression of its sense of loss and in recognition
of his work for the city. At a public meeting
held in the Town Hall on 22 June 1900 a resolu-
tion was passed in favour of opening a public
subscription to pay for the memorial (*Mercury*,
22 July 1904). It is not certain when Frampton
was selected as sculptor, but he was presumably
an obvious choice: as the *Mercury* explained, he
had already 'distinguished himself in connec-
tion with the Rathbone statue, and…had taken
such a great interest in the laying out of St
John's Gardens'. The approved maquette
(present location unknown) is visible in a
photograph of Frampton in his studio,
published in *Cassell's Magazine* for August
1902 (cited in Stevens, 1989a: 80).

Following the successful completion of the
bronze, Lord Derby was invited to unveil the
statue in recognition of his services to the city –
in 1895 he had been Greater Liverpool's first
Lord Mayor – and of his continuing concern
for the welfare of the community. Both the
Mercury and *Courier* (22 July 1904) noted with
satisfaction that the crowd that had assembled
to pay tribute to Forwood comprised a cross-
section of all classes, creeds and political parties.
After the unveiling, Councillor James Lister, as
Treasurer of the Memorial Committee, formally
presented the statue to the city in the person of
the Lord Mayor, with the usual request that the
Corporation preserve it for the enjoyment and
edification of the citizens.

Literature: (i) LRO newscuttings: *Courier* (1904) 22
July, in *TCN 1/30*; *Mercury* (1904) 22 July, in *TCN
1/30*.
(ii) *Cassell's Magazine* (1902) June – November: 284;
Stevens, T., 'George Frampton', in P. Curtis (ed.)
(1989a): 80; *The Times* (1904) 22 July: 8.

Memorial to the King's Liverpool Regiment
The regiment, formed by Lord Ferrers in 1685 as the 'Princess Anne of Denmark's Regiment of Foot', was one of a number formed to deal with the Monmouth Rebellion. During the reign of Queen Anne, it became the 'Queen's Regiment' and then, in the reign of George I, earned the title, 'The King's Regiment' in recognition of its loyal service during the Jacobite Rebellion (1715). By the mid eighteenth century it was known as the Eighth (King's) Regiment, as it was the eighth infantry regiment in seniority. In Liverpool, in 1859, the 1st Volunteer battalion of the regiment was raised, becoming the 5th Territorial battalion in 1908. In 1881 the regiment's name was changed from the Eighth (King's) to the King's (Liverpool Regiment) (source: *The King's Regiment Gallery*).

Sculptor: (Sir) William Goscombe John

Figures in bronze
Architectural elements in grey Scottish granite

Bronze founder: A.B. Burton of Thames Ditton
Stonework contractor: Kirkpatrick Bros of Trafford Park, Manchester (*Daily Post and Mercury*, 11 Sep. 1905).

Overall h. of monument approx: 26' (7.9m)
Overall w. of monument approx: 25' (7.6m)

Inscriptions:
1. front:
– in bronze letters on the central pedestal: THE / KINGS / LIVERPOOL / REGIMENT
beneath which is: THIS MONUMENT IS ERECTED BY THE OFFICERS / NON COMMIS-SIONED OFFICERS AND MEN OF THE / REGIMENT AND BY THE GRATEFUL CONTRIBUTIONS / OF THE PEOPLE OF LIVERPOOL IN MEMORY OF / THEIR COMRADES

AND FELLOW CITIZENS WHO / DIED DURING THE CAMPAIGN IN AFGHANISTAN 1878-80 / BURMA 1885-1887 AND SOUTH AFRICA 1899-1902 / SOME FELL ON THE FIELD OF BATTLE SOME DIED / OF WOUNDS AND SOME OF DISEASE BUT ALL GAVE / THEIR LIVES FOR THE HONOUR OF THE REG- / -IMENT THEIR CITY AND THEIR COUNTRY
– left arching wing: AFGHANISTAN 1878-80. BURMA 1885-7
beneath which are the names of the dead.
– leading edge of the left arching wing: 1685
– right arching wing: SOUTH-AFRICA 1899-1902
beneath which are the names of the dead.
– leading edge of the right arching wing: 1902
– on the symbolic tomb slab: PRO PATRIA
– inscribed in the upper surface of the curved granite base, immediately in front of the wreath: NEC ASPERA TERRENT
2. rear, formerly in bronze letters, (channels still legible):
– left arching wing, top line: BLENHEIM. RAMILLIES. OUDENARDE.
– continued on the right arching wing: MARTINIQUE. NIAGARA. DELHI.
– left arching wing, middle line: MALPLAQUET. DETTINGEN.
– continued on the right arching wing: LUCKNOW. PEIWAR – KOTAL.
– left arching wing, bottom line: DEFENCE OF
– continued on the right arching wing: LADY-SMITH

Signed on the right face of the bronze base of *Britannia*: W. GOSCOMBE JOHN. A.R.A.
– also signed and dated below the right foot of the *Drummer Boy*: W. Goscombe John A.R.A. / 1905.

Founder's name on the coat-tail, below the scabbard, of the *Soldier of 1685*:

A.B. Burton / Founder
– also on the right face of the base of the *Drummer Boy*:
A.B. Burton / Founder. Thames Ditton

Exhibited: Royal Academy of Arts 1904 (cat. 1840), as *Sketch model of a monument to commemorate the King's Liverpool Regiment. To be erected in Liverpool*; WAG Liverpool Autumn Exhibition 1904 (cat. 1777), as *Model for Memorial to King's Liverpool Regiment, to be placed in St. John's Gardens.*

Unveiled by Field Marshal Sir George White, V.C., Saturday 9 September 1905.

Owner/ custodian: Liverpool City Council
Listed status: Grade II

Description: Located in the centre of the gardens, between the *Canon T Major Lester* and *Monsignor Nugent* monuments. Surmounting the central pedestal is the standing figure of *Britannia*, mourning the regiment's dead. She raises her right hand, whilst in her left she holds a spray of laurel and carries a round shield decorated with sea-horses. On her head is a helmet topped by a ship's prow with a sea-horse crest – both references to maritime power. Bronze swags are placed round the upper edge of the pedestal. At the ends of the arching walls soldiers stand at ease: on the left stands a soldier of 1685, the year of the regiment's enrolment, and on the right, a contemporary soldier of 1902. Guns, and other military accoutrements lie on the sloping step at the foot of the central pedestal, intermingled with wreaths and palms and covered with the Union Jack. Before this assemblage is a laurel wreath and below that, the regimental motto: "Nec aspera terrent" ('Undaunted by difficulties'). At the rear, on the pedestal, moving from top to bottom, is the badge of the regiment, then a

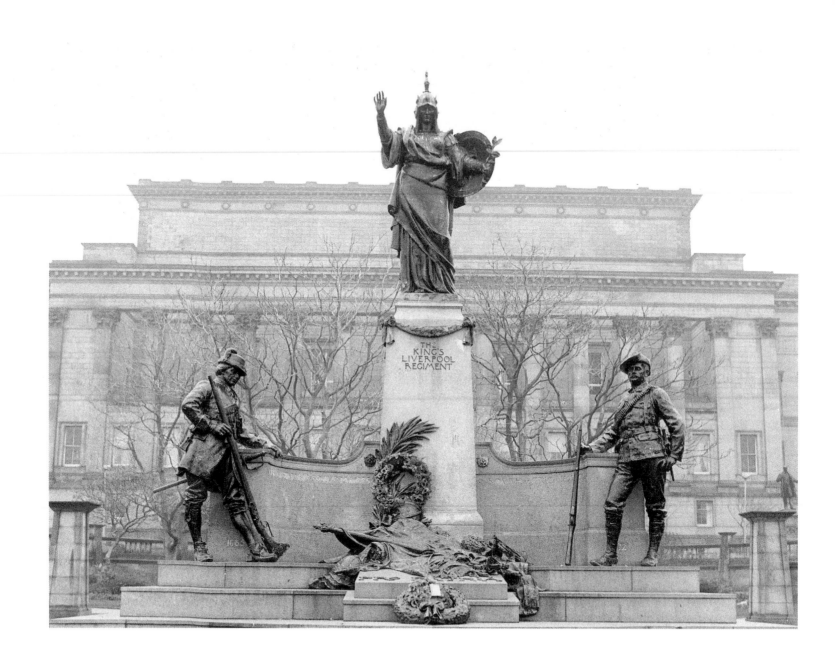

sphinx and laurel twig device with the inscription: EGYPT. Below this is the figure of the *Drummer Boy*, dressed in the uniform of the period of the battle of Dettingen (1743). He sits upon a rock, beating a call to arms. Behind him are banners, a canon and a musket. Before him on the base was once a bronze plaque (now missing), with the motto of Liverpool: DEUS HAEC OTIA FECIT and a Liver Bird.

Condition: The black epoxy paint is now wearing off the bronze in many places. There is considerable applied graffiti on the stonework. All the bronze letters are missing (though the channels into which they were once fixed allow the inscriptions still to be read). From the pile of military accoutrements, the top blade of the palm is missing, as is the plume from the shako and the flagstaff that once rested diagonally across the steps (see photograph in *Art-Journal*, 1905, p. 350). Also, the surface of the pile is badly worn (from clambering feet etc.). Parts of the trigger mechanisms of the guns of both the 1685 and 1902 soldier are missing and the black paint is very scratched around these areas. The lance-point of the lower of the two flagstaffs behind the *Drummer-boy* is missing – the figure of the boy has suffered some wear, but it is intact. The figure of *Britannia* appears to be in satisfactory condition.

Related works:
(a) by William Goscombe John
1. *The Drummer Boy*: (i) Plaster sketch, h. 16" (40.6 cms), Cardiff, National Museum of Wales (cat. 1464); (ii) Bronze statue, h. 89" (226 cms), (exhibited at the RA 1905, cat. 1645), now Cardiff, National Museum of Wales (cat. 1254), presented by the sculptor; (iii) Bronze reduction, or possibly a cast of a preliminary clay or wax model now lost (perhaps part of the above-mentioned model of the memorial shown at the RA and WAG in 1904), h. 15" (38 cms), 1904, Liverpool WAG (cat. 6313); (iv) A large edition of the *Drummer Boy* as a bronze statuette is believed to have been produced in the years following the unveiling of the memorial.
2. *Britannia*: Bronze maquette, h. 2¼" (5.6cms), NMGM King's Regiment Collection (cat. 58.83.780).
(b) related memorial:
Memorial to the Eighth King's Regiment, Whitley Gardens, Shaw Street – erected to those men of the regiment who died during the Indian Mutiny, 1857-58; formerly located in the grounds of Chelsea Hospital, London, and moved to Whitley Gardens in October 1911 (see below, pp. 211–12).

Following the Burma campaign of 1885-87, the officers of the two line battalions of the regiment decided to launch a fund for a memorial to those who had died in that, and the earlier Afghan campaign (1878-80). About £170 was collected, but it was not until 1901, after the outbreak of the war in South Africa, that steps were taken to carry out the scheme. Colonel S.H. Harrison, then commanding the First Battalion, met with two leading Liverpool citizens, Louis S. Cohen and H.K. Kyrke-Smith, to discuss the possibility of opening up the regimental fund to incorporate a public subscription (Cannon, 1904: 546). The proposed monument was then redesignated to commemorate the 420 officers and men who had died in all three campaigns – in Afghanistan, Burma, and South Africa – whether they had died in action or (and this formed the majority) from epidemic diseases (*Mercury*, 11 September 1905).

The Lord Mayor, Sir Charles Petrie, agreed to call a public meeting for 11 February 1902, during the course of which the following reso-

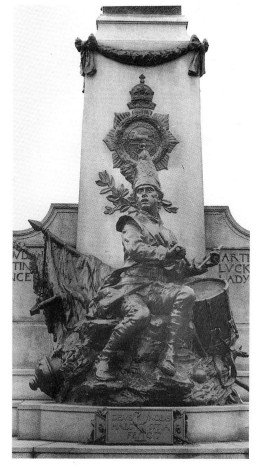

lution was unanimously passed:

That with a view of commemorating the splendid services that the King's Liverpool Regiment has rendered to the country and as a proof of the kindly feeling now existing between the City and its Territorial Regiment, it is resolved that a memorial be erected on a site to be arranged with the Corporation of Liverpool, to the memory of

the Officers and Men of the Regiment (Regulars, Militia, and Volunteers) who have fallen in Afghanistan, Burmah, and South Africa, and that a public subscription be at once opened for that purpose (Cannon, 1904: 546).

A Memorial Committee including some of Liverpool's most influential citizens was formed to raise subscriptions. Apart from Cohen, who had been Lord Mayor in 1899 – 1900, there was also John Lea who was to be Lord Mayor at the time of the unveiling. The sum of £3,000 was raised and the sculptor William Goscombe John (perhaps at the suggestion of his friend, John Lea) was asked to submit designs for a monument suitable for placing at the centre of St John's Gardens (*Daily Post and Mercury*, 11 September 1905). On 7 November 1902, John attended a meeting of the Memorial Committee and submitted two models (present locations not known), one of which was unanimously selected, subject only to approval by the Corporation (*Daily Post*, 8 November 1902); which approval was duly given by the Council on 1 April 1903 (*Council Minutes*).

The Memorial Committee met again on 6 April 1903 and, having re-inspected Goscombe John's model in the light of the Council approval, unanimously requested that the sculptor proceed with the work, subject to a few minor modifications being made. A Sub-Committee was then appointed 'to approve the bronze figures and other details from time to time', consisting of, in addition to Cohen, Kyrke-Smith, and Lea, W. Watson Rutherford (the then Lord Mayor), Colonel J.W. De Silva, E.R. Pickmere, Robert Gladstone, and Major A.J. Evans (*Mercury*, 7 April 1903). Completed and erected in the gardens by 4 August 1905, and unveiled a month later to critical acclaim,

the monument is a rare example of a pre-First World War, large-scale regimental monument in a public setting.

Literature: (i) LRO (a) manuscript sources: *Council Minutes*, 1/41: 11. (b) newscuttings: *Courier* (1905) 9 September, in *CH&T 6*: 130-31; *Courier* (1905) 11 September, in *CH&T 6*: 132-43; *Daily Post and Mercury* (1905) 9 September, in *CH&T 6*: 132; *Daily Post and Mercury* (1905) 4 August, in *TCN 1/31*; *Journal of Commerce* (1905) 11 September, in *CH&T 6*: 151-52; *Mercury* (1903) 7 April 1903, in *TCN 1/30*. (c) *Photographs of War Memorials in Liverpool...*, 1923: 2 (monument, front), 2a (plaster model, front), 2b (plaster model, rear), 3 (monument, rear), 3b (unveiling). (ii) *Art-Journal* (1905): 350; Cannon, R. (1904): 546-550; *The King's Regiment Gallery* (undated); *Daily Post* (1902) 8 November: 5; *Daily Post* (1903) 17 April: 8; *Daily Post and Mercury* (1905) 11 September: 9; National Museum of Wales (1948); Read, B., 'From Basilica to Walhalla', in P. Curtis (ed.) (1989): 39; Reilly, C.H. (1927a): 4; *Studio* (1904), 32: 29.

Monument to Monsignor James Nugent

(1822-1905). Born in Liverpool, he was educated at St Cuthbert's College, Durham, and the English College, Rome, before being ordained priest at St Nicholas pro-Cathedral, Copperas Hill, Liverpool, in 1846. He was the leading Catholic proponent of temperance and in 1863 was appointed the first Catholic chaplain of Walton Gaol. He founded the Catholic Institute, Hope Street, and the Boys' Refuge, St Anne Street. He popularized Penny Savings Banks among the Liverpool Irish poor and was active in assisted emigration societies. He was created Monsignor in 1892. (sources: Orchard, 1893; Waller, 1981*)*

Sculptor: Frederick William Pomeroy

Statue in bronze
Pedestal in sandstone

h. of statue (approx.): 10' (3.05m)
h. of pedestal (approx.): 12' (3.66m)

Inscriptions on the pedestal:
– on a bronze plaque on the front face of the dado: MONSIGNOR / JAMES / NUGENT / 1822 –1905
– in the stone beneath the plaque: SAVE THE BOY
– on the front face of the plinth: ERECTED BY PUBLIC SUBSCRIPTION / UNVEILED 8TH DECEMBER 1906
– on the left face of the plinth: HIS WORDS. / SPEAK A KIND WORD. TAKE THEM GENTLY BY THE HAND. / WORK IS THE BEST REFORMING AND ELEVATING POWER. / LOYALTY TO COUNTRY AND TO GOD.
– on the rear face of the plinth: AN EYE TO THE BLIND, A FOOT TO THE / LAME, THE FATHER OF THE POOR
– on the right face of the plinth: THE APOSTLE OF TEMPERANCE / THE PROTECTOR OF THE ORPHAN CHILD / THE CONSOLER OF THE PRISONER / THE REFORMER OF THE CRIMINAL / THE SAVIOUR OF FALLEN WOMANHOOD / THE FRIEND OF ALL IN POVERTY AND AFFLICTION.

Signed and dated (in script) on the left face of the bronze base: F.W. Pomeroy Sculpt. 1905.

Unveiled by Robert D. Holt, D. L., Chairman of the Monsignor Nugent Memorial Committee, Saturday 8 December 1906.

Owner/ custodian: Liverpool City Council
Listed status: Grade II

Description: Located on the south side of the

gardens, on the central axis with the *Memorial to the King's Liverpool Regiment* and the *Memorial to Canon T Major Lester*, and balancing the latter, the two-figure group represents Monsignor Nugent standing in Roman Catholic clerical dress, his right hand raised in a gesture of benediction. At his left is a poor young boy, stripped to the waist and wearing ragged short trousers which end above the knee. The boy's hands are raised together in thanks as he looks up to the Monsignor, whose left arm is placed protectively around his shoulders.

Condition: The pedestal is rather weathered, and has green biological growth on the lower parts. The bronze figures appear to be in fair condition. The inscriptions were originally in metal letters, now all missing. The channels into which they were fixed allow the words still to be read.

Related work: F.W. Pomeroy, *Marble Bust of Monsignor Nugent*, Walker Art Gallery (cat. 4203).

At a public banquet given in honour of Monsignor Nugent in 1903, Louis S. Cohen, a former Lord Mayor of Liverpool (1899-1900), suggested that a statue should be erected 'to commemorate the Monsignor's all-embracing labours on behalf of the poor' (*Liverpool Obituary Notices* – specific source not recorded – typed transcript in the WAG JCS files). A public subscription was launched and the then Lord Mayor, W. Watson Rutherford, writing on behalf of the Memorial Committee, applied to the Corporation Finance Committee for a site in St John's Gardens. The site was granted on 9 October 1903. The required amount was soon raised and F.W. Pomeroy was commissioned to execute the statue.

On 2 March 1904, Pomeroy gave a private view of his one-fifth scale model (present location unknown) to the Memorial Committee, the Lord Mayor (Sir Robert A. Hampson) and the press. The *Daily Post* for 3 March 1904 (quoted in Read, 1989: 38) reported that the sculptor was to use a bust of the Monsignor (now cat. 4203 in the WAG) as a model for the head and acclaimed his idea of featuring the Monsignor protectively laying his hand on a ragged boy's shoulder as 'electrical'. The Memorial Committee obviously thought so too as it 'highly complimented [Pomeroy] upon the new idea' and gave its approval for him to proceed with the full size model.

The specific site in St John's Gardens ultimately occupied by the monument was partly determined by the desire of the memorial committees of this and the *Memorial to Canon T Major Lester*, also under way at the time, to create a symmetry between the two figures who, as Catholic Monsignor and Anglican Canon, differed widely in their religious convictions, whilst remaining the dearest of friends, pursuing parallel paths, working for the poorest elements of their society. The Parks Committee had originally suggested placing the two monuments in close proximity, but neither committee found this an attractive proposition. It seems to have been former Lord Mayor W.W. Rutherford, of the Lester Memorial Committee, who suggested the present arrangement whereby the monuments stand at opposite sides of the gardens (see below, p.183). This solution was approved by the Parks Committee, following its meeting with a joint deputation of the two Memorial Committees, headed by Lord Mayor John Lea (*Daily Post and Mercury*, 21 December 1904).

On 19 October 1906, the Corporation Surveyor, Thomas Shelmerdine, reported that

the statue was in position and was ready to be unveiled. A small extra expense had been incurred in laying the foundations, however, as human remains had been uncovered by the excavations and Shelmerdine had authorised their re-interment in a receptacle within the concrete base in order to avoid the greater expense and trouble of re-interring them in another cemetery (*Finance Committee Minutes*).

According to the *Daily Post and Mercury* (10 December 1906), the unveiling ceremony was attended by all the usual dignitaries, plus 'a great gathering representative of all churches and...social reform movements of the city'. The late Monsignor's selfless devotion to helping the children of the poor was praised by the Chairman of the Memorial Committee, Robert D. Holt, and emphasis was given to his 'complete absence of sectarianism', reference to which drew applause from the gathered crowds. Even louder applause was evoked by the Roman Catholic Bishop of Liverpool, Dr Whiteside, who said that Nugent's work as a social reformer meant that he belonged not just to the Roman Catholic community, but to the 'whole community of the city'. Shrewdly he also praised the wealthy merchants of the city, many of whom, he said, had responded generously in the past to the Monsignor's frequent pleas for urgent financial assistance for his causes. The warmth of the Roman Catholic Bishop's address was echoed by that of the Anglican Rector of Liverpool, Canon J.A. Kempthorne, who said how honoured he felt to be allowed to take even a small part in a ceremony to a man he was proud to call a fellow-citizen. The tasteful conclusion to these gratifyingly non-sectarian proceedings was made by James P. Reynolds, one of the Joint Honorary Treasurers of the Nugent Memorial

Committee, who made 'a graceful reference' to the *Monument to Canon T. Major Lester*, shortly to be erected as a 'companion statue'.

Literature: (i) LRO manuscript sources: *Finance Committee Minutes*, 1/53: 733; *Finance Committee Minutes*, 1/56: 618-19.
(ii) WAG JCS files – typed transcript (specific source not given) from LRO *Liverpool Obituary Notices* (1905): 130.
(ii) Bennett, Canon J. (1949): 135; *Courier* (1904) 21 December: 11; *Daily Post* (1904) 3 March: 7; *Daily Post and Mercury* (1906) 8 December: 10; *Daily Post and Mercury* (1906) 10 December: 9; *Liverpolitan* (1932) July: 20; Read, B., 'From Basilica to Walhalla', in P. Curtis (ed.) (1989): 38; *The Times* (1906) 11 December: 12.

Memorial to Canon T Major Lester

(1829-1903) Honorary Canon of Liverpool from 1884. Born in London, he was Anglican vicar of St Mary's with St Lawrence, Kirkdale, from 1855, and founder, Superintendent, and Treasurer of Kirkdale Industrial Ragged Schools and Homes from 1856. He was Chairman of Liverpool Self-Help Emigration Society from 1880. From 1885 he was a member, and from 1891 Chairman, of the Liverpool School Board. He died a poor man but had raised, it is said, at least £1 million for charity (sources: *Who Was Who 1897-1915*; Waller, 1981).

Sculptor: (Sir) George Frampton

Statue and plaque in bronze
Pedestal in sandstone

Bronze founder: A.B. Burton of Thames Ditton Stonework contractors for the pedestal (to Frampton's design): Kirkpatrick Bros of Trafford Park, Manchester (*Daily Post and Mercury*, 27 May 1907).

h. of statue (approx.): 10' (3.05m)
h. of pedestal (approx.): 12' (3.66m)

Inscriptions on the pedestal:
– bronze plaque on the front face of the dado:
T. MAJOR LESTER / 1829 – 1903
– inscribed on the front face of the dado below the panel: "GIVE THE CHILD A FAIR CHANCE."
– on the left face of the dado: HE WAS A PIONEER IN FOUNDING / HOMES AND SCHOOLS WHERE / DESTITUTE CHILDREN COULD / BE FED, CLOTHED, EDUCATED / AND STARTED IN LIFE AND / WORKED ENTHUSIASTICALLY / FOR THEM TO THE END OF / HIS DAYS.
– on the rear face of the dado: HE WAS LOVED BY ALL BECAUSE / HE SHOWED LOVE TO ALL.
– on the rear face of the plinth: ERECTED BY CITIZENS OF ALL / CLASSES, CREEDS AND PARTIES.
– on the right face of the dado: VICAR OF ST MARY'S KIRKDALE / FOR FIFTY YEARS HONORARY / CANON OF LIVERPOOL RURAL / DEAN OF LIVERPOOL NORTH / LAST CHAIRMAN OF THE / LIVERPOOL SCHOOL BOARD / A FOUNDER AND CHAIRMAN / OF STANLEY HOSPITAL / FOUNDER OF MAJOR STREET / RAGGED SCHOOL AND THE / KIRKDALE CHILD CHARITIES.

Signed and dated on the left face of the bronze base: GEO FRAMPTON R. A. / 1907 (note: the 'N' is reversed)

Exhibited: Royal Academy of Arts 1906 (cat. 1764), as *The late Canon Major Lester, Sketch model for the monument to be erected at Liverpool*; Royal Academy of Arts 1907 (cat. 1689), as *The late Canon Major Lester. Model of bronze statue to be erected in Liverpool*.

Unveiled by Frederick Arthur Stanley, 16th Earl of Derby, Saturday 25 May 1907

Owner/ custodian: Liverpool City Council

Listed status: Grade II

Description: Located on the north side of the gardens, on the central axis with the *Memorial to the King's Liverpool Regiment* and the *Monument to Monsignor James Nugent*, and balancing the latter, this also is a two-figure group. Lester is represented in Anglican clerical dress, over which he wears a flowing robe. According to Frampton 'the idea of the statue was to show the late Canon in the actual performance of the work with which he had been identified. The idea was that he had met a child by the wayside and had taken it up in his arms and was carrying it to some shelter.' (*Courier*, 21 December 1904, quoted in Stevens, 1989a: 81).

Condition: The stone of the pedestal appears very weathered, the inscriptions are faint and the underside of the pedestal cornice is flaking. The bronze base of the statue is pock-marked. Some of the epoxy black paint has worn off the figure.

The idea that a public subscription should be opened to pay for some sort of monument to Canon Lester was proposed at a meeting of eminent citizens, including the Lord Mayor, W. Watson Rutherford, just a few days prior to the Canon's death. A Committee was formed to supervise the proposal and at a public meeting on 30 October 1903, it was resolved that the monument should take the form of a statue in St John's Gardens (*Courier*, 29 March 1907; Grey-Edwards, 1906: 214). Lester's unexpected death a few days later on 3 November 1903 gave additional impetus to what was to become a subscription for his memorial statue.

By 20 December 1904, the Memorial Committee was able to announce that it had received £1,684, of which £100 had been

donated by Lord Derby alone (*Courier*, 21 December 1904). A remarkable testament to the warmth of feeling locally for Canon Lester was that £500 of that total had been raised from door-to-door collections amongst his parishioners in the extremely impoverished Kirkdale area (Grey-Edwards, 1906: 214). The Committee resolved that the sum of £1,500 should be set aside for the statue, with the remainder forming a gift to the Canon's widow (*Courier*, 29 March 1907).

The Parks Committee had originally offered a place close to the site reserved for the

proposed *Nugent Monument*, a suggestion that did not suit either of the Memorial Committees. The Chairman of the Lester Memorial Committee (each successive Lord Mayor acted as Chairman, this being John Lea), thought that the two statues should be placed in different parts of the gardens to 'balance each other', while former Lord Mayor Rutherford suggested that perhaps the solution might be to have the two statues placed on the vacant plots at opposite sides of the gardens near the main entrance. This was unanimously agreed (*Daily Post and Mercury*, 21 December 1904). Notwithstanding the express wish of both Committees that the two monuments should be set further apart, the non-sectarian predispositions of both Lester and Nugent would suggest strongly a similar attitude in their Memorial Committees. Thus, rather than betokening any degree of mutual animosity, it is entirely reasonable to conclude that their actions merely indicate that each Committee considered its own subject worthy of a maximum of space. Indeed, Lea, in his capacity as current Lord Mayor rather than Lester Memorial Committee Chairman, headed a joint deputation of the two Memorial Committees to make a respectful protest to the Parks Committee (*Daily Post and Mercury*, 21 December 1904). As a result of this combined action, the *Lester Monument* was re-allocated to the position which it occupies to this day, on 22 February 1905 (*Parks and Gardens Committee Minutes*).

Frampton, whose *Rathbone Monument* was already in place and whose *Forwood Monument* was shortly to be unveiled in the gardens, was selected by the Memorial Committee in March 1904 (Stevens, 1989a: 80). He was in attendance at the meeting on 20 December 1904, where he submitted a 'plaster model of the statue, and a large bust, prepared from photographs of the

deceased, and the descriptions of some of his friends and relations'. The Committee approved this design unanimously and expressed admiration for the portrait likeness of the 'large bust' (*Daily Post and Mercury*, 21 December 1904, quoted in Stevens, 1989a: 80-81). The sketch model was shown at the Royal Academy in 1906 and the full-size plaster model in 1907. On 1 March 1907, the Finance Committee authorised the Corporation Surveyor, Thomas Shelmerdine, to have the foundations for the pedestal excavated at the Corporation's expense (as was the practice for a monument that had been approved a public site), suggesting that work on the bronze must have been nearing completion or have been finished by this date.

At the unveiling ceremony the Revd W. Stanton Jones, then vicar of St Mary's, requested that Mr John Japp, the Lord Mayor, accept the memorial on behalf of the city. The ceremony was notable for the number of children in attendance: on the steps of the Museum were about five hundred poor children, assembled by the Food and Betterment Society (of which Lester had been president for four years) and fifty children representing the Ragged School Union. In the reserved enclosure the Liverpool Battalion of the Boy's Brigade formed a guard of honour and prior to the ceremony the band of the Boy's Orphanage played selections of music. In addition, many children from the Canon's parish came with their parents. More than once in the proceedings, satisfaction was expressed at the fact that the crowd was multi-denominational and ranged across the classes. Also, similarities were drawn between Canon Lester and his Roman Catholic friend and counterpart, Monsignor Nugent: the Revd Stanley Rogers, (representative of the Kirkdale branch of the Memorial Committee) observed:

> Whether Roman Catholic or Protestant, or whatever class or creed, they all loved the man and honoured the man...It was with him as it was with Father Nugent – he was worthy of the best love of Liverpool city (*Courier*, 27 May 1907).

In their exhaustive accounts of the unveiling, both the *Courier* and the *Daily Post and Mercury* even bother to record that the silken cord and tassel used at the unveiling (which was obviously supplied by Frampton) had also been pulled by the King (Edward VII) in July 1905 when he unveiled Frampton's *Monument to the Lancashire Fusiliers* in Salford, and by Princess Louise in September 1905 when she unveiled his *Monument to Queen Victoria* in Blackburn.

Literature: (i) LRO (a) manuscript sources: *Finance Committee Minutes*, 1/54: 321; *Finance Committee Minutes*, 1/56: 618-19; *Finance Committee Minutes*, 1/57: 136, 397; *Parks and Gardens Committee Minutes*, 1/23: 513, 529. (b) newscuttings: *Courier* (1907) 29 March, in *TCN 1/32*; *Courier* (1907) 27 May, in *TCN 1/32*; *Daily Post* (1903) 4 November, in *TCN 1/30*; *Daily Post and Mercury* (1907) 27 May, in *TCN 1/32*.
(ii) *Courier* (1904) 21 December: 11; *Daily Post and Mercury* (1904) 21 December: 9; Grey-Edwards, A.H. (1906): 212-14; Read, B., 'From Basilica to Walhalla', in P. Curtis (ed.) (1989): 38-39; Stevens, T., 'George Frampton', in P. Curtis (ed.) (1989a): 80-81.

St Nicholas Place *Memorial to the Engine Room Heroes.* See Pier Head.

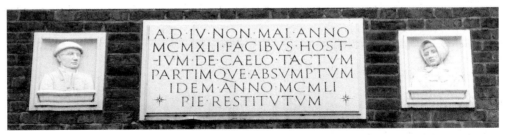

BLUECOAT CHAMBERS

A Queen Anne style building, erected 1716-17, and considerably restored following air-raid damage in May 1941. Originally the home of the Bluecoat School until its move to new premises at Wavertree in 1906, the building was subsequently rented by what was to become the Sandon Studios Society, so called after their former home at Sandon Terrace, demolished in 1907. In 1927, following a period in which the fabric of the building had fallen into neglect, Bluecoat Chambers was bought by public appeal and the Bluecoat Society of Arts, most of whose members were from the Sandon Studios Society, was formed to manage the property (Brack, 1965: 48-50). Since that time it has been a thriving arts centre, staging regular art exhibitions, and housing various local arts societies, a crafts shop, an arts bookshop, and a popular café. There are also sculptors' workshops at the back of the building, beyond the inner garden. It was here that George Herbert Tyson Smith had his workshop, the celebrated 'Studio 49', from 1925 until his death in 1972. These workshops are currently the home of the Merseyside Sculptors Guild, formed by three of Tyson Smith's former assistants (see above, p. xv).

Owner of building: Bluecoat Society of Arts
Listed status: Grade I

The façades overlooking the cobbled forecourt have sculptural decoration:

(a) *Cherub Head Keystones* over the windows facing onto the cobbled forecourt. Six were executed by **George Herbert Tyson Smith** in 1950 to replace originals damaged or destroyed in the Second World War air-raid.

Condition: Good

(b) Over the first doorway of the lefthand wing are two *Relief Panels*, one each side of an *Inscription Plaque*. The panel on the left shows a Bluecoat schoolboy, and that on the right, a Bluecoat schoolgirl.

Sculptor: George Herbert Tyson Smith

Relief panels in artificial stone.

Inscription on the plaque in between the relief panels: A.D. IV. NON. MAI. ANNO / MCMXLI. FACIBUS. HOST- / -IUM DE CAELO TACTUM / PARTIMQUE. ABSUMPTUM / IDEM. ANNO. MCMLI / PIE RESTITUTUM.
['*May 1941. Struck from heaven by the fires of enemies and partly destroyed. 1951 the same devotedly restored.*']

Condition: Good

Related works: (i) polychrome versions of *Bluecoat Schoolboy* and *Bluecoat Schoolgirl* reliefs, Bluecoat School, Wavertree; (ii) polychrome statuettes of *Bluecoat Schoolboy* and *Bluecoat Schoolgirl*, half-life-size, yellow pine and mahogany, Bluecoat School, Wavertree.

Tyson Smith completed the Bluecoat Chambers reliefs and inscription plaque in 1951. A studio account book for the period includes a costing for work on the Bluecoat Chambers, dated '24. 1. 51', which mentions, amongst other items, an 'inscription panel'. On a separate sheet of paper of the same date is a reference to stone 'side panels' and with it a sketch of the final arrangement of two relief panels either side of the inscription panel (George Herbert Tyson Smith Archive).

(c) Over the main entrance, set within an open-topped segmental pediment, is a *Cartouche Bearing A Liver Bird* in relief, mounted on a pedestal and surmounted by a cherub head.

Sculptor: George Herbert Tyson Smith

Cartouche in artificial stone with a gilded Liver Bird

Inscription, carved into a Westmorland greenstone plaque, and gilded, to the right of the main entrance: THE RESTORED CARTOUCHE ABOVE THIS / DOOR WAS DESIGNED AND EXECUTED BY / HERBERT TYSON SMITH FOR THE BLUECOAT / BROTHERLY SOCIETY AS A

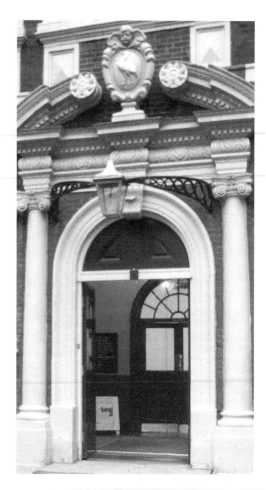

GIFT TO THE / PRESENT OWNERS OF THE BUILDING, THE / BLUECOAT SOCIETY OF ARTS ...[1965]

Condition: Good

Literature: (i) LRO manuscript sources: George Herbert Tyson Smith Archive, Boxes 12, 13, 18, 25. (ii) Brack, A. (1965): 48-51; Pevsner, N. (1969): 161-62; Poole, S.J. (1994): 367, 445; Willett, J. (1967): 59, 83.

Sefton Park

Memorial to William Rathbone the fifth (1787–1868). Born in Liverpool, he succeeded his father as head of the family company trading with the Americas. In a predominantly Conservative Liverpool, he was a staunch Liberal. He strove for parliamentary and municipal reform and after the passing of the Municipal Reform Act, was honoured with a public presentation for his services. As Mayor of Liverpool 1837-38, he laid the foundation stone of St George's Hall. In 1846-47, he was in charge of the distribution of Irish famine relief contributed by the New England states. He was a consistent advocate of Roman Catholic emancipation, a keen educationalist, and one of the founders of the Liverpool Mechanics' Institute (sources: *DNB; MEB*).

Sculptors: John Henry Foley and (Sir) Thomas Brock

Statue in Sicilian marble
Reliefs in bronze
Steps and lower part of pedestal in Cornish granite
Upper part of pedestal and cornice in Aberdeen granite

Bronze founder: Cox & Sons of Thames Ditton

h. overall: 24' 6" (7.5m)
h. of statue: 9' 6" (2.9m)
Bronze relief panels: 37½" × 33" (95 × 84cms)

Inscription on the bronze plaque at the rear of the pedestal: WILLIAM RATHBONE / BORN 1788 / DIED 1868

Signed by the sculptors:
– on the rear face of the marble base of the statue: J. H. FOLEY R. A. SC.
– on each bronze relief at the bottom left of the frame: T BROCK / SC. 1876
Signed by the founder on each bronze relief at the bottom right of the frame: COX & SONS FOUNDERS

Exhibited: Royal Academy of Arts 1877: *Commerce* (cat. 1445); *Charity* (cat. 1447); Royal Academy of Arts 1878: *Education* (cat. 1415)

Unveiled by James Aikin, Chairman of the Memorial Committee, Monday, 1 January 1877

Owner/ custodian: Liverpool City Council
Listed status: Grade II

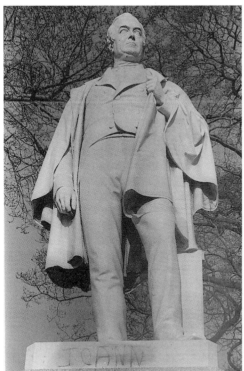

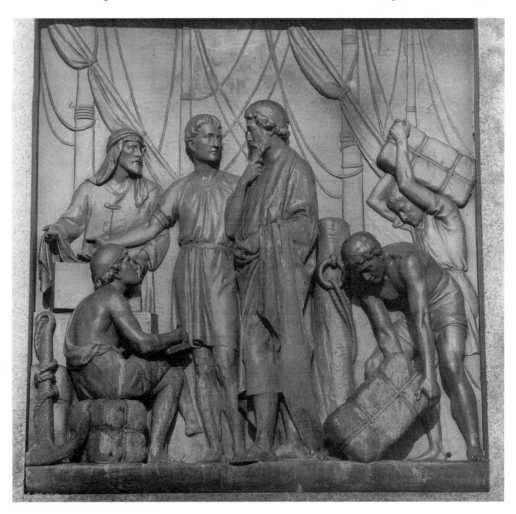

figures are portrayed in antique and oriental costume, on board a sailing ship, masts and rigging forming the background. A merchant in the centre strokes his beard thoughtfully as a young man directs his attention to some cloth which an arab trader at the extreme left is lifting from a box for his perusal. In front of the box, sitting on a bale, sits another young man looking up at the potential buyer, his ledger on his knee, pen poised to write. To the right of the central figure of the merchant are two porters, one bending forward to lift a bale, the other behind him carrying a bale upon his back.

On the left face of the pedestal was

Description: The memorial is located near the Palm House overlooking the lake. A flight of three steps leads up to a high pedestal surmounted by a statue of Rathbone, standing before an ornamental pedestal. Rathbone is represented in confident stance, his head erect, looking directly ahead. He wears a suit and a loose cape, the lapel of which is grasped firmly in his left hand. His right hand is relaxed against his weight-bearing right leg, whilst his left leg, flexed at the knee, is placed slightly forward.

Set into the left, front and right faces of the pedestal were bronze relief plaques, now removed (the rear plaque bearing the inscription). On the front face was *Commerce*. The

Education. In the centre of the relief a child stands between the knees of a young seated woman who leans forward, her right arm resting on the child's shoulder, her left hand pointing along the lines of a book held by the child. Behind the child is a terrestrial globe resting upon a pile of books. At the right, behind the seated woman, stands a young man, his back to the viewer, reading from a scroll unrolled in his hands. At the left two young men read from a book. The young man on the extreme left holds the book in his left hand, whilst his right hand is poised above the page, perhaps demonstrating a point to his companion who, with his right hand resting on the shoulder of the first, looks attentively at the page. The figures are portrayed in antique dress.

On the right face of the pedestal was *Charity*. Left of centre stands a bearded man who offers a loaf of bread to a woman who kneels at his feet, her left hand holding a baby at her breast, her right arm (now missing) presumably once extended to take the donation. A young boy to the right of the donor stands, looking at the supplicant and holding a basket containing more loaves. To the left of the kneeling woman are a man bowed with age and supporting himself with a staff and holding the hand of a young boy who looks away to his right, and a woman, her head covered by a mantle, holding a baby to her shoulder. Again, the figures are portrayed in antique dress.

Condition: The pedestal has extensive graffiti. The granite at the corners of each of the recessed panels is damaged where in June 1987 vandals attempted to remove or, in one case, were successful in removing, the bronze reliefs then set into them. The lost relief, *Education*, has not, as yet, been recovered; the other two, *Commerce* and *Charity*, are now in store. The

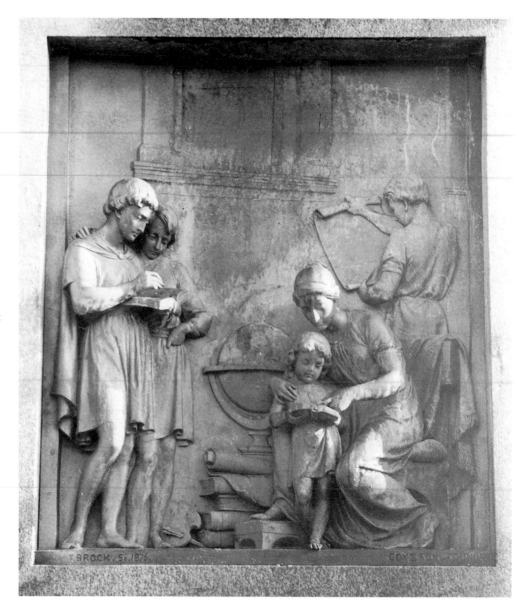

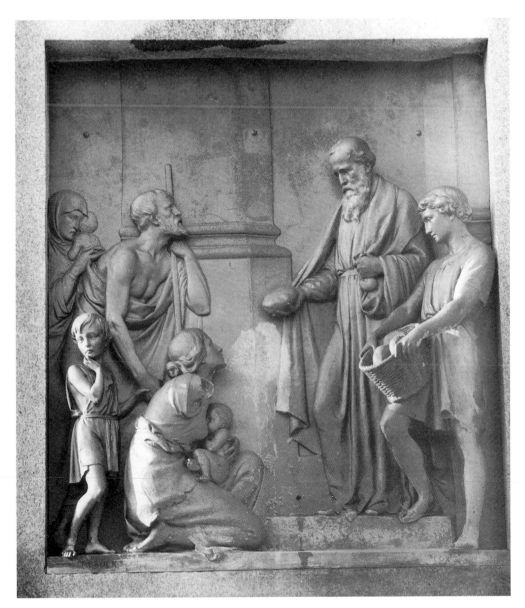

head of the porter lifting the bale in *Commerce* has been severed, as has the right arm of the mother receiving bread in *Charity*. Additionally, the surfaces of these remaining reliefs are pitted with small holes. The marble statue, not surprisingly given its exposed location, appears to be somewhat weathered.

On 17 February 1864 the Mayor of Liverpool, Charles Mozley, issued a letter to the town councillors, calling a meeting for 23 February to discuss how the town might express to William Rathbone the respect and esteem in which he was held 'by all classes of the community'. The councillors duly met and unanimously agreed that some form of memorial would indeed be fit and proper, and resolved to adjourn till the 27th to give the matter full consideration (*Special and Sub Committees Minutes*). In the meantime, however, Rathbone had heard of their intentions and wrote to the Mayor, thanking him and his fellows for their kind thoughts, but pleading with them to drop the matter. His letter would suggest that he considered the erection of a statue to be money misspent and the foundation of a useful institution needless of such an excuse as his commemoration. Reluctantly, his friends yielded to his wishes (*Special and Sub Committees Minutes*).

Nevertheless, when almost exactly four years later Rathbone died, some sort of public commemoration became inevitable. James Aikin called a meeting of Rathbone's friends and together they discussed not whether, but how they were to commemorate him. They agreed, after a very short discussion, that his memorial should take the form of a full-length statue and that it must be 'executed by the best living artist'. The suggested location, at this stage, was St George's Hall (*Mercury*, 2 January 1877).

In order to expedite matters they appointed a deputation to approach the then Mayor, Edward Whitley. The Mayor agreed to convene a public meeting at the Town Hall on Monday, 10 February 1868. At the meeting, attended by about two hundred of Liverpool's leading citizens, it was resolved that a Committee be appointed for receiving subscriptions. Even the smallest amount would be welcome, but there would be a maximum for each individual contribution of ten guineas. The Committee would be authorised to decide on the most appropriate form of commemoration (*Mercury*, 2 January 1877).

James Aikin was appointed Chairman of the Rathbone Memorial Committee and amongst its 107 illustrious members were S. R. Graves, Charles Turner, John Laird, Robertson Gladstone, Hardman Earle, John Torr, Joseph Hubback, James Allanson Picton, William Preston and George Holt (*The Porcupine*, 29 February 1868). By 23 May 1868, the sum of £2,980. 0s. 1d. had been received and it was confirmed that a monument with a portrait statue would be commissioned and a smaller Executive Committee appointed to supervise its execution (*Mercury*, 2 January 1877).

Even though the amount subscribed was generous, some surprise was expressed that the working classes for whom Rathbone had done so much had 'not in any way responded' to the appeal, particularly as there had been no lower limit imposed upon individual contributions. On the evidence of the affronted tenor of the two letters 'from working men' published in *The Porcupine* (14 March 1868, quoted in Read, 1989: 38), it would seem that ingratitude had been proposed as a likely explanation for this lack of response. It was not ingratitude, the writers insisted – there quite simply had been no provision made for the working classes to

contribute. The Memorial Committee had failed to consider the pride of working class people, embarrassed by the relative meagreness of their individual contributions and daunted by the prospect of personally entering the Town Hall or the offices of the Memorial Committee in Castle Street – offices from which they would normally be excluded – to make such contributions. Furthermore, some were simply too busy working long hours to provide for their families to take the time off from work: the suggestion was proffered by one of the correspondents that 'the workshops' be organised to make group collections so that all would be given 'a chance of showing their love for a good man'. (Given that the unveiling was attended by 'rich and poor, in numbers unequalled', according to the *Mercury*, 2 January 1877, one can only assume that steps were subsequently taken to redress this situation).

By 10 June 1868, Sefton Park had been agreed upon as the location for the memorial in deference to the Rathbone family's wish that it be sited in a location more public than St George's Hall and as close as possible to the family home at Greenbank. The choice of Sicilian marble for the statue, instead of the more usual and, for an outdoor setting, more practical, bronze, was also theirs. In order to mitigate the harmful effects of the weather on the marble, however, it was proposed that a canopy be erected over the statue, though this does not seem to have ever been constructed (*Mercury*, 3 December 1874).

On 3 July 1868, it was resolved to offer the commission to John Henry Foley, by far the most celebrated sculptor of his generation in Britain. Foley accepted, but advised the Memorial Committee that owing to his heavy workload he would not be able to complete

within the three years specified. In deference to Foley's reputation, the Committee agreed to an extension. The Rathbone family paid for the sculptor's materials and made available to him portrait medallions, busts and other necessary information in order that the likeness be as accurate as possible (*Mercury*, 2 January 1877; quoted in Read, 1989: 38).

Foley's workload and later his declining health extended the subscribers' wait for completion and it was not until 30 November 1875 that the Committee felt itself to be in a position to make a formal request to the Council for a specific site in Sefton Park (*Council Minutes*). The Council duly referred the matter to the Parks, Gardens and Improvement Committee which, on 5 January 1876, officially granted to the Memorial Committee 'the open space on the headland at the North end of the Lake' (*Council Minutes*).

Foley finished only the plaster model for the statue before he fell ill with pleurisy and died. With the approval of the Committee, Thomas Brock (Foley's assistant) completed the memorial and is responsible for the design of the pedestal and the bronze reliefs (*Mercury*, 2 January 1877).

Literature: LRO (a) manuscript sources: *Council Minutes*, 1/20: 38-9, 76; *Special and Sub-Committees Minutes*, 1/3: 414-24. (b) newscuttings: *Daily Post* (1876) 30 December, in *TCN 1/12*; *Mercury* (1874) 3 December, in *TCN 1/10*; *Mercury* (1876) 19 December, in *TCN 1/12*; *Mercury* (1876) 30 December, in *TCN 1/12*; *Mercury* (1877) 2 January, in *TCN 1/12*.
(ii) WAG JCS files newscutting: *Daily Post* (1987) 26 June.
(iii) *Art-Journal* (1869): 258; *Art-Journal* (1874): 20; *Art-Journal* (1877): 87; Picton, J.A. (1875, revised edn 1903) ii: 267-68, 493; *Porcupine* (1868) 29 February: 479; *Porcupine* (1868) 14 March: 493; Read, B., 'From Basilica to Walhalla', in P. Curtis (ed.) (1989): 38.

Memorial to the Right Honourable Samuel Smith

(1836–1906), philanthropist, Liberal politician and staunch presbyterian. Born in Kirkcudbright, he was educated at Edinburgh University and in 1853 was apprenticed to a Liverpool cotton-broker, becoming manager of the cotton sale-room in 1857. He travelled to the USA and India on business in the early 1860s, his visit to India engendering a life-long concern for the well-being of its people. At home he interested himself in child welfare and was an ardent proponent of temperance reform. In 1876 he became President of the Liverpool Chamber of Commerce and in 1882-85 was Liberal M.P. for Liverpool. He revisited India in 1886 and 1904-05 and died there in 1906 (source: *DNB supplement 1901-11*).

Architects: William Edward Willink and Philip Coldwell Thicknesse
Sculptor: Charles John Allen

Obelisk and pedestal in red granite
Four panels in bronze

Bronze founder: A.B. Burton of Thames Ditton
Stonework contractor: Kirkpatrick Bros of Trafford Park, Manchester.

h. of obelisk: 60' (18.3m)
Area of base: 7' 9½" × 7' 9½" (2.37 × 2.37m)

Inscriptions on the pedestal:
– on the left face of the plinth: WHOSOEVER DRINKETH OF THIS WATER SHALL THIRST / AGAIN: BUT WHOSOEVER DRINKETH OF THE WATER / THAT I SHALL GIVE HIM SHALL NEVER THIRST (repeated on the right face of the plinth)
– on a bronze plaque formerly set into the rear face of the dado: SAMUEL SMITH / BORN AT BORGUE KIRKCUDBRIGHT / 4TH. JANUARY 1836 / DIED AT CALCUTTA / 28TH. DECEMBER 1906 / MERCHANT OF LIVERPOOL / MEMBER OF PARLIAMENT FOR / LIVERPOOL 1882 TO 1885 / AND FOR FLINTSHIRE 1886 TO 1906 / PRIVY COUNCILLOR 1906 / CHRISTIAN PHILANTHROPIST AND / SOCIAL REFORMER / A FRIEND OF INDIA / "Them that honour ME, I will honour" / ERECTED BY PUBLIC SUBSCRIPTION

Signed by the sculptor on the lower edge of the relief panel formerly on the right face of the pedestal: C. J. ALLEN SC.

Unveiled by H. Chaloner Dowdall, Lord Mayor of Liverpool, Friday 21 May 1909.

Owner/ custodian: Liverpool City Council
Listed status: Grade II

Description: Located near the north-west (Sefton Park Road) entrance to the park, the memorial is essentially a drinking fountain in the form of an obelisk raised upon a pedestal. From the ground a flight of three shallow steps leads up on each side to the square base of the monument which is formed of three courses of granite blocks, the lower two rusticated, the uppermost course dressed but unpolished (as is the pedestal and obelisk above). From the left and right sides of the base semi-cylindrical basins project.

The pedestal mounted upon this base formerly had a recessed bronze relief set into each face. Each was cast in the form of a rectangle with a smaller extension at the top. The panel set into the front face of the pedestal (now in store) contains a head-and-shoulders full-face portrait of Smith encircled by an oval of laurel leaves and, outside the oval, a rose motif at each corner. Smith is portrayed in contemporary dress and sports a full beard.

The descriptions of the two following panels,

 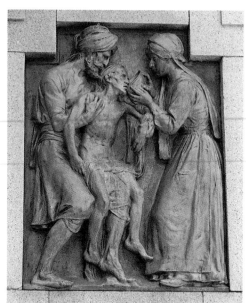 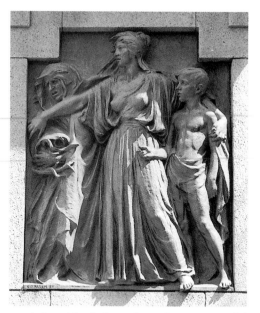

stolen in 1987, are taken from surviving photographs: the panel set into the left face of the pedestal, *Indian Famine Relief*, shows a nurse giving water to an emaciated youth who is lifted up by a turbanned man who crouches slightly to take his weight against his lap, one hand under the youth's right armpit and the other holding his left forearm to steady him. On the right face of the pedestal was originally *Virtue Thrusting Evil from the Path of Youth*. As befits their status as allegories, the figures are in generalised classical dress. The central figure, *Virtue*, dominates the panel. Attired in a long, deeply modelled gown, girdled at the waist, she stretches her right arm forward to push back *Evil*, a cowled hag carrying a basket of serpents. She puts her left arm protectively around the shoulders of *Youth*, a young boy dressed only in a loin-cloth. *Virtue* and *Youth* look past the hag, their poses harmoniously

rhyming, their left legs in step, the toes of their left feet protruding over the bottom edge of the panel. The rear panel, currently in store, carries the inscription.

Resting upon the pedestal and encircling the bottom of the obelisk is a bronze collar consisting on each side of a scallop shell linked by garlands to corner consoles topped by palmettes.

Condition: Extensively vandalized. The pedestal has some grafitti and all four bronze panels have been removed. The Council removed the inscription plaque and the portrait relief in June 1987 immediately following the theft of the relief panels of *Indian Famine Relief* and *Virtue Thrusting Evil from the Path of Youth*. (The *Education* panel from the *Rathbone Monument* was stolen at the same time. See above p. 188.) The remaining inscription plaque and portait panel (in store, as indi-

cated above) both show signs of an unsuccessful attempt at removal, the bottom right-hand corners of each being bent forwards slightly. The fountain is no longer in working order.

On 10 May 1907, Oliver Jones, Honorary Secretary of the Samuel Smith Memorial Committee, wrote to the Corporation Parks Committee requesting a site for the proposed obelisk within Sefton Park, either at the Croxteth Gate or Lodge Lane entrance (*Parks Committee Minutes*). The recommendation of the Parks Committee that the Croxteth Gate site be allocated was rejected by the Council on 5 June and the Parks Committee was asked to reconsider (*Council Minutes*). Evidently the allocation of either site was problematic as each necessitated extensive alterations to the surrounding area but, following a resubmission on 31 July 1907, the Council approved the alternative site at the Lodge Lane entrance

(*Council Minutes*).

Although the Memorial Committee believed this site to be acceptable, the architects evidently did not. The space was occupied by a circular shrubbery, eighty feet in diameter, consisting of established lime trees and hollies. Presumably the Parks Committee was not willing to remove all of these plants merely to accommodate the obelisk and the architects believed their monument should command a clear view. Whatever the reason, on 25 September 1907, the Parks Committee received a new submission from the architect, William Edward Willink, (with the approval of the Memorial Committee) and the Parks Committee agreed that the only way to settle the matter was to actually go to the site and inspect it (*Parks Committee Minutes*). This new proposal, to place the obelisk slightly further into the park at the head of the Long Walk (but still near the Lodge lane entrance), was approved by the Parks Committee and confirmed by the Council on 23 October 1907 (*Council Minutes*).

Early in 1908, the Memorial Committee became concerned that the subscription would not reach the required amount and Oliver Jones was compelled to make two requests to the Corporation for financial assistance with incidental expenses. The first, on 6 March 1908, was to the Finance Committee to ascertain whether the Corporation would bear the cost of putting in the foundations (*Finance Committee Minutes*). Fortunately this was not a problem for, as the Corporation Surveyor, Thomas Shelmerdine, explained to the Finance Committee in his report on 20 March, the Corporation usually bore that cost anyway. The Finance Committee therefore honoured its traditional obligation and approved the memorial architects' estimate of £75 for the job as a

maximum (*Finance Committee Minutes*).

The second request, in a letter dated 26 February 1908, was considered by the Parks Committee on 25 March. Jones revealed that the target of £1,730 for the memorial was short by £279 and asked the Committee if the Corporation would agree to pay £191 towards incidental expenses incurred by the necessary alterations to the area of the park around the obelisk (*Parks Committee Minutes*).

It would appear that this second request was ultimately rendered unnecessary, since the subscription evidently reached its target. In his speech at the unveiling ceremony Jones quoted a final expenditure greater than his estimate of 26 February 1908, stating that

the total cost of the memorial was £1,850. The Corporation had given £75 towards the building of the foundations, and the balance had been fully subscribed, so that [the Memorial Committee] were enabled to unveil the memorial free of all debt (*Daily Post and Mercury*, 22 May 1909).

Finally, on 24 November 1909, Jones informed the Corporation (who, having formally accepted the memorial at the unveiling ceremony, was now officially responsible for its care and maintenance) that the Memorial Committee had taken the decision 'to insure the Memorial against damage by lightning in the sum of £1,800 in perpetuity, on payment of a single premium of £25' paid out of its own resources. The grateful Parks Committee conveyed their 'best thanks' to the Memorial Committee for 'effecting this insurance on behalf of the Corporation' (*Parks Committee Minutes*).

Literature: (i) LRO (a) manuscript sources: *Council Minutes*, 1/45: 430, 493, 600; *Finance Committee Minutes*, 1/57: 822; *Finance Committee Minutes*, 1/58:

7-8; *Parks Committee Minutes*, 1/24: 504, 531-32; *Parks Committee Minutes*, 1/25: 18, 57, 65, 166, 545.
(b) newscuttings: *Courier* (1909) 21 May, in *TCN* 1/35; *Daily Post and Mercury* (1909) 22 May, in *TCN* 1/35.
(ii) WAG JCS files newscutting: *Daily Post* (1987) 26 June.
(iii) *Studio* (1909) xlvii: 302.

Peter Pan

Sculptor: Sir George Frampton

Sculpture in bronze

h: 120" (304.8cms)
– base: 50" × 50" (127 × 127cms)

Signed: GEO: FRAMPTON. R.A.

Unveiled Saturday 16 June 1928

Owner/ custodian: Liverpool City Council
Listed status: Grade II

Exhibited: Royal Academy of Arts 1911 (cat. 1960): the plaster model for the Kensington Gardens *Peter Pan*, of which the present sculpture is a replica (illustrated in *The Studio*, vol liii, p. 18; fragments in London, Victoria and Albert Museum, see below); WAG Liverpool Autumn Exhibition 1919 (cat. 1583): *Peter Pan* bronze statuette; The Fine Art Society Ltd, *British Sculpture 1850 – 1914*, (exhibition 30 September – 30 October 1968, cat. 51): *Peter Pan* bronze statuette, originally contributed by the artist to a Red Cross sale in 1918; at the time of the exhibition in the collection of W.E. Bridge.

Description: Peter Pan stands barefoot at the summit of a tree stump alive with rabbits, mice, a lizard, a frog, a snail and a squirrel. Fairy folk, represented as mature young women, some with wings, emerge from the tree, a number appearing to metamorphose from the very

substance of the wood itself. Frampton has also modelled some appropriately named Dryads' Saddles (*Polyporus squamosus*), growing from the bark in various places. Near the top of the stump is Wendy, standing on tiptoes and leaning forward to look up at Peter. Peter, dressed in a short tunic, appears to preside over the characters below him. With his lips pursed, he turns his head to his left to play the triple pipes once held in his left hand, but now missing. His right arm is raised in front of him and is balanced by the forward placing of his left foot, which, combined with the contrary turn of his shoulders and head, gives him a dance-like pose.

Condition: Extensively vandalised. The heads of two of the fairies have been severed, and the upper of these has a bent index finger and is minus a thumb. A squirrel, formerly addressed by two other fairies, has been completely removed. The triple pipes are missing, having repeatedly been removed over the years: the first recorded incidents being in August 1935, when twice within two weeks the pipes were broken off, on the first occasion being retrieved from the adjacent shrubbery, the second time from the lake (unattributed newscutting, dated 20 August 1935 in LRO *Sefton Park Newscuttings*). On the second occasion they were brazed back on, but are now permanently missing. There are several other small losses and much graffiti.

Related works: (i) fragments from the original plaster model for the Kensington Gardens *Peter Pan*, London, Victoria and Albert Museum: head of Peter Pan (cat. A5-1991), right arm (cat. A6-1991) and left arm (cat. A7-1991) of Peter Pan, pipes (cat. A8-1991; broken), heads of fairies (cats. A9-1991, A10-1991, A11-1991); (ii) original bronze cast, Kensington Gardens,

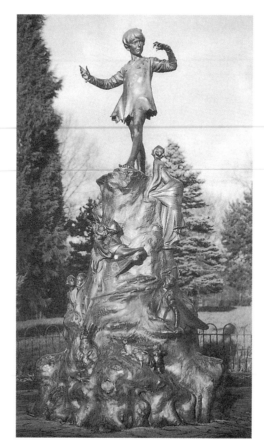

London, installed 1912; (iii) replicas: Bowring Park, St John's, Newfoundland (unveiled 1925); others at Camden, New Jersey; and Brussels; (iv) reduced versions: bronze statuette on a brown striated marble base, figure 19" (48cms), base 1¹/₂" (4.5cms), signed and dated G.F. 1915, also initialed P.P. within a circle, current location unknown (source: photocopied page from unattributed sale room guide, WAG JCS files); bronze statuette (dimensions not given), 'contributed by the artist to a Red Cross sale in

1918', collection of W.E. Bridge, Esq., as at 1968 (*Fine Art Society Ltd*, 1968).

Frampton's original *Peter Pan*, commissioned as a gift to the public from the subject's literary creator, J.M. Barrie, was unveiled in Kensington Gardens in 1912 (Stevens, 1989: 84). The model for the figure of *Peter Pan* was Nina Boucicault, the actress who played the part in the original stage adaption of Barrie's story, 'The Little White Bird' (Gray, 1985: 183).

The replica for Sefton Park, one of Frampton's last works, was commissioned by George Audley of Southport. In the spring of 1927, Audley had visited Frampton's studio with a deputation from the Liverpool Arts Committee in connection with the Liverpool Autumn Exhibition and had seen there the original cast of *Peter Pan*. He thereupon conceived the idea of commissioning a replica for Sefton Park as a gift to the children of Liverpool and managed to persuade Frampton to execute it (unattributed newscutting: Frampton obituary, dated 22 May 1928, WAG JCS files).

Although Frampton completed the work, he died on 21 May 1928, just four weeks before the unveiling. The ceremony, attended not just by the Lord Mayor of Liverpool and the usual civic dignitaries, but also by crowds of children, was followed by a pageant which proved so popular that repeat performances were held for those unable to gain admission the first time.

Literature: (i) LRO newscuttings *Daily Post and Mercury* (1928) 18 June, in *CH&T 1928*; various newscuttings in *SPN*: 30, 32.

(ii) Fine Art Society Ltd (1968): 23 – 24; Gray, A.S. (1985): 183; Stevens, T., 'George Frampton', in P. Curtis (ed.) (1989): 84; *Studio* (1911) liii: 18,19.

Eros Fountain

Sculptor: Sir Alfred Gilbert

Fountain in bronze
Figure of *Eros* in aluminium (approx. 95%
aluminium, with traces of other metals)

Bronze founder: A.B. Burton of Thames Ditton

Fountain: h: 432" (1097cms);
diameter of octagonal basin: 204" (518cms)
h. of figure of *Eros*: 74" (188cms)

Inscription (very worn) on a small plaque fixed
to the south-east face of fountain: THIS FOUN-
TAIN IS A REPLICA / OF THE / SHAFTESBURY
MEMORIAL FOUNTAIN / ...BY / SIR ALFRED
GILBERT..., (remainder too worn to be legible)

Founder's name on the base of the west face:
A. B. BURTON / FOUNDER

Unveiled by Alderman J.C. Cross, Lord Mayor
of Liverpool, Saturday 23 July 1932

Owner/ custodian: Liverpool City Council
Listed status: Grade II

Description: The Sefton Park *Eros Fountain* is a
replica of Gilbert's *Memorial to Anthony
Ashley-Cooper, Earl of Shaftesbury*, executed
for Piccadilly Circus, London, in 1886-93. The
lowest stage is a shallow octagonal basin of pot-
bellied profile, decorated at the eight corners
with mouldings in the shape of childlike
helmeted figures, each with a pair of fantastic
fish, which perform the function of console
brackets for the little dishes that once held the
chained drinking cups above them. From the
centre of the basin rises a pedestal, whose undu-
lating profile echoes that of the basin below.
The plinth course of the pedestal is decorated at
each corner with a pair of sleeping baby heads.
With each stage the forms become increasingly

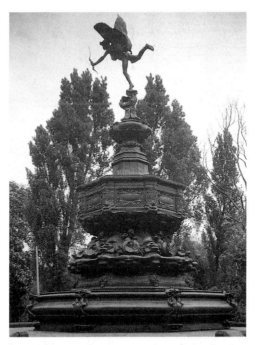

less architectural, more organic, culminating in
the series of eight smaller basins which form a
kind of 'molten' cornice to the pedestal. Above
each basin a helmeted merbaby grasps the tail of
a large writhing fish in his left hand and a
smaller fish in his right; each merbaby/fish
group separated by deliquescent shell/web/rock
forms which are topped by the screaming head
of another helmeted baby. Architectural form
returns with the great octagonal cistern above,
each face and each rounded corner decorated
with a blank cartouche, the vestiges of the
narrative panels originally requested by the
London Shaftesbury Memorial Committee.
Above the cistern rises the vertical sequence of
pedestal, urn, and *Eros*, only the ball of Eros's
left foot making contact with his nautilus-
shaped perch, his right leg sweeping out behind

him as he hurls himself forward to release an
arrow from his bow. Gilbert has here taken full
advantage of the lightness and tensile strength
of aluminium – such an extreme dispacement of
the figure's centre of gravity could not have
been sustained by one slender ankle had bronze
been used. Although always known as *Eros*, the
Greek god of carnal love, Gilbert was quite
adamant that the figure represented (more
appropriately) his twin brother *Anteros*, the god
of selfless, philanthropic love. The model for
the figure was Angelo Colorossi, general assis-
tant in Gilbert's studio and son of a leading
model of the previous generation who had
posed for, among others, Burne-Jones and
Millais (Dorment, 1985: 111).

Condition: At the time of writing (early 1994),
the figure of *Eros* is in store, undergoing
conservation. It is intended that a replica figure
(100% aluminium) will be installed on the
fountain in summer 1996 and the original
placed on public display in the new NMGM
Conservation Centre at Victoria Street (the
former Midland Railway Goods Station).

The fountain has at some time been coated in
gold paint. The joins in the bronze show
through as cracks: the horizontal circumferen-
tial join above the heads of the boys holding
fishes being the most noticable. A vertical seam
has also become visible on the west-south-west
corner. The surface of the metal is stippled with
holes, but the body of the fountain appears to
be in generally fair condition.

Related works: *Shaftesbury Memorial*, bronze
and aluminium, Piccadilly Circus, London,
1886-93; *Model for the Cistern of the
Shaftesbury Memorial*, wood and plaster, h. 9"
(22.9cms), c.1890, Royal Academy of Arts;
Model for the Shaftesbury Memorial, wood and
plaster, h. 18½" (47cms), c.1891, Museum and

Art Gallery, Perth; *Eros*, first bronze casting (1925) from first sketch of 1891, h. 24" (60.9cms), Tate Gallery (cat. 4176); *Eros*, second bronze casting (1925) from first sketch of 1891, h. 24" (60.9cms), Royal Academy of Arts.

Following the death of Lord Shaftesbury in 1885, a Shaftesbury Memorial Committee was formed and took the decision to raise two monuments. One, a marble statue for Westminster Abbey went to Joseph Edgar Boehm and, on his advice, the second, which was originally intended to be a straightforward portrait statue for an unspecified outdoor location in London, went to Boehm's former pupil, Alfred Gilbert (Dorment, 1986: 135). According to Gilbert's own account, Boehm had (accurately) warned the Committee not to expect Gilbert to agree to produce a conventional portrait statue. Additionally Gilbert stated that when approached by the Committee he had audaciously informed them 'I can't undertake the statue of Lord Shaftesbury; I prefer something that will symbolise his life's work' (McAllister, 1929: 104). Nonetheless, the Committee offered Gilbert the commission and eventually agreed to most of his ideas. The fountain form had been evolved by Gilbert and accepted by the Committee by 1888, but the location, Piccadilly Circus, was not settled until 1890. Consequently, not knowing whether his monument had to fit into a square or a circus, Gilbert produced an octagonal form which was intended to be adaptable to either (Dorment, 1985: 101). Gilbert even managed to dispense with the narrative reliefs originally suggested by the Committee and there is reason to believe that Gilbert's ideas were so fluid all through the years of his work on the commission that the Committee members themselves were not sure of the eventual appearance of the fountain until

it was unveiled on 29 June 1893. Nevertheless, Gilbert did not have it all his own way and the commission caused him much grief and a substantial amount of his own money (Dorment, 1986: 136).

The form of the fountain as it now stands is less grandiose than Gilbert had planned. The basin was originally intended to be much larger, but the London County Council informed Gilbert that it would form an obstruction in the busy thoroughfare and he was instructed to reduce its size. This, in turn, meant that some of the water-jets had to be suppressed and others made so small that there was a consequent weakening of the overall effect (Dorment, 1986: 136). To make matters worse, Gilbert's fountain was clearly not suited to the busy, heavily built-up and untidy triangle (i.e. neither circus nor square) in which it was sited.

The fact that Gilbert had not produced a conventional portrait monument to Lord Shaftesbury had the fortunate side-effect that the fountain was easily adaptable to a different setting and for a different purpose. Regardless of its faults as a functioning fountain in a London street, and despite its disastrous critical reception, it very soon came to be regarded warmly by the public and is now one of the most familiar of London's landmarks. It obviously appealed to George Audley of Liverpool, since he chose to commission a replica from Gilbert for Sefton Park, the setting of his earlier gift to the children of Liverpool, George Frampton's *Peter Pan* (see above, pp. 193–4). The commission was apparently engineered by the indefatigable secretary of Gilbert's later years, Isabel McAllister (Dorment, 1985: 315).

The *Daily Post* for 7 January 1932 announced that the Sefton Park *Eros* was to be, unlike the London version, 'in the form the sculptor intended in his original design'. What

the paper meant by this was that the jets of water that Gilbert had planned to have playing around the figure of *Eros* and which had been vetoed by the London County Council to save on water bills and to avoid drenching passers-by in the bustling London thoroughfare, were to be re-introduced for the Sefton Park replica. Gilbert certainly suggests an effect such as this when he describes to Joseph Hatton in 1903, his original intention for a glistening figure of *Eros*, bathed in 'jets of varied shapes and forms upwards, inwards, downwards and crossways (as quoted in Dorment, 1985: 111), although despite the paper's optimism, the Sefton Park fountain seems not ultimately to have been set up in this way as is attested by the photograph of the unveiling ceremony in the paper's edition for 25 July 1932, in which there is a notable absence of water jets anywhere.

Nevertheless, the delicate, intricate form of the fountain suits its parkland surroundings which, remote from the bustling traffic of a main urban thoroughfare, also facilitate the sort of lingering examination from close quarters the fountain invites. Gilbert himself, in his speech at the unveiling ceremony, expressed his pleasure at the Sefton Park setting (WAG JCS files; specific source not given), although he was by now presumably long past the age when he could have taken advantage of the more open location by increasing the dimensions of the lower basin to the size intended in his original plans. Audley paid £10,000 for the fountain but sadly died a few months before the unveiling.

Literature: (i) LRO newscuttings: *Daily Post and Mercury* (1932) 7 January; 20 January; 9 February; 25 July; *Evening Express* (1932) 15 April, in *SPN*.
(ii) Beattie, S. (1983): 217 – 18; Bury, A. (1954): 38, 83-4; Curtis, P. (1988): 64; *Daily Post* (1932) 25 July: 5; Dorment, R. (1985): 315; Dorment, R. (ed.) (1986): 40, 135–43; Gray, A. S. (1985): 191; McAllister, I. (1929): 103–13; Victoria & Albert Museum (1936): 19.

THE PALM HOUSE, designed and built by McKenzie and Moncur in 1896 for Henry Yates Thompson as a gift to the City of Liverpool. The Palm House is octagonal with an entrance at each cardinal point of the compass.

I. EXTERIOR

At each of the eight corners, a granite pedestal projects from the base of the building. The eight statues for which these pedestals were designed are currently in store, awaiting the restoration of the Palm House. Four of the statues are in bronze and four in marble. All statues by Leon-Joseph Chavalliaud

Owner/ custodian: Liverpool City Council

Listed status: Grade II*

In a speech delivered on the occasion of his becoming a freeman of the City of Liverpool on 17 October 1901, Henry Yates Thompson explained the 'principle upon which [he] had acted' in regard to the gifts he had bestowed upon the people of Liverpool. After explaining that it had been his wish to do something good for the people, and thanking the successive Lord Mayors for their unstinting support in executing his scheme, he moved on to the subject of the specific statues he had selected, how they and their inscriptions had been completely his choice and the reasons behind his selection:

> All towns have statues – public statues; but, as far as I know, they are generally confined to statues of kings and queens, such as George III and Queen Victoria here; or admirals and generals, such as Nelson and Wellington here; or local worthies. In thinking over the Liverpool statues – I dare say my recollection is not quite complete – I can only think of Lord Beaconsfield, Michael Angelo, and Raphael, who do not come into those categories. In my little building at Sefton Park I endeavoured to make a sort of Valhalla to those not included in these categories; and endeavoured to make the people of Liverpool, and especially the younger people, acquainted with men who were at the head of their profession in various ways, not only in Liverpool or in England, but all the world over. This being a garden park, I thought the first people to be ennobled, as far as I could do it, would be gardeners. The name of the first of these, John Parkinson, is not perhaps very familiar to you. It has not been long familiar to myself, and his statue is really there because your old townsman, Mr. Enoch Harvey, a great gardener himself, told me of his merits, and of the fact that he was the author of the first book in which flowers and plants in a garden were dealt with, not for their medical virtues, but for their beauty and scent. That was the first work of the sort, and I strongly recommend anybody who may have the opportunity to peruse it. Thus I thought that I would put him first in the list of gardeners, and there he stands in the Elizabethan costume – he was apothecary to James I – and the sculptor, being eminently practical, has also clothed him with an apron to protect his costume from the soil and dust. Well, various other gardeners are there. Andrew Le Notre [sic] is there; and when I was in Paris I saw M. Andre, the man who laid out Sefton Park, and he told me that Le Notre was a gardener-architect, and therefore he is described as such. Having got through the list of gardeners, I thought the explorers should come in – men by whose discoveries of new plants the labour of botanists has been greatly extended. Now, any little Liverpool boy going into the park may find some inspiration in a figure in bronze of the great Captain Cook, clad in the costume of the Navy of a previous century, and may spell out with some edification an inscription which states that James Cook was constantly at sea from his youth, and that he filled every post and every station of a seaman, from an apprentice in the coal trade to post captain in the British Navy. I think that completes what I have to say about the statues, except that one still remains to be added, and perhaps the most important of all, and perhaps the most suggestive of Liverpool. I mean the noble Genoese navigator who discovered America, and who may be said, therefore, to have been the founder of Liverpool in its great development of American trade. His portrait was very difficult to get, not because there were not many portraits, but because none of them resembled the other. My artist has done the best he could, but whether the features are like or not, the attitude is significant, because he is represented looking to the West, with his hands over his eyes, scanning the distant horizon to see if possible that great continent which ought to have borne his name. His motto I shall take, with your permission, from an inscription in Spanish at Seville, which I saw long ago, the translation of which means, "Columbus, o'er the Atlantic main, found a new world for glorious Spain." His bones were recently carried from Havana, where they were refound, to a final and more fitting resting-place in Seville Cathedral, and there, I hope they will no longer be disturbed, because that is the most appropriate final resting-place for them; but I cannot imagine a more appropriate place for his statue than Liverpool. (From an unattributed photocopy in the WAG JCS files)

Starting left of the south entrance, the statues are described in clockwise order around the exterior of the Palm House.

Statue of Charles Darwin

(1809–82), a naturalist, his most famous publication was *On the Origin of Species...* (1859), in which he expounded his theory of evolution

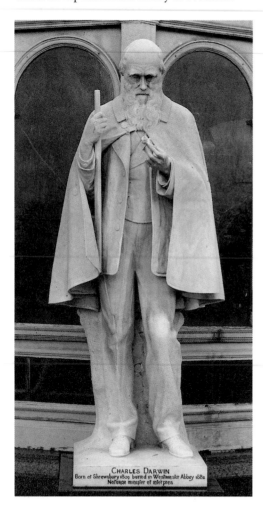

CHARLES DARWIN
Born at Shrewsbury 1809 buried in Westminster Abbey 1882
Naturae minister et interpres

through natural selection. He also published many important works on botany, including: *The Fertilisation of Orchids* (1862), *Different Forms of Flowers* (1877), and *The Power of Movement in Plants* (1880) (source: *DNB*).

Sculptor: Leon-Joseph Chavalliaud

Statue in marble

h. excluding marble base: 79" (201cms)
h. of marble base: 3¹/₂" (9.5cms)
h. of granite pedestal: 48" (122cms)

Inscriptions on the marble base:
– on the front face: CHARLES DARWIN / Born at Shrewsbury 1809 buried in Westminster Abbey 1882 / Naturae minister et interpres
– on the left face: [...illegible; very weathered]
– on the right face: Modelled by L J [...illegible; very weathered]

Listed status: as for building

Description: Darwin, shown in contemporary dress, wears a half-length cape over a three-piece suit. He stands before a tree stump. He is contemplating a flowerbud held in his left hand. His right hand is raised to shoulder height and holds a stick which disappears underneath the lower edge of his cape (perhaps the top half of a walking stick, the lower half of which has broken off). The portrayal of Darwin with bald head, full beard and half-length cape is similar to that in the portrait by John Collier (1883; replica at London, NPG, cat. 1024), although the idea of showing him contemplating the flowerbud may be Chavalliaud's own.

Condition: The index finger and tip of the thumb of the left hand are missing, along with the botanical specimen once held. The stick, held in the right hand, is lost above the hand and below the hem of the cape. The bottom

corner of the cape (the figure's left side) has a triangular piece (7¹/₂") missing and there are chips missing along the hem. There is both black encrustation and green biological staining in places.

Statue of Christopher Columbus

(1451–1506), Genoese-born explorer. He was the first historically important European discoverer of the American continent. His original aim had been to reach India by sailing westwards. His four voyages of 1492-3, 1493-6, 1498-1500 and 1502-04, in effect 'opened the way for European exploration, exploitation and colonization' of the Americas (source: *Encyclopaedia Britannica (micropaedia)*, 15th ed.).

Sculptor: Leon-Joseph Chavalliaud

Statue in bronze

Bronze founder: E. Gruet II of Paris

h. of statue: 79" (201cms)
h. of bronze base: 4¹/₂" (11cms)
h. of pedestal: 48" (122cms)

Inscription on the front face of the bronze base: COLUMBUS
Inscriptions on the pedestal:
– on the front face of the cornice: LAND SIGHTED FRIDAY OCTOBER 12 1492
– on the front face of the dado: A CASTILLA Y A LEON / NUEVO MUNDO DIO COLON / THE DISCOVERER OF AMERICA WAS / THE MAKER OF LIVERPOOL

Unsigned by the sculptor
Signed by the founder on the left face of the base: E. GRUET JNE. FONDEUR. PARIS.

Listed status: as for building

Description: Columbus is shown wearing a hat

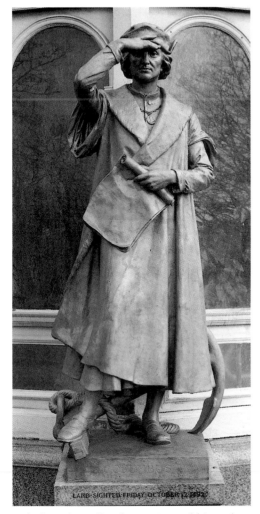

on the shank of a ship's anchor, the rest of which is located behind him.

Condition: The statue seems to be in generally good condition, although it has at some time been painted gold and there is verdigris on the upper surface of the base.

Left of the west entrance:

Statue of Henry the Navigator

(1394–1460) A Portuguese prince, he was the son of Philippa of Lancaster, daughter of John of Gaunt. A patron and sponsor, rather than a navigator, his explorers discovered the Madeira Islands and travelled down the western coast of Africa in an attempt to outflank Islam by establishing a base south of the Sahara, and to secure a gold supply for Portugal (source: *Encyclopaedia Britannica (micropaedia)*, 15th ed.).

Sculptor: Leon-Joseph Chavalliaud

Statue in bronze

h. of statue: 78" (198cms)
h. of bronze base: 4" (10cms)
h. of pedestal: 48" (122cms)

Inscription on the front face of the bronze base:
PRINCE HENRY THE NAVIGATOR
Inscriptions on the cornice of the pedestal:
– front face: BORN AT OPORTO 1394 DIED AT SAGRES 1460 / THE FATHER OF ATLANTIC EXPLORATION / THE PROTECTOR OF THE STUDIES OF PORTUGAL.
– left face: HIS FATHER WAS JOHN I KING OF PORTUGAL / HIS MOTHER WAS PHILIPPA DAUGHTER OF / JOHN OF GAUNT "TIME HONOURED LANCASTER"
– right face: MODELLED BY L CHAVALLIAUD / AFTER THE STATUE AT BELEM / MESS<u>RS</u> FARMER & BRINDLEY 1898.

Signed and dated on the raised mound beneath the figure's left foot:
L. Chavalliaud / London 98

Listed status: as for building

Description: Henry is shown sporting a full beard. He is bareheaded, but wears a suit of armour over which is a tunic decorated with castles, fleurs-de-lys and shield motifs bearing a

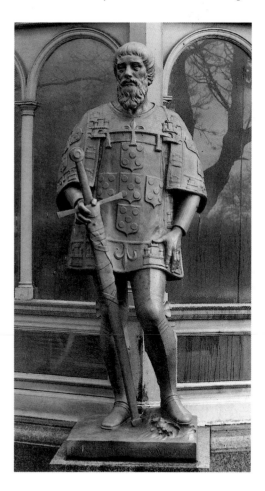

and a long fur-collared coat. Around his neck hangs a medallion bearing the image of Queen Isabella. With his right hand he shields his eyes from the sun as he gazes into the distance. In his left hand he holds a half-unrolled scroll, perhaps intended to be a map. His left foot rests

device of five circles. His weight is borne on his right foot. His left leg is flexed to rest his left foot on a raised piece of rock and his left hand is placed against the top of his left thigh. In his right hand he holds the handle of a longsword, the tip of which rests on the ground between his feet.

Condition: The statue appears to be in generally good condition, although it has been coated in gold paint at some time.

Related work: The present statue is derived from a figure in stone believed to represent Henry the Navigator, on the trumeau of the south portal of the church of Santa Maria (formerly a Hieronymite monastery) at Belém, Lisbon, in Portugal. Erected during the sixteenth century and largely reconstructed in the nineteenth century, the church occupies the site of a mariner's chapel founded by Henry the Navigator.

Statue of John Parkinson

(1567–1650). Herbalist and apothecary, firstly to King James I. He was created 'Botanicus Regius Primarius' by Charles I on the strength of his treatise, *Paradisus Terrestris* (1629) which described nearly 1,000 plants which are cultivable in English gardens (source: *DNB*).

Sculptor: Leon-Joseph Chavalliaud

Statue in marble

h. of statue: 77¹/₂" (197cms)
h. of marble base: 4¹/₂" (11cms)
h. of pedestal: 48" (122cms)

Inscriptions on the marble base:
– on the front face: JOHN PARKINSON / APOTHECARY TO KING JAMES I / BORN 1567 – DIED 1650
– on the left face: AUTHOR OF PARKINSONS

PARADISUS / OR THE GARDEN OF PLEASANT FLOWERS / LONDON 1629
– on the right face: Modelled from Contemporary Engravings / by L Chavalliaud London 1807 *(sic)*

Listed status: as for building

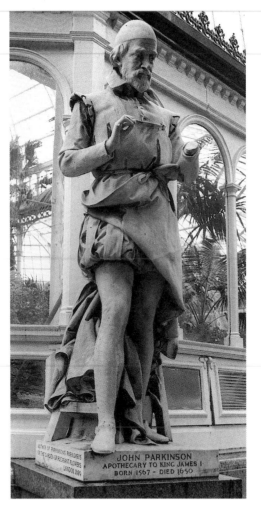

Description: Parkinson is shown in seventeenth-century dress. He wears a skullcap and an apron which is tucked up in a bunch over his belt. He stands with his weight borne on his left foot, his right foot forward, its tip overhanging the front edge of the base. He stands before a trestle underneath which is a pot of tulips and over which is draped a cloak (the clasp at each end of the collar being clearly visible). His gaze is directed at something, now lost, which he once held in his left hand. In his right hand is the stump of an object which may have been part of that which was held in his left hand – presumably a flower, as in the engraved portrait in Parkinson's *Paradisus Terrestris*, (London, 1635 edn) which image may have provided the model for the present statue.

Condition: The left hand is lost as are all digits of the right hand, along with the object once held in that hand. The bunched-up part of the apron has small chips missing and, most noticeably, a 7¹/₂" long chip along the edge. There are areas of black encrustation, black sooty mould and green biological stains.

Left of the north entrance:

Statue of André Le Nôtre

(1613–1700), the creator of the French style of landscape gardening, he designed the gardens at Versailles and laid out St James's Park in London (source: *Chambers Biographical Dictionary*).

Sculptor: Leon-Joseph Chavalliaud

Statue in marble

h. of statue: 80" (203cms)
h. of marble base: 4¹/₄" (11cms)
h. of pedestal: 48" (122cms)

Inscriptions:

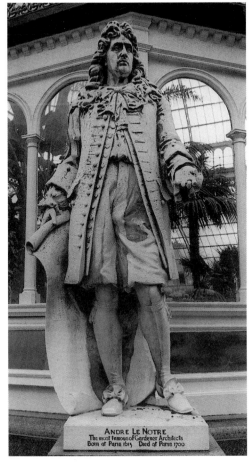

tions on the left and right faces, now illegible.

Description: Le Nôtre is shown in seventeenth-century dress. He stands with his weight on his right foot, his left heel raised, as if he has just moved forward. His left hand is extended, whilst in his right he holds a large scroll which reaches to the ground behind him, the end of which is trodden upon by his right heel. Upon this scroll is inscribed a garden plan and a list of his most famous commissions. There are at least two sculptures of Le Nôtre from which the present likeness may derive: a full-length statue in the garden at Chantilly which shows him seated and holding a garden plan (referred to, but not identified, in WAG JCS files), and a marble bust (after 1700) by Antoine Coysevox (1640 – 1720) in the church of St -Roch, Paris.

Condition: The marble has areas of black encrustation and green biological staining. There are also some salt deposits. All the digits of the left hand are missing. The lower six buttons (excepting the fifth) are chipped.

Statue of Captain James Cook

(1728–79), English circumnavigator. In 1768, he sailed in the 'Endeavour' for Tahiti round Cape Horn, charted the coasts of New Zealand, the east coast of Australia, part of New Guinea, and returned to England via the Cape of Good Hope. On what was to be his last trip in 1779, his ship had to put in at Hawaii after a storm and Cook was attacked and killed by natives (source: *DNB*).

Sculptor: Leon-Joseph Chavalliaud

Statue in bronze

Bronze founder: E. Gruet II of Paris

h. of statue: 80" (203cms)
h. of bronze base: 3¹/₂" (9.5cms)

– on the front face of the marble base: ANDRE LE NOTRE / The most famous of Gardener Architects / Born at Paris 1613 Died at Paris 1700
– on the scroll held by Le Nôtre: TUILLERIES / VERSAILLES / CHANTILLY / ST JAMES'S PARK / GREENWICH / ALTHOME

The statue may have been signed on the side of the marble base. There are very worn inscrip-

h. of pedestal: 48" (122cms)

Inscription on the front face of the base: CAPTAIN COOK
Inscriptions on the pedestal:
– on the front face of the cornice: JAMES COOK BORN IN CLEVELAND YORKSHIRE FEBY. 1728 / KILLED BY SOUTH SEA ISLANDERS FEBY. 1779 / THE EXPLORER OF AUSTRALASIA
– on the front face of the dado: CONSTANTLY AT SEA FROM HIS / YOUTH HE PASSED THROUGH ALL THE / STATIONS BELONGING

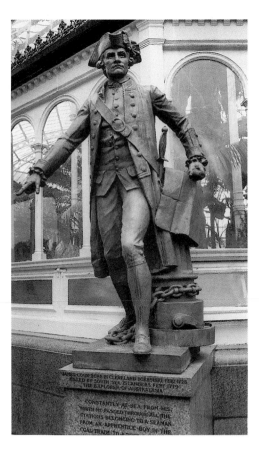

TO A SEAMAN / FROM AN APPRENTICE BOY
IN THE / COAL TRADE TO A POST CAPTAIN IN
/ THE BRITISH NAVY

Unsigned by the sculptor
Signed by the founder on the left face of the
bronze base: E GRUET JNE. FONDEUR. PARIS.

Listed status: as for building

Description: Cook is shown in eighteenth-
century naval uniform. His pose is active; both
knees are flexed and his left leg moves forward.
His right arm extends forward as he points
downwards slightly with his index finger, while
his left arm is flexed backwards, a telescope held
in his left hand. He looks across to his left.

Condition: The statue appears to be in generally
good condition, although it has been coated
with gold paint at some time.

Left of the east entrance:

Statue of Mercator
(1512–94). The Latinized form of Gerhard
Kremer, a Flemish mathematician, geographer
and map-maker. The projection which has since
borne his name was first used in his map of
1568 (source: *Chambers Biographical
Dictionary*).

Sculptor: Leon-Joseph Chavalliaud

Statue in bronze

Bronze founder: E. Gruet II of Paris

h. of statue: 78" (198cms)
h. of bronze base: 4" (10cms)
h. of pedestal: 48" (122cms)

Inscription on the front face of the bronze base:
MERCATOR
Inscriptions on the pedestal:
– on the front face of the cornice: BORN 1512

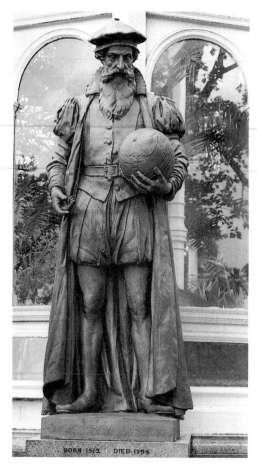

DIED 1594
– on the front face of the dado: THE SON OF A
POOR SHOEMAKER NEAR ANTWERP / THE
FATHER OF MODERN CARTOGRAPHY / BY
MERCATORS PROJECTION THE NAVIGATORS /
OF THE SUCCEEDING CENTURIES SAILED ON
/ THEIR VOYAGES OF DISCOVERY

Unsigned by the sculptor
Signed by the founder on the right face of the

bronze base: E GRUET JNE. FONDEUR. PARIS

Listed status: as for building

Description: Mercator is shown sporting a
luxuriant beard. He is depicted in sixteenth-
century dress, specifically a floor-length coat
and flat cap. He contemplates a terrestrial globe
which he holds in his left hand. The tradition-
ally accepted likeness of Mercator, which
Chavalliaud here follows, was known through
many engravings, for example that in the 1584
edition of his *Tabulae Geographicae Cl.
Ptolemaei*. Also traditional is the device of
showing him with terrestrial globe and
compasses.

Condition: The statue appears to be in generally
good condition, although it has been coated
with gold paint at some time.

Statue of Linnaeus
(1707–78), a Swedish botanist, the founder of
modern taxonomy The system for classifying
living things by two Latin names, the first being
its genus, the second its species, was first
published in his *Philosophia Botanica* of 1751
(source: *Pears Cyclopaedia*).

Sculptor: Leon-Joseph Chavalliaud

Statue in marble

h. of statue: 79" (201cms)
h. of marble base: 4¼" (11cms)
h. of pedestal: 48" (122cms)

Inscription on the front face of the marble base:
LINNÆUS
Inscriptions on the pedestal:
– on the front face of the cornice: CARL LINNE
BORN AT RASHULT IN SOUTH SWEDEN MAY
1707 / DIED AT UPSALA [sic] JANUARY 1778 /
TANTUS AMOR FLORUM
– on the front face of the dado: THE LORD

Unsigned

Listed status: as for building

Description: The statue here follows closely a
painting of 1737 by Martin Hoffman, known

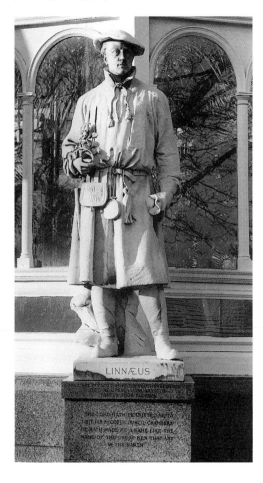

through the mezzotint engraving by Dunkarton
in Thornton's *Temple of Flora.* The following
identification of the details of the portrayal
derives from Blunt (1971: 118): Linnaeus stands
before a rocky outcrop, his weight borne on his
right foot. He is dressed in Laplander costume
with flat cap and reindeer skin boots. Around
his waist is a girdle from which are suspended
two pouches, a small brush and a knife in a
sheath. In his gloved left hand he holds his right
glove, whilst in his right hand he cradles a spec-
imen of *Linnaea borealis.*

Condition: There are areas of black encrusta-
tion, some green biological staining and salt
deposits (the latter, e.g., on the right glove). The
marble is chipped in various places: on the left
of the rock, the pouch, the tip of the left shoe.

Literature: Beskow, I.T. (1968 edn): 32; Blunt, W.J.W.
(1971): 118.

2. INTERIOR

At the time of writing (early 1994), only the
Commemorative Garden Bench remains in the
Palm House. All of the sculptures formerly in
the Palm House have been damaged and in 1986
two were stolen: one, a *Statue of Europa*,
remains untraced, the other, *A Child in the Tub*,
was recovered and has been placed in store with
the remaining sculptures.

The Angel's Whisper

Sculptor: Benjamin Edward Spence

Sculpture in marble

h. of statue group: 29¹/₂" (74.9cms); d: 40"
(101.6cms); w: 33" (83.8cms)
h. including pedestal: 32¹/₂" (82.5cms)

Signed and dated on the side of the marble base:

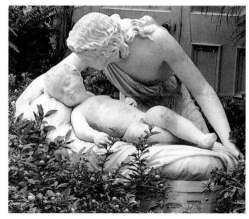

B.E. SPENCE / ROME 185... (illegible, possibly
'7' or '9')

Owner/ custodian: Liverpool City Council. It
was transferred to the Palm House some time
after 1898, previously having been in the
Walker Art Gallery collection, to which institu-
tion it was bequeathed in 1892 by James
Barkeley Smith, the son of the original
purchaser, James Smith (*Courier*, 1 October
1898).

Status: not listed

Description: An angel leans forward with arms
outstretched to either side of the head and feet
of a sleeping baby who is lying on a small couch
covered with a cloth. The angel looks down at
the baby's smiling face, which, uptilted by a
pillow, is turned towards the viewer.

Condition: The sculpture is in very poor condi-
tion. The angel's wings are missing – described
by the *Art-Journal* (1863: 16) as 'still unfolded
as if she had just descended on the earth' – and
the marble has brown rust stains and green
biological stains, mottled with darker areas of
lichen. All the fingers of the angel's right hand

are missing, as are the tip of the thumb, index finger and little finger of the left hand. Also the toes of the left foot are chipped. There are streaks of staining from the top of the angel's head down the forehead and there is some loss to the nose, perhaps through weathering. A longitudinal crack runs over the angel's left shoulder, down the back to the gown. The baby's right hand has lost the index finger and thumb, most of the left foot is missing, as are the big toe and second toe of the right foot. There is also a crack running around the baby's throat. Finally, a piece of the base has broken off at front right, but has been retained. Currently in store.

Related work: Another copy, originally in the collection of Mr & Mrs H.R. Sandbach of Hafodunos Hall, was bought in 1969 by Crowther of Syon Lodge Ltd and, after entering a private collection in London, was sold at Christie's, London, 15 July 1993, lot 235 (Christie's, 1993: 98-99). It was purchased by the Musée d'Orsay, Paris (cat. RF44445).

The *Art-Journal* (1863: 16) explained that the title derives from a popular lyric by Samuel Lover which tells of the musings of a fisherman's wife as she looks at her child:

> The baby still slumbered, / And smiled in her face as she bended her knee; / Oh! blessed be that warning, / My child, thy sleep adorning, / For I know that the angels are whispering with thee.

Though the lyric is homely, explains the *Art-Journal*, the sculptor has rendered the subject

> in harmony with the dignity of sculptural art...It is altogether a work wherein are combined great elegance of design and poetical feeling, with execution of a high order.

The group was at this time the property of James Smith, Esq., of Seaforth, Liverpool. Gunnis (1951: 363) gives 1863 as the date of execution.

Literature: *Art-Journal* (1863): 16; Christie's (1993): 98-99; Gunnis, R. (1951): 363; Read, B. (1982): 43, 206, *267*; Stevens, T. (1971): 228-29; *Weekly Courier* (1898) 1 October: 2.

A Child in the Tub

Sculptor: Patric Park

Statue in marble

h: 37½" (95.3cms); d: 25" (63.5cms); w: 18½" (47cms)

Inscription on the front of the base: ONE WHOM THE GODS LOVED

Signed and dated on the side of the tub: P. PARK SCULP. / LONDON 1840.

Owner/ custodian: Liverpool City Council
Status: not listed

Description: The sculpture represents a small girl sitting on a towel on the edge of a tub, her left hand clasping the edge of the tub to support herself. She leans forward slightly, her right hand reaching towards her left foot, her head turned to her right.

Condition: The statue has been broken in two at some time and repaired. The seam runs through the left wrist, left hip, over the buttocks, under the right thigh and through the right ankle. The tub is in two pieces, the rear half of the side and bottom of the tub are with the figure, the front half of the side is separated – the break runs through the signature at the s of SCULP and downwards through the second N of LONDON below it. The head has been broken off and replaced, the cement being now

discoloured. The missing last joint of the index finger of the right hand has been replaced with a substance also now discoloured. The toes on the left foot, noted as missing in the WAG 1977 survey, have been similarly replaced. A chip of marble is missing from the hair on the left side of the figure's head towards the back. Currently in store.

A Child in the Tub was stolen in April 1986 and retrieved at a London art dealers in July 1986, much of the damage being sustained and the repairs carried out whilst the statue was missing.

Literature: WAG JCS files newscutting: *Echo* (1986) 23 April.
(ii) Read, B. (1982): 43, *47* .

Commemorative Ornamental Garden Bench
facing the west entrance.

Designer/ executant unknown

Bench in marble
Inscription panel inlay in red marble

Length of bench: 9' approx. (2.74m)
Length of marble base: 10' (3m)

Inscription (inlaid with gold leaf) in the red
stone panel inlay of the seat-back: THIS PALM-
HOUSE WAS PRESENTED TO THE CITY OF
LIVERPOOL / AD 1896 BY HENRY YATES
THOMPSON GRANDNEPHEW OF / RICHARD
VAUGHAN YATES THE FOUNDER OF PRINCES

PARK / WHO LOVES A GARDEN LOVES A
GREENHOUSE TOO. / COWPER.

Unsigned

Owner/custodian: Liverpool City Council
Status: not listed

Description: The bench is fitted with a wooden
slatted seat and footrest. The two ends of the
bench are each carved in the form of a chimaera.
Similar chimaera motifs, derived from classical
models, are illustrated in the influential
Household Furniture and Interior Decoration
(1807) by Thomas Hope: plate 15, figure 1 illus-
trates a tripod table with legs fashioned as
chimaeras, each with a lioness head, acanthus
covering the breast and standing upon a single
stylized foot, while plate 29, figure 5, shows a
sofa with winged arms and taloned feet, very
close to the present bench. Whether the anony-
mous designer of Thompson's bench conflated
these two motifs or followed another classical
model is not known.

Condition: Extensively damaged. Both chimera
heads have been knocked off and re-fixed. The
repairs are visible and there is some loss to the
marble on each chimera's breast below the
break. In addition, the left-hand chimera's left
ear is missing. The red marble inscription tablet
is cracked and the top left-hand corner is lost.
There are some rust stains from the roof. The
bench is currently encased for protection *in
situ*.

Literature: Musgrave, C. (ed.) (1970): *5, 15, 29*.

Europa
(stolen on 8 December 1986; current location
unknown)

Sculptor: Vincenzo Luccardi

Statue in marble

h: 106" (269.2 cms); w: 32½" (82.5 cms);
d: 32½" (82.5 cms)

Signed and dated: V. Luccardi Roma 1872

Owner/ custodian: Liverpool City Council
Status: not listed

Description: An idealised, classically-draped
young woman represented stepping forward in
a dance-like manner, her weight having shifted
to her right foot, her left knee bent, her left heel
raised. With both hands she holds a garland of
flowers above her head. A rose is tucked into
the extremely low neckline of her dress which
has slipped to reveal her breasts. On the ground
at her feet are more flowers. A band inscribed
with a low-relief carving of a bull and three
seven-pointed stars crosses the centre of the
circular base beneath her right foot.

The statue is not titled, but the details
suggest that the subject is *Europa*. Ovid
(*Metamorphoses*, 2: 836 – 875) tells how the
beautiful nymph Europa was gathering flowers
in a meadow by the sea when Jupiter saw her
and desired her. In order to seduce her he trans-
formed himself into a white bull. Europa,
deceived by the passivity of the bull,
approached closely and draped garlands of
flowers upon its horns. It may be this tender
moment before the brutal abduction that
Luccardi is suggesting.

Condition: Unknown (see below)

Europa was the subject of two thefts. It was
first stolen on 12 July 1986. On 14 July, the
Echo published an account of the theft and an
appeal was broadcast on local radio by Alan
Rose, foreman at Sefton Park. Two days later
(16 July), the *Echo* reported that police,
responding to a tip-off, had recovered the statue
'following a raid on a Tuebrook House'. The

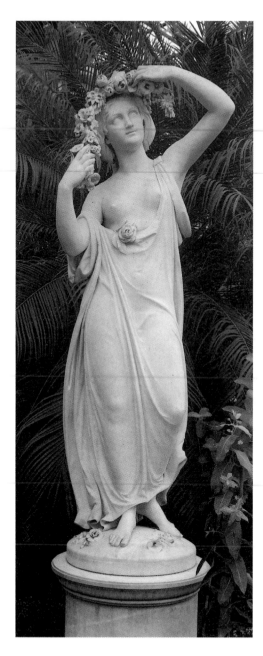

statue was then re-installed in the Palm House. Extra locks were installed at the Palm House, security was stepped up and the statue cemented more securely to its pedestal (*Echo*, 9 December 1986). Before the end of the year, however, on 8 December, the Palm House was again broken into and the statue again stolen (this time with the pedestal to which it had been cemented). To this date Luccardi's *Europa* remains untraced.

Literature: (i) WAG JCS files newscuttings: *Echo* (1986) 14 July; *Echo* (1986) 16 July; *Echo* (1986) 9 December.
(ii) *Art-Journal* (1877): 100.

Highland Mary

The sobriquet of Mary Campbell. Believed to have been the daughter of a Clyde sailor, she was a maid servant of Auchenmore and was one of Robert Burns' lovers, immortalised in his song, 'The Highland Lassie O'. The couple had intended to emigrate to Jamaica, but she died in childbirth, shortly after their betrothal, in 1787 (Wynne-Davies, 1989: 376).

Sculptor: Benjamin Edward Spence

Statue in marble

Statue: h: 65" (165cms); d: 22½" (57cms); w: 21" (53cms)

Pedestal: h: 50½" (128cms)

Inscriptions:
– on the front of the pedestal:
 The golden Hours on angel wings / Flew o'er me and my dearie; / For dear to me as light and life / Was my sweet Highland Mary.
– on the left face of the pedestal:
 Robert Burns / born at Alloway 1759 / died at Dumfries 1796
– on the right face of the pedestal:

Benjamin Evans *[sic]* Spence. / Sculptor. / born at Liverpool 1822. / died at Leghorn 1866.

Signed on the side of the marble base at the rear:
B. E. SPENCE / FT. ROMAE

Exhibited: French International Exhibition of 1855 (*DNB*)

Owner/ custodian: Liverpool City Council
Status: not listed

Description: Highland Mary is portrayed as a young woman standing in contemplative pose, wrapped in a fringed plaid cloak which also covers her head. She gathers it at her throat with her left hand and holds a book in her right, at thigh level. On the ground are some thistles. Spence has portrayed Mary as she appeared at her last meeting with Burns on the banks of the Ayr, the book in her hand presumably intended to represent the Bible which Burns had given her (Greenwood, 1989: 55).

Condition: The tip of the nose is lost. There is a 9" longitudinal chip off the roll of a fold of the plaid cloak at the left back. There is extensive yellowish staining. Currently in store.

Related works: There are several versions. The earliest marble was carved for Charles Meigh, of Grove House, Shelton, *c.*1852 (engraved in the *Art-Journal*, 1852; untraced). In 1854 Prince Albert commissioned a copy (now at Osborne House), as a birthday present for Queen Victoria. The Walker Art Gallery has another, originally commissioned by John Naylor of Leighton Hall (cat. 6585). After Spence's death his wife presented the original plaster model, with all his other surviving models, to the City of Liverpool: it currently stands in a niche under the portico of the Picton Library, William Brown Street (see below, p. 250).

Highland Mary is Spence's best known and most popular work. It was repeated at least five times (Greenwood, 1989: 55), its appeal to the original Victorian audience no doubt residing in its charming blend of fact, poetry and romantic legend.

Literature: *Art-Journal* (1852): 259; *Art-Journal* (1854): 352; *Daily Post* (1936) 31 October: 6; Greenwood, M., 'Victorian Ideal Sculpture', in P. Curtis (ed.) (1989): 55; Stevens, T. (1971): 228.

Two Goats

Sculptor: Giovita Lombardi

Sculpture in marble

Group: h: 52" (132cms); d: 24" (61cms); w: 32½" (82.5cms)
Pedestal: h: 51" (129.5cms)
Overall h: 106" (269.2cms)

Signed on the 'ground' at the rear left, behind the tree stump: G. LOMBARDI / ROMA

Owner/ custodian: Liverpool City Council
Status: not listed

Description: Two goats are depicted in a rocky setting. The larger one, a female, rests a foreleg on an oak tree-stump and looks back. Beneath her a kid kneels on its left foreleg and looks past its mother. The kid wears a collar.

Condition: There are losses to the sculpture at all extremities: the lower part of the kid's left foreleg is missing, as are the horns, ears and tail; the mother's left ear, half of her left horn and the tip of the right horn are all missing. The base is in three sections: two adjacent smaller pieces (forming together an approximately 20" long join with the greater section of the base) have been separated (the signature is on one of the smaller pieces). They are smoothly joined, however, and scored on the vertical faces of the

join apparently with a claw chisel, the greater part of the base being perhaps the limit of the original marble block. The forward of the two smaller pieces has a metal peg inserted which once secured the join. There is also a 20" crack running from front to back of the larger section

of the base between the kid's legs. The sculpture in addition has areas of yellowish staining. Currently in store.

Second version: Rezzato, Italy, collection of Davide Lombardi, (h: 137 × 73cms). Exhibited: *Brescia postromantica e liberty, 1880-1915*, (cat. no. 1.4.), 1985, Comune di Brescia.

Neither of the two known versions is dated, the *terminus ante quem* provided by Lombardi's death in 1879.

Literature: Comune di Brescia (1985): 168.

Seymour Street

On the landscaped triangular plot of land where Seymour Street meets Copperas Hill:

Sea Circle

Sculptor: Charlotte Mayer

Sculpture in bronze

h: 83" (211cms); d: 66" (167.5cms); w: 122" (310cms).

Inscription on a descriptive plaque affixed to the circular brick base:
SEA CIRCLE 1984 / Sculptor: Charlotte Mayer. / This shell like form embodies Merseyside's / strong links with the sea. It's [*sic*] spiral is / a symbol of outward growth and inward return. / It reflects the constant coming and going of / men, women and ships to and from this great / port. / MERSEYSIDE COUNTY COUNCIL / Chairman of the County Council, Councillor Ben Shaw / Chairman of Highways and Tunnels Committee, Councillor O. J. Doyle / Engineer to the Works, R. J. Williams.

Installed 7 December 1984

Owner: Liverpool City Council
Status: not listed

Condition: Good

The following account summarises that published by Alex Kidson (1989: 116-18). *Sea Circle* was commissioned by John Barry, a Development and Planning Officer with Merseyside County Council. When the site above Lime Street Station first became available it was suggested that some kind of assemblage involving a disused railway signal be erected there. The lack of imagination such a suggestion displayed was similar to that behind the previous scheme initiated by Merseyside County Council, the erection of the Warship's Mast on the roundabout by St Nicholas's Church. Barry, who had a keener interest in contemporary art than his colleagues, rejected this solution and sought the advice of Timothy Stevens, then Director of Merseyside County Art Galleries.

Stevens suggested that Barry visit the 'British Sculpture Show', then showing at the Hayward and Serpentine Galleries in London. Barry also contacted the sculptors' agent, McDonald Rowe, whose advertisement he had seen in an art magazine. The agent sent Barry a catalogue with illustrations of his clients' work. Barry

attempted to draw up a short list in consultation with his colleagues, but they failed to reach a consensus. He then resolved to compose his own short-list, aided only by a project assistant, Brian Griffiths.

Together they narrowed the field down to four names and began the task of visiting the sculptors' studios, calling at Charlotte Mayer's studio on 30 September 1983. Several weeks later Barry and Griffiths arrived at their decision, contacted the sculptor's agent and offered

Mayer the commission. Their choice of Mayer was evidently inspired by seeing her 1982 piece, *Care,* for Johnson and Johnson, the toiletry manufacturers, outside their offices in Slough. It consists of a ring of open hands, suggestive of the title and, in the wake of the Toxteth riots of 1981, it struck a sympathetic cord with the two men from Liverpool. Mayer told them that she had been working on *Care* at the time of the riots and had thought then that she would like to create something similar for Liverpool.

Mayer travelled to Liverpool at the end of October (not actually having seen the site) and submitted a small tinfoil maquette. She explained that the 'Sea Circle' form, 'a combination of shell and spiral, [symbolised] at once the city's timeless seaboard character and the life of its sailors setting out on voyages and returning home again' (Kidson, 1989: 117). Barry and Griffiths liked the idea and said they would be in touch.

The two men were rather concerned about how their senior colleagues would react to such a modern piece. Yet, despite the piece being abstract, it was visually arresting and its symbolism, once explained, was easy to grasp. Barry and Griffiths ultimately managed to secure approval in April 1984, subject to Mayer submitting a finished maquette to the Council Sub-Committee. Mayer's official maquette was approved in June 1984 and she finished the full-size plaster by the end of August. It was cast in bronze at a cost of £6,000 and installed on 7 December of that year. Mayer's fee (over and above the cost of casting) was £9,000. The total sum of £15,000 was paid for out of the overall costs of the roundabout scheme (Kidson, 1989: 118).

As Kidson observes, the form of *Sea Circle* also suggests a 'fundamental theme of organic growth and renewal' (1989: 118) and yet for a number of years the urban redevelopment that would give meaning to such a reading was abandoned and the sculpture stood ironically at the centre of a stretch of wasteland. In 1992, however, Seymour Terrace was restored and the immediate setting for the sculpture landscaped and provided with benches, thus in some measure fulfilling, albeit belatedly, the original scheme of renewal.

Literature: Davies, P. (1992): 68-9; Kidson, A., 'Charlotte Mayer's "Sea Circle"', in P. Curtis (ed.) (1989): 116-18.

Shaw Street

LIVERPOOL COLLEGIATE SCHOOL, or INSTITUTION designed and built by Harvey Lonsdale Elmes between 1840-43 (Picton, 1875, revised edn 1903, i: 489, 496; ii: 343-44). The school was founded to provide a Church of England-based education, in direct response to the secular-based education on offer at the recently established Mechanics' Institute (later Liverpool Institute School). The Shaw Street frontage is embellished with sculpture.

Sculptor: unknown (although it has been suggested by Timothy Stevens that he may be William Spence).

Liverpool Collegiate School was officially opened Friday 6 January 1843

Owner of building: Inner City Enterprises
Listed status: Grade II*

General condition: Given the high location of the sculpture, only the more obvious losses or areas of damage are visible. The sculpture is smoke-blackened in places, a condition partly ascribable to the 1994 fire in which the building was severely damaged.

(i) above the main entrance porch, the *Coat of Arms of Liverpool College*:

High relief carving in stone

Description: The coat of arms is located against the central gable of the parapet over the main entrance, above the string course. Set beneath a bishop's mitre, it consists of a shield between supporters. The shield has a wide horizontal strip in the upper part carved with the imperial crown upon a cushion in front of a crossed crosier and sceptre; below the strip is an open book. The supporters are portrait statues of, on the left, Francis Egerton, Earl of Ellesmere, and, on the right, Edward Smith Stanley, 13th Earl of Derby; respectively, the first president and

patron of the school. Each rests his inner arm on a top corner of the shield and each wears a long cloak over a belted tunic and hose. Ellesmere wears a cap, whereas Derby is bare-headed. Beneath the string course, inscribed on a scroll, is the motto of Liverpool College: NON SOLUM INGENII VERUM ETIAM VIRTUTIS ['Not only of intellect but also of virtue']. According to the College of Arms, the Liverpool College coat of arms is (as are those of many such foundations) borne without authority.

Condition: At such a height the condition is difficult to detect, but there appear to be no significant losses.

(ii) above the oriel windows, against the parapet, at each end of the Shaw Street frontage are semi-hexagonal niches with elaborate semi-hexagonal ogee-arched canopies. Each niche is flanked by diagonally-set pillars of square section. Where the pillars meet the canopy at the level of the parapet are bearded heads. Each niche contains a portrait statue on a high hexagonal pedestal.

At the left end of the Shaw Street frontage:
Statue of Edward Smith Stanley, 13th Earl of Derby
(1775–1851), patron of the school. Derby was Whig M.P. for Preston, 1796-1812, and for Lancashire, 1812-32. He was called to the peerage as Baron Stanley of Bickerstaffe in 1832 and succeeded to the earldom in 1834. He was president of the Linnean Society, 1828-33, and also of the Zoological Society (and established a private menagerie at Knowsley). It was his museum that his son, the 14th Earl, presented to Liverpool after his death. (source: *DNB*)

Statue in stone

Description: Derby is represented *contrapposto* with his weight is borne on his left leg, his right leg flexed and brought forward. His left hand is raised to chest height, gathering up the left side of the cloak, while the right arm is lowered. Beneath the niche is the coat of arms of the Stanley family: three stags' heads on a diagonal strip.

Condition: The statue is missing the head and right arm below the elbow.

Listed status: as for building

At the right end of the Shaw Street frontage:
Statue of Francis Egerton, Earl of Ellesmere
(1800–57), the first president of the school. Born the younger son of the Duke of Sutherland (G.G. Leveson-Gower), Ellesmere grew up to be a statesman and a minor poet. He was Tory M.P. for Bletchingley, Surrey, 1822-26; Sutherlandshire, 1826-30; and South Lancashire, 1834-46. He was a lord of the Treasury, 1827, Under-Secretary of State for the Colonies, January-May 1828, Chief Secretary to the Lord-Lieutenant of Ireland, 1828-30, and Secretary at War, July-November 1830. Keenly interested in the arts, he assembled an art collection which he opened to the public at his home in London and was, from 1835, a trustee of the National Gallery. On the death of his father in 1833, he assumed the surname and arms of his mother's family and inherited the estate of his uncle, the Earl of Bridgewater. He was created Earl of Ellesmere in 1846 (source: *DNB*).

Statue in stone

Listed status: as for bulding

Description: Ellesmere is represented standing with his right leg advanced. His arms are folded across his chest. Beneath the niche is the

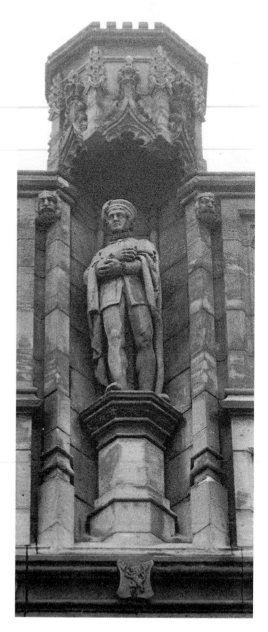

Egerton family coat of arms, a lion rampant between three pheons.

Condition: There appear to be no significant losses.

Literature: *Chronicle* (1843) 7 January: 5.

In WHITLEY GARDENS:
Memorial to the Eighth (King's) Regiment
The Eighth (King's) Regiment is the name by which the present-day King's Regiment was known from the mid-eighteenth century until 1881 (see also the *Memorial to the King's Liverpool Regiment*, St John's Gardens, pp.177–80). The regiment was so-called because it was the eighth infantry regiment in seniority (source: *The King's Regiment Gallery*).

Designer: unknown

Cross of white Sicilian marble on a base of red Mansfield stone and a sub-base of Greenmore stone (Cannon, 1904: 544)

h: 22' (6.7m)

Inscriptions:
– on the front face of the red Mansfield stone base: THIS CROSS / COMMEMORATES THE SERVICES AND DEATH / OF / 243 OFFICERS, N.C. OFFICERS AND PRIVATE SOLDIERS / LOST BY THE / 8TH THE KING'S REGIMENT / WHILE ENGAGED IN SUPPRESSING THE GREAT SEPOY MUTINY / OF 1857-1858 / SOME DIED IN BATTLE, SOME OF WOUNDS / SOME OF DISEASE / ALL / IN THE DEVOTED PERFORMANCE OF DUTY
– on the left face: ERECTED AT PORTSMOUTH / 1863
– on the right face : REMOVED TO CHELSEA / 1877
– on the rear face: REMOVED TO LIVERPOOL / 1911

– on the left face of the white marble cruciform base of the cross shaft: DELHI CAPTURED
– on the right face: AGRA DEFENDED
– on the rear face: LUCKNOW RELIEVED

Owner / custodian: Liverpool City Council
Listed status: Grade II

Description: The memorial stands in Whitley Gardens, in a semi-circular plot of grass, close to Shaw Street. It is in the form of a Celtic ringed cross with a gable top. The shaft and arms are edged with cable moulding. The front face of the cross is carved with (very eroded)

reliefs. On the top arm is a figure of *Christ the Saviour*, in the centre a *Glory*, and on the downward arm, three narrative reliefs. These represent, from top to bottom: (i) *The Bivouac*: an army encampment with, in the foreground, two reclining figures, and in the background, a tent on the left and an Indian tree on the right; (ii) *The Battle*: two figures sword fighting over a third lying prone on the ground; and (iii) *The Burial*: two figures carrying a dead comrade over a rock against which a rifle rests (Cannon, 1904: 544). The shaft of the cross is buttressed by a white marble base of cruciform section with trefoil-topped gables. Below this is a red Mansfield stone base. The upper corners of each of its faces are cut to ogee shapes. Beneath the base projects the low sub-base.

For a good photograph of the memorial as it stood in the grounds of Chelsea Hospital, see Cannon, 1904, opposite p. 544; and as it was in Liverpool in 1922 see *Photographs of War Memorials in Liverpool*: 1.

Condition: The white marble cross is extremely eroded. The *Christ the Saviour* is barely legible and the *Glory* not at all, although the narrative reliefs are in rather better condition. The inscriptions on the white marble have virtually disappeared, whereas those on the red Mansfield stone are still completely legible. Cannon (1904: 544) lists the names of the 243 men of the regiment who died in the Mutiny and whose names were inscribed on the cross, while Richardson (1990: 64) states that 'faint traces can still be seen, on the sides of the cross, of the names of the men concerned' (although it is difficult to see where these traces might be). The trefoil cap and some of the gable top to the right-hand arm of the cruciform base are missing. The square low-walled stone enclosure evidently once had railings, the holes into

which the railings were inserted now being plugged. The memorial was restored in 1986 (Richardson, 1990: 64).

Related work: (Sir) William Goscombe John, *Memorial to the King's Liverpool Regiment*, 1901–05, St John's Gardens (see above, pp. 177–80)

The *Memorial to the Eighth King's Regiment* was commissioned by Lieutenant-General A.C. Robertson, C.B., and presented to the regiment to commemorate those of its men who had died during the Indian Mutiny of 1857-58 (Cannon, 1904: opp. 544). The conflict began as a mutiny of the Bengal Army, but soon escalated into a civil war. The main causes were resentment at the erosion of ancient Indian traditions, deep

concern that Christianity would be forced upon the population, and the issue of cartridges greased with cow-fat or pig-fat, the former offending the religious beliefs of the Hindus and the latter, the Muslims. In May 1857, Indian mutineers seized Delhi, and in June British troops and their families were beseiged at Cawnpore and Lucknow. In late June 1857, a force of 4,000 British troops marched on Delhi, eventually taking it in September. Meanwhile the British garrison at Cawnpore had been massacred after surrendering to the mutineers, but that too was retaken in the autumn. The mutiny was finally suppressed in July 1858.

The regiment had been in India for ten years when the Mutiny broke out and took part in the seige of Delhi. Following this they marched

to Agra, where they fought a battle, and then participated in the re-taking of Cawnpore and the relief of Lucknow. Later the regiment formed part of a mobile flying column, fighting near Agra and Oude (*King's Regiment Gallery*: 4).

The *Memorial to the Eighth King's Regiment* was originally erected in Portsmouth in 1863. In 1877 it was removed to the grounds of Chelsea Hospital, London, and finally, in October 1911, was re-erected at Whitley Gardens, Shaw Street, Liverpool.

Literature: (i) LRO *Photographs of War Memorials in Liverpool...*, 1923: 1.
(ii) Cannon, R. (1904): 544; *The King's Regiment Gallery*, undated: 4; Richardson, A. (1992): 64-5.

Springfield Park

Within the park, on a circular plot of grass two-thirds of the way along a path between two hedges, leading from East Prescot Road:

Nelson Obelisk

Designer: unknown

Sandstone

Inscription on a brass-framed plaque half way up the obelisk shaft, facing the road:
Sacred to the memory of the illustrious NELSON / who gloriously fell in defence of his country / and to whose skill and valour / BRITONS are

indebted for domestic security / and tranquil enjoyment of / the produce of their industry.

Owner/ custodian: Liverpool City Council
Listed status: Grade II

Description: The obelisk appears to have formerly been painted cream. The pedestal has four recessed panels, but no plaques remain. The pedestal is surrounded by a low square wall which once had railings, now all sawn off.

Condition: There is extensive graffiti on the pedestal. An inscription plaque was formerly fixed into the panel on the front face of the

pedestal, but this is now gone and a replacement has been fixed, apparently recently, half-way up the obelisk shaft. The paint which once covered the obelisk is now very weathered and the stone is showing through in many places.

According to Richardson (1990: 43-5), the obelisk was paid for by a local sugar refiner by the name of Mr Downward. He offered it to the Corporation, who declined it, deeming it insufficiently grand. Mr Downward, therefore, erected it in the grounds of his own house, Springfield.

Literature: Richardson, A. (1990): 43-5.

Eleanor Rigby

The sculpture is named after Paul McCartney and John Lennon's song on the theme of loneliness from the Beatles album, *Revolver*, 1966.

Sculptor: Tommy Steele

Statue in bronze

h: 50¹/₂" (128cms); d: 37³/₄" (96cms); w: 47¹/₄" (120cms)

Inscription on the wall plaque to the right of the figure: ELEANOR RIGBY / DEDICATED TO / "ALL THE LONELY PEOPLE…" / This statue was sculptured and donated to the City of Liverpool / by Tommy Steele as a tribute to the Beatles. / The casting was sponsored by the Liverpool Echo. / DECEMBER 1982

Unveiled by Tommy Steele Friday 3 December 1982

Owner/ custodian: Liverpool City Council
Status: not listed

Description: The bronze sculpture consists of a seated woman, her shopping bag and a copy of the *Echo*, upon which is a sparrow and a piece of bread. The bronze is fixed to a stone bench placed against the wall of the former Post Office. The woman looks down at the sparrow, which she is feeding. Poking out from her shopping bag is an *Express Dairy* milk bottle (the distinctive 'E' logo visible); on her lap is a small handbag.

Condition: Good.

In 1981, whilst appearing in a show in Liverpool, Tommy Steele approached the City Council with an offer to make a sculptural tribute to the Beatles. His fee would be just three pence – an allusion to his hit show, *Half a Sixpence* (*Echo*, 1 November 1982). Steele chose *Eleanor Rigby* as his theme, taking nine months to complete the work. As he explained to the *Echo*:

> I came to Liverpool unannounced eight times in the formative months and just walked around…I wanted this statue to be absorbed in the environment without

sticking out like a sore thumb...I was struck by how many people there were on the streets walking around, and I wanted her to be where the people are, rather than in places they might visit. I wanted her to be a lonely figure, in the crowd but not part of the crowd.

Steele put various items into a sack and, at the casting stage, dropped them into the molten bronze:

a four-leaf clover for good luck, a page from the Bible for spiritual help, a sonnet for lovers, an adventure book for excitement, and even old football socks for action

– this, as he said, was to imbue the sculpture with magical properties (*Echo*, 1 November 1982).

The Council accepted the sculpture for the city in the hope that it would help boost the tourist trade in the wake of the renewed interest in the Beatles, generated by the recent re-release of their first record, *Love Me Do*. The *Liverpool Echo* donated the sum of £4,000 to pay for the casting so that there should be a permanent tribute to the Beatles in a public place (*Echo*, 1 November 1982).

The sculpture is obviously held in great affection, as fresh flowers are frequently placed on the 'newspaper' along with, sometimes, personal messages of sympathy.

Literature: *Echo* (1982) 1 November; *Echo* (1982) 4 December; WAG (1984a): 77, 80.

Tithebarn Street

The former EXCHANGE RAILWAY STATION, now Mercury Court. The keystones of the two entrance arches are carved with portrait heads of Edward, Prince of Wales, and Princess Alexandra (sculptor unknown).

On the pier between the two entrance arches:

Memorial to John Pearson
(1824 – 87). Elected to the Chair of the Lancashire and Yorkshire Railway in March 1883, he initiated a 'complete reform of both the traffic and engineering departments' (source: Nock, 1969).

Sculptor: Francis John Williamson

Relief in bronze

h: 51¼" (130.5cms); w: 45" (114.5cms)

Inscription on the bronze plaque below the portrait: JOHN PEARSON, / BORN 1824. DIED

1887. / CHAIRMAN OF THE LANCASHIRE AND YORKSHIRE RAILWAY, / MAYOR OF LIVER-POOL 1871-2 / HIGH SHERIFF OF LANCASHIRE 1875-6 / ERECTED BY HIS FRIENDS.

Signed and dated on the bevelled lower edge of the portrait frame: F. J. WILLIAMSON. SC. / ESHER 1890.

Owner of building: English Partnerships
Status: not listed

Description: The memorial is a high relief portrait bust in a roundel contained within a square bevelled frame, edged with a ³/₄" moulding of semi-circular profile. Pearson is portrayed full-face, looking slightly to his right. He wears a jacket and waistcoat. The space between the square of the frame and the portrait roundel is filled with heraldic roses and coats of arms: top left – the Duchy of Lancaster;

top right – York (or, in this context, more likely Yorkshire which, since it did not have its own coat of arms, was frequently represented by those of the city of York); bottom left – Liverpool; bottom right – Manchester.

Condition: Apparently good, although a layer of paint, now much worn, has been applied at some time.

University of Liverpool Precinct

Founded in 1881 as University College, Liverpool, it was admitted into Victoria University, Manchester, in 1884. When the University of Liverpool was established in 1903, University College was absorbed into it. The diversity of the sculpture collection reflects the varied processes of acquisition over time. The majority of works were obtained either as gifts (usually portraits and small-scale works from University benefactors), as architectural decoration, or as works commissioned to complement a new building. The latter was often the case during the period of rapid expansion following the Second World War. The selection process for sculpture, with no central planning, has characteristically depended upon individual departments, architects and ad hoc committees.

The following catalogue of the more publicly-sited sculpture in the collection of the University is arranged in alphabetical order by building. For an historical overview of the development of the University collection as a whole, see Carpenter, J. 'The University of Liverpool', in P. Curtis (ed.) (1989): 60-2.

ASHTON BUILDING, designed and built for the Faculty of Arts by Briggs, Wolstenholme, Thornely and F.W. Simon in 1912-14.

Owner: University of Liverpool
Listed status: Grade II

The main window over the central door onto the quadrangle is framed by columns and crowned with a pediment. Seated above the

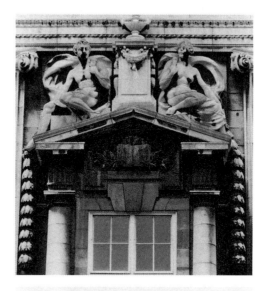

raking cornices of the pediment are *Two Sculptural Figures* and from the ends of the pediment, garlands are suspended. The roof line of each wing of the Ashton Street frontage is decorated with a pair of *Egyptian Sphinxes*.

Sculptor: William Birnie Rhind

All sculpture in Portland stone

Description: The nude male and female figures, apparently derived from Michelangelo's Sistine Ceiling *ignudi*, are seated upon blocks above the pediment, either side of a garland-hung pedestal upon which stands a vase. Each figure clasps a billowing cloak to its shoulder and looks across the quadrangle.

Condition: There is black encrustation on both seated figures overlooking the quadrangle. The two pairs of Egyptian sphinxes above Ashton Street appear to be in good condition.

At a meeting of the New Arts Building Committee on 6 November 1912, William Birnie Rhind's model 'for the sculpture for the central door in the quadrangle' was firmly approved and 'a model of the sphinxes, to be placed on the Ashton Street frontage' was approved 'subject to modifications in detail to be made by the sculptor in consultation with Professor Bosanquet', then Professor of Classical Archaeology (*New Arts Building Committee Minutes*).

Literature: (i) University of Liverpool Archives – *New Arts Building Committee Minutes*: Meeting of 6 November 1912.
(ii) *Scotsman* (1933) 11 July: 8.

CHADWICK BUILDING

Located in the entrance hall of the Physics Department (access only by prior arrangement):

Relief ('Bubble Chamber Tracks')

Sculptor: Geoffrey Clarke

Relief in cast aluminium, 1966-68

h: 94½" (240cms); l: 137¾" (350cms); d: 9" (23cms)

Inscription on a descriptive plaque at the bottom left: Relief by / Geoffrey Clarke

Owner: University of Liverpool
Status: not listed

Description: Although apparently abstract, the relief is in fact based on the pattern made by a trail of bubbles left behind in liquid by a flying particle. The story of how the sculptor evolved the idea for the design of the relief was recalled by David Edwards (letter, dated 19 April 1994, to the author), then senior lecturer in the Physics Department:

> Mr Clarke spent some time in my group just observing the technicians working on bubble-chamber pictures. I recall that we sat side-by-side for a few hours looking at film from CERN, Geneva: I tried to explain the significance of the bubble trains – their curvature and thickness and he taking notes.
>
> The resultant work was not meant to be scientifically accurate, rather an artistic impression. It shows the (nearly) straight incoming beam tracks with some typical outgoing interaction. The small spirals excited him [Clarke] more than anything else and he incorporated rather more than would normally be seen.

Condition: Good

Relief ('Bubble Chamber Tracks') was commissioned for the entrance hall of the Oliver Lodge Physics Laboratories, but was moved to its present location in the Chadwick Laboratories to make way for a porter's lodge.

The original suggestion for the decoration of the entrance hall of the Oliver Lodge Physics Laboratories was proposed on 7 March 1966 at a meeting of the New Physics Building Sub-Committee (*New Physics Building Sub-Committee Minutes*). The first idea was for a mosaic mural, similar to that already designed by Clarke and then located at the lecture room entrance to the Chadwick Building. As usual, the architect of the building (in this case Tom Mellor) was asked to consider the matter and report back. On 5 July 1966, Mellor's representative, a Mr Knowles, reported that Geoffrey Clarke, on being approached, had suggested a relief in cast aluminium, rather than a mosaic. The Committee considered an idea submitted by the artist as well as looking at photographs

of some of his related works. It was noted that Mellor and Committee member Professor Cassels (Professor of Physics, 1956 – 82) both favoured this type of art form (*New Physics Building Sub-Committee Minutes*).

The sculptor's proposed fee of £1,050, to include design, construction, delivery and installation, was considered satisfactory and the Building Sub-Committee sought approval for University funding. At the meeting of 28 November 1966, it was noted that the University Finance Committee had approved the grant and Clarke was asked to produce a maquette (*New Physics Building Sub-Committee Minutes*).

At the meeting of 27 June 1967, Mellor submitted two of Clarke's maquettes, each

measuring 12" × 9" with forward projections of about 1". The Committee members expressed some concern regarding the depth of the projections on the finished work but were assured that the projections on the maquette were not to scale. Nonetheless, they did request the removal of a projecting scroll that evidently suggested a possible hazard to passers-by and, subject to Clarke attending to this, one of the two maquettes was approved and Mellor was asked to oversee further arrangements (*New Physics Building Sub-Committee Minutes*).

In June 1968, in response to the Committee's enquiry, Clarke wrote that the relief would probably be available for erection at the end of July and, as no further reference is made to the subject, it is reasonable to assume that the sculptor met the deadline (*New Physics Building Sub-Committee Minutes*).

Literature: (i) University of Liverpool Archives – *New Physics Building Sub-Committee Minutes*: Meetings of 7 March, 5 July, 16 August, 10 October, 28 November 1966; 27 June 1967; 21 May, 25 June 1968.
(ii) Strachan, W.J. (1984): 188.

CIVIC DESIGN BUILDING, Abercromby Square

Located in the courtyard (access only by prior arrangement):

The Quickening

Sculptor: Mitzi Solomon Cunliffe

Sculpture in Portland stone
Pedestal and base in concrete

Sculpture: h: 23¹/₂" (60cms); l: 39¹/₂" (100cms); w: 22" (56cms)
Pedestal: h: 41" (104cms); l: 14¹/₄" (36cms); w: 13³/₄" (35cms)

Inscription on a descriptive plaque affixed to the pedestal: QUICKENING BY MITZI SOLOMON CUNLIFFE 1951

Owner: University of Liverpool
Status: not listed

Description: Carved from a single piece of Portland stone, the sculpture represents in broad, simplified forms, a bird resting in the palm of a colossal right hand. The single, slightly raised right wing of the bird is balanced by the thumb of the hand. The concrete pedestal is topped by a 2¹/₂" high neck, which visually separates the sculpture from the bulk of the pedestal below, giving it a floating appearance.

Condition: The stone appears to be in fair condition, although it is in need of cleaning.

The Quickening was bought in 1951, specifically for its present location, along with two other works by Cunliffe: the bronze reef knot handles of the main entrance doors and *Loosestrife* (a sculpture mounted on the back wall of nearby Studio 2).

Cunliffe's other work for Liverpool: (i) In collaboration with the Design Research Unit,

Misha Black and Robert Gutman, Cunliffe also executed decorative screens for Lewis's Red Rose Restaurant (*Echo*, 28 May 1957; *Evening Express*, 13 August 1958). The restaurant was closed down in the 1980s and the screens returned to the artist (information supplied by a representative of Lewis's in conversation with the author). (ii) Sculpture for Childwall Hall County College (see below, p. 301).

Literature: Carpenter, J., 'The University of Liverpool', in P. Curtis (ed.) (1989): 61; *Precinct* (1986) 17 January: 8; Strachan, W.J. (1984): 187.

Adjacent to THE GREEN, between the Oliver Lodge Physics Laboratories and the Chadwick Building:

Sculpture ('Three Uprights')

Sculptor: Hubert Dalwood

Three figures in cast aluminium

Each figure h: 12' (3.66m) approx.

Inscription on a descriptive plaque affixed to the front of the paved brick platform: SCULPTURE / BY / HUBERT DALWOOD

Erected 1960

Owner: University of Liverpool
Status: not listed

Condition: Good

At a meeting of the Physics Building Sub-Committee on 6 May 1958, the Chairman asked Sir Basil Spence, the architect of the new building, for his advice regarding the selection of an appropriate sculpture for the site. Spence suggested 'a competition amongst sculptors known not only in Britain but abroad as well' and added that there was, in fact, a school of

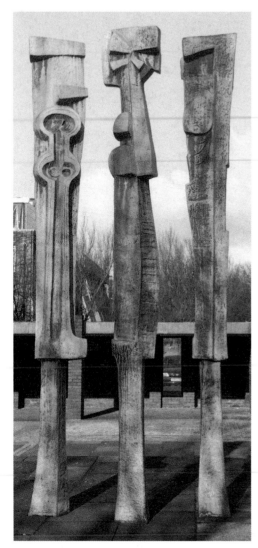

very promising young British sculptors, arguably of world class, of whom the University should avail themselves. His offer to contact half a dozen of these sculptors to find out whether they would be interested in participating in a limited competition was accepted by the Sub-Committee and in the following meeting, on 7 July 1958, Spence reported that five sculptors: F.E. McWilliam, Robert Adams, Kenneth Armitage, William Turnbull and Hubert Dalwood, had expressed interest. By December 1958, first Armitage and then McWilliam, had withdrawn through pressure of work and Robert Clatworthy and Austin Wright were then invited to enter (*Chadwick Physics Building Sub-Committee Minutes*).

The conditions of the competition, agreed at the meeting of 3 December 1958, specified that the sculpture:

> should be conceived as an integral part of the pool and layout of the garden and due regard must be paid to the background of the Physics Building tower and the single-storey blocks (*Chadwick Physics Building Sub-Committee Minutes*)

– to this end all competitors were encouraged to come to Liverpool to view the site. It was stressed that the Physics Department stood for 'the pursuit of knowledge by humanity and [that therefore] the design need not necessarily be abstract' (*Chadwick Physics Building Sub-Committee Minutes*).

The choice of material was left to the artist, but each entrant was advised to consider the industrial atmosphere the sculpture would have to withstand, and also the desirability of using the water that the proposed site provided. A maquette, 'to the scale of 1½ inches to the foot', had to be submitted by 31 March 1959, for which each entrant would receive £100, with the Sub-Committee reserving the right to request modifications to any winning design, should it be deemed necessary. In the case of the winner, the £100 would be merged into the total payment of £1,750 for the finished work. The successful entry would be commissioned by 1 June 1959 and was to be in place by 31 December 1959 (*Chadwick Physics Building Sub-Committee Minutes*).

In the meeting of 6 May 1959, the assessors (who included Spence) declared Dalwood the winner. Had Dalwood not felt himself able to complete the work for the stated sum (which included 'his fee, casting, transport, delivery, erection, builders' work and all other expenses') then the commission would have passed to the runner-up, Austin Wright. Dalwood accepted the commission and at the request of the Committee on 15 June 1959, agreed to modify the design of one of his figures. By the time of the meeting of 24 September a problem had arisen over the construction of the proposed pool and Dalwood and the architect were asked to consider a temporary alternative site (*Chadwick Physics Building Sub-Committee Minutes*).

At the meeting of 18 December 1959, the architect reported that only one of the three figures had been cast and it became obvious not only that the deadline of 31 December would not be reached but increasingly likely that the work, further delayed by the sculptor's illness, would not be ready for the official opening of the building on 29 April 1960 (*Chadwick Physics Building Sub-Committee Minutes*).

On 22 January 1960, the architect recommended from the options available, that the sculpture should be erected at 'right angles to the building in the car park by Peach Street'; in which location it was eventually erected at some (unrecorded) time after April 1960. The ornamental pool for which the sculpture was intended to be the centre-piece, was eventually constructed, but according to a contemporary account (related in correspondence to the

author by David Edwards, retired senior lecturer in the Physics Department), the pool soon became a receptacle for empty cans, etc and consequently it was filled in. Dalwood's *Sculpture* is shown in this position, but without the pool, in Willett (1967: 113). At a later (unrecorded) date Dalwood's sculpture was moved to its present site near the covered walkway to Abercromby Square, to make way for the Oliver Lodge Fire Assembly Point.

Literature: (i) University of Liverpool Archives – *Chadwick Physics Building Sub-Committee Minutes*: Meetings on 6 May, 7 July, 3 December 1958; 23 January, 12 March, 6 May, 15 June, 24 September, 6 November, 18 December 1959; 22 January, 12 February 1960; *The Chadwick Laboratory and the Laboratories of Civil Engineering and Building Science* (official opening brochure), 1960.
(ii) Davies, P. (1992): 67; Strachan, W.J. (1984): 187; Willett, J. (1967): 111, 113.

HAROLD COHEN LIBRARY, Ashton Street, designed by Harold A. Dod (of Willink & Dod) and officially opened on 21 May 1938. The Ashton Street frontage is of Portland stone with seven large windows.

Owner: University of Liverpool
Listed status: Grade II

Above the middle window is a relief:

Learning

Sculptor: Eric Kennington

High relief in Portland stone, 1938

h: 81" (206cms); 93¾" (238cms)

Description: The relief is in the form of a large open book, its edges incised into the stone of the building, the block from which the relief was carved projecting forward from the front plain of the wall. Standing against the middle of the book, with the open pages to either side of her, is a female figure dressed in a medieval-style full-length, sleeved gown and wearing a tiara. She is a head taller than the book and her long wavy hair spreads out along the tops of the pages. She bears the attributes of *Learning*: a lantern in her right hand and an enormous key, held in her left hand, its end on the ground at her left side. She stands upon the ornamental keystone of the window immediately below her.

Condition: Fair. There is some black encrustation, mostly on the right side of the figure, i.e. the sufaces facing south.

Related works: At the opening day ceremony on Saturday, 21 May 1938, the Vice-Chancellor of the University presented to Mrs Cohen, the widow of the founder of the library, two replicas of *Learning*, in the form of book-ends (present location unknown). He explained:

> ...I beg you to accept them – the one a symbol of learning and the literature to which your husband's Library is for ever dedicated; the other a symbol of the gratitude which will be for ever due to him from all those who will use it (*A Record of the Opening of the Harold Cohen Library...*,1938: 12-13).

At the meeting of the New Library Building Committee on 12 January 1937, the architect of the building, Harold Dod, reported that he had successfully approached Eric Kennington on the subject of executing a piece of sculpture over the centre window of the Ashton Street frontage of the Library for the sum of £400 (*New Library Building Committee Minutes*). Kennington subsequently carved the relief *in situ* in 1938 (Carpenter, 1989: 61).

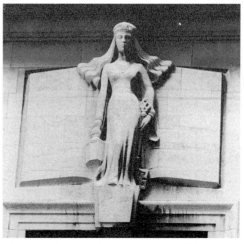

Literature: (i) University of Liverpool Archives – *New Library Building Committee Minutes*: Meeting of 12 January 1937; *A Record of the Opening of the Harold Cohen Library...* (1938): 12-13, 18.
(ii) Carpenter, J., 'The University of Liverpool', in P. Curtis (ed.) (1989): 61.

On the main staircase:

Memorial Tablet to William Garmon Jones

(1884–1937). Born at Birkenhead, Garmon Jones was Dean of the Faculty of Arts from 1916 – 20; Associate Professor of History from 1924 until his death; University Librarian from 1928 – 37 (in which capacity he modernized and greatly improved the library service); and was closely involved with the architect Harold Dod in the planning of the new library, although he died before its completion (source: Kelly, 1981).

Designer: Lionel Bailey Budden (Professor of Architecture, 1933 – 52)
Sculptor: George Herbert Tyson Smith

Bas-relief in limestone

h: 42" (106.5cms); l: 78" (198cms); d: 3" (7.5cms)

Inscription: GULIELMUS GARMON IONES /
BIBLIOTHECAE NOSTRAE PER ANNOS NOVEM
PRAEERAT LECTORUM / PRAECEPTOR
LIBRORUM CUSTOS HUMANISSIMUS ARTIUM
LIBERALIUM / CULTOR ERUDITUS OMNIUM
CELTARUM SUORUM LITTERAS / ET MONU-
MENTA MAXIMO AMORE IOVIT SUMMO
INGENIO / ILLUSTRAVIT IDEM LEGUM ACAD-
EMICARUM INTERPRES / LIBERTATIS PROP-
UGNATOR ET DEFENSOR IN NEGOTIIS /
NOSTRIS CONSILIARIUS PERITISSIMUS
SODALIS / IUCUNDUS AMICUS STABILIS ET
CONSTANS EXSTITIT / DIE XXVIII MENSIS
MAII ANNO SALUTIS MCMXXXVII ANNO
AETATIS LIII / SUBITA MORTE ABREPTUS * *
* LUX PERPETUA LUCEAT EI
– as freely translated by E.T. Campagnac:
*William Garmon Jones was for nine years our
Librarian, gentle guide of readers and loving
guardian of our books; he fostered all the arts
with learned care, but gave his mind with
supreme devotion to illumine the letters and
monuments of his native land. He was a skilful
interpreter of our academic law and regulations,
a champion and defender of our liberties, full of
wise counsel in all our undertakings. He shewed
himself a charming companion, a staunch and
true friend. May the light eternal shine on him.*
(from *William Garmon Jones*, commemorative
booklet)

Sculptor's name at bottom left: H. TYSON
SMITH. FECIT
Designer's name at bottom right: LIONEL B.
BUDDEN. INVT.

Unveiled Wednesday 29 June 1938

Owner: University of Liverpool
Status: not listed

Description: A rectangular inscription tablet
with, at left, a medallion portrait of Jones in
profile facing right.

Condition: Fair, though there is a small chip
from the lower edge of the relief. and some
graffiti.

Literature: University of Liverpool (undated, though
clearly 1938) *William Garmon Jones*, (commemora-
tive booklet)

LIFE SCIENCES BUILDING, Crown Street

In the entrance hall, outside Lecture Theatre 2
(access only by prior arrangement):

Bust of Justus von Liebig

(1803–73). Leading nineteenth-century chemist,
specialising, from the late 1820s in organic
chemistry and from 1838 onwards in biochem-
istry. Born in Darmstadt, he studied under
Kastner, gained his PhD when only nineteen
and was a professor of chemistry at the
University of Giessen by the age of twenty-
three. Although at the forefront of some of the
most important advances in his field, his most
famous achievement was the development of
the beef extract today known as OXO (source:
The Guardian [Education supplement], 17 May
1994).

Sculptor: Michael Wagmüller

Bust in marble

h: 28" (72cms); w: 19" (48cms); d: 14" (36cms)

Signed and dated on the underside of the right
shoulder:
M. Wagmüller. / München 1873

Owner: University of Liverpool
Listed status: not known

Condition: Good, but in need of cleaning

Related works: *Bust of Baron Justus von Liebig*,
marble, h. 29" (74cms), signed and dated 1873,
Department of Biochemistry, University of
Glasgow; *Bust of Baron Justus von Liebig*

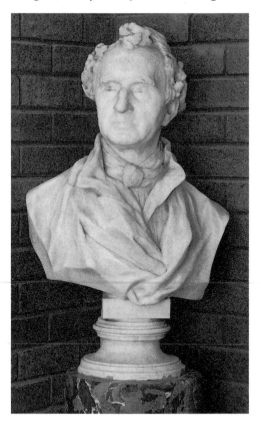

(repetition by or copy after Wagmüller of either the Liverpool or Glasgow bust), marble, h. 23¹/₂" (60cms), Department of Biochemistry, University of Cambridge; *Liebig Monument*, Carrara marble, Maximiliansplatz, Munich, commission won in open competition 1878, executed 1881-3, completed by Wilhelm von Rümann (Pecht, 1888: 305; Thieme-Becker, 1942: 26; Lieb, 1971: 307).

The University inventory label (1649) affixed to the bust (at the time of writing) states simply: 'Bust of an Unknown Man', although the academic staff of the University chemistry department have long believed it to be a portrait of Liebig. The evidence of photographs of the chemist, plus Wagmüller's other busts and the head of the figure of Liebig in the *Liebig Monument* in Munich (see above) render this identification beyond doubt.

It is possible that either the Liverpool or Glasgow bust is that mentioned by Pecht, who notes that in executing the Munich monument, the sculptor '...was indisputably favoured before all competitors because of his personal acquaintance with the famous chemist whose excellent likeness he had rendered so successfully in a bust of many years before' (Pecht, 1888: 305; translation of quotation from the original German by Imke Valentian).

Literature: Goodison, J.W. (1955): 57; Pecht, F. (1888): 305.

MATHEMATICS AND OCEANOGRAPHY BUILDING, designed by Bryan Westwood and officially opened 27 October 1961.

Status: not listed

At the Bedford Street entrance is an ***Open-Work Metal Screen and Gate***

Designer: John McCarthy

Screen and gate in cast iron, painted black

Installed Summer 1961

Owner: University of Liverpool
Listed status: as for building

Description: The design of the open-work gate and screen is derived exclusively from mathematical symbols.

Condition: There are some areas of rust, especially along the bottom rail of the screen. The paint is scuffed and blistered in places on both gate and screen.

The sculptor, John McCarthy, was selected by the architect, Bryan Westwood, to design the decorative gates and screen. On 28 September 1960 Westwood reported that they were completed and that the sculptor had agreed to store them until needed, although by 5 May 1961 the sculptor complained that the amount of room they took up in his studio was impeding his other work in progress and the University arranged to store them on site. The University paid the sculptor a total of £1,105 for the gates and screen, of which £105 was for the design and £1,000 for the execution (*Mathematics Building Sub-Committee Minutes*).

Literature: (i) University of Liverpool Archives – *Building for Mathematics and Oceanography* (official opening brochure), 1961; *Mathematics Building Sub-Committee Minutes*: Meetings on 19 May, 28 September 1960, 5 May, 5 September, 3 October 1961; 7 February 1962.
(ii) Carpenter, J., 'The University of Liverpool', in P. Curtis (ed.) (1989): 61; Davies, P. (1992): 67; Willett, J. (1967): 96-7.

Located inside the entrance hall of the Mathematics and Oceanography Building

(access only by prior arrangement):

1. *Sculptured wall relief* (facing the main entrance).

Sculptor: Eric Peskett

Relief in black concrete, before 1961

h. (estimated): 168" (426cms)*; w: 30" (76cms)
*note: the estimation of height is very approximate.

Owner: University of Liverpool
Listed status: as for building

Description: The relief, which is composed of three unequal panels, reaches from floor to ceiling and the design is based on oceanographical motifs.

Condition: Apparently good, although the top third of the relief is obscured now by a lighting gantry and the bottom portion by a fixed shelf and a bank of tables.

Bryan Westwood, the architect of the building, explained:

> Inside the main entrance hall, black sculptured concrete has been used on the wall facing the entrance doors, designed by the sculptor Eric Peskett. This gives a contrast of plain, shiny surfaces and rugged, sculptured ones (*Building for Mathematics and Oceanography*, 1961).

Literature: University of Liverpool Archives – *Mathematics Building Sub-Committee Minutes*: Meetings of 5 September, 3 October 1961; *Building for Mathematics and Oceanography* (official opening brochure), 1961.

2. *The Five-Panel Mural: 'The Growth of Mathematical Ideas'* (on the south wall of the entrance hall).

Sculptor: John McCarthy

Five reliefs of various dimensions in *terrossa ferrata*

Installed 1961

Owner: University of Liverpool
Listed status: as for building

Description: The work consists of five composite panels on the righthand wall of the main entrance hall of the Mathematics and Oceanography Building. The overall theme concerns the essence of mathematics. The main and culminating panel, *The New Era*, is above the doorway to the Forsyth Lecture Theatre. Here are represented some of the ways in which the application of pure and applied mathematics has initiated scientific and technological progress in the twentieth century. The four remaining panels depict aspects of the history of mathematics. To the left of the doorway is *The Development of Measurement*, on the wall under the stairway to the right is *The Recording of Time*, above the flight of stairs is *The Influence of Greece and Rome* and above this at the extreme right of the wall is *From Rome to the Nineteenth Century*. The architect commented:

> Their colour will contrast very pleasantly with the black concrete [of Peskett's panel], and their surface effect harmonizes with the character of the concrete elsewhere (*Building for Mathematics and Oceanography*, official opening brochure, 1961).

Condition: Good

At a meeting of the Mathematics Building Sub-

Committee in the summer of 1958, the building's architect, Bryan Westwood, recommended that one wall of the entrance hall be decorated with a design based on mathematical quotations. Professor Rosenhead (Chair of Applied Mathematics 1933-73) was asked to assess the merits of the idea. In his report to the meeting of 3 October 1958, he admitted that he had at first been attracted to the architect's proposal, but having given the matter his own full consideration and also having sought advice from other mathematicians, he had come to the conclusion that mathematics could not be

reduced to a mere set of quotations and, furthermore, expressed his concern that the result might appear 'either trite or pretentious' (*Mathematics Building Sub-Committee Minutes*).

Westwood was asked to suggest an alternative scheme and on 24 November 1959 he submitted to the Committee 'a clay model showing part of the suggested treatment for the entrance hall walls'. He explained the artistic conception and the Committee, although accepting it in general terms, suggested that the details of the proposal should be discussed with

Professor Rosenhead, presumably in the light of his earlier reservations. The fruits of this discussion were revealed at the next meeting, on 7 January 1960, in a drawing, submitted by Westwood, of revised details of the panels. The Committee approved the way the work was developing and Rosenhead undertook to continue conferring with the architect and sculptor (John McCarthy) on the rest of the scheme. At the meeting of 11 February, Westwood reported that he and Professor Rosenhead had met with the sculptor and that the Professor had supplied further guidance (*Mathematics Building Sub-Committee Minutes*).

At this point, however, the Committee expressed concern that the original breadth of the idea might be becoming lost in a welter of detail. Nevertheless, it agreed to reserve judgement pending submission of the sculptor's large-scale drawings. The Committee was also concerned about the durability of the 'clay material' in which it was proposed that the mural be executed and suggested the use of aluminium. On 9 March 1960, Westwood reported that the sculptor had accepted the Committee's reservations concerning the durability of the clay, whilst at the same time opposing the use of aluminium on the grounds that 'the utilisation of such a material would result in losing the original conception of the treatment'. With the Committee's concern for durability in mind, McCarthy supplied Westwood with a sample of a material strengthened with resin and this was approved at the meeting of 13 April 1960. Westwood also showed the Committee a sketch by McCarthy, and the Committee, having listened to Westwood's account of the work, decided that it would be useful to invite the sculptor to the next meeting to discuss the overall scheme.

McCarthy attended the 19 May meeting and submitted his large-scale drawing. Whilst accepting the drawing in general, the Committee suggested that the sculptor confer with Professor Rosenhead to clarify certain details (*Mathematics Building Sub-Committee Minutes*).

By 14 February 1961 the sculptor's work was sufficiently advanced for Westwood to submit a slide showing an assembly of some of the completed panels. On the instructions of the Committee, the sculptor made certain modifications to the arrangement and by the meeting of 8 June 1961 Westwood was able to report that the panels were virtually completed and were in the process of being crated for shipment, together with McCarthy's decorative screen and gate (see above, p. 222) (*Mathematics Building Sub-Committee Minutes*).

By 18 July 1961, the panels had been delivered to the University. On arrival, however, it had been found that twelve of the individual plaques forming the composite panels had shattered beyond repair and Westwood was instructed to request McCarthy to have them replaced as soon as possible. The replacements were completed by 5 September, while others that had been only slightly damaged had been repaired. By 3 October 1961, it was reported that the mural had been installed, barring a few further broken plaques which were yet to be replaced. At its meeting of 19 December the Committee was informed that the installation was now at last complete and, in consideration of the detailed work and extra expense incurred by the sculptor in replacing the broken plaques, increased his fee from £1,000 to £1,250 (*Mathematics Building Sub-Committee Minutes*).

Literature: University of Liverpool Archives – *Mathematics Building Sub-Committee Minutes*, (S2936), Meetings of 3 October 1958; 23 September, 24 November 1959; 7 January, 11 February, 9 March, 13 April, 19 May, 28 September 1960; 14 February, 5 May, 8 June, 18 July, 5 September, 3 October, 19 December 1961; *Building for Mathematics and Oceanography*, (official opening brochure), unpaginated, 1961; *The Five-Panel Mural in the Building for Mathematics and Oceanography*, 1961.

MECHANICAL ENGINEERING BUILDING, Brownlow Hill. Designed by Alfred Waterhouse and paid for by Sir Andrew Barclay Walker, the building was originally known as the Walker Engineering Laboratories.

In the entrance hall to the Walker Laboratories (access only by prior arrangement):

Statue of H.R.H. Leopold, Duke of Albany (1853–84), the youngest son of Queen Victoria and Albert, Prince Consort (and cousin to the sculptor of the present work). Leopold's sickly constitution precluded him from taking part in sports, but he early on showed an aptitude for literature, modern languages and music. An undergraduate at Oxford 1872 – 76 (during which time he nearly died of typhus), he graduated with the honorary degree of DCL. Always keenly interested in education, he spoke publicly for university extension, for technical education, and for the establishment of a national conservatoire of music. He was created Duke in 1881, married in 1882 and, declining health permitting, continued to promote education publicly until his death (source: *DNB*).

Sculptor: Count Victor Gleichen

Statue and base in marble

h. (excluding base): 72" (183cms)

Inscription on the front of the circular marble base: H.R.H. / LEOPOLD, DUKE OF ALBANY /

BORN 1853, DIED 1884

Signed and dated on the rear of the circular base: Gleichen Sct. / 1886.

Unveiled on the occasion of the official opening of the Walker Engineering Laboratories by Lady Walker, Saturday 2 November 1889.

Owner: University of Liverpool
Listed status: not known

Description: The Duke is portrayed in his academic gown which is bunched up over his left forearm to reveal the insignia of the Order of the Garter pinned to the jacket of his dress suit. His hair is wavy and he sports a moustache and small beard. He holds a closed book in his right hand, his place marked by his index finger, inserted between the pages. The book rests against his forward-placed right leg; on the ground behind his left foot is a pile of three more books.

Condition: The original octagonal pedestal (see illustration) is now lost and the statue stands directly on the floor. The thumb and index finger of the left hand are missing. Cleaned by Harrison Hill Ltd in 1990.

The statue was given to University College in 1889 by Sir Andrew Barclay Walker, to be placed in the Walker Engineering Laboratories (erected at his expense in 1887-89). In response, the College Principal declared that 'the interest of the Building will be enhanced by the statue, which will be suitably placed in the entrance hall' (as quoted in the University of Liverpool Art Collections archives).

At a meeting of the Engineering Committee on 27 September 1889, it was resolved that a Sub-Committee be appointed to ensure that the statue was installed in an appropriate position in the entrance hall in time for the official opening of the Laboratories on 2 November (*Engineering Committee Minutes*).

The particular significance of the statue to the University Engineering Laboratories was highlighted by Mr Shield of the Engineering Committee in his address at the official opening of the building (*Mercury*, 4 November 1889):

> The future devotee of science, on entering the portals of this building, will be reminded by the effigy of the student prince which graces it of the unvarying interest displayed by the highest in the land to the technical education of the nation, and will have recalled to his mind the efforts towards developing it that so distinguished the life of the Prince Consort and which have become hereditary in his family.

A photograph in the official commemorative album of the opening ceremony (p. 20: here reproduced) shows the statue in its original location against the back wall of the entrance hall. It stands upon a Gothic Revival octagonal pedestal, the carving of the figure enhanced by the lateral fall of light from the window to the left (cf. Chantrey's advice to the Canning Memorial Committee on the ideal lighting conditions for a statue sited indoors; see above, p. 78). In its present location at the foot of the stairs and facing into the hall, the statue is unsatisfactorily back lit and, without its pedestal, loses much of its potency.

Literature: (i) University of Liverpool Archives – *Engineering Committee Minutes*, Meeting of 27 September 1889; *The Walker Engineering Laboratories Opening Ceremony*, 1889: 9, 20.

(ii) Carpenter, J., 'The University of Liverpool', in P. Curtis (ed.) (1989): 60; *Mercury* (1889) 4 November: 6.

SENATE HOUSE, 1966-68, by Tom Mellor & Partners, with a purpose-built rostrum to the right of the building in Abercromby Square, for:

Squares with Two Circles

Sculptor: Barbara Hepworth

Sculpture in bronze on a concrete base

Bronze founder: Morris Singer

Approximate dimensions:
118" × 56³/₄" × 11³/₄" (300 × 144 × 30cms) on a bronze base 4³/₄" × 63" × 30¹/₄" (12 × 160 × 77cms)

Inscription on a plaque affixed to the front face of the concrete base:
Square [*sic*] with Two Circles / by Barbara Hepworth / Purchased with the help of the / Arts Council of Great Britain

Signed and dated on the upper surface of the bronze base: Barbara Hepworth 1964 0/3

Signed by the founders on the front face of the bronze base at left: Morris / Singer. / FOUNDERS. / LONDON.

Exhibited: Gimpel Fils, June 1964 (cat. 35), as *Maquette for a Monolith*

Owner: University of Liverpool
Status: not listed

Condition: Good

Three further copies: 1. Tate Gallery, London. 2. Rijksmuseum Kröller Müller, Otterlo. 3. Mr and Mrs R. Nasher, Dallas, Texas (as at 1971).

In a conversation recorded on 19 February 1965, Hepworth told the compiler of the Tate Gallery catalogue entry (regarding edition no. 1) that she was 'interested in the proportion of the sculpture in relation to the human figure and [thus] the apertures are placed in relation to human vision and help to give the sensation of depth.'

The Liverpool edition of *Squares with Two Circles* is numbered 'O'. The edition numbered 'O' is normally the artist's copy, but sometimes, as in this case, it is sold or presented by the artist to an institution or individual (Bowness, 1971: 29).

Towards the end of 1966, the Fine Arts and Senate House Sub-Committees examined some photographs of sculptures by Barbara Hepworth, with a view to selecting a piece to be placed in Abercromby Square, to the right of the new Senate House building. Having agreed that a piece called *Rock Form* was the most likely possibility, the Senate House Sub-Committee resolved that the Chairman, the Registrar, and the architect of the Senate House, Tom Mellor, should visit the artist in St Ives to make a specific recommendation (*Senate House Building Sub-Committee Minutes*).

In the meantime, the University Finance Committee, at its meeting of 7 February 1967, had approved the sum of £5,000 for the sculpture (£2,000 of which had been granted by the Arts Council of Great Britain on the understanding that the University raise the rest of the amount from their own resources). At a joint meeting of the Fine Arts and Senate House Sub-Committees on 11 April 1967, the delegation reported its preference for a sculpture it had seen in St Ives called *Squares with Two Circles*, and the Committee agreed that negotiations be initiated with Hepworth for this piece rather than *Rock Form*, offering the sum of £5,000, and resolving to seek the sculptor's agreement that a total of no more than three copies of the work be cast (*Senate House Building Sub-Committee Minutes*; Carpenter, 1989: 61).

On 4 May 1967, the Registrar reported the successful completion of negotiations and the Committee agreed that the sculpture should be

brought to Liverpool as soon as the roads from Cornwall cleared after the summer holiday season, so that it would definitely be available for the proposed completion date of the building in July 1968 (*Senate House Building Sub-Committee Minutes*).

By the early part of 1968, the expense of the proposed platform, specifically designed for the

sculpture, was causing concern and there was some debate as to whether or not it should be omitted. Ultimately, however, the Committee appreciated the importance of the platform to the overall design of the sculpture's environment and, notwithstanding the extra cost, instructed the architect to proceed. The platform was eventually completed by the end of 1968 and the sculpture was installed in time for the official opening ceremony of the Senate House on 15 May 1969.

Literature: (i) University of Liverpool Archives – *Senate House Building Sub-Committee Minutes*: Meetings of 30 January, 22 March, 4 May, 3 July, 20 November 1967 (incuding, as an insertion into the 1967 volume, minutes of a Joint Meeting of Fine Arts Sub-Committee / Senate House Building Sub-Committee on 11 April 1967); meetings of 30 May, 1 August, 1 October 1968; 20 January 1969. (ii) Bowness, A. (ed.) (1971): 29, 36; Carpenter, J., 'The University of Liverpool', in P. Curtis (ed.) (1989): 61-2; Davies, P. (1992): 67-8.

SYDNEY JONES LIBRARY, Chatham Street, designed and built by Sir Basil Spence, Glover & Ferguson. On the entrance ramp:

Red Between

Sculptor: Phillip King

Sculpture in steel, painted in dark metallic red gloss

h: 72" (183cms); l: 180" (457cms); w: 156" (396cms)

Exhibited: Liverpool, WAG, 'Magic & Strong Medicine', 27 July – 28 October 1973; London, Hayward Gallery, 'Phillip King', 24 April -12 June 1981; Edinburgh, Fruit Market Gallery and Princes Street Gardens, 'Phillip King, 12 Sculptures 1961-81', 26 September – 31 October 1981.

Owner: University of Liverpool
Status: not listed

Red Between is one of a series of works executed between 1971 and 1973 which includes *Blue Between* and *Yellow Between*. Pieces of steel, some of which are of pre-existing standard shape, are welded together in open groupings, unified in each case by one overall colour. *Red Between* was started in 1971 with the elements of the work arranged close to the ground. The work was then put to one side and, in 1971, King executed *Blue Between* and *Yellow Between*. The component elements were in these raised from the ground. King then returned to *Red Between* and grouped its elements higher off the ground: 'In this way, space was made to move around it, lending its

own kind of dynamic life' (Carpenter, 1978: 18-19). King wrote: 'In this work one of the more conscious aims was to use bunches of shapes in the same way that one might strike a musical chord where notes sound simultaneously' (as quoted in Strachan, 1984: 187).

Condition: The paint is scuffed, blistering and there are some areas of paint loss. *Red Between* was repainted most recently in August 1982 and May 1986 by R.G. Rome (Painting & Decorating Contractor) of Birkenhead, using primer, two coats of undercoat and two coats of finishing paint.

At a meeting of 30 September 1975, the Library Building Sub-Committee considered the architects' report, in which was expressed the

opinion that the appearance of the building would be enhanced by the presence of a piece of modern sculpture near the entrance. The Committee agreed that the installation of a sculpture would also be an attractive way of marking the official opening of the new library, and asked the architect to come back with some suggestions as to appropriate works (*Sydney Jones Library Sub-Committee Minutes*).

The architect subsequently met with Timothy Stevens, then Director of the Walker Art Gallery, and they discussed the work of a number of sculptors. By 14 April 1976 a Working Party, which included Stevens, had been formed and recommended the purchase of a major piece of abstract sculpture, preferably by Phillip King, to be located on the entrance ramp. The Committee was shown photographs of some of King's work and, with the provisoes that the work be at the same time durable and not hazardous to any local children who might be tempted to play on it, approved the choice of sculptor. Subsequently an application was made to the Fine Arts Committee to approve the necessary funding, which was estimated to be in the region of £10,000. The University could raise no more than £5,000 from its own resources, so an application was made to the Arts Council of Great Britain, which made available a grant of £4,000 (*Sydney Jones Library Sub-Committee Minutes*).

At a Committee meeting on 1 September 1977, the architect reported that the Working Party had chosen *Red Between* and that the price agreed was £9,000. He explained to the Committee:

> The sculpture will be located on the slope to the south-west and in proximity to the west stair towers where it is felt that it will link the building and landscape and maintain the integrity of the immediate environment (*Sydney Jones Library Sub-Committee Minutes*).

Red Between was purchased on 7 October 1977 (University of Liverpool Art Collection archives) and its installation (it retains its original location) was personally supervised by the sculptor (Carpenter, 1989: 62).

Literature: (i) University of Liverpool Archives – *Fine Arts Sub-Committee Minutes*: Meetings of 23 June, 13 December 1976; 15 June 1977; 24 January 1978; *Sydney Jones Library Sub-Committee Minutes*: Meetings of 30 September, 11 November, 16 December 1975; 14 April, 10 September 1976; 18 January, 2 March, 1 September 1977.
(ii) Carpenter, J. (1978): 17-19; Carpenter, J., 'The University of Liverpool', in P. Curtis (ed.) (1989): 62; Curtis, P. (1988): 56; Davies, P. (1992): 68; Scottish Arts Council (1981); Strachan, W.J. (1984): 187; *Studio International* (1974) June: 277-80.

THOMPSON-YATES LABORATORIES
designed by Alfred Waterhouse and officially opened on 8 October 1898.

Owner: University of Liverpool
Listed status: Grade II

The main bay of the frontage overlooking the north side of the quadrangle is decorated below the first floor windows with a sculptural figured bas-relief. Depicted on the bas-relief are:

Physiology and Pathology

Designer: Charles John Allen

Executed from Allen's model by J.C. Edwards of the Ruabon Terracotta works

Bas-relief in terracotta

h: 6' 5½" (1.97m); l: 16' 2" (4.93m)

Inscriptions:
– to the left of the left-hand figure:
PHYSIOLOGY
– to the right of the right-hand figure:
PATHOLOGY

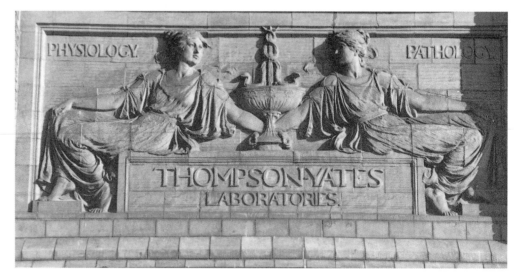

– between the figures: THOMPSON-YATES / LABORATORIES

Signed and dated on *Pathology*'s footrest: C. J. Allen 1896

Description: Two women, wearing classical Greek chitons, sit either side of a stemmed vase on the lid of which stands a staff coiled about with two snakes – the attribute of Asclepius, the Greek god of medicine. The women lean backwards and each stretches out one arm to grasp the far side of the base of the vase, their wrists crossing as they do so. At the same time they turn to face each other. Although the faces are obviously idealised, C.S. Sherrington, Professor of Physiology 1895-1913, stated that Allen modelled the personification of *Physiology* on his wife, Mrs Sherrington, and that of *Pathology* on Mrs Boyce, the wife of the Professor of Pathology (Kelly, 1981: 97).

Condition: Good, though dirt has accumulated on upper surfaces.

At a meeting of the Thompson-Yates Building Committee on 19 July 1895, Alfred Waterhouse, the building's architect, was asked to instruct C.J. Allen to prepare a design for a terracotta panel to fill the space under the South Theatre window (*Thompson-Yates Laboratories Building Committee Minutes*). By January 1896, Allen had submitted two alternative designs, one in a triple arrangement and the other a single panel. In a letter dated 30 January 1896, G.H. Rendall (Principal of University College, as the University of Liverpool then was), wrote to Waterhouse, expressing a preference for the single panel which he considered more unified in design. His description of the sketch relates closely to the finished panel: 'I like the "Pathology & Physiology" in the corners, & the central snakes & bowl' (*Private*

Letter Book). Despite the higher cost of the single panel's larger design (£200 had been estimated by Allen) and the fact that the Committee would 'have to raise from friends the amount for this piece of decoration', the prospect of having a 'finer and better' work to decorate the new laboratories, motivated the Committee's selection of the more expensive alternative (*Thompson-Yates Laboratories Building Committee Minutes*).
Notwithstanding the Principal's concern that the design might be too big to be successfully executed in terracotta, it eventually was – although not without incident. The final reference we have to the progress of the relief is in the postscript of a letter dated 20 November 1896, from A.M. Paterson (then Professor of Anatomy, writing in his capacity as Dean of the Faculty) to the architect, in which he reports that J.C. Edwards of the terracotta works at Ruabon 'has had a mishap with the heads for the Panels' and that 'new blocks are being prepared, & Mr. Allen goes over to Ruabon to inspect them on Wednesday' (*Private Letter Book*).

Literature: (i) University of Liverpool Archives – *Thompson-Yates Laboratories Building Committee Minutes*: Meetings of 19 March, 19 July 1895; 4 February, 3 March 1896; *Private Letter Book*, correspondence to Waterhouse from G. H. Rendall (30 January 1896) and A. M. Paterson (20 November 1896).
(ii) Kelly, T. (1981): 97; Carpenter, J., 'The University of Liverpool', in P. Curtis (ed.) (1989): 61.

UNIVERSITY LECTURE ROOMS
BUILDING by Robert Gardner-Medwin (Roscoe Professor of Architecture, University of Liverpool, 1952-73), in association with Saunders, Boston and Brock, 1965-67.

Owner: University of Liverpool
Status: not listed

The entrance wall is decorated with:

Abstract reliefs

Designer: David Le Marchant Brock in collaboration with
Sculptor: Frederick Bushe,

Series of pre-cast concrete panels (three to the left, eight to the right of the entrance)

Each 72" (183cms) square

Condition: The edges of the panels are chipped and worn. There are some stains and graffiti.

Gardner-Medwin, representing the architects, submitted a sketch for the relief panels to the Building Sub-Committee on 23 July 1965 (*University Lecture Room Building Sub-Committee Minutes*). The idea embodied in the sketch was that, moving inwards from the corners of the building, each successive relief would gain in complexity of abstract patterning, thereby clearly identifying the main entrance (information from Professor Gardner-Medwin in a letter, dated 17 June 1994, to the author).

Literature: (i) University of Liverpool Archives – *University Lecture Room Building Sub-Committee Minutes*: Meeting of 23 July 1965.
(ii) Pevsner, N (1969): 201; Willett, J. (1967): 112n.

VETERINARY MEDICINE BUILDING
designed by E. Maxwell Fry and officially opened October 1961.

Owner: University of Liverpool
Status: not listed

The Brownlow Hill frontage is decorated with two reliefs:

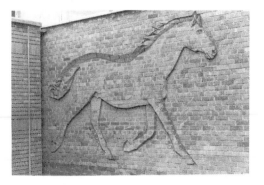

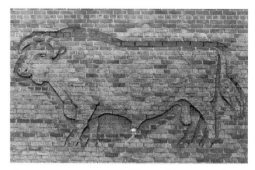

Horse
at the Paddington end of the building, opposite Crown Street;

Bull
at the Peach Street end of the building

Sculptor: Eric Peskett

Reliefs incised directly into the brick wall, 1960-61

Horse: 96¹/₂" (245cms) × 162¹/₂" (413cms)

Bull: 78³/₄" (200cms) × 154¹/₄" (392cms)

Condition: The *Horse* is in relatively good condition, although the brickwork is chipped on the nostril and along the bridge of the nose. The hoof of the *Bull*'s right foreleg is chipped and the brickwork in the area of the genitals is damaged and daubed with white paint.

Fry had suggested to the Veterinary Building Sub-Committee that appropriate low relief designs might be considered for the exterior of the building and at a meeting on 3 June 1960, the architect was asked to arrange for the sculptor, Eric Peskett, 'to submit models of possible subject matter for consideration at the next Committee Meeting'. Peskett seems to have been fully occupied throughout the summer, and the architect eventually returned on 12 September 1960 with 'two small models' of incised murals depicting a *Bull* and a *Horse*. The former was found satisfactory, but it was generally considered that the latter 'should

show more movement'. The architect was then asked to procure from Peskett some drawings showing possible revisions to the *Horse*. On 21 November 1960 he submitted three drawings to the Committee which considered them and requested one more revision. On 5 January 1961, the architect reported that Peskett would have his final illustrations of both animals ready for the next meeting on 16 March. The illustrations were duly submitted and the Committee again considered the *Horse*, making 'certain comments' which the architect undertook to convey to the sculptor. Whether these were requests for even more modifications, or thanks to the sculptor for at last producing something to the Committee members' satisfaction, is not clear. On 18 May 1961, the sculptor was report-

edly preparing his full size drawings and was expected to start work on the actual murals 'in the near future'. The incised murals of the *Bull* and the *Horse* were completed by the time of the public opening of the building in October 1961 (*Veterinary Building Sub-Committee Minutes*).

Literature: University of Liverpool Archives: *Veterinary Building Sub-Committee Minutes*: Meetings of 3 June, 26 July, 12 September, 21 October, 21 November 1960; 5 January, 16 March, 18 May 1961; *Faculty of Veterinary Science: The New Building in Liverpool* (1961): 19.

VICTORIA BUILDING Brownlow Hill. Designed and built by Alfred Waterhouse 1889-92 (access only by prior arrangement).

Listed status: Grade II

In the entrance hall, to the right:

Statue of Christopher Bushell

(1810–87). An educationist, his principal work was in the promotion and encouragement of elementary education, in which capacity he was first Chairman of the Liverpool School Board, appointed under the Forster Act of 1870, and President of the Liverpool Council of Education, from its foundation in 1874 until his death. He was also, in 1874, a founder member of the Society for the Promotion of Higher Education in Liverpool and, with William Rathbone, the first vice-president in 1881 of University College (sources: Ormerod, 1953b; Kelly, 1981).

Sculptor: Albert Bruce-Joy

Statue in Carrara Marble
Pedestal in wood

h. of statue: 84" (213cms) approx.

h. of pedestal: 41³/₄" (106cms)

Inscription on the front face of the marble base: CHRISTOPHER BUSHELL

Signed on the left face of the base towards the rear: ALBERT BRUCE-JOY SCT. / LONDON

Unveiled by the Archbishop of York in the great hall of the William Brown Free Library,

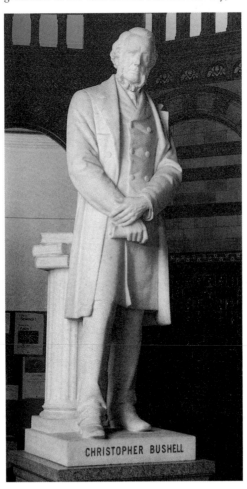

Liverpool, Friday 30 January 1885.

Owner: University of Liverpool
Listed status: not known

Description: Bushell is represented standing, his weight borne chiefly upon his left leg, his right leg flexed at the knee and placed forward. His head is inclined slightly forward and he looks contemplatively towards the right. He holds before him in his right hand some papers, while his left hand is clasped in a relaxed attitude over his right wrist. He wears an overcoat over a three-button double-breasted frock coat and a wing-collared shirt with tie. He sports side whiskers and is bare-headed, with hair brushed back. He stands before a fluted column which rises to hip height and upon which is placed a pile of three books. The original red granite pedestal, now lost, was replaced in 1986 by one of wood, 'marbled' to give the appearance of the original granite.

Condition: Fair. The statue had suffered wear and damage in the past, presumably some of which was sustained during the years of its exposure in Abercromby Square, although in 1986 it was well restored by Harrison Hill Ltd of Northamptonshire. The figure's nose, which had been lost, was replaced with a construction of polyester resin mixed with an aggregate of ground alabaster, colour-matched to the marble. Lesser areas of damage, such as the small chips missing from the hem of the coat were not replaced, as these were not considered disfiguring. Black sulphate deposits, which had accumulated in sheltered areas of the sculpture, were removed and the whole surface was invisibly coated with a compound to act as a barrier to condensation and future deposits of dirt.

Some four years before his death in 1887, it was decided to commemorate Bushell's educational

work in general and his efforts towards the establishment of Liverpool University College in particular, with the raising of a statue and the foundation of the Bushell Entrance Scholarship at the College. A voluntary subscription was set up and Albert Bruce-Joy commissioned to execute the statue. Bruce-Joy's ability as a portraitist was already known in Liverpool through his portrait busts of W.E. Gladstone and Mary Anderson, which were also at that time in the great hall of the William Brown Free Library, the temporary location of the statue from 1885 pending the completion of the University's Victoria Building in 1892 (*Mercury*, 31 January 1885).

During the course of the unveiling ceremony at the Free Library, the Archbishop of York professed that 'he had never before seen such an admirable likeness', S.G. Rathbone praised it as 'a speaking and living likeness', and the *Mercury*'s own correspondent rated it as 'almost perfect' as portraiture, and cast in a pose 'eminently characteristic' of Bushell. Furthermore, the drapery was 'natural and telling in all its details' (*Mercury*, 31 January 1885). When the Victoria Building was completed it was furnished with an entrance hall containing an apse designed specifically to receive the statue, especial thought being given to lighting conditions (Carpenter, 1989: 60).

In the late 1960s, the statue was removed from the entrance hall and placed in the open air at the rear of Staff House, Abercromby Square. It stayed in that position till the mid-1970s, whereupon it was moved into store. The statue was finally returned to the Victoria Building in 1986 (information from the University of Liverpool Art Collection archives).

Literature: (i) LRO newscutting: *Mercury* (1885) 31 January, in *TCN 1/18*.

(ii) Carpenter, J., 'The University of Liverpool', in P. Curtis (ed.) (1989): 60; Ormerod, H. A. (1953b): 10.

In the entrance hall, opposite the doorway to Brownlow Hill:

University of Liverpool War Memorial

Architect: Gordon Hemm
Sculptor: Charles John Allen

Memorial in Hoptonwood stone, with eight inscription tablets of 'ivory-coloured' French marble, and gilded ornamentation.

Max. h. of centre panel: 10' 6¼" (3.21m) (approx.)
h. of side panels: 6' 6¼" (1.99m)
w. of centre panel: 6' 11" (2.11m)
w. of each side panel: 4' 4¾" (1.34m)

Inscriptions:
– on a frieze in the upper part of the central panel:
ΟΥΔΕ ΤΕΘΝΑΣΙ ΘΑΝΟΝΤΕΣ
beneath which is the English translation: THEY DIED YET ARE NOT DEAD
– on a frieze in the upper part of the left panel:
1914
– on a frieze in the upper part of the right panel:
1919

Unveiled by Edward George Villiers Stanley, 17th Earl of Derby, Friday 13 May 1927.

Owner: University of Liverpool
Listed status: not known

Description: The *University War Memorial* is located in the entrance hall of the Victoria Building, in the large window bay opposite the main doorway from Brownlow Hill, and occupies the whole space of the bay beneath the window. It is a large triptych, effecting the appearance of an altarpiece. Ranged across the three panels are eight inscription tablets, two on each of the outer wings and four on the central panel, recording the names of the 205 members of the University who lost their lives in the First World War. Above the central panel are the arms of the University supported on each side by a putto with downcast head, holding a drooping palm branch which sweeps outwards to the edges of the panel. Ornamental details, including the arms and putti, are gilded.

Note: The *University War Memorial*, in common with many others, bears the dates 1914-1919 not, as one might expect, 1914-1918. This is because although hostilities were suspended on 11 November 1918 (Armistice Day), Britain's official 'Peace Day' Victory Parade did not take place until 19 July 1919, following the signing of the peace settlements with Germany (28 June 1919) and her allies (Boorman, 1988: 2).

Condition: Good

At the first meeting of the University of Liverpool War Memorial Committee on 17 November 1919 it was decided that the commemoration of those members of the University who had died in the First World War should take two forms. One was to be a memorial tablet, to be erected 'as soon as possible' and the other – a longer term (and, as it turned out, overly-ambitious) project – a memorial hall in which to house the tablet (*War Memorial Committee Minutes*: 29).

Almost two years passed before the Committee met again on 8 December 1921, by which time the sculptor C.J. Allen, whose connections with the University were long-standing, had been approached and had submitted alternative designs for the memorial, each with an estimated cost of 'not more than

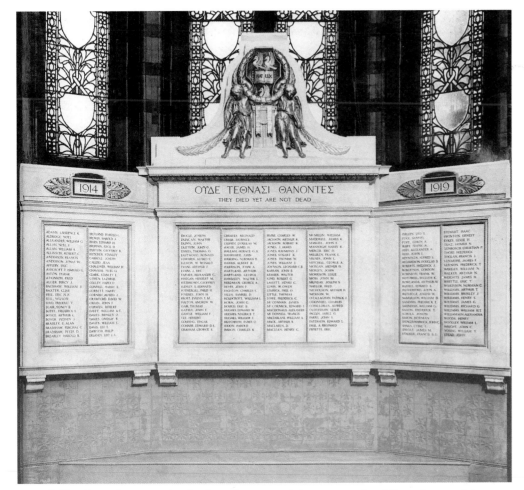

What Reilly's involvement amounted to is not known, but this is the last that is heard of him in this connection.

By 5 May 1922 the subscription had climbed to a disappointing £574. 12s. 6d. It was agreed that all efforts should be made to reach £1,500 as soon as possible and that the help of Convocation, the Old Students' Association and the Guild of Undergraduates should be enlisted with immediate effect. By this date Allen had evidently completed a model of the memorial, as it was agreed that a circular should be distributed to Committee members notifying them of the times at which it would be available to view in the sculptor's studio (*War Memorial Committee Minutes*: 112).

The next meeting was not held until after the summer vacation, on 18 October 1922. Sadly, the subscription had reached just £637. 18s. 4d. from a total of seventy subscribers. The Committee agreed that the Chairman and Clerk of Convocation, and the President and Secretary of the Old Students' Association should be 'interviewed' as soon as possible about the necessity of making greater efforts to raise more money (*War Memorial Committee Minutes*: 128).

When the situation was again reviewed on 17 January 1923, the subscribed amount had risen by less than a pound and the Committee agreed to take no further action until the result of their renewed appeals to Convocation and the Old Students' Association were known (*War Memorial Committee Minutes*: 134). Over a year passed before the Committee met again on 31 January 1924 and a mere £29. 1s. 10d. had been added to the subscription. With the realisation that the necessary funds were never going to be raised within the University, it was decided to take what must have been a desperate step and to write 'personal letters to

£1,000'. The Committee agreed to begin gathering subscriptions for the memorial tablet immediately, on the understanding that it was to be placed temporarily, pending the erection of the memorial hall, in the entrance hall of the Victoria Building (*War Memorial Committee Minutes*: 82).

Matters now began to move more quickly and the next meeting followed a month later, on 5 January 1922. Here a draft circular for the subscription appeal was considered, and amended, and the meeting was informed that Allen and the Professor of Architecture (then C.H. Reilly), were at present collaborating on 'a sketch of a proposed scheme for a memorial tablet' (*War Memorial Committee Minutes*: 88).

certain friends of the University' (*War Memorial Committee Minutes*: 150).

Two years later, and notwithstanding this extraordinary measure, the subscription had risen by only £127. 8s. od. All thoughts of a purpose-built memorial hall were evidently abandoned at this point and the entrance hall of the Victoria Building had to be accepted as the memorial tablet's permanent home. Allen was now asked 'to submit a [presumably revised and undoubtedly cheaper] design' for the tablet and to give his opinion regarding the best location for it within the entrance hall (*War Memorial Committee Minutes*: 161).

On 23 February 1926, Allen attended his first War Memorial Committee meeting. He submitted his new design for the memorial tablet, suggesting that the structure be made of 'French ivory stone' and the inset inscription panels of 'Westmorland grey slate'. He estimated the cost at £650, exclusive of fixing, and proposed 'the wall between the main entrance...and the stairs leading to the Tate library' as the most suitable permanent location for the memorial (*War Memorial Committee Minutes*: 162).

The Committee agreed to consider Allen's proposals, but obviously found his suggested location unacceptable in some way for, at the next meeting, on 12 March 1926, Allen submitted new designs, composed specifically to suit two alternative positions, one 'in the arches at the east end of the Hall' and the other 'under the oriel window'. The Committee settled for the latter position and 'generally approved' his

> model design...comprising a central and two side tablets...of French white stone relieved in gilt, with the names inscribed in black letters, the ornamentation over the central

tablet to include the Arms of the University in colour with a suitable inscription over the tablet.

The total cost, now inclusive of fixing, Allen estimated at £665 (*War Memorial Committee Minutes*: 163).

At the meeting of 27 April 1926, armed with what it was hoped would be the final list of 203 names, the Committee arranged to re-submit them to the relatives in order that any corrections might be made. The deadline for these corrections was set for 8 May 1926, as it was hoped that the memorial would be ready for unveiling on Armistice Day (11 November) of that year. The Vice-Chancellor agreed to ask Lord Derby if he would perform the ceremony in his capacity as Chancellor of the University and Allen informed the Committee that he hoped to have a 'large model' of the memorial ready for the members to view in his studio in about three weeks time (*War Memorial Committee Minutes*: 164-5). By mid-May, however, it was clear that the Committee's hopes for a November unveiling were not to be realised, for Allen advised the members that he was not able to get the stone for the memorial delivered in sufficient time to complete the work by then (*War Memorial Committee Minutes*: 166).

On 31 May 1926 the Committee met at Allen's studio and approved his full-size model. Their numbers were at this point augmented by Dr John Sampson (Librarian from 1892-1928, first to the University College and then to the University) who had already devised the Greek inscription for the central panel and was now delegated to confer with Allen on the style of lettering for the monument as a whole. It was agreed that the names of the dead (which were to be in alphabetical order, with only the first

Christian name in full), should be listed without military decorations. Lastly, Allen was asked to see if he could complete one of the panels and have it put temporarily into position during the autumn term so that the Committee could view it *in situ* (*War Memorial Committee Minutes*: 167-8).

At the meeting of 1 December 1926, the Committee, having presumably seen the sample panel in position, decided that a 'drop-light' would need to be installed in the window bay to give sufficient frontal illumination. By now the 'several portions' of the memorial had been completed and it was estimated that the Easter vacation would be the earliest convenient time to erect the memorial in the hall. With this agreed, it was resolved that a convenient day in May should be appointed for the unveiling ceremony (*War Memorial Committee Minutes*: 171).

On 18 March 1927, the Committee viewed the completed memorial at Allen's studio and, after making another inspection of the gloomy site in the Victoria Building entrance hall, evidently decided that even with the recently-installed electric light there would still be too much unfiltered sunlight coming through the window panes and silhouetting the memorial. Thus, it was decided that the existing plain glass should be replaced by 'light-coloured yellow glass' (*War Memorial Committee Minutes*: 175).

Admission to the unveiling ceremony on Friday 13 May 1927 was restricted to University staff and the relatives and close friends of the dead, plus the requisite civic dignitaries to represent the city, and the Rt Revd A.A. David, Bishop of Liverpool, to dedicate the memorial. After a service in the Arts Theatre, the company processed to the Victoria Building. The memorial had been veiled with a Union Jack and was flanked by two soldiers,

each of whom stood with bowed head, hands resting on a reversed rifle. After the unveiling and dedication, a bugler sounded the 'Last Post' and 'Reveille'. Lord Derby laid the first wreath and then the Lord Mayor of Liverpool, the Mayors of Bootle and Birkenhead, and the principal officers of the University respectfully filed past, leaving the relatives to lay their own floral tributes (*Daily Post*, 14 May 1927: 7).

The total number of University people who had served in the First World War was 1,673. By the time of the unveiling ceremony, the death toll had risen from the 203 anticipated by the Committee in April 1926 to 204, of which number 197 had been killed in action and the remainder had died as a result of their wartime injuries, in the years following the Armistice. The figure of 204 consisted of four teachers, 194 students and six employees of the University. Notably, it included two men who had been awarded V.C.s. One, Eric Frankland Bell, had been a young architect, killed half-way through the war. The second was Noel G. Chavasse, son of the previous Bishop of Liverpool, Dr F.J. Chavasse (*Daily Post*, 14 May 1927: 7), and one of only three men ever to be awarded a double V.C., the second posthumously (*Liverpool Cathedral*: 1987: 19). With yet another name added after the unveiling, the final number of wartime dead commemorated on the *University of Liverpool War Memorial* was to be 205.

Literature: (i) LRO *Photographs of War Memorials in Liverpool...*, 1923: 20a, 21.
(ii) University of Liverpool Archives – (a) manuscript source: *University of Liverpool. Minutes of Special Committees of Council*: 29, 82, 88, 112, 128, 134, 150, 161-68, 171, 175; (b) newscuttings: *Courier* (1926) 31 March, in *NC*; *Courier* (1927) 4 March, in *NC*; *Courier* (1927) 14 May, in *NC*; *Daily Post* (1927) 4 March, in *NC*; *Manchester Guardian* (1927) 14 May, in *NC*.

(iii) Boorman, D. (1988): 2; *Builder* (1927) 27 May: 842, 843; Carpenter, J., 'The University of Liverpool', in P. Curtis (ed.) (1989): 61; *Daily Post* (1927) 14 May: 7; Kelly, T. (1981): 173.

On the staircase leading from the entrance hall, on the landing between the ground and first floors:

Memorial to Charles W. Jones
(1840–1908). Wealthy shipowner, Liberal councillor, Unitarian and member of the Licensing Committee, he donated a recreation ground and sports pavilion to University College (source: Waller, 1981).

Sculptor: Charles John Allen

Triptych in coloured alabaster with, in the centre panel, an oval white marble bas-relief portrait.

h: 39½" (100cms); l: 55½" (141cms); d: 2" (5cms)
– w. of centre panel: 28½" (72cms)

Inscriptions:
– on the left wing relief on the pedestal below the scholar: HE ASSERTED / THE PRACTICAL UTILITY / OF A CLASSICAL / EDUCATION
– on the right wing relief on the pedestal below the cricketer: HE FIRST PROVIDED / THE MEANS FOR / ATHLETIC TRAINING / IN THIS UNIVERSITY
– on the centre panel beneath the portrait: at left, BORN / 1842; in the middle, CHARLES W. JONES / SHIPOWNER; at right, DIED / 1908; running beneath these inscriptions, A FOUNDER OF THE UNIVERSITY. A FRIEND OF THE STUDENT

Signed and dated on the left panel to the right

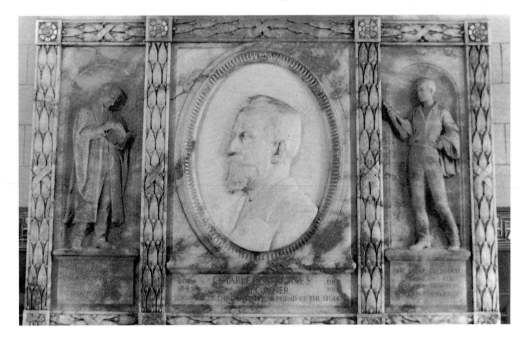

of the *scholar*'s feet, and on the right panel to the left of the *cricketer*'s feet: C.J. Allen 1910

Unveiled by Sir John Brunner, Pro-Chancellor of the University of Liverpool, Tuesday 27 June 1911

Owner: University of Liverpool
Listed status: not known

Description: The memorial is of reddish-brown alabaster and is in the form of a triptych, the centre, gabled, panel framing a white oval of marble with a relief portrait. Decorative details are picked out in gold. On the left and right wings are, respectively, a *scholar* who reads from a book held in his right hand, and a *cricketer* who holds a bat under his right arm, his left hand tucked casually into his waistband. Each stands before a niche and upon a pedestal. The pedestals carry the inscriptions relevant to the figures. The three-quarter-face portrait of Jones in the centre panel represents him facing towards the viewer's left. The individual panels are framed with bands of laurel with a rose motif at each of the corners.

Condition: Good

The memorial subscription was raised by a group consisting of Jones's colleagues, students past and present, and friends of the University. The specific purpose of the memorial was to record the nature of his personal contribution to the welfare and the very existence of the University: in the days when it was still a University College, he had been part of the movement to obtain the charter for full University status; he had been a member of the council and various of its committees for many years; and he had paid for the University playing fields and pavilion at Calderstones. According to the account of the ceremonial

unveiling in the *Daily Post* (28 June 1911), the memorial was 'greatly admired by all who inspected it'.

Literature: University of Liverpool archives newscutting: *Daily Post* (1911) 28 June.

On the staircase leading from the entrance hall, on the landing between the first and second floors:

Memorial to George Holt

(1824–96). A Liverpool shipowner, he was a leading benefactor of University College. In 1884 he donated £4,000 towards expenses incurred by the development and expansion necessary for the College to be eligible for incorporation into Victoria University; in 1891 he established the Holt Chair of Physiology with an endowment of £10,000 (plus another £5,000 for laboratory equipment); and in 1894 he endowed a similar amount to establish the Holt Chair of Pathology. In addition, he and his brothers gave Wavertree Park (108 acres) to Liverpool in 1895 (sources: *MEB*, Kelly, 1981).

Sculptor: (Sir) George Frampton

Bas-relief panel in bronze on a blue-grey marble slab

h: 48¼" (122.5cms); l: 37" (94cms); maximum d: 3¼" (8cms)

Inscriptions:
– above the head: CERTUM PETE FINEM
– below the head: GEORGE HOLT / BORN SEPT, 9TH, 1824, DIED APRIL, 3RD, 1896 / BENE-FACTOR, COUNSELLOR, FRIEND / FOUNDER OF THE CHAIRS OF / PHYSIOLOGY 1891, PATHOLOGY 1894 / QUIQUE SUI MEMORES ALIOS FECERE MERENDO
Signed and dated at the right of the panel: GEORGE FRAMPTON / 1897

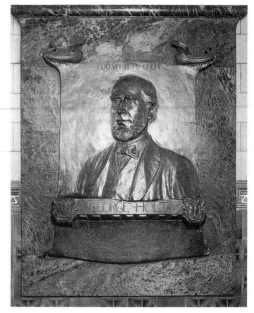

Unveiled in the Arts Theatre by Dr Gerald Henry Rendall, Principal of University College, Liverpool, Friday 6 May 1898

Owner: University of Liverpool
Listed status: not known

Description: A head and shoulders, three-quarters face, relief portrait. Holt is portrayed bareheaded, with a beard, but no moustache, and is dressed in jacket, waistcoat, shirt and bow-tie. Little 'medieval' bronze ships are placed at each of the top corners of the square sheet of bronze on which the portrait relief is modelled. They appear to stretch the top corners of the bronze square such that it resembles, perhaps, a ship's sail with shipowner Holt's portrait emblazoned on it. (Similar 'medieval' ships appear in Frampton's *Memorial to Charles Mitchell*, shipbuilder, in St George's Church, Newcastle, also of 1897.) Beneath the bronze portrait square is a

ledge inscribed with Holt's name and bounded at each end with Holt's and the University of Liverpool's crests. The effect of the portrait is enlivened by the motif of Holt's jacket and lapel slightly bulging over its top edge. Beneath this ledge is the main bronze inscription plaque. Surrounding the bronze is a rectangular, corniced, marble panel.

Condition: Good

At a meeting of the Senate of University College, Liverpool, on 22 April 1896, shortly after Holt's death, it was decided that a permanent memorial should be erected to him within the College. A working committee was duly formed, consisting of the Principal, Dr G.H. Rendall; the Vice-Principal, Professor John MacCunn; and Professors A.M. Paterson, Oliver Lodge (Honorary Secretary), and F.M. Simpson (*Senate Minutes*). The Committee met for the first time on 6 May 1896 and agreed that it would be advisable to invite the co-operation of the City Council (*Senate Minutes*). The George Holt Memorial Committee was duly formed from this collaboration with Robert Gladstone (a governor of the College) as Honorary Treasurer. The first official act of the Committee was to issue the following circular:

A committee appointed jointly by the council and senate to initiate a memorial to Mr. George Holt, and determine its most suitable form, have decided that it should be of permanent artistic value, and that it should be connected both with the college and the medical school, for which he did so much. Accordingly, they propose to provision for – (a) A bronze or silver or marble profile portrait in low relief, surrounded by a decorative border with an inscription, to be hung in some suitable place in the college;

(b) a die for a medal to be given annually to distinguished students of the medical school, having on the obverse a reduction from the portrait relief, on the reverse some other well-executed design to be settled in consultation with the artist. Desiring that the portrait should be executed in the best possible manner, the committee hope to place the work in the hands of such a man as Mr. Frampton, A.R.A., or M. Legros; and the total cost in that case could hardly fall short of £300, and might easily exceed that sum. If there were a surplus the committee would proceed to consider – (c) An endowment to provide for the expense of the annual medal, or for some other object to be decided on at a later meeting of the committee, after hearing from such of the donors as may wish to express an opinion. The committee are circulating this statement among members of the court of governors, the council, and the senate of University College, and do not propose to make any wider public appeal. At the same time, contributions will be welcomed from any personal friends who may like to take part in the commemoration... (as recorded in the *Mercury*, 17 May 1897; quoted in Stevens, 1989a: 77-8).

The Committee selected Frampton to design the memorial, which was to be the first of his solo commissions in Liverpool. The choice of Frampton over Legros may have been on the advice of Robert Anning Bell who was then teaching at the University College and with whom Frampton had collaborated on a number of works, including, in the late 1880s, a reredos for the Church of St Clare, Arundel Avenue, Liverpool (Stevens, 1989a: 75, 77-8).

The *Memorial to George Holt* was unveiled

on 6 May 1898 as Principal Rendall's last official act on the occasion of his farewell ceremony (he had resigned his Principalship in order to take up the post of Headmaster at Charterhouse). After Rendall had unveiled the memorial, Professor Lodge made a speech in which he commended the portrait as a good likeness, especially in the light of the fact that Frampton, who had not known Holt, had worked exclusively from photographs (*Daily Post*, 7 May 1898). In addition, he announced the inauguration of the annual George Holt Medal for Physiology. The medal, also designed by Frampton, is still awarded annually to students in the General and Pre-Clinical Professional Examinations (Part II) in Physiology (illustrated in Stevens, 1989a: 78).

Literature: (i) University of Liverpool Archives – *Senate Minutes*: Meeting of 22 April 1896: 193; inserted between pp. 195, 196: Minutes of the George Holt Memorial Committee meeting 6 May 1896. (ii) *Daily Post* (1898) 7 May: 7; *Mercury* (1897) 17 May: 6; *The Sphinx* (1898) May, v: 247-49; Stevens, T., 'George Frampton', in P. Curtis (ed.) (1989a): 77–8.

WHELAN BUILDING

In a niche on the first landing of the staircase (access only by prior arrangement):

Bellona (see illustration overleaf)

Sculptor: Stephen R. Hitchin

Sculpture in Portland stone
Base in dark wood
Pedestal in white-painted wood

Sculpture: h: 44" (112cms)
Base: h: 2" (5cms)
Pedestal: h: 24¹/₂" (62cms)

Owner: University of Liverpool
Status: not listed

Description: Abstract carved monolith with a flame-like silhouette

Condition: Good

Bought from the artist in May 1990 (information from the University of Liverpool Art Collection archives).

Victoria Street

Former GENERAL POST OFFICE building. Designed and built by (Sir) Henry Tanner in 1894-99 (Picton, 1875, revised edn 1903, ii: 522-3, 533), the exterior is embellished with sculpture.

(i) Seated statues of *Commerce* and *Navigation* flank the main entrance.

(ii) Ten figures, formerly on the entablature above the columns, represented the *Colonies*. The first floor was removed following damage sustained from an air raid during the Second World War.

Sculptor: Edward O. Griffith

Statues in Portland stone

Owner: untraced
Listed status: not known

Description: The figures of *Commerce* and *Navigation* are seated either side of the pediment of the main portal in Victoria Street. Within the pediment is a heraldic crest carved in high relief with seated supporting allegorical figures. The spandrels of the entrance arch below the pediment are carved with grotesque relief decoration incorporating masks, floral and fruit motifs. The spandrels are framed by youthful atlantes, forming transitional members between the entablature of the Ionic columns below and the entablature of the pediment above.

Condition: As stated above, the first floor figures personifying the *Colonies* were destroyed in an air raid. The seated figures of *Commerce* and *Navigation*, either side of the main entrance appear to be very weathered.

Literature: *Builder* (1899) lxxvii: 104; Liverpool Heritage Bureau (1978): 41; Pevsner, N. (1969): 161.

SCOTTISH LEGAL LIFE ASSURANCE building, the corner block at the junction with Whitechapel, designed by E. & H. Shelmerdine and dated 1879.

Two Allegorical Figures
representing *Industry* and *Commerce*, on the entablature at the corner of the building, between the third floor windows.

Sculptor: unknown

Statues in terracotta

h: 8' (2.4m) approx.

Owner of building: untraced

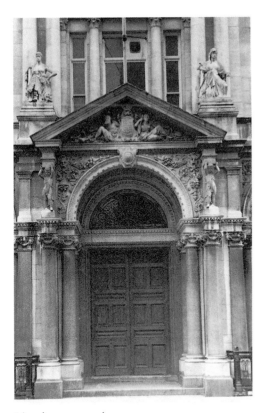

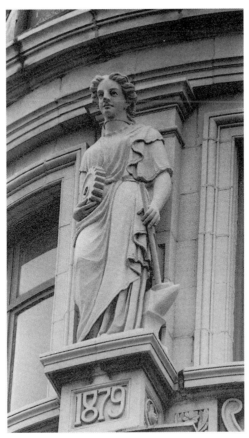

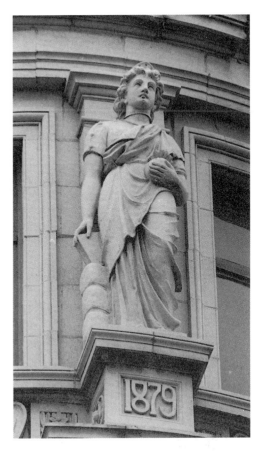

Listed status: not known

Description: Both standing figures are female and stand upon pedestals inscribed '1879'. They wear short-sleeved, full-length classical dresses. *Industry*, on the left, holds a cog-wheel in her right hand and, in her left hand, the shaft of a hammer, the head of which rests upon an anvil located on the ground at her side. The figure on the right, *Commerce*, holds a money bag in her left hand and, in her right, a ledger book which she rests upon a bale of cotton.

Condition: Both figures are grimy, but there appear to be no significant losses.

Literature: *Builder* (1880) 13 March: 312.

Water Street

INDIA BUILDINGS, by Herbert J. Rowse, in partnership with Arnold Thornely, 1923-32. The firm of Briggs & Thornely had been invited to enter a limited competition for the proposed new offices of Alfred Holt & Co, owners of the Blue Funnel Line. Briggs had recently died, however, and Thornely, being inundated with work, asked Rowse to collaborate with him on the job (*Building*, December 1930).

The building occupies an entire block on the south side of Water Street and its exterior is embellished with sculptural carving.

Sculptor: Edmund C. Thompson

Owner: Carroll Group of Companies
Listed status: Grade II

Description: The main entrance, on Water Street, consists of three arches with keystones decorated with high relief cherub heads. High above the main entrance, below the level of the top floor windows and set into a meander pattern frieze which completely enfolds the building, is a crest carved with a figure of Neptune kneeling in a scallop shell supported by two reclining Tritons. Thus, the predominant ornamental motif of the façade serves to reflect the owner's maritime commercial interests.

The main floor of the Fenwick Street frontage has seven large round-headed windows: these, like the entrance arches on Water Street, have keystones decorated with carved cherub heads (illustration at right). At either end of this line of great windows is a bay with two small rectangular windows with two rectangular panels above carved with eagle

devices and two rectangular panels below carved with crowned heads (illustration at right).

The back of the building faces onto

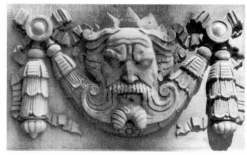

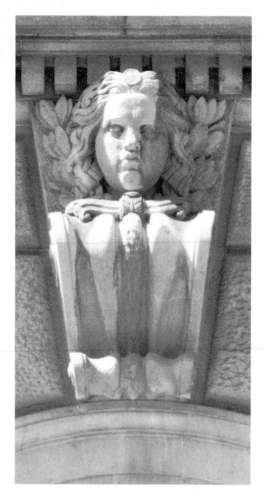

Brunswick Street. Here there is only one entrance arch, decorated with a carved cherub head. A *Neptune Crest*, matching that on the Water Street frontage is similarly set into the meander pattern.

The Drury Lane frontage matches that in Fenwick Street. Although the sculptural decoration of the building is symmetrically planned, the keystone cherub heads and relief panel crowned heads are not mechanically repeated, each being slightly varied.

Condition: The Water Street and Drury Lane frontages are in relatively good condition, having been cleaned in 1993/94. The keystone head over the back entrance arch in Brunswick Street appears eroded and is streaked with bird droppings from a nest above. The *Neptune Crest* above has black encrustations. On Fenwick Street, the seven keystone heads are generally grey in colour, the more exposed surfaces appearing very white

Related works: Plaster model for the *Neptune Crest*, private collection.

Literature: *Building* (1930) December: 528.

Former MARTINS BANK headquarters, now Barclays Bank, 4-6 Water Street. Built in 1927-32, by Herbert J. Rowse, the building occupies an entire block bounded by Water Street (front), Rumford Street and Exchange Street West (sides), and Exchange Passage West (rear). All the decorative stonework, plasterwork and ornamental metalwork was designed by George Herbert Tyson Smith in collaboration with the architect.

Exterior sculpture in Portland stone
Interior sculpture in marble and plaster
Doors in bronze

Owner: Carroll Group of Companies
Listed status: Grade II*

The unifying theme of the sculptural programme is the maritime nature of Liverpool's wealth: monetary and maritime images prevail.

The architect explained that he had chosen one sculptor only to design all the decorative enrichments in order to 'maintain unity throughout' (*The Builder*, 12 February 1932). The work was then carried out under the sculptor's supervision, by 'the craftsmen employed by the various subcontractors' (*The Architect's Journal*, 2 November 1932).

Exterior sculptural decoration:
The central sculptural feature of the Water Street frontage is a shield located above the fifth floor windows. It bears an image of the Liver Bird (for an account of the origins of which, see above, p. 130), the emblem of Liverpool used by the old Bank of Liverpool (Martins Bank was formerly styled the 'Bank of Liverpool and Martins Ltd') with, along its top, a grasshopper, derived from the family emblem of Sir Thomas Gresham (1519-79), the founder of the Royal

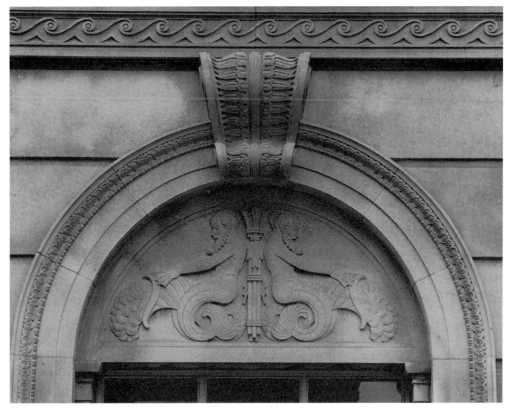

Exchange (WAG JCS files information sheet). The shield is supported by a merman and a mermaid. The Liver Bird/grasshopper device is repeated in two roundels flanking the main entrance below.

The Liver Bird also features beneath each of the thirty ground floor windows. In keeping with tradition, the Liver Bird is shown in profile, but unusually the wings are not elevated. Most of the ground floor windows are surmounted by semi-circular lunettes carrying symmetrical designs formed from two back-to-back mermaids or mermen. The bearded mermen pour out coins from cornucopiae, whilst the mermaids pour out banknotes. The mermen's beards are shaped like fish's fins, while the mermaids' hair is designed to resemble scallop shells. Between each back-to-back pair is a trident with three arrows bound around its shaft.

Over those ground floor windows and doors not crowned with lunettes are keystone heads of Midas. He wears a Phrygian cap, his asses ears showing between the side flaps. From the stylized downward-pointing cornucopiae either side of his head tumble hoards of coins.

Friezes mark the horizontal divisions of the building: beneath the entablature of the giant order in Rumford Street and Exchange Street West is a frieze of scallop shells, dolphins and tridents; further up, and entirely enfolding the building above the sixth floor widows, is a frieze of scallop shells, crabs and lobsters: again the symbolism is of the riches of the sea. The main cornice of the building is decorated with a row of Neptune's heads.

The Exchange Passage West frontage has a three-bay colonnade, the capitals of which are carved with Neptune heads and tridents.

Main entrance (Water Street):
Monumental bronze doors (each panel 9ft × 2ft) mark the main entrance in Water Street. The three jambs of the double doors are decorated with attendant females: those on the outer jambs are Viking helmeted and bear models of Viking ships, that in the centre holds a printing press. In the panels below each of these figures is a novel Tyson Smith device – the Liver Bird facing front. Hippocampi, grasshoppers, sailing ships and stylized pineapples fill the bronze frieze above. The balcony above the main entrance is decorated with three long panels of mermaids with dolphins alternated with small panels with cornucopiae.

Office entrance (Water Street):
This smaller entrance, to the left of the main entrance is surmounted by the figure of a chubby cross-legged child who holds a cornucopia in each hand and pours out sheaves of bank notes into her lap. The stone jambs are decorated with panels carved with an old man of the sea – note the webbed fingers and 'Assyrian'-shaped webbed beard. He places his hands upon the heads of two back-to-back boys holding moneybags, anchors and ropes. Either side of the old man's bald head are dolphins and

above, a grasshopper.

Side entrance (Exchange Street West):
The door jambs are each carved with a hand-maiden, dressed in a diaphanous gown, holding a large key at her side and a cornucopia above her head.

Lift lobby decoration:
The circular lobbies of both the Water Street and Exchange Street West public entrances are decorated with white-painted plaster relief panels, forming a frieze between the capitals of the eight pilasters. The pilasters are coupled, so that the frieze alternates long panels and square panels. The frieze starts above the street

entrance. Here, a large open scallop shell is filled with a pyramidal pile of money; two nude children either side each hold up a coin, whilst two others in flowing cloaks, each carrying a cornucopia full of coins, walk away to join the processions that fill the side panels and meet, appropriately, at the panel over the entrance to the banking hall, where the leaders of the procession are pouring their coins into a large sack. The procession is interrupted only by the four square panels with their stylized heaps of coins.

Condition: good

Literature: (i) WAG JCS files newscuttings: *Daily Post and Mercury* (1932) 24 February; *Daily Post and*

Mercury (1932) 4 March; *Evening Express* (1932) 8 March.
(ii) *Architects' Journal* (1932) 2 November, lxxvi: 549-53; *Architects' Journal* (1933) 11 January: 55; *Architectural Review* (1933) lxxiii: 185, 270; *Builder* (1932) 12 February: 315; Davies, P. (1992): 74; *Journal of the Royal Institute of British Architects* (1933) xl: 333; Poole, S.J. (1994): 43-44, 54, 153-66, 324, 355, 377; Stamp, G., 'Architectural Sculpture in Liverpool', in P. Curtis (ed.) (1989): 11.

TOWN HALL. See High Street.

Wavertree Botanic Gardens

Statues of *Tam O'Shanter* and *Souter Johnny* (Formerly in the Botanic Gardens, now in store)

Sculptor: James Thom

Statues in stone (see below)

Owner/custodian: Liverpool City Council
Status: not listed

Condition: Heavily eroded after many years in the open-air. Badly vandalised; both statues were decapitated in 1993.

Other versions: 1. Thom's original statues were secured for the *Burns Monument* at Alloway (Gunnis, 1951: 387). 2. Replicas at Beauport Park, Sussex (Gunnis, 1951: 388).

Some years before 1869, a Mr James Norval sold the two present statues to the Council for placement in the Museum, William Brown Street (*Council Minutes*). On 13 October 1869, the Council considered his application for the money still owed to him by the Corporation for these two statues. The Council referred the matter to the Library, Museum and Education Committee and on 1 December 1869, the Committee authorised payment to Norval of £30. It is not known when and under what circumstances the statues were moved to Wavertree Botanic Gardens.

Gunnis (1951: 387 – 88) records that Thom, a self-taught sculptor, carved statues of *Tam O'Shanter* and *Souter Johnny*, 'without so much as a preliminary sketch', from a 'local grey-stone'. So highly were they regarded that they were immediately secured for the *Burns Monument* at Alloway, first being sent on an exhibition tour (achieving critical acclaim in London in 1829) where admission charges yielded their owners a considerable profit. Richardson (1990: 65) states that the two present statues were also exhibited in Church Street, Liverpool, in 1830, with similar success. The Liverpool versions, like those Gunnis records at Beauport Park, Sussex, are presumably replicas of the originals now on the *Burns Monument*, Alloway.

Literature: (i) LRO manuscript sources: *Council Minutes*, 1/16: 426; *Library, Museum and Education Committee Minutes*, 1/7: 424.
(ii) Gunnis, R. (1951): 387-88; Richardson, A. (1990): 65.

Wavertree High Street

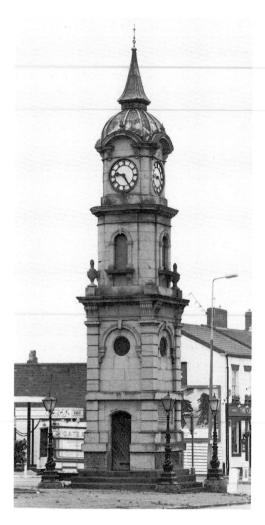

The Picton Clock

Architect: unknown

Erected by Sir James Allanson Picton, in commemoration of his wife, Sarah Pooley.

Memorial clock tower in sandstone, 1884

Inscriptions:
– West face (on a red granite slab): THIS CLOCK TOWER / DEDICATED TO THE USE OF THE PUBLIC / WAS ERECTED BY / SIR JAMES ALLANSON PICTON, / OF SANDYKNOWE WAVERTREE / IN MEMORY OF HIS BELOVED WIFE / SARAH POOLEY, / WHO AFTER A HAPPY UNION / OF FIFTY YEARS / FELL ON SLEEP FEB. 13. 1879.
– North face (on recessed panel):
Hereby we see the minutes, how they run: / How many mark the hours full complete, / How many hours bring about the day, / How many days will finish up the year. / So minutes, hours, days, weeks, months, and years, / Pass'd over to the end they were created, / Would bring white hairs unto a quiet grave.

– South face (on recessed panel):
Time wasted is existence; used is life. / – / The slow sweet hours that bring us all things good, / The slow sad hours that bring us all things ill, / And all good things from evil. Not at once, / Not all to be forgotten.

Owner/custodian: Liverpool City Council
Listed status: Grade II

Description: The clock tower is situated on a traffic island at the junction of Wavertree High Street and Church Road North. Pevsner (1969: 257) scathingly referred to it as 'thoroughly debased, in the so-called Mixed Renaissance'. There is a clock on each face of the tower and a black cast iron lamp decorated with entwined dolphins at each corner.

Condition: The surface of some of the sandstone blocks of the tower is crumbling, but all four clocks are in working order and all four lamps are intact.

Literature: Pevsner, N. (1969): 257.

Frederic Bowden Memorial Fountain
at the corner of West Derby Road and Baker Street. Frederic Bowden (1825 – 1911), a hide and leather merchant, arrived in Liverpool from Devon in 1843. In 1871 he joined the Committee of the Liverpool Dispensaries, served as Treasurer and was elected President in 1900, a post which he held until he died. He also served on the RSPCA Committee from 1878 – 94 and was Chairman from 1894 – 1903. He is buried in Anfield Cemetery (source: Richardson, 1990).

Architect: R. Wright

Drinking fountain in polished red Peterhead granite
Inscription plaque in bronze
Water outlet fittings (missing) in iron

Stonework contractor: Scott & Rae of Glasgow
Lion head water spout (missing): W. McFarlane of Glasgow

Inscription on a bronze plaque above the basin:
FREDERIC / BOWDEN / OF / NORTH DEVON / AND WEST DERBY / – / THIS FOUNTAIN IS A / COMMEMORATIVE GIFT / TO THE CITY OF / LIVERPOOL / FROM HIS DAUGHTER / MRS. HUGH McCUBBIN / 1913

Below the basin, on the left:
DESIGNED BY / R. WRIGHT ARCHT.
– and on the right:
SCOTT & RAE / SCULPTORS GLASGOW

Inaugurated Wednesday 9 July 1913

Owner/ custodian: Liverpool City Council
Listed status: Grade II

Description: Edwardian Baroque style drinking fountain

Condition: Extensively damaged. The entire balustrade to the left of the three steps leading up to the basin is lost. The lower three balusters

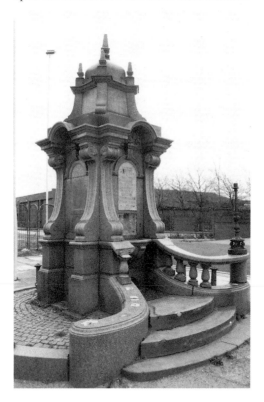

(of seven) of the right balustrade are missing. The metal plate and lion head water spout are missing. There is some graffiti.

Related work: *Thomas Bowden Memorial Fountain*, 1911, Mill Bank (see above, p. 113).

The *Frederic Bowden Memorial Fountain* was erected by Mrs Lillie Elizabeth McCubbin in memory of her father who had died 1 May 1911 (Richardson, 1990: 43). The fountain was formally accepted by Councillor Muirhead on behalf of the City on 9 July 1913. Mrs McCubbin was herself presented with a silver cup as a souvenir of the occasion by Mr Taylor of the contractors (*Courier*, 10 July 1913).

Amongst the speakers was Councillor W. H. Parkinson of the Health Committee, who reminded those present of Frederic Bowden's philanthropic work. The fountain, he said, would supply 'a long felt want in the district' (*Courier*, 10 July 1913).

These were tragic times for Mrs McCubbin. Within the space of four years her mother, father, brother and husband had all died (Richardson, 1990: 43). Earlier that year, on 9 January, she had funded the building of West Derby Village Hall as a memorial to her late husband (died 25 September 1911) and two years previously she had commissioned the *Thomas Bowden Fountain* at Mill Bank, in memory of her late brother (see above, p. 113).

Literature: LRO newscutting: *Courier* (1913) 10 July, in *CH&T 14*: 199.
(ii) Richardson, A. (1990): 41-2.

West Derby Village
Richard Robert Meade-King Drinking Fountain: *Village Cross*. See Almonds Green

Whitechapel

Post Office War Memorial
in the main hall of the Post Office, 23-33 Whitechapel (formerly at Victoria Street: see p. 238).

Sculptor: George Herbert Tyson Smith

Statue in Echaillon limestone
Pedestal in Westmorland greenstone with inlaid panels of green slate

Statue: h 52" (132cms)
Base of statue: w 24¹/₄" (61.1cms); d 28¹/₄" (71.3cms)
Pedestal: h 53¹/₂" (135.9cms)
Plinth of pedestal: w 32¹/₂" (82.5cms); d 36¹/₂" (92.7cms)

Inscriptions on the pedestal:
– on the front face of the dado: IN HONOUR / OF THOSE MEMBERS / OF THE LIVERPOOL / POST OFFICE STAFF / WHO FELL IN THE / GREAT WAR / 1914 – 1918
– on the rear face of the dado: *They died for us: / they left this blessed fortune of the light / And gave themselves to darkness, / to our love returning never. / But lo, presiding over us / like stars over the night / Quiet and lovely and supreme / lives their death for ever. / Lascelles Abercrombie*
– on the left and right faces of the dado, in three columns, are the names of the 156 Post Office employees who fell in the First World War.

Signed on the right-hand face of the base of the statue towards the rear: H. TYSON SMITH / SCULPTOR

Unveiled by T.P. O'Connor, M.P., in the main hall of the General Post Office, Victoria Street, Sunday 15 June 1924.

Owner: The Post Office
Status: not listed

Description: The memorial stands in the centre of the hall, facing the counters. It consists of a white limestone statue of an enthroned female figure in antique Greek costume mounted on a greenstone pedestal. The figure represents Britain mourning her dead, her head solemnly lowered, her chin resting on the knuckles of her right hand. Upon her right knee and supporting her right elbow is an antique Greek crested helmet. Her left arm lies along the throne's scrolled arm rest. Between the fingers of her left hand she holds the stem of a downward-hanging poppy, below which, leaning against the throne, is a wreath of poppies. A cloak, draped over the figure's right shoulder, passes over the righthand back corner of the throne and, hanging down the rear leg, reaches almost to its foot. Against the left-hand side of the throne leans a circular shield decorated with a winged Victory bearing a trumpet and a palm of victory. The throne is semi-circular backed with two rear legs in the form of pilasters terminating in lion's paw feet. It is decorated on the right-hand side with a relief of a crouched, roaring lion and, on the back, with a relief of two sphinxes facing each other, either side of a central tripod. The pedestal is of classical design, with a wide overhanging cornice, inset inscription panels on each face of the dado and festoons decorating the plinth.

According to Mr T.P. O'Connor (speaking at the unveiling ceremony) the poppy held in the figure's hand served as 'an eloquent

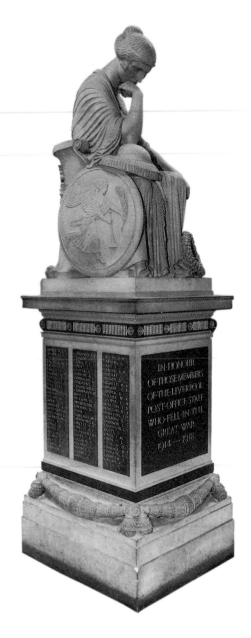

reminder...of those Flanders fields of poppies where so many of our dead lie'. He also observed that though the figure's face bore 'the marks of grief', there was 'in her expression...no trace of rancour or vengeance, but rather the spirit of calm reflection and meditation' (*Daily Post and Mercury*, 16 June 1924). The statue is typical of Tyson Smith's severe antique Greek style, concerned more with an abstract architectonic unity than with verisimilitude. Kineton Parkes (1927: 154) aptly described the design of the memorial as 'square, compact and scholarly'. Poole (1994: 100, 104) has pointed to the statue's debt to such antique Greek sources as the *Mourning Athena* relief, c.470BC (Athens, Acropolis Museum, 695. H. 0.48), and the *Stele of Hegeso*, c.400BC (Athens, National Museum, 3624. H. i.58).

Condition: Generally good. A small chip is missing from the rear left corner of the throne where the decorative entablature breaks forward over the leg. The scroll of the arm-rest on the left side of the throne is also chipped. Another small chip is missing from the upper edge of the front face of the statue's base. There appear to be old repairs at the junction of the base of the statue and the pedestal, perhaps when the statue and pedestal where separated at the time of the removal from the old Post Office at Victoria Street.

Related works: (i) *Grief – Model for Liverpool Post Office War Memorial*, plaster, h. 13¹/₂" (35cm), WAG cat. 8811; (ii) *Model for the base of the Liverpool Post Office War Memorial*, plaster, 13³/₄" × 9¹/₄" × 8¹/₄" (34.6 × 23.1 × 21cm), WAG cat. 8814.

According to Kineton Parkes (1927: 154), Tyson Smith followed his usual practice for the female figure in the *Post Office War Memorial*,

working directly from a small-scale sketch (see 'Related Works', i, above), without the aid of a full-size model. The small-scale sketch was begun without recourse to a living model, Tyson Smith preferring to draw on his accumulated 'knowledge and custom'. A life model would have only been used had the sculptor found a gap in his recollection as the model progressed. A fundamental reliance on imagination rather than observation imparted, in Tyson Smith's view, 'a personal touch and selection...apt to be lost if the living model is used from the first and in every case'.

The unveiling ceremony was evidently a moving and well-attended affair, conducted in the main hall of Liverpool Post Office, Victoria Street. At the time of the First World War, 3,000 men and 1,200 women were employed by the Post Office service in Liverpool and district. Of this number, 1,800 men and 30 women had served in the war. The *Post Office War Memorial* was erected by the employees of the Post Office to commemorate their 155 male colleagues and one female colleague (Miss E.H. Routledge, a telegraphist with the W.A.A.C.) who had lost their lives, all of whose names are inscribed in gilt on the lateral faces of the pedestal (*Daily Post and Mercury*, 16 June 1924).

Speaking at the unveiling ceremony, the Bishop of Liverpool (A.A. David), struck a fervently patriotic note when he referred to the way in which the recent abundance of memorials to the dead of the Great War had manifested such a 'glory of the human spirit' as had hitherto been associated only with the more 'spacious days' of English history. The noble and heroic self-sacrifice of those commemorated should, he felt, 'give to us, and to those who came after us, a fresh and tremendously encouraging estimate of human nature', suffi-

cient to impart renewed impetus to the work of building 'a better world' (*Daily Post and Mercury*, 16 June 1924). In a more sombre but no less patriotic tone, T.P. O'Connor, M.P., spoke of the 'nightmare of the past and...the moments of grave anxiety and loss' made tolerable only by 'the conviction that we were fighting for a righteous cause'. The memorial, however, expressed neither 'rancour or vengeance', but 'calm reflection and meditation'. The commemorated dead, 'of all creeds' and from 'many parts of the Empire', had fought and died for the same just cause and thus their enumeration served to 'proclaim the lesson of national concord and unity' (*Daily Post and Mercury*, 16 June 1924).

O'Connor evidently approved of the design of the memorial, considering it 'worthy of the great events it was meant to symbolise and perpetuate'. Another admirer was George Whitfield (1927: 309) who noted enthusiastically that 'in [the *Post Office War Memorial*] the development of realism through classical severity reaches a stage in which the immobile stone seems warmed with human sympathy'. Professor C.H. Reilly (Roscoe Professor of Architecture at the School of Architecture, University of Liverpool), who had been called in as an expert advisor by the Post Office War Memorial Committee, was also impressed by the figure, although somewhat critical of the pedestal. He was later to write:

> Probably the last public monument in this part of the world is the best, and it is not as well known as it should be. It is the seated limestone figure of Grief...This figure...has almost the intensity which is to be found in archaic Greek work. It is dignified and restrained, full of real feeling in place of soft sentiment. The pedestal, inlaid with panels of

green slates with lettering and fluting in gold, is beautiful in itself, but possibly a little too rich and complicated. It contains the finest dedication on any war memorial I have seen, and the words are by the Liverpool poet,

Lascelles Abercrombie, now Professor of English Literature at Leeds...' (Reilly, 1927a: 3)

Literature: (i) LRO: (a) *Photographs of War Memorials in Liverpool...*, 1923: 16,17; (b) George Herbert Tyson Smith Archive, Boxes 7, 33.

(ii) Compton, A., 'Memorials to the Great War', in P. Curtis (ed.) (1989): 88; *Courier* (1924) 16 June 1924; *Daily Post and Mercury* (1924) 16 June; Davies, P. (1992): 72-3; Parkes, K. (1927): 154, 155; Poole, S.J. (1994): 100-4, 373; Reilly, C.H. (1927a): 3; WAG (1975): 29; WAG (1981): cat. 182; Whitfield, G. (1927): 309.

Whitley Gardens See Shaw Street.

William Brown Street

LIVERPOOL JOHN MOORES UNIVERSITY. See Byrom Street.

PICTON REFERENCE LIBRARY and Hornby Library. The Picton Library was designed and built by Cornelius Sherlock between 1875-79.

Owner: Liverpool City Council
Listed status: Grade II*

The building is a domed rotunda sandwiched between the William Brown Library and the Walker Art Gallery. The semi-circular Corinthian portico that faces onto William Brown Street has a series of niches. In three of the niches are statues:

Jeanie Deans, The Lady of the Lake, and *Highland Mary*.

Sculptor: Benjamin Edward Spence

Plaster models, painted with bronze pigment, from which copies in marble were carved.

Owner/ custodian: Liverpool City Council
Listed status: not listed

Following Benjamin Edward Spence's death, his wife instructed the executors of her husband's estate to offer the collection of his plaster works to the Corporation of Liverpool for the cost of packing and transporting them from his studio in Rome. In a letter to (Sir) James Allanson Picton of the Library, Museum and Education

Committee, dated 26 March 1870, the executors list the sculptures as follows:

Life-size figures: *Lady of the Lake, Jeanie Deans, Lavinia, Rebecca, Highland Mary, Boy and Kid, Ophelia, Flora Macdonald.* Groups: *Angel's Whisper, Hector and Andromache, Oberon and Titania, The Finding of Moses. (Library, Museum and Education Committee Minutes)*

By 21 July 1870, the sculptures had all arrived safely at the William Brown Museum and had been set up in the great hall. Picton wrote to Mrs Spence, thanking her profusely for the gift and expressing the hope that 'they may remain [here] to hand down to future generations the

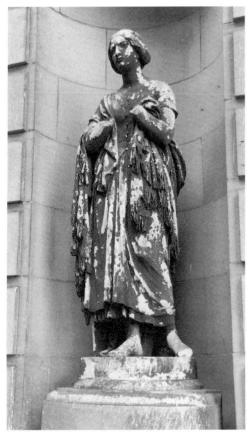

Literature: (i) LRO manuscript source: *Library, Museum and Education Committee Minutes*, 1/8: 17, 20, 74, 75.
(ii) WAG JCS files newscutting: *Echo* (1939) 6 July.
(iii) Picton, J.A. (1875, revised edn 1903), ii: 218; Stevens, T. (1971): 231.

1. *Jeanie Deans*

Sir Walter Scott's gentle heroine from *The Heart of Midlothian* (1818), one of the Waverley Novels. The central part of the story is Jeanie's journey to London on foot in order to appeal to the Duke of Argyle on behalf of her sister Effie who had been wrongfully charged with child murder. The sculpture presumably shows Jeanie on part of her journey.

h: *c*. 65" (165cms)

Description: Located in the niche at the extreme left, *Jeanie Deans* is a standing full-length figure walking forward, her weight moving onto her right foot. She is dressed in skirts, bodice and tartan shawl.

Condition: The statue is in very poor condition: both hands are missing as are the toes of the left foot; the heel of the left foot is broken off and lying loose on the base. The bronze colouring is chipped and worn away in many places.

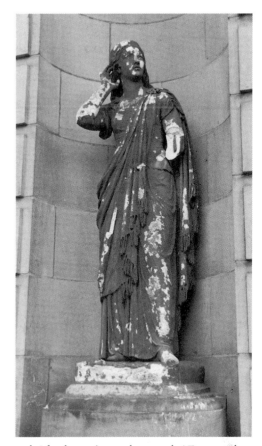

memory of the Artist and excite others to pursue a similar course of honourable ambition to excel...' (*Library, Museum and Education Committee Minutes*)

At some time in the past, six of the standing figures were moved outside to the niches around the rotunda. During the course of a riot in 1921, three (unspecified) figures were destroyed (*Echo*, 6 July 1939). Out of the entire collection of twelve sculptures, only the three standing figures presently in the niches remain.

2. *The Lady of the Lake*

h: 65" (165cms) (estimated)

Description: *The Lady of the Lake* is located in the niche to the left of the main entrance. The idea for the statue comes from Sir Walter Scott's poem (1810) of the same name, set in Scotland during the reign of James V (1513-42). It is based on the following lines:

But scarce again his horn he wound, / When lo! forth starting at the sound, / From underneath an aged oak, / That slanted from the islet rock, / A damsel guider of its way, / A little skiff shot to the bay, /...The boat had touched this silver strand / Just as the Hunter left his stand, / And stood concealed amid the brake / To view this Lady of the Lake. / *The maiden paused, as if again / She thought to catch the distant strain. / With Head upraised, and look intent, / Her eye and ear attentive bent. / And locks flung*

back, and lips apart, / Like monument of Grecian art, / In listening mood, she seemed to stand / The guardian Naiad of the strand.

The figure's left hand is now missing, but the engraving published in the *Art Journal* (1863: 188) shows that it once held one of the oars of her skiff. The engraving also reveals that the shawl worn by the Lady was decorated with a tartan pattern. The marble carved from this plaster model was a royal commission (see 'Related Work', below).

Condition: The statue is in very poor condition: the left elbow is damaged, there is some loss of the bronze colouring and the plaster is crumbling in places.

Related work: marble version, 1863, Balmoral, Royal Collection

Literature: *Art-Journal* (1863): 188.

3. *Highland Mary*
The sobriquet of Mary Campbell, one of Robert Burns' lovers, immortalised in his song, 'The Highland Lassie O' (see also p. 206).

h: 65" (165cms estimated)

Highland Mary is located in the niche to the right of the main entrance.

Condition: The statue is in very poor condition: all the toes of the right foot are missing and the bronze colouring is chipped and worn in many places.

Related works: marble copies –
1. Commissioned by John Naylor post 1852, WAG cat. 6585. 2. Commissioned by the Prince Consort 1854, Osborne House, Royal Collection. 3. Sefton Park, now in store (see above, pp. 206-7).

Literature: *Art-Journal* (1852): 312; Picton, J.A. (1875, revised edn 1903), ii: 218.

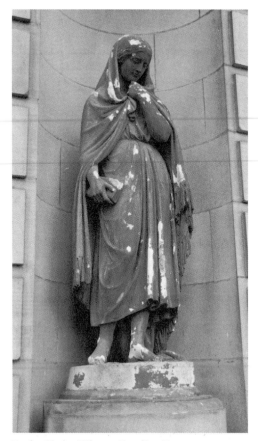

In the Picton Library Reading Room:

Bust of Sir James Allanson Picton
(1805–89) antiquary and architect, knighted in 1881. He entered the Town Council in 1849; was a member of the Wavertree local board from its commencement, becoming Chairman in 1851. He devoted himself to the foundation of the free public library and museum, for which (Sir) William Brown provided the building (the Corporation adding the Picton Reading Room in 1879) and he was the first Chairman of the Library and Museum Committee from its inception in 1851 until his death. He was also an active promoter of the Liverpool Mechanics Institute. His principal literary work was his two-volume *Memorials of Liverpool* (1875, revised edn 1903) and his Liverpool architectural commissions include Hargreaves Building (1861) (see above, p.18) and the critically acclaimed Richmond Buildings (1861; demolished 1967) (source: *DNB*).

Sculptor: John Alexander Patterson MacBride

Bust in marble

h. with pedestal: 27¼" (69cms)
h. of bust alone: 22¼" (56.5cms)

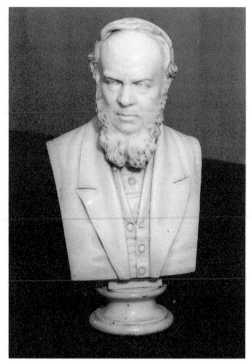

Unsigned

Description: Picton is portrayed wearing jacket and waistcoat with a bow-tie. He has a beard without moustaches and is bald at the crown with hair brushed over the patch. The pupils of his eyes are incised; he looks to his right.

Condition: Good

Literature: Picton, J.A. (1891): 345.

In the entrance hall to the Hornby Library, designed by Thomas Shelmerdine and officially opened Friday 26 October 1906:

Bust of Hugh Frederick Hornby

(1826–99). Active in the family business (H. & J. Hornby & Co. of Brunswick Street) Hugh Frederick Hornby was also a Commissioner of Taxes. Nevertheless, he took little part in public life, devoting much of his time to his cultural and philanthropic interests. He was a member of the Liverpool Philharmonic Society from its inception and a trustee until his death. He also served on the Committee of the Liverpool Sailors' Home. In his will, Hornby bequeathed to the people of Liverpool his collection of nearly 8,000 rare books and numerous prints, along with the sum of £10,000 with which to erect a suitable building in which to house them (sources: Carpenter, 1993; *Courier*, 27 October 1906).

Sculptor: Charles John Allen

Bust in white marble
Pedestal in white marble with green marble panels

h. of pedestal: 48¹/₂" (123cms)
h. of bust including base: 32¹/₂" (82.5cms)

Inscription on the front face of the base: HUGH FREDERICK HORNBY

Signed and dated on the back of the bust: CHAS J. ALLEN / SCULPT. 1906

Unveiled by Henry Hugh Hornby (cousin), Friday 26 October 1906, at the official opening

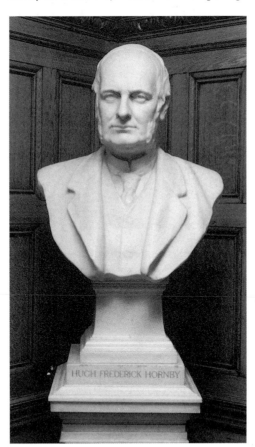

of the Hornby Library.

Owner: Liverpool City Council
Status: not listed

Description: Located in the entrance hall to the Hornby Library, the bust is mounted on a term-shaped pedestal of white marble, inlaid with green panels. Hornby is portrayed with side-whiskers and wearing a jacket and waistcoat, with a wing-collared shirt and tie.

Condition: The incised pupils contain a white cement-like substance. The general condition is good.

In his address at the unveiling ceremony, Henry Hugh Hornby marvelled at the likeness achieved by Allen who, never having seen the subject, had worked solely from photographs. Hornby thought it 'an excellent bust...a wonderful success' (*Courier*, 27 October 1906).

Literature: (i) Liverpool Public Library information sheet: Carpenter, J. (1993) *Bust of Hugh Frederick Hornby*.
(ii) *Courier* (1906) 27 October: 9.

Inside the Hornby Library:

Bas-relief: *Alexander the Great Ordering the Works of Homer to be Placed in the Sarcophagus of Achilles*

Sculptor: John Gibson

Bas-relief in terra-cotta, painted black, mounted on a slate panel and set into a wooden frame.

Bas-relief only: 9³/₄" × 21¹/₄" (24.75 × 54cms) – including wooden frame: 15³/₄" × 26" (40 × 66cms)

Signed and dated on the base of the sarcophagus: RAPH. DIS. I GIBSON. F. 1810

Owner: Liverpool City Council

Status: not listed

Description: The relief stands upon a low book-case inside the Hornby Library, to the left of the entrance. Alexander the Great is represented, left of middle, helmeted and wearing a cloak over his armour, his position of authority indicated by the commander's baton held in his right hand. At his order a servant is placing a book into a sarcophagus. Six soldiers flanking Alexander react with gestures of amazement. On the right a servant, nude but for the cloak over his shoulder, is holding the sarcophagus lid open, whilst three men look eagerly into the sarcophagus and three more echo the gestures of amazement from the other side. The relief is based on an engraving by Marcantonio Raimondi (see below) after the Raphael grisaille fresco (reversed) below the *Parnassus* in the Stanza della Segnatura (1508-11) in the Vatican.

Condition: Generally good. The panel appears to be undamaged, but the black colouring is worn away on the areas of higher relief, particularly from the head of the nude male lifting the sarcophagus lid.

According to Gibson's own account as transcribed by Lady Eastlake (1870: 29 – 30), William Roscoe called in one day at the firm of Messrs Franceys, where Gibson was working as an apprentice, to order a chimney piece for the library of his home at Allerton Hall. Gibson was introduced to Roscoe who was impressed by his work, and the young sculptor was consequently given the job of executing a bas-relief for the centre of the chimney piece. Roscoe specified the subject, lending Gibson a print

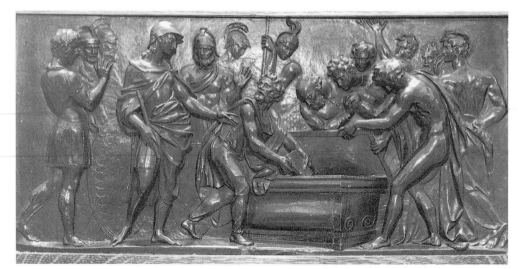

from which to copy his composition, explaining that it was by Marcantonio Raimondi after a grisaille in the Stanza della Segnatura by Raphael, which Roscoe called 'Alexander ordering Homer's "Iliad" to be placed in the casket taken from Darius'. He also specified that it should be in terra-cotta (as opposed to marble).

Gibson completed the work, though it is not known whether the chimney piece was ever installed. At Roscoe's death it was bequeathed to the Liverpool Royal Institution (WAG, 1960: 13).

During the Second World War, the trustees of the Liverpool Royal Institution handed over the building for use as a Services Quiet Club. In 1942, the secretary of the Club, assuming the relief to be made of 'non-ferrous metal', considered sending it away for salvage to help the war effort. However, J.F. Smith, the City Librarian, consulted Sir Sydney Jones (the last trustee of the Institution before it was taken over) and, realising that not only was it not of non-ferrous metal, but that it was of considerable artistic significance, had it removed to the Central Libraries. It was subsequently mounted in its present wooden frame by W. Moran and put on display in the Hornby Library, where it remains to this day (information from the transcript of a hand-written note by J.F. Smith, supplied by Liverpool Public Library).

Literature: (i) Liverpool Public Library: transcript of a hand-written note by J.F. Smith, former City Librarian.
(ii) Eastlake, Lady (1870): 29-30; Matthews, T. (1911): 11-12; WAG (1960): 13.

ST GEORGE'S HALL

represents perhaps the consummation of the neo-classical architectural style in Britain. Certainly it is the grandest and most impressive public building in Liverpool and David Watkin has gone so far as to describe it unreservedly as 'the finest neo-classical public building in Europe' (Watkin, 1974: 238). It is, in fact, the conflation of two separate building schemes, projected for widely different purposes, namely a concert hall and two assize courts.

During the 1830s there was a growing conviction among an influential group of citizens that Liverpool should have a concert hall specifically designed for its Triennial Music Festivals, the proceeds of which were donated to public charities. The Festivals had, since their inception in 1766, been held in St Peter's Church (Picton, 1875, revised edn 1903, ii: 155-56), although in recent years their increased popularity had resulted in severe difficulties accommodating the large audiences now wishing to attend them. The programme was essentially of choral music, focussing invariably on oratorios such as Handel's *Messiah* and Haydn's *The Creation* and, in line with nineteenth-century taste, involving extremely large choral forces with organ accompaniment: thus the determining factor in the design of the hall was to be the suitably grand accommodation of choir and organ, plus a sizeable audience.

In the autumn of 1836 the Mayor was persuaded to hold a public meeting to consider the matter. There seemed to be sufficient support to suggest that the concert hall could be funded by public subscription and accordingly a committee was elected to organise it. By January 1837, £25,350 had been raised and, although a specific location had not yet been proposed, it was agreed that the projected building be called St George's Hall (Knowles,

1988: 4). Later in the same year the committee applied for part of the recently-available site on the Plateau where had formerly stood the Old Infirmary (rebuilt in 1824 in Brownlow Hill). On 28 June 1838, in spite of the fact that the building had not yet been designed, but rather to mark the coronation of Queen Victoria, the foundation stone was laid by the Mayor, William Rathbone (the fifth of that name, commemorated in Sefton Park, see above, pp.186-90). In March 1839 a competition was launched, over eighty designs were submitted, and in July the winning entry was declared to be that of a relatively unknown young architect, Harvey Lonsdale Elmes (1814-47).

Shortly after Elmes' appointment as architect of the concert hall, the Corporation decided to allocate an adjacent portion of the Plateau to the erection of the city's new Assize Courts. In 1840 another competition was launched, again more than eighty entries were considered and again, remarkably, Elmes won. At about this time it was becoming evident to the St George's Hall Committee that the likely level of subscriptions was going be insufficient to meet the cost of the grandiose design it had chosen. Consequently, the members suggested to the Corporation that the concert hall and assize courts might be incorporated in one large building. On 27 October 1840, the Corporation Law Courts Committee met with the St George's Hall Committee to consider the proposal. Elmes' revised, combined design was approved and the two parties agreed to share the cost of erection. On 30 January 1841, however, the Corporation agreed to assume overall responsibility, both for the cost of erection, which ultimately exceeded £300,000, and of the building's future management (Knowles, 1988: 6).

In 1847, with the building only half-

completed, Elmes died of consumption. His successor, Charles Robert Cockerell (1788-1863), had been engaged upon various aspects of the building's erection from an early stage, most notably in his capacity as designer of the sculptured pediment of the south portico (see below, p.305). Although Cockerell remained faithful to Elmes' overall design, it is unquestionably due to him that there is such a contrast between the austerity of Elmes' Graeco-Roman temple exterior and the sumptuousness of the interior, remodelled by Cockerell in the style of a Roman public bath, most likely the Baths of Caracalla, an illustrated account of which had been published by G. Abel Blouet in 1828 (Watkin, 1974: 238). What is of importance in the present context is that, from the very outset, Elmes intended that there should be sculptural embellishment to his building, although it should be remembered that even those few parts of the full programme that were ultimately completed, were not begun in Elmes' lifetime. In 1844, Elmes had written:

> Consider...the effect produced by painting and sculpture as auxiliaries, – the latter (i.e. sculpture) devoid of colour, yet pre-eminent in form, the material harmonizing with the architecture in massive durability, while the gracefully flowing drapery, the marked expressive countenance, and the apparent capability of motion, all contrast with the greater severity of the architectural framework. Were this feeling general, – alas! for gilt frames and watch-box recesses for statues (as cited in Read, 1989: 33)

The intention behind the sculptural programme of the exterior seems to have been principally allegorical and designed to symbolise Liverpool's unrivalled status as the chief commercial port of England at the heart of the

British Empire. This is suggested by the theme of the only piece of exterior sculpture approved by Elmes and completed during the erection of the building, the now lost tympanum group over the south portico. This represented Britannia enthroned, with Neptune reclining at her feet and Mercury, the God of Commerce, presenting the Four Quarters of the Globe to her while she, in turn, presents to them the olive branch of peace. In the angles of the pediment were figures representing 'the vine, and other foreign commercial productions'. To the left of Britannia and sheltering under her protecting spear were those native commercial and intellectual activities which could only flourish under the security of her dominion and which, pertinently, had their chief commercial outlet in Liverpool (see below, p.305). The only other exterior sculpture was not executed until the very end of the century. This was the series of twelve reliefs for which Elmes had left blank panel blocks between the pilasters either side of the portico on the east frontage; the chosen themes, *The Progress of Justice* and *National Prosperity*, relating more specifically to Liverpool and, in the case of the former, indicating the legal function of the building itself (see below, pp. 256–64). It was proposed that the building's musical function should be similarly indicated by a series of smaller reliefs placed higher up on the exterior, blank panel blocks for which had again been provided by the architects (see below, p. 265). These, however, along with the allegorical statues which were proposed to be located above the *Progress of Justice* and *National Prosperity* reliefs, were never executed.

In addition to the allegorical sculpture which forms the greater part of the exterior programme, a series of six empty pedestals under the east portico suggests that portrait statues of illustrious individuals had also formed part of the overall programme from an early stage. This aspect, the commemoration of local men made good and preferably on a national scale was the principal focus of the intended sculptural embellishment of the interior of the Great Hall with its twenty-six statue niches (for objections raised to those not sufficiently 'national' in their achievement, see below, pp. 272–3 and 282–4). Here it must be stated, however, that the interior statue niches do not seem to have been part of Elmes' original design. In fact, given his above-quoted lament of 'watch-box recesses', they were probably contrary to his wishes and, significantly, the earliest known drawing suggesting such a scheme is by Cockerell (Read, 1989: 34). Nonetheless, Cockerell's drawing, albeit of a summary, sketch-like nature, clearly shows a man in a frock coat, arm raised in typical oratorical pose (Read, 1989: 33) and therefore indicates that at least the second of the Great Hall's architects agreed that it should also serve as a kind of civic pantheon. This was, of course, an entirely appropriate idea for a public interior which from the very earliest days following its inauguration functioned not just as a concert hall, but *inter alia*, as the most impressive venue available in Liverpool for civic receptions and officially-approved assemblies. Here, distinguished guests would be reminded by the surrounding series of over-life-size statues, that this city numbered among its citizens some of the most illustrious in the land.

Literature: Hughes, Q. (1964, 1993 postscript): 96-104, 186-87; Knowles, L. (1988); Picton, J.A. (1875, revised edn 1903), ii: 155-56, 180-86; Read, B., 'From Basilica to Walhalla', in P. Curtis (ed.) (1989): 33-4; Touzeau, J. (1910) ii: 834-35; Watkin, D. (1974): 237-42.

Owner of building: Liverpool City Council
Listed status: Grade I

Triton lamp-bearers
The South Portico and East Portico entrances are each flanked by a pair of Tritons. The East Portico has a female and male pair and the South Portico, two males.

**Designer: Charles Robert Cockerell
Sculptor (of figures): William Grinsell Nicholl**
Founder (of lamps): Coalbrookdale Iron Co.

Figural bearers in Huddlestone limestone
Lamps in cast iron and glass

h. excluding pedestal: 86" (218cms)
h. overall: 147½" (375cms)

Listed status: as for building

Description: The Triton lamp-bearers are mounted on pedestals. Formed in tight serpentine compositions, they are each crowned with a laurel wreath and hold a cornucopia from which once protruded a short lampstand with a globe shade in clear glass formed from four longitudinal sections (now lost). The Tritons look inwards and downwards to a point in the centre of the portico floor indicated by the paving pattern, immediately before the entrance doors. The female Triton, on the left of the East Portico entrance, has long hair trailing down her back, whilst all the male figures are bearded. The lamp-bearers flanking the Civil Court entrance in William Brown Street (see below) are from the same model.

On 9 December 1854, the Law Courts and St George's Hall Committee authorized Cockerell to 'procure from Mr. Nicholl a Model of a Triton for the Granite Pillars at the entrances at an expense not exceeding £15' and at a meeting on 3 March 1855, the Committee accepted Nicholl's tender to execute the four Triton

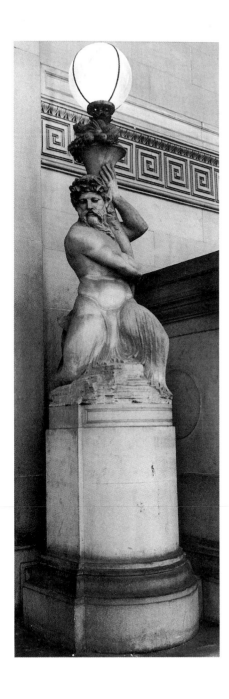

lampbearers in Huddlestone limestone (*Law Courts and St George's Hall Committee Minutes*).

Literature: LRO manuscript source: *Law Courts and St George's Hall Committee Minutes*, 1/2: 367, 388-89, 392.

Triton lamp-bearers
flanking the entrance to the Civil Court (North end of building):

Designer: Charles Robert Cockerell
Sculptor: William Grinsell Nicholl

Figures in Portland stone

Listed status: as for building

Description: Two male and two female Tritons, each bearing a cornucopia surmounted by a glass lamp bowl of four longitudinal sections. One hand is raised to support the bowl while the other crosses the body to hold the twisting stem. The weight of the cornucopia is borne on the shoulder of the bowl-bearing arm. The male and female Tritons are arranged alternately, with those to the left of the entrance mirroring those to the right. The model is the same as for the Triton lampbearers under the South and East Porticos (see above).

Condition: The white stone is partially blackened. At some time, according to the WAG JCS files, the figures were cleaned and restored by Tyson Smith. Only one lamp remains, that of the male Triton to the left of the entrance.

EAST FAÇADE RELIEF PANELS

Reliefs in Istrian stone

Each relief: 72" (182.9 cms) × 61" (154.9 cms)

Owner: Liverpool City Council
Listed status: as building

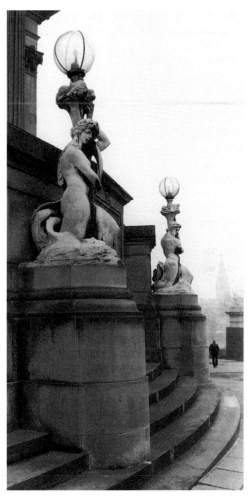

Istrian 'marble' (actually a limestone, more correctly termed Istrian stone) was chosen in preference to Carrara marble because it was harder and was considered more resistant to the industrial atmosphere of nineteenth-century Liverpool. As William Conway pointed out in his letter to the *Daily Post* on 16 December

1887, it also has the advantage of being not as white as Carrara marble and therefore is naturally more harmonious with the yellowish tone of the Darley Dale stone from which St George's Hall is built.

Yet even the use of the cream-coloured Istrian stone was censured as being out of harmony with the building by some contemporary commentators (e.g. 'Laocoon' in the *Daily Post*, 3 January 1888). Such criticism is no doubt what induced Lee to further tone down his panels with 'paraffin wax' (*Courier*, 25 May 1894). And, in fact, for the second series of panels, the Corporation paid Norbury, Paterson & Co. on 29 November 1898 for 'cutting Inscriptions, colouring the New Panels and erecting scaffolding' (*Finance Committee Minutes*).

Literature (general): LRO (a) manuscript source: *Finance Committee Minutes*, 1/49: 648; (b) newscuttings: *Courier* (1894) 25 May, in *TCN 1/25*; *Daily Post* (1887) 16 December, in *TCN 1/20*; *Daily Post* (1887) 28 December, in *TCN 1/21*; *Daily Post* (1888) 3 January, in *TCN 1/21*; *St George's Hall: Collection of Illustrations, Photographs, Newscuttings...*, prepared in the Library.

The Progress of Justice
first series of six reliefs, east façade, to the left of the central portico, reading left to right.

Sculptor: Thomas Stirling Lee

Exhibited: (first panel only) Royal Academy of Arts, 1886 (cat. 1872), as *'Justice as a child of the poor, led by Understanding into the way of Wisdom, Joy following, strewing her path with flowers'. The first of a series of panels for St. George's Hall, Liverpool.*

First relief in place by 23 January 1885
Second relief in place by 16 December 1887
Whole series unveiled by W.M. Bowring, Lord Mayor of Liverpool, Friday 25 May 1894

Owner: Liverpool City Council
Listed status: as for building

Explanatory inscription carved into the Darley Dale stone beneath each panel, as follows:

1. JOY FOLLOWS THE GROWTH OF JUSTICE, / LED BY CONSCIENCE, DIRECTED BY WISDOM.
Description: Four female figures fill the panel – a naked child representing *Justice* is led by the hand by a mature woman, representing *Understanding*. The latter faces an older woman on the right, *Wisdom*, who wears a crown of olive leaves (symbol of Athena, goddess of wisdom) and carries a lamp (held against her left breast to indicate that wisdom comes from the heart) with which she both points and lights the way (*Daily Post*, 16 December 1887). On the left, *Joy*, a young girl in a diaphanous ankle length dress, wearing a crown of rose-buds, is strewing flowers. There are roses on the ground between the two figures on the right. The four

women also represent the four ages of woman. The suggested movement of the figures implies a movement from left to right, folowing the lamp of *Wisdom*.

2. JUSTICE, IN HER PURITY, REFUSES TO BE DIVERTED / FROM THE STRAIGHT PATH BY WEALTH AND FAME.
Description: *Justice*, now a naked young woman, resists the lures of *Fame* and *Riches*, personified by two older, heavily draped women: *Fame*, on the right, wears a crown of laurel and carries a branch; she looks at *Justice* and touches her seductively on the shoulder. *Justice* raises her left arm defensively, whilst also drawing away from the figure of *Riches* on the left who holds her right arm. *Riches* wears a glittering crown to indicate her material wealth. The marked naturalism of the figure of *Justice* suggests that it was modelled directly from life.

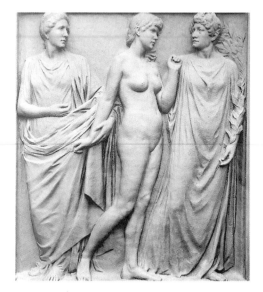

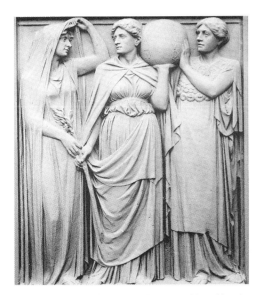

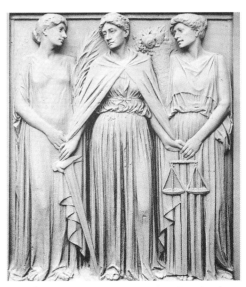

3. JUSTICE, HAVING ATTAINED MATURITY, UPHOLDS THE /
WORLD, SUPPORTED BY KNOWLEDGE AND RIGHT.

Description: A group of three female figures – *Justice*, represented in the centre of the composition as a mature woman, receives the rod of knowledge from the figure on the left who also lifts a veil from her face: this is *Knowledge* indicating the hidden things that are made plain by the exercise of justice. *Justice* supports the globe with help from *Right* who wears a breastplate to show that her heart is protected from the evils of the world. The globe bears the Roman numerals I – X, signifying God's ten commandments by which the world is ruled justly (*Courier*, 25 May 1894).

4. JUSTICE ABLE TO STAND ALONE, /
ADMINISTERS BY THE SWORD.

Description: *Justice* is represented as a single monumental figure standing in the centre of the panel. Her left hand is raised, her finger pointing upwards to show the heavenly source of true justice (*Courier*, 25 May 1894), whilst in her right hand she holds a long sword which points downwards, the tip resting on the ground. Scales as the traditional symbols of Justice are eschewed, but the idea of stability and reliance is expressed through the firm low relief outline of the classically-designed throne before which she stands. The design may owe something to Giotto's grisaille of *Justitia* in the Arena Chapel, Padua.

5. JUSTICE, RELIEVED OF HER SWORD BY VIRTUE /
AND OF HER SCALES BY CONCORD.

Description: *Justice*, in a long cloak, stands between *Virtue*, on the left, and *Concord*, on the right. The right hand of *Virtue* touches the hilt of the sword held in the right hand of *Justice*, while, on the other side, the left hand of *Concord* touches the scales held in the left hand of *Justice*. *Virtue* is dressed in a medieval robe and holds in her left hand the palm branch of victory which she is to offer *Justice* in return for the now redundant sword, all crime having been eliminated (*Courier*, 25 May 1894). *Concord* wears a sleeveless Grecian robe and holds in her right hand the cornucopia of abundance.

6. JUSTICE RECEIVES THE KISS OF RIGHTEOUSNESS, /
AND THE CROWN OF IMMORTALITY.

Description: *Justice* stands between two ministering winged figures. Her earthly robes, no longer necessary as she passes through to the higher sphere from whence she came, fall from her, exposing her left breast. She leans her head on the shoulder of *Righteousness*, who holds her right hand and caresses her head, whilst bestowing the kiss of righteousness upon her forehead. *Glory*, the figure on the right, holds a flaming heart (symbol of divine love) in her left

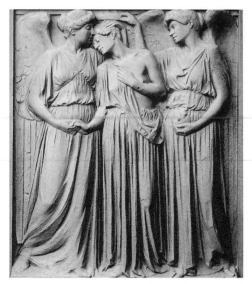

hand, whilst in the other she holds the crown of immortality over the head of *Justice* (*Courier*, 25 May 1894).

On 11 February 1885, following installation of the first panel, Lee produced an explanation of the whole cycle, consisting of a brief written introduction along with panel-by-panel descriptions, interpretations (panels fours to six, however, being treated less fully), and sketches (except for panel six which Lee said he was still working on):

> In taking for my subject "Justice" I have borne in mind what was mentioned in the condition of the Competition that the subject should be appropriate to the use of the Building.
>
> I can imagine no subject more so than the above and it gives the artist the grand opportunity of illustrating in Stone the highest Principle that governs the Earth.
>
> I have taken her from her Childhood,

Girlhood, Womanhood, Administration, Result, and Final End.

Panel No. 1
The Child Justice lead [*sic*] by "Understanding" into the way of "Wisdom" and "Joy" following strewing flowers in her path
Explanation
Justice as a child of the Gods, born among them, having sympathy with them lead [*sic*] by Understanding the guide nature as [*sic*] given us. Wisdom in her grandeur crowned with olives the richest gift of the Earth kindly showing and leading her in her path with the result that Joy, quiet inward Joy follows strewing flowers. She wears the crown of Spring rose buds. The new spring that is budding in the walk of wisdom.

Panels. Fixed but not completed.
Panel No. 2
The Girl 'Justice' refusing to be diverted from the straight way by worldly "Fame" and "Riches".
Explanation
The Girl is nude in her very purity the Grandeur of Fame crowned with laurels nor the Richness of the outward show of Riches having no charm to divert her.
Panel No. 3
Justice as a woman upholding the Globe supported by Right and receiving the rod of Knowledge.
Explanation
Justice having arrived at the full strength of woman by her moral strength and the support of Right she upholds the Globe and receives the rod of Knowledge by which she is able to administer.
Panel No. 4
Justice administering in the Service of

"Truth" with Mercy at her swords hands [*sic*].
Panel No. 5
"Justice" is met by "Concord" and "Peace". The result of right administration of Justice is individual Concord & Universal "Peace". Justice Her education, administration and result.
Panel No. 6
Justice receives the Kiss of "Righteousness" & is crowned by "Glory".
The sketch for this I am still working on (*St George's Hall: collection of Illustrations...*, inserted autograph booklet).

Condition: Panel 1. There are black encrustations on the under surfaces, whereas the exposed surfaces are very white. Overall, the surface appears weathered. Panel 2. The surface appears weathered and dirty. Panel 3. The surface appears crumbly, especially in the area of *Justice*'s robe. Panel 4. There is some cracking to the surface. Panel 5. The surface is cracking and flaking. Panel 6. The surfaces of both the relief and the stone around the inscription beneath are cracking and flaking. Overall, the first two panels appear most weathered, whereas panels three to six appear most afflicted with cracking and flaking.

According to William Conway (Conway of Allington, 1932: 84-85), it was Philip Henry Rathbone who suggested filling with sculptural reliefs the empty panels on the exterior of St George's Hall (see also McPhee, 1989: 63-66). On 16 December 1881, the Corporation Surveyor, Thomas Shelmerdine, having been instructed by the Finance and Estate Committee to investigate the probable cost of such a scheme, reported that he thought it unquantifiable, but that the best way of determining the sort of decoration that would be

most suitable for the building (and, presumably, the most effective way of controlling the cost), would be to make it the subject of a competition (*Finance and Estate Committee Minutes*).

The Committee agreed and on 6 January 1882, set prizes of £200 for the winning entry and £100 and £50 for the two runners-up. Each competitor was required to submit quarter-size drawings of at least three of the larger reliefs (i.e. those which were ultimately filled) and four of the smaller reliefs (for the sixteen panels on the upper parts of the building, never realised). By 2 June 1882, Shelmerdine was able to report that thirty-seven sets of designs had been received. A Special Sub-Committee was formed to judge them, consisting of Rathbone, Alderman [?John] Weightman, Alderman [Edward] Samuelson and, as Chairman, Sir James Allanson Picton. On 16 June it was resolved that all the entries would be put on public display until 15 July and in the meantime the services of an 'Eminent Artist' would be sought to advise on the adjudication. Neither Sir Frederic Leighton, (P.R.A.), nor G.F. Watts was available and the Committee ultimately settled for the sculptor John Warrington Wood. On 25 August 1882 the final tally of thirty-nine entries was judged and the Sub-Committee declared the winning competitor to be Thomas Stirling Lee, with J. Milo Griffith and W.S. Frith, runners-up (*Finance and Estate Committee Minutes*). Among the unsuccessful competitiors were Hugh Stannus, Alfred Stevens's pupil (Beattie, 1983: 43), and Charles Samuel Kelsey (see his letter to *The Builder*, 22 July 1882: 126).

Attempts to alter the appearance of St George's Hall, Liverpool's most revered piece of civic architecture, have always been deeply controversial, and the scheme to fill the blank panels of the façade with sculptural reliefs was to be no exception. The *Daily Post* gave a foretaste of what was to come with a remarkably vehement denunciation of what it perceived as the poor quality of the majority of the entries. Many of them, it said:

> ...are simply of a farcical character...The majority of them are merely stonecutters' conceptions, of the rule-and-compass pattern, and free from any abstruse originality; others are elegant enough in design of commonplace patterns, and full of trashy and *rococo* symbolism of recent invention, so 'localised' and rendered down to the taste of the day that it would be pitiful if it were not frequently ridiculous; and two or three only of the designs sent in...are fit to be regarded as Classic art, or as in any respect worthy of the work of which they are to form a portion (as quoted in *The Builder*, 15 July 1882: 97).

As no visual record of any of the unsuccessful entries seems to have survived, it is difficult today to form any opinion on the justness of the *Daily Post*'s attack, although *The Builder*, the journal that reported the *Daily Post*'s reaction to a wider audience, evidently considered it a rather harsh judgement, itself estimating some of the designs as 'very good' and 'well suited to their purpose'. Indeed, the *Daily Post* (19 June 1882: 6) itself had, on the Monday following the opening of the exhibition, reported that the reliefs had been: 'closely inspected on Saturday [17 June, the opening day] by a large number of people, and were all, without exception, much admired.'

Thomas Stirling Lee's prize-winning designs seemingly represented 'Wisdom', 'Justice', and 'Temperance' – presumably the three designs required for the larger series of reliefs – and 'Orpheus' ('symbolical of singing'), plus 'Tragedy', 'Comedy', and 'Astronomy' (or rather, the Muses presiding over those arts) – the four designs required for the smaller series of reliefs, these being specifically intended to decorate the apsidal end of the building housing the Small Concert Room (*Builder*, 2 September 1882: 320).

Lee was to be entrusted with the entire commission, subject to terms being agreed and the remaining designs being approved. However, at its meeting of 9 February 1883, the Special Sub-Committee recommended the abandonment of the proposed decoration of the sixteen smaller panels: the ostensible reason being that these panels were 'situated at such a height that any delicate sculpture could be hardly appreciated', the suggestion being added that 'at some future time some simple and bold designs may be sculptured in the stone blocks as they stand'. On a more fundamental level, discussions with Lee had revealed that the twelve larger panels alone would cost £5,000 and, notwithstanding the fact that this expense would be spread over the estimated five years of execution, it was evidently somewhat in excess of expectation and the Sub-Committee perhaps did not want to discourage the Corporation from at least making a start with the sculptural decoration. Nevertheless, even in the light of this abridged scheme, the Finance and Estate Committee recommended that the Corporation commit itself only to the first panel of the larger series, offering Lee £500 for the one relief if the series was afterwards abandoned and £450 if the decision was taken to proceed (*Finance and Estate Committee Minutes*). The Council approved this strategy on 4 April 1883 (*Council Minutes*) and the Finance and Estate Committee paid Lee £150, the first of his three instalments, on 18 May 1883. (This was the customary method of payment to sculptors: the first instalment following approval of the

design, the second following approval of the model, the last following completion of the work.) A second instalment, requested by Lee on 21 March 1884 suggests therefore that the model for the first relief had by this time been completed (*Finance and Estate Committee Minutes*).

On 23 January 1885, Shelmerdine reported that Lee had completed the first relief and that it had been fixed in place on the façade. The immediate public reaction was evidently one of distaste at the sight of a naked 'gutter child' as one critic, Joseph Boult, labelled the figure, being presented as a personification of Justice (*British Architect*, 14 December 1888: 429-30; as quoted in Beattie, 1983: 44).

On 30 January 1885, the Finance and Estate Committee paid Lee the balance of his £450 fee for the first panel, but declined to give approval for him to proceed with the next (*Finance and Estate Committee Minutes*). It was at this point that Lee produced his series of sketches and written explanations of the whole projected cycle. Finally, at the meeting of 4 March, the Council agreed to proceed with the series on the basis of the designs that had been originally submitted, but with a much more stringent contract weighted heavily in the Council's favour (*Council Minutes*). After protracted discussions with the sculptor, the terms of the contract were finally approved by the Finance and Estate Committee on 18 December 1885: Lee had to execute at least one panel per year; any revisions to the already approved designs had first to be passed by the Council and the Council reserved the right to terminate the contract after the delivery of any panel, having first paid for it (*Finance and Estate Committee Minutes*).

When the contract was submitted to the Council on 13 January 1886, a large minority still pushed for Lee's engagement to be summarily terminated (*Council Minutes*). Although Lee's contract was nevertheless ratified on 27 January (referred to in the minutes of the Council meeting of 4 August 1886), henceforward the Council was to be extremely wary. On 9 July 1886, the Finance and Estate Committee asked Rathbone to travel to London to inspect the model for the second relief. On 23 July 1886 he reported his approval of the model and the Committee duly authorised payment of the sum of £150 to Lee (*Finance and Estate Committee Minutes*). The anti-Lee faction in the Council chamber had grown however and, on 4 August, the Council rejected the Finance and Estate Committee's approval for Lee to continue with the work, voting overwhelmingly that the £150 should be the final payment to the sculptor and that his contract be terminated without delay (*Council Minutes*).

On 24 September 1886, the Finance and Estate Committee received a letter from Lee in which the sculptor declared the Council's termination of his contract unjust and illegal on the grounds that a designated representative of the Corporation had passed the model for the second panel as being consistent with the approved design and, furthermore, that the contract permitted termination by the Council only after a panel had been fixed and paid for in full. Consequently, a majority of the Finance and Estate Committee resolved that Lee should be offered a final settlement of £250 in fulfillment of the Corporation's contractual obligations (that is, the third instalment of £150 for the second panel, plus an extra £50 for each of the first two panels of the abandoned series). This resolution was overwhelmingly ratified in Council on 6 October. By 15 October, however, the Corporation had received a letter from Lee's solicitors, with the immediate result that it was compelled to permit the fixing of the second panel. On 4 November 1887, Lee informed the Finance and Estate Committee that the second panel was 'ready for fixing' and on 16 December Shelmerdine reported that Lee had 'fixed' it (*Finance and Estate Committee Minutes*).

The furore which greeted the unveiling of the second panel was even greater than that which had greeted the first, and on 4 January 1888 the Council terminated Lee's contract (*Council Minutes*). The 'gutter child' of the first panel had grown into a shockingly realistic naked young woman in the second. A local magistrate declared that the corrupting influence of the panels encouraged the sale of pornography (*Builder*, 6 July 1889: 5, cited in Beattie, 1989: 44); Mr Robert Gladstone, who had earlier offered the Council £5 to start a subscription to finance the removal of the first panel, now demanded that both panels be removed (*Finance and Estate Committee Minutes*); and in a paper delivered to the Liverpool Architectural Society, James Hay condemned the indecorous realism of the panels as an outrage against public decency which all too clearly betrayed 'the pernicious influences of the realistic school that is doing so much in France to degrade both her literature and her art' (*Builder*, 8 March 1890: 179; cited in Beattie, 1989: 44), an attitude which *The Builder* deemed 'truly delightful' in the light of what it perceived as France's ascendancy in the realm of 'imaginative sculpture', clearly finding such philistinism risibly provincial. In fact *The Builder*, the most influential architectural journal of the time, was constant in its support of Lee's work throughout the entire episode, and in its edition for 15 February 1890 reported that Alfred Gilbert, by then the leading British sculptor of his generation, had written to

Rathbone praising the two panels as 'the best things of their kind in England'.

The movement to get the series recontinued culminated in William Conway's letter to the Council on 24 January 1890, advising it that the Edinburgh Art Congress had overwhelmingly voted its approval of Lee's designs and enclosing a copy of a petition signed by many leading artists requesting that Lee's contract be renewed (*Finance and Estate Committee Minutes*; also Conway of Allington, 1932: 85 – 87). More importantly, on 8 February, Rathbone formally offered to pay the full cost of the execution of the remaining four panels, if the Council would reconsider Lee's case. His only stipulation was that the Council should agree to all six panels remaining in place for at least five years after their completion, before there was any consideration of their removal, should they still be deemed 'not worthy of their place' (*Finance and Estate Committee Minutes*). Rathbone was asked to submit photographs of the designs of the remaining four panels, and these were approved and his conditional offer accepted by the Council on 5 March 1890 (*Council Minutes*).

The remaining four panels were completed by 15 March 1894 and were in place by 17 May (*Finance and Estate Committee Minutes*). In his letter of that date Rathbone formally hands them over to the Council, but unaccountably reduces the moratorium on their removal from five to two years. The panels were accepted and the official unveiling of the whole series duly arranged. The *Courier*, *Mercury* and *Daily Post*, on seeing the completed series at a private unveiling for the press on 23 May 1894, were unanimous in their praise and expressed the hope that Lee would at least be allowed to execute the other six panels along the façade, if not the entire scheme as originally projected.

Literature (first series of reliefs only): (i) LRO (a) manuscript sources: *Council Minutes*, 1/24: 367, 650-51; *Council Minutes*, 1/27: 9-10, 70, 298, 342-43; *Council Minutes*, 1/28: 208; *Council Minutes*, 1/29: 590, 601; *Council Minutes*, 1/32: 580; *Finance and Estate Committee Minutes*, 1/27: 501-2, 543-44, 582-83, 657-58; *Finance and Estate Committee Minutes*, 1/28: 103, 125-26, 139-40, 162, 200, 255-56, 299, 617, 734; *Finance and Estate Committee Minutes*, 1/29: 43, 745, 787; *Finance and Estate Committee Minutes*, 1/30: 759, 782; *Finance and Estate Committee Minutes*, 1/31: 200, 281, 434; *Finance and Estate Committee Minutes*, 1/32: 68, 174, 182-84; *Finance and Estate Committee Minutes*, 1/33: 111, 135, 175, 189, 276-80, 307, 360; *Finance and Estate Committee Minutes*, 1/34: 720; *Finance and Estate Committee Minutes*, 1/35: 139, 180-81; *Finance and Estate Committee Minutes*, 1/38: 32, 46-8; *Finance and Estate Committee Minutes*, 1/43: 366, 561-62, 590, 645-46. (b) newscuttings: *Courier* (1894) 25 May, in *TCN 1/25*; *Daily Post* (1890) 22 February, in *TCN 1/22*; *Daily Post* (1894) 24 May, in *TCN 1/25*; *Mercury* (1890) 24 February, in *TCN 1/22*; *Mercury* (1894) 19 May, in *TCN 1/25*; *Mercury* (1894) 25 May, in *TCN 1/25*; *Mercury* (1894) 26 May, in *TCN 1/25*; various cuttings, etc., in *St George's Hall: Collection of Illustrations, Photographs, Newscuttings...*, *prepared in the Library*.
(ii) *Art-Journal* (1895): 318; Beattie, S. (1983): 43-46; *British Architect* (1886) xxv: 107; *British Architect* (1888) xxx: 429-30; *Builder* (1882) xliii: 97, 126, 320; *Builder* (1889) lvii: 5; *Builder* (1890) lviii: 109, 179, 200; Conway of Allington, Lord (1932): 84-7; *Daily Post* (1882) 19 June: 6; MacPhee, A., 'Philip Henry Rathbone 1828-95', in P. Curtis (ed.) (1989): 63-66; *Magazine of Art*, (1895) xviii: 40; Willett, J. (1967): 49-50.

National Prosperity

second series of six panels, located on the east façade, to the right of the central portico and reading left to right.

Sculptors:
Reliefs 1 and 2 Charles John Allen (design only) and Frank Norbury (execution)
Reliefs 3 and 4 Conrad Dressler
Reliefs 5 and 6 Thomas Stirling Lee

Inscriptions for all reliefs executed by Norbury, Paterson & Co. Ltd

Explanatory inscription in the Darley Dale stone beneath each panel, as follows:

1. LIVERPOOL, A MUNICIPALITY, EMPLOYS / LABOUR AND ENCOURAGES ART
Description: A symmetrical group of three female figures: a personification of *Liverpool* in the middle looking straight ahead, flanked by personifications of *The Arts* and of *Labour* who look inwards. *Liverpool* wears the regalia of office – a mayoral chain, a fur-trimmed cloak and a crown with sailing boat motifs. In her right hand she holds a sceptre and in her left hand one end of a scroll or charter, the other end of which *The Arts* holds against her body with her left hand, whilst in her right hand she holds a small model of St George's Hall. *Labour*, on the right, wears a long apron and holds a mason's hammer and bolster chisel. Norbury's use of the claw chisel in both of

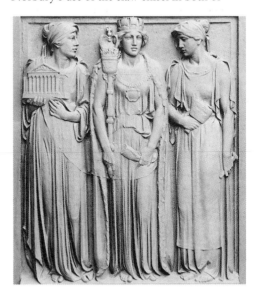

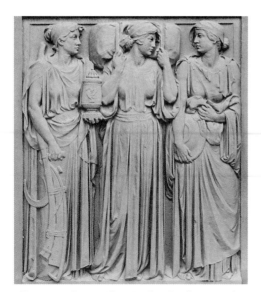

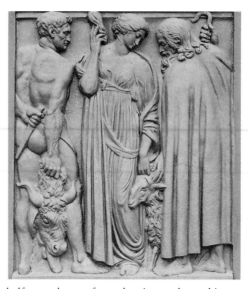

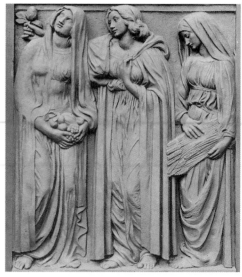

Allen's panels is evident in the clearly striated surfaces of the reliefs.

2. LIVERPOOL COLLECTS PRODUCE AND EXPORTS /
THE MANUFACTURES OF THE COUNTRY.
Description: A group of three female figures. The central figure, *Liverpool*, carries a large bale or package on her shoulders, which she grasps by its two binding straps. The figure on the right, who meets *Liverpool*'s gaze, holds a large plate or bowl to her side. The figure on the left holds in her left hand a vessel embossed with a Liver Bird, whilst in her right she holds a scythe and a sickle.

3. LIVERPOOL IMPORTS CATTLE AND WOOL, /
FOR FOOD AND CLOTHING.
Description: A female figure, *Liverpool*, flanked by two male figures. *Liverpool* holds aloft a purse and looks down to her left, at a ram which she holds by one horn. The ram's other horn is held by the bearded figure to her left,

half turned away from the viewer, dressed in a long cloak, his right hand visible beyond his far shoulder holding the shaft of a shepherd's crook. On the left of the panel is a Herculean male nude also seen from behind, who conceals behind his back a dagger held in his left hand, whilst his right hand holds onto an ox, seen on its knees between his legs. The tongue of the ox hangs out and touches the ground, denoting that the animal is dead. Dressler's figures in both panels are more robust and appear crammed into the picture space: as Lee observed in his report dated 27 May 1901 to the Finance Committee, Dressler's figures are cropped by the frame (*Finance Committee Minutes*). Also, as Professor Simpson noted in his report to the same meeting 'the surface [of Dressler's two panels] is finished in a different way, [in so far as] it is not claw tooled'.

4. LIVERPOOL, BY ITS IMPORTS, SUPPLIES /
THE COUNTRY WITH FOOD AND CORN.

Description: Three Botticelli-esque female figures. That on the left looks up to her right. She cups her hands before her to hold a mass of fruit. The central figure turns towards her, one hand to her own breast, the other reaching behind and past her companion's head, holding some fruit. The figure on the right faces inwards looking down and carrying a sheaf of corn.

5. LIVERPOOL, BY HER SHIPWRIGHTS, /
BUILDS VESSELS OF COMMERCE.
Description: *Liverpool*, personified as a female dressed in a long robe, is flanked by two bare-foot male *Shipwrights* in short, belted tunics. *Liverpool* holds a model of a sailing ship in both hands and looks to the *Shipwright* on her right, who in turn looks at the ship. In his right hand he holds a block and in his left, a hammer. The *Shipwright* on her left cradles an adze, the blade of which hangs over his left forearm. The ground beneath *Liverpool*'s feet is carved to resemble waves (cf. Warrington Wood's

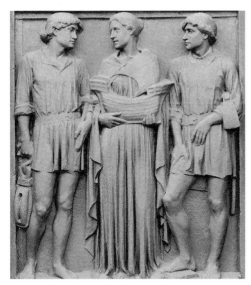

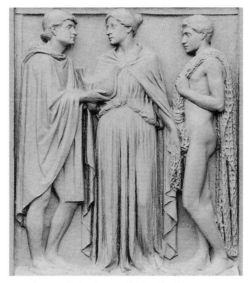

Liverpool on the roof of the Walker Art Gallery, see below, p. 297), denoting that her prosperity is founded on the sea. Like Norbury (Allen's carver), Lee has clearly finished off the surfaces of both his panels with a claw chisel.

6. LIVERPOOL, A FISHING VILLAGE, GIVES / HER SONS THE BOAT AND THE NET.

Description: *Liverpool* stands in the centre, flanked by two male figures. She hands the model of a boat to the cloaked figure on the left – their gazes meet. A male nude stands in profile to the right, holding a fishing net over his left shoulder.

Condition: All panels have black encrustation in crevices and on undersurfaces. The exposed middle grounds and backgrounds are a dirty buff-yellow colour. Some of the highest relief of Allen's panels (i.e. the most exposed parts) looks weathered and bleached; a greater area of the higher relief of Lee's panels has suffered this way, but Dressler's panels, in between these two, have relatively small bleached areas.

On 5 June 1895, Liverpool Council resolved to commission a series of sculptural reliefs to fill the remaining six large panels on the east side of the Hall, at a cost not exceeding £3,000 (*Council Minutes*). Philip Henry Rathbone, as Chairman of the Special Sub-Committee appointed to consider the matter, submitted a report to the Corporation Financial Sub-Committee, on 24 September 1895, in which he argued the case for the sculptor Thomas Stirling Lee having a 'moral claim' to at least part of the commission. As related above (p. 259), Lee had won the 1882 open competition to design all the St George's Hall relief panels, that is, twelve large and sixteen small panels. The Corporation had decided to abandon its plans for the decoration of the latter and had drawn up a contract with Lee for the twelve large panels. Notwithstanding the fact that this contract had been terminated by the Corporation after the execution of the second relief, Lee had gone on (with Rathbone's funding) to complete this first series to their satisfaction (*St George's Hall Management Special Sub-Committee Minutes*).

Rathbone recommended a compromise, intended in part to appease those who had been offended by Lee's treatment of the first series: Lee would design only two of the reliefs, the remaining four being entrusted to two local sculptors, Charles John Allen and Conrad Dressler. In order that unity of design be maintained, however, Lee would act as overall supervisor. Rathbone further proposed that Frederick Simpson, then Professor of Architecture at University College, Liverpool, be appointed to arbitrate in any disputes that might arise and to approve (with Councillor John Lea, Chairman of the Arts Committee) each stage of the execution of the reliefs. The sculptors would be paid £450 for each relief (payable in instalments on completion of approved design, plaster model and finished work), with Lee, as supervisor, receiving a further £50. Finally, the series was to be completed and installed within two years of the date of the contract. Rathbone's recommendations were agreed, with the rider that all designs had to be first sent to the Town Clerk, not later than 21 October 1895, so that they could be approved by the Council (*St George's Hall Management Special Sub-Committee Minutes*). Working to a general scheme devised by Lee, the three sculptors submitted their allotted designs to the Financial Sub-Committee by the designated time, at which point both the designs and the draft agreement were approved. The final agreement was dated 1 November 1895 (*Finance and Estate Committee Minutes*).

Both Lee and Allen worked to schedule, but on 18 February 1898 Councillor Lea and Professor Simpson reported to the Finance

Committee that Dressler had not yet submitted even his first plaster model for approval. Following an official warning, Dressler's contract was terminated on 5 April 1898. By 19 April, Dressler had evidently completed the models, for he wrote to the Corporation requesting that the President of the Royal Academy (Sir Edward Poynter) be called in as arbitrator. The Corporation refused to comply. On 24 May 1898, Professor Simpson suggested to the Financial Sub-Committee that the two completed 'marble' [sic] reliefs by Lee and Allen should be installed and that Dressler's plaster models for the central reliefs be temporarily fixed in place between them, so that a fair judgement could be made as to the overall effect. At the request of Dressler's solicitors, the Corporation allowed Dressler to appoint Professor Sir William Blake Richmond as an independent arbitrator, they retaining the services of Professor Simpson (*Finance Committee Minutes*).

By 15 November 1898, Dressler's plaster models had been examined by the arbitrators and judged acceptable, subject to a few alterations being made: notably the reduction of the figures' scale to harmonise with those of the panels on either side. Remarkably, considering that Dressler was lucky to have retained the commission at all, he at first attempted to make certain conditions with the Corporation, though at their refusal to discuss the matter he seems to have quickly capitulated and his contract was renewed. His completed reliefs were in place by 7 June 1901 (*Finance Committee Minutes*).

Professor Simpson, in his final report to the Finance Committee, dated 25 May 1901, remarked that Dressler's figures were still rather bigger than those in Lee's and Allen's panels, but that the effect was mitigated by the central position of his reliefs within the series. He also noted that where Lee's and Allen's reliefs had been finished with claw chisels, Dressler's had not; although he reassured the Committee that the difference was not necessarily discernible from below. But then again such differences were inevitable, he observed, when a commission was entrusted to three men instead of to one, and consequently he recommended that Dressler receive his final payment (*Finance Committee Minutes*).

Lee, in his final report to the Finance Committee, dated 27 May 1901, expressed his qualified satisfaction that 'the work is now as harmonious as it is possible for three men with different leanings and individualities ever to be', but complained that the Corporation had rendered his position as supervisor virtually ineffectual by not investing him with any compulsory powers. Dressler, it seems, had given him a deal of trouble. In his assessment of Dressler's work, Lee points out the areas in which Dressler had not conformed to the guidelines set for the series: his figures are cut off by the edges of the frame; the downward returns of the mouldings which frame each of Allen and Lee's reliefs are omitted in Dressler's, thus giving the effect that each of his reliefs is part of a continuous frieze rather than a self-contained unit; and lastly, Dressler's figures are more robust, whereas Lee had recommended, in the light of his own experience, a 'flatter and straighter' treatment (to harmonise with the lines of the architectural setting).

Notwithstanding these problems he does concede that Dressler's reliefs are in themselves 'not inferior' to the others as works of art. The commission being thus brought to completion, the Committee authorised payment of £400 to Dressler as the balance owed for his two reliefs and £50 to Lee for his work as series supervisor

(*Finance Committee Minutes*).

Literature (second series of reliefs only): (i) LRO (a) manuscript sources: *Council Minutes*, 1/33: 337; *Finance and Estate Committee Minutes*, 1/45: 111, 234, 649-50; *Finance and Estate Committee Minutes*, 1/47: 155, 523; *Finance Committee Minutes*, 1/49: 181, 228, 236, 266, 327-28, 386-87, 448-49, 620, 648; *Finance Committee Minutes*, 1/50: 530; *Finance Committee Minutes*, 1/51: 720-23; *Finance Committee Minutes*, 1/52: 138-39; *St George's Hall Management Special Sub-Committee Minutes*, October 1895. (b) newscuttings: *Mercury* (1895) 6 June, in *TCN 1/25*; various newscuttings, etc., in *St George's Hall: Collection of Illustrations, Photographs, Newscuttings...*, prepared in the Library. (ii) *Art-Journal* (1895): 318; MacPhee, A., 'Philip Henry Rathbone 1828-95', in P. Curtis (ed.) (1989): 66; *Magazine of Art* (1895) xviii: 40; *Studio* (1899) xvi: 54-7; *Studio* (1916) lxviii: 175-76.

Thomas Stirling Lee's scheme for the completion of the sculptural decoration of St George's Hall

Within Liverpool Corporation, there was a small group of men led by Philip Henry Rathbone who wanted the sculptural decoration of St George's Hall completed in conformity with Elmes' original intentions. Rathbone also considered that Thomas Stirling Lee, having won the original competition for a rather wider sculptural scheme than was ultimately approved, had a moral right to be involved in at least a supervisory capacity. The majority of the Council were no doubt concerned about the high level of expenditure involved, but a significant minority continued to reject any alterations to the Hall, especially, it seems, if those alterations involved any sculpture by Thomas Stirling Lee.

It was on 1 February 1895 (the first six panels having been unveiled) that the Finance and Estate Committee first recommended the completion of the scheme and on 12 February

the Financial Sub-Committee commissioned Lee to produce a sketch of his designs for the whole building (*Finance and Estate Committee Minutes*). Rathbone also hoped that they might be able to secure the services of such talents as Edward Onslow Ford, Harry Bates and even (somewhat optimistically) Alfred Gilbert, to work under Lee's supervision, to transform St George's Hall into an English Parthenon (*Mercury*, 6 June 1895). Approval could be secured only for the execution of the remaining six large panels on the eastern façade, however, and, responding somewhat to local pressure, two Liverpool artists were employed to work with Lee (see above, p. **).

Once Lee had completed his two panels, he renewed his requests to be allowed to carry out the sculptural decoration for the whole of the exterior of the Hall. On 9 December 1898, his rough estimate of the potential costs involved was submitted to the Finance Committee. The details of his proposed scheme are as follows (*Finance Committee Minutes*):

1. Two Equestrian Groups: *Winged Dawn* and *Winged Evening* in bronze, 10 ft high: £4,000.

2. Twelve 8ft 4in. high figures for the spaces between the piers above the reliefs on the eastern façade; each a winged symbolic figure embodying the theme represented below. Those above the *Progress of Justice* cycle were to have been the *Spirits of*, respectively, *Wisdom, Counsel, Strength, Justice, Peace*, and *Eternal Light*; and above the *National Prosperity* series, the *Spirits of*, respectively, *Industry, Patience, Truth, Energy, Love*, and *Progress* (identities as given in the *Daily Post*, 24 May 1894, and the *Courier*, 23 July 1903). Cost of all twelve in Istrian 'marble': £7,200.

3. Sixteen small reliefs for the panels around the upper part of the building in two groups as follows: (i) The eleven for the northern apsidal end and adjacent corners, with the nine Muses represented on the apse itself, flanked by *Orpheus* (symbolic of singing) and *Tubal Cain* (symbolic of harmony) – the subjects reflecting the position of the small concert room; and (ii) the five panels at similar altitudes on the south, east and west walls with subjects emblematic of the Arts (all small relief subjects as given in the *Courier*, 25 May 1894). Each panel 4ft 4in. square in stone. Total cost £4,000.

4. Twelve 8ft 4in. high figures in stone 'in the screen facing the City', amounting to £4,800.

5. Four groups of three or four figures in stone, 12ft high (proposed location unspecified), amounting to £6,000.

6. 'Twenty carved stones' to crown the building, amounting to £600.

7. Six portrait statues in bronze for the vacant pedestals under the east portico, amounting to £6,000.

The total cost to the Corporation was estimated at £32,600. The Finance Committee decided to defer any decision, ostensibly for three months, but in reality, indefinitely.

On 17 June 1903, Lee again applied to the Corporation. This time the Finance Committee resolved to recommend that Lee be engaged to 'execute [the] twelve figures above the panels on the front side of St George's Hall' (*Finance Committee Minutes*). When the matter was referred to the Council meeting of 2 September 1903, however, 'the feeling against it was so strong that the Chairman of the Finance Committee asked permisson of the Council to be allowed to withdraw the recommendation'. This was how Thomas Shelmerdine, the Corporation Surveyor, recalled it in his report to the Financial Sub-Committee nearly a decade later, on 30 January 1912, following another petition from Lee on 11 January: *Finance Committee Minutes*).

Lee made one last desperate plea on 13 February 1912, but on 12 March, received a final and categorical avowal from the Council that it would not alter its previous decision (*Finance Committee Minutes*).

Literature: LRO (a) manuscript sources: *Finance and Estate Committee Minutes*, 1/44: 636, 658; *Finance Committee Minutes*, 1/49: 645, 668-69; *Finance Committee Minutes*, 1/53: 548, 563, 672; *Finance Committee Minutes*, 1/61: 238, 305, 345. (b) newscuttings: *Courier* (1894) 25 May, in *TCN 1/25*; *Courier* (1903) 23 July, in *TCN 1/30*; *Daily Post* (1894) 24 May, in *TCN 1/25*; *Mercury* (1895) 6 June, in *TCN 1/25*.
(ii) MacPhee, A., 'Philip Henry Rathbone 1828-95', in P. Curtis (ed.) (1989): 66.

Statue of Benjamin Disraeli, 1st Earl of Beaconsfield

(1804–81) statesman and author. The son of an Anglicized Jew, he was born in London, raised as a Christian and studied law. He won acclaim with his first novel, *Vivian Grey* (1826) and travelled Europe (1828-31). His political career began in 1837 with his successful candidacy for the Maidstone constituency, a seat which he continued to hold until he was raised to the House of Lords as Earl of Beaconsfield in 1876. His ambition to widen the base of the Tory party culminated in his successful piloting of the Reform Bill of 1867. He also opposed Peel's abrogation of the Corn Laws, strongly favouring market protection for British agriculture. He was Prime Minister twice, firstly for a brief spell in 1868, then from 1874 to 1880, during which period he enjoyed a unique and confidential relationship with Queen Victoria. His domestic reforms included extending legal protection to trade unions and introducing Factory Acts and a Public Health Act. He was, however, just as much concerned with the concept of empire as he was with domestic reform, as is evidenced by his advice to the

Queen in 1876 that she assume the title Empress of India (source *DNB*).

Sculptor: Charles Bell Birch

Statue in bronze
Pedestal in Darley Dale stone

Bronze founder: James Moore of Thames Ditton (*Courier*, 15 December 1883).

h. of statue and bronze base: 132" (335cms)
h. of pedestal: 27½" (69.8cms)

Inscription on the front of the stone pedestal: THE EARL OF / BEACONSFIELD K.G. / 1804–1881

Signed and dated on the left side of the bronze base: C. B. BIRCH. SCA.R.A / LONDON. 1883

Exhibited: Royal Academy of Arts 1883, as *The Earl of Beaconsfield; model for statue, St George's Hall, Liverpool* (cat. 1537); and *The Earl of Beaconsfield; study for Colossal statue* (cat. 1629).

Unveiled by Sir Richard Assheton Cross, M.P., Friday 14 December 1883.

Owner/ custodian: Liverpool City Council
Listed status: Grade II

Description: Located originally on the plateau on a high pedestal midway between the *Equestrian Statue of Prince Albert* (see above, pp. 91–5) and the *Equestrian Statue of Queen Victoria* (see above, pp. 95–7), the *Disraeli* was moved to its present location on a much lower pedestal, at the top of the first flight of the steps to the east portico of St George's Hall in 1927, in order to make way for Budden and Tyson Smith's *Cenotaph* (see above, p. 100; for a photograph of the removal operation, see Willett, 1967: 90).

The original *Disraeli* monument was 23 feet high overall, the sumptuous pedestal itself being 12 feet high. A detailed description was published in the *Courier*:

The pedestal is designed in Greek form, the aim being to make it harmonious with the severe and classical character of St George's Hall and its surroundings. It is chiefly formed of large blocks of polished red Peterhead granite, raised on a lower base-plinth of unpolished grey Aberdeen granite. The whole of the upper portion of the pedestal, or entablature, consisting of a

cornice with dentils and a frieze enriched with the national floral emblems, is of bronze. The lower member of the base-moulding of the pedestal is also of bronze, and is decorated with oak leaves. Four ornamental panels of bronze attached to the sides of the upper base course symbolise Lord Beaconsfield's memorable words "Peace with honour", each panel bearing a wreath of bay, intercrossed with branches of olive. The inscriptions on the front and sides of the monument are in incised and gilt letters, and are as follows:- "The Right Honourable Benjamin Disraeli, K.G." On one side, "Born 31st December, 1805", and on the other, "Died 19th April 1881". It is also proposed to place on the back panel an inscription to the effect that the monument was erected by public subscription (*Courier*, 15 December 1883).

This original granite pedestal was carved by Messrs John Molem & Co., of Westminster, and the whole monument erected by local contractors, Holme & Nicol.

Disraeli is represented wearing his peer's robes over 'the official costume of a Cabinet Minister' (*Courier*, 15 December 1883). He stands looking to his left, his weight on his right foot, his left foot forward, the toes overhanging the front of the pedestal. His right arm relaxes at his side, whilst his left forearm is raised to support the gathered bunches of his robes.

Condition: Good

Related works: (i) Liverpool, WAG (cat. 6304): *32" high plaster model for Beaconsfield statue*. Presented to the WAG by the sculptor's great-nephew in 1965, this is possibly the model shown to Liverpool Council in 1882 (see below, p.267) and may also have been the model shown

at the RA in 1883 (cat. 1537). (ii) London, Junior Carlton Club, life-size marble, 1893 (possibly cat. 1673 in the RA exhibition of 1893: *The late Earl of Beaconsfield, K. G.; statue*).

Following the traditional pattern for such matters, a number of Disraeli's admirers convened a public meeting at Liverpool Town Hall to discuss how the town might commemorate the recently deceased statesman. The convenors considered Disraeli's achievements for the Empire sufficiently great that the question of his commemoration should rise above political differences. Not unexpectedly, however, many non-Conservatives disagreed and, realising a consensus was impossible, the meeting was abandoned. The members of the Liverpool Conservative Club therefore decided to raise the money for a memorial principally from within their own ranks. Many of the town's wealthiest merchants were, of course, Conservatives and thus the subscription was soon raised (*Courier*, 15 December 1883).

On 26 June 1881, Alfred Turner, Chairman of the resultant Beaconsfield Memorial Committee, wrote to the Mayor, asking for approval to erect the intended statue 'at the South Angle of the Platform in front of St George's Hall'. The letter was duly referred to the Finance and Estate Committee, which would only give general approval for a site 'on or about the area of St George's Hall', subject to the Council's approval of 'the design of the Statue' (*Finance and Estate Committee Minutes*).

Meanwhile, a rumour had begun to circulate that the Beaconsfield Memorial Fund Committee was going to appropriate the prime site between the equestrian statues of the Queen and the Prince Consort. The *Daily Post* (13 December 1881), stated that it had heard the rumour some time before, but discounted it as 'inherently incredible': to position Disraeli between the royal couple would effectively relegate them to the role of 'heraldic supporters to the late Prime Minister'. The paper considered the very idea the height of 'bad taste'. Furthermore, the commission was 'not the act of the town at large', but only 'a party memorial' and it would be 'an unmistakable sign of unscrupulous party supremacy' (the Mayor at this time being Memorial Committee member, John Hughes) to 'appropriate to their purpose the central and choicest site at their disposal'. Nevertheless, on 1 February 1882, the Council approved without question the Finance and Estate Committee's recommendation that the centre of St George's Plateau was the most appropriate site for the statue (*Council Minutes*).

A competition had been held to select a suitable design (*Courier*, 15 December 1883) and C.B. Birch was announced as winner in December 1881 (*Daily Post*, 13 December 1881). His model for the statue (see 'Related Work' above) was approved by the Council on 4 January 1882 (*Council Minutes*). Holme & Nicol commenced work on the foundations in March 1883 and the bronze statue was completed and in place by November 1883 (*Finance and Estate Committee Minutes*). The total cost of the monument was 2,200 guineas (£2,310) (*Courier*, 15 December 1883).

Literature: (i) LRO manuscript sources: *Council Minutes*, 1/23: 518; *Council Minutes*, 1/24: 61, 93; *Finance and Estate Committee Minutes*, 1/27: 208, 613-14; *Finance and Estate Committee Minutes*, 1/28: 692; *Finance and Estate Committee Minutes*, 1/29: 421-22.
(ii) *Art-Journal* (1883): 254; *Athenaeum* (1883) 16 June: 770; *Courier* (1883) 14 December: 5; *Courier* (1883) 15 December: 7; *Mercury* (1883) 15 December: 5; Picton, J.A. (1875, revised edn 1903), ii: 508; Read, B., 'From Basilica to Walhalla', in P. Curtis (ed.) (1989) 37-8; Reilly, C.H. (1927a): 4; Reilly, C.H. (1927b): 131; Willett, J. (1967): 89, 60.

Statue of Major-General *William Earle*

(1833–85) military hero. The third son of (Sir) Hardman Earle of Allerton Tower, he entered the army in 1851 and served in Crimea, receiving a number of decorations. By the end of the war he had been promoted to captain. In 1859-60 he was assistant military secretary to the Governor of Gibralter, whose daughter he married. His military career took him to Nova Scotia and then to India, by which time he had risen to the rank of colonel and had been made a Companion of the Star of India. In 1882, now a Major-General, he was sent to Egypt where, for his services, he was made a Companion of the Bath. In 1884 he went up the Nile to rescue Gordon at Khartoum. En route his company was attacked by a large body of arabs. The attack was repulsed and the enemy positions taken, but during the conflict Earle, whilst leading his men forward, was shot through the head, dying instantly. He is buried at Allerton (source *DNB*).

Sculptor: Charles Bell Birch

Statue in bronze
Pedestal in Darley Dale stone

Bronze founder: James Moore of Thames Ditton (*Courier*, 17 December 1887).

Statue: h. 108" (274 cms)
Pedestal: h. 147¼" (374cms)

Inscription on the plaque attached to the pedestal: MAJOR GENERAL / WILLIAM EARLE C. B., C. S. I. / BORN IN LIVERPOOL, 1833; / KILLED IN COMMAND OF / HER MAJESTY'S TROOPS / AT THE BATTLE OF KIRBEKAN / IN THE SOUDAN, 1885. / ERECTED BY PUBLIC SUBSCRIPTION / C. B. BIRCH, A. R. A, SC. /

Exhibited: Royal Academy of Arts 1886 (cat. 1786), as *Major-General Earle, C.B., C.S.I., killed in action in Egypt, Feb. 10, 1885. Model for a bronze statue to be erected in Liverpool.* Royal Academy of Arts 1888 (cat. 1942), as *Small copy of statue erected at Liverpool to the memory of Major-General Earle, etc.* WAG Liverpool Autumn Exhibition 1889 (cat. 1518), as *Major-General Wm. Earle, C.B., C.S.I., (original study for the statue in front of St. George's Hall): In Plaster £26 5s; in Bronze £131 5s; in Marble £157 10s.*

Unveiled by Viscount Wolseley (Garnet Joseph Wolseley), Friday 16 December 1887

Owner/ custodian: Liverpool City Council
Listed status: Grade II

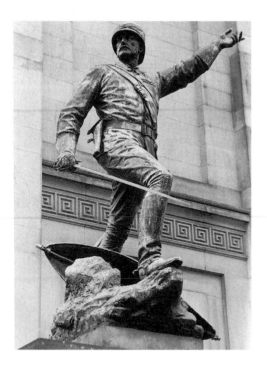

Description: The pedestal upon which the statue stands projects from the south end of the base course of the east façade of St George's Hall. Earle advances, his right foot forward on a rocky outcrop. He wears military uniform, gauntlets, boots with spurs, and a pith helmet. His left hand is raised as he looks back to encourage his men. In his right hand he holds a sword; by his left side is the sword sheath, and strapped to his back is a canteen. At his right side, attached to his belt, is a pistol in its holster. Between his legs, lying against a rock, is an African warrior's shield.

Condition: Good.

Related work: WAG, cat. 4189: *Major-General Earle*, h. 30", plaster model, coloured bronze. (Possibly the piece exhibited at the RA 1886, cat. 1786, and WAG LAE 1889, cat. 1518 – see above).

Following Earle's death in action, a group of friends and admirers petitioned the Mayor to call a public meeting 'to consider in what way the city can most suitably commemorate the distinguished services of the late General Earle' (*Mercury*, 25 February 1885). The meeting was held at the Town Hall on 24 February 1885 and there was, according to the newspaper, 'a large attendance, including many working men'. A Committee was appointed to supervise the raising of a public subscription. It was agreed that the memorial should take the form of a statue either 'in St George's Hall or in some other central position' and that a maximum of two guineas should be placed on each contribution to the fund. This limit was set for the usual reason: 'to make the movement wide and general', as one of the convenors of the meeting explained. The newspaper agreed: 'Every inhabitant of Liverpool has an equal share in the

honour of [Earle's] old family connection with the city, and ought to have the privilege of acknowledging it, if so disposed, by helping towards a perpetuation of his memory'.

On 15 April 1885, Alfred Turner, Deputy Chairman of the Earle Memorial Fund, made a formal request to the Corporation to have the statue placed on one of the pedestals under the eastern portico of St George's Hall (*Council Minutes*). The matter was referred to the Finance and Estate Committee which suggested utilising instead the pedestal at the south-eastern corner of the building, and after some debate with the Earle Memorial Fund, this was finally agreed on 4 September 1885 (*Finance and Estate Committee Minutes*).

Viscount Wolseley, who performed the unveiling, was an old friend of Earle's, having known him for about thirty years. He had served with him in the Crimea and in Canada, and lastly in Egypt and the Sudan where he had been Earle's Commander-in-Chief (*Courier*, 17 December 1887).

On 21 September 1888, less than a year after the unveiling of the statue, the Corporation Surveyor, Thomas Shelmerdine, reported to the Finance and Estate Committee the need to renew the inscription, which had been 'badly executed at the outset and afterwards maliciously damaged'. At the request of Earle's widow, the Corporation approved the insertion of a bronze inscription plaque into the front face of the pedestal, the expense of which was born by Mrs Earle (*Finance and Estate Committee Minutes*).

Literature: (i) LRO (a) manuscript sources: *Council Minutes*, 1/26: 344; *Finance and Estate Committee Minutes*, 1/31: 173, 387, 415, 594, 622; *Finance and Estate Committee Minutes*, 1/36: 121, 132. (b) news-cuttings: *Courier* (1887) 17 December, in *TCN 1/21*; *Mercury* (1885) 25 February, in *TCN 1/18*; *Mercury*

(1887) 12 December, in *TCN 1/20*.
(ii) *Art-Journal* (1886): 331; *Liverpool Review* (1887) 17 December: 9; *Liverpool Review* (1887) 24 December: 10-11; *Portfolio* (1886): 123; Read, B., 'From Basilica to Walhalla', in P. Curtis (ed.) (1989): 38; Reilly, C.H. (1927a): 4; Reilly, C.H. (1927b): 131; *The Times* (1886) 16 June: 4; *The Times* (1887) 17 December: 8.

2. INTERIOR:

The Great Hall contains twenty-six statue niches, twelve in each of the two long walls and two in the short wall at the south end. The hall is five bays long, the second and fourth bays containing three niches, the first, third and fifth two niches and a door. The central niches of the second and fourth bays are square-headed with strongly projecting pedestals; all others are round-headed with console pedestals. The two niches of the short wall are round-headed with a full pedestal. Only twelve niches were ever filled. The accounts below are given in chronological order of erection in the Hall.

Statue of George Stephenson

(1781-1848), inventor of steam locomotion and founder of the railways. Apprenticed in the collieries at an early age to his fireman father, he learnt to read at night school and extended his scientific knowledge in his remaining leisure time. Whilst employed as a colliery engineer, he spent most of his spare time familiarising himself with the operation of the engines, such that his working knowledge soon surpassed all others and earned him promotion to colliery engine-wright. His earliest attempts at steam locomotion were sponsored by his employers at the colliery and by 1815 he had invented a greatly improved engine using the steam-blast, he being the first to realise its importance for the efficient working of the locomotive; in this year he also invented a much-needed safety lamp for miners. It was in 1824 that Stephenson was sought out to plan and construct the Liverpool and Manchester Railway, necessitated by the increased trade which the canal could no longer accommodate. The directors weighed the advantages of either haulage by the use of fixed engines spaced along the line, or various locomotive systems. With the help of Henry Booth's advice that he use a multi-tubular boiler (see below, p. 293), Stephenson won the 1829 open trials at Rainhill with his *Rocket* and established the principles governing the future development of the railways. The Liverpool and Manchester Railway was officially opened on 15 September 1830 and in recognition of the benefits thereby conferred upon Liverpool, the Council resolved on 3 July 1833 to present Stephenson with the Freedom of the Borough (sources: *DNB*; Touzeau, 1910).

Sculptor: John Gibson

Statue in marble

Statue h: 68" (173 cms); w: 33" (83 cms); d: 41" (105 cms)
Pedestal h: 61½" (156.2cms)

Inscription on the front of the base: GEORGE STEPHENSON 1781-1848. / SCULPTOR JOHN GIBSON.

Signed on the right end of Stephenson's stool: OPUS IOANNIS GIBSON / ROMÆ

Exhibited: Royal Academy of Arts 1851 (cat. 1267), as *Statue, in marble, of the late George Stephenson, Esq.*

Unveiled at the inauguration of the Hall by John Buck Lloyd, Mayor of Liverpool, Monday 18 September 1854.

Owner: National Museums and Galleries on Merseyside, transferred from the City Estates, 1972.

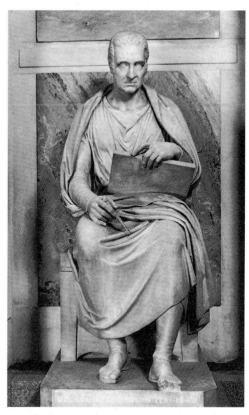

Listed status: not known

Description: Located on the west side of the Great Hall in the ninth niche from the north end. The figure, wearing classical drapery, is seated on a stool. With his left hand he holds a drawing board over his lap and in his right he holds a pair of compasses. The tip of his left foot, now broken off, once protruded over the forward edge of the base. Gibson explained the rationale which had governed his representation of Stephenson:

Mrs Lawrence says that Stephenson should

have a look of energy – a man of action more than contemplation. I will endeavour to give him a look capable of action and energy, but he must be contemplative, grave, and simple. He is a good subject. I wish to make him look like an Archimedes. Activity and energy are momentary, contemplation is more suited to marble. The statue must give an idea of his studious moments (Eastlake, 1870: 121).

Condition: There is a small chip, approximately ³/₄" (2 cms), missing from the left forward corner of the stool upright. The forward part of the left foot, once overhanging the base, is missing. The surface of the statue is generally dirty.

Gibson's *Statue of George Stephenson* was commissioned by the combined Liverpool & Manchester & Grand Junction Companies and executed by the sculptor in Rome. According to Smiles (1857: 490), the statue was 'on its way to England' when Stephenson died on 12 August 1848. On hearing of his death, the Board of the Liverpool Company recorded its high esteem for Stephenson and the extent of its debt to him in the following minute from the meeting of 6 September 1848:

> Two years ago, the directors entrusted to Mr. Gibson, of Rome, the duty and the privilege of producing a statue that might do honour to their friend, then living amongst them. They did not anticipate that on the completion of this work of art the great original would be no more, – that they should be constrained to accept the marble effigy of the engineer in lieu of the living presence of the man (Smiles, 1857: 491).

On 21 March 1851, Henry Booth and Charles Lawrence, representatives of the London and North Western Railway, into which the former companies had by then merged, met with the St George's Hall and Law Courts Committee, to obtain permission to place the statue in St George's Hall, then still under construction. They examined various possibilities, including the northern and southern vestibules, but eventually decided to wait and seek Gibson's opinion when he visited Liverpool in the forthcoming summer (*The Times*, 27 March 1851: 8). That there should be no mention of the statue niches in the Great Hall may seem surprising, but in all probability they were not yet conceived. To judge by an elevation drawing of a section of the Great Hall by Elmes, the building's original architect (reproduced as ill. 10 in the *Architects' Journal*, 18 June 1986: 40), statue niches were never part of his plans. The first indication we have of them is in an elevation drawing of a similar section of the hall by Cockerell, the architect who replaced Elmes in 1851 (reproduced as ill. 11 in *Architects Journal*, 18 June 1986: 40; see also Read, 1989: 33-4).

 With the introduction of statue niches to the Great Hall, came a corresponding change of emphasis in the building's function, for as well as serving as the venue for Liverpool's Triennial Music Festivals and other officially-approved events as originally intended (see above, p.253), the Great Hall was now established as a nascent civic Pantheon. The directors of the London and North Western Railway were, along with the Peel Testimonial Committee (see below), the first to take advantage of the new opportunity with their statues of, respectively, George Stephenson and Sir Robert Peel. Both statues were unveiled during the building's inaugural ceremony on 18 September 1854.

Literature: *Architects Journal* (1986) 18 June: 40; *Building Chronicle* (1854): 83; Eastlake, Lady (1870): 121; *Mercury* (1854) 19 September: 7; Ormond, R. (1973) i: 479-80; Picton, J.A. (1875, revised edn 1903), i: 515; Read, B., 'From Basilica to Walhalla', in P. Curtis (ed.) (1989): 33, 34; Smiles, S. (1857): 490-91; *The Times* (1851) 27 March: 8.

Statue of Sir Robert Peel

(1788–1850) statesman. The son of a Lancashire cotton manufacturer, he was a Tory politician from 1809 onwards, becoming Secretary for Ireland in 1812, and then Home Secretary in 1822, in which latter capacity he established the Metropolitan Police. He resigned in protest against Canning's motion for Catholic emancipation, though following Canning's death he resumed his post and, furthermore, successfully piloted the bill himself when he realized the country was for it. Peel was Prime Minister twice: briefly in 1834-35 (four months) and then 1841-46, during which term of office he repealed the Corn Laws in response to the Irish famine. This action split the party, with Disraeli leading the rebels who subsequently defeated Peel's Irish Coercion Bill, forcing his resignation. The merchants of Liverpool would presumably have admired Peel chiefly for his reorganization of the Bank of England and his repeal or reduction of many import duties, thereby stimulating consumption and ensuring for English trade the leading position in the world (source: *DNB*; see also Read, 1989: 35).

Sculptor: Matthew Noble

Statue in Carrara marble

Statue h: 82" (209 cms); w: 28" (70 cms); d: 32" (82cms)
Console pedestal h: 61½" (156.2cms)

Inscription on the front of the marble base: SIR ROBERT PEEL BART. 1788-1850. / SCULPTOR M. NOBLE.

Signed and dated on the left side of the marble base: M. NOBLE. SC. / LONDON. 1853.

Exhibited: Royal Academy of Arts 1851, as *Sketch of the late Sir Robert Peel* (cat. 1349). Royal Academy of Arts 1852, as *Statuette of the late Sir Robert Peel, to be executed in marble, for St George's Hall, Liverpool'* (cat. 1347).

Unveiled at the inauguration of the hall by John Buck Lloyd, Mayor of Liverpool, Monday 18 September 1854

Owner: National Museums and Galleries on Merseyside, transferred from the City Estates, 1972
Listed status: not known

Description: Located on the west side of the Great Hall in the seventh niche from the north end. The figure is standing, looking straight ahead, wearing a long gown over a waistcoat and tight-fitting trousers. In his right hand, held down at his side, he holds a scroll, whilst his left is raised to his chest to gather up the folds of the gown. His left foot protrudes over the forward edge of the base.

Condition: There is a small chip out of the fold of the gown where it lies against the right side of the base. The statue's surface is generally dirty.

Related works: (a) statues: Peel Park, Salford, bronze, 1852; Tamworth, Staffordshire, bronze, 1853; Parliament Square, London, bronze, 1876-77 (a replacement of an earlier statue of Peel by Baron Marochetti). (b) busts: Collection of Earl Peel, life-size, marble, 1850 (exhibited at the RA 1851, cat. 1379); National Portrait Gallery, London, reduced replica of the preceding, marble, 1851 (cat. 596a); National Portrait Gallery, London, life-size, marble (cat. 596).

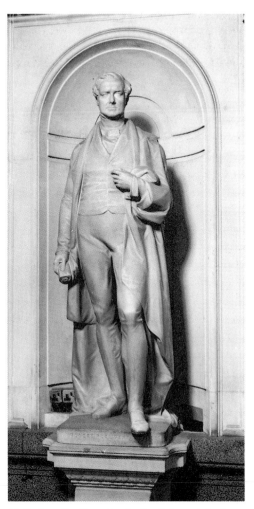

Sir Robert Peel's untimely death from injuries sustained in a fall from his horse engendered a nationwide spate of schemes for commemorative public monuments, unprecedented in its scale. In the years immediately following his death in 1850, over twenty monuments to him were commissioned, mostly in the industrial

midlands and north where the bedrock of his support had lain (Read,1982: 107). In a few short years, statues of Peel were erected in, for example, Birmingham (Peter Hollins, 1855), Bradford (W. Behnes, 1855), Bury (E.H. Baily, 1852), Leeds (W. Behnes, 1852), Manchester (W. Calder Marshall, 1853), Preston (Thomas Duckett, 1852), Salford (Noble, 1853), Tamworth (Noble, 1853), and, of course, Liverpool.

The Liverpool statue, in common with the majority, was funded by public subscription. The Committee of the Subscribers to the Liverpool Peel Testimonial favoured St George's Hall, then in the course of construction, as the most appropriate location for its statue and duly made an application to the Corporation's Law Courts and St George's Hall Committee for the statue 'to be placed upon one of the Pedestals on the East side of St George's Hall'. The application was approved by the Committee and, on 13 August 1851, the Council gave its necessary ratification (*Council Minutes*).

Although the statue was ultimately installed in one of the niches in the Great Hall, the Testimonial Committee is here clearly requesting one of the pedestals on the outside of the building, under the eastern portico. The explanation is that the statue niches in the Great Hall had probably not yet been devised. They were certainly not part of the original architect H.L. Elmes's plans, as may be seen in his elevation drawing of a section of the Hall (reproduced as illus. 10 in *Architects Journal*, 18 June 1986: 40). Elmes died prematurely, however, and was replaced in 1851 by C.R. Cockerell, who transformed certain aspects of the building, particularly the interior. Cockerell's elevation drawing of the Great Hall does include statue niches (reproduced as illus. 11 in *Architects Journal*, 18 June 1986: 40; see also Read, 1989: 33-4). The way was thus opened for

St George's Hall to become Liverpool's civic Pantheon, and the Peel Testimonial Committee was one the first to take advantage of it.

In April 1854, T.A Bushby, the Secretary of the Peel Statue Fund, received a letter from Noble stating that the statue was completed and ready for transmission to Liverpool. And in its meeting of 22 April, the Law Courts and St George's Hall Committee, to whom Bushby had passed the sculptor's letter, resolved:

> That Mr Bushby be informed, that the Committee are prepared to receive the same, and that Mr Noble be requested to select one of the niches in St George's Hall in which it may be placed (*Law Courts and St George's Hall Committee Minutes*).

Noble's *Statue of Sir Robert Peel* was unveiled at the inauguration of the Hall, along with Gibson's *Statue of George Stephenson* (see above, p. 270). The *Mercury* (19 September 1854) commented:

> Among the worthies who have conferred lasting benefits upon their country none more fit could have been selected, with the view of honouring their memories in this community, than the two men whose monuments are the first to grace the niches in St George's Hall.

Literature: (i) LRO manuscript sources: *Council Minutes*, 1/6: 233; *Council Minutes*, 1/7: 213-14; *Law Courts and St George's Hall Committtee Minutes*, 1/2: 298.
(ii) *Architects' Journal* (1986) 18 June: 40; *ILN* (1854) 18 November: 513; *Mercury* (1854) 19 September: 7; Picton, J.A. (1875, revised edn 1903), i: 515; Read, B., 'From Basilica to Walhalla', in P. Curtis (ed.) (1989): 34-5.

Statue of the Reverend Jonathan Brooks

(1775–1855) rector and archdeacon. The son of a Liverpool merchant, he was educated at Macclesfield School and Trinity College, Cambridge (BA 1798, MA 1802). He was curate, consecutively, of Walton on the Hill; St James, Liverpool; and St George's, Liverpool. From 1829 until his death he was senior rector of Liverpool and from 1848 archdeacon. He was also Chairman of the first St George's Hall Committee and Chairman of the Liverpool quarter sessions for many years (source: *MEB*).

Sculptor: Benjamin Edward Spence

Statue in marble

Statue h: 80" (202 cms); w: 29" (74 cms); d: 26" (66 cms)
Pedestal h: 61½" (156.2cms)

Inscription on the front of the oval base: REVD. JONATHAN BROOKS / ARCHDEACON OF LIVERPOOL 1775-1855

Signed and dated on the right side of the oval base: SC. B. E. SPENCE/ FECIT ROMA 1858

Owner: National Museums and Galleries on Merseyside, transferred from the City Estates, 1972
Listed status: not known

Description: Located on the east side of the Great Hall in the ninth niche from the north end. Brooks is represented standing, wearing clerical robes, pointing with his right hand to the text in an open volume held in his left hand. He looks down at the viewer, tilting the volume forward so that the pages may be seen. His weight is borne upon his right foot, deep-cut drapery folds stressing the verticality of the supporting right leg. His left leg flexes, the form of the knee surfacing through the dissipated drapery folds, his left foot protruding over the forward edge of the oval base.

The Times (20 August 1858) reported that it

was 'said to be an excellent likeness', although the *Courier* (21 August 1858) made the qualified criticism that Spence's stylistic tendency had 'given a classic grace to the figure not strictly natural', whilst nonetheless praising its 'artistic beauty and wonderful finish'. The drapery came in for especial praise: 'The texture of the various parts is indicated with admirable success, and the marble is made to tell which is silk and which is lawn as forcibly as if the textures themselves were presented to the eye'.

Condition: A semicircular piece of stole (*c.* 15cms/6") has at some time been broken off and replaced; subsequent to the statue being

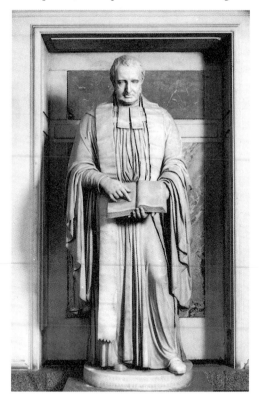

photographed for the Conway Library in 1985 another semicircular piece of the edge of the stole (*c.* 7.5cms/3") has been broken off. The surface of the statue is generally dirty.

Following the death of Archdeacon Brooks, a group of his friends and admirers in Liverpool gathered together and agreed that a memorial statue should be erected to him. It was decided that the statue should be funded by public subscription and that the sculptor should be selected by competition. The winner of the competition was B.E. Spence, Liverpool-born, but for some years resident in Rome (*Art-Journal*, 1856: 252).

The advertisement for the competition had stated that the amount which had been set aside for the statue was £1,800. However, following the award of the commission to Spence, the Executive Sub-Committee for the Memorial resolved to lower the fee to £1,200 'in order to appropriate a portion of the sum to another object', justifying this duplicity 'on the grounds that first-rate artists could be found to execute the commission for that sum'. Spence felt that he had been unfairly dealt with, but nonetheless tried to reach a settlement with the Committee by proposing a larger monument for the original amount. Notwithstanding 'a somewhat stormy discussion', with the General Committee who recommended that the original price be adhered to, the Executive Sub-Committee stuck to their reduced fee of £1,200 (*Courier*, 15 October 1856).

The work was executed by Spence in his studio in Rome and it arrived in Liverpool on 19 August 1858 (*The Times*, 20 August 1858). It was first 'placed for inspection in the northern vestibule' (*Courier*, 21 August 1858) before later being permanently installed in its niche in the Great Hall.

After Spence had been paid there was a surplus which it was proposed should be divided proportionally amongst the subscribers. The official recommendation from the Memorial Committee was that subscribers should donate any refunded money to the Liverpool Royal Infirmary (*Courier*, 9 October 1858). Many subscribers thought differently, however. One, who signed himself "Alpha", wrote to the *Courier* on 27 October 1858, stating his conviction that 'good faith [had] not been kept with Mr Spence' regarding the remuneration for his 'splendid statue'. He complained that a petition from 'a large number of the leading men in Liverpool', requesting a meeting of all subscribers to discuss 'the disposal of the surplus' funds had been 'positively refused' by the Executive Sub-Committee. Consequently, several of the petitioners had deposited their refunds at Moss's Bank for the purpose of making up the sculptor's shortfall. "Alpha" invited all those who also felt that the sculptor had been poorly treated to do the same.

A more numerous group, however (to judge by the large amount of letters to the local press), favoured donating their refunds to the now destitute family of the late Archdeacon. A similar account was duly established as a relief fund for them, also at Moss's Bank (*Courier*, 20 October 1858; *Courier*, 23 October 1858).

Regarding the statue itself – and notwithstanding the praise heaped upon it as a work of art – there were those who privately questioned Brooks's eligibility for commemoration in the Hall, for although he appears to have been a genial man who performed his office well, his inclusion in a hall otherwise reserved for the celebration of men of exceptional merit, did not go uncriticised (see, for example, Picton, 1875, revised edn 1903, ii: 350).

Literature: (i) LRO (a) manuscript source: *Law Courts and St George's Hall Committee Minutes*, 1/2: 452.
(ii) *Art-Journal* (1856): 252; *Art-Journal* (1858): 300; *Courier* (1856) 15 October: 407; *Courier* (1858) 21 August: 534; *Courier* (1858) 9 October: 647; *Courier* (1858) 20 October: 675; *Courier* (1858) 23 October: 679; *Courier* (1858) 27 October: 691; *Courier* (1858) 3 November: 707; Picton, J.A. (1875, revised edn 1903), ii: 350; Read, B., 'From Basilica to Walhalla', in P. Curtis (ed.) (1989): 35, 36; *The Times* (1858) 20 August: 10.

Statue of Sir William Brown

(1784–1864) merchant, banker, alderman, politician and benefactor to Liverpool. While still a young man he travelled to the USA with his parents. His father set up a linen trade business there and by 1809 William had returned to England to set up a company branch in Liverpool, while his brothers established other branches in America. At the same time, the family was expanding its business activities into international banking, thereby significantly increasing its wealth. William was an alderman of Liverpool from 1831-38 and, ever an advocate of free trade, the unsuccessful Anti-Cornlaw League candidate for South Lancashire in 1844. In 1846, however, he was elected, holding office until 1859. Throughout this time he continued to expand his business interests in Liverpool, but is best remembered for his funding of the construction of the Free Public Library and Derby Museum (now Liverpool Museum), opened in 1860. In 1863 he was created baronet (source: *DNB*).

Sculptor: Patrick MacDowell

Statue in marble

Statue h: 89" (227 cms); w: 30" (76 cms); d: 27" (70 cms)
Console pedestal h: 61½" (156.2cms)

Inscription on the front of the marble base: SIR WILLIAM BROWN BART. 1784-1864. / SCULPTOR. P. MAC. DOWELL.

Signed on the right side of the ornamental pedestal behind the figure: P. MAC. DOWELL. R.A. / SCULP. *LONDON.*

Unveiled by Thomas D. Anderson, Mayor of Liverpool, Thursday 18 October 1860 at the banquet celebrating the opening of William Brown's Free Library and Museum.

Owner: National Museums and Galleries on Merseyside, transferred from the City Estates, 1972
Listed status: not known

Description: Located on the west side of the Great Hall in the sixth niche from the north end. Dressed in a frock coat, Brown stands looking to his right, his weight on his left leg, his left hand on his hip, his right hand down at his side, holding a scroll. His right foot over-hangs the forward left corner of the base.

The statue was originally placed in the niche now occupied by the *Roscoe* statue (see below, pp. 285–6), but was re-located in November 1893 to make way for the latter statue, so that the seated *Roscoe* would balance the seated *Stephenson* in the corresponding niche on the other side of the door.

Condition: There is a small chip (*c.*1.5cm / ¹/₂") missing from the tip of the right foot over-hanging the edge of the base. The general condition is fair, but the statue is in need of cleaning.

On 1 January 1857, Liverpool Town Council resolved to find some way of recording for posterity its gratitude for Brown's gift of the Free Library and Museum, which it esteemed highly as 'an Institution so admirably adapted

to conduce to the welfare and improvement to all classes of the community' (*Council Minutes*). A Special Committee was immediately formed to execute the project and on 7 January 1857 reported back to the Council their recommen-dation that the memorial should take two forms: one a full-length painted portrait 'by an Artist of the highest eminence', to be hung in the Library and bearing a suitable inscription,

and the other a marble statue, to be placed in one of the niches in St George's Hall (*Council Minutes*).

Patrick MacDowell was commissioned to execute the statue and Sir John Watson Gordon, the painting (*Art-Journal*, 1857: 163). (The painting is now in the WAG, cat. 1138.) MacDowell wrote to Liverpool Corporation on 7 March 1860 to report that the statue was 'quite finished' (*Council Minutes*), and it was officially unveiled at a ceremonial banquet, held on the evening of 18 October 1860 in St George's Hall, as part of the celebrations for the inauguration earlier that day of Brown's Free Library. The importance of the occasion was such that the Council had declared a general holiday, extending 'even to Birkenhead', as the *Mercury* (19 October 1860) reported in its extended coverage of the day's proceedings.

Sir William Brown was to live on till 1864 and thus became the first subject to be honoured during his lifetime with a statue in the Great Hall.

Literature: (i) LRO manuscript sources: *Council Minutes*, 1/8: 27, 38; *Council Minutes*, 1/9: 281; *Finance and Estate Committee Minutes*, 1/42: 637-38, 722; *Documents Connected with the Opening of the Brown Library.*
(i) *Art-Journal* (1857): 163; *Mercury* (1860) 19 October: 5, 6, 7; Read, B., 'From Basilica to Walhalla', in P. Curtis (ed.) (1989): 35.

Statue of Joseph Mayer

(1803–86) antiquary, collector and benefactor to Liverpool and Bebington. Born in Staffordshire, at twenty he settled in Liverpool and became a goldsmith, silversmith and jeweller in Lord Street. His first gift to the people of Liverpool was the collection of Saxon antiquities that he had purchased from Revd Dr Godfrey-Faussett. This was followed in 1867 with the presentation of his collection of arts

and antiquities to the Corporation. Then in 1866 he established a free library in Bebington, bearing the entire cost himself. Both the library and the grounds in which it stood were dedicated to the free use of the people. The *DNB* records that he 'was much interested in floriculture, and was accustomed to distribute flowers during the summer months to readers who came to change their books' (sources: *DNB*, *MEB*).

Sculptor: Giovanni Giuseppe Fontana

Statue in Carrara marble

Statue h: 89" (225 cms); w: 35" (89 cms); d: 35" (89 cms)
Pedestal h: 61½" (156.2cms)

Inscription on the front of the marble base:
JOSEPH MAYER F.S.A. / SCULPTOR GIOVANNI FONTANA.

Unveiled by Thomas Dover, Mayor of Liverpool, Tuesday 28 September 1869.

Owner: National Museums and Galleries on Merseyside, transferred from the City Estates, 1972.
Listed status: not known

Description: Located on the east side of the Great Hall in the fourth niche from the north end. The figure stands with his weight borne upon his left foot, his right leg forward with the foot protruding over the edge of the base. He looks to his right, the deed of gift by which Liverpool received part of his collection in his right hand (*ILN*, 14 August 1869, cited in WAG 1977, i: 308), his left hand held out in a declamatory gesture. Over his left forearm is draped a fur-trimmed coat or robe. Behind him on his left is a pile of two books, whilst on his right is represented an Egyptian sculpture from

his gift, resting on another book. The original was a votive statue made for Amen-neb, *c.*1400 BC, (cat. M13503 in the Liverpool Museum), unfortunately destroyed in an air raid during the Second World War (WAG 1977, i: 308).

Condition: All the fingers and thumb of the left hand are missing. The surface of the statue is generally dirty.

Related works: (i) plaster model for the present statue, present whereabouts unknown, photo-

graph in *Binns Collection*, xxx: 97. (ii) two marble busts of Joseph Mayer (WAG cat. 7599; 7603). Possibly the busts referred to by Joseph Clarke in a letter to Joseph Mayer dated 8 July 1868: '[Fontana] was finishing a second bust which I consider an improvement upon the one at the Royal Academy' (*Joseph Mayer Papers*) – the bust exhibited at the 1868 Royal Academy was cat. 1013: *Joseph Mayer, F.S.A., &c. – marble*.

At a meeting of the Liverpool Corporation Library, Museum and Education Committee on 28 March 1867, the Chairman, (Sir) James Allanson Picton, proposed that 'a statue of Mr Mayer be erected in St George's Hall at the expense of the Corporation' in acknowledgement of his donation to the town of part of his collection of antiquities. Picton's proposal was approved by Liverpool Town Council on 3 April 1867 (*Library, Museum and Education Committee Minutes*, cited in WAG 1977, i: 308). Mayer himself selected the London-based Giovanni Fontana as his sculptor (*ILN*, 14 August 1869, cited in WAG 1977, i: 308). He had first become acquainted with Fontana during the mid 1850s and, throughout the 1860s and 1870s, commissioned from him a series of portraits of his family and friends.

On 25 April 1867 Fontana wrote to Picton, thanking him for the commission and promising a work 'that cannot fail to give satisfaction'. The statue would be a standing figure 'seven feet high without the plinth', a size arrived at in order that it should 'harmonize with the other statues' in the Hall. As far as the costume was concerned, Fontana stated that he preferred to consult with Mr Mayer (he 'being an artist'), before arriving at any decision. He would then 'model a sketch' for the Committee's approval, whereupon he would

'be in a position to give a definite answer as to price' (*Library, Museum and Education Committee Minutes*). On 23 May 1867, Fontana travelled to Liverpool to submit his model of the statue to the Library, Museum and Education Committee. He also presented a letter in which he pledged himself to devote all his talents to complete the commission 'in the best statuary marble' for the sum of £1,000 and to deliver the completed work within two years. The Committee, however, asked him to make a few sketches of alternative ideas before giving their approval and in the meeting of 20 June 1867, a certain 'Sketch No. 1' was approved. The terms of agreement were approved on 26 September 1867 (*Library, Museum and Education Committee Minutes*, cited in WAG 1977, i: 308).

Evidently Fontana viewed this as his most important commission to date. His wife was equally convinced: she told Joseph Clarke, a mutual friend of the sculptor and his patron, that 'she gets up every morning at five o'clock to kneed [*sic*] the clay, and is in such extacies that she says she shall never want again and their fortune is quite made' (*Joseph Mayer Papers*; note: the letter, dated 26 August 1867, states that it was Fontana's wife who rose at five each morning to knead the clay, not Fontana himself as is stated in WAG 1977, i: 307-08). A full-scale model was completed by 12 December 1867, in return for which Fontana was paid £250 (*Library, Museum and Education Committee Minutes*, cited in WAG 1977, i: 308). By 24 November 1868, Clarke reported that the statue was 'cut out in the rough and the lower half finished or nearly so' and declared himself extremely impressed, speculating that this work, when finished, would 'set Fontana up in the world'. The marble (again according to Clarke) was eventually completed by 2 May 1869 (*Joseph Mayer Papers*, cited in WAG 1977, i: 308).

On 22 March 1869 Fontana had written to Liverpool, asking for the Committee's permission to exhibit the marble statue at the Royal Academy or, should the marble not be completed by the submission date, the plaster model (*Library, Museum and Education Committee Minutes*, cited in WAG 1977: 308). In fact, he had earlier told Clarke that he did not intend to submit the marble because he feared accidental damage (letter from Clarke to Mayer, dated 24 January 1869: *Joseph Mayer Papers*, cited in WAG 1977, i: 308). Fontana was evidently torn between this fear and a desire to show off his masterpiece in the most important exhibition of the year. Ultimately, he sent neither the plaster nor the marble.

At the beginning of May 1869, Fontana wrote to the Committee, announcing the completion of the marble and asking for further instructions. The Town Clerk (Joseph Rayner) replied on 10 May, asking him to keep the statue in his studio for a month, until the Hall was ready to receive it (it was to be unveiled at the same time as Theed's *Statue of the 14th Earl of Derby*, see below). At the agreed time, Fontana travelled to Liverpool with the statue, attended the Committee meeting on 17 June, and received his official instruction to install the statue. Fontana personally supervised the installation and on 25 June the Finance and Estate Committee, on receiving the certificate of the Corporation Surveyor, E.R. Robson, that the statue had 'been properly and securely fixed', authorised payment of the £550 balance due to the sculptor (*Finance and Estate Committee Minutes*).

Fontana's *Statue of Joseph Mayer* had been installed in the Great Hall by 23 June at the latest, for Joseph Boult, a friend of the sculptor's, called in to see it. He thought it a fine work, but considered the niche entirely inappropriate as one could not 'obtain a proper view of the full face without going into the orchestra!' He wrote to the Deputy Chairman of the Library, Museum and Education Committee, Edward Samuelson, informing him of his concern on the same day. The Corporation Surveyor evidently felt the same way for, in his letter to the Committee meeting of 22 July, he advised that, although the statue was undoubtedly 'securely fixed', which was all the Committee had asked him to report on previously, it nonetheless 'stands improperly in relation to the pedestal and does not suit the niche selected' (*Library, Museum and Education Committee Minutes*, cited in WAG 1977, i: 308). Notwithstanding the observations of both Boult and Robson, the statue was never relocated and remains in its original niche to this day.

The critic of the *Art-Journal* (1869: 195), writing prior to the statue's installation (presumably having viewed it during its month-long stay in Fontana's London studio) was particularly enthusiastic about the work, classing it 'among the most excellent portrait-statues of our time', and the *Illustrated London News* (14 August 1869) thought Mayer's confidence in his choice of sculptor 'well placed'. Mayer, described as a 'retiring and modest man' by Picton in his address at the unveiling, did not attend the ceremony (*Daily Post*, 29 September 1869).

Literature: (i) LRO (a) manuscript sources: *Finance and Estate Committee Minutes*, 1/15: 497-98; *Library, Museum and Education Committee Minutes*, 1/6: 358, 367, 370-71, 383-83, 399, 454, 489; *Library, Museum and Education Committee Minutes*, 1/7: 5, 55, 84, 246, 288-89, 313, 314-15, 334-35, 338-39, 353-54, 359; *Joseph Mayer Papers*, letters from Joseph Clarke dated 26 August 1867, 8 July 1868, 24 November

1868, 24 January 1869, 2 May 1869, 30 August 1869.
(b) newscutting: *Daily Post* (1869) 29 September, in
TCN 1/4. (c) photograph of plaster model for *Statue
of Joseph Mayer* in *Binns Collection*, xxx: 97.
(ii) *Art-Journal* (1867): 126; *Art-Journal* (1869): 194-
95, 258, 353; *ILN* (1869) 14 August: 169; Picton, J.A.
(1875, revised edn 1903), i: 535; *Porcupine* (1869): 257;
Read, B., 'From Basilica to Walhalla', in P. Curtis (ed.)
(1989): 35-36; *The Times* (1869) 29 September: 7;
WAG (1977) i: 307-9.

Statue of Edward George Geoffrey Smith Stanley, 14th Earl of Derby

(1799–1869) statesman. Born at Knowsley Hall,
Stanley was, from 1822-44, Whig M.P. for,
respectively, Stockbridge, Preston, Windsor and
North Lancs. He was Irish Secretary 1830-33,
during which time he supported parliamentary
reform. In 1833, as Colonial Secretary, he intro-
duced proposals to abolish slavery in the
colonies. He joined the Conservative opposi-
tion in 1835, becoming Colonial Secretary again
in 1841, under Peel. He resigned in 1844 when
Peel declared in favour of free trade and
accepted leadership of the anti-freetraders.
Stanley succeeded to hereditary earldom on the
death of his father in 1851. He was Prime
Minister February – December 1852, February
1858 – June 1859 and June 1866 – February
1868, whereupon he resigned through ill-health.
He was both a classical scholar and a devotee of
sport (sources: *DNB*, *MEB*).

Sculptor: William Theed the Younger

Statue in Carrara marble

Statue h: 83" (211 cms); w: 39" (98 cms); d: 42"
(107 cms)
Console pedestal h: 61½" (156.2 cms)

Inscription on the front face of the marble base:
EARL OF DERBY 1799-1869. / SCULPTOR
WILLIAM THEED.

Signed and dated on the right side of the marble
base: W. THEED SC. / LONDON 1869

Unveiled by Thomas Dover, Mayor of
Liverpool, Tuesday, 28 September 1869

Owner: National Museums and Galleries on
Merseyside, transferred from the City Estates,
1972
Listed status: not known

Description: Located on the east side of the
Great Hall in the sixth niche from the north
end. The figure is represented standing, dressed
in the robes of a Knight of the Garter (the
garter below the left knee showing part of the
motto, *viz*, 'MAL Y PENSE') and wearing the
chain and jewel of the Order of St George. He
wears a sword at his left side and holds a scroll
in his left hand while with his right he points
downwards in a declamatory gesture, 'as [if]
addressing the House of Lords' (*ILN*, 14
August 1869: 169). His weight is borne upon
his left leg, the foot of his flexed right leg over-
hanging the forward edge of the base.

Condition: The tip of the third finger of the
right hand is missing, damage which has been
sustained since the Conway library
photographs were taken in 1985. The pommel
of the sword is missing. The surface of the
statue is generally dirty.

Related works: (i) *The Right Hon. the Earl of
Derby, K.G. – marble*, shown at the Royal
Academy of Arts 1868, cat. 972 (i.e before the
present statue was completed in marble),
present location unknown; (ii) *Statue of the
14th Earl of Derby*, 1872, Junior Carlton Club,
London (Gunnis, 1951: 387).

On Wednesday 5 June 1867, Liverpool Town
Council, at the suggestion of (Sir) James
Allanson Picton, Chairman of the Library,

Museum and Education Committee, unani-
mously resolved to erect (though not specified,
at the Corporation's expense) a statue in St
George's Hall to its townsman, the Earl of
Derby. The Council's reasons, clearly-stated in
the minutes of the meeting, were its pride in
Derby's national achievements and its grateful
acknowledgement of his gift to the town of the
Derby Museum (*Library Museum and
Education Committee Minutes*).

Derby's preference of sculptor was sought and, on 15 August 1867, the sculptor of his choice, the London-based William Theed the Younger, successfully submitted to the Library, Museum and Education Committee a small model previously approved by the subject. On his return to London, the sculptor had the model photographed and instructed his son, N.S. Theed, to send a copy to the Committee, which he duly did on 27 August 1867. He had at the same time sent six copies to the Mayor (John Grant Morris) and subsequently received an order for seventy more from Picton (all copies untraced) (*Library Museum and Education Committee Minutes*).

A contract was drawn up by the Town Clerk (Joseph Rayner) and signed by Theed on 11 October 1867. On 18 April 1868, Theed wrote to Rayner, reminding him that 'some time' had passed since he, along with Mr Edward Samuelson, the Deputy Chairman of the Library, Museum and Education Committee, and Mr Newlands, the Borough Engineer, had seen and approved the completed full-size model and that under the terms of the agreement the second instalment of £250 was now due to him. Theed added encouragingly that the model had also been admired by the M.P. for Liverpool, S.R. Graves, and, most importantly, by Lord Derby and his entire family. The matter was referred to the Corporation Finance and Estate Committee who authorised the payment on 24 April 1868 (*Finance and Estate Committee Minutes*).

On 22 May 1869, Theed wrote to Picton, stating that he expected to finish the marble by the end of the month and seeking the Library, Museum and Education Committee's consent for him to retain the statue 'for a week or ten days' in order that he could show it to Lord Derby 'and his [Lordship's] friends and admirers' in London. Theed was evidently very proud of his work and stressed the elaborate nature of the carved details (*Library Museum and Education Committee Minutes*). In the event, the Committee asked him to keep the statue in his studio for a further month until they were ready to receive it. Theed replied that he would be happy to keep the statue for a month, but requested that it be no longer, as he was 'almost blocked up in [his] studio with the large portions of [his] colossal group of *Africa* [for the Albert Memorial], now in a very advanced state' (*Library Museum and Education Committee Minutes*). The viewing in Theed's studio was attended by a writer from *The Times* who expressed great admiration for the new statue, which he specifically categorised as 'not colossal, but of what is known as the "heroic size"'. He was especially impressed by the way in which Theed had enlivened his sculptural conception with an acutely rendered naturalism: 'The hands show delicacy and grace in perfection, and in the minuter points, such, for instance, as the veins in the back of the left hand, the sculptor has been exquisitely true to nature' (*The Times*, 10 June 1869).

Towards the end of June 1869, Theed wrote to Rayner stating that, with the Library and Museum Committee's approval, he proposed to have the statue packed and out of his studio on 3 July, to arrive in Liverpool two days later on the morning of Monday the 5th. Should this schedule be acceptable to the Committee, he requested that it order the necessary 'appliances and scaffolding' to be made available for that date so that he might get the statue installed within its niche without undue delay (*Library Museum and Education Committee Minutes*).

It is not clear whether or not this schedule was kept to, since the next minuted reference to the statue does not appear until 22 July 1869, when the Corporation Surveyor, E.R. Robson, reported to the Library, Museum and Education Committee that the statue had been 'securely fixed' in its niche and was 'in every way satisfactory' (*Library Museum and Education Committee Minutes*). Finally, in its meeting of the following day, the Finance and Estate Committee, on the recommendation of the Library, Museum and Education Committee, authorised payment of the £530 balance due to the sculptor (*Finance and Estate Committee Minutes*). Theed's *Statue of the 14th Earl of Derby* was two years in execution and he was paid a total of £1,000 for the work (*Daily Post*, 29 September 1869).

Literature: (i) LRO (a) manuscript sources: *Finance and Estate Committee Minute Book*, 1/14: 137-38; *Library, Museum and Education Committee Minutes*, 1/6: 390, 394, 395, 423, 429, 430, 437, 464-65; *Library, Museum and Education Committee Minutes*, 1/7: 67, 322-23, 327, 337, 353-54, 359. (b) newscutting: *Daily Post* (1869) 29 September, in *TCN 1/4*.
(ii) *Art-Journal* (1867): 195; *Art-Journal* (1869): 258, 353; *ILN* (1869) 14 August: 169; Picton, J.A. (1875, revised edn 1903), i: 535; *Porcupine* (1869): 257; Read, B., 'From Basilica to Walhalla', in P. Curtis (ed.) (1989): 35-36; *The Times* (1867) 6 June: 7; *The Times* (1867) 13 June: 9; *The Times* (1869) 10 June: 5; *The Times* (1869) 29 September: 7.

Statue of W. E. Gladstone

(1809–98) statesman and renowned political orator. The son of a Liverpool merchant, he intended first becoming an Anglican priest, but instead entered politics in 1832 as Tory member for Newark. By 1845 he was Peel's Colonial Secretary and took his premier's side in the Corn Law dispute. A mistrust of aristocratic government, exacerbated by a visit to Naples in 1851, when he witnessed the reprisals exacted by King Ferdinand against the rebels, led ultimately to him transferring to the Liberal party.

By 1859 he was Palmerston's Chancellor of the Exchequer, a post he still held in 1864, when the present statue was commissioned. He was subsequently Liberal Prime Minister: in 1867-74, 1880-85, 1886 and 1892-94 (see also pp. 173–5). His appeal to the merchants of Liverpool, over and above the fact that he had been born there and lived not far away, at Hawarden, near Chester, would have presumably been his free-trade policy and the various tax reductions he introduced as Chancellor, thereby contributing substantially to the increase of their wealth (source: *DNB*).

Sculptor: John Adams-Acton

Statue in Grestela marble

Statue h: 83" (211 cms)
– diameter of the circular marble base: 31" (79 cms)
Console pedestal h: 61¹/₂" (156.2cms)

Inscription on the base: RIGHT HON. W. E. GLADSTONE 1809-1898 / SCULPTOR J. ADAMS ACTON.

Signed and dated on the surface of the base: JOHN ADAMS=ACTON / FECIT 1868

Exhibited: Royal Academy of Arts 1868 (cat. 1085), as *Right Hon. W.E. Gladstone, M. P.* Royal Academy of Arts 1869 (cat. 1216), as *The Rt. Hon. William Gladstone...Executed for the St. George's Hall, Liverpool.*

Unveiled by Alderman Joseph Hubback, Mayor of Liverpool, Wednesday 14 September 1870

Owner: National Museums and Galleries on Merseyside, transferred from the City Estates, 1972
Listed status: not known

Description: Located on the east side of the Great Hall in the seventh niche from the north end, to the right of the central door. The decision to allocate this specific empty niche to the statue was determined by the fact that the *Gladstone* statue exactly corresponds in height to the *Lord Derby* statue already installed to the left of the door. (*Finance and Estate Committee Minutes*, 1/16: 679-80).

Gladstone is standing, looking straight ahead, his right hand placed upon his chest, his left holding a scroll. His right leg bears his weight, the left leg flexed with the foot protruding over the forward edge of the circular base. Gladstone is represented in the embroidered official robes of the Chancellor of the Exchequer, his title at the time of the statue's execution (although he had attained the position of Prime Minister by the date of the official unveiling).

Condition: The statue appears to be undamaged, but is in need of cleaning.

Related works: Adams-Acton completed numerous busts of Gladstone in 1865 (shown that year at the Royal Academy of Arts, cat. 1030: *The Right Hon. The Chancellor of the Exchequer, W. E. Gladstone – marble*), 1868, 1869, 1873 and 1879.

According to the *Illustrated London News* (1870: 529), the stimulus to commemorate Gladstone had been provided by his visit to the city of his birth five years previously (actually 12 and 13 October 1864). The subscribers were a group of 'Liverpool gentlemen of all classes and sects' (*Daily Post*, 15 September 1870) and intended the statue 'as a permanent memorial of the services [the Right Hon. W. Gladstone] has rendered to the town, and the country at large' (*Art-Journal*, 1864: 362, quoted in Read,

1989: 35).

When John Adams (as Adams-Acton was known until 1869) was announced as sculptor early in 1865, the *Art-Journal* (1865: 29, quoted in Read, 1989: 35) dismissed him as a 'second or third-class' artist and suggested that the choice was either uninformed and made out of 'utter ignorance' on the part of the commissioning body, or that some form of favouritism had

been at work. The critic Francis Palgrave, was also dismayed. In his review of the 1865 Royal Academy show he scornfully described a marble bust of Gladstone by Adams as an example of Darwinism in reverse: Gladstone portrayed as 'a leading instance' of 'the human species...rapidly returning to the gorilla type'. He further expressed the hope that 'in the interests of the great western port [i.e. Liverpool]...[the] commission...will be revoked' (*The Saturday Review*, 10 June 1865, and Palgrave, 1866: 123).

And yet the bust was apparently much-prized by Gladstone. More relevantly, Adams-Acton seems to have enjoyed a cordial relationship with the subject (Read, 1989: 35) and thus, in the absence of any contradictory evidence, it is likely that (as in the case of the *Statue of the 14th Earl of Derby*, see above, p. 278) Gladstone had himself determined the choice of sculptor for the subscribers.

In 1866 it was noted that Adams-Acton's design (i.e. the full-size model) for the marble statue had been 'on private view during the past few days in Liverpool' (*The Times*, 11 October 1866: 7). It was anticipated at this time that the work would take a year and a half to complete.

According to the *Illustrated London News* (21 May 1870: 529), the statue had been modelled in the sculptor's studio in Rome and completed in London. Gladstone had given Adams-Acton 'upwards of twenty sittings, including several on the occasion of Mr Gladstone's last visit to the "Eternal City"'.

The Gladstone Memorial Committee presented the statue to the Corporation on 2 March 1870 and, on 6 May, the Corporation Surveyor, E.R. Robson, reported that he, the sculptor and the gentlemen of the Committee had agreed that the most suitable niche in St George's Hall would be that on the other side

of the central door from *Lord Derby* – an agreeable symmetry being provided by the exact correspondence of their heights and by the fact that the subjects were both Lancashire-born Prime Ministers (*Finance and Estate Committee Minutes*).

For the ceremony of unveiling, 'the grand hall was crowded in every part' and the Mayor's pride was augmented by the fact that the subject of the ceremony had, since the statue was first commissioned, risen from Chancellor of the Exchequer to the highest position a commoner could achieve in Her Majesty's realm, that of Prime Minister. He was now 'better known, not in this country alone, but throughout the civilised world, than any other commoner living' (*Daily Post*, 15 September 1870).

The Daily Post considered that Adams-Acton had portrayed 'the features of the distinguished gentleman with wonderful fidelity'; the *Illustrated London News* (1870: 529) thought that the sculptor had captured an 'expression of thoughtfulness and intellectual power'; and even the *Art-Journal* (1870: 190), notwithstanding any former reservations about the sculptor's ability, rated the work as 'dignified and sculpturesque'; indeed, by the time the *Art-Journal* came to publish an engraving of the statue (1876: 244), it estimated Adams-Acton's statue as 'certainly the most pleasing portrait of the eminent statesman and author we remember to have seen'. Only Palgrave remained unimpressed: in his article for *The Saturday Review* (1869: 710) he judged it to be

a rickety-looking figure, huddled under a mass of what man-milliners call "Frogs", with fidgety hands, and arms as inarticulate as those of a child's favourite doll [and as for the face, he complained that it] expresses

neither energy nor eloquence nor force of thought.

(As transcribed in WAG JCS files.)

Literature: (i) LRO (a) manuscript sources: *Finance and Estate Committee Minutes*, 1/16: 472, 489, 679-80; *Finance and Estate Committee Minutes*, 1/17: 125-26. (b) newscuttings: *Albion* (1870) 19 September, in *TCN 1/5*; *Courier* (1870) 14 September, in *TCN 1/5*; *Daily Post* (1870) 15 September, in *TCN 1/5*; *Mail* (1870) 17 September, in *TCN 1/5*.
(ii) WAG JCS files transcription: *Saturday Review* (1869) 29 May: 710.
(iii) *Art-Journal* (1864): 362; *Art-Journal* (1865): 29; *Art-Journal* (1869): 258; *Art-Journal* (1870): 156, 190; *Art-Journal* (1876): 244; *Artist* (1899) xxv: 111; *ILN* (1869) 14 August: 169; *ILN* (1870) 21 May: 529; Matthew, H.G.C. (ed.) (1978) vi: 31, 311, 471, 483; Palgrave, F. (1866): 123; Read, B., 'From Basilica to Walhalla', in P. Curtis (ed.) (1989): 35; *Saturday Review* (1865) 10 June: 698-9; Stirling, A.M.W. (1954): 125, 127-28; *The Times* (1866) 11 October: 7.

Statue of the Reverend Doctor Hugh McNeile, Dean of Ripon

(1795–1879) Born in County Antrim, he was educated at Trinity College, Dublin (BA 1815, MA 1821, BD and DD 1847). He was Perpetual Curate of St Jude's, Liverpool, 1834-48, and St Paul's, Princes Park, 1848-67. He was Honorary Canon of Chester Cathedral, 1845-68, and became Dean of Ripon in 1868, a post which he resigned in 1875. A fervent Protestant, he strongly opposed the Church of Rome and was frequently involved in disputes in the press. Following his victory in a disagreement with the Liverpool Town Council over the management of a Corporation School, he was awarded a large sum with which he founded four scholarships at the Liverpool Institute (sources: *DNB; MEB*).

Sculptor: George Gamon Adams

Statue in Carrara marble

Statue h: 89" (225 cms); w: 32" (82.5 cms); d: 36" (92 cms)
Pedestal h: 61½" (156.2cms)

Inscription centred on the front of the marble base: REVD. HUGH MCNEILE D.D. / DEAN OF RIPON.
– and to the right on the front of the marble base: SCULPTOR / G. G. ADAMS.

Exhibited: Royal Academy of Arts 1870 (cat. 1123), as *The Very Rev. Dr. McNeile, Dean of Ripon*. Royal Academy of Arts 1871 (cat. 1258), as *Model of the statue of Dr. Hugh McNeile...executed in marble in St. George's Hall, Liverpool.*

Unveiled by the sculptor, Monday 5 December 1870

Owner: National Museums and Galleries on Merseyside, transferred from the City Estates, 1972
Listed status: not known

Description: Located in the left-hand niche of the short wall at the south end of the Great Hall. McNeile is represented standing, his weight borne upon his right leg, his left leg advanced a little with the foot protruding over the forward edge of the base. He is dressed in the robes of a Doctor of Divinity and is holding a small book in his left hand, making a demonstrative gesture with his right, as in the act of preaching. His head is erect and he looks forward earnestly. A second book lies on the base. The *Illustrated London News* (1871: 398) praised the naturalistic treatment of the drapery and remarked that the likeness was regarded as perfect by those who knew McNeile. The *Daily Post* (6 December 1870) records that the block from which the statue was carved weighed originally eight tons, reducing to

three tons after carving.

Condition: Good

The present statue was commissioned by a number of McNeile's friends and members of his congregation in Liverpool to commemorate his appointment to the Deanery of Ripon on 9 September 1868 (*Daily Post*, 6 December 1870). The McNeile Statue Committee was duly formed and by May 1869 had selected George

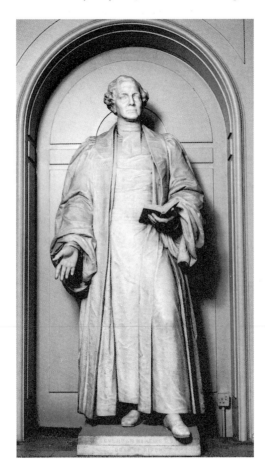

Gamon Adams as sculptor (*The Times*, 15 May 1869).

On 27 October 1870, the Chairman of the McNeile Statue Committee, John Campbell, wrote to Liverpool Town Council, requesting that the statue be accepted for placement in St George's Hall (*Council Minutes*), but in the Council meeting on 28 October Campbell's request was opposed by a substantial minority, mainly on the grounds of McNeile's extreme anti-Catholicism and the division his views had caused within the community (*Daily Post*, 10 November 1870, cited in Read, 1989: 41). Given that the honour of a place in St George's Hall had, by precedent, always been the result of a unanimous decision, the motion to accept the *McNeile* statue was withdrawn.

Notwithstanding the amount of opposition to the statue, the hard core of McNeile's admirers among the Council members, most of whom were Conservatives, determined to push the motion through. Immediately before the next meeting of the Council, on 9 November 1870, the Conservatives held a caucus to secure maximum backing for a re-proposal (*Mercury*, 10 November 1870). It fell to Conservative leader Mr Edward Whitley to raise the subject again and he was immediately opposed by Mr Bidwell who suggested that consideration of the motion be postponed until 'January next to give the ratepayers an opportunity of expressing their opinions upon the subject'. A vote was taken and Bidwell's amendment was over-ruled by forty votes to twelve (*Council Minutes*). The objectors to the statue then put forward some strongly felt and rationally argued opposition – Mr Fairhurst 'spoke against the reception [of the statue] as an insult to one-third of the community', and Mr Whitty:

inveighed against Dr McNeile as one who

had devoted himself to the promotion of ill-blood among the classes, and as having no national or local claim to such a position as was implied in the proposed honour. [He also] cited a statement that Dr McNeile had advocated punishing with death those clergy who heard auricular confession (*Daily Post*, 10 November 1870).

McNeile's supporters seem to have based their argument for his inclusion in the Hall largely upon his undoubted skill as a writer and orator. Even the *Post*, which clearly disapproved of McNeile as 'a vituperative and socially injurious partisan', had to concede that his 'repute as an orator must go far to reconcile the town to the honour which [he] is thus paid'. After the debate a vote for the statue's inclusion in the Hall was taken, the McNeile supporters winning by thirty-six votes to sixteen (*Council Minutes*) and, disregarding the traditional requirement for unanimity (which the *Post* considered the strongest objection), the proposal was pushed through and McNeile's statue accepted for placement in the Hall. It is perhaps worth noting that this was the first Council meeting under the newly-elected Mayor, the Conservative and pro-McNeile, Alderman J.G. Livingston.

The Finance and Estate Committee, whose responsibility it was to supervise the installation, instructed the Corporation Architect and Surveyor, E.R. Robson, to select an appropriate niche in the Hall and report back. His report to the meeting of 9 December 1870 implies that the decision to place the statue in relative isolation in one of the two niches on the south end wall was taken, not for any reasons of political discretion, but for aesthetic reasons, because quite simply the 'statue was not designed for the Hall and is larger than any of the others

fixed' (*Finance and Estate Committee Minutes*). Interestingly, this does not seem to be substantiated by the facts: the statues of *William Brown* and *Joseph Mayer*, both already occupying niches in the Hall, are of corresponding dimensions (see above, pp. 273, 275).

The *Statue of Hugh McNeile* had been about eighteen months in execution in the sculptor's London studio. It was delivered to Liverpool, placed on its pedestal in St George's Hall on the night of 2 December 1870, and unveiled 'without any ceremonial' on the 5th, with McNeile and the Mayor in attendance and 'in the presence of the members of the committee of subscribers and a number of ladies'. The statue had cost the subscribers 'about £1,000' (*Daily Post*, 6 December 1870).

The final irony for the only statue in St George's Hall to have caused offence because of the character of its subject, is that it is also the only statue to have received unanimous acclaim as a work of art. The *Art-Journal* (1871: 180), reviewing the 1871 Royal Academy exhibition (in which Adams showed his plaster model), remarked that it 'has quiet bearing, yet seems to speak'; the *Illustrated London News* (22 April 1871: 398) praised the statue's drapery (see above, p. 281) and considered that the pose imbued the figure with 'great dignity and freedom'; and the *Daily Post* (15 December 1870) proclaimed:

> Mr G.G. Adams, the artist who has given us the one good statue in St George's Hall...People may quarrel with the objects of the promoters of the memorial, but no one can withhold a tribute of admiration to the rare ability of the sculptor.

Literature: (i) LRO (a) manuscript sources: *Council Minutes*, 1/17: 260, 291–93; *Finance and Estate Committee Minutes*, 1/17: 307, 311, 389. (b) newscut-

tings: *Daily Post* (1870) 10 November, in *TCN 1/6*; *Daily Post* (1870) 6 December, in *TCN 1/6*; *Mercury* (1870) 10 November, in *TCN 1/6*.
(ii) WAG JCS files: newscutting: *Daily Post* (1870) 15 December.
(ii) *Art-Journal* (1871): 8, 180; *ILN* (1871) 22 April: 398; Read, B., 'From Basilica to Walhalla', in P. Curtis (ed.) (1989): 36; *The Times* (1869) 15 May: 11.

Statue of Samuel Robert Graves

(1818–73). Born in Ireland, he moved to Liverpool and established himself as a merchant and shipowner. From 1856 he was Chairman of Liverpool's Shipowners' Association and the local marine board. He was Mayor of Liverpool 1860-61 and Conservative M.P. from 1865 until his death. In 1868 he polled 16,766 votes, the 'largest number polled by any borough member' (source: *MEB*).

Sculptor: Giovanni Giuseppe Fontana

Statue in Carrara marble

Statue h: 88"(224 cms); w: 31"(78 cms); d: 38"(97 cms)
Console pedestal h: 61½" (156.2cms)

Inscription on the front of the marble base:
S. R. GRAVES, M.P. / FOR LIVERPOOL FROM 1865 UNTIL HIS DEATH IN 1873. / ERECTED BY PUBLIC SUBSCRIPTION

Unsigned

Exhibited: WAG Liverpool Autumn Exhibition 1873 (cat. 1045), as *The late S. R. Graves, Esq., M. P., bronzed design of statue to be executed in marble and placed in St. George's Hall, Liverpool.*

Unveiled by Richard Assheton Cross, M.P., Home Secretary, Wednesday 29 December 1875.

Owner: National Museums and Galleries on Merseyside, transferred from the City Estates,

1972
Listed status: not known

Description: Located on the east side of the
Great Hall in the eleventh niche from the north
end. Graves is represented standing, wearing a
frock-coat. A fur-edged coat is draped on a
pillar at the left. His right hand holds a scroll
high over the left side of his chest, whilst his left
hand is outstretched to the side in a declama-
tory gesture, 'as addressing the House of
Commons...[and giving] expression to the
observations which he is supposed to be
making' (*Mercury*, 19 June 1873). The leftward
movement of the arms is emphatically counter-
pointed above and below by the rightward axes
of the subject's head and legs. The weight is
borne on the right foot, whilst the left leg
moves forward emphatically, the foot
protruding over the forward edge of the base.

Condition: The back of the right shoulder has
been repaired at some time; the surface of the
statue is generally dirty.

On 25 January 1873, a few days after Graves's
death, the Mayor (Edward Samuelson), in
response to a 'numerously signed' petition, held
a public meeting at Liverpool Town Hall to
discuss how most fittingly to commemorate the
deceased. William Rathbone proposed and the
meeting agreed that a public subscription (the
Graves Memorial Fund as it came to be known)
should be established, with a limit imposed of
five guineas per person in order that a balance
should be struck, with no individual predomi-
nating amongst the many whom it was antici-
pated would wish to contribute. Further, it was
agreed that a Committee should be appointed
(with authority to add to their number, if neces-
sary), to decide upon the most appropriate form
of commemoration, and to supervise the

subscriptions (*Mercury*, 27 January 1873).

(Sir) James Allanson Picton and Thomas
Edwards Moss, whilst supporting the proposal,
thought it rather vague and considered that
'subscriptions would be stimulated' and the
Committee given some sense of the general
feeling of the subscribers, if the possible form of
the memorial were discussed there and then.
Moss suggested the erection of a statue in 'our
local Walhalla' (St George's Hall) and, notwith-
standing the objection from a minority that the
Hall was too exclusive and that a more public
setting should be considered where all the
populace might enjoy the memorial ('a colossal
statue...at the top of Lord Street' was
suggested), the majority favoured the Hall and
the motion was carried (*Mercury*, 27 January
1873).

By 18 February, subscriptions had reached
almost £2,000 (not £200, as is stated in WAG
1977, i: 307). As it had by now become clear
that expectations would be exceeded, it was
suggested that a statuette (the Committee later
decided on a bust instead) might also be
commissioned as a gift to Graves' widow (*Daily
Post*, 18 February 1873, cited in WAG, 1977,
i: 307).

Once the subscription had reached £2,450, a
competition was held and 'a number of the
most celebrated artists were invited to send in
models in competition for the execution of the
statue and bust' (*Mercury*, 19 June 1873, quoted
in WAG 1977, i: 307). Models for ten statues
and six busts were submitted and on 18 June
1873 at Liverpool Town Hall the winners were
announced as Giovanni Fontana for the statue
and George Gamon Adams for the bust.
(Fontana's bronzed plaster model was exhibited
at the WAG Liverpool Autumn Exhibition in
1873 [see above] and Adams's marble bust in
1874, cat. 1078). It was estimated that the statue

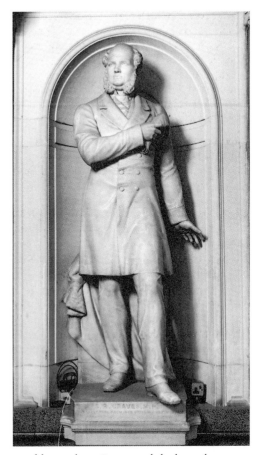

would cost about £1,000 and the bust about
£250, leaving a substantial amount which it had
been decided would be donated to a public
charity (*Mercury*, 19 June 1873).

Fontana's statue was completed by 11
December 1875 (*Mercury*, 11 December 1875,
cited in WAG 1977, i: 307). On 29 December it
was unveiled, though for the first time in the
history of St George's Hall there appeared a
dissenting voice questioning whether the

subject's credentials were adequate for commemoration in the Great Hall – the Revd Hugh McNeile's commemoration therein had certainly been opposed in 1870, but purely because of his divisive opinions (see above, pp. 281–2). Graves' commemoration on the other hand was the first to be publicly criticised on the grounds of the subject's lack of lasting achievement. An unidentified 'Borough Magistrate' who had been invited to the unveiling ceremony wrote to the *Daily Post* (29 December 1875) explaining that this was his (and that of a few others, he suggested) only reason for declining to attend, notwithstanding his respect for the subject himself. 'Our civic temple [St George's Hall]' he wrote: 'should, I submit, be graced with statues of men of cosmopolitan reputation, of great genius, or of such national or local reputation as admits of no dispute.'

Literature: (i) LRO (a) manuscript sources: *Council Minutes*, 1/20: 23–4; *Finance and Estate Committee Minutes*, 1/22: 31. (b) newscuttings: *Daily Post* (1873) 18 February, in *TCN 1/8*; *Daily Post* (1875) 29 December, in *TCN 1/11*; *Daily Post* (1875) 30 December, in *TCN 1/11*; *Mercury* (1873) 27 January, in *TCN 1/8*; *Mercury* (1873) 28 January, in *TCN 1/8*; *Mercury* (1873) 19 June, in *TCN 1/9*; *Mercury* (1875) 11 December, in *TCN 1/11*.
(ii) *Art-Journal* (1876): 61; Picton, J.A. (1875, revised edn 1903), i: 542; Read, B., 'From Basilica to Walhalla', in P. Curtis (ed.) (1989): 36; WAG (1977) i: 306–7.

Statue of William Roscoe

(1753–1831) writer, historian, collector, patron of the arts, banker and politician. Born in Liverpool, his father owned a market garden and ran a tavern. Roscoe left school at twelve, but afterwards pursued his own education. He read Latin, French and Italian and was actively involved in societies which promoted the arts in Liverpool. He wrote poetry, though achieved success only with *The Butterfly Ball*, of 1806, which became a nursery classic. He also wrote biographies of Lorenzo de' Medici and Pope Leo X. His stand in parliament against the slave trade may have made enemies in Liverpool and possibly contributed to the brevity of his political career (MP for Liverpool 1806-7). Following his bankruptcy in 1815, Roscoe's friends purchased some of the books from his library and returned them to him in order that he could himself present them to the Athenaeum, thereby ensuring that he had continued use of them. Roscoe was also patron of local sculptors John Gibson and William Spence. The appreciation of his contribution to culture in Liverpool was reflected in the celebration of the centenary of his birth in 1853 (sources: *Athenaeum information leaflet; DNB*; Picton, 1875, revised edn 1903).

Sculptor: Sir Francis Legatt Chantrey

Statue in marble

Statue h: 64" (162.6 cms); w: 26" (66 cms); d: 42" (106.7 cms)
Pedestal h: 61½" (156.2cms)

Inscription on the forward edge of the curved base: WILLIAM ROSCOE. 1753-1831./ FROM THE COLLECTION OF THE LIVERPOOL ROYAL INSTITUTION.

Signed and dated on the left end of Roscoe's bench: CHANTREY. / SCULPTOR: 1841.

Exhibited: Royal Academy of Arts 1840 (cat. 1071), as *Statue in marble of William Roscoe, Esq., of Liverpool.*

Erected originally in the Gallery attached to the Liverpool Royal Institution; removed to St George's Hall Monday 12 June 1893.

Owner: National Museums and Galleries on Merseyside, transferred from the City Estates, 1972.
Listed status: not known

Description: Located on the west side of the Great Hall in the fourth niche from the north end, Roscoe is represented as a seated figure in contemporary dress, his loose overcoat affecting the appearance of classical drapery. His right arm crosses his upper body to rest his right hand upon his left which, in turn, he supports on the edge of an untitled folio volume – decorated on the cover and spine with arabesques – leaning upright against his left side. The figure's right foot protrudes over the forward edge of the base.

Condition: The repairs following the accident of 1893 (see below) are visible on the statue's forehead, nose, chin, shoulders, right knee, and both ankles. Consistent with this line of damage, there are abrasions to the upper surface of the right elbow and the area of the collar above. The filler has become discoloured. The surface of the statue is generally dirty.

Related work: *Plaster model*, Ashmolean Museum, Oxford (cat. 624-112)

In 1835 Sir Francis Chantrey was commissioned by John Foster Jnr and James Yates to execute a statue of William Roscoe. Foster and Yates were probably acting on behalf of the Liverpool Royal Institution, in the foundation of which Roscoe had played a leading role. A period of three years was allowed and a fee of £1,500 agreed. At the time of the negotiation only £1,200 in public subscriptions had been collected, but Foster, who had also been instrumental in negotiating with Chantrey the contract for the *Canning* statue for the Town Hall three years previously (see above, pp. 76–9), was confident that the agreed sum

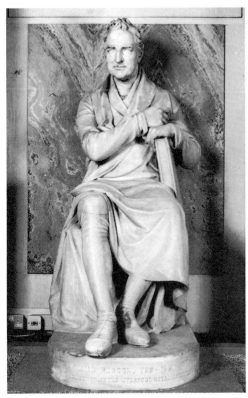

would be reached by the end of the allotted time, partly through the accumulation of interest. The required amount was reached and in 1841 the statue was presented by the Roscoe Memorial Committee to the Liverpool Royal Institution, where it was erected in the gallery (Ormerod, 1953: 34; Yarrington *et al*, 1994: 295).

The statue remained in the gallery for some years. Then, in 1870, the Corporation Finance and Estate Committee received a letter from the Institution offering the statue for erection in St George's Hall. The Committee replied that it could not accept the statue without it first being formally 'offered to and accepted by the Council' (*Finance and Estate Committee Minutes*).

Nothing more is heard on the subject until 13 January 1893 when the Finance and Estate Committee again received a letter from the Institution offering the statue for erection in St George's Hall, although this time the offer was made in connection with the donation to the Council – for 'depositing in the Walker Art Gallery' – of a collection of paintings and sculpture belonging to the Institution. In the first draft of the agreement the Institution had included the *Roscoe* statue. On further consideration, however, the members of the Institution agreed that to commemorate Roscoe merely as a patron of the arts was to minimise his greatness: as 'a Man of Letters and [as] a Citizen conspicuous in his public services to Liverpool' he deserved the grandest commemoration that Liverpool could offer – a place in St George's Hall. This time the Finance and Estate Committee found no fault with the form of the offer and, the proper procedures having been followed, the Committee gratefully accepted the statue (*Finance and Estate Committee Minutes*).

The Corporation Surveyor, Thomas Shelmerdine, was duly dispatched to the Great Hall to select a suitable niche. Unfortunately, as he reported on 5 May 1893, the statue, being 'in a sitting posture', was 8" too deep for any of the remaining niches. After some deliberation, and a visit to the hall itself, the Committee eventually decided on 31 May that the only possible location was 'in the Centre of the Gallery over the Entrance to the North Vestibule' (*Finance and Estate Committee Minutes*).

On Monday, 12 June 1893, the contractors, Norbury, Paterson & Co., after having successfully removed the statue from the Institution, were winching it into position in the north vestibule when – with the statue about fifteen feet in the air – the chain snapped, precipitating the statue to the floor where it smashed into pieces and embedded itself in the flagstones below, narrowly missing a couple of workmen. The damage was so extensive that the contractors feared that the statue was irreparable. Shelmerdine, on being called to view the damage, hoped otherwise, covering the larger portions with a cloth and gathering together the smaller pieces, wrapping them in cotton wool and sealing them in a box (*Finance and Estate Committee Minutes*).

The Liverpool Royal Institution made it clear (via its solicitors) that it expected the Corporation to seek expert advice on the restoration. At this point, the Lord Mayor, Robert D. Holt, contacted the British Museum authorities, who obligingly sent one of their experts, a Mr Loxston, to Liverpool. Loxston declared the sculpture reparable and the Museum then dispatched two sculptors to carry out the work. The British Museum authorities advised Holt that Chantrey's original plaster was in the University Galleries, Oxford, and Holt obtained permission to have casts taken from the plaster to act as guides for the repair. On 1 September 1893, Shelmerdine was able to report that the repairs were completed and the statue safely hoisted into position (*Finance and Estate Committee Minutes*).

Remarkably, on having finally got the statue into the desired position, Holt seems to have immediately suggested moving it to the Great Hall. The problem seems to have been that in the gallery of the north vestibule it was back-lit by the principal light source, the windows overlooking William Brown Street. Holt's plan involved moving the *William Brown* statue to the niche on the other side of the doorway

from the *Robert Peel* statue, thus creating a balance of two standing statues, and putting the *Roscoe* into the niche thereby vacated to create a balance with Gibson's seated *Stephenson* statue. Shelmerdine, who had presented the Mayor's ideas to the Committee, informed it that he had had a 'wooden template' of the *Roscoe* statue made and ascertained that there was an overlap of the pedestal of only 'about three quarters of an inch'. (When Shelmerdine had originally reported that the *Roscoe Statue* was too deep for any of the remaining niches, his choice had been restricted to the round-headed niches which could only be fitted with a relatively shallow console pedestal; the four square-headed niches, with their more strongly projecting pedestals, all being occupied at that time.) The Committee approved the suggestion and the moves were effected by 28 November 1893 (*Finance and Estate Committee Minutes*).

The last significant mention of the *Roscoe* statue is in the Financial Sub-Committee meeting of 12 December 1893, when the present inscription was approved (*Finance and Estate Committee Minutes*).

Literature: LRO manuscript scources: *Finance and Estate Committee Minutes*, 1/17: 311; *Finance and Estate Committee Minutes*, 1/41: 609-10; *Finance and Estate Committee Minutes*, 1/42: 211, 229-30, 281, 298, 336-40, 357-58, 420, 450, 522, 562-63, 637-38, 654, 681, 722; *Finance and Estate Committee Minutes*, 1/43: 82.
(ii) *Art-Union* (1840) ii: 93; *Athenaeum* (1840) 16 May: 402; Holland, J. (1851): 290; Jones, G. (1849): 84; *Mercury* (1893) 13 June: 6; Ormerod, H.A. (1953a): 34; Picton, J.A. (1875, revised edn 1903), i: 433; *Studio* (1893) i: 168; Yarrington, A. *et al* (1994): 295.

Statue of Edward Whitley

(1825–92). Born in Liverpool and educated at Rugby, Whitley practised as a solicitor in Liverpool from 1849, was a magistrate from 1868 and in 1877-78 was president of the Liverpool Law Society. He was a member of the Town Council from 1866 and Mayor 1867-68. A Conservative, he was M.P. for Liverpool, 1880-85, and M.P. and County Councillor for Everton from 1885 until his death. He was a politician with 'a popular touch', winning his seat in the 1880 by-election with 52% of all votes in an 80% turnout. His success was due as much to his involvement in such activities as Bible classes (he was a Sunday School teacher for forty years), Orange Lodges and cricket clubs, as it was to the causes he stood for, such as Sunday closing, and those he opposed, such as Irish Home Rule (sources: *MEB;* Waller, 1981).

Sculptor: Albert Bruce Joy

Statue in Carrara marble

Statue h: 89" (226 cms); w: 28" (71 cms); d: 32" (81 cms)
Console pedestal h: 61¹/₂" (156.2cms)

Inscription on the front face of the marble base:
EDWARD WHITLEY, M. P. / FOR LIVERPOOL FROM 1880 TO 1885, AND FOR THE EVERTON DIVISION OF LIVERPOOL / FROM 1885 UNTIL HIS DEATH IN 1892. / ERECTED BY PUBLIC SUBSCRIPTION.

Unsigned

Unveiled by the Rt Hon. Viscount Cross (Richard Assheton Cross), Monday 21 January 1895

Owner: National Museums and Galleries on Merseyside, transferred from the City Estates, 1972
Listed status: not known

Description: Located on the east side of the

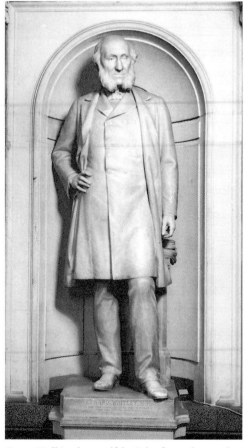

Great Hall in the twelfth niche from the north end. Whitley is represented standing, wearing a frock coat and greatcoat, his right hand on his hip, his left hand down at his side. His left leg is placed forward and the foot protrudes over the edge of the base. A pile of pamphlets rests on a pillar behind and to the left of him. The *Liverpool Courier* (22 January 1895) remarked: 'As a likeness of Mr. Whitley it is fidelity itself, while as to pose and details it shows all those

rare artistic qualities which characterise the work of Mr. Bruce-Joy.'

Condition: The statue appears to be in good condition, but needs cleaning.

Related work: The *Edward Whitley Memorial Drinking Fountain* (artist unknown) was unveiled on 1 September 1896 in Shaw Street public gardens, later renamed Whitley Gardens (Kelly's *Annals of Liverpool*). The memorial no longer exists.

On 22 January 1892, a meeting of councillors and other eminent citizens was convened by the Mayor of Liverpool to consider the most fitting way to perpetuate the memory of their recently deceased townsman, Edward Whitley. Following the usual expressions of sympathy, it was suggested by Councillor Arthur Bower Forwood that Whitley's devotion to the public good and the resultant admiration in which he was held by all classes of the community, earned him the right to a permanent memorial in the form of a statue 'in the greatest of [Liverpool's] municipal buildings', St George's Hall. He recommended that a public subscription be set up so that the widest portion of the community could contribute. He was confident that more would be subscribed than would be necessary for just the statue, and so suggested that the residue should be spent on an outdoor memorial in Shaw Street Gardens, in the district that Whitley had 'loved so much and served so ably' (*Courier*, 23 January 1892).

It was proposed that a limit should be imposed upon individual contributions in order to attract the broadest cross-section of the community to the subscription. An initial suggestion of a limit of ten guineas was quickly rejected as discouragingly high for potential subscribers from the poorest sections of the community who might only be able to spare a few pennies, and so ultimately a limit of five guineas was agreed (*Courier*, 23 January 1892).

One Councillor remarked that a meeting of 'Everton workingmen' had already been arranged to discuss the matter and he felt sure that 'the workingmen of Everton in their thousands would subscribe their shillings' towards the proposed memorial in Shaw Street Gardens' (*Courier*, 23 January 1892).

On 3 June 1892, the traditional formal request for a place in St George's Hall was made to the Finance and Estate Committee and the statue was allocated the niche 'at the left of the Southeast door' (*Finance and Estate Committee Minutes*).

The *Liverpool Mercury* (22 January 1895) noted that the execution of the work had been considerably delayed owing to a 'severe accident to the eminent sculptor during a trip to America in 1893'. Nevertheless, the sculptor recovered sufficiently to complete the statue on his return to England and to attend the unveiling ceremony on 21 January 1895.

In his speech at the unveiling ceremony, Viscount Cross gave a clear exposition of one of the principal motivations behind such public commemoration and the value it had for the City Council:

> You have erected [this statue] that there should be...in this hall something to which you and others who come after you may look to, and learn a lesson from him which we should all do well to take advantage of – namely, that we have something in this world to do besides pleasing ourselves and seeking our own honour and wealth and comfort. It was that passionate devotion to public duty that placed Mr Whitley on the pedestal on which he stood in your approbation, and you have erected this statue so that those who may come after may look upon the man and learn from his example to entertain and encourage that spirit of self-sacrifice so conspicuous in his character, and which it would be well for many of us to follow (*Courier*, 22 January 1895; *Daily Post*, 22 January 1895).

Literature: (i) LRO (a) manuscript sources: *Finance and Estate Committee Minutes*, 1/41: 37; *Finance and Estate Committee Minutes*, 1/45: 324. (b) newscuttings: *Courier* (1892) 23 January, in *TCN 1/23*; *Courier* (1895) 22 January, in *TCN 1/25*; *Daily Post* (1895) 22 January, in *TCN 1/25*; *Mercury* (1895) 22 January, in *TCN 1/25*.
(ii) *Artist* (1895) February: 66; Read, B., 'From Basilica to Walhalla', in P. Curtis (ed.) (1989): 38.

Statue of Frederick Arthur Stanley, 16th Earl of Derby

(1841–1908) second son of the 14th Earl of Derby (see above, p. 277). After a period in the Grenadier Guards, he was elected Conservative M.P. for, successively, Preston (1865-68) and North Lancashire (1868-85). Following the Redistribution Act of 1885 he was M.P. for the Blackpool Division until his elevation to the peerage in 1886. His political offices included Financial Secretary to, respectively, the War Office (1874-77) and the Treasury (1877-78). He was then Secretary of State for the War Office (1878-80) and the Colonies (1885-86), before leaving the Commons in 1886 on being created Baron Stanley of Preston. He was a successful and apparently popular Governor-General of Canada (1888-93), resigning only when he succeeded to the Earldom on the death of his elder brother. His official posts now ended, he not only maintained an active interest in the welfare of the colonies but also became a prominent figure in Liverpool as the first Lord Mayor of Greater Liverpool (1895-96) and the

first Chancellor of the University of Liverpool (in 1903). He received the freedom of the city in 1904 (source: *DNB* 1901-1911).

Sculptor: Frederick William Pomeroy

Statue in Carrara marble

Statue h: 80" (203 cms); w: 43½" (110 cms); d: 32" (81 cms)
Console pedestal h: 61½" (156.2cms)

Inscription (originally in gilt) on the front of the marble base: FREDERICK 16TH EARL OF DERBY 1841-1908.

Signed and dated on the right side of the marble base: F. W. POMEROY. ARA. SC. 1911.

Exhibited: Royal Academy of Arts 1918 (cat. 1460), as *'Model of Statue, "The Late Lord Derby." Placed in niche of St George's Hall, Liverpool'*

Unveiled by the 1st Earl of Halsbury (Hardinge Stanley Giffard), Friday 3 November 1911

Owner: National Museums and Galleries on Merseyside, transferred from the City Estates, 1972
Listed status: not known

Description: Located on the east side of the Great Hall in the fifth niche from the north end. Derby is represented standing, dressed in his Lord Mayor's robes and wearing his chain of office over court dress, with the Order of the Garter (awarded in 1897; part of the motto: 'QUI MAL Y PENSE' visible) below his left knee. In his right hand he holds his Lord Mayor's hat, whilst in his left he holds his gloves. The tip of his left foot overhangs the forward edge of the base.

Condition: The statue appears to be in good condition, but needs cleaning.

Related works: (i) bronze statuette exhibited at the WAG Liverpool Autumn Exhibition 1912 (cat. 2190), as *The late Earl of Derby, K.G.; statuette, bronze. (Lent by the Chairman* [John Lea] *of the Liverpool Art and Exhibitions Sub-Committee).* This may or may not be identical with the following, presented to the WAG by John Lea in 1927: (ii) bronze cast of the sketch model for the present statue: ht. 13½" (34.3cm), inscribed 'Octobr. 1910 / SKETCH FOR THE STATUE FREDK. A. 16 EARL DERBY / F.W. POMEROY SC., National Museums and Galleries on Merseyside, Sudley Art Gallery, cat. 4124.

In 1909, a group of citizens met to discuss how best to commemorate the late Earl, a man who in their estimation had done so much to establish the University and to facilitate the building of the Cathedral, and who they proudly remembered as the first Lord Mayor of Greater Liverpool. They resolved to request that a statue should be placed in one of the niches of the Great Hall of St George's Hall, provided that they could secure the services of a suitably distinguished sculptor (*Daily Post*, 4 November 1911).

An Executive Committee was formed which Lord Mayor H. Chaloner Dowdall (and, in turn, each successive Lord Mayor) agreed to chair. J. Hope Simpson was elected Honorary Treasurer, and F.M. Radcliffe and P.F. Corkhill, Honorary Secretaries (*Daily Post and Mercury*, 4 November 1911). The sculptor F.W. Pomeroy's work was already well known in Liverpool through his highly regarded *Monument to Monsignor Nugent* in St John's Gardens (see above, pp. 180–2) and his *Bust of Bishop Ryle* (present location unknown), and it was Pomeroy that they selected to execute the commission (*Courier*, 10 October 1911).

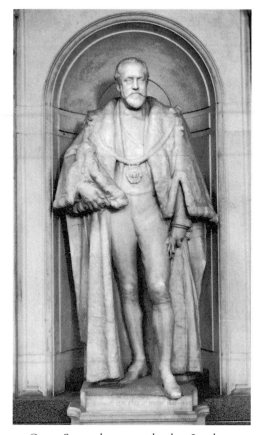

On 29 September 1911, the then Lord Mayor, S.M. Hutchinson, wrote to the Corporation Finance Committee, announcing that the statue was completed and making formal application for a specific niche which the Memorial Committee had indicated on an enclosed plan (*Finance Committee Minutes*). As the *Courier* (10 October 1911) later revealed it was 'the niche to the left of the existing statue of the [sic] 15th Earl of Derby'. This request was approved and the statue was officially unveiled on 3 November 1911 before 'a large gathering',

where it was accepted on behalf of the City by Alderman Cohen, in his capacity as Deputy Chairman of the Finance Committee (*Daily Post and Mercury*, 4 November 1911).

Pomeroy's rendering of the facial likeness and characteristic pose of the late Earl was considered extremely successful, not least by the latter's son (the Seventeenth Earl, shortly to be installed as the next Lord Mayor of Liverpool), who expressed the usual wonderment that the sculptor had been able to capture his father's likeness without ever having actually met him (*Daily Post and Mercury*, 4 November 1911). The *Courier* (10 October 1911) considered that in addition to its appeal as a work of art, it would have historical value as a record of 'the distinctive official dress of a Lord Mayor of Liverpool in the early days of its history as an enlarged city'.

Literature: (i) LRO (a) manuscript sources: *Finance Committee Minutes*, 1/61: 7-8, 180. (b) newscuttings: *Courier* (1911) 10 October, in *TCN 1/36*; *Daily Post and Mercury* (1911) 4 November, in *TCN 1/37*. (ii) *The Times* (1911) 4 November: 6; WAG (1981).

Winged Allegories
in the spandrels formed by the five lateral arches beneath the barrel vault of the Great Hall.

Designer: Charles Robert Cockerell
Sculptor: Mr Watson (Goodchild, 1888: 249)

Reliefs in plaster, white painted, *c.*1852-54

Owner: Liverpool City Council (as with all sculptures which are part of the building fabric both inside and outside St George's Hall). Listed status: as for building

The six reliefs running north to south on the east side of the hall are duplicated running south to north on the west side: represented are the four Cardinal Virtues, plus *The Arts* and *Science*. Each allegory is referred to by complementary inscriptions in Latin and English on the edges of the raised walkway immediately below.

The allegories are as follows:

1. *Temperance* (illustration at right). In the half-spandrels of the north-east and south-west corners. A seated winged female figure pours liquid from one vessel into another. A wingless *putto* helps her tilt the pouring vessel. Inscriptions on the walkway below: NE QUID NIMIS and ADD TO KNOWLEDGE TEMPERANCE.

2. *Justice* (illustration below). In the spandrels between the first and second arches from the north on the east side and the first and second arches from the south on the west side. A seated winged female figure

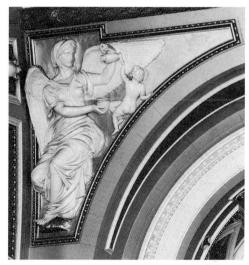

wearing a crown, holds a sword in her right hand and scales in her left. She is flanked by two winged *putti*, that on her right holds a

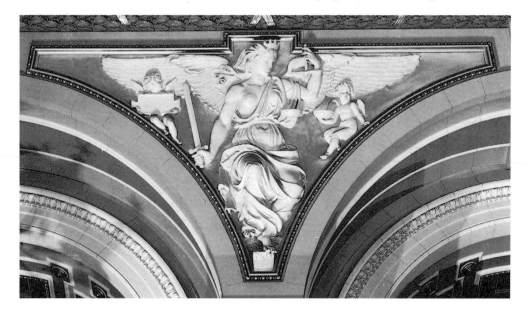

blank inscription tablet, that on her left helps support one of the bowls of the scales. Inscriptions on the walkway below: DISCITE JUSTITIAM MONITI ET NON TEMNERE DIVOS and BY ME KINGS REIGN AND PRINCES DECREE JUSTICE

3. *The Arts* (illustration above right).
In the spandrels between the second and third arches from the north on the east side and the second and third arches from the south on the west side. A seated winged female figure wearing a crown of laurel and holding a book (literature) in her right hand and a lyre (poetry and music) in her left, flanked by two large male masks (drama). Two winged *putti*, one either side of her, hold blank inscription tablets. Inscriptions on the walkway below: ARS OPERUM INVENTRIX NATURÆ QUE ÆMULA PROLES and HE HATH GIVEN ME SKILL THAT HE MIGHT BE HONORED.

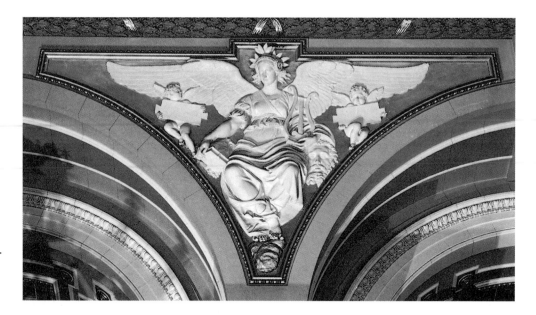

4. *Science* (illustration below right).
In the spandrels between the third and fourth arches from the north on the east side and the third and fourth arches from the south on the west side. A seated winged female figure, possibly a personification of *Astronomy*, wearing a crown of six stars, she points downwards with the index finger of her right hand, her left hand raised with two fingers pointing upwards. Beneath her left elbow is the multi-breasted goddess, Diana of Ephesus (a traditional attribute of Science personified, also used by Cibber in his relief on the *Monument to the Great Fire of London*, 1674). Two winged *putti* at the sides carry what appear to be rocks. Inscriptions on the walkway below: FELIX QUI POTUIT RERUM COGNOSCERE CAUSAS and THE FEAR OF THE LORD IS THE BEGINNING OF KNOWLEDGE.

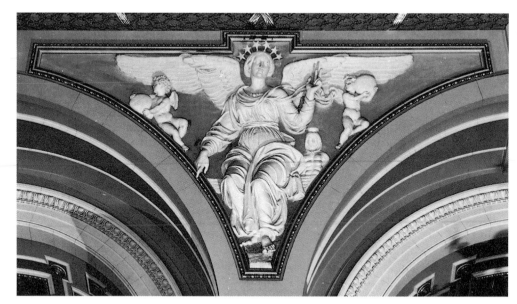

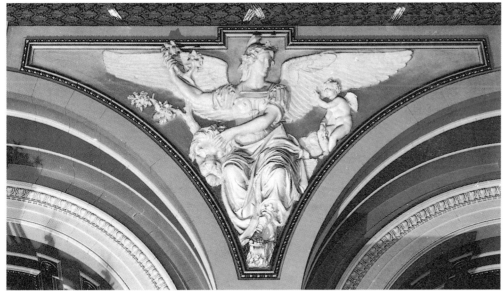

5. *Fortitude* (illustration above).
In the spandrels between the fourth and fifth arches from the north on the east side and the fourth and fifth arches from the south on the west side. A seated winged female figure wearing a helmet and cuirass holds the branch of an oak tree in her right hand and folds her left arm across her body to touch the head of a lion under the oak tree. She is accompanied by one winged *putto* to her left. Inscriptions on the walkway below: TU NE CEDE MALIS SED CONTRA AUDENTIOR ITO and IN THE LORD I HAVE RIGHTEOUSNESS AND STRENGTH.

6. *Prudence* (illustration at right).
In the half-spandrels of the south-east and north-west corners. A seated winged female figure gazes into a mirror held up by a *putto* who also carries a torch. She has a male mask fixed to the back of her head to indicate her circumspection: her ability to see both causes

and effects simultaneously. Inscriptions on walkway: NULLUM NUMENABEST IS SIT PRUDENTIA and I WISDOM DWELL WITH PRUDENCE

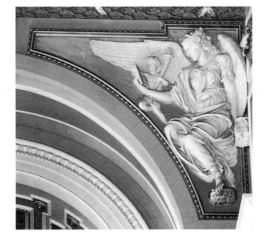

Condition: All reliefs appear to be in good condition.

It was J.E. Goodchild who, writing some thirty years after the event, seems to have been the first to refer to Mr Watson as modeller of Cockerell's spandrel designs (*RIBA Journal*, 26 April 1888: 249). Although it is remarkable that an otherwise unknown sculptor should have been awarded such a prestigious commission and to have carried it out with such success, Goodchild's position as Cockerell's chief architectural assistant at the time of its execution must lend support to his statement.

The spandrel compositions are loosely derived from Raphael's frescoes in the Stanza della Segnatura (1508-11) in the Vatican Palace (The *Builder*, 1855, xiii: 3), specifically the ceiling roundels of the four faculties (*Theology, Philosophy, Poetry, Justice*) and the lunette of *Three Cardinal Virtues* (Fortitude, Prudence and Temperance) at the top of the wall showing scenes of *Justice*. The closest resemblances are found in Cockerell's spandrel of *The Arts* and Raphael's ceiling roundel of *Poetry*, followed by both artists' representations of *Fortitude*. The torch held by the *putto* in Raphael's *Prudence* is more clearly a torch than is that held by the *putto* in Cockerell's *Prudence* (which is in danger of singeing *Prudence*'s wing); while Cockerell's *Science* takes the downward pointing right hand from Raphael's *Theology* and the image of Diana of Ephesus from his *Philosophy*.

Literature: *Builder* (1855) xiii: 3; *Building Chronicle* (1854): 84; Goodchild, J.E., 'St George's Hall, Liverpool, and the late Professor Cockerell, R.A.', *RIBA Journal* (1888) 26 April: 249; Knowles, L. (1988): 19; Stamp, G., 'Architectural Sculpture in Liverpool', in P. Curtis (ed.) (1989): 9; Watkin, D. (1974): 239-40.

Relief decoration of the coffered vault.
On 8 March 1852, Cockerell and John Weightman, the Liverpool Corporation Architect and Surveyor, were instructed to make arrangements for Mr [Charles Samuel] Kelsey 'to attend in London in order to prepare such Models as Mr. Cockerell may have to submit for the Ceiling of the Hall' (*Law Courts and St George's Hall Committee Minutes*).

Later in life Kelsey was to recall how he had started work as an assistant to his father, James Kelsey, helping to make 'full-size models in London for the Corinthian capitals and other portions of [the exterior] architectural sculpture' and how, following the virtual cessation of work on the Hall after Elmes' death, he himself was engaged in 1849 to 'execute the models for the interior decorations' under the superintendence of W.H. Wordley (who had been Elmes' resident drawing clerk) and John Weightman. Kelsey adds that, following Cockerell's assumption of control, he completed, under the latter's supervision 'the various models and works required, having two of the rooms in the building for a studio. All these works were completed in the year 1856' (letter to the *Builder*, 22 July 1882, p. 126).

Literature: (i) LRO manuscript source: *Law Courts and St George's Hall Committee Minutes*, 1/2: 150.
(ii) *Builder* (1882) xliii: 126; *Building Chronicle* (1854): 84; Gunnis, R. (1951): 224.

Pair of *Atlantes*
'supporting' the towers of pipes each side of the organ, at the north end of the Great Hall.

Designer: Charles Robert Cockerell
Sculptor: Edward Bowring Stephens
(Goodchild, 1888: 249)

Atlantes in Portland stone, *c*.1852-54

Owner: Liverpool City Council
Listed status: as for building

Description: The bearded, heavily-muscled *Atlantes* stand beneath the towers of pipes either side of the organ, their hands resting upon their heads, helping to 'support' the superincumbent weight. They are cast in the role of Hercules wearing the skin of the Nemean Lion, the rear paws of which are tied across the waist, concealing the junction between human torso and supporting console. Hanging to each side of the *Atlantes* are

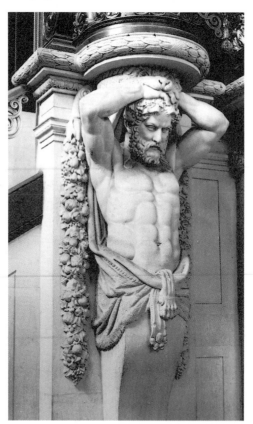

garlands of fruit and flowers.

Condition: good.

Literature: Goodchild, J.E., 'St George's Hall, Liverpool, and the late Professor Cockerell, R.A.', *RIBA Journal* (1888) 26 April: 249.

3. NORTH VESTIBULE OR ENTRANCE HALL:

'Parthenon' frieze

Sculptor: Edward Bowring Stephens

Relief in plaster, painted blue and white, 1854

Owner: Liverpool City Council
Listed status: as for building

Condition: good

The north entrance hall, intended as the main entrance to St George's Hall, consists of a flight of steps leading up to a Doric colonnaded balcony, the surrounding walls of which are decorated with a frieze running between pilasters, based on the Ionic frieze of the Parthenon, Athens (447-433 BC; part of the 'Elgin Marbles', in the British Museum since 1816).

Stephens's tender of £125 for the execution of the frieze was accepted on 24 May 1854, and on 22 July of that year Cockerell gave notice that the work was completed and ready for installation (*Law Courts and St George's Hall Committee Minutes*).

Literature: (i) LRO manuscript source: *Law Courts and St George's Hall Committee Minutes*, 1/2: 307, 332.
(ii) Knowles, L. (1989): 14; Olley, J., 'St George's Hall, Liverpool', *Architects' Journal* (1986) 18 June: 43, 44, 45, 47.

Statue of Henry Booth
(1788–1869) railway projector. Born in

Liverpool, the son of a corn merchant, he began work in his father's office, but found his true *métier* with the introduction of the scheme for the Liverpool and Manchester Railway. He became chief promoter and wrote the prospectus for the new line. When the bill for the railway was passed in 1825, Booth was appointed Company Secretary, Treasurer and Managing Director. The line was finished in 1830 and Booth was instrumental in ensuring that the steam engine designed by his friend, George Stephenson (with some assistance from Booth himself – see above, p. 269) was established as the motive power of the railway. To Booth is due the multi-tubular boiler, coupling screws, spring buffers, and lubricating material for carriage axles (source: *DNB*).

Sculptor: William Theed the Younger

Statue in marble

h: 85" (216 cms); w: 26" (66 cms); d: 31" (78 cms)

Inscription on the front of the base: HENRY BOOTH, 1788-1869. / SCULPTOR. W. THEED.

Unsigned

Erected in the Great Hall of William Brown Library October 1874; moved to the north vestibule of St George's Hall May 1877

Owner: National Museums and Galleries on Merseyside, transferred from the City Estates, 1972
Listed status: not known

Description: Booth is represented standing, wearing a frock coat, his right hand raised slightly, his index finger pointing demonstratively. His left hand rests upon a screw-coupling inscribed 'M. S. & L.', beneath which, on an ornamental pedestal, is a drawing of the

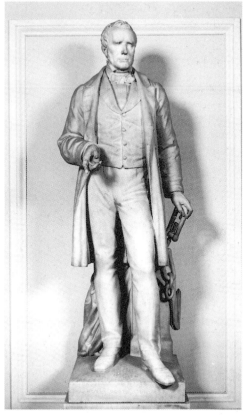

Rocket (incised into the marble/paper).

Condition: The last two joints of the forefinger of the right hand are missing and the little finger has been repaired.

At a meeting on 5 August 1874, Liverpool Council considered a letter from Charles B. Vignoles, F.R.S., Chairman of the Booth Memorial Committee, in which was offered to the Corporation: 'a full-length Marble Statue by Mr Theed of the late Mr Henry Booth, the first Secretary of the London and North Western

Railway Company.' The Council accepted the statue and resolved that it should be 'placed in St George's Hall or in such other public building as the Council may select' (*Council Minutes*).

On 14 August 1874, Theed wrote to Liverpool Corporation 'with reference to the removal of the Booth Statue to Liverpool', but the Corporation Finance and Estate Committee, to whom executive responsibility had now been duly passed, deferred taking any action (*Finance and Estate Committee Minutes*). By 16 October, with the matter still undecided, the Finance and Estate Committee received a letter from E.A. Ross, the Honorary Secretary of the Memorial Committee, in which he asked where and when the statue was to be erected. This at last prompted a consideration of the matter, but the Finance and Estate Committee found itself unable to agree on any permanent site, deciding only, after a vote, to place it 'for the present' in the Great Hall of the Free Library (*Finance and Estate Committee Minutes*).

With the decision to place the statue in the Free Library, executive responsibility passed to the Library, Museum and Arts Committee. On 19 November 1874 the Committee approved the execution of two different pedestals: one, in yellow pine covered in a maroon cloth, to be made by Mr Moore, the Museum Joiner, and costing £1. 15s., was presumably intended as a purely temporary measure while the statue was accommodated in the Library; the other, of a more permanent nature, was to be made from St Helens stone, to be supplied and fixed by William Thornton for the sum of £6. 10s. 0d (*Library, Museum and Arts Committee Minutes*).

By early 1877 at the latest, it seems that St George's Hall had been determined as the permanent location for the *Booth Statue*, for on

1 March and again on 21 April, Theed wrote letters to Liverpool Corporation pressing for some sort of action. With the agreement to remove the statue to St George's Hall, responsibility had once again returned to the Finance and Estate Committee which, on receipt of Theed's second letter, finally resolved in its meeting on 27 April 1877 to recommend to the Council that the statue should be placed in the 'North Entrance Hall of St George's Hall'. Following ratification by the Council, the move from Library to Hall was made under the supervision of the Corporation Surveyor, Thomas Shelmerdine, who, on 22 May 1877, confirmed with the Financial Sub-Finance Committee that the *Booth Statue* was now in the 'Northern Vestibule' on a temporary pedestal. Theed did not personally attend the move of his statue but sent an (unnamed) representative who suggested that the design for the permanent pedestal (which was now due to Theed) would be better executed in Sicilian marble. As Shelmerdine pointed out, the 1874 estimate had provided only for (the less expensive) St Helens stone. The Sub-Finance Committee duly referred the matter to the Finance and Estate Committee who, on 25 May, instructed Shelmerdine to obtain tenders for execution in Sicilian marble (*Finance and Estate Committee Minutes*).

On 1 June 1877, the Committee considered tenders from Edwin Stirling, Messrs Norbury, Upton & Paterson and Messrs G.F. Chantrell & Son, the job going to Stirling, who submitted the cheapest tender at £24 for 'a Sicilian Marble pedestal in one block' (*Finance and Estate Committee Minutes*).

The last significant reference to the *Booth Statue* occurred on 28 February 1888, when the Building Superintendent of St George's Hall submitted a report, explaining how the statue came to be damaged during the course of a Liverpool Engineers Volunteers ball on the night of 3 February 1888. At about midnight a group of forty or fifty young men and women were reportedly engaged in a game of 'Kiss in the Ring' in the north vestibule. The Superintendent, 'seeing the disorderly nature of the game at once stopped it', but unfortunately not before a 'pedestal light' had been broken and, more seriously, the forefinger of the *Booth Statue*'s right hand knocked off. Although the Superintendent reported that a cleaning woman had found and returned the lost finger the following morning (*Finance and Estate Committee Minutes*) and although it was presumably restored, it has been subsequently lost nevertheless.

Literature: (i) LRO manuscript sources: *Council Minutes*, 1/19: 304; *Council Minutes*, 1/20: 584; *Finance and Estate Committee Minutes*, 1/21: 107, 191-92; *Finance and Estate Committee Minutes*, 1/23: 268, 299-300, 345-46, 353, 371; *Library, Museum and Arts Committee Minutes*, 1/10: 12, 19, 34. (ii) Read, B., 'From Basilica to Walhalla', in P. Curtis (ed.) (1989): 36.

Standing to either side of the *Statue of Henry Booth* are a pair of Greek style *Caryatids* (broadly based on those of the Erechtheion on the Acropolis, Athens) with baskets of flowers on their heads. One holds a tambourine and wreath; the other a lyre and plectrum.

Sculptor: unknown (although it has been suggested by Timothy Stevens that he may have been Giovanni Fontana).

Caryatids in plaster, painted white

h. 104" (264cms)

It is not certain when these two caryatids were first placed here or where they came from.

Condition: fair

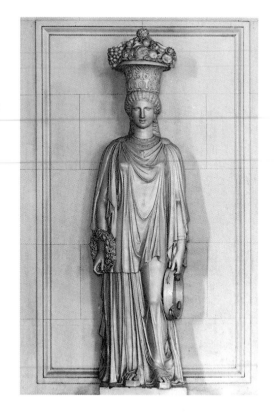

4. THE SMALL CONCERT ROOM designed entirely by C.R. Cockerell and opened 5 September 1856.

The eliptical balcony is supported by a ring of sixteen *Caryatids* in the guise of *Flora* and *Pomona* – the goddesses, respectively, of Spring and Flowers and of Fruit and Gardens.

Designer: Charles Robert Cockerell Sculptor: M. Joyon (Goodchild, 1888: 249)

Caryatids possibly in lithodipra, a contemporary synthetic material (Greene, F.J., 1993: 406), painted white with gilded baskets, 1854-5.

h: 74¹/₂" (189cms)

Owner: Liverpool City Council
Listed status: as for building

Condition: good

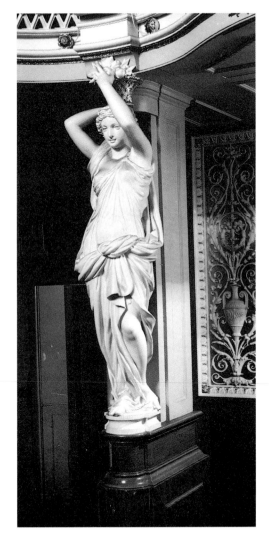

On 14 November 1853, the Law Courts and St George's Hall Committee approved Cockerell's modified designs for the Concert Room, including 'the figures in front of the pillars supporting the Gallery'. Just over three months later, on 20 February 1854, his 'Model of the proposed supports under the Gallery front in the Concert Room' was also approved (*Law Courts and St George's Hall Committee Minutes*).

Although in its meeting of 14 November 1853 the Committee also approved Cockerell's engagement of Charles Kelsey as modeller of the 'enrichments for the Concert Room', Kelsey's responsibilities evidently did not include modelling the caryatids. In his own, later, account of his work at St George's Hall (*Builder*, 22 July 1882), Kelsey makes no mention of them and indeed some years further on J.E. Goodchild, Cockerell's principal architectural assistant at the time, states that they were executed by 'M. Joyon, a French artist' (*RIBA Journal*, 1888: 249). As with the Mr Watson who executed the spandrel reliefs in the Great Hall (see above, pp. 289–91), Monsieur Joyon seems to be a rather obscure name for such accomplished works, although Goodchild's close involvement with the work on St George's Hall must lend his testimony considerable credibility.

Literature: (i) LRO manuscript source: *Law Courts and St George's Hall Committee Minutes*, 1/2: 253-54, 270, 271.
(ii) *Builder* (1855) 8 December: 594; Goodchild, J.E., 'St George's Hall, Liverpool, and the late Professor Cockerell, R.A.', *RIBA Journal* (1888) 26 April: 249; Greene, F.J., 'St George's Hall', in R.J. van Vynckt (ed.) (1993): 406; Stamp, G., 'Architectural Sculpture in Liverpool', in P. Curtis (ed.) (1989): 9; Watkin, D. (1974): 241-42.

Griffin frieze and other architectural decoration

Designer: Charles Robert Cockerell
Sculptor: Charles Samuel Kelsey

Frieze and other decorations in plaster, painted and gilded, 1854-55

Owner: Liverpool City Council
Listed status: as for building

Description: The *Griffin Frieze* runs around the entire room beneath the cornice, broken only by the ornate capitals of the pilasters. Each section around the auditorium consists of a pair of affronted eagle-winged griffins either side of a circular shield inscribed in raised gilt letters with the name of a composer. The griffins in the centre of the section at the rear of the concert platform stand either side of a lyre, the instrument of Apollo, Greek god of music.

The front faces of the pilaster capitals are decorated alternately with lyres and busts of Apollo, with festoons of bay leaves suspended from consoles to each side. The cove which springs from the cornice of the auditorium is panelled in circular and diamond-shaped compartments. The flat central zone of the ceiling, separated from the cove by a decorated band, has radiating open latticed panels around an oval sky-light, this latter framed by a band of sculptured fruit and flowers. A rich colour scheme adds the finishing touch to the exquisite elegance of the interior: the ceiling and coving in cream and blue with details picked out in gold; the frieze white against a gold background; the deal panelling of the auditorium walls painted to imitate ornamental woods.

Condition: good

In its meeting on 14 November 1853, the Law Courts and St George's Hall Committee authorised Cockerell to engage Kelsey 'to model the

enrichments for the Concert Room in order that the Work may proceed under Mr. Cockerell's superintendence' (*Law Courts and St George's Hall Committee Minutes*).

Literature: (i) LRO manuscript source: *Law Courts and St George's Hall Committee Minutes*, 1/2: 253-54.
(ii) *Builder* (1855) 8 December: 594; Knowles, L. (1989): 24-5; Olley, J., 'St George's Hall, Liverpool', *Architects' Journal* (1986) 18 June: 43, *48*, *49*.

Steble Fountain. See Commutation Row.

WALKER ART GALLERY
designed and built by Cornelius Sherlock and H. H. Vale 1874-77. The cost of erection and the sculptural decoration of the building was met in entirety by Sir Andrew Barclay Walker (Picton, 1875, revised edn 1903, ii: 302).

Statues and sculptural friezes

Sculptor: John Warrington Wood

Owner: National Museums and Galleries on Merseyside
Listed status: Grade II*

Flanking the main entrance:

Raphael and *Michelangelo*

Statues in Carrara marble

Raphael: h: 8' 8" (2.65m)
Michelangelo: h: 8' 9" (2.66m)

Raphael inscribed: RAPHAEL / Born 1483 Died 1520
Michelangelo inscribed: MICHAEL ANGELO / Born 1474 Died 1583

Michelangelo signed on the right face of the marble base: J. WARRINGTON WOOD / ROME 1877

Descriptions:
(i) *Michelangelo* (from the *Mercury*, 30 March 1876):

represents the great artist holding his chisel in his left hand, and leaning back in his chair, while gazing upwards as if to contemplate in earnest thought, and with self-searching criticism, some work commenced or maturing itself into imagined existence. Beside him is the hammer, which he seems carelessly to have laid on his chair, and which partly covers a plan for the dome of St Peter's. At the back of his chair is introduced a lyre, fit emblem for one who was a true poet as well as a sublime artist; and in front we see his palette and brushes for painting – the three arts in which he excelled being thus symbolised. His costume is historically correct, flowing, ample, and treated in a bold, large style; the thoughtful, intensely gazing countenance answering (as it seems to us) our highest, and also best, authorised ideal of this

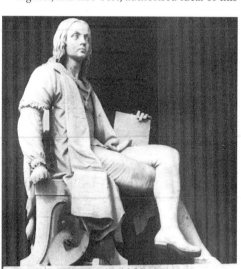

great man's individuality...

(ii) *Raphael*, executed later, was described by the *Mercury* on 13 July 1877 as follows:

The statue of Raffaelle is somewhat different from that of Michael Angelo in arrangement. The painter is represented cross-legged, and the foreshortening of one of the limbs rendered the use of a block necessary to support the foot, which by no means improves the general appearance of the figure, but is necessary to assist in carrying the weight of the marble. Raffaelle has in his right hand a pencil, with which he has just drawn an outline of his memorable Madonna and Child upon a medallion, and at the foot of his seat the enrichment of an easel and brushes has been cleverly introduced. The countenance of the artist is of a very refined character, almost in contrast to that of the other statue, yet equally effective and noble.

Condition: Both figures are in very poor condition. *Raphael* is missing the toes of both feet, and

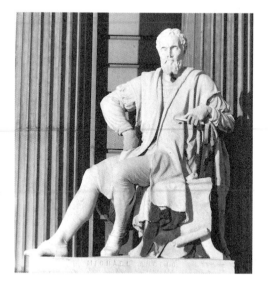

the right hand and wrist. In addition, the face has been vandalized. The face of the *Michelangelo* is badly eroded. Both figures have black encrustation and some of the surfaces are crazed.

The sculptor, John Warrington Wood, had first come to Andrew Barclay Walker's attention in 1871, when he admired and bought the sculptor's statue, *Eve*. Consequently, Wood was Walker's natural choice for the commission to execute the sculptural embellishment of his new gallery.

On the roof over the main entrance:

Allegorical Statue of Liverpool

Sculptor: John Warrington Wood

Statue in Carrara marble, with bronze details of Liver Bird, mason's mallet and trident.

h: 9' 7" (2.92m); w: 8' 2½" (2.5m); d: 4' 5½" (1.36m)

Owner: National Museums and Galleries on Merseyside
Listed status: as for building

Description: *Liverpool* is portrayed as a colossal regal female, wearing upon her head a castellated crown and laurel wreath. She is seated upon a bale of cotton, her symbolic bird, the Liver Bird, close beside her left arm. In her left hand she holds the propeller of a steamship, whilst in her right hand is a trident, symbol of her dominion over the sea. At her sandalled feet, resting against a bale of cotton (emblematic of commerce), are a painter's palette, a compass and a set square. This juxtaposition being intended to indicate that it is 'in commerce that art finds its support' (*Daily Post*, 21 June 1877).

Condition: Very poor. Removed on 24 October 1993 to the NMGM conservation studios at

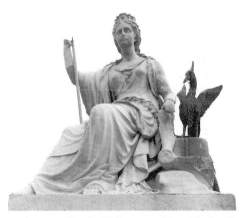

Bootle. A replica in Chinese marble with details in aluminium (see below) will replace the original on the WAG roof towards the end of 1996, whilst the original will be displayed in its unrestored state in the new NMGM conservation centre at Crosshall Street (the former Midland Railway Goods Station).

All three statues were executed in the sculptor's Rome studio as part of a commission to decorate the Walker Art Gallery. The *Daily Post*, 28 February 1876, reported that the *Michelangelo* (clay model) had been completed and was judged by local opinion to be a 'truly grand work'. A year later, the Gallery was nearing completion and the Mayor and benefactor of the building, Sir Andrew Barclay Walker, decided to visit the sculptor in Rome to ascertain the state of progress of the sculptures, it having been decided that the official opening would be delayed until the whole ensemble was complete. Meanwhile, the *Mercury* (16 February 1877) expressed the hope that the *Steble Fountain* (see above, pp. 23–5) would also be complete in time for the Gallery's inauguration, so as to give the final polish to the

dignity of proceedings that would inevitably enhance the town's honour. On his return from Rome, the Mayor reported that not only were the statues finished and ready for shipment, but that all three had received unanimous acclaim from the artistic community in Rome.

The largest of the three, the *Allegorical Statue of Liverpool*, was, at an estimated twelve tons, too heavy for any waggon to bear. After being crated-up, it was conveyed through the streets of Rome on rollers, taking four days and the efforts of a great many labourers to move it from the sculptor's studio to the railway station (*Mercury*, 25 April 1877). The three sculptures were shipped from Livorno and arrived in Liverpool on 16 June 1877 (*Courier*, 18 June 1877).

Liverpool was put on public display at the entrance to the gallery on 5 and 6 July (*Courier*, 6 July 1877), prior to its elevation to the roof in the week commencing 16 July. The lifting operation took three days. While the sculpture was slowly and painstakingly hoisted, a scaffolding was erected beneath it to prevent a disastrous fall. Eventually it was passed through an aperture behind the pediment and safely placed in position on the roof. At seven-thirty on the evening of Friday 20 July, the cheers of the workmen marked the successful completion of the job and were answered by those of the watching crowd below. The gallery was officially opened by Edward Henry Stanley, 15th Earl of Derby, on 6 September 1877 (*Courier*, 23 July 1877).

Over the years Warrington Wood's three Carrara marble statues have suffered greatly from the city's polluted atmosphere. By the early 1990s the *Allegorical Statue of Liverpool* had reached such a state of deterioration that it was removed from the Walker Art Gallery roof and taken to the NMGM conservation studios

at Bootle. The NMGM conservation team, headed by John Larson, decided that the statue's deterioration should be halted, but that no restoration should be carried out. Instead, a replica would be made for the Walker Art Gallery roof and the unrestored original would be placed on public display in the new NMGM Conservation Centre, Victoria Street, as an example of the ravages exacted upon stone by the pollutants in a modern urban atmosphere.

Meanwhile, however, it was necessary to recreate the appearance of the original in its pristine state to serve as a model for the replica. Carrara marble was rejected as the medium for the replica owing to its expense and the difficulty of obtaining it in the first place. After investigating several other alternatives, it was discovered that the most cost-efficient route was to use Chinese marble which had been rough-hewn before shipment from China by local masons.

Using 1920s photographs as guides, the NMGM conservation team rebuilt the deteriorated surfaces of the original sculpture with plasticine. They then took a series of new photographs and made detailed measurements of the rebuilt original which were sent to China. From the NMGM team's photographs and measurements, a Chinese craftsman made a small-scale model which was sent to Liverpool for approval. After the model had been approved, four Chinese masons set to work on a forty-two ton block of Chinese marble and the result of their labours was transported to Liverpool, where the final carving was carried

out. The bronze details of the original – Liver Bird, mason's mallet and trident – were replicated in aluminium (to avoid the inevitable green staining of the marble) and patinated to look like bronze, at the NMGM studio (conservation information supplied by John Larson).

Literature: (i) LRO newscuttings: *British Architect* (1877) 6 July, in *WAG 1877; Courier* (1877) 18 June, in *WAG 1877; Courier* (1877) 6 July, in *WAG 1877; Courier* (1877) 23 July, in *WAG 1877; Daily Post* (1876) 28 February, in *WAG 1877; Daily Post* (1877) 21 June, in *WAG 1877; Mercury* (1876) 30 March, in *WAG 1877; Mercury* (1877) 16 February, in *WAG 1877; Mercury* (1877) 6 July, in *WAG 1877; Mercury* (1877) 13 July, in *WAG 1877.*
(ii) *Art-Journal* (1876): 276; *Art-Journal* (1877): 317; *Echo* (1996) 2 April: 3; Picton, J.A. (1875, revised edn 1903), ii: 495; Wilmot, T. (1891): 136.

Bas-relief Friezes

beneath the cornice of the building. These represent four royal visits to Liverpool and are, from right to left, beginning in Mill Lane:
1. *The Embarkation of King William III and his army at Hoylake in 1690.*
– and continuing in William Brown Street:
2. *King John granting the First Charter to the burgesses of Liverpool, A.D. 1207.*
3. *The Visit of Queen Victoria in 1851* (illustration on opposite page).
4. *The Laying of the Foundation Stone of the Walker Art Gallery by the Duke of Edinburgh in September 1874.*

Bas-reliefs in sandstone

Owner: National Museums and Galleries on Merseyside

Listed status: as for building

Condition: There appear to be no losses, but all upper surfaces are spattered with bird droppings.

Related works: the plaster models for the friezes are in the collection of the Walker Art Gallery.

The plaster models were executed at the artist's studio in Rome and the designs subsequently carved directly into the stone of the building (*Daily Post*, 21 June 1877). The *Mercury* for 29 July 1878 announced the uncovering of the first of the reliefs, *The Visit of Queen Victoria in 1851*. In general, the paper approved of the work:

> As the space is limited, the designer has very wisely abstained from so filling it with figures as to render the bas-relief an almost indistinguishable crowd...The figures stand prominently forward, and the chiselling generally is well finished. It is hardly possible in such a production to introduce the portraits of individuals, but the artist had attempted to do this with the illustrious visitors, and, so far as can be seen from the roadway below, he appears to have succeeded in his object.

Literature: (i) LRO newscutting: *Mercury* (1878) 29 July, in *TCN 1/13.*
(ii) *Porcupine* (1879) 3 May 1879: 75.

Wellington Memorial. See Commutation Row.

VILLA ROMANA
Italian Restaurant, 6-8 Wood Street, at the corner of Roe Alley. Along the upper part of the exterior wall, positioned over the windows and entrance to the restaurant:

Five Classical Style bas-reliefs

Sculptor: Jim McLaughlin

Bas-reliefs in cast terracotta

h: 24" (61cms); l: 43" (109.2cms)

Bas-reliefs at the extreme left and right signed:
J. MCLAUGHLIN / NDD FRSA
Bas-relief at the extreme right dated: 1994
(followed by copyright symbol: CR)

Owner of restaurant: Giuliano Sciarini
Status: not listed

Description: Three of the reliefs depict classical figures; these are interspersed with two reliefs with decorative swag motifs. The relief at the extreme left shows a male nude reclining on an antique-style couch with a semi-nude woman who holds up a bunch of grapes. The centre relief shows a reclining Neptune, his right arm resting upon an overturned urn from which liquid spills, his left hand holding his trident. The relief at the extreme right shows a nude

huntsman spearing a deer.

Condition: Good.

Related works: Plaster models for the 'banquet' relief and 'Neptune' relief are in the sculptor's studio at the Bluecoat Chambers.

The five bas-reliefs were commissioned from the sculptor by the owner of the restaurant, Giuliano Sciarini.

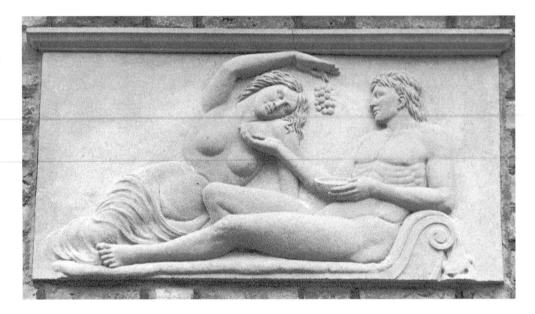

Lost Works

ANFIELD TECHNICAL COLLEGE

Willett (1967: 93) states that William Mitchell executed a relief (no description given) for Anfield Technical College, since demolished.

BOLD STREET

Formerly at the corner of Bold Street and Colquitt Street:
Standing Figure

Sculptor: Robin Riley

medium: not recorded

h: 144" (366cms)

Unveiled by Douglas Roberts, Vice-Chairman of the Bold Street Association, Sunday 18 September 1960.

Description: At the time of writing, no reliable description of this work was available.

The *Standing Figure* was commissioned by Bold Street Traders' Association in the early part of 1960. The proposed location was a

Second World War bomb-site at the corner of Bold Street and Colquitt Street, owned by poster contractors, Arthur Maiden Ltd (Willett, 1967: 118-19). The traders' association had hoped to get a sculpture that would 'beautify' the street and moreover 'attract more customers' to the shops (*Daily Post*, 19 September 1960). It would appear, however, that the usual procedure of approving the preliminary drawing and *maquette* was not followed: it is obvious from the horrified dismay expressed at the unveiling by the Vice-

Chairman of the association that both the style and form of the sculpture were completely unexpected. He protested, 'I think something much more cheerful, possibly not a male form at all, would have been more appropriate'.

The obtrusive masculinity of the figure and its lack of arms were the principal factors contributing to the adverse response of the crowd of onlookers who reportedly found the sculpture 'shocking', 'disgusting', and 'vulgar': the *Daily Post* (20 September 1960) even purported to have found someone who thought it looked 'as though it's got a nasty mind'. The site owners, Arthur Maiden Ltd, responded by summarily ordering the removal of the sculpture the very day after its erection. The Managing Director confessed that he feared that the hostile public reaction 'might be directed against us when we are in no way responsible for it.'

The statue was initially relocated to a private garden whilst a new purchaser was sought. Among the few people who had reacted positively to the sculpture was Councillor C. Maguire who had hoped to persuade Crosby Council to have it erected on the Blundellsands sea-front, 'I think' he said, 'it typifies the struggle of our merchant seamen during the war' (*Daily Post*, 20 September 1960). The Council did not take up the Councillor's suggestion, however, and the present location of Riley's *Standing Figure* is unknown.

Literature: *Daily Post* (1960) 19 September: 2; *Daily Post* (1960) 20 September: 9; Willett, J. (1967): 117-20.

CHILDWALL COUNTY COLLEGE

Willett (1967: 93) states that Mitzi Solomon Cunliffe executed some sculpture (no description given) for Childwall County College. According to Liverpool City Council Educational Directorate, Childwall County College was closed some years ago. It has not been possible to ascertain whether the sculpture still exists.

DALE STREET

QUEEN (QUEEN INSURANCE) BUILDINGS, 8-10 Dale Street, by (Sir) James Allanson Picton, *c.*1857. According to Whitty: 'Over the entrance portal, elevated on a pedestal, is a full length **Statue of Queen Victoria**, in her coronation robes, with the orb and sceptre, gilt. The likeness is excellent (1871: 38).' It is not known at what time the statue was lost.

Literature: Whitty (1871): 38.

EXCHANGE FLAGS

The NEW LIVERPOOL EXCHANGE BUILDING (1863-67), by T. H. Wyatt, was demolished and replaced in 1937 by the present Exchange Building by Gunton and Gunton. Wyatt's building, apparently built in a 'sort of Flemish Renaissance' style (Picton, 1875, revised edn 1903, ii: 32) incorporated a significant amount of sculptural decoration, all of which remains untraced.

Statues of explorers and navigators:
Christopher Columbus, Captain James Cook (illustration p. 302, centre), *Sir Francis Drake* (illustration p. 302, right), *Galileo* (illustration at right), *Mercator* (illustration p. 302, left), *Sir Walter Raleigh*; and
Pediment sculpture group:
Wisdom sending forth her Messengers to the Nations of the Earth.

Sculptor: William Frederick Woodington

h. of each statue: 84" (213.4cms)

Exhibited: Royal Academy of Arts 1869 (cat.

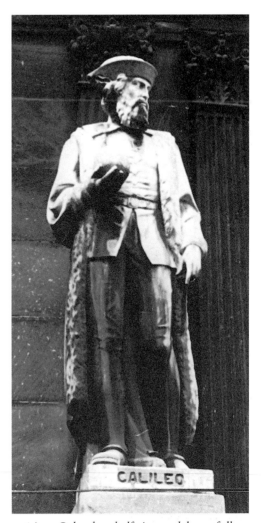

1269), as *Columbus; half-size model; one full size, 7 feet. Executed for the New Exchange, Liverpool.* Royal Academy of Arts 1874 (cat. 1153), as *Original design for pediment, executed in stone, figures 8 feet high. For the Liverpool Exchange.*

The *Art-Journal* (1867: 195) records that the *Columbus* and *Sir Francis Drake* statues had recently been positioned either side of the entrance to the Newsroom of the New Exchange Building. The figures were intended to represent, respectively, 'the commercial marine' and 'the war marine' and were praised by the journal as 'works of great merit, dignified in character and expression, and elegant in their sculpturesque forms'. The other statues were not yet *in situ* but were expected to be erected 'on the piers of the open arcade'. Woodington was reported to be currently engaged upon the sculptures of the pediment.

The pediment group was presumably lost at the time of the building's demolition in 1937, but the six statues of explorers and navigators were donated to the Corporation of Liverpool by the Liverpool Exchange Company in 1937 (*Daily Post*, 4 August 1937; *Daily Post*, 5 August 1937). At the time of the donation the local press speculated that the statues would

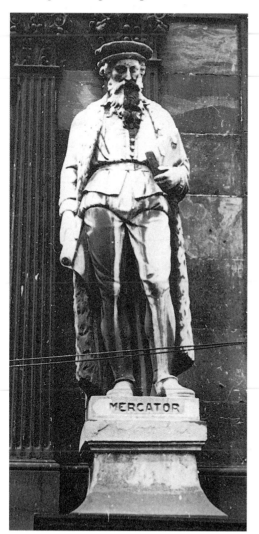

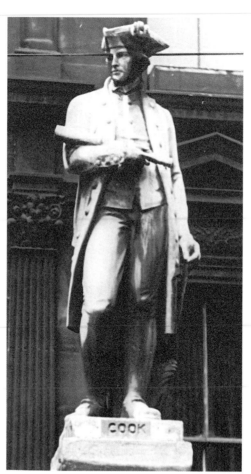

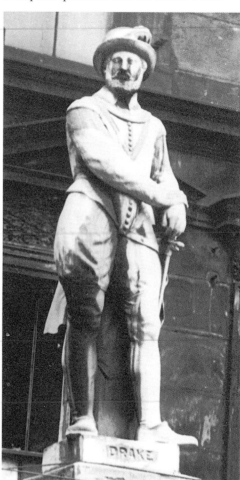

probably be erected in one of Liverpool's public parks. If this was Liverpool Corporation's intention it seems never to have been carried out and the present Corporation has absolutely no knowledge of the statues (letter to the author dated 27 May 1994).

Literature: (i) LRO newscuttings: *Daily Post* (1937) 4 August, in *TCN 1/65*; *Daily Post* (1937) 5 August, in *TCN 1/65*.
(ii) *Art-Journal* (1867): 195; Gunnis, R. (1951): 441; Picton, J.A. (1875, revised edn 1903), ii: 32.

HIGH STREET

TOWN HALL.
Bas-relief on the original pediment (now removed and lost, or possibly concealed behind the present south portico).

Sculptor: William Stephenson

According to Gunnis (1951: 373):

In 1752 it was decided to add a bas-relief to the pediment of Liverpool Town Hall and the Council engaged Stephenson to carry out the work. On its completion, however, they were not at all satisfied and offered the sculptor eighty guineas, instead of the larger sum which they had originally mentioned. In 1756 Stephenson petitioned the Council for a further £20, but they refused his request, considering that the relief was "ill-executed" and that "Mr. Stephenson had been already paid more than he deserved and that they would pay him no more" (City Archives).

The Corporation Treasurer's accounts for 18 October 1753 record a payment to 'Wm. Stephenson in full for carving pediment £84. os. od'.

Literature: Gunnis, R. (1951): 373.

NORTH JOHN STREET

According to *The Builder* (1848: 614), in 1848 Charles Samuel Kelsey carved the *Sculpture Above the Doorway* of the ROYAL INSURANCE OFFICE in Liverpool (cited in Gunnis, 1951: 224). This was the building by William Grellier, replaced by James Francis Doyle's 1896-1903 Royal Insurance Offices in North John Street (see above, pp. 120–2).

SCOTLAND ROAD

Patrick Byrne Memorial Drinking Fountain, demolished apparently after being vandalised in the 1970s. Irish-born Patrick Byrne (1850 – 90) started his adult life as a docker, became a wealthy Liverpool publican and from 1883 was the Irish Nationalist councillor for one of the two Scotland wards of Liverpool. Deeply concerned for the welfare of his poverty-stricken constituents, he was an advocate of sanitary reform, fought for improved wages for scavengers and was a benefactor to Catholic churches, schools and charities. In his will he bequeathed £5 for each year of service to each of his employees (source: Waller, 1981).

Designer: unkown

Drinking fountain in red and grey Aberdeen granite

Inscription: ERECTED IN MEMORY OF / PATRICK BYRNE / City Councillor, who was distinguished for his / services to the Ratepayers, benefactions to the / poor, and ardent devotion to his native land. / Died, 5th May, 1890.

Inaugurated March 1892

Owner: Liverpool City Council
Not listed

Description: No photograph, or even a written description of the *Byrne Memorial Fountain* has been traced up to the time of writing.

Following the death of Councillor Patrick Byrne, a group of his friends and supporters decided to have a memorial erected to him and set up the Byrne Memorial Fund to raise money for that purpose. It was agreed that a drinking fountain would be the most appropriate form for the memorial and a site (opposite Byrne's Morning Star Hotel) in Scotland Road selected (*Liverpool Review*, 26 March 1892). The Memorial Committee duly applied to the Corporation Health Committee for permission to erect the fountain and permission was summarily refused. On 25 February 1891, C.J. O'Connor, the Chairman of the Byrne Memorial Fund, wrote again to the Health Committee offering to make any reasonable changes to the fountain (specifically he offered to 'abandon the idea of a bust and withdraw their request for the removal of the urinal') so long as the memorial character of the fountain was retained. On 27 February 1891, the application was again rejected (*Liverpool Review*, 26 March 1892).

Any decision made by the Health Committee, or indeed any of the Corporation committees, needed ultimate approval from the City Council and it was at this point that the Council apparently intervened and compelled the Health Committee to reconsider, for on 12 March 1891, O'Connor was invited to submit a design for the fountain and the plan of its proposed location for further consideration by the Health Committee. O'Connor submitted his new design and plans on 27 April 1891, with the undertaking that 'the work will be entrusted to a local sculptor [unspecified] whose reputation is a guarantee of satisfaction to your

committee' (*Liverpool Review*, 26 March 1892). On 3 June 1891, O'Connor received a letter enclosing a Council resolution approving the erection of the fountain (*Liverpool Review*, 26 March 1892).

The fountain was erected and O'Connor wrote to James Barkeley Smith, Chairman of the Health Committee, asking when it would be convenient for the Corporation to accept it formally. On 5 March 1892, O'Connor received a reply from George Atkinson, the Town Clerk, explaining that he had been instructed by the Health Committee to point out that the Council had given approval only for the erection of the fountain – that there had been no acceptance of the fountain by the Corporation and that therefore the Health Committee was not committed to accept responsibility for its maintenance (*Liverpool Review*, 26 March 1892). It was, of course, vital that the future maintenance of any monument, especially a drinking fountain, be accepted by the Corporation and the *Liverpool Review* expressed outrage at this obviously vindictive decision in a series of articles (on 26 March, 2 April and 9 April 1892) which clearly accuse James Barkeley Smith and his Health Committee 'cronies' (as the *Review* for 26 March 1892 called them) of mounting a campaign against the fountain. Although never referred to by the *Liverpool Review*, it seems beyond doubt that it was Patrick Byrne's Irish Nationalist political platform that prompted James Barkeley Smith and his Conservative allies on the Health Committee into attempting to block and then inconvenience the memorial to him.

Notwithstanding Smith's opposition, the Council forced the Health Committee to reconsider and, on 4 May 1892, following the City Engineer's report that the workmanship appeared to be 'of good quality and the material of a very lasting character', the *Byrne Memorial Fountain* was accepted by the Council and instructions issued that it be supplied with water (*Council Minutes*).

Literature: LRO (a) manuscript source: *Council Minutes*, 1/31: 309.
(ii) *Liverpool Review* (1892) 26 March: 6; *Liverpool Review* (1892) 2 April: 4; *Liverpool Review* (1892) 9 April: 12.

SPRINGFIELD PARK COMPREHENSIVE SCHOOL

Boy by a Pool,
Stanley English. See Gateacre Comprehensive.

STANLEY PARK PALM HOUSE

Flora MacDonald

Sculptor: Benjamin Edward Spence

Statue in marble

Dated:1865

Owner: Liverpool City Council
Status: not listed

Description: A seated female figure, she looks downwards contemplatively, her hands clasped on her left knee.

This statue was donated to the City of Liverpool by George Audley in January 1929 and housed in the Palm House at Stanley Park. During the 1980s, the Palm House suffered neglect; it and its contents (including the *Flora MacDonald*) becoming increasingly vandalised. The Palm House was finally sold off in July 1986 to a private company (Richardson, 1990: 63). The statue is believed by the Council's Development and Environment Directorate to have been destroyed (presumably by vandals) shortly after this time, whilst the building was

being refurbished.

Literature: Read, B. (1982): 206; Richardson, A. (1990): 63-4.

Boy with a Fish

Sculptural group by an unknown sculptor. As with Spence's *Flora Macdonald* (see above), this was housed in the Palm House at the time of the sale of the property, although Liverpool Development and Environment Directorate has no knowledge of its current location (letter to the author, 27 May 1994).

WILLIAM BROWN STREET

ST GEORGE'S HALL

Sculptural group
formerly in the tympanum of the South Pediment

Designer: Charles Robert Cockerell
Sculptor: William Grinsell Nicholl

Sculptural group in Caen stone, *c.*1845-54

Exhibited: Royal Academy of Arts, 1846 (cat. 1254), as *Design for the sculpture of the pediment of St. George's Hall, at Liverpool, now erecting under the direction of H. Lonsdale Elmes, Esq., architect. Composed upon the Greek system of the Parthenon and other examples, in entire statues, with symmetry of parts, and eurythmy of lines and quantities...The subject represents Britannia in the centre, and Neptune at her feet: in her left she holds out the olive branch to Mercury and the four quarters of the globe, of whom the last, Africa, does homage for the liberty she and her children owe to her protection; beyond, are figures representing the vine, and other foreign commercial productions: in her right she extends her protecting spear over her own productions – agriculture, sciences, domestic happiness, the plough, the loom, and the anvil.*

Description: the *Builder* (17 March 1855: 126, 127) published a detailed description and full page engraving (the latter possibly derived from Hullmandel and Walton's lithograph after Stevens; illustrated p. 306). The general concept remains close to Cockerell's first drawing, exhibited with a descriptive title at the RA in 1846 (see above). In the centre, seated upon a rock, is *Britannia*. In her left hand she holds an olive branch and in her right a spear. At her left side is her lion and, at her feet, *Neptune* (indicating her dominion over the sea). To her left, *Mercury*, patron of commerce, steps forward to present personifications of the four quarters of the globe, with *Africa* on her knees, though with her shackles broken. Beyond these, *Bacchus*, representing the vine, is seated with his leopard. In the acute angle of the pediment, two reclining figures, plus a bale of cotton, represent 'foreign productions'. On *Britannia*'s right, is a quadriga driven by *Apollo* in his guise as patron of the Arts. His passenger is a female personification of *Agriculture* clasping a cornucopia. Beyond these are a seated 'husbandman' with his plough in his right hand, his naked child leaning against his knee (derived from the Christchild in Michelangelo's *Bruges Madonna*); next is his wife with a distaff, the pair representing 'industry, manufacture, and domesticity'. Finally, in the acute left angle, are two crouched workers in metal, making anchors and armour, etc. In all there are eighteen figures, plus a leopard and four horses, carved, for the most part, fully in the round.

Related works: 1. C.R. Cockerell: (i) *Idea for the Frontispiece of a Public Building in England*, pen drawing, 1843 (RIBA OS5/5); (ii) four preliminary studies in pencil for St George's Hall pediment sculpture, comprising two alternative sketch designs for the right-hand half (RIBA J10/38¹, J10/38²), one sketch design for the figures in the centre (RIBA J10/38³) and one sketch elevation of the whole pediment (RIBA J10/38⁴); (iii) *Design for the Sculpture of the Pediment of St George's Hall*, pen drawing, exhibited at the RA 1846, (WAG 1896); (iv) two preliminary ink sketches for the pediment sculpture (University of Liverpool MS.10.5¹, MS.10.5²). 2. Alfred Stevens: (i) original drawing, 1849, for St George's Hall pediment sculpture (V&A D2054-1885); (ii) copies of the lithograph by Hullmandel and Walton taken from the preceding drawing (V&A E3B-1888; University of Liverpool MS.10.5¹⁻⁸).

The origins of the design for the lost pediment sculpture are still a matter of debate. Two things are, however, certain: the sculptural group was designed originally by Cockerell and executed

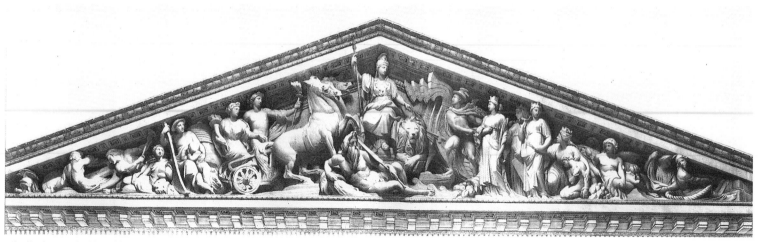

wholly by Nicholl and his workshop. In 1843, Cockerell executed a drawing, *Idea for the Frontispiece of a Public Building in England*. Harvey Lonsdale Elmes, the architect of St George's Hall, was sufficiently impressed by it to recommend its use to the Law Courts (and St George's Hall) Committee for the south pediment (Watkin, 1974: 238). He submitted Cockerell's 'rough sketch' and explanatory letter to the Committee on 25 November 1845. Cockerell wrote that should his design be accepted he would want it executed by Nicholl who had already carved pediment sculptures for George Basevi at Cambridge (Fitzwilliam Museum, 1838) and for himself at Oxford (Taylorian Institute, 1846) (*Law Courts and St George's Hall Committee Minutes*).

On 27 June 1846 Cockerell wrote to the Directors of the New Assize Courts at Liverpool (the Law Courts Committee) advising them that Nicholl was awaiting their permission to show them the completed model of the pediment sculpture 'made by him under my superintendence with some variations' on the original sketch, which he hoped the Committee would approve. He estimated the cost of the sculpture at about £3,500 (it ultimately cost £3,937) and this expenditure, to be derived from 'surplus income', received Council approval in November 1846. The Town Clerk was then directed to confirm with Cockerell the arrangements for the execution of the work. Meanwhile, Elmes was requested to arrange the supply of necessary stone. On 28 April 1847, after considering whether Darley Dale stone might not be better for the pediment group than the Caen stone proposed by Elmes, and eventually ruling out the former on cost grounds, the Law Courts Committee directed the Town Clerk to draw up a contract for Nicholl to execute the work (*Law Courts and St George's Hall Committee Minutes*).

The sculpture as completed differed somewhat from Cockerell's original design. The unresolved question is whether that original design was later modified by anyone apart from Cockerell himself, and if so, who that person was. *The Building Chronicle*, as early as 1854, stated that the work was 'executed under the superintendence of Sir C. Eastlake'; whereas *The Builder* (17 March 1855) stated simply that it was 'designed by Professor Cockerell, and executed by Mr Nichol [*sic*]'. And so things remained for over thirty years until William Conway, in a letter to the *Daily Post* (16 December 1887) regarding the sculptural decoration of the Hall in general, precipitated what was to become a heated debate by asserting that the pediment group had on the contrary been 'magnificently designed by [Alfred] Stevens'. This assertion was repudiated a few days later by Joseph Boult (*Daily Post*, 22 December 1887), who wrote declaring that he had it on the 'best authority' (he had been on friendly terms with Cockerell) that the pediment sculpture was designed wholly by Cockerell and executed by Nicholl under Cockerell's supervision. Boult's letter was, in turn, answered by Robert Rawlinson (*Daily Post*, 28 December 1887), formerly Corporation Engineer and close collaborator with both Elmes and Cockerell,

who reaffirmed the *Building Chronicle*'s statement that the 'pediment was designed by Professor Cockerell and Sir C. Eastlake [and] carved by Nichol [*sic*]'.

Conway gave a more detailed substantiation of his claim for Stevens's intervention in the design of the pediment sculpture, in his article in the *Builder* of 31 March 1888. Conway here submitted the testimony of Stevens' pupil, James Gamble:

> I know that he [i.e. Stevens] rearranged the whole of the sculpture in somebody's studio in Liverpool [Nicholl's studio was actually in Grafton Street, London; see below], that he compressed the figures, and added two of his own with accessories at each end, including anchor, hammer, shield, bale of cotton, etc...(*Builder*, 31 March 1888: 224).

According to Conway, two more of Stevens's pupils, Reuben Townroe and Hugh Stannus, were also insistent that Stevens modified the design. Stannus affirmed this in his book, published three years later, when he stated that Stevens designed 'new groups for the difficult spaces at the ends [of the pediment, and that they were] modelled by the Master' [i.e. Stevens] (Stannus, 1891: 9). Conway then moved on to counter the testimony of J.E. Goodchild, who had recently denied Stevens a share in any part of the Hall's decoration (the question of whether Stevens had contributed to the design of the Minton tile floor of the Great Hall had also been raised). Conway questioned why Goodchild, whom he described as Cockerell's 'pupil', should have necessarily known about anything that occurred outside Cockerell's office. The following week, Goodchild replied to Conway's article (*Builder*, 7 April 1888: 252), protesting that he was at the time not Cockerell's 'pupil' but, from 1833 – 59,

his principal assistant and business confidant. Refuting Conway's suggestion that he was ignorant of matters outside the architect's office, Goodchild referred to his frequent visits to Nicholl's studio in Grafton Street, London, where he saw the figures in progress and where he particularly remembered being told by a studio assistant called Johnson that 'the anchor-smith at the extreme left of the pediment' (which Gamble alleged was wholly modelled by Stevens) was in fact 'from one of Nicholl's [favourite] models'. Goodchild even pointed out that Stevens was not yet in practice as a sculptor, thereby intending to cast doubt on the likelihood that Stevens would have actually modelled new figures himself.

None of the participants in this debate denied that in 1849 Cockerell had asked Stevens to make a drawing of the pediment group for publication as a lithograph, before work on the sculpture itself had been completed in the summer of 1850. The fact that Stevens' 1849 drawing has seven fewer figures than Cockerell's original twenty-five has also been pointed out (Towndrow, 1951: 18). The Stevens advocates believe that instead of just drawing an impression of the completed group from Nicholl's work in progress, Stevens made significant revisions, reducing the overall number of figures while at the same time adding four of his own, and that Cockerell, realising that Stevens' pared down version would work better than his original idea, instructed Nicholl to rearrange the existing figures and to carve the four new figures from the models that Stevens then produced.

Neither did a comparison of Stevens' drawing with the completed sculptural group offer incontestable evidence: whereas Conway asserted a close agreement which could only have resulted from Nicholl following Stevens'

revised drawing and new models for the later stages of the work (*Builder*, 31 March 1888: 224), Goodchild professed to perceive a stylistic variation which could only have resulted from Stevens having to imagine the finished state from the uncompleted sculptures (*Builder*, 7 April 1888: 252).

One point that both Conway (*Builder*, 31 March 1888: 223) and Stannus (1891: 9) made in support of their argument that Cockerell would have been open to Stevens' suggestions was that Cockerell himself constantly examined and often improved his own work even after a design had been contractually approved. This argument, however, cuts both ways: Cockerell could have accepted Stevens' revisions at this stage – nobody denies 'that Cockerell had a high opinion of Stevens' powers' (Conway in the *Builder*, 31 March 1888: 223) – but given that constant reappraisal was an essential part of Cockerell's practice, he may well have introduced his own revisions as he observed the progress of the work in Nicholl's studio.

Unfortunately, in the absence of some new documentary evidence coming to light, the question will have to remain open. By the time the sculpture was removed from the pediment it was in a sufficiently ruinous state as to be virtually unidentifiable and furthermore there do not appear to be any reliable photographs from the time prior to that. The question of Stevens's intervention would seem still to be open.

The loss of the pediment sculpture:
At 3.30pm on 21 August 1950, portions of the decayed stonework of the sculpture fell from the tympanum of the south pediment of St George's Hall, necessitating the immediate removal of the rest of the group (*City Estates Surveyor's Report*). In 1966, the Council met to consider the desirability of a replacement in a

lighter and more durable material such as 'stone faced reinforced plastic' and a tender for £75,000 was considered. No action was taken at this point, however, as there were insufficient funds available (letter from the City Estates Surveyor to the Historic Buildings Council, 8 August 1972).

The matter was raised again in 1972 and the advice of the then director of the Walker Art Gallery, Timothy Stevens, was sought on the question of whether the replacement should be an exact replica of the original or a new group depicting persons who had made a significant contribution to the City. Stevens insisted that only an exact replica would be in keeping with the decorative unity of the building as a whole (letter from Stevens to the City Estates Surveyor, dated 3 March 1972, WAG JCS files). An appeal for funding was proposed and the Victorian Society (Liverpool Group) approached. Not having significant disposable funds of their own, they offered to give the appeal publicity on the understanding that only an exact replica be produced, 'the records of the original sculpture which exist [being] sufficient to allow a close replica to be made' (letter from Edward Hubbard, then Honorary Secretary of the Liverpool Group of the Victorian Society, to the Town Clerk, dated 30 July 1972, WAG JCS files). All attempts to secure funds proved fruitless, however, and the idea was abandoned indefinitely.

Since their removal the original sculptural remains from the pediment had been lying in storage in the basement of St George's Hall, their disintegration allegedly thereby hastened. Before long the stone had decayed beyond recognition and in the early 1960s the remains were disposed of (letter from the City Estates Surveyor to the Town Clerk, dated 31 August 1972, WAG JCS files).

As early as 5 August 1856, there is evidence of the rapid deterioration of the pediment sculpture. Nicholl, directed to examine the stonework, considered 'that the stone had suffered very little', but recommended that the figures be coated with a protective layer of oil (*Law Courts and St George's Hall Committee Minutes*). Nevertheless, on 17 September 1863, the Corporation Surveyor, John Weightman, was instructed to re-examine it, as pieces were by now dropping into the street (*Law Courts and St George's Hall Committee Minutes*). Given such early degeneration, it is remarkable that it lasted until 1950.

Caen stone had been agreed upon in good faith by Elmes and the Corporation as preferable to Darley Dale stone, because its softness allowed for bold carving and, as noted above, because it was the cheaper alternative. As attested at the time by both Cockerell (letter to the Law Courts Committee, 30 August 1847) and independent expert Sydney Smirke (letter to the Law Courts Committee, 1 September 1847), sculpture carved from Caen stone had survived well on many ancient buildings in Britain, whereas Darley Dale stone was relatively untested. Sadly, as it turned out, Caen stone could not withstand Liverpool's polluted atmosphere.

Currently, the Merseyside Sculptors Guild have plans to execute a replica to replace the original (see Hughes, 1964, 1993 postscript: 186-87). Using original lithographs and contemporary records, scale drawings have been produced which, in turn, have been used as the basis for the creation of a one-sixth scale model. The Council have approved the replacement, provided that the Guild can secure the requisite funding.

Literature: (i) LRO (a) manuscript sources: *Law Courts and St George's Hall Committee Minutes*, 1/1:

248-50, 256, 284, 286, 305, 318-19, 377, 407-9; *Law Courts and St George's Hall Committee Minutes*, 1/3: 42, 414, 420; *Treasurer's Department Ledger*, 1/1/11: 60-61 (insert between these pages). (b) newscuttings: *Daily Post* (1875) 2 January, in *TCN 1/10*; *Daily Post* (1887) 16 December, in *TCN 1/20*; *Daily Post* (1887) 22 December, in *TCN 1/21*; *Daily Post* (1887) 28 December, in *TCN 1/21*; *Daily Post* (1888) 3 January, in *TCN 1/21*.
(ii) WAG JCS files – photocopies of various correspondence of 1972 between John Tilney, M.P., the Town Clerk, the City Estates Surveyor, Timothy Stevens (then Director of the WAG) and Edward Hubbard (then Honorary Secretary of the Liverpool Group of the Victorian Society), concerning a proposed replacement for the lost pediment group; Town Clerk's Report, dated 1972, also relating to the pediment sculpture.
(iii) Beattie, S. (1975): 31; *British Architect* (1888) 14 December: 429; *Builder* (1846) 15 August: 395; *Builder* (1846) 17 October: 500; *Builder* (1846) 12 December: 593; *Builder* (1855) 17 March: 126, 127; *Builder* (1855) 7 April: 165; *Builder* (1855) 12 May: 225-26; *Builder* (1888) 31 March: 223-24; *Builder* (1888) 7 April: 252; *Building Chronicle* (1854): 83; Hughes, Q. (1964, 1993 postscript): 186-87; Picton, J.A. (1875, revised edn 1903) ii: 182-83; Stannus, H. (1891): 9; Towndrow, K. R. (1939): 87 – 88; Towndrow, K. R. (1951): 17 – 19; WAG (1968): 12-14; Watkin, D. (1974): 238.

ST GEORGE'S HALL – outside

According to the *DNB* entry for the sculptor Charles Bell Birch: 'A colossal statue of Lord Beaconsfield is at Liverpool; a statue of General Earle, and *a large group 'Godiva', are placed in front of St George's Hall in the same city*' (*DNB* supplement, 1901, i: 199). Birch certainly executed an equestrian sculpture of Godiva: the Royal Academy exhibition catalogue for 1884 lists under Birch's name: *Lady Godiva "Anon she shook her head, etc"* (cat. 1823) and a photograph of a sculpture by Birch entitled *Lady Godiva* appears in *The Magazine of Art* (1894: 82). The photograph caption, however, states that the group was then at Crystal Palace. There

appears to be no evidence that this sculpture was ever erected outside St George's Hall and it is difficult to see (a) where exactly it could have been placed (especially given the problems the proposed siting on the plateau of the *Equestrian Statue of Edward VII* was to pose a few years later, see above, pp. 140–3); (b) how a sculpture of a naked woman on a horse could have been found acceptable in front of the very reliefs that gave such offence for their depiction of naked female flesh such a few years before (see above, pp. 258–61); and (c) what possible relevance the historical figure of Lady Godiva could have had to the citizens of Liverpool. In the light of these conditions and in the apparent absence of any documentary evidence, the *DNB* statement must be presumed to be erroneous.

FORMER LOCATIONS UNSPECIFIED

Statues of Aesculapius and Hygeia

Gunnis states that (presumably in the late 1830s) Musgrave Lewthwaite Watson was employed by William Croggan (cousin and successor in 1821 to Eleanor Coade's artificial stone manufactory at Lambeth). For Croggan, Watson designed and modelled statues of *Aesculapius* and *Hygeia* in artificial stone 'for a hall in Liverpool' (Gunnis, 1951: 415).

Statue of Lord Nelson

The Monthly Magazine (1807, i: 396) reported that George Bullock's *Statue of Lord Nelson* (1807, artificial stone) had been erected in Liverpool (cited in Gunnis, 1951: 69). The statue is untraced.

Appendix: Church Street

Located outside Littlewoods, directly opposite Basnett Street:

Statue of Sir John Moores and Cecil Moores

The brothers, born in Eccles, were two of a family of eight children. Sir John Moores (1896-1993), the eldest son, moved to Liverpool in 1923 and founded Littlewoods Pools, the management of which he handed over to his brother Cecil (1902-89) in 1924, allowing himself to concentrate on the establishment, in 1932, of the mail order business. Sir John followed this in 1937 with the opening of his first store in Blackpool. From 1956-93 he was Chairman of the Liverpool Motorists' Outing for Physically Handicapped Children. In 1957 he launched the John Moores Exhibition, held annually at the Walker Art Gallery to encourage aspiring artists. In 1960-65 and 1972-73 he was Chairman of Everton FC. In 1970 he was made Freeman of the City of Liverpool and in 1993 became the only person to have a university, Liverpool John Moores University, named after him during his lifetime. He was awarded the CBE in 1972, received an Honorary LLB from the University of Liverpool in 1973, was the first winner of the Merseyside Gold Medal for achievement in 1978 and was knighted in 1980 (sources: *The Annual Obituary 1993; Who's Who 1993*; plus archival information from The Littlewoods Organisation plc).

Sculptor: Tom Murphy

Designer of base: The Design Department, Littlewoods Organisation plc

Group in bronze on a hexagonal pedestal and surrounding seat of concrete clad in Dakota Mahogany granite

h. of pedestal: 37" (94cm)

h. of bronze group: 88" (223.5cm)

h. overall: 125" (317.5cm)

Incised gilt inscriptions on the upper part of the pedestal:
– *on the lefthand forward oblique face*: SIR JOHN MOORES / 1896 – 1993
– *on the righthand forward oblique face*: MR CECIL MOORES / 1902 – 1989
– *on the righthand rear oblique face*: Donated to the City of Liverpool by the Moores family
– *on the lefthand rear oblique face*: Sculpture by Tom Murphy

Unveiled Thursday 19 September 1996 by John Moores Jnr, son of Sir John Moores, and David Moores, son of Cecil Moores

Owner / Custodian: Liverpool City Council
Status: not listed

Description: The sculpture is situated on the south side of Church Street, facing west. The pedestal, of dark mahogany-coloured granite, incorporates a surrounding seat. Gilt inscriptions are incised into the upper part of the pedestal – the seat-back – above a semi-circular black moulding approximately 5" (13cm) from the top. The two brothers, Sir John on the left and Cecil on the right, are portrayed in their mid-sixties. Portly and active, they are briskly walking to some destination – an appropriate activity for the sculpture's location in a busy, pedestrianised shopping street – and are enthusiastically engaged in discussion. They are

dressed in business suits – Sir John with waist-coat, Cecil without – the jackets of which appear to billow backwards in the wind. The composition is unified and the two brothers linked psychologically by the placement of Cecil's left hand on the back of Sir John's right shoulder, by the inward turn of their heads, and by the fact that each man leads with his outer leg (though Sir John's, significantly, is slightly further forward). The brisk forward momentum is checked by the gesticulating hands of the men, particularly the left hand of

Sir John, raised in front of him, palm upwards, index finger slightly extended to make a point.

The sculptor described his aims as follows:

The challenge was to create a double sculpture of two elderly men in a busy business and shopping area. My objectives were: to make the work relevant to the location; to provide interest from every viewing angle; to achieve a good likeness [of how they looked in middle age]; to capture the energy, dynamism and spirit of the brothers; to maintain interest and for the work to be accessible to a variety of people over many years. This was achieved by showing them in a walking pose, deep in conversation. By using a hand on the shoulder to join them, their close business and family relationship in indicated. The work [uses] harmonious lines which infuse motion and energy into the figures...The motion is controlled by the central arm which acts as a slight discord... (Tom Murphy, artist's statement to Gordon Lock, Design Manager, Littlewoods Organisation plc, dated 18 February 1997).

Condition: good

Related works: *Bust of Sir John Moores* (competition piece), resin, h. 3" (7.6cm), property of Gordon Lock; *Maquette for the Statue of Sir John and Cecil Moores*, clay, h 18", property of the artist.

The following account of the sculpture is, unless otherwise stated, derived from conversations with, or printed statements made available by, the sculptor and the Design Department of Littlewoods plc.

The decision to commemorate Sir John and Cecil Moores with a publicly-sited statue was taken by Littlewoods in November 1995 as part of its plans to celebrate the centenary, in the following year, of Sir John Moores's birth. The Littlewoods Centenary Committee hoped that the statue 'would serve as a lasting reminder to all Merseyside citizens of the important contribution made by both Sir John and Cecil Moores to Littlewoods and Merseyside as a whole' (Gordon Lock, The Littlewoods Organisation).

The 1996 centenary celebrations of Sir John Moores's birth were intended to reflect his principal leisure interests: the visual arts, music, and football. Apart from the sculpture, the key events organised by Littlewoods were as follows: (i) the renaming of Littlewoods' headquarters at 100 Old Hall Street as the Sir John Moores Building; (ii) an exhibition of Sir John's life at the Museum of Liverpool Life; (iii) an exhibition of past winners of the John Moores Exhibition at the Walker Art Gallery; (iv) an arts competition involving selected schools throughout the Liverpool area, the results of which were displayed in St George's Hall; (v) a concert of a selection of Sir John's favourite music by the Liverpool Philharmonic Orchestra at the Philharmonic Hall; (vi) a football tournament involving Liverpool FC, Everton FC, FC Porto (Portugal), and München Gladbach (Germany); and lastly (vii) a commemorative coin, bearing a portait of Sir John, designed by IMI Birmingham Mint Ltd, and presented to every member of Littlewoods' staff.

Following the decision to erect a statue, Gordon Lock of the Littlewoods Design Department contacted the National Portrait Gallery and the Mall Galleries, London, for advice on a suitable sculptor. In that same month, November 1995, a larger-than-life-size statue of John Lennon had been sited temporarily in the Clayton Square Shopping Centre as part of its 'Art in the Square' exhibition. The name and telephone number of the sculptor, Tom Murphy, were displayed at the statue's foot. Impressed by the work, Lock noted down Murphy's details. From a total of sixteen sculptors initially considered, the Littlewoods Centenary Committee drew up a shortlist of five. These five, which included Murphy, were then invited to submit photographs of their work with a tender for a life-size portrait statue. At this stage the sculptors were not informed of the subject of the commission.

Murphy, alone among the contenders, correctly assumed that the subject would be Sir John Moores and duly modelled a small portrait bust of him for submission to the Committee. His strategy worked, for both the Littlewoods Organisation and, more importantly, the Moores family – who were, of course, to have the final say – were won over by Murphy's acumen, the portrait likeness and the acceptability of his tender.

Meanwhile, Littlewoods Design Department met with the City Council and successfully negotiated the Church Street site. Gordon Lock and his colleague Clive Pitts then got together with freelance designer Steven Cooke to consider the design of the pedestal. After looking at various options, and taking into account the Council's suggestion that, given the sculpture's location in a pedestrianised shopping centre, it would be desirable if the pedestal were to incorporate seating, Lock came up with the present low hexagonal pedestal. To Lock, such a design had several advantages: the pedestal's height was sufficient to give good visibility in the crowded street, whilst presumably avoiding the elitist elevation of Victorian and Edwardian monuments, and the hexagonal plan allowed for two shoppers to sit along each length of seating (whereas an octagonal plan would have left each shopper seated in isola-

tion). The pedestal's orientation, with the front and rear presenting oblique aspects, had obvious advantages. The names of both brothers could be given relatively equal billing on each of the two receding faces of the front of the pedestal, whilst the sides of the pedestal would be parallel to the flow of mainly pedestrian traffic. The colour of the pedestal was chosen with an eye to: '...sensitively [harmonising] with the surrounding pavers of the pedestrianised shopping area and suitably complementing the bronze figures' (Gordon Lock, The Littlewoods Organisation).

It was only at the point at which Murphy won the competition that he was told that the commission was for a double portrait statue – his fee, of course, then being adjusted accordingly. His brief, which was kept fairly open, was to show the brothers as they had appeared in their mid-sixties – the poses were left to the sculptor to suggest. The brief also stated that the figures were to be life-size, but here Murphy convinced the Committee that the statues would need to be larger than life-size to register adequately in a public setting. Working from photographs, Murphy produced an 18" high maquette showing the two men engaged in animated discussion as they walked along. This was unanimously approved – subject to the sculptor making a few small adjustments at the request of the Moores family – in February 1996.

By June 1996, Murphy had completed the full-size clay model. Specialists from the Castle Fine Art Foundry of Oswestry then visited the sculptor's studio and, with the sculptor's help, took about twelve negative piece-moulds in silicon rubber which they backed with fibreglass for rigidity (colour photographs of the process are in Littlewoods archives). The specialists returned to the foundry and coated

the moulds with wax to the approximate thickness of the bronze. Once dry, the rigid waxes were removed from the moulds and the sculptor was called in to apply the finishing touches of modelling and detailing, lost in the preceding mechanical part of the process. The remainder of the work of casting into bronze was carried out by the foundry in the usual way. Once the casting was complete and the bronze surfaces cleaned up, the parts were assembled over stainless steel armatures.

At the suggestion of Steven Cooke, a time capsule containing Littlewoods and Moores family memorabilia was incorporated into the foundations in Church Street. The concrete foundations were laid by Cooke and his son, Richard, and the granite-clad pedestal was ready for the arrival of the sculpture on the Sunday before the unveiling. On this day, the bronze group, weighing over three quarters of a ton, was lifted over the surrounding hoarding and into position. On the following day the Moores family were given a private view before the sculpture was wrapped up pending the official unveiling. Early on the morning of the unveiling ceremony the wrappings were replaced by a seven metre square blue cloth and the hoarding was removed. At the appointed time and with calculated dramatic effect, the cloth was drawn off from behind so that the subjects appeared to surge forward from it (see colour photograph in the report of the unveiling, *Daily Post*, 20 September 1996). John Moores Jnr and David Moores, the sons of both men, shared the honour of cutting the official ribbon. The former then spoke, expressing the family's delight at the sculpture, though at the same time wondering what his father would have thought of having a statue erected to him:

In his heart he would have loved it, but he

didn't like a fuss. He would have been moved, though, that people wanted to do this. He loved being loved.

John Moores Jnr then formally presented the sculpture to the City and the donation was officially accepted on behalf of the City by the Lord Mayor, Frank Doran. At the request of the Moores family, the unveiling was video-taped (a copy is in Littlewoods archives). The total cost of the sculpture was £60,000' (*Daily Post*, 20 September 1996).

The *Statue of Sir John and Cecil Moores* is unique for Liverpool in the second half of the twentieth century, in so far as it recalls the Victorian tradition of erecting statues to prominent businessmen who had achieved popular celebrity through their civic and philanthropic involvement (for the last example one has to look back to 1913 and Frampton's *Memorial to Sir Alfred Jones* at Pier Head, for which see above, p. 135). The commission was traditional in a number of ways: from the declaration of the committee that a permanent memorial should be raised to the subject(s) in the form of a portrait statue, to the search for a suitable sculptor through a limited competition, to the traditional tripartite method of payment to the sculptor following the completion of each of the three main stages of the work: the maquette, the full-scale model, and the finished bronze, to, finally, the public ceremony of unveiling in which the Lord Mayor accepted the statue on behalf of the city. And yet in two important ways it was untypical: firstly, the decision to make it a double portrait (in Liverpool, one thinks only of Hamo Thornycroft's *Monument to Charles Turner and Charles William Turner* in the Turner Memorial Home, for which see above, p. **) and, above all, the democratic and accessible character of the memorial with its

useful seating, its low pedestal and the informal portrayal of the subjects engaged in congenial conversation.

Literature: (i) various documents etc from the archives of The Littlewoods Organisation Plc.

(ii) *Daily Post (Welsh edn)* (1996) 9 January; *Daily Post (Welsh edn)* (1996) 25 January; *Daily Post (North West edn)* (1996) 20 September; *Echo (Late edn)* (1996) 25 January; *Echo (PM edn)* (1996) 1 August; *Echo (PM edn)* (1996) 19 September (transcripts supplied by *The Liverpool Daily Post and Echo Limited*).

Appendix: Mathew Street

Close to the North John Street end of Mathew Street is 'The Cavern Wall of Fame', incorporating

Statue of John Lennon

Sculptor: David Webster

Statue in fibreglass, painted gold and black.

Life-size

Inscription on adjacent plaque: john lennon / circa 1960

'The Cavern Wall of Fame' and *Statue of John Lennon* were unveiled by Gerry Marsden on Thursday 16 January 1997.

Owner: Cavern City Tours

Status: not listed

Description: The life-size statue of John Lennon is sited in a doorway and represents him with his hair greased and combed back, Rocker-style. He wears a black leather jacket over a roll-neck sweater, denim jeans and boots. He leans against the doorway, hands in pockets, one leg crossed over the other, as he appeared on the cover of his *Rock 'n' Roll* album (1975). Each of the bricks on the wall around the doorway is inscribed with the name of a group or singer that appeared at the Cavern Club.

Condition: good

'The Wall of Fame' was unveiled by Gerry Marsden in January 1997 to celebrate the fortieth anniversary of the opening of the Cavern Club in 1957. Marsden had himself risen to pop stardom following his appearances at the Cavern in the early 1960s with his group Gerry and the Pacemakers. The wall and statue was conceived and funded by Cavern City Tours, supported by the Beneficial Bank.

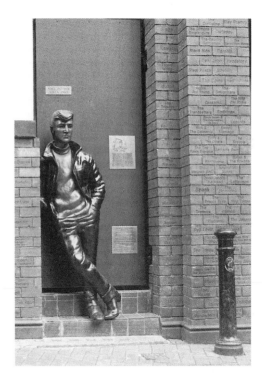

Glossary

abacus: the flat slab on top of the *capital* of a *column*.

acanthus: an architectural ornament, derived from the Mediterranean plant of the same name, found mainly on *capitals*, *friezes* and *mouldings* of the *Corinthian order*.

accretion: an accumulation of extraneous matter on the surface of a *monument* or *sculpture*, e.g. salts, dirt, pollutants, bird excrement etc.

aedicule: a statue *niche* framed by *columns* or *pilasters* and crowned with an *entablature* and *pediment*; also a window or door framed in the same manner.

alabaster: a soft translucent stone which is a form of gypsum, occurring white, yellow, red etc.

allegory: a work of art in which objects and / or figures represent abstract qualities or ideas.

aluminium: a modern, lightweight white metal obtained from bauxite. On exposure to the atmosphere it rapidly develops an inert and protective film of aluminium oxide which protects the surface of the metal from corrosion.

apse: a semi-circular or semi-polygonal termination to a building, usually vaulted; hence **apsidal**.

arcade: a range of *arches* carried on *piers* or *columns*, either *free-standing* or attached to a wall (i.e. 'a blind arcade').

arch: a curved structure, which may be a *monument* itself, e.g. a Triumphal Arch, or an architectural or decorative element within a monumental structure.

architrave: the main beam above a range of *columns*; the lowest member of an *entablature*. Also the *moulding* around a door or window.

archivolt: a continuous *moulding*, or series of mouldings, framing an *arch*.

armature: the skeleton or framework upon which a modelled *sculpture* is built up and which provides an internal support.

artificial stone: a substance, usually cement or reconstituted stones, moulded and then fired rather than carved.

ashlar: masonry cut into squared, smoothed blocks and laid in regular courses.

astragal: a small *classical moulding*, circular in section, often decorated with alternated bead and reel shapes.

atlantes (sing. **atlas**): supports in the form of full- or half-length male figures, sculptured in the round or in *relief*. See also *caryatid*.

attic course / attic storey: the course or storey immediately above the *entablature*, less high than the lower storeys.

attribute: a symbolic object by which an *allegorical* or sacred personage is conventionally identifiable.

baldachin / baldacchino: in monumental architecture, a *canopy* carried on *columns* or *piers*.

baluster: one of a series of short posts carrying a railing or coping, forming a **balustrade**.

barrel vault: a continuous vault of semi-circular section.

basalt: a dark, hard igneous rock, commonly greenish- or brownish-black.

base: the lowest visible course of masonry in a wall; the lowest section of a *column* or *pier*, between the *shaft* and *pedestal*; the lowest integral part of a *sculpture* (sometimes mounted on a pedestal). Loosely, the lowest portion of any structure.

basement: the lowest storey of a building or architectural *monument*, sometimes partly, sometimes wholly below ground level. If wholly above ground level, the basement storey is of less height than the storey above.

bas-relief. See *relief*.

battered: of a wall, inclined inwards.

bay: a vertical division of a building or architectural *monument*, marked by supporting members such as *pilasters*, *buttresses*, *engaged columns*, etc.

black encrustation: a black crust-like deposit forming on stone where there is atmospheric pollution.

bollard: a thick post of stone, wood, or metal, for securing ropes, etc., commonly on a quayside or ship.

brass: an alloy of copper and zinc, yellowish in colour.

bronze: an alloy of copper and, usually, between 1% and 10% tin. Some modern bronzes also contain zinc and lead. Alfred Gilbert experimented with different coloured patinations by substituting silver or gold for tin or zinc.

bronze resin. See **cold-cast bronze**.

bust. See *sculpture*.

buttress: a mass of masonry or brickwork projecting from a wall, or set at an angle against it, to give additional strength.

cable moulding: a *moulding* imitating the twisted strands of a cable.

Caen stone: a pale beige *limestone* from Caen, Normandy.

Calvary. See *cross*.

capital: the head of a *column* or *pillar*.

canopy: a hood or roof-like structure, projecting over a *niche*, or carried on *columns* or *piers* over a *monument* or sculpture etc.

Carrara marble. See *marble*.

cartouche: an ornamental *panel* in the form of a scroll or sheet of paper with curling edges, often oval and usually bearing an inscription or emblem.

caryatid: a sculptured female figure, used in place of a *column* or *pier* as an architectural support. See also *atlantes*.

cast: to reproduce an object by making a negative mould or moulds of it and then pouring material (e.g. liquid plaster, molten metal) into the moulds. A cast is an object made by casting. An 'after-cast' or 'recast' is a subsequent cast taken from moulds, not of the original object, but of the first, or even later, cast (and often not authorised by the artist). A metal after-cast is inevitably slightly smaller than its original since metal shrinks on cooling.

cast iron. See *iron*.

castellated: fortified with battlements. By extension, the term is descriptive of something that is ornamented with a battlement-like pattern, e.g. a castellated crown.

Celtic cross. See *cross*.

cenotaph: a *monument* which commemorates a person or persons whose bodies are elsewhere; a form of First World War memorial popularised by Sir Edwin Lutyens' precedent at Whitehall, London.

ciment fondu: a hard and quick-setting aluminous cement, widely used by sculptors.

cire perdue (Fr. 'lost wax'): metal *casting* technique used by sculptors, in which a thin layer of wax carrying all the fine modelling and details of the *sculpture* is laid over a fire-proof clay core and then invested within a rigidly-fixed, fire-proof, outer casing. The wax is then melted and drained away ('lost') through vents, and replaced with molten metal. The resulting cast is an extremely faithful replication of the wax original.

classical: in its strictest sense, the art and architecture of ancient Greece and Rome, especially that of Greece in the 5th and 4th centuries BC and later Roman work copying it or deriving from it. By extension, any post-antique work that conforms to these models. **Neo-classical** describes work of this sort produced across Europe from the mid-eighteenth to the mid-nineteenth centuries.

Coade stone: an artificial stone of extreme durability and, importantly, resistance to frost, manufactured and marketed by Mrs Eleanor Coade. Her firm, operating from Lambeth, was a highly successful supplier of cast sculpture and architectural ornaments from 1769 to 1833.

cold-cast bronze (bronze resin): a synthetic resin that has been coloured by means of a powdered bronze filler to simulate, and so provide a cheaper substitute for, a work in *cast bronze*.

colonnade: a range of *columns* supporting an *entablature*.

colonnette: a small, usually ornamental, *column*.

column: a free-standing *pillar*, circular in section, consisting of a *shaft* and *capital*, sometimes with a *base*. An **engaged column** is one which appears to be partly embedded in a wall - also called an attached, applied, or half-column.

Composite order. See *order*.

concrete: a composition of stone chippings, sand, gravel, pebbles, etc., mixed with cement as a binding agent. Although concrete has great compressive strength it has little tensile strength and thus, when used for any free-standing *sculpture*, must be reinforced with an *armature* of high tensile steel rods.

console: a decorative bracket with a compound curved outline, resembling a figure 'S' and usually taller than its projection.

contrapposto (It. 'set against', 'opposed'): a way of representing the human body so as to suggest flexibility and a potential for movement. The weight is borne on one leg, while the other is relaxed. Consequently the weight-bearing hip is higher than the relaxed hip. This is balanced by the chest and shoulders which are twisted in the opposite direction.

copper: a naturally occurring red-coloured metal. Characteristically malleable, it is often used for *repoussé* work. As an alloy, it is the main constituent of *brass* and *bronze*.

Corinthian order. See *order*.

cornice: (i) the overhanging *moulding* which crowns a *façade*; (ii) the uppermost division of an *entablature*; (iii) the uppermost division of a *pedestal*. The sloping mouldings of a *pediment* are called **raking cornices**.

cornucopia (pl. **cornucopiae**): the horn of plenty.

corona: the overhanging vertical-faced member of a *cornice*, above the bed-moulding and below the *cymatium*.

corrosion: a process in which metal is gradually eaten away through chemical reaction with acids, salts etc; the process is accelerated when these agents combine with moisture.

crazing: a network of minute cracks on a surface or in a coating.

crocket: in *Gothic* architecture, an upward-pointing ornamental spur sculptured into a vegetal form. Found in series on the angles of spires, pinnacles, gables, canopies etc.

cross: (i) Calvary, Wayside cross. A sculptural representation of the Crucifixion, sometimes with a *canopy*; (ii) Celtic cross. A cross with a tall shaft and a circle centered on the point of intersection of its short arms; (iii) Latin cross. A cross whose shaft is much longer than its three arms.

cupola: a small dome.

cusp: in *Gothic tracery*, a projecting point at the meeting of two *foils*.

cymatium: in a *classical entablature*, the uppermost member of a *cornice*.

dado / die: on a *pedestal*, the middle division above the *plinth* and below the *cornice*.

Darley Dale stone: a range of *sandstones* from Derbyshire. All are even-grained and, owing to their high silica content, are relatively hard. The predominant colour is yellow-brown.

delamination: the splitting away of the surface layers of stone etc.

Diocletian window. See *thermal window*.

Doric order. See *order*.

dormer: vertical-faced structure situated on a sloping roof, sometimes housing a window.

dressed: of masonry, worked to a desired shape, with the exposed face brought to a finish, whether polished, left matt, or moulded.

drum: (i) a cylindrical *pedestal*, supporting a *monument* or *sculpture*; (ii) a vertical wall, circular in plan, supporting a dome; (iii) one of the cylindrical stone blocks making up the *shaft* of a *column*.

Echaillon limestone: a crystalline *limestone* from l'Echaillon quarries, St Quentin, France. It is highly fossiliferous, polishes well, and occurs in white, cream and bright yellow.

echinus: the plain convex *moulding* supporting the *abacus* of a *Doric capital*; term used also for the decorated moulding of similar profile on an *Ionic* capital.

écorché (Fr. 'flayed'): a representation of a human figure or animal, with the skin removed to show the musculature.

effigy. See *sculpture*.

egg and tongue: classical moulding of alternated egg and arrow-head shapes (also called **egg and dart**).

engaged column. See *column*.

entablature: in *classical* architecture, the superstructure carried by the *columns*, divided horizontally into the *architrave*, *frieze* and *cornice*.

equestrian statue. See *sculpture*.

erosion: the gradual wearing away of one material by the action of another or by, e.g., water, ice, wind etc.

façade: the front or face of a building or *monument*.

fasces: originally a bundle of rods tied around an axe, a symbol of a Roman magistrate's authority. In architecture, a decorative motif derived from this.

fascia (pl. **fasciae**): in *classical* architecture, one of the two or three plain, overlapping, horizontal bands on an *architrave* of the Ionic, Corinthian, and Composite *orders*.

festoon: a sculptured ornament representing a garland of flowers, leaves, fruit etc., suspended between two points and tied with ribbons. Also called a **swag**.

fibreglass: a material made of resin embedded with fine strands or fibres of glass woven together to give it added strength. As it does not shrink or stretch, has high impact strength and can withstand high temperatures it has become a popular material for modern *sculpture*.

finial: in architecture, a terminal ornament on a spire, pinnacle etc.

fluting, flutes: concave grooves of semi-circular section, especially those running longitudinally on the *shafts* of *columns*, *pilasters* etc.

foil: in *Gothic tracery*, an arc- or leaf-shaped decorative form which meets its neighbour at its *cusp*.

foliate: sculptured with leaf ornament.

foundation stone: a stone situated near the base of a building or *monument*, bearing an inscription recording the dedicatory ceremony.

founder's mark: a sign or stamp on a sculpture, denoting the firm / individual responsible for its *casting*.

free-standing: of a *monument* or *sculpture*, standing independently.

frieze: the middle horizontal division of a *classical entablature*, above the *architrave* and below the *cornice*, often decorated with *relief* sculpture. The term is also applied to any band of sculptured decoration.

frontage: the front face of a building.

frontispiece: (i) the main *façade* of a building; or (ii) its decorated entrance *bay*.

gargoyle: a spout projecting from the gutter of a building or *monument*, usually representing a *grotesque* animal or human figure.

gazebo: a small summer house, or similar structure, usually in a garden or park.

giant order: an *order* whose *columns* or *pilasters* rise through two or more storeys. Also called a colossal order.

gilding, gilt: to gild is to cover a surface with a thin layer of gold, or with a gold-coloured pigment; gilding is the golden surface itself.

glass-reinforced concrete: cement which has been mixed with chopped, *c.*50mm long strands of glass fibre for enhanced strength.

glass-reinforced polyester: a polyester resin strengthened with glass fibres.

glory: light radiating from a sacred personage.

glyptic: of sculpture, carved rather than modelled (cf. *plastic*).

Gothic: descriptive of medieval art and architecture from the end of Romanesque to the beginning of the Renaissance. In architecture it is the style typified by the pointed *arch*. In Britain, Gothic architecture is divided into three chronological periods: Early English (mid C12 - late C13), characterised by lancet windows without *mullions*; Decorated (late C13 - second half of C14), characterised by a profusion of decoration and *tracery*; and Perpendicular (mid C14 - mid C16), characterised by *panel* motifs, an emphasis on rectilinearity and the use of flattened arches.

Gothic Revival: a revival of the forms of Gothic art and architecture, beginning in the mid-eighteenth and lasting throughout the nineteenth centuries.

graffiti: unauthorised lettering, drawing, or scribbling applied to or scratched or carved into the surface of a *monument* or *sculpture*.

granite: an extremely hard crystalline igneous rock consisting of feldspar, mica and quartz. It has a characteristically speckled appearance and may be left either in its rough state or given a high polish. It occurs in a wide variety of colours including black, red, pink, grey-green.

Greenmore stone: a Coal Measures *sandstone*, from the Greenmore quarry in Yorkshire. Hard and durable, it has been used principally for paving.

Grestela marble. See *marble*.

grotesque: a type of decorative sculpture or painting in which human figures and/or animals are fancifully interwoven with plant forms. Popular in ancient Rome, the rooms that were decorated thus were buried for centuries. When excavated they were known in Italian as *grotte* ('caves') and so the style of their decoration became known as grotesque. By extension, this term is now applied to any fanciful decoration which involves distortion of human or animal form.

guilloche: a running pattern formed by two or more bands which interweave like a plait to form circular openings sometimes filled with circular ornaments.

high relief. See *relief*.

Hollington sandstone: a *sandstone* from Staffordshire, occurring in light grey or pink; it is relatively hard and has an even texture suitable for carving.

hood-mould: a projecting *moulding* placed above a window, doorway, or archway to throw off the rain.

Hopton Wood stone: a *limestone* from Derbyshire, occurring in light cream and grey. In common with other polishable limestones it is sometimes referred to incorrectly as a *marble*.

Huddleston limestone: a magnesian *limestone* from Yorkshire, usually of a creamy-white colour. Soft when first hewn, it hardens on exposure; its fine grain renders it suitable for carving.

in situ: (i) of a *monument* or *sculpture*, still in the place for which it was intended; (ii) of an artist's work, executed on site.

Ionic order. See *order*.

iron: a naturally occurring metal, silver-white in its pure state, but more likely to be mixed with carbon and thus appearing dark grey. Very prone to rust (taking on a characteristic reddish-brown colour), it is usually coated with several layers of paint when used for outdoor *sculptures* and *monuments*. As a sculptural material it may be either (i) **cast** - run into a mould in a molten state and allowed to cool and harden; or (ii) **wrought** - heated, made malleable, and hammered or worked into shape before being welded to other pieces.

Istrian stone: sometimes called 'Istrian *marble*', it is actually a *limestone* from Capo d'Istria, near Trieste.

jamb: one of the vertical sides of a door, window, or archway.

keystone: the wedge-shaped stone at the summit of an *arch*, or a similar element crowning a window or doorway.

kinetic sculpture. See *sculpture*.

landscape format: of panels, etc., rectangular, and wider than they are high (cf. *portrait format*).

lantern: a small circular or polygonal windowed turret, surmounting a dome, *cupola* or *canopy*.

Latin cross. See *cross*.

limestone: a sedimentary rock consisting wholly or chiefly of calcium carbonate formed by fossilised shell fragments and other skeletal remains. Most limestone is left with a matt finish, although certain of the harder types can take a polish after cutting and are commonly referred to as *marble*. Limestone most commonly occurs in white, grey, or tan.

lintel: a horizontal structural member, usually of stone or wood, placed over a doorway or window, to take the weight of the superincumbent masonry.

lunette: semi-circular surface on, or opening in, a wall, framed by an *arch* or vault.

mahogany: a very hard, fine-grained, reddish-brown wood obtained from certain tropical trees and capable of taking a high polish.

Mansfield stone: a sandstone from Nottinghamshire, occurring pale yellow ('white') or pinkish-brown ('red'). It is fine-grained and therefore cuts well, but it is also

relatively soft and prone to weathering.

maquette (Fr. 'model'): in sculpture, a small three-dimensional preliminary sketch, usually roughly finished.

marble: in the strictest sense, *limestone* that has been recrystallized under the influence of heat, pressure, and aqueous solutions; in the broadest sense, any stone (particularly limestone that has not undergone such a metamorphosis) that can take a polish. Although true marble occurs in a variety of colours, white has traditionally been most prized by sculptors, the most famous quarries being at **Carrara** in the Apuan Alps, Tuscany, and on the island of Paros (i.e **Parian** marble) in the Aegean. Also prized is **Pentelic** marble, from Mount Pentelikos on the Greek mainland, characterised by its golden tone (caused by the presence of iron and mica). Other types include: **Grestela** marble, a dark-veined white marble, found in the Carrara quarries; and **Sicilian** marble, a term applied to all marbles from the Apuan Alps that are white with cloudy and irregular bluish-grey veins.

mausoleum: a monumental tomb. The term derives from the Tomb of King Mausolus (one of the Seven Wonders of the Ancient World) at Halicarnassus, *c.*350 BC

meander pattern: a continuous geometric pattern of alternated vertical and horizontal straight lines joined at right angles.

medallion: in architecture, a circular frame (i.e. shaped like a medallion or large medal).

memorial. See *monument*.

metope: In a *Doric frieze*, one of the rectangular surfaces alternating with *triglyphs*, frequently sculptured.

modello (It. 'model'): a small-scale, usually highly-finished, sculptor's (or painter's) model, generally made to show to the intended patron.

monolithic: of a large *sculpture*, *pillar*, *column* etc., made from a single stone.

monument: a structure with architectural and / or sculptural elements, intended to commemorate a person, event, or action. The term is used interchangeably with *memorial*.

mosaic: a design comprised of small, coloured, pieces of glass, *marble*, stone, tile etc., cemented to a surface.

moulding: in architecture, a decorative contour designed to enrich a projecting or recessed member.

mullion: one of the vertical stone or timber members dividing a window into lights.

Neo-classical. See *classical*.

newel-post: the terminal post at the head or foot of a flight of stairs.

niche: a recess in a wall, often semi-circular in plan, usually intended to house a sculpture.

obelisk: a monumental tapering shaft of stone, rectangular or square in section, ending pyramidally.

oculus: a circular opening or window.

ogee: a line with a double curve resembling a letter 'S'; descriptive of a *moulding* with such a shape. An ogee *arch* is one with lower concave and upper convex curves meeting at a point.

open-work: any kind of decorative work which is pierced through from one side to the other.

order: in classical architecture, an arrangement of *columns* and *entablature* conforming to a certain set of rules. The Greek orders are (i) **Doric**, characterised by stout columns without *bases*, simple cushion-shaped *capitals*, and an entablature with a plain *architrave* and a *frieze* divided into *triglyphs* and *metopes*; (ii) **Ionic**, characterised by slender columns on bases, capitals decorated with volutes, and an entablature whose architrave is divided horizontally into *fasciae* and whose frieze is continuous; and (iii) **Corinthian**, characterised by relatively slenderer columns, and a bell-shaped capital decorated with *acanthus* leaves. The Romans added **Tuscan**, similar to the Greek Doric, but with a plain frieze and bases on the columns; **Roman Doric**, in which the columns have bases and occasionally *pedestals*, while the *echinus* may be decorated with an *egg and tongue moulding*; and **Composite**, an enriched form of Corinthian with large *volutes* as well as acanthus leaves in the capital.

oriel window: a bay window corbelled out from the wall of an upper storey.

palazzo: in Italian architecture, an imposing civic building or town house.

palmette: an ornament, somewhat resembling the splayed fingers of a hand, derived from a palm leaf.

panel: a distinct part of a surface, either framed, recessed, or projecting, often bearing a sculptured decoration or an inscription.

pantheon: originally, a temple dedicated to all the gods, specifically the Pantheon in Rome, completed *c.* A.D. 126. By extension, the name came to be used for places where national heroes etc were buried or commemorated (e.g the Panthéon, Paris).

parapet: a wall bordering the edge of a high roof, or bridge etc.

Parian marble. See *marble*.

patina: the surface colouring, and sometimes encrustation, of metal, caused by chemical changes which may be deliberately effected in the foundry or occur naturally through exposure.

pavilion roof: a roof inclined equally on all four sides to form a pyramidal shape.

pedestal: the *base* supporting a *sculpture* or *column*, consisting of a *plinth*, a *dado* (or die) and a *cornice*.

pediment: in *classical* architecture, a low-pitched gable, framed by a cornice (the uppermost member of an *entablature*) and by two *raking cornices*. Originally triangular, pediments may also be segmental. Also, a pediment may be open at the apex (i.e. an open-topped or broken-apex pediment) or open in the middle of the horizontal cornice (an open-bed or broken-bed pediment). The ornamental surface framed by the pediment and sometimes decorated with *sculpture* is called the **tympanum**.

Pentelic marble. See *marble*.

Peperino stone: an igneous stone, specifically a leucite tuff (volcanic ash), from the Marino quarries near Rome. The groundmass is characteristically studded with black particles of scoriae resembling peppercorns (hence the name).

Perpendicular Gothic. See *Gothic*.

personification: a representation of an abstract idea, or moral quality, or actual thing, by an imaginary person.

phosphor bronze: a type of *bronze* with *c.*1% phosphorus added, giving enhanced strength.

pier: in architecture, a free-standing support, of rectangular, square or composite section. It may also be embedded in a wall as a *buttress*.

pillar: a free-standing vertical support which, unlike a *column*, need not be circular in section.

pilaster: a shallow rectangular *pier* projecting less than half its width from a wall.

pilaster strip: a *pilaster* without a *base* or *capital*. Also called a lesene.

Pisanesque: in the style of, or inspired by, the Italian sculptors Nicola (d. 1278/84) and Giovanni (d. after 1314) Pisano.

pits / pitting: small holes and other faults in a metal surface caused either by imperfections in the *casting* process or by *corrosion*.

plaque: a *panel*, usually of metal, fixed to a wall or *pedestal*, bearing sculptured decoration and / or an inscription.

plaster: a range of materials ideal for casting. The type most often used by sculptors is specifically known as **plaster of Paris**, a mixture of dehydrated gypsum and water. It is mixed together as a liquid and may be poured into negative moulds (which themselves may be made of plaster) to make positive casts of a fragile clay model, or as a studio record of a finished work. Plaster of Paris sets in a compact mass of even consistency and, most importantly, can reproduce fine details from the mould, since it expands slightly in setting. When a sculptor's model is referred to as a plaster, or as a plaster cast, it is usually understood that it is specifically plaster of Paris that is referred to.

plastic: (i) any synthetic substance that can be modelled and will then harden into some permanent form; (ii) a term descriptive of *sculpture* that is modelled rather than carved (cf. *glyptic*).

plinth: (i) the lowest horizontal division of a *pedestal*; (ii) a low plain *base* (also called a *socle*); (iii) the projecting base of a wall.

podium: a raised platform.

pointing machine: a sculptor's device for the exact replication of a statue or full-sized model, or the enlargement of a small-scale model to a full-size *sculpture*. It consists of an upright frame with moveable arms equipped with adjustable measuring rods to enable the sculptor to precisely mark and replicate at the same or other scale, any number of points on the form to be copied.

polychromy: the practice of finishing a *sculp-*ture, etc., in several colours.

polyester resin: a commercially-produced synthetic material capable of being moulded. Its chief virtues are its tensile strength (which can be enhanced through the addition of glass fibres, i.e. *glass-reinforced polyester*) and its versatility: it can either be allowed to retain its natural transparency through the addition of transparent dyes, or it can be made opaque through the addition of powder fillers (e.g., *cold cast bronze*) or opaque pigments.

portico: a porch consisting of a roof supported by *columns*.

Portland stone: a *limestone* from Dorset, characterised by its bleached white appearance when exposed to the elements.

portrait format: of panels, etc., rectangular, and higher than they are wide (cf. *landscape format*).

putto (pl. **putti**): a representation of an idealised nude male child.

pylon: strictly, the monumental gateway to an ancient Egyptian temple, consisting of a pair of rectangular, tapered towers connected by a lower architectural member containing the gate; more loosely, a tapering tower resembling one of the towers from such a gateway.

pyramid: a square-based structure with four inward sloping triangular sides meeting at an apex.

quadriga: a chariot drawn by four horses abreast, sometimes represented as a sculptured group surmounting a Triumphal Arch.

rail: a horizontal member in the framework of a door.

raking cornice. See *cornice*.

relief: a sculptural composition with some or all areas projecting from a flat surface. There are several different types, graded according to the degree of their projection. The most

common are (i) **bas-relief**, or low relief, in which the figures project up to less than half their notional depth from the surface; and (ii) **high relief**, in which the main parts of the design are almost detached from the surface. Many reliefs combine these two extremes in one design.

repoussé (Fr. 'pushed back'): *relief* design on metal, produced by hammering from the back.

reredos: strictly, a decorated screen or wall rising behind and above an altar; more loosely, an altarpiece.

Rococo: the elegantly decorative style which predominated in France in the eighteenth century during the reign of Louis XV, characterised by asymmetry; shell, rock, and plant motifs; and the use of S-curves and C-scrolls. The term is used to describe any later work which embodies those characteristics.

Roman Doric. See *order*.

rosette: a rose-shaped decorative motif.

rostral column (*columna rostrata*): originally in ancient Rome, a free-standing *column* erected to celebrate a naval victory, decorated with representations of the prows (*rostra*) of ships.

rostrum: a platform.

rotunda: a circular building, usually domed.

roundel: a circular decorative *panel*. See also *tondo*.

Runcorn stone: a type of fine-grained *sandstone* obtained from quarries at Runcorn, Cheshire.

rustication: stonework cut in massive blocks, separated from each other by deep joints. The surfaces are often left rough to suggest strength or impregnability. A rusticated *column* has a *shaft* comprising alternated rough (or textured) and smooth *drums*.

St Helens stone: it has not been possible to find any other reference to this stone, although given the location of St Helens in South Lancashire, it is likely to be a *sandstone*.

sandstone: a sedimentary rock composed principally of particles of quartz, sometimes with small quantities of mica and feldspar, bound together in a cementing bed of silica, calcite, dolomite, oxide of iron, or clay. The nature of the bed determines the hardness of the stone, silica being the hardest.

scroll: a spiral architectural ornament, either one of a series, or acting as a terminal, as in the *volute* of an *Ionic capital*.

sculpture: three-dimensional work of art which may be either representational or abstract, relief or free-standing. Among the many different types are: (i) **bust** - strictly, a representation of the head and shoulders (i.e. not merely the head alone); (ii) **effigy** - representation of a person, the term usually implying that of one who is shown deceased; (iii) **equestrian** - representation of a horse and rider; (iv) **kinetic** - a sculpture which incorporates actual movement, whether mechanical or random; (v) **relief** - see separate entry; (vi) **statue** - representation of a person in the round, usually life-size or larger; (vii) **statuette** - a small-scale statue, very much less than life-size; (viii) **torso** - representation of the human trunk without head or limbs.

shaft: the trunk of a *column*, between the *base* and the *capital*.

Sicilian marble. See *marble*.

silicon bronze: alloy of *copper* and c.1-3% silicon and often a small amount of manganese, tin, *iron*, or zinc. Originally developed for the chemical industry because of its exceptional resistance to *corrosion*. Its other chief characteristics are strength, hardness, and ease of welding.

slate: a metamorphic rock of sedimentary origin, its chief characteristic is the ease with which it can be split into thin plates.

socle: a low undecorated *base* or *plinth*.

spalling: in stone or brick, the splitting away in slivers or fragments parallel to the surface.

spandrel: the surface, roughly triangular in shape, formed by the outer curves of two adjoining *arches* and a horizontal line connecting their crowns. Also the surface, half this area, between an arch and a corner.

Stancliffe stone: a siliceous *sandstone* from *Darley Dale*, Derbyshire, chiefly prized for its hardness.

statue, statuette. See *sculpture*.

steel: an alloy of *iron* and carbon, the chief advantages over iron being greater hardness and elasticity.

stele, stela (pl. **stelae**): an upright slab of stone, originally used as a grave marker in ancient Greece. It may bear sculptured designs or inscriptions or carry *panels* or *tablets*.

stop: projecting stones, sometimes sculptured, at the ends of a *hood-mould*, acting as terminals.

string course: a continuous horizontal band projecting from or recessed into a *façade*.

swag. See *festoon*.

tabernacle: a *canopied niche* in a wall or *pillar*, usually containing a *statue*.

tablet: a small slab of stone or metal usually bearing a sculptured design or an inscription.

tempietto: a small temple-like structure, especially one of an ornamental character, set in a garden.

term: a sculptured human figure, either just the head, or the head and shoulders, or the figure all the way down to the waist, rising from a pillar. Also known as a **terminal figure**.

terracotta (It. 'baked earth'): clay that has been fired at a very high temperature and which is

usually unglazed. It is notable for its hardness and was much used for architectural ornament in the second half of the 19th century.

terrossa ferrata: a type of plaster, strengthened with iron oxide .

Thermal window: a window divided into three lights, the central being round-headed, the side straight-headed. Also known as a Diocletian, Palladian, or Venetian window.

tondo (pl. **tondi**): a circular *panel*. Also known as a *roundel* or *medallion*.

torso. See *sculpture*.

torus: a bold convex *moulding*, semi-circular in section, especially on the *base* of a *column*.

tracery: ornamental intersecting ribwork, characteristic of *Gothic* architecture, notably in the upper parts of windows, *panels*, and blind *arches* etc.

triglyph: on a *Doric frieze*, one of the vertically-grooved blocks alternating with the *metopes*.

trophy: representation of a group of arms and/or armour commonly found on military *monuments* and war *memorials*.

Tuscan order. See *order*.

tympanum. See *pediment*.

urn: vessel of an ovaloid form with a circular base, often used in antiquity to hold the ashes of the dead. Ornamental urns are sometimes used in *monuments*.

verdigris: a green deposit which forms naturally on the surface of copper, *bronze*, and *brass*.

volute: one of the spiral *scrolls* on *Ionic* and *Composite capitals*.

wayside cross. See *cross*.

Westmorland greenstone: a grey-green *slate*.

Westmorland marble: not a true *marble*, but so-called because of its polishability; actually a type of *limestone*.

white encrustation: a white crust-like deposit forming on stone where there is atmospheric pollution.

wrought iron. See *iron*.

Yorkshire Silex stone: a compact Coal Measures *sandstone*, yellow-buff in colour, quarried near Halifax. Hard and durable, it has been frequently used for sills, doorsteps, and paving. Also called Silex York stone.

Biographies of Sculptors and Architects

Jane Ackroyd (b. 1957)
Born in London, she studied at St Martin's School of Art, 1974–79, and the Royal College of Art, 1980–83. In 1983 she won the Melchett Award in Steel and the Fulham Pottery Award. She has work in the collections of the Arts Council of Great Britain and Leicestershire Education Authority.
(source: *Festival Sculpture*, 1984)

George Gamon Adams (1820–1898)
He enrolled at the RA Schools in 1840 as sculptor and medallist, winning a silver medal in the same year. In 1846–47 he studied under John Gibson in Rome. In the year of his return to England he won the RA Gold Medal for his group, *The Murder of the Innocents*, which he also showed at the Great Exhibition of 1851. In 1852 Adams was chosen to take a death mask of the Duke of Wellington, the marble bust he executed from it being regarded by the Duke's heirs as highly successful. His 1856 *Statue of General Napier* for Trafalgar Square, however, was scathingly criticised by the *Art Journal* of 1862 as 'perhaps the worst piece of sculpture in England'. From 1841 to 1885 he exhibited 119 sculptures at the RA and 4 at the British Institution. He was elected Fellow of the Society of Arts in 1869.
(sources: Gunnis, 1951; *MEB*)

John Adams-Acton (1830–1910)
Born at Acton Hill, Middlesex, he added Acton to his surname to avoid confusion with other artists called John Adams. He trained under Timothy Butler then Matthew Noble before attending the RA Schools, 1853–58, where he won first medals in the antique and life-classes and, in 1855, a gold medal for an original sculpture group, *Eve Supplicating Forgiveness at the Feet of Adam*. In 1858 he gained the RA's travelling studentship and went to Rome, staying until 1865. His ability as a portraitist was admired by John Gibson, who sent many visitors (including Gladstone) to his studio. From 1865, he was resident in London. Important

works include the *Monument to Bishop Waldegrave* (c.1869, Carlisle Cathedral), the *Cruikshank Memorial* (c.1871, St Paul's Cathedral), the *Wesley Memorial* (1875, Westminster Abbey), and the *Memorial of Cardinal Manning* (1908, Westminster Cathedral). He also executed a colossal *Statue of Sir Titus Salt* for Bradford (1874); statues of *Queen Victoria* for Kingston, Jamaica, and the Bahamas; a *W. E. Gladstone* for Blackburn (as well as Liverpool) and also produced ideal works. He exhibited regularly at the RA until 1892.
(source: *DNB*)

Charles John Allen (1862–1956)
Born at Greenford, Middlesex, from 1879–89 he was at first apprenticed, and then employed, as a carver in stone and wood to Farmer & Brindley of Lambeth. He studied at the South London Technical Art School under W.S. Frith, 1882–87, and subsequently at the RA Schools, where he won four silver medals. From 1890–94 he was chief modelling assistant to Hamo Thornycroft – the influence of whose *Mower* can be seen in Allen's *Agriculture* group from the *Victoria Monument* in Derby Square. He exhibited both at the RA and abroad. From 1894 he was a member of the Art Workers Guild. In 1900, at the Paris International Exhibition, he received a gold medal for his bronze group *Love and the Mermaid* (WAG) and his plaster group *Rescued*, the latter of which was subsequently commissioned in bronze by Queen Alexandra. Allen lived for many years in Liverpool. From 1894 he was instructor in sculpture at the School of Architecture and Applied Art and, from 1905, was Vice-Principal at the School of Art, Mount Street. He was also associated with the Della Robbia Pottery at Birkenhead. He retired from

his appointments in 1927.
(sources: Beattie, 1983; Johnson & Greutzner, 1976; *Magazine of Art*, 1901; WAG archives; Waters, 1975).

Graham Ashton (b. 1948)
Mixed media artist, born at Birkenhead. He studied at Manchester College of Art, 1966–67; Coventry College of Art, 1967–70; University of Calgary, 1970–71, and held his first solo exhibition in 1977. He was artist-in-residence at the Walker Art Gallery and Bridewell Studios, Liverpool, 1983–84.
(sources: *Festival Sculpture*, 1984; Spalding, 1990)

Kevin Atherton (b. 1950)
Born in the Isle of Man, he studied at Douglas School of Art, 1968–69, and Leeds Polytechnic (Fine Art), 1969–72. During the 1970s he taught part-time at Middlesex Polytechnic, and Chelsea, Maidstone, and Winchester Schools of Art. His commissions include *A Body of Work* (1983, Langdon Park School, Tower Hamlets).
(sources: *Festival Sculpture*, 1984; Spalding, 1990; Strachan, 1984)

Alain Ayers (b. 1952)
Born at Dartford, Kent, he studied at Hereford College of Art, 1975–76, Exeter College of Art, 1976–79, and Birmingham Polytechnic, 1981–82. He was awarded the South West Arts Bursary in 1980, the Greater London Arts Bursary in 1981, the Junior Sculpture Fellowship at South Glamorgan Institute of Higher Education, Cardiff, in 1982–83, and the Welsh Arts Council Young Artist's Grant in 1983. He has shown in group exhibitions since 1980.
(source: *Festival Sculpture*, 1984)

Arthur Ballard (1915–94)
Liverpool artist and teacher. He entered

Liverpool College of Art as a junior in 1930 and returned after the war as a member of staff, 1947–80, rising to the post of Head of Foundation Studies. During the 1950s, he painted mainly landscapes, exhibiting regularly at the Roland, Browse and Delbanco Gallery in London. A six-month stay in Paris in the winter of 1957/58 encouraged him to turn to abstract painting, under the influence of the post-war School of Paris painters, particularly Nicolas de Stael. His new manner did not find favour with his former dealers and he ceased to exhibit in London. In the 1960s he moved from abstraction to a type of figuration influenced by Pop Art, his most notable work from this period being the painting, *Punch and His Judy* (1973), based on Manet's *Olympia*. He is perhaps best known as the teacher who encouraged Stu Sutcliffe and prevented John Lennon's expulsion from art college. He was also President of the Liverpool Academy.
(sources: *Guardian* [obit.], 29 November 1994; *Independent* [obit.], 2 December 1994)

Henry Bloomfield Bare (d. 1911)
A Liverpool decorative artist, associated with the Arts and Crafts Movement. He exhibited at the WAG between 1884 and 1911, with one appearance at the RA in 1888 (cat. 1723: *Decoration of a Drawing Room*) in which same year he was elected a fellow of the RIBA. He was also the Liverpool correspondent and writer of occasional articles for *The Studio*.
(sources: *Studio*, 1911 [obit.]; Johnson & Greutzner, 1976).

Robert Anning Bell (1863–1933)
Painter, decorative artist, and illustrator, designing mosaics, stained glass, fabrics (for Morris & Co.), and wallpapers (for Essex & Co.). Born in London, he was first articled to

an architect, later studying at the RA and in Paris. For a time he shared a London studio with George Frampton with whom he collaborated. He was Professor of Art in the Department of Applied Art, University College, Liverpool, 1894–98; Professor of Decorative Art at Glasgow School of Art from 1911; and Professor of Design at the Royal College of Art, London, 1918–24. He was a Member of the Arts and Crafts Exhibition Society, and the Royal Watercolour Society. He was also a member of the Art Worker's Guild, becoming a Master in 1921. He was elected ARA in 1914 and RA in 1922. Important commissions include the tympanum mosaics in the main porch of Westminster Cathedral (1902, to a design by J.A. Marshall); the main front mosaics on the Horniman Museum, South London, 1902; the north front mosaics on Birmingham University and also the *St Andrew* and *St Patrick* mosaics in the central lobby of the House of Lords (1923–24).
(source: Gray, 1985)

Philip Bews (b. 1951)
After taking a degree course in Landscape Architecture at Manchester Polytechnic, 1970-74, he was employed by Runcorn New Town Development Corporation as an associate landscape architect, 1974–82. From 1982–86 he was at Liverpool Polytechnic, where he was awarded first class BA (Hons) in Fine Art. In 1986–87 he was awarded a Sir John Moores Scholarship in Fine Art and, in the same years, was sculptor-in-residence at Birchwood Community and High School, Warrington. In 1988–89 he was part-time tutor in sculpture and three-dimensional studies at Wirral Metropolitan College. He has shown in various group exhibitions and his major commissions include *Covetina* (1988, Norton Priory

Museum, Runcorn); *Survivor* (1989, Wirral Country Park, Thurstaston); *Deal Porters* (1990, Surrey Quays, London Docklands); *Pigs and Donkey* (1992, Barnards Wharf, London Docklands); *Brian Bevan Memorial* (1993, Warrington); and *Stone Carving* (1994, Grosvenor Park Garden for the Blind, Chester). His most important public work in Liverpool has been executed in collaboration with Diane Gorvin.
(source: Bews)

Charles Bell Birch (1832–93)
Born at Brixton, London. From 1844–46 he was a pupil at the School of Design, Somerset, but moved in 1846 to Berlin with his father, studying at the Academy of Arts and in the studios of Ludwig Wilhelm Wichmann and Christian Rauch. Whilst still in Berlin he executed a plaster bust of the English ambassador, subsequently carried out in marble for the King of Prussia. On his return to England in 1852 he entered the RA Schools, gaining two medals. He then worked for ten years as pupil and then principal assistant in the studio of J.H. Foley, and on his master's death in 1874 succeeded to his Regent's Park studio. In 1864 Birch won a premium of £600 from the Art-Union for his life-size figure, *A Wood Nymph*. From this time he was a frequent exhibitor at the RA, where his dramatically-composed, naturalistically-conceived military groups were much admired. These and his many commissions for portrait statues led to his election as ARA in 1880.
(*DNB*, 1901; *Magazine of Art*, 1894)

Charles Frederick Blythin (d. 1953)
FRIBA. He was senior partner in the firm of Riches and Blythin, of Croydon. One of his latest buildings was John Newnham School,

Selsdon Park Road, Croydon, 1951–53, with L.C. Holbrook.
(sources: *Builder* [obit.], 17 July 1953; Cherry & Pevsner, 1983)

Stephen Broadbent (b. 1961)
Born in Wroughton, he trained with Arthur Dooley in Liverpool, 1979–83, and, at the time of writing, works mainly from the Bridewell Studios, Liverpool. His first one-man show was at the Aberbach Gallery, London, 1982. His public commissions include *The Trades and Professions of Edinburgh* (bronze relief panels, 1991, Saltire Court, Edinburgh); *A Celebration of Chester* (1992, Chester Town Hall square); and *Challenge* (bronze sculpture, 1993, outside Capital House, Chester).
(source: *Sculpture in the Making: A Celebration of Chester*, 1992)

Sir Thomas Brock (1847–1922)
Born at Worcester where he attended the Government School of Design, in 1866 he moved to London and became a pupil of J.H. Foley, leaving the following year to go to the RA Schools. In 1869 he gained the RA gold medal in sculpture for his group, *Hercules Strangling Antaeus*. When Foley died in 1874, Brock undertook to complete many of his unfinished commissions, including the *William Rathbone* for Sefton Park, thereby succeeding to much of his practice. Among Brock's numerous commissions for London, the most prestigious was the *Memorial to Queen Victoria* (with Aston Webb) in front of Buckingham Palace, earning him his knighthood at its unveiling in 1911. Brock was elected ARA in 1883 and RA in 1891. He was first president of the Royal Society of British Sculptors at its founding in 1905 and membre d'honneur of the Société des Artistes Français. He was made

honorary ARIBA in 1908, honorary DCL at Oxford University in 1909, and honorary RSA in 1916.
(sources: Beattie, 1983; *DNB 1922–1930*)

The Bromsgrove Guild
Formed in the 1890s by Walter Gilbert, its roots were in the Arts and Crafts Movement of late Victorian England. Guild members produced a whole range of craft objects in metal, wood, stained glass, embroidery, plaster etc. George Cowper joined the Guild from Coalbrookdale in 1907, bringing metalwork and casting skills with him. The Guild's most prestigious commission at this time was the gates of Buckingham Palace. On Merseyside, Bromsgrove Guild work can be seen in the church of the Holy Trinity, Southport (wood-work, metalwork and glass), and the Anglican Cathedral (chancel gates, reredos and sanctuary rails). The Guild lasted until the 1960s.
(source: Crawford, 1977)

Albert Bruce Joy (or **Bruce-Joy**) (1842–1924)
Born in Dublin, he studied at the South Kensington and RA Schools, and in Paris and Rome. He trained also under J.H. Foley. He was elected ARHA (Associate of the Royal Hibernian Academy) in 1890 and RHA in 1893. He exhibited at the Royal Academy, London, from 1866. His ability to record his sitter's like-ness with remarkable accuracy made him a highly sought after portraitist. His public sculp-tures include statues of *John Laird* (1877) for Hamilton Square, Birkenhead; *W. E. Gladstone* (1882) for Bow Churchyard, London; and *John Bright* (1891) and *Oliver Heywood* (1894) both for Albert Square, Manchester.
(sources: Gleichen, 1928; Johnson & Greutzner, 1976; Spielmann, 1901; Waters, 1975)

Lionel Bailey Budden (1887–1956)
Liverpool architect, most importantly of the *Birkenhead War Memorial*, 1923–25, and the *Liverpool Cenotaph*, 1926–30, St George's Plateau, both with the sculptor, Tyson Smith. He graduated from the School of Architecture, University of Liverpool, in 1909, with first class honours, winning also the University travelling scholarship and the Holt travelling scholarship with which he funded a year in Athens. He taught at the School of Architecture from 1911 and was successor to C.H. Reilly as Roscoe Professor of Architecture from 1933, until his retirement in 1952. He exhibited four times at the WAG between 1924 and 1930 and once at the RA, 1924, with his design for the *Birkenhead War Memorial*.
(source: *RIBA Journal*, September 1956).

George Bullock (d. 1818)
Liverpool sculptor. He exhibited at the RA and the Liverpool Academy, 1804–16, and was President of the latter, 1810–11. He also produced work under the company name 'Mona Marbles', after the quarry he had discov-ered on the Isle of Anglesey, which yielded greenish-blue and purple marbles. The company was sufficiently successful for him to move to London in 1813, where he set himself up as a director of the Mona Marble Works. Mona marbles were used in his monuments to the *Revd Glover Moore* (St Cuthbert's, Halsall, Lancs) and to *Anna Maria Bold* (St Luke's, Farnworth, Lancs).
(source: Gunnis, 1951).

A. B. Burton (see Thames Ditton Foundry)

Frederick Bushe (b. 1931)
Sculptor, born in Scotland. He studied at Glasgow School of Art, 1949–53. In 1966–67 he

attended the University of Birmingham School of Art, where he gained an Advanced Diploma in Art Education. In 1970 he won an Arts Council award. His public sculptures include *2 + 1 Standing Forms* (1975, King's College, Aberdeen University) and *Horizontal Landscape* (1981, Landmark Visitors Centre, Carrbridge, Scotland).
(source: Strachan, 1984)

George T. Capstick (d. c.1967)
A Liverpool architectural sculptor, he worked mainly in partnership with E.C. Thompson in the firm Thompson & Capstick, which closed down in 1939. Capstick exhibited only once at the WAG, in 1911. He was married to Edward Carter Preston's sister, Winifred.

William Douglas Caröe (1857–1938)
Born at Blundellsands, he was the son of the Danish Consul in Liverpool. He was articled to the Liverpool architect Edmund Kirby, 1879, then worked in the London office of J.L. Pearson, 1881–85. In 1885 he was appointed as an architect to the Ecclesiastical Commissioners, becoming Senior Architect in 1895. He ran a very successful practice, winning both ecclesiastical and secular commissions. He was a brother-upholder of the Art Workers' Guild and also wrote a history of Sefton. For Liverpool he also built the Swedish Seaman's Church (Gustaf Adolfs Kyrka), Park Lane (1883–84).
(source: Gray, 1985)

George Carter (b. 1948)
Born in London, he studied at the University of Newcastle upon Tyne, 1966–72. In 1972–74 he worked as a museum assistant in the Geffrye Museum, London, and, in 1974–79 did free-lance exhibition design, graphics and sculpture.

His solo exhibitions include *An Order of Field Architecture* (a portable roof garden on the roof of the Hatton Gallery, University of Newcastle upon Tyne), and *Folly at Marble Hill*, Marble Hill House, Twickenham, 1978.
(source: *Festival Sculpture*, 1984)

John Cartwright
Sculptor employed by Norbury, Paterson & Co. Ltd, Liverpool. In addition to the figure of *St Luke* on the Liverpool Eye and Ear Infirmary, Myrtle Street, his work for them included the model for the frieze on the frontage of the Sessions House, William Brown Street (WAG Spring Exhibition 1893, cat. 923).

Sir Francis Legatt Chantrey (1781–1841)
Born in Derbyshire, his father was a carpenter. In Sheffield he served five years of a seven year apprenticeship to a woodcarver, before breaking his indentures and turning briefly to portrait painting. In 1802 he moved to London where he studied intermittently at the RA Schools, whilst again working for a woodcarver. By 1809 he had married his wealthy cousin and achieved sufficient financial security to be able to move to Pimlico and have his own studio built. From 1804 he exhibited chiefly portrait busts at the RA with great success. As a consequence, both the number of his commissions and the prices he could charge for them increased. Many of the most distinguished men of his time sat for him. He also executed many important full-length portrait statues, as well as bronze equestrian statues of the *Duke of Wellington* and *George IV* for London, building his own foundry so that the bronze could be cast to his own exacting standards. His first trip abroad was not until 1814, by which time his personal style was already formed. He was elected ARA in 1815, RA in 1818, and was knighted in 1835 by William IV. He was also an honorary DCL of Oxford University and an honorary MA of Cambridge.
(Sources: *DNB*; Gunnis, 1951; Whinney, 1988)

Siegfried Joseph Charoux (1896–1967)
Sculptor born in Vienna, of French descent. He studied at Vienna School of Fine Arts, 1919–24, and the Vienna Academy, 1924–28. He worked as a political cartoonist until 1933. His public commissions in Vienna include the *Robert Blum Memorial*, 1928, the *Matteotti Memorial*, 1930, and, in the Judenplatz, the *Memorial to Gotthold Ephraim Lessing*, 1933–35, destroyed by the Nazis in 1938 and re-created by Charoux in 1968. Charoux moved to England in 1935 (naturalised in 1946). In 1938 he carved the stone figures for the new School of Anatomy and the Engineering Laboratory at Cambridge. His most famous public commissions in Britain include the *Memorial to Amy Johnson* for her native Hull, *The Cellist*, 1958, for outside the Festival Hall, London, and *The Motorcyclist*, 1962, for the Shell Building, London. In 1948 he received the city of Vienna's highest award for sculpture and in 1958 was made an honorary professor of the Republic of Austria. In 1949 he was elected ARA and in 1956 RA. He was also a FRBS.
(sources: *DNB*; Spalding, 1990; Strachan, 1984)

Léon-Joseph Chavalliaud (1858–1921)
Born at Rheims, he studied under Jouffroy and Roubeaud II. He obtained honourable mentions in 1885 and 1886 and was elected as a member of the Société des Artistes Français in 1890. In 1891 he was awarded a third class medal. Shortly thereafter he moved to England, showing at the RA from 1893 onwards. His RA exhibits included portrait busts and statues, in both bronze and marble. Some of his sculptural work was executed for Farmer & Brindley. In Dublin (NG) is his bronze *Bust of Revd James Healy*, presented by Henry Yates Thompson. His public commissions in Britain include *Cardinal Newman* (1896, for Brompton Oratory) and *Sarah Siddons* (1897, for Paddington Green).
(sources: Bénézit, 1976; Gleichen, 1928; Gray, 1985; National Gallery of Ireland, 1975)

Geoffrey Clarke (b. 1924)
Born in Derbyshire, he trained at Preston and Manchester Schools of Art and then served in the RAF, 1943–47. He studied at the Royal College of Art, 1948–52, and taught there in the Light Transmission and Projection Department, 1968–73. He won the silver medal at the Milan Triennale and appeared at the Venice Biennale in 1952 and 1960. His first one-man exhibition was at the Taranman Gallery in 1976. His commissions include *The Spirit of Electricity* for Thorn House in London (1958), the ceremonial entrance portals for the civic centre at Newcastle upon Tyne (1969) and *Cast Aluminium Relief* for the Nottingham Playhouse. He was elected ARA in 1970 and RA in 1976.
(sources: Nairne & Serota, 1981; Strachan, 1984; Tate Gallery Liverpool, 1988)

John Clinch (b. 1934)
Born at Folkestone, Kent, he studied Fine Art at Kingston School of Art, 1951–55, and sculpture at the Royal College of Art, 1957–61. In 1962 he was awarded the Sir Robert Sainsbury Scholarship. In 1979 he won the Arts Council Major Award and, in 1989, the Welsh Arts Council Travel Award. He has shown in group exhibitions since 1960 and had his first one-man exhibition in London in 1982. He is an ARBS and an ARCA.

(sources: *Chelsea Harbour Sculpture 93*; *Festival Sculpture*, 1984; Spalding, 1990)

Charles Robert Cockerell (1788 – 1863)
Neoclassical architect. The son and pupil of S.P. Cockerell, he became assistant to Sir Robert Smirke in 1809. In 1810–17 he travelled in Greece (working on the discoveries at Aegina and Phigaleia), Asia Minor, and Italy. He wrote extensively and knowledgeably on archaeology, architecture and sculpture (including *Iconography of the West Front of Wells Cathedral*, 1851) and illustrated the 1830 edition of Stuart and Revett's *Antiquities of Athens and Other Places of Greece, Sicily, etc.* In 1833 he became architect to the Bank of England, designing its branches in Liverpool and Manchester. He took over as architect to St George's Hall, following Elmes' death in 1847 and built the Liverpool and London and Globe Insurance Offices, Dale Street, 1855–57. Among his principal buildings outside Liverpool are the Cambridge University Law Library (1842) and the Taylorian-Ashmolean Museum, Oxford (1845). He was Professor of Architecture at the RA, the first recipient of the RIBA Gold Medal in 1848, and RIBA President in 1860.
(sources: Fleming, Honour and Pevsner, 1991; Watkin, 1974)

George Cowper
(see The Bromsgrove Guild)

Stephen Cox (b. 1946)
Born in Bristol, he studied at Bristol, Loughborough and Central schools of art, 1964–68. His first one-man exhibition in London was in 1976 (Lisson Gallery), since when he has exhibited widely in Britain, Italy and elsewhere. In 1986 he had a one-man exhibition at the Tate Gallery, London. Since 1979 he has spent increasing amounts of time in Italy, pursuing his interest in the Italian tradition of marble and stone carving.
(sources: Tate Gallery 1986; Tate Gallery Liverpool 1988)

Cox & Sons (see Thames Ditton Foundry)

Tony Cragg (b. 1949)
Born in Liverpool, Cragg moved with his parents to the South of England, where he studied at Gloucester, Wimbledon, and the Royal College of Art, 1969–77. In 1977 he moved to Germany, returning to Liverpool in 1986 to make *Raleigh*. He usually works with discarded found objects and various ephemeral materials. Since 1970, he has had solo exhibitions in Hamburg, Berlin, London, Paris, Milan, Tokyo, New York etc.
(source: Tate Gallery Liverpool, 1986)

Mitzi Solomon Cunliffe (b.1918)
Born in New York City, she graduated in Science and Arts at Columbia University, 1939–40. In the late 1960s she had a number of one-woman exhibitions in Britain. From 1971–76 she lived in London. Commissions in Britain (outside Liverpool) include a mural for Heaton Park Reservoir Valve House, Manchester. The BAFTA award is based on her design for the Guild of Television Producers and Directors, first presented in 1955.
(sources: Strachan, 1984; various)

Hubert Cyril Dalwood (1924–76)
Born in Bristol, he was an apprentice engineer to the British Aeroplane Company, 1940–44, and served in the Royal Navy, 1944–46. He studied at Bath Academy, 1946–49, under Kenneth Armitage and William Scott. In 1955–59 he was awarded the Gregory Fellowship in Sculpture at Leeds University. Between 1956 and '64 he taught at Leeds, Hornsey, and Maidstone colleges of art and was Head of the Sculpture Department at Hornsey, 1966–73, and Central School of Art, 1974–76. In 1959 he won the Liverpool John Moores Exhibition and in 1962 was awarded the David E. Bright Prize for younger sculptors at the Venice Biennale. In 1976 he was elected ARA. He was commissioned to make sculpture by various universities (in addition to Liverpool), including Leeds (1961), Nuffield College, Oxford (1962), Manchester (early 1960s), and Nottingham (1974). Other public sculpture outside Liverpool includes *Untitled* (1974, Haymarket, Leicester). A retrospective memorial exhibition was devoted to him at the Hayward Gallery, 1979.
(sources: Nairne & Serota, 1981; Spalding, 1990; Strachan, 1984; Tate Gallery Liverpool, 1988).

Arthur Joseph Davis (1878–1951)
Architect, born in London, educated firstly in Brussels and then in Paris at the École des Beaux-Arts and in the ateliers of J. Godefroy and J.-L. Pascal. In 1900 he entered into junior partnership with Charles Mewés. Working in a French classical style, the two moved to England, the most notable fruits of their partnership being the Ritz Hotel, Piccadilly, London (1906–09), Inveresk House, Aldwych, WC2 (1907), and the RAC Club, Pall Mall, SW1 (1908–11). Mewés died in 1914 and Davis, after serving in the First World War, went into partnership with C.H. Gage. In addition to his consultancy work with Willink and Thicknesse on the Cunard Building (1913–18) and his design of the war memorial outside, Davis was responsible for the decorations of the *Aquitania*, *Laconia* and *Franconia*, as well as some of the rooms on the *Queen Mary*, all for

Cunard White Star. Throughout the '20s and '30s he designed a number of acclaimed buildings, including what is now the National Westminster Bank building in Threadneedle Street, London (1922–31), a design which earned him the London Street Architecture Medal in 1930. He also designed the Armenian Church of S. Sarkis at Iverna Gardens, W8 (1928) and Cunard House, Leadenhall Street, EC3 (1930). Davis was a member of the Royal Fine Art Commission, and was elected ARA in 1933 and RA in 1942. Also, he was Chevalier de la Légion d'Honneur (France) and was decorated with the Ordre de la Couronne avec Palmes (Belgium).
(sources: *Builder* [obit.], 27 May 1951; Gray, 1985; *RIBA Journal* [obit.], November 1951).

Edward Davis (1813–78)
Born in Camarthen, he trained in the studio of E.H. Baily and attended the RA Schools in 1833, exhibiting at the RA, 1834–77. He specialised in portrait statues and busts, including a *Statue of the Duke of Rutland* for the Corn Exchange, Leicester (1851), and a *Bust of William Rathbone* for St George's Hall, Liverpool (1857). He exhibited at the Liverpool Academy in 1837 (*Bust of William Tooke*) and 1838 (*Bust of F. Raincock*). At the Great Exhibition of 1851 he exhibited a marble group, *Venus and Cupid* (now Salford Art Gallery), and at the International Exhibition of 1862, a figure of *Rebecca*. The RA commissioned from him a *Bust of Daniel Maclise* in 1870 and a *Bust of John Constable* in 1874.
(source: Gunnis, 1951)

Arthur Dooley (1929–94)
Born in Liverpool, he was at various times an apprentice welder at the Birkenhead shipyards, heavyweight boxing champion of the Irish Guards, worker at Dunlop's Speke factory, and a cleaner at St Martin's School of Art, London. It was while working at this last job (from 1953) that he started studying art. He had his first one-man show at St Martin's Gallery, London, in 1962, but generally eschewed the London art world. He was born a Protestant, but converted to Catholicism in 1945 (remarkably joining the Communist Party at the same time). Much of his best work has been executed for churches, the most accomplished of which is generally considered to be the *Stations of the Cross* for St Mary's Church, Leyland, Lancashire. He also executed work for churches in Latin America and Spain. His apprenticeship as a welder gave him experience in working with metals and his most characteristic work is usually in bronze or scrap metal. One of his latest works was a bronze sculpture of *St Mary of the Key*, 1993, for Liverpool Parish Church. His work is represented in the collections of the University of Liverpool and the WAG. He also executed the sculpture of Christ outside the Methodist Church, Princes Avenue.
(sources: *Echo* [obit.] 8 January 1994; *Guardian* [obit.] 17 January 1994.)

John Doubleday (b. 1947)
Sculptor, born in Essex. Following a period of several months in Paris where he sketched at the Musée Bourdelle, he attended first Carlisle School of Art and then Goldsmith's College of Art. He has exhibited regularly since 1967 in Britain, Holland, and Germany. He had his first one-man exhibition at Wolverhampton Art Gallery in 1975, and is represented in the British Museum, the V&A, the National Museum of Wales and elsewhere. His bronze *Statue of Sir Charles Chaplin* was erected in Leicester Square, London, in 1981.
(sources: Byron, 1981; Spalding, 1990)

Conrad Dressler (1856–1940)
Sculptor and potter. He was born in London of German descent and studied at the National Art Training School under Edward Lanteri during the early 1880s. He exhibited at the RA from 1883. In 1886 he stayed at Coniston with Ruskin, receiving encouragement which influenced his future stylistic development. From 1891 he was a member of the Art Workers Guild. In December 1893 he set up the Della Robbia Pottery at Birkenhead with Harold Rathbone and, in 1897, joined Medmenham Pottery at Marlow. He was elected FRBS in 1905.
(sources: Beattie, 1983; Johnson & Greutzner, 1976; Waters, 1975)

Stanley Sydney Smith English (b. 1908)
Sculptor in wood, stone and bronze, born at Romford, Essex. He studied at Lambeth School of Art and the RA Schools and exhibited at the RA in 1939 and 1940. In 1946 he was appointed teacher of ceramics at Liverpool College of Art.
(sources: Spalding, 1990; Waters, 1975)

Sir Jacob Epstein (1880–1959)
Born in New York to wealthy Jewish immigrants from Poland, he showed an early interest in drawing from life around him. He was attracted to sculpture, learning bronze casting by working in a foundry and studying modelling at evening classes. Fees from book illustrations paid for his passage to Paris in 1902 where he studied firstly at the Beaux-Arts School, then at the Académie Julien. He moved to London in 1905 and was naturalised in 1911. He studied at the British Museum, especially the Greek, Egyptian, and ethnographic collections. His very unclassical nude figures for the British Medical Association Building in the Strand, commissioned by the building's architect,

outraged the British public when unveiled in 1908 and were virtually destroyed when the building transferred to the Southern Rhodesian Government in 1937. Others of his public works also met with prurient attacks. Both the RBS and the RA denied him membership in his early years and several major museums rejected his controversial works (e.g. the Fitzwilliam, V&A and Tate Gallery all refused *Lucifer*), though he had achieved acceptance with his portrait bronzes from at least the 1920s and was esteemed by artists such as Augustus John and Sickert. Apart from an honorary LL.D. from Aberdeen in 1938, he enjoyed little official recognition before the 1950s when he received a knighthood (1954) and numerous public commissions.

(sources: Buckle, 1963; *DNB*; Gardiner, 1992; Silber, 1986)

Farmer & Brindley

A firm of decorative craftsmen and church furnishers providing architectural sculpture under contract, based at Westminster Bridge Road, London. William Farmer was the director of the firm, whilst William Brindley acted as chief executant. Many of the workers for the firm, including C.J. Allen and Harry Bates, trained at the South London Technical Art School. The firm provided decorative sculpture for many of the most important architects up until the First World War, their major contracts including work on Sir George Gilbert Scott's *Albert Memorial*, London, and Alfred Waterhouse's Natural History Museum, London, and Town Hall, Manchester. After Farmer's death, the firm continued to flourish under Brindley, but was eventually amalgamated with another firm in 1929. No records appear to survive from their heyday.

(sources: Beattie, 1983; Read, 1982)

John Henry Foley (1818–74)

Born in Dublin, he entered the Royal Dublin Society Schools at the age of thirteen, gaining first prizes for human form, ornamental design, animals, and architecture. He moved to London in 1834 and was admitted to the RA Schools the following year. In 1840 his group, *Ino and Bacchus*, was purchased by Lord Ellesmere and in 1844 his entry for the competition at Westminster Hall secured him a commission to execute a *Statue of John Hampden* for the Houses of Parliament. Henceforward, Foley was one of the most sought after sculptors in Britain. He was elected ARA in 1849 and RA in 1858. In 1861 he was elected full member of the Royal Hibernian Academy and, in 1863, the Belgian Academy of Arts. His equestrian *Viscount Hardinge* (for Calcutta, now private collection) was acclaimed as his masterpiece, but his *Prince Albert* and *Asia* for the Albert Memorial were perhaps his most prestigious commissions. It was while working in the open air on the cold wet clay of *Asia* that Foley is believed to have contracted the pleurisy that killed him, leaving unfinished numerous works including the Sefton Park *William Rathbone*, which his pupil, Brock, completed.

(sources: *DNB*; Gunnis, 1951)

Giovanni Giuseppe Fontana (1821–1893)

Sculptor and watercolourist, born at Carrara. He gained a gold medal at Carrara Academy and later was awarded a scholarship to Rome. He aligned himself politically with Garibaldi and came to England as an exile in 1848. Subsequently he became a naturalised British citizen and remained here for the rest of his life. He exhibited in London from 1852 to 1886, notably at the RA and the New Watercolour Society. In addition to the Corporation of Liverpool, he received commissions from the Governments of Sydney and New South Wales. A number of his works are in the collection of the WAG.

(sources: *Art Journal* [obit.], 1894; Bénézit, 1976)

James Forsyth

An architectural sculptor, he exhibited between 1880 and 1889 at the RA and the Glasgow Institute of the Fine Arts. He was the father of sculptor, James Nesfield Forsyth.

(source: Johnson & Greutzner, 1976)

Sir George James Frampton (1860–1928)

Sculptor and craftsman, born in London. He worked first in an architect's office, then for a firm of architectural stone carvers, before training at the Lambeth School of Art under W.S. Frith and, in 1881–87, at the RA Schools. His group, *An Act of Mercy*, exhibited at the RA in 1887, won the gold medal and travelling scholarship and in 1888–90 Frampton was in Paris, studying sculpture under Antonin Mercié. His *Angel of Death* gained a gold medal at the Salon of 1889. In the 1890s he became interested in the Arts and Crafts movement and wrote influential articles on enamelling, woodcarving, and polychromy etc, in addition to actually producing works in those media. His *Mysteriarch* of 1893, which shows the influence of French symbolism, was awarded the médaille d'honneur at the Paris International Exhibition 1900. Frampton was a member of the Art Workers Guild from 1887 and a Master from 1902. He was elected ARA in 1894 and RA in 1902. In 1908 he was knighted. From 1911 to '12 he was president of the RBS, having been a founder member. Such recognition brought increasing public commissions, most of which date from after 1900.

(sources: Beattie, 1983; *DNB*)

Arthur P. Fry
A Liverpool architect, he exhibited between 1893 and 1905 at the WAG.
(source: Johnson & Greutzner, 1976)

Raf Fulcher (b. 1948)
Born in Essex, he studied at the University of Newcastle upon Tyne, 1966–72. He has shown in several group exhibitions, including *The Sculpture Show*, Serpentine and South Bank, 1983. Commissions include Jesmond Metro Station, Newcastle upon Tyne.
(source: *Festival Sculpture*, 1984)

John Gibson (1790–1866)
Born in Wales, he moved at the age of nine with his family to Liverpool. In about 1806, whilst apprenticed to a wood-carver, he met F.A. Legé who brought him to the notice of his employers, Messrs Franceys, the Liverpool statuaries, who paid to cancel Gibson's existing indentures so that he might take an apprenticeship with them. His work there attracted the attention of William Roscoe, who supplied him with commissions, contacts, and access to his collection of antique sculpture. In 1817 Gibson moved to London, armed with letters of introduction from Roscoe. That same year, however, he left for Rome, where he trained mainly under Canova, but also with Thorvaldsen and, apart from occasional visits to England on business, he remained in Rome for the rest of his life, taking lucrative commissions from the many wealthy English visitors. His most prestigious patron was Queen Victoria, upon whose statue he first introduced touches of colour, as Canova had done before him, in accordance with ancient Greek practice. The culmination of his experiments in polychromy is *The Tinted Venus* (WAG). Despite the Greek precedent, many contemporaries found the naturalistic result an unsettling clash with the formal idealization of the figure. In 1833 Gibson was elected ARA and in 1838 RA, exhibiting at the RA from 1816 until 1864. On his death, his fortune and the contents of his studio were left to the RA.
(sources: *DNB*; Gunnis, 1951)

Sir Alfred Gilbert (1854–1934)
Born in London, he was the elder son of a musician. Gilbert had hoped to become a surgeon, but was distracted by the more congenial prospects of a career in art and managed to get into the RA Schools in 1873. He also received in 1874 some instruction from J.E. Boehm who recommended he should study in Paris. This he did, followed by six years working in Italy, where he executed his earliest ideal bronzes and learnt the lost-wax casting process, which he re-introduced to England in a series of bronzes in which the sensitive control of modelling obtainable through this process helped make Gilbert the most influential British sculptor of his generation. His *Icarus* of 1884, commissioned by Lord Leighton (PRA), secured Gilbert's election as ARA in 1887. He was a member of the Art Workers Guild from 1888 and, in 1892, was elected RA. He won important commissions from the Royal Family, including the prestigious *Tomb of the Duke of Clarence* for Windsor. In 1897 he was appointed MVO and in 1900 was nominated Professor of Sculpture at the RA Schools. In 1901, however, he became bankrupt and, amidst a scandal over his unauthorized sale of figures from the unfinished royal tomb, fled to Bruges, returning only in 1926 after George V had personally requested that he finish the tomb. On his return he was awarded the gold medal of the RBS and, in 1932, was knighted.
(sources: Beattie, 1983; *DNB*; Dorment, 1985)

Count Victor Gleichen (1833–91)
The youngest son of Prince Ernest of Hohenlohe-Langenburg, his mother was half-sister to Queen Victoria. He assumed the lesser title of Count Gleichen following his marriage to a commoner in 1861. His distinguished naval career ended in 1866 when, owing to repeated illness, he had to retire on half-pay. In 1867 he was created KCB and appointed governor and constable of Windsor Castle. After his retirement from the navy he studied sculpture under William Theed the Younger for three years and the Queen granted him permission to set up a studio in a suite of apartments in St James's Palace. His success as a sculptor allowed him to have a small house erected near Ascot. He executed imaginative groups, monuments and portrait busts. In 1885 the Queen permitted the Count and Countess to revert to the titles Prince and Princess and, in 1887, Prince Victor was promoted to GCB and admiral on the retired list.
(source: *DNB*)

Diane Gorvin
Trained at Bournemouth and Poole colleges of art, 1973–77, in 1981 she took a part-time stone carving course at Weymouth Technical College and, 1981–86, was employed as Town Artist by the Warrington and Runcorn Development Corporation. She has had three-week residencies at Norton Priory Museum, Runcorn (1988), Groundwork Trust, Knutsford (1989), and Gorse Covert School (1992). Since 1978 she has produced over thirty publicly-sited sculptures at, e.g., the Art Centre, Poole, and the Winter Gardens, Bournemouth (relief sculptures for the Western Orchestral Society), Norton Priory Museum (sculpture trail), and London Docklands (bronze sculpture: *Dr Salter's Daydream*). Gorvin also works in ceramics, her

Big Yellow Head winning the 1989 purchase prize at Warrington Art Gallery. Her most important public work in Liverpool has been executed in collaboration with Philip Bews.
(source: Gorvin)

Edward O. Griffith
A Liverpool sculptor, he exhibited at the WAG five times from 1888 to 1912. He executed all the sculptural work on the New Post Office in Victoria Street and worked with Rhind on the New Cotton Exchange in Old Hall Street. He also executed all the stone carving in the church of the Holy Trinity, Southport.
(source: Johnson & Greutzner, 1976)

Theo Grunewald (b. 1927)
Born in Germany, he worked as a blacksmith in Glamorgan from 1964.
(source: *Festival Sculpture*, 1984)

Gordon Hemm (?1891–1956)
Born at Stockport, Hemm trained under C.H. Reilly at the School of Architecture, University of Liverpool. At the time of his collaboration with C.J. Allen on the *University of Liverpool War Memorial* (1927), he was a partner in the architectural firm of Foden, Hemm, and Williams, of Liverpool and Manchester. He was elected ARIBA in 1931. He was also the author of several books on Merseyside architecture and a painter of Liverpool architectural subjects, contributing to the RA summer exhibition in 1940 and 1947 (views of the Anglican Cathedral), and in 1953 (a view of the industrial dockside).
(sources: *Builder*, 27 May 1927; *RIBA Journal* [obit.], April 1957).

Barbara Hepworth (1903–75)
Born in Yorkshire, the daughter of a civil engineer, she entered Leeds School of Art in 1919 before moving to the Royal College of Art in 1920. In 1924 she won a scolarship for one year's study abroad and went to Italy with John Skeaping, whom she married in 1925. They stayed in Rome until 1926. In Italy Hepworth learned to carve stone, a skill not taught at the Royal College, as it was at this time considered stonemason's work. She had her first major exhibition in 1928 (Beaux Arts Gallery, Hampstead, with Skeaping), her work consisting of stone carvings of figures and animals. During the early 1930s she simplified her forms to the point of complete abstraction, a process encouraged by her association with Ben Nicholson, who was to become her second husband in 1932 after the dissolution, in 1931, of her first marriage. The couple visited Paris and were in touch with the international avant-garde, notably Picasso, Brancusi, Braque and Mondrian, both becoming members of the Paris-based Abstraction-Création. They were also members of the English Seven-and-Five Society and Unit One. In 1939 they moved to St Ives, where Hepworth stayed for the rest of her life, allowing the Cornish landscape to influence her abstract forms. She had numerous retrospective exhibitions, including the Sao Paolo Bienal of 1959, where she was awarded the grand prix. Her most prestigious commission was *Single Form* (1963) for the UN building in New York. She was appointed CBE in 1958 and DBE in 1965. She received honorary degrees from several British universities and, in 1973, honorary membership of the American Academy of Arts and Letters.
(sources: *DNB*; Nairne & Serota, 1981)

Henry Gustave Hiller (1865–1946)
A Liverpool artist, he was principally a designer of painted gesso reliefs and stained-glass. He studied at Manchester School of Art and exhibited at the WAG, 1903–25.
(source: Johnson & Greutzner, 1976)

Stephen Robert Hitchin (b. 1953)
Born in Liverpool, he trained at St Helens Art College, 1971–72; Liverpool Polytechnic, 1972–76 (B.A. Fine Art First Class Hons.); Manchester Polytechnic, 1976–77 (M.A. Fine Art); and Liverpool Polytechnic, 1977–78 (Art Teacher's Diploma). At the time of writing (1994) he teaches at Clwyd College of Art. He has exhibited at the RA since 1988. In 1978 he had his first one-man exhibition, at the Atkinson Gallery, Southport, and, in 1989, his first one-man show in London, at the Chapman Gallery. He exhibits regularly in Bridewell Studios Artists Group Shows.
(source: Hitchin)

Thomas Huson (1844–1920)
Born in Liverpool, he was principally a landscape and genre painter and engraver. He began as an analytical chemist, pursuing his career as an artist in his spare time. He exhibited frequently at the WAG (he is listed 116 times) and at many other venues, including, from 1871, nine times at the RA. In 1881, he was elected a member of the Royal Society of Painter-Etchers and Engravers and, in 1883, a member of the Royal Institute of Painters in Water Colours. In 1894 he published *Round about Snowdon* and in 1895 *Round about Helvellyn*.
(sources: Johnson & Greutzner, 1976; Waters, 1975)

Sir William Goscombe John (1860–1952)
Born in Cardiff, the son of a woodcarver. After his move to London he worked, from 1881–86, for an architectural carver and, from 1886–87, for C.B. Birch. Meanwhile he studied at the

South London Technical Art School and then, from 1883, the RA Schools. In 1889 he won the RA gold medal and travelling studentship, visiting Sicily, North Africa, and Spain, before setting up a studio in Paris for a year, where he was influenced by his contact with Rodin. Throughout the 1890s he exhibited ideal bronzes and, in 1900, won a gold medal at the Paris International Exhibition for *The Elf*, *Study of a Head*, and *Boy at Play*. He received many commissions for public statues and portrait busts and also designed the regalia for the investiture of the Prince of Wales in 1911, the year in which he was knighted. He was a member of the Art Workers Guild from 1891 and was elected ARA in 1899 and RA in 1909. In 1942 he was awarded the gold medal of the RBS and continued to exhibit annually at the RA until 1948.
(sources: Beattie, 1983; *DNB*)

Allen Jones (b.1937)
Painter and sculptor. Born in Southampton, he studied at Hornsey College of Art from 1955–59 and afterwards at the Royal College of Art. He has taught in Germany, Canada, the UK, and the USA. Jones first came to prominence in the 1960s as a Pop artist, producing work notable for its erotic content. His first international exhibition was at the 1961 Paris Biennale where he gained the Prix des Jeunes Artistes. The first retrospective of his painting was in 1979, starting at the WAG and then touring England and Germany. He was elected RA in 1986.
(sources: *Chelsea Harbour Sculpture 93*; *Who's Who 1993*)

Charles Samuel Kelsey (1820–after 1882)
He entered the RA Schools on the advice of the painter, William Etty, in 1843, winning a Silver

Medal in 1845. He exhibited at the RA from 1840 to 1877. In 1846 the Society of Arts awarded him a Silver Medal for a design for an admission ticket to the Society's rooms. His first known commission in Liverpool was in 1848 for the sculpture above the doorway of the Royal Insurance Building, North John Street (demolished). His publicly-sited work outside Liverpool includes two large stone figures of women outside Smithfield Market, London (1868), and a relief, *Queen Victoria and the Prince of Wales attending a thanksgiving service in St Paul's following the latter's recovery from typhoid*, Temple Bar Memorial, Strand (1880). He is last heard of in 1882 when, as an unsuccessful entrant in the St George's Hall relief panels competition, he writes to the *Builder* (22 July 1882: 126) and recalls the work that he executed as assistant to his father, James Kelsey, who had been employed by Elmes: together, he states, they made 'the full-size models in London for the Corinthian capitals and other portions of architectural sculpture'. Subsequently, in 1849, after a brief hiatus following Elmes' death, he was re-employed in his own right and was given studio space in the Hall, completing his work in 1856 under Cockerell's superintendence.
(sources: *Builder*, 22 July 1882; Gunnis, 1951)

David Kemp (b. 1945)
Sculptor, born in Walthamstow. He was in the Merchant Navy, 1963–67, after which, from 1967–72, he attended Farnham and then Wimbledon schools of art where he was awarded a Diploma in Fine Art. He had his first one-man exhibition in 1970 at the Newlyn Orion Gallery, Penzance, and in 1973, moved to west Cornwall. He was resident sculptor at Grizedale Forest in 1981–82 and at Yorkshire Sculpture Park, Bretton Hall, in 1983. His

public sculptures, usually assembled from found objects, recycled scrap metal etc, include *Deerhunter* (1982, Grizedale Forest), *Iron Horse* (1982, Newcastle upon Tyne Civic Centre) and *Lower Orders* (1983, Yorkshire Sculpture Park).
(sources: *Festival Sculptures*, 1984; Strachan, 1984)

Eric Henri Kennington (1888–1960)
Born in Chelsea, he was the son of a painter. Following a mediocre academic record at school, he was encouraged to go to Lambeth School of Art and then to the City and Guilds School, Kennington. His early success was as a painter of portraits, cockney types, and London scenes. He enlisted for service in the First World War, but was invalided out in 1915, later returning to the front as an official war artist. He continued to paint after the war, taking up sculpture only when his old regiment (the 24th East Surrey Division) needed a war memorial; the result, a stone carving of three infantrymen, was erected in Battersea Park in 1924. He also executed the British Memorial at Soissons in 1927–28. Other sculptures by him include the carvings in the School of Hygiene and Tropical Medicine in Gower Street, London; a bronze memorial head of Thomas Hardy at Dorchester; and the recumbent effigy of his friend T.E. Lawrence for St Martin's, Wareham. He was again an official war artist during the Second World War. He was elected ARA in 1951 and RA in 1959.
(sources: *DNB*; Gleichen, 1928)

Phillip King (b. 1934)
Born in Tunisia, he came to England in 1946. After studying modern languages at university, he entered St Martin's School of Art, training as a sculptor under Anthony Caro, 1957–58. In

1959–60 he worked as an assistant to Henry Moore, and briefly to Eduardo Paolozzi. He taught at St Martin's, 1959–78, during which time he was also visiting teacher at Bennington College, Vermont (1964), and Hochschule der Künste, Berlin (1979–80). In 1980–92 he was Professor of Sculpture at the Royal College of Art. Having worked initially in clay and plaster, from 1960 King began producing work in fibreglass and metal, and then, from the late 1960s, in metal, wood and slate. His first one-man exhibition was in 1964 at the Rowan Gallery, London, and he was one of the 'New Generation' sculptors who exhibited at the Whitechapel Gallery in 1965. His commissions include sculptures for C & J Clarke, Street, Somerset, 1972; the European Patent Office, Munich, 1978; and Romulus Construction Ltd, London, 1979. He was awarded the CBE in 1974 and was elected ARA in 1977 and RA in 1991.
(sources: *Chelsea Harbour Sculpture 93*; Nairne & Serota, 1981; Spalding, 1990)

Andrew (?–?) and George Anderson (1832–1904) Lawson

Andrew Lawson won the commission for the *Wellington Monument* with his design for a 110 ft high Doric column. The commission for the statue to surmount it was given to his brother, George. George had trained under the sculptor A.H. Ritchie and in the schools of the Royal Scottish Academy. He spent some time in Rome, where he admired Gibson's work, and returned to England, making his home firstly in Liverpool and then, from 1866, in London. In 1871 he executed a *Statue of Mayor John Biggs* (cast in bronze in 1930 by J.H. Morcom) for Leicester and in c.1888 architectural sculpture for the City Chambers, Glasgow.
(sources: *DNB*; Pevsner & Williamson, 1984)

Thomas Stirling Lee (1857–1916)

Born in London, he was apprenticed to J. Birnie Philip, who was at the time working on the Albert Memorial. Lee studied at the RA Schools, 1876–80, winning a gold medal in 1877 and a travelling scholarship in 1879. He went first to Paris, studying at the École des Beaux-Arts, 1880–81, and then to Rome for further tuition, 1881–83. Back in England he assisted Alfred Gilbert with his experiments in the lost-wax casting process. Architectural sculpture outside Liverpool includes stone reliefs for Edgar Wood's Lindley Clock Tower, Huddersfield (1902). In addition to his architectural sculpture, he produced ideal work (*The Music of the Wind*, silver, 1907, Leeds City Art Gallery) and portraiture (*Bust of Alderman Edward Samuelson*, marble, 1885, WAG). In 1887 he became a member of the New English Art Club. From 1889 he was a member of the Art Workers Guild, becoming a Master in 1898. He was a founder member of the RBS and, in 1910, was elected a member of the National Portrait Society.
(sources: Beattie, 1983; Johnson & Greutzner, 1976; *Studio* [obit.], August, 1916; Waters, 1975)

F.A. Legé (1779–1837)

Legé worked for the Liverpool stonemasons, Messrs Franceys, bringing to their attention the work of the young John Gibson, who subsequently served an apprenticeship with them. In about 1805 Legé carved the *Royal Coat-of-Arms* on the Liverpool Union News Room, Duke Street. He later moved to London, where he was employed as a carver by Chantrey, working on the famous *Monument to the Robinson Children* (1817) in Lichfield Cathedral. He exhibited at the RA from 1814 to 1825.
(source: Gunnis, 1951)

Paul Liénard (1849–1900)

French sculptor, born in Paris, a pupil of Duret. His work includes portrait busts and statues, ideal groups and animal subjects. He exhibited at the Salons of 1864, 1866 and 1890. His public sculpture in France includes a marble *Bust of Fragonard* (1877) for a public garden at Grasse and a marble *Statue of Lord Brougham* (1879) for Cannes.
(sources: Bénézit, 1976; Kjellberg, 1987)

Giovita Lombardi (1837–76)

An animal sculptor, born at Rezzato near Brescia, he died at Rome. Examples of his work in marble are to be found in the National Gallery of Melbourne.
(source: Bénézit, 1976)

Vincenzo Luccardi (1811–76)

Sculptor and history painter, born at Gemona. He trained in Venice before moving to Rome where he became a professor at the Academy of Saint Luke. He was a knight of the Legion of Honour and of the Order of St Gregory the Great.
(source: Bénézit, 1976)

John Alexander Patterson MacBride (1819–90)

He trained under William Spence of Liverpool, before moving to London in about 1841. His entry for the Westminster Hall competition of 1844 was badly received, although Samuel Joseph was sufficiently impressed to engage MacBride as a pupil without charging the usual fee. MacBride eventually became Joseph's chief assistant before returning to Liverpool in about 1852 where he became Secretary of the Liverpool Academy. In Liverpool he competed unsuccessfully for the commission for the Wellington Column statue. Gunnis lists

amongst his works a *Bust of Dr Raffles* for Great George Street Chapel, Liverpool, a *Bust of John Laird* (1863) for Birkenhead Hospital, and a *Memorial Tablet to Dr Stevenson* (1854) for St Mary's Church, Birkenhead, now housed at the Oratory, St James's Cemetery, Liverpool. The Liverpool Art Union awarded models of his *Lady Godiva* as prizes in 1850.
(sources: Gunnis, 1951; WAG JCS files)

John McCarthy

He exhibited statues and busts at the RA from 1954 to 1960, during which time he was based in London. For the exterior screen wall of Corporation House in Manchester, he executed an abstract stone relief.
(sources: Pevsner, 1969; *Royal Academy Exhibitors*)

Terence McDonald (b. 1930)

A Liverpool sculptor, he studied at Liverpool City College of Art, was an assistant to Tyson Smith at the Bluecoat studio and is a member of the Merseyside Sculptors Guild.
(source: Merseyside Sculptors Guild)

Patrick MacDowell (1799–1870)

Born in Belfast, his tradesman father died whilst he was in his infancy, leaving the family impoverished. MacDowell's interest in drawing was originally encouraged by an engraver who ran a boarding school at which he was lodged in Belfast. By 1811 the family had moved to Hampshire and by *c.*1817 MacDowell was lodging with the sculptor Peter Francis Chenu and had begun his first successful attempts at modelling. In 1822 he had a bust accepted at the RA. He did not immediately enter the RA Schools, but was advised to do so in 1830 by John Constable and, once there, made rapid progress. An early patron paid for a period of

eight months study in Rome. He successfully entered the Westminster Hall competition in 1844 and was commissioned to execute a *Statue of William Pitt the Younger*. In 1846 he was elected RA, having been ARA since 1841. He exhibited at the RA from 1822–70 and was represented at the Great Exhibition of 1851. Shortly before his death he completed the marble group *Europe* for the Albert Memorial in London.
(sources: *DNB*; Gunnis, 1951)

James McLaughlin (b. 1938)

A Liverpool sculptor, he studied at Liverpool City College of Art, was an assistant to Tyson Smith at the Bluecoat studio and is a member of the Merseyside Sculptors Guild. He has a NDD and is a FRSA.
(source: Merseyside Sculptors Guild)

R. MacLeod

A Liverpool sculptor, he exhibited at the WAG in 1883 and 1887.
(source: Johnson & Greutzner, 1976)

Alfred R. Martin (d. 1938)

Raised in Liverpool, Martin studied under Augustus John at the Liverpool School of Art. After finishing the murals of the State Restaurant he travelled to South Africa, where he stayed for the rest of his life, revisiting Liverpool in the 1920s only when his murals needed restoring. He exhibited at both the WAG Liverpool Autumn Exhibition and, in 1907–14, at the RA.
(sources: Johnson & Greutzner, 1976; WAG JCS files)

Charlotte Mayer

Sculptor, born in Prague. She came to England in 1939 and attended the Royal College of Art

and Goldsmiths College, London. In 1980 she was elected to the Royal Society of British Sculptors, winning its silver medal in 1981. Public sculptures outside Liverpool include *Care*, 1982, for Johnson and Johnson's offices at Slough and *Ascent* for the Barbican Centre, London.
(source: Sladmore Gallery, London) ·

Ferdinand Miller (or Müller) (1813–87)

German sculptor and bronze founder. He was a pupil of his uncle, Johannes Stiglmair, and at the Munich Academy. From 1844, he was Inspector, and from 1878, owner of the Royal Foundry at Munich. Among the numerous public monuments he is responsible for casting are William Wetmore Story's *Statue of George Peabody* (1869), Royal Exchange Buildings, E.C.2, and Thomas Crawford's *Equestrian Statue of George Washington* (1849) at Richmond, Virginia.
(sources: Thieme-Becker, 1942; personal knowledge)

Dhruva Mistry (b.1957)

Born in India, he graduated with an MA at the Faculty of Fine Arts, University of Baroda, 1981. In the same year he had his first solo exhibition in New Delhi. In 1981–83 he was at the Royal College of Art on a British Council scholarship. He was a Fellow of Churchill College, Cambridge, 1984–85, and was also artist-in-residence at Kettles Yard, the culmination of which was a large touring exhibition of his sculptures and drawings. The WAG staged a one-man exhibition of his works in 1986. In 1988 he was sculptor-in-residence at the V&A, London. Public commissions include works for the National Garden Festival, Stoke-on-Trent (1986), Nichiman Corporation, Japan (1987), Glasgow Garden Festival (1988), Victoria

Square, Birmingham (1992) and Quaglino's, London (1992). In 1990 he represented Britain at the 3rd Rodin Grand Prize Exhibition in Japan. In 1991 he was elected RA.
(sources: *Chelsea Harbour Sculpture 93*; *Who's Who 1993*)

William Mitchell
London sculptor. His public sculptures include the abstract relief decoration of the porch and belfry of the Metropolitan Cathedral of Christ the King, Liverpool (late 1960s), and *Water Feature* (1975, fountain in metal, Station House Courtyard, Cherrydown, Essex).
(source: Strachan, 1984)

James Moore (see Thames Ditton Foundry)

Tom Murphy (b. 1949)
Liverpool sculptor and painter. His main sculptural commissions, apart from the Liverpool *Statue of Sir John and Cecil Moores*, include a *Bust of Sir Hector Laing* for UB Brands, a *Bust of Margaret Thatcher* for the BBC's commemorative programme, 'Ten Glorious Years', and busts of *Bill Shankly* and *John Lennon* for David Moores. His *Statue of John Lennon* was shown in Liverpool's Clayton Square Shopping Centre from November 1995 as part of the 'Art in the Square' exhibition. In 1996 The Littlewoods Organisation Plc commissioned him to paint an oil *Portrait of John Moores Jnr* to commemorate the subject's retirement. He has shown work in both group and solo exhibitions and his awards include first prize in BBC Art '88 and the Channel Islands New Design Award in 1990.
(source: the artist)

William Eden Nesfield (1835–88)
Architect, born at Bath, the son of a landscape gardener. Educated at Eton, he trained firstly with William Burn and then with his uncle, Anthony Salvin. He set up his own architectural practice in 1858. In 1862 he published *Specimens of Mediaeval Architecture*, drawn from his travels in France and Italy. From 1866 to 1868 he was in partnership with Richard Norman Shaw. His more important works include: Kinmel Park, Denbigh (gutted); Cloverly Hall, Shropshire (partly demolished); the hall and church at Loughton, Essex; Gwernyfed Hall, Brecknockshire; Farnham Royal Church; and lodges at Kew Gardens and Hampton Court.
(sources: *DNB*; Dixon & Muthesius, 1985)

William Grinsell Nicholl (1796–1871)
After attending the RA Schools in 1822 he worked principally as an architectural sculptor. His most important commission outside Liverpool was for George Basevi's Fitzwilliam Museum, Cambridge, where, in 1837, he carved the decorative details of the frieze and capitals to Basevi's designs and, in 1838, the pediment figures to designs by Sir Charles Eastlake. In the following year he carved the four stone lions guarding the entrance steps. His submission to the Westminster Hall competition of 1844 was received badly and he was awarded no commissions. Nicholl never achieved wealth but did obtain regular work from the architect C.R. Cockerell from 1821 (carved doves for the Corinthian capitals supporting the dome in the Hanover Chapel, London) onwards and it was through Cockerell that he achieved a limited degree of fame with his most prestigious commissions, those for St George's Hall and Plateau in the 1850s. Nicholl exhibited at the RA from 1822 to 1861.
(sources: Gunnis, 1951; Watkin, 1974)

Matthew Noble (1818–76)
Born in Hackness, Yorkshire, he trained in London under the sculptor, John Francis. His first appearance at the RA was in 1845 with two busts. He exhibited thereafter 100 works, chiefly portrait busts. His first important public commission was the *Wellington Monument*, Piccadilly, Manchester (1856), won in competition. Also important are the colossal marble *Statue of the Prince Consort* for Thomas Worthington's *Albert Memorial*, Albert Square, Manchester (1865), and the bronze *Statue of Oliver Cromwell*, now in Wythenshawe Park (1875). Among his many other public statues are those in Parliament Square, London, of *Lord Derby* (1874) and *Sir Robert Peel* (1876). At his death, his widow presented his models to the Corporation of Newcastle.
(sources: *DNB*; Gunnis, 1951; Redgrave, 1878)

Patric Park (1811–55)
Born in Glasgow, his father and grandfather were statuaries and masons. Following his schooling, in which he distinguished himself in classics, he was apprenticed as a stone-cutter to a builder engaged in the erection of Hamilton Palace. Park was next employed for two years as an architectural carver at Murthley Castle. When he went to Rome in 1831, the Duke of Hamilton, who had been impressed with his work, furnished him with a letter of introduction to the sculptor Thorvaldsen. Park stayed with Thorvaldsen for two years, returning to Britain in 1833, executing classical subjects and, specifically to earn a living, portrait busts and statues. He competed unsuccessfully for the *Scott Monument* in Edinburgh and for the *Nelson Monument* in London. Although he had ambitions to create monumental public works, his real area of ability may be inferred from the many portrait commissions he received.

Napoleon III was both patron and sitter: in 1853 he commissioned from Park a *Bust of Sir Charles Napier* and in 1854 the Duke Of Hamilton commissioned from Park a *Bust of Napoleon III*. Park was elected an Associate of the Royal Scottish Academy in 1849 and a full member in 1851. According to *DNB* he died at Warrington railway station from a burst blood vessel sustained in trying to help a porter lift a heavy trunk.
(sources: *DNB*; Gunnis, 1951)

Henry Alfred Pegram (1862–1937)
Born in London, he attended West London School of Art, winning book prizes in the National Art Competitions in 1881 and 1883. Sponsored by Thomas Heatherley (Principal of Heatherley's Academy, Newman Street, London), Pegram entered the RA Schools in 1881, winning prizes in 1882, 1884, and 1886. From 1887–c.1891 he worked as an assistant to Hamo Thornycroft (e.g. on the *Memorial to Charles Turner and son*, see above, pp.44–5). Pegram first achieved recognition with the Gilbert-influenced bronze relief, *Ignis Fatuus* (RA 1889; selected for purchase by the Chantrey Bequest, now Tate Gallery). His public commissions include the pair of bronze candelabra in the nave of St Paul's Cathedral (1897–98), the Suffolk Street frieze (c.1906) on the United Universities Club, London, W1, for the architect Reginald Blomfield, and the *Monument to Edith Cavell* at Norwich. Pegram was elected a Member of the Art Worker's Guild in 1890, ARA in 1904, and RA in 1922.
(sources: Gray, 1985; Beattie, 1983; *Who Was Who 1929–1940*)

Eric Harry Peskett (b. 1914)
Born in Guildford, he studied at Brighton College of Art, 1929–35, and at the Royal College of Art, 1935–39. He exhibited at the RA in 1944. He was elected ARBS in 1948 and FRBS in 1961.
(source: Waters, 1975)

Joseph Phillips
A Liverpool sculptor, working from St George's Studio, 1–5 Back Canning Street. He exhibited in 1910 at the RA Summer Exhibition, and in 1911 at the WAG Liverpool Autumn Exhibition, and in those same years attended evening classes at Liverpool College of Art. He executed some work for Liverpool's Anglican Cathedral.
(sources: Johnson & Greutzner, 1976; *RA Exhibitors*; *WAG LAE catalogue, 1911*)

Frederick William Pomeroy (1856–1924)
Born in London, he was first apprenticed to a firm of architectural carvers, attending the South London Technical Art School part-time where he learnt modelling from Jules Dalou and W.S. Frith. He was at the RA Schools, 1880–85, winning the gold medal and travelling studentship in 1885. He travelled to France and Italy, studying in Paris under Antonin Mercié. In 1887 he collaborated with Frith on the *Victoria Fountain* in Glasgow. He exhibited with the Arts and Crafts Society from 1888 and was a medallist at the Paris International Exhibition of 1900. In addition to his work for the architect Mountford in Liverpool, he also worked for him at the Paisley, Sheffield, and Lancaster Town Halls, and at the Central Criminal Court, Old Bailey, London (to Pomeroy is due the famous gilt bronze figure of Justice surmounting the diome). Pomeroy's portrait statues include *Dean Hook*, Leeds City Square, and *W.E. Gladstone*, Houses of Parliament, both 1900. He was a Member of the Art Workers Guild from 1887 (Master from 1908) and was elected ARA in 1906 and RA in 1917. He was also, in 1911, a founding member of the Society of Portrait Sculptors.
(sources: Beattie, 1983; Nairne & Serota, 1981; *Who Was Who, 1916–1928*)

Nicholas Pope (b. 1949)
Born in Sydney, Australia, he came to England and studied sculpture at Bath Academy of Art, 1970–73. In 1974 he was awarded the Southern Arts Association Bursary, in 1974–75 the Romanian Government Exchange Scholarship and, in 1976, the Calouste Gulbenkian Foundation Award. His first solo exhibition was in 1976 at the Garage Gallery Limited. He has public sculpture at Peter Symonds College, Winchester (*Four Odd Words*), Southampton University (*Three Wilderness Stones*) and the Sun Life Assurance building, Bristol (*Five Amorphous Shapes*).
(sources: Spalding, 1990; Strachan, 1984)

Edward Carter Preston (1885–1965)
Born in Liverpool, he was, until the First World War, principally a painter. He studied at the School of Applied Art, Liverpool University, until its amalgamation with Liverpool School of Art in 1905, whereupon he joined the rival Sandon Terrace Studios. After the war he devoted himself to sculpture, making his name as a medallist when he won first and second prizes in the government competition for a plaque for the next of kin of those who had died in the war. His most prestigious commission was his sculptural work for the Anglican Cathedral (1931–55). He was brother-in-law to Herbert Tyson Smith.
(source: Spalding, 1990)

Sir Charles Herbert Reilly (1874–1948)
London-born architect and teacher, trained in

the office of his father, the architect C.T. Reilly. He was subsequently articled to John Belcher and then went into partnership with Stanley Peach. In 1902 he entered the Liverpool Cathedral competition, earning a commendation from the assessors. He was elected ARIBA in that same year, invited to join the RIBA board of architectural education in 1906, elected to the RIBA's council in 1909 and elected fellow in 1912, finally serving as vice-president in 1931–33. From 1904 to 1933 he was Roscoe Professor of Architecture at the University of Liverpool and is generally considered to have been a pioneer of architectural education in Britain. The year after his retirement he was awarded an honorary degree of LL.D by the University and was made an emeritus professor. His most important building in Liverpool is the Students' Union Building (1910–13; extended by Reilly, L.B. Budden and J.E. Marshall in the 1930s). A regular contributor to the *Manchester Guardian* and *Liverpool Post* and frequent reviewer of buildings and books for *Architects' Journal* and *Architectural Review*, he was also for a time architectural editor of *Country Life*. His most famous book is probably *Scaffolding in the Sky: a semi-architectural autobiography*, 1938. Reilly was awarded the Royal Gold Medal for Architecture in 1943 and was knighted in 1944.
(sources: *DNB*; Wodehouse, 1978)

William Birnie Rhind (1853–1933)
Born in Edinburgh, he was the eldest son of the sculptor, John Rhind, under whom he studied prior to attending first the School of Design, Edinburgh, and then the Life School of the Royal Scottish Academy (for five years). Subsequently he practised mainly in Edinburgh, executing principally architectural sculpture, but also many public statues and memorials.

His architectural sculpture includes the reliefs and historical figures in canopied niches around the central doorway of the Scottish National Portrait Gallery, Edinburgh (1891–98), and an allegorical figure, *Science*, on the Glasgow Art Gallery and Museum, Kelvingrove (1898). His best known works, however, are probably his Edinburgh war memorials to the *Royal Scots Greys* (1905), the *Black Watch* (1908), and the *Kings Own Scottish Borderers* (1919). He also executed works for England (London and Newcastle), Canada (Winnipeg), Australia (Adelaide and Melbourne) and India, and was an unsuccessful competitor for the Liverpool *Victoria Monument* (with T. Duncan Rhind; design exhibited at the Royal Scottish Academy, 1902, cat. 572). He was elected Royal Scottish Academician in 1905, having been an Associate since 1893. He exhibited at the RSA from 1878 to 1929.
(sources: *The Scotsman* [obit.], 11 July 1933; *Who Was Who 1929–1940*, plus information supplied by Fiona Pearson)

Seán Rice (1931–97)
Born in London, he studied sculpture at Brighton College of Art, 1947–51, and the RA Schools, 1951–53. He was awarded a Prix de Rome Scholarship in Sculpture in 1953 and studied and worked in Rome for two years thereafter. He lectured at West Sussex College of Art, 1955–59, and was in Nottingham, 1959–63, where he set up his own foundry and lectured at the College of Art. He taught sculpture at Liverpool School of Art, 1963–80, before leaving to devote himself full-time to the practice of sculpture. In 1969 he established an enlarged studio and foundry at Walton. He exhibited in London (one-man shows at the Alwin Gallery), Nottingham, Manchester, Liverpool, and Rome. His major commissions

include a *Crucifix*, 12 ft high, steel, St Margaret's Church, Anfield (1969); *Poseidon*, 11 ft high, bronze, Gravesend (1976); *Noah and the Four Winds*, 16 ft high bronze fountain, Chester Zoo (1977); *David*, life-size bronze, Nebraska, USA (1978); 'Krypton Factor' trophies, 1984–91 (for Granada Television); and the *Stations of the Cross*, bronze, Metropolitan Cathedral of Christ the King, Liverpool. His wife, Janet Rice, a specialist in lost wax casting and argon arc and gas welding, was his principal assistant in the production of metal sculpture.
(sources: Rice; *Independent* [obit.], 15 January 1997)

Robin Riley (b. 1933)
Born in Liverpool, he studied at Liverpool College of Art. He has worked in Switzerland and Italy and lectured at Preston, Manchester, and Coventry colleges of art, and Manchester University. His commissions include work for St Kevin's School (1961), Arndale Shopping Centre (1968) and the Manchester G.P.O. Headquarters (1968). In 1972, he won the Ministry of Environment, Manchester sculpture competition.
(source: WAG archives)

Joseph Rogerson
Sculptor. Apart from the *William Simpson Fountain*, his other work on Merseyside includes the sculptural decoration and figures on the Birkenhead School of Art (1870–71), now the John Laird Centre.
(source: *Daily Post*, 28 September 1871)

Edna Rose (1899 – 1981)
Sculptor of animal subjects, born in Ireland. On moving to England, she trained at, and then taught sculpture at, Liverpool School of Art. She also taught pottery at the Laird School of

Art, Birkenhead. She was a member of the Society of Wild Life Artists and the Liverpool Academy of Arts, an associate member of the Royal Cumbrian Academy, and President and Secretary of the Deeside Arts Group. She exhibited at the RA, Manchester City Art Gallery, and the WAG Liverpool Autumn Exhibition.
(source: WAG, 1988)

John Charles Felix Rossi (1762–1839)
Born at Nottingham, the son of a quack-doctor from Siena. Rossi first studied under, then worked for, the sculptor Locatelli. In 1781 he entered the RA Schools, winning a silver medal the same year and a gold medal in 1784. In 1785 he won the travelling scholarship and went to Rome, staying until 1788. On his return he worked at the Derby China Works and shortly afterwards for Coade's of Lambeth, the manufacturers of decorative sculpture in durable artificial stone. Later Rossi was to develop an artificial stone of his own composition (he executed much work in artificial stone at Buckingham Palace, 1827–29). Coade's also gave him valuable experience in modelling with terracotta and, in 1796, in partnership with John Bingley, he produced the terracotta figures and reliefs for the Assembly Rooms at Leicester. In 1798 Rossi was elected ARA and in 1802 RA. His practice flourished and he received a number of prestigious commissions, none more so than those for national monuments in St Paul's. In the 1810s his career faltered and he even considered taking up the offer of a commission in Haiti, but he stayed in England and in 1819 won the commission for the terracotta caryatids for the Church of St Pancras, London. Throughout his career he worked successfully as a portraitist and held the post of sculptor to both George IV and William IV.

Despite achieving recognition, he died in fairly straitened circumstances – his large family (sixteen children from two marriages) absorbing so much of his income that he 'bequeathed to his family nothing but his fame' (*Art-Union*). (sources: *Art-Union* [obit.], 1839; *DNB*; Gunnis, 1951)

Herbert James Rowse (d. 1963)
Architect, educated at the University of Liverpool. He commenced practice in Liverpool in 1918. Apart from his many buildings in Liverpool, he designed the new headquarters building for the Compania de Aplicaciones Electricas S.A., Barcelona, 1930; the new headquarters building for the Pharmaceutical Society of Great Britain, Brunswick Square, London, 1935; and diplomatic buildings in Delhi and Karachi in 1951. He also won first prize in a competition to design a new library and chambers at King's College, Cambridge, in 1924, although his design was never executed. He was a FRIBA and then, in 1944–50, a member of the RIBA council.
(source: *Who Was Who 1961–1970*)

Professor Frederick More Simpson (1855–1928)
He entered the RA Schools in 1880. He was articled to G.F. Bodley, then spent some time in the office of Charles Ferguson of Carlisle. In 1894 he was appointed first Professor of Architecture at University College, Liverpool, and then in 1903 at the University of London. His architectural work in Liverpool was executed in collaboration with the firm of Willink and Thicknesse. In London he designed a number of buildings for University College, including the Institute of Physiology.
(source: Gray, 1985)

John Skeaping (1901–80)
Sculptor, born in South Woodford, Essex. He studied at Goldsmith's College, 1915–17, Central School of Art and Design, 1917–19, and the RA Schools, 1919–20. He worked in Italy, 1924, where he learnt stone carving and met and, in 1925, married Barbara Hepworth (divorced 1931). In 1924 he was awarded the Prix de Rome. His first major exhibition (with Hepworth) was at Alex Reid and Lefevre, Glasgow, 1928. In the same year he became a member of the London Group and, in 1932, the 7 & 5 Society. He was an Official War Artist, 1940–45, and worked in Mexico, 1949–50. He taught at the Royal College of Art from 1948 and was Professor of Sculpture, 1953–59. He exhibited at the RA from 1922–70 and was elected ARA, 1950, and RA, 1960. Skeaping executed mainly figures and animal subjects, with a particular emphasis on equine sculptures (e.g. *Blood Horse*, 1929, white pinewood, Tate Gallery).
(sources: Nairne & Serota, 1981; Spalding, 1990)

George Herbert Tyson Smith (1883–1972)
Born in Liverpool, the son of a lithographic printer and engraver, he left school early to become an apprentice letter cutter in Sefton Park, at the same time taking evening classes in clay modelling, stone carving and plaster casting at Liverpool College of Art. He studied drawing at the 'Art Sheds' under Augustus John. His career, interrupted by the First World War, resumed in 1919 and he established a successful studio, working almost wholly on Liverpool commissions and specialising in sculptural reliefs, inspired variously by classical Greece and ancient Egypt. In 1925 he moved his studio into larger premises at the Bluecoat Studios. In the 1920s he executed a number of

important war memorials in collaboration, like much of his work, with various architects: the *Liverpool Post Office War Memorial* (1924, with Professor C.H. Reilly as advisor); the *Southport War Memorial* (1927, with Grayson, Barnish and McMillan) and the *Liverpool Cenotaph* (1926–30, with Lionel Budden). He also executed a number of portraits, including a *Bust of George V* (bronze, Birkenhead Library) and the bronze busts of *George V* and *Queen Mary* either side of the Birkenhead entrance to the Kingsway tunnel. He was a member and, from 1956, President of the Sandon Studios Society. His sister was married to the Liverpool sculptor Edward Carter Preston.
(sources: Compton, 1989; Davies, 1992; WAG 1981)

Stanley Harold Smith (1907–50)
ARIBA. After training at the Northern Polytechnic he secured his first appointment with the Ministry of Works (Ancient Monuments Branch). In 1928 he joined the staff of the London County Council and at the time of his early death was second in command of a team of architects engaged on work at the South Bank, notably the Royal Festival Hall.
(sources: *Builder* [obit.], 20 January 1950; *RIBA Journal* [obit.], March 1950)

Benjamin Edward Spence (1822–66)
Born in Liverpool, he was the son of the sculptor William Spence. In 1846 he was awarded the Heywood Silver Medal by the Royal Manchester Institution for a group in clay, *The Death of the Duke of York at Agincourt*. His father's friend, John Gibson, persuaded him to send Benjamin to Rome to complete his education. In Rome he entered the studio of R.J. Wyatt, also receiving much help from Gibson himself. Spence carved the monu-ment over Gibson's grave in the Protestant cemetery in Rome. At Wyatt's death he completed his unfinished works and took over the studio, spending thereafter most of his life in Italy. He nonetheless maintained contacts with Liverpool, enjoying consistent patronage from collectors from his native town. He showed at the RA five times between 1849 and 1867, contributed one work, *Highland Mary*, to the French International Exhibition of 1855, and two works, *The Finding of Moses* (now WAG) and *Jeanie Deans before Queen Caroline*, to the International Exhibition of 1862. Spence's other work in Liverpool includes *Mrs Georgina Naylor and Children* (1855, Sudley Art Gallery) and *Psyche* (c. 1864, WAG). He died at Livorno.
(sources: *DNB*; Gunnis, 1951)

William Spence (1793–1849)
Sculptor, born in Chester and trained in Liverpool. In Liverpool he met and formed a friendship with John Gibson, who recom-mended him to his employers, Messrs. Franceys. Spence ultimately became a partner in the firm, despite entreaties for him to further his studies in Rome, following the success of his *Bust of William Roscoe* at the Liverpool Academy in 1813. He exhibited at the Liverpool Academy from 1812 until his death, and at the RA from 1821 to 1844. He was for many years Professor of Drawing at the Liverpool Academy. His works in Liverpool include busts of *George Canning* (1824) and *John Foster Snr* (1831) at the WAG, memorials to *John Gore* and to *Henry Faithwaite Leigh, George Leigh and Catherine Pulford* at the Oratory, St James's Cemetery, and the *Monument to John Bibby* at All Hallows, Allerton.
(sources: Gunnis, 1951; Sharples, 1991)

Tommy Steele (b. 1936)
Light entertainer and stage and film actor. He appeared as Arthur Kipps in both the stage (London and New York) and the film version of the musical *Half a Sixpence*. Sculpture and squash are listed as his principal recreations.
(source: *Who's Who 1994*)

Edward Bowring Stephens (1815–82)
Born in Exeter, he trained as a sculptor under E.H. Baily in London. In 1836 he won a Silver Medal from the Society of Arts for a model of a figure. In the same year, he joined the RA Schools and in the following year won the RA Silver Medal for his model, *Ajax Defying the Gods*. In 1838, he won his first commission, a *Bust of Miss Blanche Sheffield*. From 1839 to 1841 he was living and working in Italy. He returned to the RA Schools in 1842 and won the Gold Medal for his relief, *The Battle of the Centaurs and Lapithae*. In 1845 he executed two reliefs for the Summer Pavilion at Buckingham Palace and in the following year carved a marble fireplace for the same building. He executed statues of *Dr Priestly* for the University Museum, Oxford (1860) and *Leonardo da Vinci*, *Christopher Wren*, and *Sir Joshua Reynolds* for the façade of Burlington House, London (1873). He exhibited at the RA, 1838–83, and at the British Institution, 1838–53. He was elected ARA in 1864.
(source: Gunnis, 1951).

Alfred George Stevens (1817–75)
Painter, designer and sculptor, born in Dorset, the son of a house painter. He was sent to study in Italy at the age of fifteen, working with Thorvaldsen in Rome and studying the Renaissance masters. He returned to England in 1842 teaching at the Board of Trade's School of

Design and working as chief artist to a Sheffield firm of bronze- and metal-workers, before moving to London in 1852. In 1856 he won the competition for the *Wellington Monument* in St Paul's (not completed until after his death in 1912). It was beset with delays both as a result of bureaucratic indecision and Stevens' own tendency to procrastination, but the monument is nonetheless considered to be both his masterpiece and the finest sculptural monument produced in England in the nineteenth century. His other major work is the fireplace and other decorative elements for Dorchester House (c.1856; the house is demolished but the fittings are now in the V&A and the WAG). He was also a first-rate draughtsman and representative collections of his drawings are held in Cambridge, Liverpool, London (Tate), Oxford, and Sheffield.
(source: Chilvers, 1990).

Edwin Stirling (1819–67)
Born in Scotland, his clay modelling abilities were noticed when still a child and he was apprenticed to a stone carver at Darnick, following which he studied at Edinburgh School of Art. He later settled in Liverpool, first working for, and then working in partnership with, an architectural carver named Canavan. His work outside Liverpool includes the statue for Liverpool architect Edward A. Heffer's *Memorial to the Prince Consort* at Hastings (1863) and the statues on the south front of Horton Hall, Cheshire (1867). Stirling is buried in St James Cemetery, Liverpool.
(sources: Darby & Smith, 1983; Gunnis, 1951)

Thames Ditton Foundry (*fl.* 1874–1939)
One of the leading bronze foundries in the country throughout its sixty-five year history, it was established in 1874 under the name Cox &

Sons. In 1880 it became Drew & Company and in 1883, when former foundry manager James Moore took over, Moore & Company. From 1897 until 1902 it was run by A.J. Holinshead and A.B. Burton (F.J. Williamson's *Statue of Queen Victoria* at Croydon, dated 1903, is inscribed 'Holinshead & Burton'), but at the death of the former, Burton took over and the company continued to operate as A.B. Burton, until the foundry's closure in 1939.
(sources: James, 1972; personal knowledge)

William Theed the Younger (1804–91)
His father was William Theed, sculptor, of Staffordshire. He received some initial instruction in his father's studio, afterwards entering the studio of E.H. Baily and attending the RA Schools. In 1826 he went to Rome and studied under Thorwaldsen, Gibson, R.J. Wyatt and Tenerani. In response to the Prince Consort's request for designs for marble statues by British sculptors working in Rome, Gibson submitted, among others, two by Theed which were chosen and executed for Osborne House (*Psyche* and *Narcissus*, 1847). Theed returned to England in 1848 and soon established a successful practice, principally producing public statues and portrait busts. He also executed much work for the Prince Consort and, at his death in 1861, was selected by Victoria to take the death mask. Victoria continued to commission work from Theed, the most remarkable piece perhaps being *Queen Victoria and Prince Albert in Anglo-Saxon Dress*, 1868. Theed's best known work is probably the colossal group, *Africa*, for the London *Albert Memorial* (1869). He exhibited at the RA, 1824–85, at the British Institution in 1852 and 1853, and at the Great Exhibition of 1851.
(sources: *DNB*; Gunnis, 1951)

Philip Coldwell Thicknesse (see Willink & Thicknesse)

James Thom (1802–50)
Born in Lochlee, Scotland, he was, whilst still a boy, apprenticed to a local builder as an ornamental carver. In 1827, having had no formal training as a sculptor, he executed a much-praised *Bust of Robert Burns*. His ambition fired, he next attempted a couple of life-size figures, hewn out of the stone apparently without even a preliminary sketch: these were the figures, *Tam O'Shanter* and *Souter Johnnie*. After being secured for the Burns Monument at Alloway, they were sent on a tour of the country and raised much money from admission charges. The works were favourably received even in London and Thom was encouraged to produce new works – these, however, being not so well-received. In 1836 Thom had to travel to the USA in pursuit of his agent who, having taken some of Thom's work to the USA for exhibition, subsequently refused to part with the proceeds. Thom recovered his money and stayed on, settling in Newark and carrying on his career as a sculptor in stone (he executed most of the Gothic style carving for Trinity Church in New York). By the time of his death he was a wealthy man.
(source: Gunnis, 1951)

Edmund C. Thompson (1898–1961)
Born in Belfast, he enlisted with the infantry at the outbreak of the First World War and was demobilised in 1919. By this time he had married and moved to Mold in North Wales. He began teaching art in Liverpool, exhibited three times at the WAG between 1928 and 1932, and acquired a house and a studio, perhaps at 11 Cypress Street, the address from which he worked for some years in partnership with G.T.

Capstick in the firm of Thompson and Capstick (ceased business in 1939). After the Second World War, Thompson moved to London, where he was involved with Arcon, a firm of architects. He later became an architectural model maker employed by the Ministry of Housing and Local Government, for which work he was awarded the MBE in 1959.
(sources: Johnson & Greutzner, 1976; Kaylor, 1993)

Thomas Thornycroft (1815–85)
Born in Cheshire, he was six when his father, a farmer, died. He was first apprenticed to a surgeon, but proved to be ill-disposed towards the profession and his mother ultimately relented and sent him to London to study under the sculptor, John Francis. Here he met the sculptor's daughter, Mary, whom he married in 1840. After a trip to Italy he established a studio in London, but his sculptural career got off to a slow start and he seems to have spent much time exercising his enthusiasm for inventing machinery. The consolidation of his relationship with Prince Albert and Queen Victoria led to a series of commissions, however, particularly following the Prince's death when he managed to win a number of the commissions for commemorative equestrian monuments. He also executed the marble group, *Commerce*, for the London *Albert Memorial*. He seems to have been not above cutting corners occasionally – not only was there the matter of the bronze which turned out to be gun metal on the Liverpool monuments (see above, pp. 94, 97) – but his *Statue of the Second Marquess of Westminster*, 1869, for Chester, was revealed, after a piece fell off during a frost, to have been assembled from more than just the one block of marble the clients had been led to believe it was. His best

known work is the bronze group *Boadicea* on Westminster Bridge (begun in the 1850s, but cast and unveiled posthumously in 1902).
(sources: *DNB*; Gunnis, 1951)

Sir William Hamo Thornycroft (1850–1925)
Born in London, the son of sculptors Thomas and Mary Thornycroft. From 1868 he studied sculpture, firstly under his father and subsequently at the RA Schools. Then followed a period of study in Italy. On his return he assisted his father with the *Poets Fountain* (1875, formerly Park Lane). In 1875 he won the RA Gold Medal for his group, *A Warrior bearing a Wounded Youth from Battle*. His first major success was *Artemis* (shown as a plaster at the RA 1880 and commissioned in marble by the Duke of Westminster). In 1881 his RA entry, *Teucer*, was purchased by the Chantrey Trust and in the same year he was elected ARA (RA in 1888). His *Mower* (1884, WAG) and *Sower* (1886, Kew Gardens) introduced a note of contemporaneity to figures that were nonetheless ideal. Success brought with it increased demand for public monuments and statues, principal examples being *General Gordon* (1888, Victoria Embankment Gardens); *Oliver Cromwell* (1899, outside Westminster Hall); the *Gladstone Memorial* (1905, Strand) and the *Lord Curzon Memorial* (1909–13, Calcutta). Thornycroft was also responsible for the figurative friezes on John Belcher's Institute of Chartered Accountants at Moorgate in the City of London (1890–91), on which commission C.J. Allen worked as an assistant. He was knighted in 1917.
(sources: Beattie, 1983; *DNB*)

Michael Wagmüller (1839–81)
He studied at the Munich Academy, but lived and worked from 1868–74 at Richmond, Surrey,

exhibiting portrait busts, medallions and statues at the RA, 1870–74.
(sources: Thieme-Becker, 1942)

Richard Westmacott the Elder (1747–1808)
Sculptor of church monuments, architectural sculpture and chimney-pieces with classical ornaments, some of the latter being designed for Wedgwood. A number of Westmacott's chimney-pieces and architectural sculptures were executed for houses built by the architect, James Wyatt, and some of the church monuments were executed to Wyatt's designs (e.g. *Monument to the tenth Earl of Pembroke*, Wilton, Wilts.). He was the father of Sir Richard Westmacott (see below).
(sources: Gunnis, 1951; Penny, 1977)

Sir Richard Westmacott (1775–1856)
The son of Richard Westmacott the Elder (see above), he became the leading Neo-classical sculptor of heroic monuments in England. He studied under his father before going in 1793 to Italy where he became friends with Canova. By 1795 he had been elected a Member of the Academy of Florence and had won the Gold Medal of the Academy of St Luke for his bas-relief, *Joseph and his Brethren*. He returned to England in 1797 and soon established his own studio, running a flourishing practice producing statues, busts, ideal works, chimney-pieces and monuments. He exhibited at the RA from 1797–1839, was elected ARA in 1805 and RA in 1811, and was appointed Professor of Sculpture in 1827. He won commissions for several of the national monuments in Westminster Abbey and St Paul's, his most accomplished being the *Monument to Charles James Fox* (1810–23, Westminster Abbey). The success of his practice was exceeded only by that of Chantrey. Like Chantrey he owned his own foundry, thus

managing to secure many prestigious public commissions, including the colossal bronze *Achilles* (1814–22, Hyde Park) – closely modelled on one of the *Dioscuri* in Rome, it is a monument to the Duke of Wellington. Westmacott was knighted in 1837.
(sources: Busco, 1994; *DNB*; Gunnis, 1951; Whinney, 1988)

Charles E. Whiffen
Sculptor, exhibiting from 1889 to 1916 at the RA (eight times), Royal Society of British Artists (once), and the WAG (twice). In London he executed the War Memorial at Waterloo Station.
(sources: Gleichen, 1928; Johnson & Greutzner, 1976)

Francis John Williamson (1833–1920)
Born in Hampstead, he was a sculptor, principally of portrait statues and busts. He was John Bell's pupil and then, successively, apprentice and assistant to J.H. Foley. He exhibited throughout his career at the RA and leading London galleries. He was private sculptor to Queen Victoria in the 1880s and '90s, modelling portraits of most of the family, as well as being commissioned by Victoria herself to produce her Jubilee bust and, by the Royal College of Physicians, to execute her statue (the latter unveiled by Edward, Prince of Wales). In 1903 he executed a statue of Victoria for Croydon (Katherine Street) and also for Australia, India, and Rangoon, and executed the earliest statue of Victoria for Ireland. Spielmann considered his most accomplished work to be his *Memorial to Dean Milman* (St Paul's Cathedral).
(sources: *Daily Post*, 16 October 1889; Fish, 1901; Read, 1982; Spielmann, 1901; Waters, 1975; *Who Was Who 1916–1928*)

Willink & Thicknesse
The architectural partnership of William Edward Willink (1856–1924, the son of the vicar of St Paul, Tranmere) and Philip Coldwell Thicknesse (1860–1920, third son of the Bishop of Peterborough) was established in 1884. Thicknesse had been articled to Richard Norman Shaw and Willink to Alfred Waterhouse. The firm's principal works in Liverpool not covered by the present catalogue are Parr's (now National Westminster) Bank, Castle Street (1900, with Norman Shaw), Liverpool University Zoology Building, Brownlow Street (1905), the Hope Street extension to the College of Art (1910), and the Cunard Building, Pier Head (1913, with Arthur Davis).
(sources: Gray, 1985; Pevsner, 1969)

T. & W. Wills
Sculptor brothers who became specialists in the design of iron drinking fountains, to facilitate the production of which they established a close working relationship with the Coalbrookdale Iron Works. London-based (they kept a studio at Euston Road in the 1860s), they exhibited at the RA from 1857 to 1884.
(source: *Art-Journal*, 1860)

Francis Derwent Wood (1871–1926)
Born at Keswick, he studied first at the Karlsruhe School of Art, returning to England in 1887 and working as a modeller for Maw & Co and for Coalbrookdale Iron Co. He trained under Lanteri at the National Art Training School, South Kensington, and, in c.1890–92, assisted Alphonse Légros at the Slade School of Art. Sponsored by Lanteri, he entered the RA Schools in 1894 whilst working as assistant to Thomas Brock. In 1895 Wood won the Gold Medal and Travelling Studentship with

Daedalus and Icarus (plaster at Russell-Cotes Art Gallery, Bournemouth; bronze at Bristol City Art Gallery) and went to Paris. From c.1897 to 1901 he was modelling master at Glasgow School of Art. He was elected a Member of the Art Worker's Guild in 1901; ARA in 1910; RA in 1920, and was a founder member of the RBS. From 1918 to 1923 he was Professor of Sculpture at the Royal College of Art. Wood's public commissions include decorative sculpture for Glasgow Art Gallery, Kelvingrove, 1898 (won in a competition assessed by George Frampton); the kangaroo and ram group, emblematic of Australia, for Brock's *Queen Victoria Memorial* in the Mall, London; and, perhaps his most famous public sculpture, the *Machine Gun Corps Memorial*, Hyde Park Corner (unveiled 1925), a nude youth deriving from Donatello's *David*. He also produced portrait busts and ideal work and is represented in many public collections.
(sources: *DNB*; Gray, 1985; Beattie, 1983)

John Warrington Wood (1839–86)
A pupil at the School of Art at Warrington, he interpolated the name of his birthplace in to his own name to distinguish himself from two other student sculptors also called John Wood. After art school, he went to Rome, received some tuition and much influence from John Gibson, and remained in Rome for most of his working life, being elected, in 1877, to the Guild of St Luke. Nonetheless, he sent regularly to the RA, exhibiting twenty-seven times between 1868 and 1884. His main works are ideal statues, but he also received numerous commissons for portrait statues and busts. A.B. Walker was to become one of his earliest and most important patrons, his first purchase being the sculptor's *Eve* (1871). The citizens of Warrington, proud of his achievement, also

supported him with their patronage, e.g. *St Michael overcoming Satan* (1877) was executed for his home town. He died at Warrington.
(sources: *MEB*; Wilmot, 1891)

James Woodford (1893–1976)
Sculptor, born in Nottingham, the son of a lace designer. He studied at Nottingham School of Art prior to the First World War, served with the 11th Sherwood Foresters and, at the close of war, resumed his training at the Royal College of Art, where he was awarded the Prix de Rome for sculpture. He was elected ARA in 1937 and RA in 1945, exhibiting at the RA from 1926 onwards. He was also a FRBS. His public commissions include stone figures and panels for Huddersfield Library and Art Gallery (1935), the *Queen's Beasts* for Westminster Abbey (1953; now housed at Kew), the *Second World War Memorial* in the courtyard of the BMA, Tavistock Square (1954) and reliefs for Lloyds Building in Lime Street, London (1956). He was awarded the OBE in 1953.
(sources: Byron, 1981; Johnson & Greutzner, 1976; Spalding, 1990; Waters, 1975)

William Frederick Woodington (1806–93)
Principally a sculptor (he also painted), he was trained in the workshop of R.W. Sievier. He first showed at the RA in 1825 and exhibited regularly until 1882. In addition to ideal groups and reliefs of sacred and poetical subjects, he received numerous commissions for portrait busts. He submitted two sculptures to the 1844 Westminster Hall competition and was awarded second premium in the competition for the *Wellington Monument* in St Paul's Cathedral. His most important public commissions include the bronze relief, *The Battle of the Nile* (1850), for the pedestal of *Nelson's Column* in Trafalgar Square, a colossal *Bust of Sir Joseph Paxton* at Crystal Palace (1856), and the statues of explorers and navigators, plus pediment sculpture, for the Exchange Buildings, Liverpool (1867; demolished). He was, from 1851, curator of the School of Sculpture at the RA and in 1876 was elected ARA. He died at Brixton and is buried in Norwood Cemetery.
(sources: *DNB*; Gunnis, 1951)

Matthew Cotes Wyatt (1777–1862)
Both a sculptor and a painter, he was the youngest son of the architect James Wyatt. He studied at the RA and exhibited paintings there, 1803–14, his only sculptural contribution being a *Bust of King George III* in 1811. His father's influence greatly helped the start of his career, obtaining for him employment at Windsor Castle and also, perhaps, helping him win the competition for the Liverpool *Nelson Monument*, his first important commission (according to Gunnis, he also executed mural paintings inside the Town Hall). His *Cenotaph to Princess Charlotte* in St George's Chapel, Windsor (1824) was much admired and he also prepared designs for a national monument to George III showing the King driving a *quadriga* – the designs were well received but lack of funds led to its abandonment and Wyatt had to settle instead for an equestrian statue (1836, Cockspur Street, London). His most unsuccessful work is generally considered to be his *Equestrian Statue of the Duke of Wellington* (1838–46), executed for Decimus Burton's arch at Hyde Park Corner, but so reviled that it was removed to Aldershot in 1883, where it remains to this day. Wyatt's *DNB* entry comments, 'Thanks to royal and other influential patronage, Wyatt enjoyed a reputation and practice to which his mediocre abilities hardly entitled him, and he amassed considerable wealth'.
(sources: *DNB*; Gunnis, 1951).

Bibliography

1. Books, catalogues and periodicals
Anon, 'The Monuments of Our Provincial Towns: 1 – Liverpool', *The Builder* (1916) 21 January: 61–3.

Anon, 'The Monuments of Our Provincial Towns: 1 – Liverpool (continued)', *The Builder* (1916) 28 January: 81–3.

Arnolfini (1985) *Stephen Cox: We Must Always Turn South: Sculpture 1977–85* (exhibition catalogue), Bristol.

Atkinson, E. H. W., 'The Mersey Tunnel', *Architectural Review* (1934) June: 202–4.

Bayley, S. (1981) *The Albert Memorial*, London.

Beattie, S. (1975) *Catalogue of the Drawings of*

the Royal Institute of British Architects: Alfred Stevens, Farnborough.

— (1983) *The New Sculpture*, New Haven and London.

Bennett, Canon J. (1949) *Fr. Nugent of Liverpool*, Liverpool.

Beskow, I. T. (1907) *Linnéporträtt: Supplement till Tycho Tullberg*, Linnéporträtt, 1968 edn, Stockholm.

Bisson, R. F. (1965) *The Sandon Studios Society and the Arts*, Liverpool.

Blunt, W. J. W. (1971) *The Compleat Naturalist*, London.

Boorman, D. (1988) *At the Going Down of the Sun. British First World War Memorials*, York.

Borg, A. (1991) *War Memorials from antiquity to the present*, London.

Bowness, A. (ed.) (1971) *The Complete Sculpture of Barbara Hepworth 1960–69*, London.

Brack, A., 'For Art's Sake', *Lancashire Life* (1965) December, xiii: 48–51.

— 'Seventy Sculpting Years', *Lancashire Life* (1968) April, xvi: 48–51.

Buckle, R. (1963) *Jacob Epstein: Sculptor*, London.

Bury, A. (1954) *Shadow of Eros*, London.

Busco, M. (1994) *Sir Richard Westmacott, Sculptor*, Cambridge.

Cannon, R. (1904) *Historical Record of the King's Liverpool Regiment of Foot*, Enniskillen.

Carpenter, J., 'Phillip King: Sculptor of the New Generation', *University of Liverpool Recorder* (1978) lxxvi: 17–19.

— 'The University of Liverpool', in P. Curtis (ed.) (1989) *Patronage and Practice: Sculpture on Merseyside*, Liverpool.

Cave, K. (ed.) (1982) *The Diary of Joseph Farington*, vol. 7: January 1805 – June 1806,

New Haven and London.

Child, F.J. (ed.) (1882–98) *The English and Scottish Popular Ballads*, 5 vols, 1956 edn, New York.

Christie's (1993) *The Nineteenth Century* (sales catalogue), London.

City of Liverpool Public Health Congress Handbook, 1903.

Compton, A., 'Memorials to the Great War', in P. Curtis (ed.) (1989) *Patronage and Practice: Sculpture on Merseyside*, Liverpool.

Comune di Brescia (1985) *Brescia postromantica e liberty, 1880–1915* (exhibition catalogue).

Conway of Allington, Lord (1932) *Episodes of a Varied Life*, London.

Cunningham, C., and Waterhouse, P. (1992) *Alfred Waterhouse 1830–1905: Biography of a Practice*, Oxford.

Curtis, P. (1988) *Sculpture on Merseyside*, Liverpool.

— 'Liverpool Garden Festival and its Sculpture', in P. Curtis (ed.) (1989) *Patronage and Practice: Sculpture on Merseyside*, Liverpool.

Davies, P. (1992) *Liverpool Scene*, Bristol.

Darby, E., and Smith, N. (1983) *The Cult of the Prince Consort*, New Haven and London.

Darke, Jo (1991) *The Monument Guide to England and Wales*, London.

Dean and Chapter of Liverpool Cathedral (1987) *Liverpool Cathedral* (official guide book), Liverpool.

Dorment, R. (1985) *Alfred Gilbert*, New Haven and London.

— (ed.) (1986) *Alfred Gilbert: Sculptor and Goldsmith*, Royal Academy of Arts Exhibition Catalogue, London.

Eastlake, Lady (ed.) (1870) *Life of John Gibson, R.A. Sculptor*, London.

Festival Sculpture (1984) (1984 International Garden Festival, Liverpool, catalogue),

Liverpool.

Fine Art Society Ltd (1968) *British Sculpture 1850 – 1914* (exhibition catalogue), London

Fischer Fine Art Ltd (1984) *Graham Ashton: Recent Watercolours on Two Themes* (exhibition catalogue), London.

Foot, M.R.D., and Matthew, H.G.C. (eds.) (1978) *The Gladstone Diaries*, vol. 6, Oxford.

Freeman, J.M. (1990) *W.D. Caröe: His Architectural Achievement*, Manchester.

Gardiner, S. (1992) *Epstein: Artist Against the Establishment*, London.

Gosse, E., 'The Place of Sculpture in Daily Life – iii. Monuments', *The Magazine of Art* (1895): 407–10.

Gray, A. S. (1985) *Edwardian Architecture*, London.

Greene, F.J., 'St George's Hall', in R.J. van Vynckt (ed.) (1993) *International Dictionary of Architects and Architecture – 2 Architecture*, Detroit, London and Washington D.C: 404–06.

Greenwood, M., 'Victorian Ideal Sculpture', in P. Curtis (ed.) (1989) *Patronage and Practice: Sculpture on Merseyside*, Liverpool.

Grey-Edwards, A.H. (1906) *A Great Heart; or the Life of Canon Major Lester, M. A.*, London.

Gunnis, R. (1951) *Dictionary of British Sculptors 1660 – 1851*, new revised edn undated, London.

Hall, J. (1974) *Dictionary of Subjects and Symbols in Art*, rev. edn 1979, London.

Haskell, F., and Penny, N. (1981) *Taste and the Antique*, New Haven and London.

Hetherington, J.N. (ed.) (1903) *The Royal Insurance Company's Building, Liverpool*, London.

Holland, J. (1851) *Memorials of Sir Francis Chantrey*, Sheffield.

Hughes, Q. (1964) *Seaport*, London, reprinted with postscript 1993, Liverpool.

— (1969) *Liverpool*, London.

Imperial War Graves Commission (1952) *The War Dead of the British Commonwealth and Empire. The Register of the Names of those who fell in the 1939 – 1945 War and have no other Grave than the Sea. The Liverpool Memorial, Lee-on-the-Solent Air Arm Memorial, Lowestoft Naval Memorial*, London.

Jones, G. (1849) *Sir Francis Chantrey, RA, Recollections of his Life, Practice and Opinions*, London.

Jung, C.G. (1962, ed. A Jaffé 1983) *Memories, Dreams, Reflections*, London.

Kelly, A. (1990) *Mrs Coade's Stone*, Upton-upon-Severn.

Kelly, T. (1981) *For Advancement of Learning*, Liverpool.

Kettle's Yard Gallery (1985) *Dhruva Mistry: Sculpture and Drawings* (exhibition catalogue), Cambridge.

Kidson, A., 'Charlotte Mayer's "Sea Circle"', in P. Curtis (ed.) (1989) *Patronage and Practice: Sculpture on Merseyside*, Liverpool.

The King's Regiment Gallery: the story of the Regiment from 1685 to the present day (undated), Liverpool.

Knowles, L. (1988) *St George's Hall, Liverpool*, Liverpool.

Lieb, N. (1971) *München, die Geschichte seiner Kunst*, Munich.

Liverpool Heritage Bureau (1978) *Buildings of Liverpool*, Liverpool.

Lundie, R.H. (1889) *Alexander Balfour: A Memoir*, London.

McAllister, I. (1929) *Alfred Gilbert*, London.

McMorran, S., 'Alfred Stevens', *R.I.B.A. Journal* (1964) 71: 435 – 40.

MacPhee, A., 'Philip Henry Rathbone 1828–95', in P. Curtis (ed.) (1989) *Patronage and Practice: Sculpture on Merseyside*, Liverpool.

Manning, E. (1982) *Marble and Bronze: the Art and Life of Hamo Thornycroft*, London and New Jersey.

Marshall, J. (1969) *The Lancashire and Yorkshire Railway*, vol. 1, Newton Abbot.

Matthews, T. (ed.) (1911) *The Biography of John Gibson, R.A., Sculptor, Rome*, London.

Meecham, P. (1991) *The Eleven Commissioned and Purchased Sculptures on the Site of the International Garden Festival Liverpool 1984*, unpublished M.A. thesis, Leeds Polytechnic.

Mersey Tunnel Joint Committee (1934) *The Story of the Mersey Tunnel, officially named Queensway*, Liverpool

Merseyside Sculptors Guild (mission statement, undated).

The Modern Building Record, i: public buildings (1910), London.

Musgrave, C. (ed.) (1970) *Household Furniture and Interior Decoration executed from designs by Thomas Hope*, London.

National Gallery of Ireland (1975) *Catalogue of Sculptures*.

National Museum of Wales (1948) *Catalogue of Sculpture by Sir William Goscombe John, R. A., LL. D., in the National Museum of Wales*, Cardiff.

Nock, O. S. (1969) *The Lancashire and Yorkshire Railway: a Concise History*, London.

Orchard, B.G. (1893) *Liverpool's Legion of Honour*, Liverpool

Ormerod, H.A. (1953a) *The Liverpool Royal Institution*, Liverpool.

— 'Miscellany: Christopher Bushell', *The University of Liverpool Recorder* (1953b) April, ii: 10.

Ormond, R. (1973) *Early Victorian Portraits* (National Portrait Gallery), London.

Palgrave, F.T. (1866) *Essays on Art*, London and Cambridge.

Palmer, A. (1962) *The Penguin Dictionary of Modern History*, 2nd edn 1983, London.

Parkes, K., 'Modern English Carvers. IV – H. Tyson Smith', *Architectural Review supplement* (1927) October: 154–55.

Pearson, F. (1979) *Goscombe John at the National Museum of Wales* (exhibition catalogue), Cardiff.

Pecht, F. (1888) *Geschichte der Münchner Kunst im 19 Jahrhundert, Verlagsanstalt für Kunst und Wissenschaft*, Munich.

Penny, N., 'Grand and National Obsequies', *Country Life* (1976) 26 August: 547–48.

— (1977) *Church Monuments in Romantic England*, New Haven and London.

— 'English Sculpture and the First World War', *Oxford Art Journal* (1981), November, vol. 4, no. 2: 36–42.

Pevsner, N. (1969) *South Lancashire* (The Buildings of England), Harmondsworth.

Picton, Sir J.A. (1875) *Memorials of Liverpool Historical and Topographical*, revised edn 1903, 2 vols, London and Liverpool.

Picton, J.A. (1891) *Sir James A. Picton, a Biography*, London and Liverpool.

Pike, W.T. (ed.) (1911), *A Dictionary of Edwardian Biography: Liverpool*, reprinted 1987, Edinburgh.

Poole, S.J. (1994) *A Critical Analysis of the Work of Herbert Tyson Smith, Sculptor and Designer*, unpublished PhD. thesis, University of Liverpool.

Rathbone, E.F. (1905) *William Rathbone: a Memoir*, London.

Read, B. (1982) *Victorian Sculpture*, New Haven and London.

— 'From Basilica to Walhalla', in P. Curtis (ed.)

(1989) *Patronage and Practice: Sculpture on Merseyside*, Liverpool.

Read, G. (1976) *The Liver Bird* (Merseyside Maritime Museum information sheet).

'Reconciliation' (unveiling ceremony brochure), 1990.

Reilly, C.H. (1921) *Some Liverpool Streets and Buildings in 1921*, Liverpool.

— (1923) 'A Note on the Architecture of Liverpool' in Holt, A. (ed.) *Merseyside: a Handbook to Liverpool and District prepared on the occasion of the Meeting of the British Association for the Advancement of Science in Liverpool, September, 1923*, Liverpool and London.

— 'Some Liverpool Monuments' *The Liverpool Review* (1927a) February: 1–5.

— 'St George's Hall, Liverpool', *Country Life* (1927b) 23 July: 127–31.

— 'Mainly about Liverpool – a Causerie', *The Liverpool Review* (1929) February: 43–6

Report of the Committee for Superintending the Erection of the Monument to the Memory of the Late Right Honourable Vice-Admiral Lord Viscount Nelson, in the Area of the Liverpool Exchange (1823), Liverpool.

Richardson, A. (1990) *Well, I Never Noticed That!*, Liverpool.

Roberts, H.D. (1909) *Hope Street Church, Liverpool, and the Allied Noncomformity*, Liverpool.

The Royal Academy Illustrated, 1916.

Scottish Arts Council (1981) *Phillip King 12 Sculptures 1961–1981* (exhibition catalogue).

Sharples, J. (1991) *The Oratory, St James's Cemetery, Liverpool: a guide to the building and its monuments* (NMGM catalogue), Liverpool.

Shaw, C.F. (1971) *My Liverpool*, London.

Silber, E. (1986) *The Sculpture of Epstein*, Oxford.

— 'Epstein's Liverpool Colossus', in P. Curtis (ed.) (1989) *Patronage and Practice: Sculpture on Merseyside*, Liverpool.

Smiles, S. (1857) *The Life of George Stephenson*, London.

Stamp, G., 'Architectural Sculpture in Liverpool', in P. Curtis (ed.) (1989) *Patronage and Practice: Sculpture on Merseyside*, Liverpool.

Stannus, H. (1891) *Alfred Stevens and his Work*, London.

Stevens, T., 'Roman Heyday of an English Sculptor', *Apollo* (1971) xciv, September: 226–31.

— 'George Frampton', in P. Curtis (ed.) (1989a) *Patronage and Practice: Sculpture on Merseyside*, Liverpool.

— 'Sculptors working in Liverpool in the early nineteenth century', in P. Curtis (ed.) (1989b) *Patronage and Practice: Sculpture on Merseyside*, Liverpool.

Stirling, A.M.W. (1954) *Victorian Sidelights: from the papers of the late Mrs Adams-Acton*, London.

Strachan, W.J. (1984) *Open Air Sculpture Britain*, London.

Tate Gallery Illustrated Biennial Report 1986–88 (1988), London.

Tate Gallery Liverpool (1986) *Events Summer 1986* (exhibition catalogue), Liverpool.

Touzeau, J. (1910) *The Rise and Progress of Liverpool from 1551 to 1835*, 2 vols, Liverpool.

Towndrow, K. R. (1939) *Alfred Stevens*, London.

— (1951) *Alfred Stevens*, Liverpool.

The Turner Home (brochure)

Victoria & Albert Museum (1936) *Models and Designs by Sir Alfred Gilbert R. A.*, London.

Waddington Gallery (1984) *Nicholas Pope* (exhibition catalogue), London.

Walker Art Gallery (1960) *Liverpool Academy of Arts: 150th Anniversary* (exhibition catalogue).

— (1965) *Industry and the Artist* (exhibition catalogue).

— (1968) *Early English Drawings and Watercolours*.

— (1975) *Annual Report and Bulletin of the Walker Art Gallery Liverpool 1974–5*, vol. v.

— (1977) *Foreign Catalogue*, 2 vols, text and plates.

— (1981) *The Art Sheds 1894–1905* (exhibition catalogue).

— (1984a) *The Art of the Beatles* (exhibition catalogue).

— (1984b) *Dumb Reminders* (exhibition catalogue).

— (1984c) *Supplementary Foreign Catalogue*.

— (1988) *Women's Works* (exhibition catalogue).

Walker, R. (1985) *Regency Portraits* (National Portrait Gallery, 2 vols) London.

Waller, P.J. (1981) *Democracy and Sectarianism: a political and social history of Liverpool 1868 – 1939*, Liverpool.

Watkin, D. (1974) *The Life and Work of C. R. Cockerell, R.A.*, London.

Whitfield, G., 'Liverpool Artists. No. 1 – Herbert Tyson Smith', *Liverpool Review* (1927) ii, September: 306–09.

Whittick, A. (1946) *War Memorials*, London.

Whitty (1871) *Whitty's Guide to Liverpool*, Liverpool.

Willett, J. (1967) *Art in a City*, London.

Wilmot, T., 'John Warrington Wood, Sculptor', *The Magazine of Art* (1891) xiv:136–40.

Wynne-Davies, M. (ed.) (1989) *Bloomsbury Guide to English Literature*, London.

Yarrington, A., 'Nelson the Citizen Hero: State and Public Patronage of Monumental Sculpture 1805–18', *Art History* (1983) vi,

September: 315 – 29.
— (1988) *The Commemoration of the Hero 1800–1864: Monuments to the British Victors of the Napoleonic Wars*, New York and London.
— 'Public Sculpture and Civic Pride 1800 – 1830', in P. Curtis (ed.) (1989) *Patronage and Practice: Sculpture on Merseyside*, Liverpool.
Yarrington, A., Lieberman, I.D., Potts, A., and Baker, M. (1994) *An Edition of the Ledger of Sir Francis Chantrey, R.A., at the Royal Academy, 1809–1841*, Walpole Society 1991/92, lvi.
Zimmern, H. 'A Sculptor's Home', *Magazine of Art* (1883) vi: 512–18.

2. Liverpool Public Library Local Record Office sources

(a) Corporation manuscripts:

Canning Memorial Meeting and Committee Minute Book (352 MIN 13/1/1)
Council Minute Books (352 MIN/COU II)
— 1/6, September 1850 – November 1853.
— 1/7, November 1853 – November 1856.
— 1/8, December 1856 – March 1859.
— 1/9, April 1859 – July 1861.
— 1/10, July 1861 – August 1863.
— 1/13, November 1865 – July 1866.
— 1/15, August 1867 – October 1868.
— 1/16, October 1868 – January 1870.
— 1/17, February 1870 – August 1871.
— 1/19, October 1873 – October 1875.
— 1/20, November 1875 – August 1877.
— 1/23, June 1880 – November 1881.
— 1/24, December 1881 – March 1883.
— 1/25, April 1883 – July 1884.
— 1/26, August 1884 – January 1886.
— 1/27, January 1886 – June 1887.
— 1/28, June 1887 – January 1889.
— 1/29, February 1889 – April 1890.

— 1/31, November 1891 – February 1893.
— 1/32, February 1893 – August 1894.
— 1/33, September 1894 – February 1896.
— 1/41, April 1903 – March 1904.
— 1/42, April 1904 – January 1905.
— 1/45, December 1906 – November 1907.
— 1/53, April 1920 – April 1922.
Finance Committee Minute Books (352 MIN/ FIN II)
— 1/7, April 1855 – March 1858.
— 1/8, March 1858 – January 1861.
Finance and Estate Committee Minute Books, (352 MIN/FIN II)
— 1/12, November 1865 – March 1867.
— 1/14, February 1868 – February 1869.
— 1/15, February – October 1869.
— 1/16, October 1869 – June 1870.
— 1/17, June 1870 – May 1871.
— 1/21, June 1874 – November 1875.
— 1/22, November 1875 – December 1876.
— 1/23, December 1876 – December 1877
— 1/24, December 1877 – December 1878.
— 1/25, December 1878 – February 1880.
— 1/27, March 1881 – April 1882.
— 1/28, April 1882 – April 1883.
— 1/29, May 1883 – April 1884.
— 1/30, April 1884 – February 1885.
— 1/31, February – October 1885.
— 1/32, October 1885 – May 1886.
— 1/33, May 1886 – February 1887.
— 1/34, February – November 1887.
— 1/35, November 1887 – July 1888.
— 1/36, July 1888 – April 1889.
— 1/38, January – November 1890.
— 1/41, May 1892 – February 1893.
— 1/42, February – November 1893.
— 1/43, November 1893 – July 1894.
— 1/44, July 1894 – March 1895.
— 1/45, March – November 1895.
— 1/47, July 1896 – April 1897.
Finance Committee Minute Books (352

MIN/FIN II),
— 1/49, November 1897 – January 1899.
— 1/50, January 1899 – April 1900.
— 1/51, April 1900 – June 1901.
— 1/52, June 1901 – September 1902.
— 1/53, September 1902 – October 1903.
— 1/54, October 1903 – October 1904.
— 1/55, November 1904 – November 1905.
— 1/56, December 1905 – December 1906.
— 1/57, January 1907 – March 1908.
— 1/58, March 1908 – June 1909.
— 1/61, September 1911 – October 1912.
— 1/62, November 1912 – October 1913.
— 1/64, November 1914 – February 1916.
— 1/65, February 1916 – July 1917.
— 1/67, January – November 1919.
— 1/68, November 1919 – November 1920.
— 1/69, December 1920 – February 1922.
Law Courts and St. George's Hall Committee Minute Books (352 MIN/LAW)
— 1/1, 6 May 1840 – 4 July 1849.
— 1/2, July 1849 – January 1856.
— 1/3, 11 January 1856 – 5 October 1864.
— 1/4, October 1864 – October 1866.
Library, Museum and Education Committee Minute Book (352 MIN/LIB)
— 1/6, July 1864 – November 1867.
— 1/7, December 1867 – March 1870.
— 1/8, March 1870 – April 1872.
— 1/10, October 1874 – July 1876.
Parks and Gardens Committee Minute Book (352 MIN/PAR)
— 1/23, October 1902 – February 1905.
Parks Committee Minute Books (352 MIN/PAR)
— 1/24, Mar 1905 – Jun 1907.
— 1/25, July 1907 – November 1909.
Proceedings of Liverpool City Council 1949–50, vol. 1
St. George's Hall Management Special Sub-Committee Minute Book (352 MIN/FIN II)

vol. 14/1, April–November 1877, October 1895.

Special and Sub-Committees Minute Book (352 MIN/SPE) 1/2.

Special and Sub-Committees Minute Book (352 MIN/SPE)
— 1/3, March 1854 – October 1866.

Minutes of the Sub Building Committee ...in respect of the Municipal Offices (352 MIN/SPE)
— 1/3, March 1854 – October 1866.

Treasurer's Department Ledger (352 TRE)
— 1/1/3, 18 January 1734 – 10 October 1759 (unpaginated).
— 1/1/11, 31 August 1851 – 31 December 1891.

(b) other manuscripts, etc:

Binns Collection, iii: 97 (Hf 942.72 BIN)

Documents Connected with the Opening of the Brown Library (ed. A. Hume), Liverpool, 1861, unpaginated (Hf 027.41 HUM)

Dod, U. P. (1950) *Jet of Iada, D.M. M.F.V*, (unpaginated typescript) (Hq 636. 7 JET)

George Herbert Tyson Smith Archive (archive no. 2765)

Joseph Mayer Papers, 1860 – 1869 folder, Joseph Clarke Correspondence (920 MAY)

Photographs of Statues and Monuments in Liverpool, prepared in Reference Library Liverpool, 1922 (Hf 731.732 PHO)

Photographs of War Memorials in Liverpool and District, prepared in Reference Library Liverpool, 1923 (Hf 940.465 PHO)

Records relating to the statue of King George III, 1809 – 1822 (731 GEO)

(c) newscuttings:

Cuttings Historical and Topographical Relating to Liverpool (FQ 1003)
— vol. 3, 1901–2.
— vol. 5, 1903–4

— vol. 6, 1905
— vol. 13, 1912
— vol. 14, 1913
— 1916
— 1921
— 1928

Documents and papers connected with laying the foundation stone, the opening ceremony...of the Walker Art Gallery, 1877 (Hf 708.5 DOC)

Liverpool Cenotaph: Memorial Volume (Hf 942.7213 CEN)

Liverpool's Town Halls, 2 vols (Hf 942. 7213 HAL)

Mersey Road Tunnel (4 vols of presscuttings and related material prepared in the library) (Hf 388.11 CUT)

St. George's Hall: Collection of Illustrations, Photographs, Newscuttings..., prepared in the Library, (Hf 942.7213 GEO)

Sefton Park – Newscuttings 1929 – 1958 (Hq 712.54 SEF)

Town Clerk's Newscuttings (352 CLE/CUT)
— 1/4, 9 September 1869 – 9 May 1870.
— 1/5, 7 February – 1 November 1870
— 1/6, 4 November 1870 – 18 July 1871
— 1/8, 25 June 1872 – 5 June 1873
— 1/9, 6 June 1873 – 27 October 1874
— 1/10, 28 October 1874 – 21 October 1875
— 1/11, 21 October 1875 – 14 November 1876
— 1/12, 15 November 1876 – 11 December 1877
— 1/13, 8 December 1877 – 31 March 1879
— 1/14, 2 April – 27 December 1879
— 1/18, 1 January – 20 August 1885
— 1/20, 23 October 1886 – 16 December 1887
— 1/21, 17 December 1887 – 6 February 1889
— 1/22, February 1889 – June 1890
— 1/23, 6 June 1890 – 12 December 1892
— 1/25, 1 January 1894 – 20 June 1895
— 1/28, 6 June 1900 – 4 February 1902

— 1/30, 12 February 1903 – 14 September 1904
— 1/31, 16 September 1904 – 26 September 1906
— 1/32, 27 September 1906 – 16 November 1907
— 1/35, 10 February 1910 – 25 February 1911
— 1/36, 25 February 1911 – 2 November 1911
— 1/37, 3 November 1911 – 31 October 1912
— 1/38, 1 November 1912 – 1 July 1914
— 1/62, 6 February – 16 July 1936
— 1/64, 26 November 1936 – 9 April 1937
— 1/65, 9 April – 16 September 1937
— 1/70, 18 March – 8 September 1939

3. Royal Academy of Arts Library, London

John, Sir William Goscombe, *Sketchbook* (621. I) undated, with letter from P. Corkhill (1912) inserted, with sketches on reverse.

4. University of Liverpool archives sources

(a) Minute books

New Arts Building Committee Minute Book (S. 278)

Chadwick Physics Laboratory Building Sub-Committee Minute Book (S.174)

Minutes of Meetings of the Engineering Committee (5150)

Fine Arts Sub-Committee Minutes, no. 1 (S3936)

New Library Building Committee Minute Book (5149)

Mathematics Building Sub-Committee Minute Book (S2936)

New Physics Building Sub-Committee Minute Book (S.3072)

Senate House Building Sub-Committee Minute Books (S497) and (3073)

Senate Minutes 1889–97 (51/2)

Sydney Jones Library Sub-Committee Minutes

(0733)
Thompson-Yates Laboratories Building Committee Minute Book (5149)
University Lecture Room Building Sub-Committee Minute Book (S.2945)
University of Liverpool. Minutes of Special Committees of Council (S.297)
Veterinary Building Sub-Committee Minute Book (S.175)

(b) Newscuttings
Newspaper Cuttings 1922 to 1928 (S.2517)

(c) Official opening brochures
The Chadwick Laboratory and the Laboratories of Civil Engineering and Building Science (official opening brochure), 1960
A Record of the Opening of the Harold Cohen Library..., 1938
Building for Mathematics and Oceanography (official opening brochure), 1961
Faculty of Veterinary Science: The New Building in Liverpool, 1961
The Walker Engineering Laboratories Opening Ceremony (commemorative album), 1889

(d) other sources
The Five-Panel Mural in the Building for Mathematics and Oceanography, 1961.
Private Letter Book, 1896 (S2444).
University of Liverpool (undated, though clearly 1938) *William Garmon Jones* (commemorative booklet).

(e) Cunard Steamship Company Archives
Minutes of the Executive Committee of the Cunard Steamship Co. regarding the War Memorial outside the Cunard Building at Pierhead (D42/B4/50-58).

5. WAG archives sources
Crawford, A. (1977) *The Bromsgrove Guild* (typescript of lecture).

6. Sources used only for biographies:
Arts Council of Great Britain (1983) *The Sculpture Show* (exhibition catalogue), London.
Avery Obituary Index of Architects (1963) 2nd edn 1980, Boston, Mass.
Bénézit, E. (1976) *Dictionnaire des Peintres, Sculpteurs,...*, Paris.
Byron, A. (1981) *London Statues*, London.
Cherry, B., and Pevsner, N. (1983) *London 2: South* (The Buildings of England), London.
Chilvers, I. (ed.) (1990) *The Concise Oxford Dictionary of Art and Artists*, Oxford.
Collins, L.M., and Mabunda, L.M. (eds), *The Annual Obituary 1993*, Detroit, London and Washington DC.
The Concise Dictionary of National Biography (1992) 3 vols, Oxford.
Dictionary of National Biography, 63 vols., London, 1885–1900.
— *Supplement*, 3 vols., London, 1901.
— *Second Supplement*, 3 vols., London, 1912.
— *Supplement 1901–1911*, London, 1912.
— *1922–1930*, London, 1937.
— *1951–1960*, London, 1971.
— *1961–1970*, Oxford, 1981.
— *1971–1980*, Oxford, 1986.
Dixon, R., and Muthesius, S. (1978) *Victorian Architecture*, 2nd edn 1985, London.
Fish, A., 'Her Majesty's Private Sculptor: Mr F. J. Williamson', *The Magazine of Art* (1901): 252–54.
Fleming, J., Honour, H., and Pevsner, N. (1966) *Dictionary of Architecture*, 4th edn 1991, London.
Gleichen, Lord E. (1928) *London's Open-Air Statuary*, London.

Gregory, R.L. (ed.) (1987) *The Oxford Companion to the Mind*, Oxford.
James, D., 'The Statue Foundry at Thames Ditton', *Foundry Trade Journal* (1972) 7 September: 279–89.
Johnson, J., and Greutzner, A. (1976) *The Dictionary of British Artists 1880–1940*, Woodbridge.
Kaylor, L. (1993) information sheet accompanying an exhibition of photographs of works by Edmund C. Thompson held at the Philharmonic Hall, 1993.
Kjellberg, P. (1987) *Les Bronzes du XIXe Siècle: Dictionnaire des Sculpteurs*, Paris.
Modern English Biography (1892–1901),1965 edn, vols 1–3, London.
— *Supplement* (1908–21), 1965 edn, vols 4–6, London.
Nairne, S., and Serota, N. (eds.) (1981) *British Sculpture in the Twentieth Century*, London.
Pevsner, N., and Williamson, E. (1984) *Leicestershire and Rutland* (The Buildings of England), London.
Redgrave, S. (1878) *A Dictionary of Artists of the English School*, London.
Spalding, F. (1990) *Twentieth-Century Painters and Sculptors* (Dictionary of British Art, vol. vi), Woodbridge.
Thieme, U., and Becker, F. (1942) *Allgemeines Lexikon der Bildenden Künstler*, xxxv, Leipzig.
Waters, G.M. (1975) *Dictionary of British Artists Working 1900–1950*, Eastbourne.
Who Was Who 1897–1915 (1929) London.
— *1916–1928* (1929), 4th edn 1967, London.
— *1929–1940* (1941), 2nd edn 1967, London.
— *1961–1970* (1972) London.
Wilmot, T., 'John Warrington Wood, Sculptor', *The Magazine of Art* (1891): 136–40.
Wodehouse, L. (1978) *British Architects, 1840–1976*, Detroit.